CLOTH
THAT
CHANGED
THE
WORLD

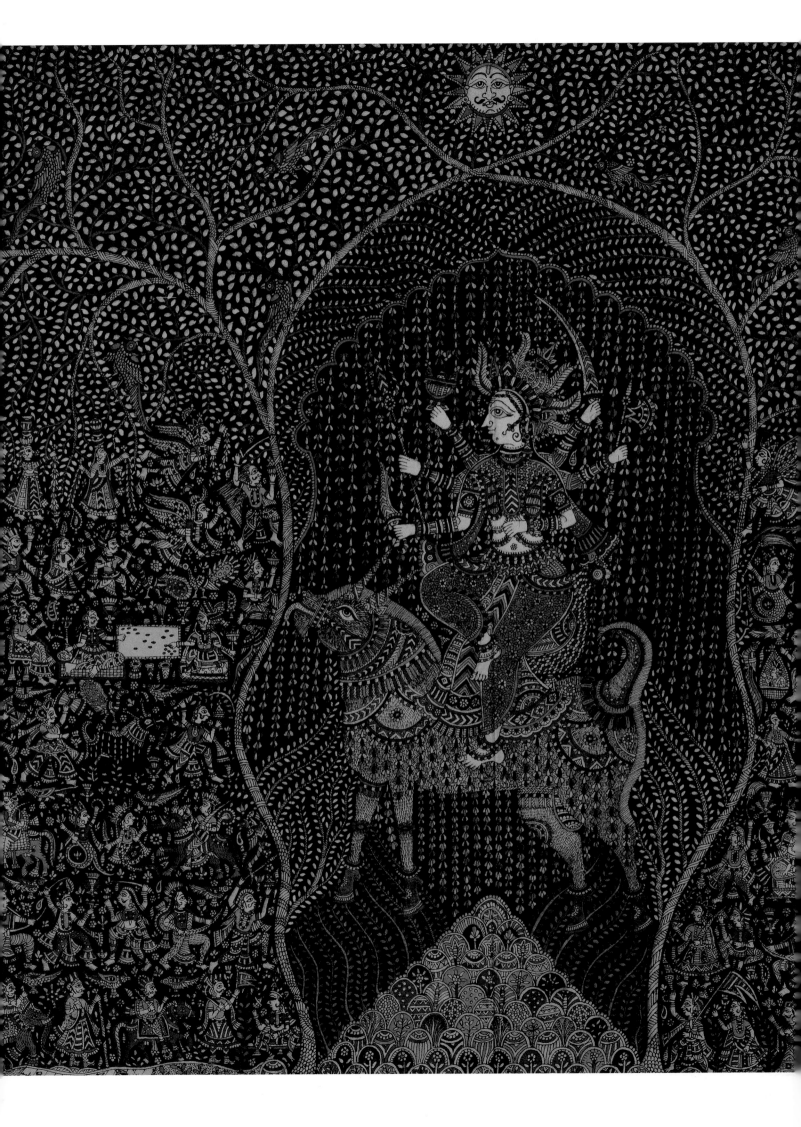

CLOTH
THAT
CHANGED
THE
WORLD

The Art and Fashion of Indian Chintz

EDITED BY SARAH FEE

ROM Yale

DISTRIBUTED BY YALE UNIVERSITY PRESS,
NEW HAVEN AND LONDON

CONTENTS

FOREWORD

The tradition of Indian chintz has yielded a wealth of beautiful objects over the millennia. Since at least the tenth century, the printed or painted cotton textiles, renowned for their brilliant colours and intricate patterns, have been highly sought around the globe. Chintz transformed art and fashion, revolutionized production and trade, and reshaped the world.

This publication traces the expansive story of chintz from its origins in the Indian subcontinent, through the impact of its global demand, to its present-day influence on contemporary fashion. *Cloth That Changed the World* draws from the chintz collection at the Royal Ontario Museum—a collection that ranks among the best on a global basis. The breadth of the chintz collection is mirrored by the ROM's entire collection of fashion and textiles, which is one of the largest and most comprehensive in the world.

For centuries, Indian chintz has been highly coveted for elegant dress and lavish furnishings. Exotic scenes and floral patterns adorned chintz wall-hangings, robes and gowns for the Asian, African, and European elites, while the less affluent settled for more modest accessories. Indian chintz became so popular that it sparked protests from European textile manufacturers, leading to protectionist tariffs and bans and a redirection of exports. To meet the significant worldwide demand, the British East India Company increasingly colonized India's textile-producing centres, while mechanization and more efficient cotton spinning, weaving, and printing techniques contributed to the Industrial Revolution.

Sarah Fee, ROM curator and the editor of this book, has assembled a group of leading voices on textile history to bring the story of chintz to life within these pages. As Fee has said, "The world would be a drab place without India," and this book details the profound influence the country has had on the fashion mores of South Asian and Western cultures. Today, there is a resurgence in the popularity of this extraordinary textile, recognized in fine arts circles and couture design for its beauty and craftsmanship.

The ROM celebrates this renaissance with this publication and the ROM-original exhibition *The Cloth that Changed the World: India's Painted and Printed Cottons* (April 4, 2020 to September 27, 2020). The essays that follow explore the uniqueness of Indian chintz, its meticulous techniques, and its global reverence. Each essay in this volume lends a distinct perspective on chintz, from ancient times to its very vibrant present. Along the way, readers get a unique—and elegantly decorated—lens through which to understand historical patterns of supply, demand, and global economics.

Cloth that Changed the World is the result of the extensive and innovative research of its contributors—culminating in a book that delights the eye and opens the mind.

Josh Basseches
Director & CEO, Royal Ontario Museum

PREFACE

This important book, and the exhibition that goes with it, displays extraordinary surviving examples of these cottons—especially the exquisitely painted, printed, and dyed chintzes that were prized throughout Asia and Africa and became all the rage in seventeenth-century Europe. It tells the story of the technical ingenuity and creative imagination of South Asian artisans and situates their story and the story of the cloth they spun, wove, painted, and dyed across the millennium-long history of trade, consumption, empire, and capitalism. Viewing these cottons will leave you awed by their extraordinary beauty, understanding the story of how they were made will recalibrate your thinking about history.

Cotton manufacturing was the world's largest industry for almost a thousand years. Until the nineteenth century, the heart of that industry beat on the Indian subcontinent. Indian farmers grew remarkable quantities of cotton, the subcontinent's highly skilled artisan workers spun and wove the fiber into light and sturdy cloth, and then it was painted, printed, and dyed in the most long-lasting and vibrant colours manufactured anywhere until the late nineteenth century brought the advent of synthetic dyes. The cloth then traveled to the far-flung corners of the world, into South East Asia, all along the African coast, into the Arab world and, in small quantities, to Europe. In Cairo and Rome, on Java and in Isfahan, these Indian textiles were treasured; anyone who saw them recognized the wealth and power of their owner. Chintz was a global commodity long before the idea of globalization entered any language, and its influence can be seen in the work of artisans producing Japanese *yuzen*, Indonesian *batiks*, and Alsatian chintz.

Perhaps surprisingly, these textiles were also at the heart of some of the changes that would make the modern industrial world—and many of the inequalities that have come to characterize it. European rulers and merchants had long known that the world's manufacturing center was in the East, and they very much wanted access to its wares, especially Indian textiles. They were tired of having to depend on Ottoman and Arab middlemen who gathered cottons in Baghdad, Istanbul, and Cairo for shipment to European markets. By the fifteenth century, European rulers and merchants were actively searching for sea routes to India that they hoped would emancipate them from their dependence on the Islamic world. In 1492, Christopher Columbus landed in what he believed to be India and immediately set out to search for the fabulous Indian textiles that he had known from Genoa, his hometown. When he encountered great quantities of cotton and cloth—his diary described islands "full of ... cotton"—his belief that he had indeed landed in India was confirmed.[1]

While Columbus, as we know, was mistaken, Vasco da Gama successfully reached the port of Calicut on India's West coast in 1498, returning not just with highly desired spices, but some of India's fabulous cottons. This was the beginning of a trade that was often violent and continuously growing and that climaxed a hundred years later with the establishment of various European East India Companies that would bring millions of pieces of cloth to Europe, finding ever more appreciative consumers there—first among the elites, then among

the expanding middle class. These companies came to understand the enormous power that having greater control over the cotton trade brought them: Indian cottons allowed them to acquire spices in South East Asia, elephant tusks on the coast of east Africa, and enslaved captives on that continent's western edges— captives that now became essential for working the newly captured lands in the Americas, first and foremost the West Indies (the very lands Columbus had thought of as India).

So great and so valuable was the market for Indian cloth, that European entrepreneurs also tried to insert themselves into its production, achieving modest success in India. They were more successful in Europe, where they built a vast proto-industrial network in which farmers spun cotton in their cottages, then wove it—mixed with linen—into fabrics that were printed, painted, and dyed in mostly urban workshops. But the quality was far below Indian standards, and the limited supply of raw cotton and the difficulties of coordinating production among thousands of independent farmers spinning and weaving across remote hamlets made it hard to expand.

Knowing that the world market for cottons was virtually limitless, European entrepreneurs began to recast the world's cotton industry, a truly audacious move that catapulted them beyond their ever more central role in global cotton networks and deep into the world of production.

Their first move, in the early eighteenth century, was to expand the production of raw cotton in places they controlled, especially the West Indies, where they applied the lessons of the slave-driven sugar system to cotton. Then at mid-century, they focused their energies on cutting labour costs for domestic cotton production by increasing their workers' efficiency and exerting greater control over them. English artisans, driven by the enormous markets for cottons, tinkered with ever more elaborate machines, and when they succeeded—two important steps were the spinning jenny invented by James Hargreaves in 1764 and Richard Arkwright's waterframe in 1768—it took much less labour power to spin yarn. This allowed the English to finally compete with South Asian producers—on price, that is. Quality was still a problem. Instead of workers working unsupervised in their homes, they laboured in central locations where they could be closely supervised. The industrial world that we know had begun to take shape—and we should pause for a moment to acknowledge that it all started with cotton.

At the same time, European investors and artisans began to pay greater attention to the superior craftsmanship of Indian artisans, especially the printers, painters and dyers. They travelled to the Indian subcontinent, observed these highly skilled workers and wrote lengthy treatises about the processes they employed—lessons they eventually applied to production processes in Europe. Slowly, they began to match the quality of most Indian textiles, including chintz, even though some of the finest made-in India fabrics remained without competition well into the nineteenth century.

By then, building upon their prior domination of cotton networks and intercontinental trade, Europeans had turned the world's most important manufacturing industry upside down. They had appropriated Asian technologies, deployed enslaved African labour in the Americas to plant and pick cotton, built a radically more efficient production site and sent these ever more plentiful cotton fabrics into the markets of the world.

It was this system of production, embedded in these kinds of relationships and these kinds of hierarchies, that would come to characterize the modern world. The world we recognize today had its origins in the growing and transformation of a fluffy white fiber into a vast range of textile products, including the spectacular chintzes you will encounter in this volume.

Cloth That Changed the World and the accompanying exhibition at the Royal Ontario Museum display works of great technical skill, artistic sensibility, and stunning beauty. But the chintzes also tell a story that is much larger, and often much less pleasant—a tale of armed trade, colonialism, slavery, and the dispossession of native peoples.

In fact, this book and the exhibition undermine Eurocentric notions about the world. When we think about the contemporary world in general, and globalization in particular, we too often imagine it as emanating from the West and unique to it. This exhibition shows that these global connections are neither new nor of solely Western origin. The story of chintz brings a fresh timeframe to the story of the making of the modern world, as well as a new set of actors—the Indian spinners, weavers, textile printers, and dyers who made these extraordinary pieces of cloth and against many odds transmitted their knowledge and skills into contemporary times. As we look at their work, we should pause for a moment to appreciate them not just for their remarkable skills, but also for a subtler message that their works transmit—if we listen: The world we inhabit is the result of the creativity and hard work of all the world's people, even if the structures of the global economy, with its winner and losers, often obfuscates that fact.

Sven Beckert
Laird Bell Professor of History, Harvard University

1 Quotation from Christopher Columbus, November 4, 1492, *The diario of Christopher Columbus's first voyage to America: 1492–1493*, abstracted by Bartolomé de las Casas, transcribed and translated into English, with notes and a concordance of the Spanish, by Oliver Dunn (Norman: University of Oklahoma Press, 1989), 131–135. See also the entries of 16 October, 3 November and 5 November, 1492, 85–91, 131, 135.

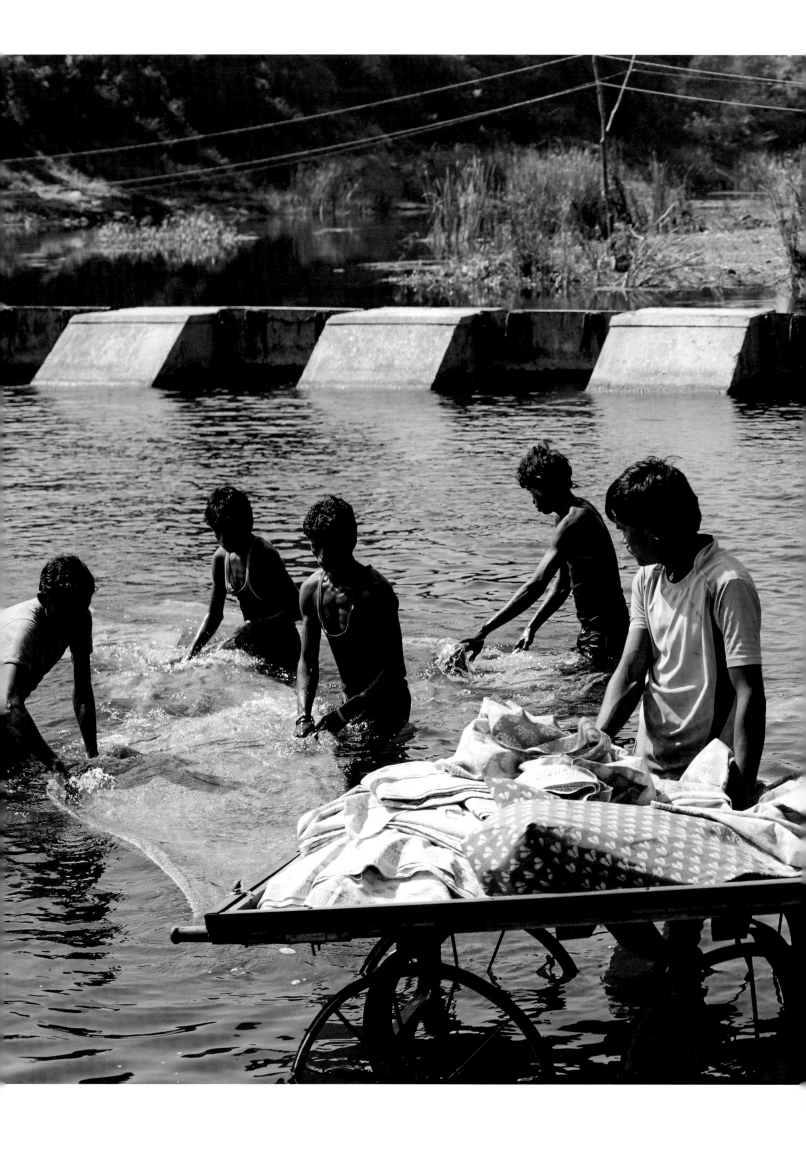

ACKNOWLEDGEMENTS

I t takes a large village to tell the big story of Indian chintz from early times to the present. Thanks are due first to this book's seventeen authors, who generously shared their deep knowledge and wide networks. Many travelled far distances to attend a workshop in Toronto on the Royal Ontrio Museum's Indian chintz collection; several valiantly delivered essays under tight deadlines. ROM curators Deepali Dewan (South Asian Art & Culture), Deborah Metsger (Botany) and Alexandra Palmer (Fashion & Textiles) acted as advisors to the accompanying exhibition *Cloth that Changed the World: India's Painted and Printed Cottons*, embracing the challenge of a multidisciplinary approach, and contributing key ideas. For several decades, Palmer has studied and developed ROM chintz holdings, and was a key contributor to this present project. Exhibition external advisors Ruth Barnes and Eiluned Edwards, as well as Rosemary Crill, Rajarshi Sengupta, and Philip Sykas, generously provided additional support and guidance. The group wishes to recognize ROM volunteer Jane Liu for her gracious assistance of many kinds.

ROM CEO Josh Basseches and Deputy Director of Research & Collections Mark Engstrom enthusiastically supported the project from its inception, with Deputy Director of Engagement Jennifer Wild Czajkowski, Vice President of Exhibitions & Project Management Lory Drusian, and Head of Exhibitions & Interpretive Planning Tamara Onyshuk expertly guiding the exhibition to life. Many teams and individuals at the ROM devoted their full talents to bringing stories to life. Fashion & Textiles technicians Kristiina Lahde and Karla Livingston deeply invested themselves in the project, and together with Assistant Curator Anu Liivandi, brilliantly oversaw complicated information management, photography, and mounting of fragile masterworks to highlight their true splendour; special help was provided by Karen Donaldson and Stephanie Kean. Textile conservators Chris Paulocik and Anne Marie Guchardi brought their impeccable professionalism and good cheer to skillfully conserving pieces which had not been displayed in fifty years, further initiating testing of dates and dyes, and creatively solving problems related to display and mounting.

The Exhibition core team—Luciana Calvet, Kendra Campbell, Steven Laurie, Daniela Rupolo, and Rachel Wong—masterfully translated ideas into a compelling visual experience. Further support came from Stephanie Allen, Nur Bahal, Jenna Cosentino, Mariano Galati, Erin Kerr, Richard Lahey, Diana Lu, Connie Macdonald, Mary Montgomery, Dominique Picouet, Sandhya Reguraman, Oleg Sokruto, Anne Vranic, Tricia Walker, and Nicola Woods. Brian Boyle, Tina Weltz, and Wanda Dobrowlanski of ROM's Ivey Imaging Centre took more than 3,000 images in preparation of the catalogue and exhibition. Brendan Edwards, Max Dionisio, and Charlotte Chaffey (ROM Library & Archives) went above and beyond to locate sources. Susan Horvath and Allison Gillies from the ROM Governors embraced the subjects of Indian chintz and florals, and made possible the resources to communicate their wonder and beauty to wide audiences.

In true and reliable collegial spirt, ROM curators and technicians from both Art & Culture and Natural History offered their expertise: Arni Brownstone, Mary Burridge, Santiago Claramunt,

Douglas Currie, Timothy Dickinson, Silvia Forni, Lisa Golombek, Antonia Guidotti, Peter Kaellgren, Ed Keal, Burton Lim, Robert Little, Jacqueline Miller, Trudy Nicks, Mark Peck, and Fahmida Suleman. The early pioneering scholarship on the ROM Indian chintz collection by Katharine B. Brett and Veronika Gervers inspired the project throughout. Virginia King Wearne in 1934 had the great generosity of spirit to donate to the ROM the entire chintz collection of her late husband, Harry Wearne.

Heartfelt thanks go to ROM Publications. Sheeza Sarfraz, Manager of Publishing, took a deep interest in the subject and graciously choreographed over several years a complex publication with many moving parts and people. Senior Designer Tara Winterhalt beautifully brought this book to life with her characteristically elegant design aesthetic, carefully and creatively interpreting text and images to shape this publication. I am grateful to Carla DeSantis for her meticulous work in editing the publication, Marnie Lamb for her expert indexing, and Barbara Czarnecki and Anne Holloway for their exacting proofreading. Two anonymous peer reviewers provided immensely valuable feedback that helped to refine elements large and small.

The Friends of Textiles and Costume championed Indian chintz from the start, providing logistical, moral, and financial support, as did the Friends of South Asia. For their particular interest and aid, I would like to recognize ROM supporters Neera Chopra, Michael Gervers, Patricia Harris, Jayshree Khimasia, Aruna Panday, and Patricia Sparrer. Very special thanks go to Angela Weiser for graciously taking on research assistance, sourcing challenging image rights, and for keeping all dots connected. Her versatile skills, dedication, and flexibility proved invaluable to getting the publication through its many stages. Thanks also to ROM Summer Interns Antonia Anagnostopoulos, Rose Ting-Yi Liu, and Chandni Rana who carried out research and exhibition tasks large and small, investigating stories that might otherwise have remained untold.

For generously sharing their treasured textiles in the catalogue and exhibition, and their expert knowledge of them, the ROM is grateful to Charllotte Kwon, Sophena Kwon, and Tim McLaughlin (Maiwa, Vancouver), to Peter Lee (Singapore), Banoo and Jeevak Parpia (Ithaca, NY), and the "Sarah Clothes family"—Sarah, Andrée, and Madeleine Pouliot (Ottawa and Jaipur). All opened their arms and supported the project in many ways. Tim McLaughlin very kindly allowed his beautiful photography to be featured in the book.

In India, many colleagues took hours or days from their busy lives to share their art and knowledge: Aneeth Arora, Vaishali Bahel, Rachel Bracken-Singh, Garuppa Chetty, Chandrakant Chitara and family, Jayantibhai Chitara, Kirit Chitara, Sharada Devi, Mahesh Dosaya, Judy Frater, Kuldip Gadhvi, Baishali Gosh, Suraiya Hasan, Gurpreet Kaur and Orijit Sen of People Tree, Jayshree Khimasia, S. Ahmed Khatri, Ahmed and Sarfaraz Khatri, Sufiyan Khatri, Abdulrazzak M. Khatri, Gangadar Khondra, Anuradha Kumra, Jagdash Mittal, P. Muni Raghavulu, Nirav Panchal, Andrée Pouliot, Jagada Rajappa, Ramesh and family, Bina Rao, Eswarudu Rao, Renuka Reddy, M. Viswanath Reddy, A. Tihlak Reddy, Ritu Sethi, Mala and Pradeep Sinha, Archana Shah, Shilpa and Prafal Shah, Brigitte Singh, Deepika Singh, Jasmeet Singh, Pitchuka and Coromandel Srinivas, and Uzramma. Very special thanks go to filmmaker Indraneel Lahiri and the family of Abduljabbar M. Khatri for opening their home.

Experts of many kinds from around the world consulted on many matters: Munira Amin, Mark E. Balmforth, Wayne Barton, Susan Brown, Sheila Canby, Dominique Cardon, Joan Cummins, Pulin Chandaria, Karina Corrigan, Julie Crooks, Alexandra Dalferro, Siplinwita Das, Ajit Kumar Das, Shila Desai, Silvia Dolz, Avalon Fotheringham, Francesca Galloway, John Gillow, Shima Golchin, Suzanne Gott, Titi Hall, Adrienne Hood, Jonathan Hope, Sjouk Hoitsma, Jacqueline and Bernard Jaqué, Kate Irvin, Paula Ivanova, Niranjan Jonnalagadda, Jamie Kelly, Louise Lalonger, Beverly Lemire, Rachel MacHenry, Lynne Milgram, Heba Mostafa, Thomas Murray, Vanessa Nicholas, Roxane Shaughnessy, Karun Thakar, Jessica Urick, John Vollmer, and Roxana Waterson and the Write Club. For their enthusiam in carrying out scientific analyses of select objects, I am thankful to Gregory Hodgins (University of Arizona AMS Laboratory), Jennifer Poulin (Canadian Conservation Institute), and Brandon Rizzuto.

Museum funding support was essential. Grants from the Louise Hawley Stone Charitable Trust provided major funding for the acquisition of important Indian chintz pieces and the publication of the catalogue. The exhibition was made possible through funding from the ROM Friends of Textiles and Costume, The Burnham Brett Endowment Fund, and the Royal Exhibitions Circle. Grants from the Department of Art & Culture and the Office of the Deputy Director of Research & Collections enabled curatorial research. The Veronika Gervers Research Fellowship fund made possible the Indian chintz workshop of 2018 and in years past provided a period of research residency at the ROM for six of the volume's authors: Ruth Barnes, Rosemary Crill, Hanna Martinsen, Alexandra Palmer, Giorgio Riello, and Philip Sykas. Elements of my research were supported by an Insight Grant from the Social Science and Humanities Research Council of Canada, and from India Capital.

Finally, deepest thanks go to my mother Evelyn Fee, and to my husband Michael Phillippo, who supported me throughout this project, carefully editing chapter drafts, joining research travels, and bestowing sustenance of many kinds.

Sarah Fee
Senior Curator, Eastern Hemisphere Textiles & Fashion,
Royal Ontario Museum

*This volume is dedicated to Arti Chandaria (1960–2015)
whose love for the textile arts of India continues to inspire.*

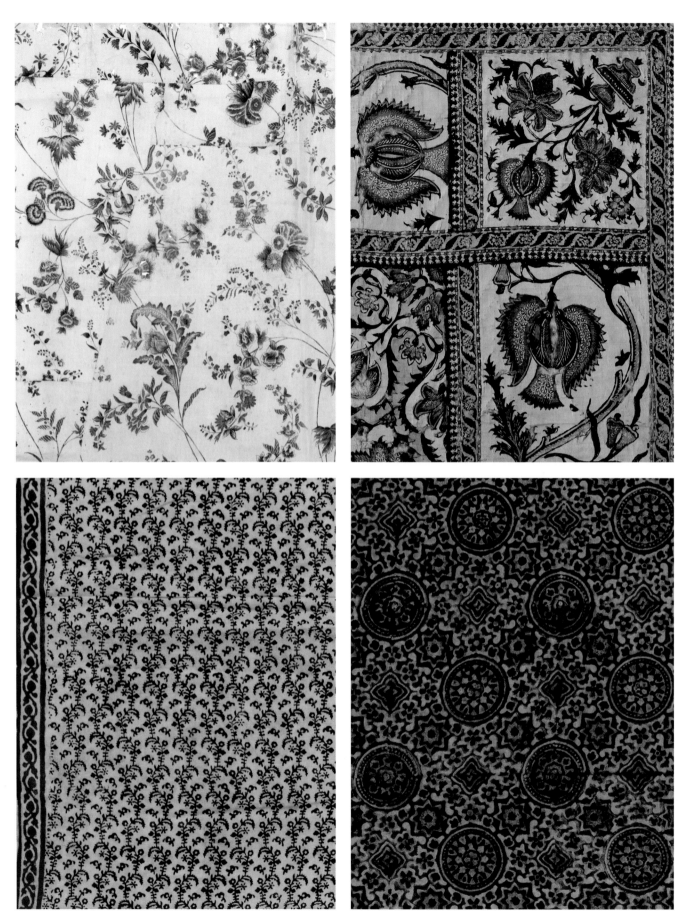

Clockwise from above: Hand-drawn chintz; *Kalamkari* with block printed and hand drawn details; *ajrakh*; *syahi begar*.

EDITOR'S NOTE

THE TERMINOLOGY OF INDIAN CHINTZ: "MORDANT-DYED," *KALAMKARI,* AND *SARASA*

Words literally fail to describe Indian chintz. A wide, and sometimes confusing, array of terms has been used over time to reference the cloth that is the focus of this present volume: cotton cloth embellished through the techniques of mordant and resist dyeing. These unique dyeing processes employ metallic salts (mordants) to attract plant dye colourants and wax (or other substances) to resist them.

The term *Indian chintz* requires some explanation. Although specifying "India," we recognize the art form is shared across the wider South Asian subcontinent before the 1947 division into the modern countries of Pakistan and India. After all, the heart of the origin of Indian cottons and mordant dyes likely lies in the Indus Valley, the area bridging the two countries.

The term *chintz* itself has meant various things to English speakers over time. It derives from the Hindi *chint,* variously translated as "spotted," "variegated," "speckled," or "sprayed."[1] By the eighteenth century, anglophones used only the plural form *chints*—or *chintz*—and invented a new plural, *chintzes.* Early British traders used the term *chintz* to designate cotton cloth that was decorated using either the kalam pen or wooden printing blocks.[2] In the twentieth century, however, art historians generally came to restrict it to only those cloths embellished using the *kalam* pen.

The designations *painted cottons* and *painting* are useful shorthands for hand-drawn chintz but are somewhat misleading in suggesting that pigment or dye is applied directly to the cloth. In fact, only natural yellow and light blue can be applied this way; patterning with natural reds, dark blues, and blacks requires mordants and resists. Moreover, the kalam instrument is more akin to a pen than a brush.

The term *kalamkari* has shifted meaning: a word of Persian origin meaning "pen work," that is, *hand drawn,* in the twentieth century it has also come to designate an ornamental style of *block-printed* cloth made in the area of Machilipatnam in coastal southeast India.

Some terms such as *ajrakh, bagh, dabu,* and *syahi begar* refer to regional varieties, while others, such as *sarasa,* are used in Japan and Southeast Asia—and have been adopted by scholars of these areas. In place of the older expression Coromandel Coast, we employ the geographic designation coastal southeast India.

In this multidisciplinary volume, authors use the terminology appropriate to their field and subject matter. Image captions endeavour to identify the precise techniques used in the creation of the given piece, and a glossary is provided at the end.

1 Historic British English spellings include *cit, chit, cheete, chites, chint,* and *chints*; see Beer, *Trade Goods,* 1; Gittinger, *Master Dyers,* 27; Crill, *Chintz,* 8.

2 The similar Dutch term is *sits.* Tellingly, the French term is *indienne* (Indian).

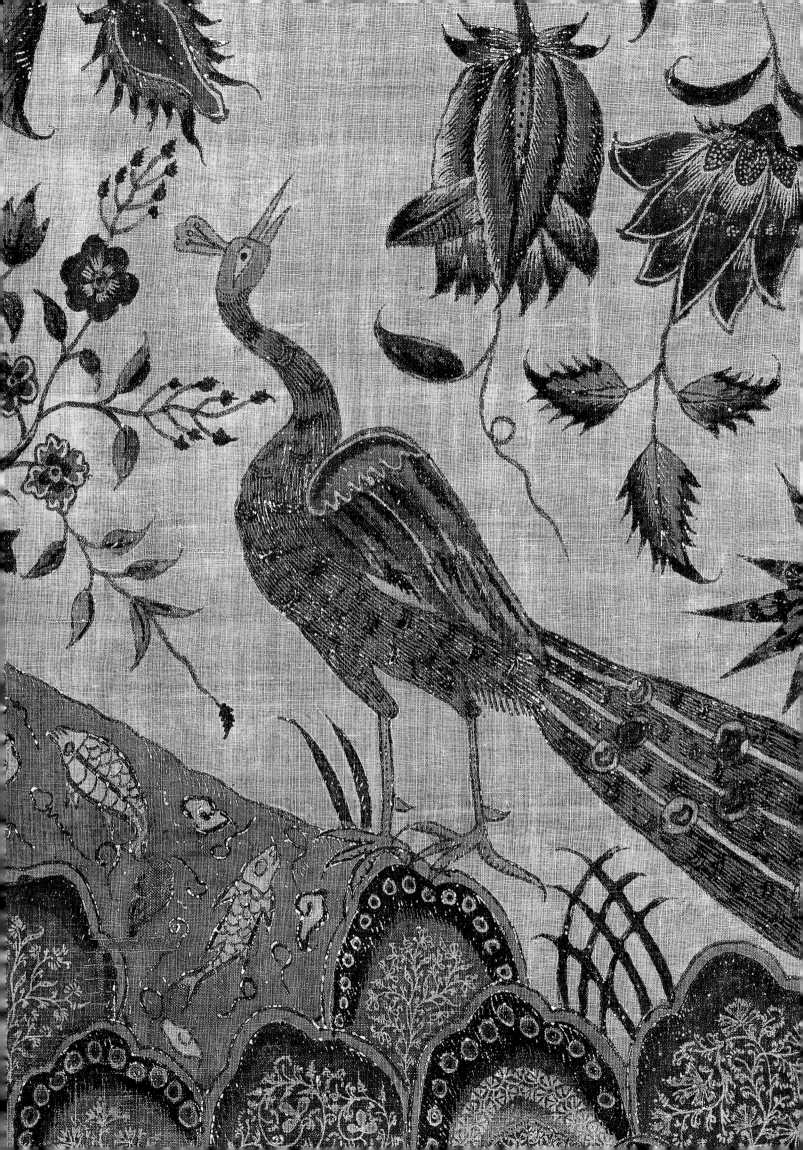

1

INDIAN CHINTZ

COTTON, COLOUR, DESIRE

SARAH FEE

F ALL THE REMARKABLE TEXTILE TRADITIONS THAT INDIA HAS bestowed on the world, its printed and painted cotton textiles,[1] popularly known as chintz, have arguably had the longest and greatest global impact. Over the millennia, these vibrantly coloured and boldly patterned cottons have been coveted as fashionable dress and luxury furnishings, as gifts and sacred objects, both throughout the Indian subcontinent and around the world. The desire first to possess and then later to imitate Indian chintz transformed the arts, industries, and economies on five continents, with reverberations still felt today.

This volume re-presents the Royal Ontario Museum's (ROM) renowned collection of these extraordinary textiles, many last seen in the 1970 landmark exhibition and publication *The Origins of Chintz*.[2] Based on the meticulous, pioneering research of Katharine B. Brett at the ROM and John Irwin at the Victoria and Albert Museum, the exhibition showcased India's painted cottons made for export to Europe before 1800. Since then, the ROM's collections of Indian chintz have continued to grow, alongside new studies from the fields

Detail: Gilded eighteenth-century palampore made in coastal southeast India (p. 108).

of art history, fashion and design, economic history, botany, chemistry, and anthropology. Just as spectacular, the twenty-first century has witnessed extraordinary revival and innovation in the art and fashion of Indian chintz—now seen on the runways of Mumbai's Lakme Fashion Week, in urban art studios and international "high street" boutiques. The essays that follow, contributed by a multidisciplinary group of scholars, explore the ingenuity, the global reach, and the impact of Indian chintz, from its storied past to its re-energized present.

FIG. 1.1

Hanging (detail). Coastal southeast India, ca. 1640–50. Cotton, hand-drawn, mordant-dyed, resist-dyed, painted details, 252 × 173 cm.

The finest mordant- and resist-dyed cottons were created for Indian courts, such as this scene of horsemen from a magnificent hanging, thought to have been made for Thirumal Nayak, who ruled the state of Madurai. See fig. 2.6 for full overview.

Private Collection

The Origins of Chintz in India: Painting and Printing Cottons

Readers today might associate the word *chintz* with old-fashioned floral printed cottons, factory made in Britain, or a product of inferior quality, "chintzy." But such associations are many steps and many centuries removed from the remarkable handmade Indian originals.

From ancient times, the great Indian subcontinent clothed itself, and much of the world, with its cotton cloth. The majority was plain or patterned with stripes or checks, some ornamented by brocading or embroidery. A very different embellishment was created by specialized artisans who used cotton fabric as a sort of canvas; upon it they drew or printed special substances, known as mordants and resists, which, once combined with vegetable dyes, produced bold designs in vibrant colours that did not fade. Europeans came to refer to these exquisitely patterned textiles as chintz.

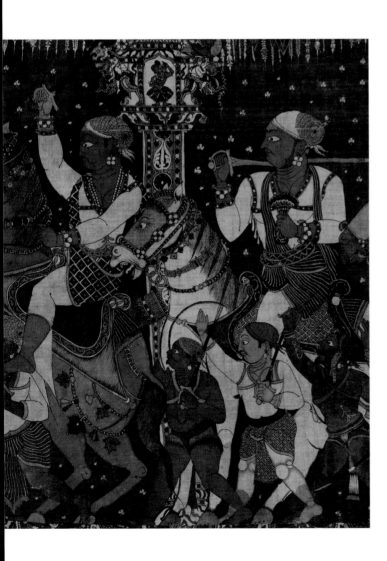

For brevity's sake, this essay similarly employs the single term *chintz* to cover Indian cottons embellished using both the techniques of hand drawing and block printing, as well as traditions known by regional terms (e.g., *dabu, ajrakh*),[3] for all are variations on the same theme: creating colourful patterns on cotton cloth through the application of mordants, resists, and dyes.[4] Indeed, many pieces illustrated here combine hand drawing, block printing, and direct painting with dyes to form their design.[5] Mastering these versatile materials and methods, India's artisans created an incredible range of compositions, from tiny repeating floral blossoms to enliven dress fabrics to monumental scenes of mounted horsemen in the throes of battle, commissioned to adorn palace walls (fig. 1.1).

Appreciating the art—and genius—of Indian chintz thus begins with appreciating the sophisticated techniques and colour chemistry developed by the subcontinent's artisans.[6] Certain natural features predisposed the South Asian subcontinent to create these brilliant works: unique climatic conditions that favoured the cultivation of cotton and potent subtropical dye plants, as well as waters with special mineral properties that improved colour. Production centres historically were located along rivers and widely spread; the regions of Sind, Gujarat, Rajasthan and the southeastern coastline (formerly known as the Coromandel Coast) are associated with the greatest production. But the key ingredient was human ingenuity to domesticate cotton, develop remarkably complex chemical processes, perfect unrivalled hand skills, and create sophisticated supply chains. The drive to excel was fuelled by widespread demand for chintz, from village dress to the palace furnishings of great dynasties—Mughal, Nayak, Golconda—each associated with a chintz "school" and the finest works (see ch. 2).[7]

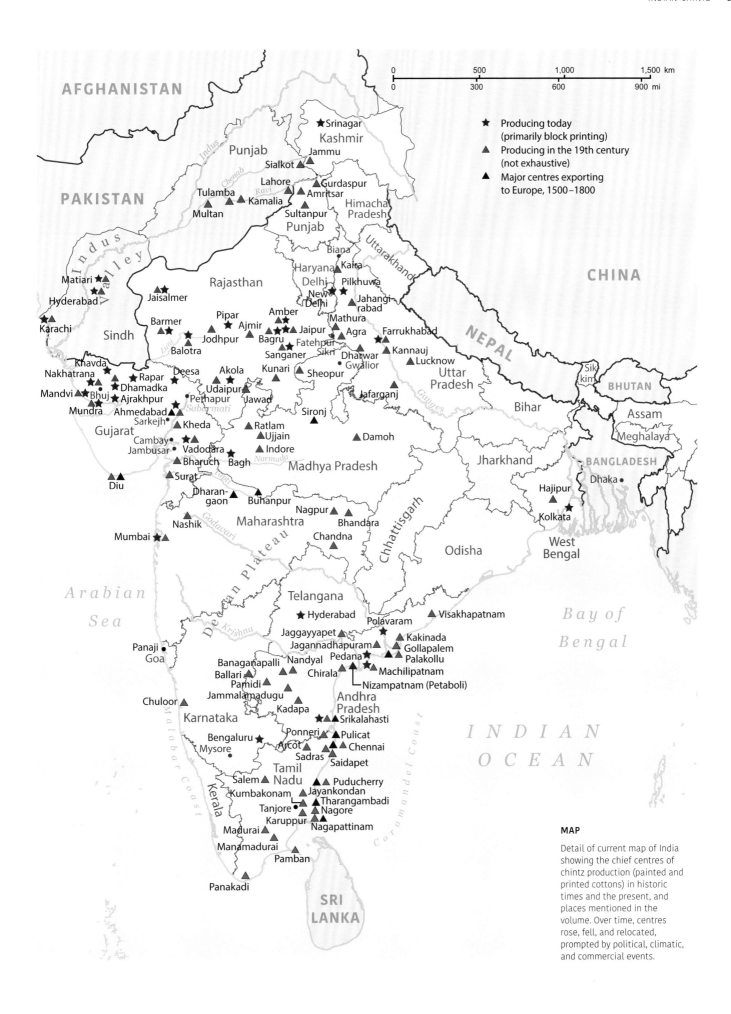

Producing today
(primarily block printing)

Producing in the 19th century
(not exhaustive)

Major centres exporting
to Europe, 1500–1800

MAP

Detail of current map of India showing the chief centres of chintz production (painted and printed cottons) in historic times and the present, and places mentioned in the volume. Over time, centres rose, fell, and relocated, prompted by political, climatic, and commercial events.

Creating Colour[1]

These kinds of cloths look as though they were gilded with divers colours.

—Cesar de Federici, 1563[2]

The technical terms *mordant dyed* and *resist dyed* provide convenient shorthand expressions for the distinctive techniques of chintz. Yet they conceal the remarkably diverse ingredients, procedures, and skills developed by India's artisans to infuse cotton cloth with glorious, long-wearing colour and design.

DIRECT DYEING

Yellow dyes are exceptional in that they can be directly painted or printed onto a cotton cloth surface.[3] Common recipes in India employ tannin-rich pomegranate skin or parts of the myrobalan tree (*Terminalia* sp.)—its fruit, seeds, or gall nuts—in combination with the mineral allum, and/or red-dye-bearing plants (*chay* root; see below).[4] Turmeric, native to India, is another option, but like all yellow dyes, it often fades quickly. Perhaps partly due to this reason, despite the ease of application, the colour yellow plays a minor role in chintz history, used only to colour small areas.

Printing or painting yellow dyes on top of areas previously dyed blue or red was the usual manner of creating green and orange respectively;[5] the fading of the yellow has left some historic chintz with blue leaves rather than their original luscious green.[6]

RESIST DYEING

By contrast, Indian chintz artisans developed permanent blues using the leaves of *Indigofera tinctoria*, a subtropical species of indigo plant that probably originated in India, but which requires demanding and complicated treatment.[7] Under normal conditions, indigo cannot be applied in a liquid form directly to a cloth surface. Rather, it must be converted into its soluble colourless state for the dye to penetrate the fibre and there regain its blue insoluble form. This process is achieved with the chemically complex indigo dye vat: *Indigofera* leaves are combined with dried seeds of the cassia plant (*Cassia tora* L.) to achieve fermentation; alkaline levels are adjusted by using ingredients as varied as lime-rich shells and sandy soil (fuller's earth).[8] Pattern is created by *resist dyeing*: first, by covering parts of the cloth surface with molten wax, mud, tree gums, or other substances to resist or repel the indigo; then, by submerging the cloth in the indigo dye vat.[9] Securing a deep blue requires repeated immersions over several days. Finally, the resist is removed in warm water to reveal the underlying patterns. It was long thought that Europeans were the first to paint indigo directly onto cotton cloth surfaces, by adding arsenic sulphate; this thinking has been challenged by the discovery of pre-1700 Indian chintz objects with evidence of painted indigo.[10]

MORDANT DYEING

India is home to three plants with exceptionally potent red-dye substances in their roots, all varieties of the *Rubiaceae* family: Indian madder (*Rubia cordifolia* L.; Hindi manjit), Indian mulberry (*Morinda citrifolia* L.; Hindi al), and chay (*Oldenlandia umbellata*; Hindi chirval).[11] The last, a tropical, grew (both wild and cultivated) only on India's southeast coast, and in northern Sri Lanka, with the best shades harvested from coastal jungle and the calcium-rich flats of the Kistna delta.[12] Due to the pure alizarin in its long taproots, chay was the brightest of Indian reds, said to "stanyeth a perfect red";[13] relatively rare and expensive, it was abandoned by Indian dyers in the late twentieth century.[14] Additional plants, such as flowers of *dhauri* (*Woodforida fruticosa* L.) might be added to deepen, or pinken, the red shade.

However, these dyes do not automatically adhere to cotton; but, as Indian dyers discovered thousands of years ago, they will permanently bind if used in conjunction with metallic oxides, known as *mordants*. The mineral alum, widely available in India, is the common mordant source for producing red. To create pattern, the chintz maker has two options: apply alum only to those areas of the pattern to take red colour, or apply resists and then cover the piece in mordant solution by dipping or brushing.[15] In either case, the cloth is then boiled for several hours with the red-dye-bearing plants, usually their dried and powdered roots and stems.

In a similar fashion, an iron mordant can be applied in various concentrations to produce violet and black shades.[16] An iron acetate solution is made by adding pieces of iron (nails or other scrap metal) to a fermented liquor of coconut, palm, or rice; tannins might also be added to help lessen the corrosive effects of the iron. Painted or printed onto the cloth, the solution reacts instantly with the tannins of the myrobalan in the pretreated cloth to yield black; subsequent boiling in a red-dye bath deepens the shade, and the dyer is able to control the creation of a "rust black" or a "light black."[17]

Master colourists manipulate all these mordants and dyes to generate a broad range of subtle shades. Adding supplementary ingredients, such as

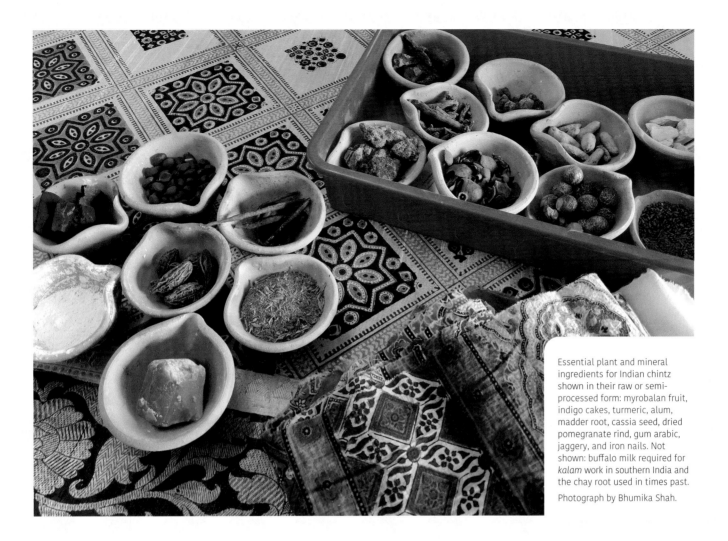

Essential plant and mineral ingredients for Indian chintz shown in their raw or semi-processed form: myrobalan fruit, indigo cakes, turmeric, alum, madder root, cassia seed, dried pomegranate rind, gum arabic, jaggery, and iron nails. Not shown: buffalo milk required for *kalam* work in southern India and the chay root used in times past.

Photograph by Bhumika Shah.

turmeric or sulphuric grit, engenders yellow reds and "autumnal" golden browns. Diluting iron and alum mordants or mixing them in various ratios produces pinks and violets; further overdyeing them in an indigo vat creates "colours ranging from chocolate brown to purplish-blue."[18]

THE UNSUNG INGREDIENTS OF INDIAN CHINTZ

Many humble ingredients are indispensable for achieving durable colour and bold design.

Myrobalan fruit (*Terminalia* sp.) has been called the "secret" to the Indian art of fixing colours, serving two roles in one: it optimizes alum absorption, and its tannic properties react with iron to produce black.[19] Its flavonoid components can further contribute to yellow dyes.

Water is key. Flowing river waters remove starch, alum, and thickeners, while washing in waters high in calcium brightens colours and contributes much

to the "beautiful combination of painting and dyeing represented by Indian cloth."[20] Sprinkling water on drying cloth oxydizes and bleaches it.

Sunshine and animal dung are further essential for whitening grounds and brightening colours. Together, they ensured that India's bleaching techniques remained vastly superior to those of Europe until the late eighteenth century.[21] India's strong sun reacts with water to achieve this effect and further melts wax to strengthen resists.[22] Animal dung (goat, sheep, or camel) contributes the necessary complex ammonia and proteins.[23]

Buffalo milk is vitally important in preparing cloth for drawing liquid mordants with the *kalam* pen. Soaking in the fatty milk creates an oily layer to prevent bleed. In addition, the milk's calcium, fats, and sugars combine with myrobalan, mordant, and dye to produce complex chemical reactions and the

permanent colour bond.[24] A smooth cloth surface is created by beating with paddles made of "close grained" wood of the tamarind (*Tamarindus indica*) or portia tree (*Thespesia populnea*).[25]

Tree gums and ground seeds are critical for block printing, for making thickeners of precise viscosity to first adhere mordants to the carved wooden blocks and then transfer them to the cloth.[26]

Special recipes of beeswax, mud, lime, resins, and gums provide the resists that have to be supple but strong, able to withstand folding, the dye bath and washing; any cracks would allow seepage and spoil the piece with streaking.

A rice-starch concoction was applied to create a protective layer before drawing with molten wax, and reapplied at the very end to produce the distinctive surface glazing that so delighted many patrons; using stones and shells, specialists polished the cloth to an even greater burnish, a "satin-like sheen."[27]

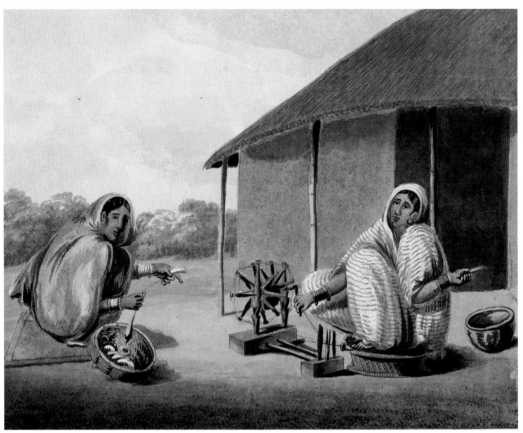

An essential element of Indian chintz is its cotton cloth base, and India's mastery of cotton dates back at least five thousand years. Archaeological evidence links the domestication of one species, the so-called tree cotton (*Gossypium arboreum*; fig. 1.2), to the rise of the great Indus Valley civilization that flourished from 3500 to 2000 BCE in the area bridging today's India and Pakistan.[8] A tall, slow-growing perennial, it was largely replaced from the sixth century CE by the annual shrub cotton (*Gossypium herbaceum*), originally from eastern Africa.[9] These cotton species, and their many local varieties, were well adapted to India's heat and drought.[10] Unlike some major fibres of the ancient world, such as wool, cotton cloth can withstand repeated and vigorous washing. It was thus in high demand throughout the subcontinent for dress (turbans, sashes, body wrappers, tailored skirts, and robes) and for home furnishings: curtains, floorspreads, coverlets, and room dividers. In addition, cotton holds a special place in South Asian religious life, representing spiritual purity for Hindus, Muslims, and tribal peoples; it was, in some contexts, "better esteemd then silke."[11]

After the cotton fibre itself had been harvested and transported—sometimes hundreds of kilometres—cleaned and fluffed, it still required the hands of many additional specialists, each critical to the end chintz product: yarn spinner, weaver, washer, stencil maker, block carver, bleacher, wax specialist, printer, drawer, indigo dyer, red dyer, beetler (beater), glazer.[12] Using a hand spindle (*takli*) and spinning in the morning to catch the dew, young women created the finest cotton thread the world has ever seen; from around the fourteenth century, women adopted the spinning wheel, likely introduced from West Asia (fig. 1.3).[13] As Renuka Reddy recounts in this volume, professional male weavers working at pit looms produced the special tight weave required for surface design; some patrons demanded single panels (without seams) up to an incredible three hundred centimetres in width.[14]

Although cotton cultivation and weaving spread out from India as early as 500 BCE[15]—reaching Africa, the Middle East, Southeast Asia, and China from 800 CE and, belatedly, southern Europe from 1200 CE—India nevertheless retained global superiority in cotton

cloth production. This abiding dominance can be traced in large part to the subcontinent's incomparable mastery of colour.[16] It is exceedingly difficult to infuse cotton fibre with brilliant and durable colour using natural dyes; yet craftsmen in the subcontinent developed and perfected recipes for a multitude of "lively brisk colours," both lightfast and washfast and "so beautiful that it was difficult to turn away one's eyes" (see "Creating colour" sidebar).[17]

Yellow dyes could be directly—and relatively easily—applied to the cloth surface, but creating deep and durable shades of blue, red, and black involved complex multistage processes, the "precise chemistry" of which modern science still cannot explain.[18] India's artisans wrested dark, resilient blues from the tiny leaves of *Indigofera* shrubs through fermentation, reduction, and oxidation. They perfected the techniques for combining metallic oxides, known as *mordants*, with certain vegetable dyes to create permanent shades of red and black. Inimitable was the skill of Indian printers, drawers, and dyers for adjusting these and other ingredients to generate subtle colour variation, such as golden yellows, and shades ranging from light pink to purple to brown, with each locality and workshop possessing unique recipes.[19]

Ingenuity was further required to manipulate these demanding substances to create patterns. India devised, refined, and mastered two basic techniques: drawing with specialized pens or printing with wooden blocks. The drawing pen (*kalam*) (fig. 1.4) was made of a bamboo shaft with a wool reservoir; its sharpened, split tip allowed liquid mordant or dye to flow with a squeeze on the reservoir. To draw fine lines in wax, the kalam pen was fitted with a metal spout and reservoir made of hair; covering larger surfaces in wax required the kalam or a cotton pad.[20] Typically the master kalam drawer first pounced or drew the design with charcoal, then traced the outlines, followed by assistants who filled larger areas.[21] As Rajarshi Sengupta emphasizes in chapter 18, printing with wooden blocks required no less skill or artistry; the small blocks historically preferred allowed infinite combinations. Master block carvers translated complex motifs and overall compositions into smaller units, and carved delicate lines able to withstand the rigours of forceful stamping (fig. 1.5 and 1.6). The printer was challenged to perfectly align impressions, so as to mask breaks, and navigate corners.[22] In both cases of hand drawing and printing, the same long series of operations followed: multiple rounds of dyeing, washing, bleaching, and direct application of any gold leaf, silver leaf, or yellow dyes.

Most demanding and costly were multicoloured chintz. Including reds, pinks, and purples in a single cloth called for complex calculations and coordination of multiple mordant solutions. Even two shades of red necessitated two rounds of mordanting and dye baths. Adding blue motifs generally entailed immersion of the entire cloth in the indigo vat; consequently, all areas that had been previously dyed red or black, together with those to remain white, had first to be covered in resists (wax, mud, or gums) to repel the indigo bath; in the case of large hangings with white grounds, this meant covering most of the piece in wax. Each section of a multicoloured printed motif required a separately carved block and extra time, skill, and care for printing alignment, as well as lengthy washing and bleaching between each colour application. Gold leaf, historically added only to high-quality pieces, was applied by designated specialists, using glues or special metal applicators.[23]

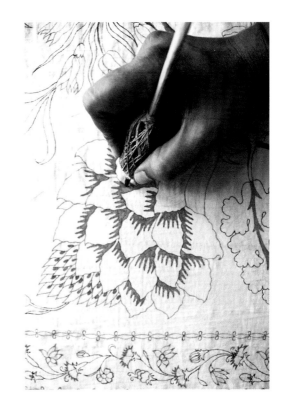

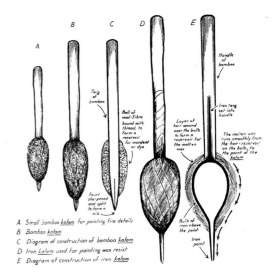

fig. vi.

FIG. 1.4

The kalam pen used to apply mordants, resists, and dyes is made of a bamboo handle with a reservoir of wool (or today, jute). Fine drawing in wax required a special metal tip.

Above: Drawing alum mordant using the kalam pen. Below: A variety of types and sizes of kalam pens.

Photograph by Renuka Reddy. Illustration from Irwin and Hall, *Indian Painted and Printed Fabrics*, 173.

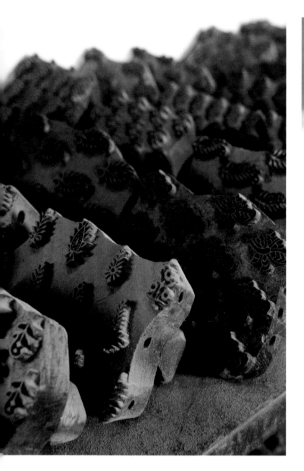

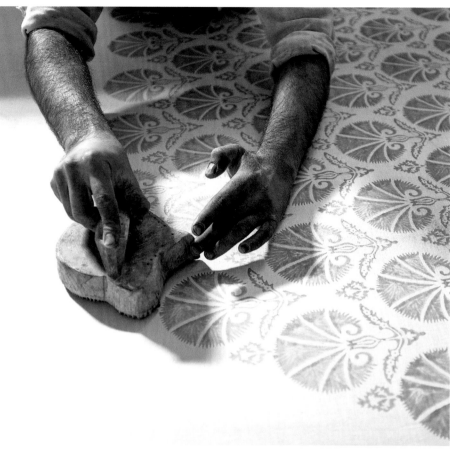

LEFT
FIG. 1.5

Wood printing blocks were
historically carved from
hardwoods—mainly teak or
rosewood—by specialists
from carpenter communities.
Each colour of a given motif
required a separately carved
block. Today the craft of block
carving is most active in Jaipur,
Sanganer, Pethapur, Pedana, and
Farrukhabad.

Bagh, 2016. Photograph by
Tim McLaughlin, Maiwa.

RIGHT
FIG. 1.6

Mordants, resists, and dyes could
also be applied using carved
wooden blocks. Here the printer is
applying the mordant alum; after
dyeing with the roots of certain
plants, the printed areas will
turn red.

Sophena Kwon, Maiwa.

Indian supremacy prevailed not only in colour but also, as the essays in this volume emphasize, in devising designs and continually revising them to please a remarkably diverse array of local and global patrons, including many hundred small niche markets.[24] Designs ranged from tiny florals to complex entwined geometric lattices to Hindu religious epics. Shapes, sizes, and scales varied from enormous floorspreads to court dress for Indian patrons, and Christian liturgical vestments and Thai warrior jackets for export markets.

The people who printed, painted, and dyed Indian chintz remain the least known part of its history. Before the 1880s, workshops and makers rarely signed their works. Weavers, printers, painters, and dyers were historically male and professional. They might work in family groups—with children and wives assisting—or in larger workshops. In the seventeenth century, designers and painters of outlines belonged to separate castes, while other painters were subdivided into four specializations.[25] Over the centuries, master kalam drawers and printers were variously described as "impoverished" and "well-off"; certainly much depended on skill and specializations.[26] While small communities guarded their special knowledge, the modern myth of the village-bound, caste-bound, unchanging Indian craftsman and unbroken lines of transmission has now been challenged.[27] Changing fashions and patronage spurred ongoing experimentation and innovation and periodic migration. In the seventeenth century, many chintz artisans moved from Gujarat to the southeastern (Coromandel) coast or shifted from servicing local dynasties to export markets; political upheavals and the rise of industrial cotton-weaving mills in India triggered the relocation of printers and dyers to cities such as Bombay (Mumbai) in the nineteenth century.[28]

From early times, demand for the colour, pattern, comfort, and washability of Indian chintz drew traders of many nations to the subcontinent. In recent years, historians have fully revealed the far-reaching—and still resounding—impacts from Europe's entry into the fray. European efforts to monopolize and imitate Indian chintz "provoked unprecedented

economic and cultural reverberations," which studies link to everything from Britain's so-called Industrial Revolution to the British colonization of India, to the intensification of slavery in the Americas.[29]

The Global Desire for Indian Chintz

India was likely exporting cotton textiles as early as 3000 BCE, with archaeological evidence suggesting that they were traded to Mesopotamia and Jordan by this time. Textual sources—Roman, Greek, and Vedic—indicate that from at least the first and second centuries, Indian cottons were moving across the breadth of the Indian Ocean to East Africa, Arabia, the Persian Gulf, the regions of the Red Sea, and Southeast Asia.[30] The cloth was carried by merchants of many nationalities: Arab, Jewish, Iranian, Armenian, Swahili, Indian, Malay.[31] Land caravans transported great quantities of Indian cottons westward toward the Levant and eastward to central Asia and China—the Silk Road was a Cotton Road when it moved east.[32] In a word, in the premodern world, "cotton cloth was the key commodity traded and India was its manufacturing core."[33]

Although the bulk of India's cotton cloth exports were not printed or painted but rather plain, striped, or checked,[34] studies show that Indian chintz played an outsized role in world history. The earliest surviving examples, found at Red Sea ports and dated as early as the tenth century, discussed by Ruth Barnes in chapter 3, reveal the deep and durable colours and intricate patterns that made them so popular (fig. 1.7).[35] From at least the Middle Ages, chintz was a key trade good for acquiring the highly coveted spices from Indonesian islands, where local traders demanded it in exchange (see ch. 5).[36] In search of these same spices, from 1498 the Portuguese sailed directly to India around the tip of southern Africa, opening new maritime routes. State-sponsored trading companies from the Netherlands, Britain, Denmark,

FIG. 1.7

Textile fragment (overview and detail). Western India, for the Egyptian market, ca.1400. Cotton, block-printed, mordant-dyed, resist-dyed, 30 × 67 cm.

The oldest surviving pieces of Indian chintz have been found in Egypt, preserved by the arid climate. This fragment, radiocarbon-dated to ca. 1400, features stylized images of birds, perhaps peacocks.

ROM 978.76.117. Abemayor Collection given in memory of Dr. Veronika Gervers, Associate Curator, Textile Department (1968–1979) by Albert and Federico Friedberg.

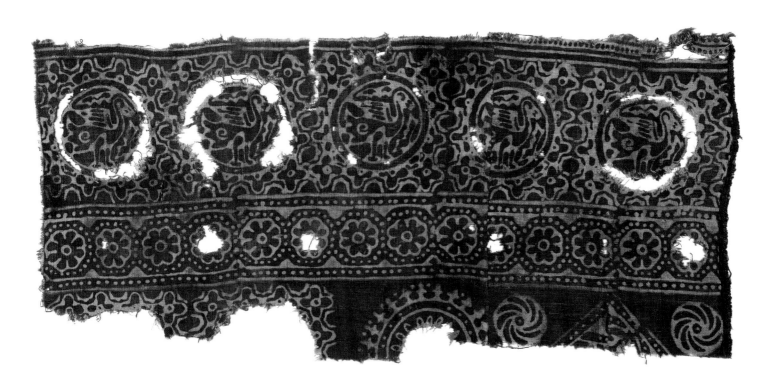

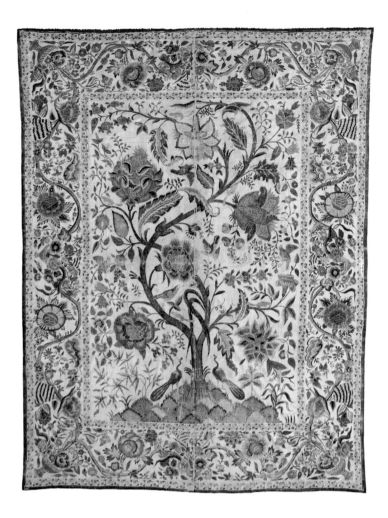

FIG. 1.8

Palampore (wall or bed hanging).
Coastal southeast India, for the
European market, ca. 1700–1750.
Cotton, hand-drawn, mordant-
dyed, resist-dyed, painted details,
261 × 206 cm.

In Europe, Indian chintz was first
desired as home furnishings, to
cover walls, beds, and windows.
The designs were variously left
to the imagination of Indian
craftsmen or closely dictated by
agents of trading companies such
as the British East India Company.

ROM 934.4.14 Harry Wearne
Collection. Gift of Mrs. Harry
Wearne.

and France followed after 1600. Altogether, Europe's growing demand for Indian chintz sowed the seeds—imperceptible at first—for disruptions in the long-standing rhythms of global production and trade, and, ultimately, in the political and economic world order.

Europeans quickly realized that populations in the Indian Ocean world generally disdained European-made trade cloths of wool and linen, and would not accept them in exchange for pepper, nutmeg, and cloves. Instead, India demanded precious metals, and Southeast Asia demanded Indian-made cloth.[37] Europeans were thus forced to join hundreds of established regional merchants in the "country trade": purchasing Indian textiles with silver and exchanging them in Southeast Asian ports for spices. Consequently, they established their first trading posts ("factories") near India's great textile production areas—Gujarat, Bengal, and the southeast coast—locating and relocating their settlements in the last area especially to "meet the requirements of the chintz trade."[38]

In the sixteenth century, trading companies in Europe discovered that profits could be made too by trading Indian chintz to Europe itself.[39] Sometimes referred to as a "calico craze," European chintz dress fashions, in fact, developed slowly, as discussed in this volume by João Teles e Cunha and Maria João Ferreira, Rosemary Crill, Alexandra Palmer, Giorgio Riello, and Philip Sykas (see ch. 8, 9, 10, 15, and 16, respectively). At first, cottons painted with exotic florals and scenes were coveted as elite home furnishings, particularly to beautify small antechambers and bedrooms with colourful carpets, wallcoverings, and bedcovers (fig. 1.8).[40] Like her noble counterparts, Queen Mary II also possessed a "fine chintz bed."[41] Through domestic embroidery, European women helped to "naturalize" and hybridize the exuberant, unfamiliar designs found on chintz.[42] By the mid-1600s, Indian chintz was embraced as fashionable dress. Men of standing across Europe desired it for informal robes.[43] Female fashions followed divergent paths. In France, elite women patronized hand-painted, highly glazed multicoloured florals, some with gilded details; the fashion trickled down to urban female working classes whose budgets permitted only small accessories, such as aprons or kerchiefs, modestly block printed with floral sprigs.[44] In England and Spain, the reverse held true, with "ladyes of the greatest quality" coming to wear tailored Indian chintz gowns from the 1670s, decades after working women had already adopted the fabric.[45] In Provence, France, and the Friesland area of the Netherlands, meanwhile, it was adopted as best country wear (and today as "folk dress"; fig. 1.10).

Cheaper than silk, and without silk's sumptuary connotations, Indian chintz brought coloured pattern to many social strata and is recognized as the first mass fashion.[46] In all of these incarnations, designs were at times purposefully exotic—"Let the Indians work their own fancies";[47] the most conspicuous examples are the famous "flowering tree" hangings that playfully mix flora, fauna, and iconographic conventions from India, Europe, Iran, and an imagined China (chinoiserie; see fig. 1.8). After 1625, dress fabrics more closely adhered to European aesthetics, with trading companies dispatching letters, samples, and drawings to guide Indian artisans.[48] At its peak in the 1680s, Indian cottons accounted for 74 percent of the homebound cargoes of the British East India Company (EIC), up to one million pieces annually, while 57 percent of French cargoes were constituted specifically of painted Indian chintz.[49]

Although EIC merchants were profiting, Europe's cloth manufacturers were not, and some authorities decried the blurring of social boundaries.[50] Long-established silk, linen, hemp, and wool manufacturers rose up in protest and even rioted against "the tawdry, bespotted" cottons, made by "Heathens and Pagans."[51] There resulted a series of protectionist tariffs and bans—outright bans in France from 1686 to 1759 and partial bans in Britain from 1700 to 1774, while Spain, Venice, and Prussia also prohibited the import, use, and/or local weaving or printing of cotton (see "Calico Acts" sidebar).[52] Despite threats of fines, imprisonment, or even death, smugglers continued to import Indian originals, while women of all classes—including "first class" ladies such as Mme de Pompadour—remained "clothed with out-law'd India-Chints."[53]

In response, European trading companies increased trafficking the cloth to areas of the world without import bans, to West and South Africa, the Pacific, and the Americas—from Canada to Brazil,[54] where it was eagerly sought by many indigenous and settler communities, especially women.[55] Although each market developed precise tastes and changing fashions in florals and ground colours, the net result was that Indian chintz had become a truly global fashion, part of the wider "Atlantic-wide fashion for cottons."[56] In chapter 15 by Riello, we learn that an iniquitous four-stop trade arose: Europeans carried Indian cottons to West Africa, which they traded for enslaved captives whom they took to the Americas to cultivate transplanted crops—sugar and, later, indigo and cotton—for consumption in Europe; the proceeds were then taken to India for the purchase of textiles and other goods.[57] At the same time, West Asia and Southeast Asia continued to consume enormous quantities of India's painted and printed cottons.

Struggling to supply escalating global demand for Indian chintz, Europeans adopted strategies that drastically reshaped the world. They variously attempted—and failed—to force sales of cloth and chay root, to monopolize Indian weavers and painters, to relocate them to European settlements, or to set up new production centres.[58] Ultimately the EIC, having extraordinary powers, including its own army, colonized India's major textile-producing areas. A concurrent movement had even more wide-reaching effects: imitating the cloth back in Europe.[59] Europeans were late to this game: Iran, Egypt, Syria, and Ottoman lands had developed home industries from the Middle Ages on, with Thailand and colonial Mexico also experimenting in the eighteenth century.[60] Nevertheless, from the seventeenth century, and especially in the eighteenth, cotton-printing workshops popped up from St. Petersburg to Venice to Madrid. Together, Europe's growing control of the global trade in cottons (more so than guns or alcohol) and its mechanization of textile manufacture (instead of railroads or iron foundries) formed "the launching pad for the broader Industrial Revolution."[61]

Many historians now argue that, rather than a "revolution," Europe's efforts to imitate Indian printed cottons represented a centuries-long transition, the fruit not of single nations but of international networks of capital and skills.[62] Avoiding the slow process of cloth painting, Europe embraced printing and, at first, all of its associated "craft-based" materials and processes: hand-carved wooden blocks, madder and indigo, river washing, dung and sun bleaching.[63] Early leaders in 1600s Marseilles, the Netherlands, and Genoa learned some techniques from Armenian and Turkish skilled workers, while later French informants observed and recorded painting techniques in India.[64] Protestant Huguenot cotton printers, expelled from Catholic France, energized Swiss and Dutch industries; the Swiss, in turn, later greatly contributed to French, Alsatian, and British industries.[65] A great advantage for Europe's printers was immediate knowledge of seasonal fashion trends, whereas Indian cottons took a year or more to reach Europe. As Sykas and Hanna Martinsen discuss in this volume (see ch. 16), a few Indian design predilections were retained, but overall European aesthetics prevailed.

Ultimately, Britain emerged as Europe's dominant textile printer, the result of entangled policies and practices, implemented at domestic, international, and imperial levels.[66] By the 1740s, Atlantic markets were increasingly accepting these British block-printed cloths in place of Indian originals. Simultaneously, labour-saving printing technologies were developed:

FIG. 1.9

From the early seventeenth century, British and Dutch trading companies began stamping bales of cloth or individual pieces with their insignia, likely in an effort to distinguish them from imitations and illegally traded goods. The changing insignia design over time helps scholars to date textiles.

Above: Insignia for the VOC.

Below: Insignia for the EIC.

FIG. 1.10

Woman's jacket. Textile made in coastal southeast India, for the Dutch market, eighteenth century. Cotton, hand-drawn, mordant-dyed, resist-dyed. Tailored and woven ribbon added in Europe. L. 58 cm.

By the late 1600s, both elite and working women in Europe aspired to wear garments made of Indian chintz. In the Friesland area of the Netherlands, chintz was widely adopted as best dress.

ROM 962.107.2

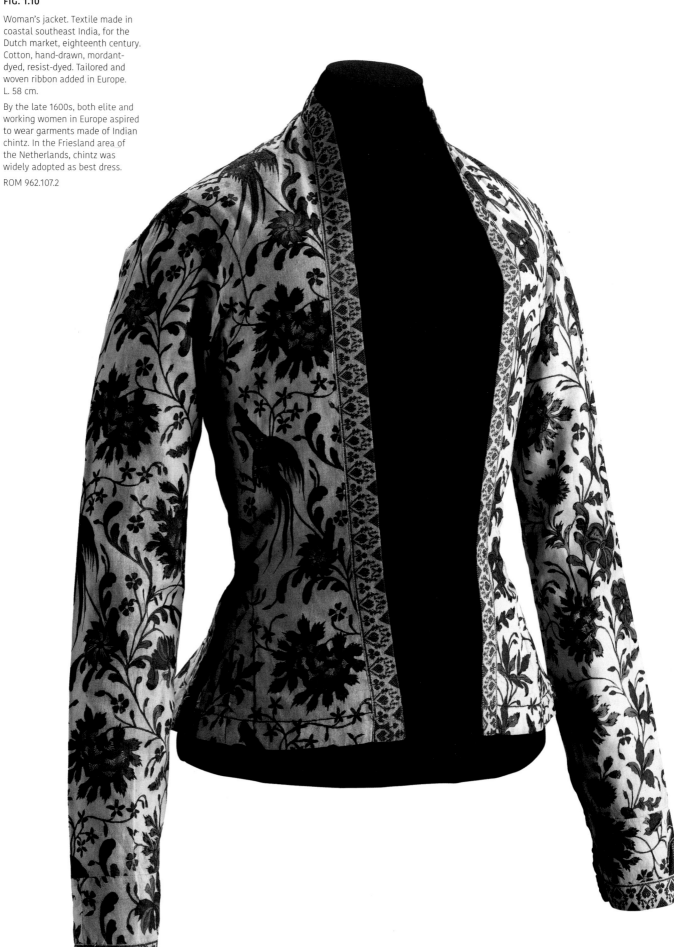

engraved copper plates (for repeat patterns, by 1752) and engraved rollers (successfully by 1790s; ch. 15).[67] Europe had mastered printing but was hindered by its inability to produce the cotton base cloth in sufficient quantity or quality, remaining dependent on imports of plain cloth from India or on locally made inferior cotton-linen blends (fustian). Efforts to weave cotton cloth domestically became the "primary stimulus" for Britain's "radical innovations,"[68] its burst of technological inventions from circa 1770 to 1830: machines to spin cotton warp yarn (1769), mechanized looms to weave cotton cloth, and then steam engines to power them (1830s), leading to the first massive factories and mill towns.[69] All of this activity in turn increased demand for reliable supplies of raw cotton, particularly the long-staple cotton species of the Americas, which were best adapted to machinery.[70] The result was the "great cotton rush": the massive planting of cotton first in the West Indies, then in the southern United States, with the tragic state-sponsored removal of indigenous American populations.[71] To plant, tend, and harvest the cotton, Europeans imported enslaved Africans in ever-increasing numbers.

From 1776, Britain lost the United States as a captive colonial market of its finished cloth, and so manufacturers shifted their efforts to Africa, Australia, and Asia.[72] Many set their sights on the huge Indian market itself. By 1820, in a stark reversal of history, factories in Manchester and Glasgow were mass producing roller-printed cottons for India, carefully studying Indian market design tastes (fig. 1.11). Pleasing customers in Asia and Africa necessitated great attention to colour. State incentives and industry-science collaborations across Europe had also focused on dyestuffs.[73] In addition to replicating and commercializing "turkey red," new "laboratory dyes" included pencil blue, chrome yellow, and lead green, followed in 1856 by synthetic dyes.[74] In 1869, German chemists synthesized the red colourant alizarin, naturally existing in its pure form in India's endemic chay plant.

Many observers predicted the utter destruction of chintz making in India. But this line of thinking underestimated the irrepressible creativity of its merchants and makers, and the loyal demand, both local and global, for the Indian originals.

Indian Chintz over the Long Nineteenth and Twentieth Centuries

Discussions of "global chintz" in the nineteenth century—as fascinating and relevant as they are—largely ascribe all agency and innovation to European entrepreneurs and inventors. For India, this same period is often ignored or dismissed as a moment of pure "decline," in quality and quantity, somehow tied to artisans' lessening skills or an inability "to cope with change."[75] New studies propose that many Indian artisans did not merely survive in the age of industrialization but also innovated and experienced regionalized "pockets of growth,"[76] and this can be seen for India's cotton printers.

It is true that the force of fashion lessened global demands for fabrics made of hand-painted Indian chintz, just as it had precipitated their rise.[77] The West's neoclassical vogue from 1800, with its "elegant simplicity"—white for women and black for men—resulted in waning European elite patronage of high-end hand-painted Indian chintz.[78] The remaining demand from middling markets was typically met by national printing industries.

However, the desire to furnish homes with India's handcrafted originals endured in some niche Euro-American circles. From the mid-1800s, the influential Arts and Crafts movement in Britain rejected industrial production and promoted instead handcrafts and Eastern designs, including those of India. It sparked a modest export of new types of printed cottons, notably from Kashmir, and as Deepali Dewan shows in chapter 17, inspired some British colonial art administrators to promote older patterns and natural dyes with Indian artisans.[79] So, too, the late Victorian vogue for Orientalist interior design stimulated consumption of new, "exotic" chintz: hangings from the southeast coast depicting either Hindu narratives or

The Calico Acts of Europe

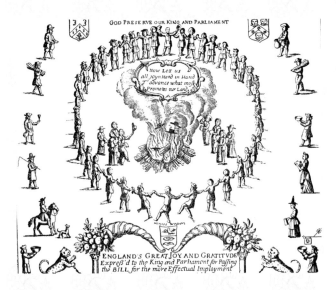

Broadsheet, "England's Great Joy and Gratitude," ca. 1720. British wool weavers and cloth workers thank Parliament and the King for banning the imports of Asian textiles, especially Indian chintz (Ephraim Lipson, *The History of the Woollen and Worsted Industries*).

During a period of one hundred years, the governments of several European countries issued decrees that prohibited imports of Indian chintz (together with other kinds of Asian textiles), as well as the sale, purchase, or use of these as dress or furnishings, and domestic printing that imitated chintz. Introduced to protect European home manufactures of silk, wool, and—in France—linen, such legislation was hotly contested by merchants, cotton printers, and consumers. Progressively introduced and repealed (often with exemptions and amnesties), and continually modified and refined, the major stages can be distilled as follows:

1685
Britain places a special duty of 10 percent on cotton goods imported from Iran, China, and the East Indies; increased to 20 percent in 1690.[1]

1686
France declares a complete ban on the making, displaying, selling, and buying of "painted cottons" made in India or of the printed "counterfeits" produced in the kingdom. French printing workshops are closed and printing blocks destroyed. In 1688, the import of plain white cottons is also prohibited.[2] Avignon, Orange, Marseilles, and Mulhouse as independent cities are exempt.

1700
Venice outlaws the import of Indian cottons.[3]

1700
France institutes a fine of fifty pounds and confiscation for "people from all walks of life" caught using "painted cottons" for apparel or furnishings, as well as for the printing of cotton within France.[4]

1700
Britain's "First Calico Act" (taking effect 29 September 1701) declared that imports of "all wrought silks, Bengals, and stuffs mixed with silk or herba, of the manufacture of Persia, China, or East Indies, and all Calicoes painted, dyed, printed or stained there" were to be locked in customs warehouses until re-exported.[5] None of the state goods were to be worn or used in England, upon risk of forfeiture and fines, but home-printed cottons were not banned, nor was the wearing of printed cottons. A 15 percent duty was further placed on imported Indian muslins, followed in 1703 by the same 15 percent on plain calicoes.

1718
Philip V of Spain prohibits the import and use of "cloths, silks, and any other cloths from China, and from other parts of Asia" in Spain and Spanish territories. In 1728, this is extended to "cotton cloth and printed calicoes" manufactured in Europe.[6] Repealed in 1760.

1721
Britain's "Second Calico Act" (takes effect 26 December 1722) prohibits within Britain "the Use and Wear of all printed, painted, stained or dyed Callicoes, in Apparel or Houshold Stuff, Furniture or otherwise," whether made in India or Britain.[7] However, there were important exemptions for muslins, neckcloths, fustians, and cottons dyed all blue. Printed linens were also exempt. Imports of Indian prints for re-export continued, using the bonded warehouse system.

1721
King Friedrich Wilhelm I of Prussia prohibits the wearing of "printed or painted chintz or calico in the province of Churmark, Magdeburg, Halberstadt and Pomerania," and mandates all clothing made from these fabrics to be destroyed.[8]

1726
France declares a life sentence to the galleys for those wearing "painted or dyed cottons, tree bark or cloth from China, the Indies and the Levant" and a death sentence for organized smugglers.[9]

1736
Britain's Manchester Act clarified the legality of printing cloths made in Britain of cotton weft and linen warp (fustian).

1755–59
France progressively lifts bans on domestic block printing, with wholesale repeal in 1759 (workshops in Angers and Paris already active from 1752 and 1754).

1774
A British act permits using and wearing "printed, painted, stained or dyed Stuffs, wholly made of Cotton" by British subjects provided they are entirely manufactured—spun, woven, and printed—in Great Britain.[10]

1780s
Sultan Abdülhamid I of the Ottoman Empire prohibits the wearing of imported Indian luxuries by non-elites.[11]

Iranian-export tastes. They were sold at some international and colonial expositions, as well as at Liberty's and Debenham's department stores in London.[80] The emerging art deco movement in the 1910s, with its passion for design and fine craftsmanship, inspired a spate of exhibits, publications, and collecting of Indian chintz in Europe and North America.[81] Within India, British colonials patronized prints for interior decor— natural dyes reportedly repelled insects and dust—causing the trade to "greatly improve."[82]

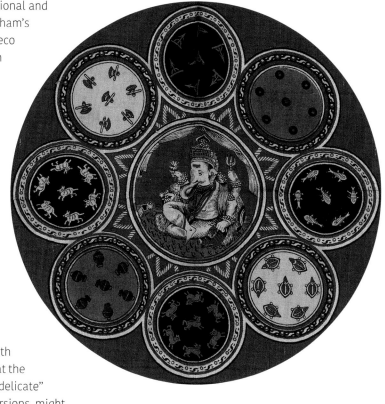

An even more significant trade continued to Indian Ocean ports and central Asia.[83] Although rulers in these regions were gravitating toward Western-inspired garment styles and palettes, as old sumptuary laws fell, desire for colour and pattern rose among commoner classes, and Indian textile printers responded. The southeast coast catered to Sri Lanka, Singapore, Indonesia, Myanmar (Burma), Nepal, and, above all, Iran (Persia), with much product now shipped out of Bombay (Mumbai).[84] As Steven Cohen demonstrates in chapter 4, the trade with Iran remained especially significant. Observers noted that the finest pieces were fully or partially hand drawn with "delicate" designs, finely waxed details, and gilding; printed versions might require up to seventy-two blocks per piece (fig. 1.12).[85] Gujarat, meanwhile, sustained or developed new export markets in southern Arabia, Thailand, Zanzibar, and Madagascar, especially for women's printed wrapper dresses.[86] On the Swahili coast, from the 1840s women's insatiable appetite for the *kisutu* printed wrappers from Surat stimulated annual imports of over ten thousand (see ch. 12).[87]

Many other chintz artisans shifted or redoubled efforts to cater to local Indian markets. A very few produced for court patrons; chintz painters in the village of Karuppur, for instance, created delicate designs on cottons brocaded with gold thread for the ruling family of Tanjore.[88] The vast majority of printers worked for the mass market. There is compelling evidence that the influx of British industrial-printed cottons, combined with rising Indian incomes, actually stimulated local printing and printers in some areas. Indian merchants were, in fact, from 1811, the first to order industrial prints from Britain; by the 1880s, they were observed to be commanding "the situation," ordering patterns from British manufacturers, based on designs drawn by Indian designers.[89] These imported prints inaugurated a "radical change in both design and colours" for women's fashion, notably in Bengal, Punjab, and the South, bringing pattern and colour—especially red—to the masses.[90] They replaced not locally made prints but white or striped hand-loomed fabrics. Although hand spinners and hand weavers lost business as a result, India's printers profited from the fashion; they used Europe's cheaper industrial yarn, cloth, and synthetic dyes to produce local versions.[91] Printers further invented novel and nuanced shades by imaginatively mixing anilines with local natural sources, developing new dyes from local plants, and experimenting with imported vegetable dyes, such as logwood; others developed new steaming and discharge techniques.[92] Attuned to local tastes, they too incorporated newly popular European-inspired motifs, ignoring British scholars' condemnation of the same as "mongrel" or "gaudy."[93]

No longer tied to special waters, many printers relocated to new urban centres, notably Lucknow, Calcutta (Kolkata), Madurai, Madras (Chennai), and Bombay (Mumbai).[94] The new mills of Bombay and their 4,500 mechanized looms proved a big draw; from 1872, much of the output was treated by printers living in their vicinity.[95] Meanwhile, some rural practitioners came to specialize in religious textiles, ranging from exquisitely hand-drawn

FIG. 1.11

Kerchief. Britain, for the Indian market, ca. 1880. Cotton, synthetic and natural? dyes, roller-printed, 63.5 × 71 cm.

In a reverse of history, from the 1830s, mills in Britain began producing massive numbers of industrial printed cottons for export to India, both copying Indian designs and creating new ones.

ROM 2004.75.1

Above: Detail of kerchief made for Indian market, featuring the Hindu deity Ganesh surrounded by *ganjifa* cards, a popular Indian card game originating in Persia.

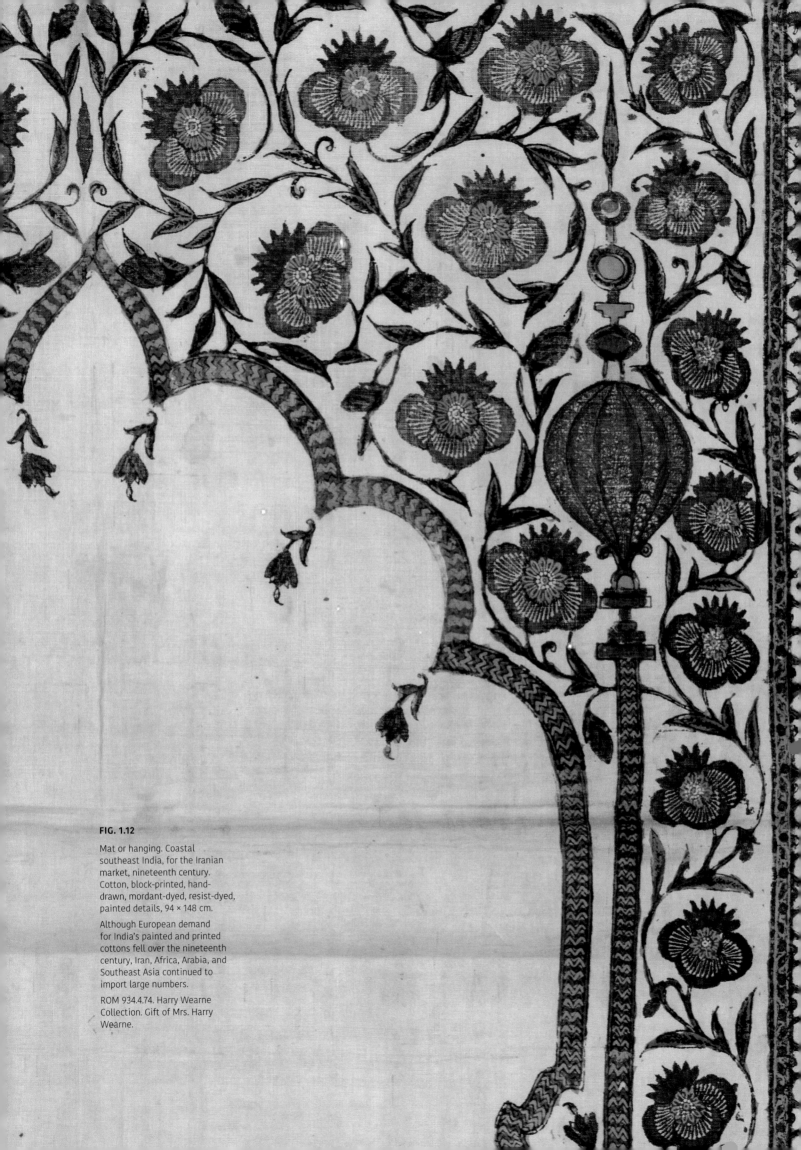

FIG. 1.12

Mat or hanging. Coastal
southeast India, for the Iranian
market, nineteenth century.
Cotton, block-printed, hand-
drawn, mordant-dyed, resist-dyed,
painted details, 94 × 148 cm.

Although European demand
for India's painted and printed
cottons fell over the nineteenth
century, Iran, Africa, Arabia, and
Southeast Asia continued to
import large numbers.

ROM 934.4.74. Harry Wearne
Collection. Gift of Mrs. Harry
Wearne.

The Origins of Indian Chintz at the ROM

Katharine B. "Betty" Brett, ca. 1970, showing the quilted palampore (fig. 9.5) which she acquired from the Dutch collector Alida Eecen van Setten. © Royal Ontario Museum.

How the Royal Ontario Museum (ROM) assembled its renowned collections of Indian chintz is entangled with wider trends in the cloth's production, circulation, and interpretation.

The first pieces entered the museum by misunderstanding, acquired as examples of Iranian and Egyptian craft by ROM founding director Charles T. Currelly (1876–1957). An ordained minister and amateur archaeologist, Currelly originally envisioned museum displays that would illustrate everyday life in the Holy Lands. To this end, he purchased a dozen printed and painted cottons that he (like his contemporaries) believed represented ancient manufactures of Egypt or Persia (see fig. 1.12). Today we know these distinctive types and designs were instead created in India for *export* to Egypt and Iran; furthermore, those made for Iranian markets are not "ancient" but date to the nineteenth century.[1]

Nationalist economic interests also drove museums, including the ROM, to collect Indian chintz. From the 1830s, the British government strove to aid British manufacturers in improving their industrial design (see ch. 17).[2] Indian textiles were deemed to be of "good design," and large numbers were displayed—together with many other decorative arts—at London's new South Kensington Museum, today's Victoria and Albert Museum. Currelly urged the ROM likewise to be "a museum of industrial art," to inspire Canadian design in furniture, textiles, wallpapers, and silver.[3] In 1934, to Currelly's great delight, the ROM received a donation of over eighty exquisite Indian chintzes from the widow of Harry Wearne. The British-born Wearne (1852–1929) had enjoyed a successful career designing wallpaper and textiles for firms in Alsace and the United Kingdom. Like many Western producers, Wearne had sought design inspiration in exotic and historic textiles, and for this purpose amassed a large private collection—over one thousand pieces; purchased in France after 1918, the vast majority were early cotton prints made in Europe. Some eighty pieces, however, were Indian chintz; they included twenty spectacular hand-drawn eighteenth-century Indo-European palampores, dress articles, and fragments, made for English and French markets, in addition to a dozen Indo-Iranian cottons.[4] Into the 1960s, a dedicated gallery in the ROM displayed selections from the Wearne collection, where it seems Toronto's design students, rather than industrialists, sought inspiration.

From 1945, incoming ROM curator Katharine B. Brett (pictured above), a trained print maker, took an art-historical approach to the museum's Indian chintz holdings. In addition to her pioneering research on design and technique,[5] Brett made strategic purchases to fill gaps in ROM holdings. They ranged from fine historic pieces for Indian markets to medieval Indo-Egyptian archaeological fragments. Interested in fashion above all, Brett obtained for the ROM a dozen significant eighteenth-century European garments made of Indian chintz, including a man's banyan with Japanese-inspired design aesthetics and several women's sumptuous overdresses (see ch. 10).[6] Her friendly relations with Alida Eecen van Setten, a passionate collector based in the Netherlands, brought the museum several additional masterpieces of Indian chintz for the Dutch market (see ch. 9 and 10).[7]

Generous donations further grew ROM holdings. From 1968 to 1971, the museum was gifted five large temple hangings depicting narrative scenes from Hindu epics, made in Tamil Nadu and Andhra Pradesh (see ch. 2 and 18). Among the donors were the estates of Canada's first major art collectors: William Cornelius Van Horne and Mrs. A. Murray Vaughan, a passionate, eclectic textile collector. How they acquired the temple hangings is uncertain, but we know that cloths of this type were sold as Orientalist decor from the late 1800s at expositions and shops in India, Europe, and the United States (see ch. 17). At least two ROM hangings are likely products of the twentieth-century revival of kalam painting in the town of Srikalahasti (fig. 18.8).

The 1970s and 1980s were a relatively quiet time for chintz collecting at the ROM, with two significant exceptions. Curator Veronika Gervers, a specialist of East-West textile connections, acquired thirty-four Indo-Egyptian archaeological fragments, part of a larger acquisition of over one thousand Middle Eastern textiles originally assembled by the antiquities dealer Michel Abemayor in Cairo before 1945. Recent stylistic study and radiocarbon dating confirm the medieval dating for most of these textiles (see ch. 3).[8] Curator John Vollmer orchestrated the acquisition of a remarkable Thai soldier's coat made of hand-painted Indian chintz, featuring four large fanged demon faces and imitation chain mail, which came via the renowned London-based Thai manuscript scholar Henry Ginsburg (fig. 6.3).

Since 2007, the generosity of the Louise Hawley Stone Charitable Trust and the Friends of Textiles & Costume has enabled the ROM to obtain stellar examples of historic Indian chintz made for Asian regional tastes, in addition to works by India's contemporary chintz artists and fashion designers. Today's digital world releases all these masterworks to again travel the globe, far beyond museum walls, to inspire awe and admiration.

and gilded hangings (*pichhwai*) for wealthy Vishnu temples and processional banners for more modest clients, to block-printed canopies for marginalized communities to erect as temporary shrines.[96] In Rajasthan and Gujarat, as Eiluned Edwards has shown, most printers settled into making understated block-printed wrapper cloths and skirt yardage—"caste dress"—for immediately local clients; although restrained in design, the cloth carried enormous social significance by creating and communicating group identities.[97] Migrations and product changes brought occupational mobility and social advancement: washers became dyers, dyers and weavers became printers, weavers became merchants, et cetera.[98]

The complex and contradictory fates of Indian chintz over the nineteenth century will continue to inspire debate and research, as Dewan discusses in this volume. Museum collections certainly testify that high-quality chintz continued to be made, as do observations that printing in particular remained (or became) a "successful calling," "found here and there all over the country" and retaining large numbers of practitioners—still some twelve thousand to fifteen thousand estimated in Ahmedabad alone in 1920.[99]

Movements aimed at Indian independence—achieved in 1947—carried textile arts forward into the twentieth century. In the famed Swadeshi campaigns begun in the 1890s, early nationalists urged economic independence through the purchase of Indian-made goods, particularly cotton cloth (both the industrial and the handmade). Mohandas K. Gandhi, in the 1920s, famously promoted hand spinning and wearing handwoven cottons.[100] Although weavers and undyed khadi cloth were the focus of these

movements, chintz and its artisans also benefited. As Sengupta and Edwards elaborate in the final part of this book (see ch. 18 and 19), passionate individuals and organizations variously championed chintz, among them craft activists and NGOs (nongovernmental organizations), a few local rulers, and new government agencies—such as the All India Handicrafts Board and the National Institute of Design.[101] These advocates strove to reintroduce natural dyes, train new artisans, teach product development, provide sales outlets, and modernize design for contemporary urban consumers—aided by the input of trained artists including Nellie Sethna.[102] Independent designer-entrepreneurs such as Archana Shah reinvigorated the fashionability of chintz with new designs, colours, and retail boutiques.[103] A census in 1961 registered nearly forty-nine thousand textile printers and kalam drawers.[104]

Despite these monumental efforts, the 1960s to the 1980s, as Edwards notes, found printers generally in the doldrums, as local consumers flocked to new synthetic fabrics. Most printers belonged to small "units," or father-son workshops—some depending on cloth advanced by merchants or hawking their goods at local markets, many employing toxic naphthol dyes.[105] The West's hippie movement of the 1960s thus came as "a godsend" for some Indian printers. It drew a new wave of foreign entrepreneurs from Europe, North America, and Japan, looking to produce, design, and export for local and home markets; they included Sarah Pouliot of Canada, whose little-known business history is explored by Palmer in chapter 20. The state-sponsored Festival of India, held in London in 1982 and subsequently in several cities throughout the United States, further reintroduced Indian chintz and its makers to the global stage. Even so, as the twentieth century closed, observers widely dismissed India's painted and printed cottons as "a disappearing artistic endeavour," just as they had at the close of the previous century.[106] Little did they anticipate the start of a new fashion cycle from 2010 or its phenomenal scale and inventiveness.

Indian Chintz in the World Today

Our work must always draw from our traditions . . . that is what makes it unique and gives it purpose and meaning.

— Kirit Chadrankant, *mata ni pachedi* artist,
Ahmedabad, December 2018

Rather than simply homogenize, the recent phase of globalization has increased visibility and trade in world textile arts, and inspired people to look to their own roots and craft heritage. The liberalizations of the Indian economy in 1991, combined with a rising global demand for natural dyes and "slow fashion," have spurred many remarkable—and commercially successful—revitalizations and innovations.[107] Painting and, above all, printing cottons continues today in Andhra Pradesh, Tamil Nadu, Uttar Pradesh, Punjab, Gujarat, and Rajasthan, as well as in the megacities of New Delhi, Bengaluru, Mumbai, and Kolkata. A few father-son workshops in remote areas still produce for local clients, mostly votive cloths and men's wrappers, or for a few branches of the ancient Indian Ocean trade: hand-printed veils for the women of Sana'a, Yemen, ceremonial cloths for the Babar archipelago of Indonesia.[108] The most flourishing individuals and workshops, however, have tapped into new urban, tourist, diasporic, and global markets.

The exploding global interest in slow fashion, natural dyes, and fibres over the past twenty years has renewed desire for Indian chintz as both urban dress fashion and home furnishings. Many collaborations have developed between printers and designer-entrepreneurs, both national and international. Smart phones, the internet, and cheaper international travel have enabled direct communication with retailers in New Delhi, Bangkok, Tokyo, Paris, Sydney, Vancouver, and New York.[109] Some designers are dedicated to long-term relationships with printing families, rather than one-off, boom-and-bust

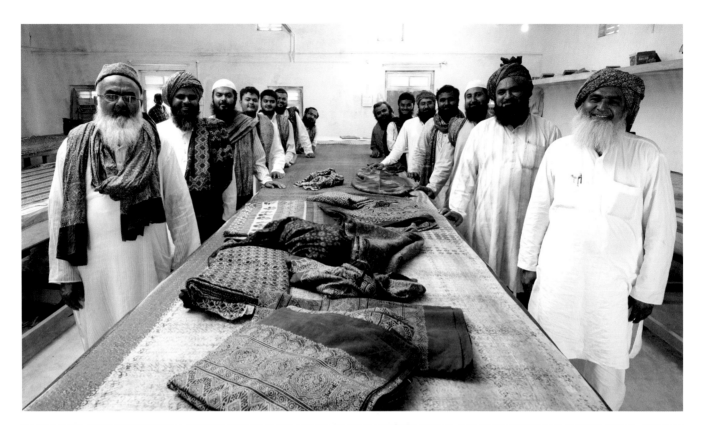

orders. Higher-end lines are made of organic cottons and all-natural dyes, or "eco-friendly" colours. Innovations for new audiences include working on cotton-silk blends, silk and linen, eco-friendly new fibres such as lyosell, new dye plants such as rhubarb, and developing contemporary designs. In Kachchh, Gujarat, a special category of prints known as *ajrakh* (geometric designs in deep reds and blues) has known phenomenal success in the past decade as soft furnishings, mainstream dress, and runway fashion (see ch. 19 and 21).[110] Abduljabbar Khatri has made a name creating masterworks with historic patterns (fig. 1.15), while his nephew Sufiyan Khatri collaborates with numerous national and international designers on conceptual compositions.

A few chintz painters have found global or national recognition and patronage as fine artists. Some such as Chandrakant Chitara of Ahmedabad, Gujarat, come from a long line of textile artisans. For generations, his family painted and printed religious hangings known as *mata ni pachedi*, or "mother goddess curtains." Chandrakant and his uncle Jayantibhai have in recent years specialized in fine art pieces intended for art collectors, galleries, and museums (see ch. 2). Their tableaux still feature the mother goddesses but in larger scale and in open landscapes, incorporating some design conventions of South India, such as the rocky mound. For a work commissioned by the ROM, Chandrakant chose to highlight the Chitaras' recent exclusion from the Sabarmati River (fig. 2.9). Other artists—who now include women— followed other paths. Renuka Reddy is a trained textile specialist, based in Bengaluru; she is especially fascinated by process, colour, and recapturing lost kalam techniques, notably hand-drawing details in wax prior to dyeing in madder and indigo. Her work, which draws on exhaustive historic and empiric research, plays mainly on eighteenth-century Indo-European chintz, with its many nuanced shades (fig. 1.16). Ajit Kumar Das, based in Kolkata, worked in cloth dyeing and printing before turning to kalam drawing. Likewise fascinated by the qualities of natural dyes, Das's tableaux explore esoteric subjects, ranging from early meditations on Vedic astrology and Tantric religious art to personal experiences and the medium itself. In his *Prosothor* (Stone) series, he explores memories of early personal and professional struggles; the intricately coloured and impossibly stacked boulders—their rough surfaces in tension with the soft palette and cotton—simultaneously convey anxiety and equilibrium (fig. 1.17).[111]

Consumption in India today—with its population of some 1.3 billion people—offers the largest growth and most exciting developments. While silk, embroidery, and hand weavings remain the preferred luxury fabrics, rising income and growing appreciation of India's unique textile heritage have brought resurging demand for hand-printed cottons. Anokhi, a block-print enterprise founded in the early 1970s largely as an export concern, is today prospering from twenty-four outlets located across India.[112] Prints now account for 25 percent of the garments and furnishings offered by the giant retailer FabIndia, an enterprise originally created as an outlet for hand-loomed goods; currently with 266 boutiques in 98 Indian cities, it plans to open 40 to 50 new stores per year.[113] The offerings of these two companies range from cotton saris, printed with historic patterns for "loyalist" customers, to shalwar kameez (tunic trousers) and accessories, with contemporary designs for younger generations. General lifestyle and mainstream retailers such as Good Earth and Reliance also carry lines of hand-printed cottons. Finally, as Divia Patel notes, many of India's top couture designers are today looking inward, driven as much by "selling the modernity of the product as [by] . . . the tradition of village-based craftsmanship," with heritage fabrics key to creating "Indian chic" and competing with luxury Western brands.[114] The final essays of this volume present designers, such as Aneeth Arora of the Péro label and Gaurang Shah, who have worked with master artisans to launch seasonal lines of printed and painted

OPPOSITE ABOVE
FIG. 1.14

Sons and grandsons of Khatri Mohammed Siddik, of Kachchh, Gujarat, who in the 1980s championed a return to natural dyes (Dhamadka, 2017). All today collaborate with national and international designers in developing novel fibres and designs.

Tim McLaughlin, Maiwa.

OPPOSITE BELOW
FIG. 1.15

Contemporary *ajrakh* masterwork (detail) designed and printed by Abduljabbar Khatri. Cotton, natural dyes, 150 × 225 cm.

ROM 2019.42.1. This acquisition was made possible with the generous support of the ROM Textiles Research and Acquisitions Endowment Fund.

BELOW
FIG. 1.16

Renuka Reddy painting indigo with the kalam pen, Bengaluru, 2019. Reddy has researched and revived the practice of drawing wax resists with the kalam prior to madder and indigo dyeing.

Photograph by Vandana Radhakrishnan.

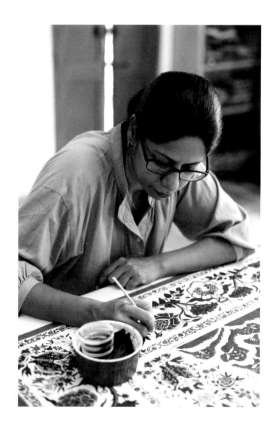

OPPOSITE
FIG. 1.17

Ajit Kumar Das, *Prosthor* (Stone), 2014. Cotton, drawn mordants, dyed, painted details, 215 × 155 cm.

ROM 2019.35.1. This acquisition was made possible with the generous support of the Louise Hawley Stone Charitable Trust, Peer Review Fund.

LEFT
FIG. 1.18

Instagram feed from the New Dehli-based *pret* label 11:11/ eleven eleven, devoted to using vegetable dyes, hand skills, and handwoven cotton and silk. Its sub-brand 100%HANDMADE provides the biography of each garment "from seed to stitch."

silks and cottons, publicized through Lakme Fashion Week, promotional videos, and India's multiplying fashion magazines and social media (fig 1.18).[115]

Success always begets challenges. Water, as Edwards stresses, is an increasingly worrisome issue, for India is notoriously running short.[116] Both cotton growing and dyeing—even with natural products—require vast quantities of water. Since 2016, India is again the world's largest producer of cotton, but is now planting thirsty genetically modified hybrids of American species.[117] Were dyers to return to using wild varieties of the chay plant, demand might outstrip sustainable harvesting. Large orders encourage screen printing with artificial dyes and polluting runoff.[118] Artisans deplore struggles to protect designs from being copied by hand or rotary screen printing in distant states.[119] Yet, challenges in turn incentivize solutions, such as recent successes in water-efficient dyeing and reintroducing indigenous drought-resistant cotton species, so-called *kala* cotton.[120] Sons who left family practices to pursue formal education in engineering or graphic design, such as Kirit Chitara and Eswarudu Rao, swearing they would never enter the field, have in the past few years returned to successful ventures that they are steering in new directions.

The five-thousand-year history of Indian chintz enters a new chapter. The essays that follow explore the qualities and particularities of Indian chintz that have made it perennially admired, desired, emulated, and imitated, from Gujarati villages to Golconda courts, from Japan to Ottawa, from the Swahili coast to Brazil.

In Focus

In Praise of Cottons

by RENUKA REDDY

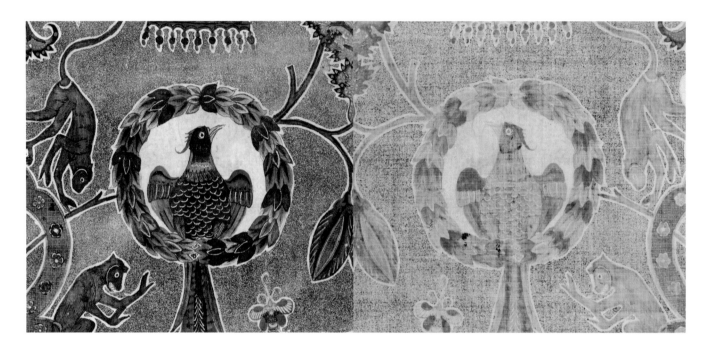

Detail: Front and back sides of a bed canopy. Coastal southeast India, for the European market, ca. 1720–1740. ROM 934.4.15.D

In the eighteenth century, several French authors sought to record the many steps that go into making Indian chintz.[1] They revealed the purposeful role of each ingredient in the production process and its contribution to the final product, notably the more obvious madder-type dyestuff for reds and indigo for blues. My decade of experiments to master the techniques of eighteenth-century hand-drawn Coromandel Coast chintz has led me to another conclusion: Indian chintz begins with the cotton cloth, a masterpiece in its own right.

Though cotton is one of the most difficult fibres to dye, it was the preferred choice for making chintz.[2] Cotton, unlike silk or wool, becomes stronger when wet and has the ability to withstand high temperature—properties that allow it to endure many washings and hours of dyeing under heat. Additionally, cotton is not harmed by the alkaline madder bath or indigo vat.

With some exceptions, the base cotton cloth in fine hand-painted historic chintz typically shows a single-ply yarn in warp and weft, dense, and tightly packed plain weave with little or no space in between yarns. While plain weave produces a durable cloth, it is the fabric count (ends per cm and picks per cm) that plays a crucial role in the production of hand-painted chintz.

In producing hand-painted chintz, water-based mordants such as alum and iron acetate are painted on cotton cloth, unlike in piece or yarn dyeing, where cloth or yarn is fully soaked

in mordant. In my initial experiments, alum was applied generously, rubbing it into the cloth with a *kalam* pen, since conventional wisdom was that good mordant penetration in the fibre results in better dyed properties. Mordant-painted cloth was dyed in madder and subsequently bleached by soaking the dyed cloth in dung at night and exposing it to sunlight for several days, until the background turned white. Results were always the same, especially for lighter colours: shades that seemed perfectly fine upon dyeing faded into uneven colour upon bleaching.

Research in improving lightfastness led me to a simple explanation, summarized by science: "Light fastness of a dyed fiber usually increases with increasing dye concentration."[3] Since dye molecules attach to mordants in the case of dyes such as madder, it became apparent that to minimize the change in shade when bleaching, mordant needs to be applied evenly on the surface of the cloth with minimal or no penetration. This perhaps explains why the dyed area is not as visible on the back side of a mid-eighteenth-century chintz from India (p. 26). A tightly woven cloth facilitates higher dye concentration on the surface and aids in preventing penetration of mordants, a crucial requirement in a process in which dyeing is followed by bleaching with dung and prolonged exposure to sunlight.

The structure and properties of cotton cloth influence every step in chintz making. Of particular importance is its role in the wax-resist process. Compactness of yarns provides a continuous surface to which the wax can adhere and therefore allows sharp resist lines and minimizes cracking. Visually, a tightly woven cloth of fine yarn is similar to other flat media, such as paper, which lends to the beautiful painterly quality of chintz (above, right). Using a thicker yarn to reduce the space between yarns is not ideal, as this method results in uneven surface texture and thus a difficult surface for drawing fine continuous lines; thicker yarn also increases the weight of the fabric, which makes it challenging to handle during operations.

At the same time, a very fine cloth is challenging: it is susceptible to change in shape or damage during vigorous—and

Mordant-painted, madder-dyed, and bleached cotton swatches. Bengaluru, 2018. Top row fabric is 300s warp by 200s weft, 44 ends per cm and 40 picks per cm. Bottom row fabric is 180s warp by 100s weft, 34 ends per cm and 30 picks per cm. Photograph by Renuka Reddy, 2018.

repeated—operations such as washing, dyeing, and beetling. Considering the conditions and requirements of the processes involved in chintz production, finding the right balance in cloth through fibre, yarn, and fabric structures is truly remarkable, as is also the skill required for weaving compact cloth of fine yarns in wide widths (172 cm to about 315 cm), which were fairly common in the eighteenth century.[4]

After years of experimenting with weavers in West Bengal, I have not been successful in sourcing a base cloth like the one used in historic chintz. When asked to produce cotton cloth for my work, Jyotish Debnath, an award-winning master weaver, took one look at a chintz swatch from the eighteenth century and stated quite simply that it is not possible to reproduce it in this day and age. Credit for the splendour of historic hand-painted Indian chintz must therefore go not only to painters and dyers but also to the thousands of female spinners and male weavers who created masterpieces of cotton fabric.[5]

1 For analyses of these sources, see Irwin and Brett, *Origins of Chintz*, 36–53; Schwartz, "French Documents"; Roques, *La manière de négocier*; Cardon, "Chimie empirique." **2** Gittinger, *Master Dyers*, 19. **3** Cristea and Vilarem, "Improving Light Fastness," 239. **4** Irwin and Brett, *Origins of Chintz*, 8. **5** Wendt, "Four Centuries of Decline?"

1 The terms *painted cottons* and *painting* refer not to the direct application of colour but to the application of mordants or resists, unless otherwise noted.

2 Irwin and Brett, *Origins of Chintz*.

3 "Two sorts of chintz were made in India – the painted and the printed." Schwartz, "French Documents," 41–42. Gittinger (*Master Dyers*, 197) and John Guy (*Woven Cargoes*, 7) note that terms such as *chite*, *chits*, and *chita* originally applied to both stamped and "mordant-painted" cottons. John Irwin argued for reinstating the term *chintz* to reference both painting and printing; Irwin, "Etymology of Chintz and *Pintado*," 77. For detailed discussions of the complexities of terminology related to mordant and resist dyeing, see Crill, *Chintz*, 7–9; Barnes, *Indian Block-Printed Textiles*, vol. 1, 52–55.

4 Technically, the dyes do not lie on the surface but penetrate or bind with the fibre; see Cardon, "Colours of Chintz," 50–59.

5 Combining printing and painting is evident in some great hangings (palampores) made for the European market; see Edwards, *Imprints of Culture*, 19.

6 Chintz is also among the greatest textile arts of neighbouring Pakistan, which in 1947 was separated politically from India. Indeed, cotton and chintz's early origins lie in the Indus Valley, in present-day Pakistan, and the finest *ajrakh* prints are made there today. See Bilgrami, Ahmed, and Mingeikan, eds., *Tana bana*; Bilgrami, *Sindh jo ajrakh*.

7 Irwin and Brett, *Origins of Chintz*, 13–15; Gittinger, *Master Dyers*, 66–133; Crill, *Fabric of India*, 120–28.

8 Kenoyer, "Ancient Textiles," in *Tana bana*, 18–31.

9 For good overviews on the cotton varieties of India and their changes over time, see Gittinger, *Master Dyers*; Beckert, *Empire of Cotton*; Cohen, "Materials and Making," in *The Fabric of India*, 16–77; Kawakatsu, *Lancashire Cotton Industry*; and Menon and Uzramma, *Frayed History*.

10 When hand carded and hand spun, indigenous Indian cotton reportedly takes dyes more readily; Menon and Uzramma, *Frayed History*, 24, 57, 313. As of 2017, the genetically modified Bt variety of the American cotton species *Gossypium hirsutum* accounted for 96 percent of cotton cultivation in India; Menon and Uzramma, *Frayed History*, 221.

11 John Huyghen van Linschoten, *The Voyage of John Huyghen van Linschoten to the East Indies*, quoted in Riello, *Cotton*, 20. In some contexts, however, Hindus consider silk the purer fibre; see Menon and Uzramma, *Frayed History*, 4.

12 On these various specialists, see Irwin and Brett, *Origins of Chintz*, 7–11; Roques, *La manière de négocier*, 100–108; and Varadarajan, *South Indian Traditions*, 95.

13 Riello, *Cotton*, 52.

14 On the width of panels, see Irwin and Brett, *Origins of Chintz*, 8. The cloth varieties *percallaes*, *sallampores*, *morees*, and long cloth were variously preferred as base fabrics for the European market; see Irwin, "Indian Textile Trade," 30, 34.

15 Watson, "Rise and Spread," 355–68; Riello, *Cotton*, 39, 73; Beckert, *Empire of Cotton*, 10–11; Parthasarathi and Riello, "Introduction," 2–4.

16 "For it is not material what the fancyes or works the Patterns are, so they be finely done and lively colours." Quoted in Irwin, "Indian Textile Trade," pt. 2, 33.

17 On the difficulty of printing and painting cotton, see Gittinger, "Ingenious Techniques," 4–15. Most of what we know of historic techniques for dyeing and patterning Indian chintz comes from reports made by several French travellers in the eighteenth century in connection with the European export trade; see Schwartz, appendices A–C in Irwin and Brett, *Origins of Chintz*, 36–58; Schwartz, "French Documents"; Schwartz, *Printing on Cotton*; Roques, *La manière de négocier*. Recent studies analyzing these recipes from the viewpoints of current scientific knowledge (botany and chemistry) include Cardon, "Chimie empirique," 70–78; Cardon, "Colours of Chintz;" Cardon, *Natural Dyes*; Martinsen, "Fashionable Chemistry"; Martinsen, "Kattuntryck," 5–15. See also Irwin, "Indian Textile Trade," pt. 2, 31.

18 Cardon, "Colours of Chintz," 53.

19 Irwin and Brett, *Origins of Chintz*, 39–56; Martinsen, "Fashionable Chemistry," 108–15.

20 Schwartz, appendix A in Irwin and Brett, *Origins of Chintz*, 39.

21 Irwin and Brett, *Origins of Chintz*, 46. Other sources report outlines drawn with burnt blacksmith's coal mixed with rice vinegar; see Martinsen, "Fashionable Chemistry," 110.

22 There is a tendency to denigrate printing as having "robbed the medium of its vitality." Gittinger, *Master Dyers*, 27.

23 Irwin and Brett, *Origins of Chintz*, 11.

24 Irwin, "Indian Textile Trade," pt. 2, 25.

25 Gittinger, *Master Dyers*, 61; Irwin and Brett, *Origins of Chintz*, 7.

26 Irwin and Brett, 7; Fee, "'Cloth with Names,'"49–84.

27 See, for instance, Haynes, *Small Town Capitalism*. On the trade in textile commodities on the Coromandel Coast, see Swarnalatha, *World of the Weaver*, 3.

28 Irwin and Brett, *Origins of Chintz*, 7. For other innovations, see Gittinger, *Master Dyers*, 27, 61, rn baker. On movements of cotton printers today, see Edwards, *Imprints of Culture*.

29 Lemire, *Cotton*, 30. Major titles in the recent rich study of global cotton include Riello, *Cotton*; Lemire, *Cotton*; Parthasarathi, *Why Europe Grew Rich*; Riello and Parthasarathi, eds., *The Spinning World*; Beckert, *Empire of Cotton*; Riello and Roy, eds. *How India Clothed the World*; and Kawakatsu, *Lancashire Cotton Industry*. For the global impacts of chintz fabrics in particular, see Riello, *Cotton*; Verley, "Indiennes des Indes," 13–26.

30 Barnes, *Indian Block-Printed Textiles*, 2 vols.; Riello, *Cotton*, 20–29; Guy, *Woven Cargoes*, 39–52; Barnes, "Textiles," 12–15; Shah, *Masters of the Cloth*; Ray, "Warp and Weft," 289–311.

31 Riello, *Cotton*, 23, 25; Lemire, *Cotton*, 11–20.

32 Dale, "Silk Road, Cotton Road or . . . Indo-Chinese Trade in Pre-European Times," 79–88, cited in Riello, *Cotton*, 26.

33 Riello, *Cotton*, 25.

34 Crill, *Chintz*, 11; Riello, *Cotton*, 139; Verley, "Indiennes des Indes," 16; Lemire, *Cotton*, 41.

35 Barnes, *Indian Block-Printed Textiles*; Vogelsang-Eastwood, *Resist Dyed Textiles*.

36 Guy, *Woven Cargoes*, 7–17. Maritime Southeast Asia notoriously had "an insatiable appetite for cloth." Barnes, "Textiles," 13.

37 Irwin, "Indian Textile Trade," pt. 1, 5–8; Guy, *Woven Cargoes*, 14; Gittinger, *Master Dyers*, 13. See also Verley, "Indiennes des Indes," 14; Riello, *Cotton*, 90; Parthasarathi, *Why Europe Grew Rich*, 46–50.

38 Baker, *Calico Painting and Printing*, 24.

39 Riello, *Cotton*, 90; Verley, "Indiennes des Indes," 14. Portuguese cargoes from India were already 80 percent textiles by 1593; see Lemire, *Cotton*, 40.

40 Gittinger, *Master Dyers*, 186; Crill, *Chintz*, 15–16; Verley, "Indiennes des Indes," 15.

41 Parthasarati, *Why Europe Grew Rich*, 31.

42 Lemire, *Cotton*, 27–29.

43 Lemire, 44–48; Lemire, "Fashioning Global Trade," 365–89; Verley, "Indiennes des Indes," 13; Irwin and Brett, *Origins of Chintz*, 30.

44 Crosby, "First Impressions," 85; Verley, "Indiennes des Indes," 16; housemaids comprised 66 percent of Paris's population at the time. See also Lemire, *Cotton*, 48–57. The increased trade in lower-end printed cottons was linked to lower shipping costs; see Parthasarathi, "Cotton Textiles," 36.

45 Baker, *Calico Painting and Printing*, 33; Vicente, *Clothing the Spanish Empire*, 10.

46 Verley, "Indiennes des Indes," 15; Lemire, *Cotton*, 22; Riello, *Cotton*, 129–33; Watt, "'Whims and Fancies,'" 92, 98.

47 Baker, *Calico Painting and Printing*, 36.

48 Martinsen, "Fashionable Chemistry," 105–6; Irwin, "Origins of 'Oriental' Chintz Design," 109, 113, 114; Irwin and Brett, *Origins of Chintz*, 9.

49 Gittinger, *Master Dyers*, 177; Haudrère, "La compagnie des Indes," 16.

50 Watt, "'Whims and Fancies,'" 92. Warnings in 1664 "decried the use of Indian cottons as unsuitable for pious Christians, as they were manufactured by 'infidels.'" Crill, "Textiles for the Trade," 92.

51 Kriegel, *Grand Designs*, 55.

52 These same bans, in many times and places, also applied to silk, bast, and other cloths from China, "Persia," and the Levant. Riello, *Cotton*, 121.

53 Rey, *The Weavers Truce Case; or, the Wearing of Printed Callicoes and Linnen Destructive to the Woollen and Silk Manufacturers*, quoted in Parthasarathi, *Why Europe Grew Rich*, 92; Martinsen, "Fashionable Chemistry," 107; Lemire, *Cotton*, 48–58. Even so, most of those fined during bans were of the middle class; see Verley, "Indiennes des Indes," 16.

54 From 1720 to 1770, Indian textiles accounted for 30 to 50 percent of goods traded to West Africa by French and English trading companies. Parthasarathi, *Why Europe Grew Rich*, 24. See also Inikori, "Slavery and the Revolution," 343–79; Crosby, "First Impressions," 90–91.

55 Riello, *Cotton*, 135–59; Lemire, *Global Trade*, 60, 274–79; DuPlessis, *Material Atlantic*, 63, 65, 66, 68, 78, 95, 117, 197, 202, 211, 221, 223.

56 DuPlessis, 211. On varying tastes in florals and colours, see, for instance, Riello, *Cotton*, 144, 146; DuPlessis, 63, 65, 66, 68, 78, 95, 117, 197, 202, 211, 221, 223; Peck, "'India Chints,'" 113, 118; Gittinger, *Master Dyers*, 186.

57 The percentage of Indian chintz in the trade to West Africa, although generally low compared to other kinds of Indian cottons, did in certain times and places form an important segment. Crosby, "First Impressions," 75, 90–91; DuPlessis, *Material Atlantic*, 65; and ch. 9, this volume.

58 Irwin and Brett, *Origins of Chintz*, 5; Gittinger, *Master Dyers*, 114; Riello, *Cotton*, 99–107; Swarnalatha, *World of the Weaver*, 116.

59 Moreover, Europeans realized that 50 percent of Indian cottons' value lay in the finishing, that is, in painting and printing. Parthasarathi, *Why Europe Grew Rich*, 91.

60 Gittinger, *Master Dyers*, 163; Riello, *Cotton*, 124; Phipps, "New Textiles in a New World," 1–15.

61 Beckert, *Empire of Cotton*, xiv.

62 Lemire, *Cotton*, 65–66; Riello, *Cotton*, 85, 133; Haudrère, "La Compagnie des Indes," 13.

63 Martinsen, "Fashionable Chemistry," 137–52.

64 Riello, *Cotton*, 178; Martinsen, "Fashionable Chemistry," 118; Martinsen, "Kattuntryck," 7; Cardon, "Chimie empirique," 80. Provençal floral prints are one result of early cotton printing in Marseilles.

65 The Edict of Nantes, expelling the Huguenots, had several great impacts on European chintz making; see Verley, "Indiennes des Indes," 18–20.

66 Scholars continue today to fiercely debate the cause for Britain's industrial textile success, with the most recent major titles citing some combination of captive colonial markets, continental politics, protectionist tariffs, consumer demand, and access to resources such as coal. See Beckert, *Empire of Cotton*; Parthasarathi, *Why Europe Grew Rich*; Riello, *Cotton*; Inikori, *Africans*; Berg, "Quality," 391–414. Following Stanley D. Chapman and Serge Chassagne, *European Textile Printers*, Giorgio Riello (*Cotton*) and Patrick Verley ("Indiennes des Indes") most overtly link Britain's industrial rise to its earlier printing industries.

67 Riello, *Cotton*, 179–80; Chapman and Chassagne, *European Textile Printers*, 20–21.

68 Chapman and Chassagne, 24.

69 Chapman and Chassagne, 194–95; Parthasarathi, *Why Europe Grew Rich*, 95; Riello, *Cotton*, 225–34. European spinners could not create warp thread of sufficient strength, and the collapse of the Mughal Empire disrupted Indian supplies; see Berg, "Quality," 408. French industrialist Christophe-Phillippe Oberkampf famously used Indian cloth until forced by Napoleon Bonaparte to change; see Maxine Berg, *Luxury and Pleasure*, 409; Martinsen, "Kattuntryck," 10.

70 Menon and Uzramma, *Frayed History*, xx–xxiii, 325.

71 Beckert, *Empire of Cotton*, 107–8, 353–54.

72 On the complex political and economic factors driving this shift, see Chapman and Chassagne, *European Textile Printers*, 107.

73 Verley, "Indiennes des Indes," 22.

74 Synthetic indigo was developed in only 1897. Kumar, *Indigo Plantations*, 178.

75 Baker, *Calico Painting and Printing*, 54

76 Haynes, *Small Town Capitalism*, 25; Swallow, "India Museum," 42; Fee, "Filling Hearts."

77 Lyons, "Textile Fabrics," *Textile History* 27, no. 2 (1996): 173.

78 Stewart, "Dress and Fichu," in *Interwoven Globe*, 234–35; Verley, "Indiennes des Indes," 26; Watt, "'Whims and Fancies,'" 102; Berg, *Luxury and Pleasure*, 62; Ribeiro, *Dress in Eighteenth-Century Europe*, 234.

An important exception was the Kashmir shawl, first imported from India, then also industrially imitated in Europe.

79 Mukharji, *Art-Manufactures*, 355. By 1917, British colonial administrators were creating pattern books "for Indian craftsmen"; see Hadaway, *Cotton Painting and Printing*, iii.

80 On the expositions, see Lyons, "Textile Fabrics," 179; Driver and Ashmore, "Mobile Museum," 373, 380; Havell, "Printed Cotton Industry," 19; Birdwood, *Industrial Arts*, 341; Thurston, "Cotton Fabric Industry," 30. See object records for V&A 656–1890 and 657–1890. Liberty's offered "printed curtains and palampores from various localities." "British-Indian Section," 19–22.

81 Clouzot, "Les toiles peintes," 282–94; Morris, "Indian Textiles," 170–72.

82 *Official Report of the Calcutta International Exhibition, 1883–84*, 445. New sales venues included tourist bazaars and railway stations; see Thurston, "Cotton Fabric Industry," 24.

83 Birdwood, *Industrial Arts*, 329, 338; Watson, *Textile Manufactures of India*, vol. 15, sample #200.

84 *Official and Descriptive Catalogue of the Madras Exhibit of 1855*, East India Papers 219 A mentions fine work being made at Permagudi and Pambam for export to Burma and Arabia, as well as fine production in Madura, Nagore, Combakonum, Karuppur, Palakollu, Walajanagar, Gollapallem, Saidapte, and Kalahasti. See Barnes, Cohen, and Crill, *Trade, Temple and Court*, 62, 68, 70; Mukharji, *Art-Manufactures*, 359.

85 Watson, *Textile Manufactures*, 83. Havell asserts that all cotton cloth exports from India to Persia doubled in value from 1851 to 1865; *Printed Cotton Industry*, 10, 14–15.

86 Riello, *Cotton*, 20; Edwards, *Imprints of Culture*, 120. Producers might become dependent on a single export market, such as Java or Mozambique.

87 Fee, "Cloth with Names," 61.

88 Gittinger, *Master Dyers*, 128–29.

89 Thurston, "Cotton Fabric Industry," 22.

90 Thurston, 22. "Local stained cloths with prevalent red" predominated. Thurston, 23. "Increase in population, the growing prosperity of the urban and rural elites boosted domestic consumption." Swallow, "India Museum," 42. See also Mukharji, *Art-Manufactures*, 351–52, on the many local varieties of prints being made as female dress fabrics in the North-West Province alone.

91 Mukharji, *Art-Manufactures*, 355; Watson, *Textile Manufactures and Costumes*, 92. In some regions the fugitive qualities of anilines were appreciated, since cloth could be repeatedly refreshed with them. Watt, *Indian Art at Delhi*, 238. Indian merchants managed their import—some

five million pounds worth of synthetic alizarine in 1897; see Thurston, "Cotton Fabric Industry," 21; Swallow, "India Museum," 45n51, citing Baker, *Indian Rural Economy*, 395.

92 Greys, pinks, and lavender were made with lac, safflower, and galls. Mukharji, *Art-Manufactures*, 349. On discharge printing and steaming, see Baker, *Calico Painting and Printing*, 56–57.

93 Thurston, "Cotton Fabric Industry," 23; Havell, *Printed Cotton Industry*, 19. Other new techniques including steaming to soften cloth; Edwards, *Imprints of Culture*, 120.

94 Swallow, "India Museum," 45n51; Thurston, "Cotton Fabric Industry," 23; Mukharji, *Art-Manufactures*, 350; Official Report, 2:386.

95 Aberigh-Mackay, *Times of India*, 165; see also Birdwood, *Industrial Arts*, 328. Much of the output of Bombay's mills was destined for China and Japan, which preferred it over British manufactures; see Kawakatsu, *Lancashire Cotton Industry*, 5.

96 See Barnes, Cohen, and Crill, *Trade, Temple and Court*, 200.

97 Edwards, "*Ajrakh*," 146–70.

98 Watson, *Textile Manufactures and Costumes*, 90; Fee, "Filling Hearts," 207–9.

99 Birdwood, *Industrial Arts*, 332; Thurston, "Cotton Fabric Industry," 30; Watson, *Textile Manufactures and Costumes*, 90, 93; Kipling, "Punjab Cotton Prints," 104; Mukharji, *Art-Manufactures*, 354. The Coromandel Coast alone, in 1885, may have had up to thirty thousand printers (calculated from Hadaway, *Cotton Painting and Printing*) and eleven thousand in the Punjab. George Percival Baker observed that import shortages of World War I also stimulated local production; *Calico Painting and Printing*, 56.

100 From 1834, hand weavers were petitioning the British government for real free trade. Lyons, "Textile Fabrics," 173; Patel, "Textiles in the Modern World," 190.

101 Edwards, *Imprints of Culture*, 86. Maharaja Man Singh II of Jaipur established a printers' co-op in 1949.

102 Varadarajan, *Ajrakh and Related Techniques*, 65.

103 There were several private commercial attempts in Chennai (Madras). Varadarajan, 69.

104 Edwards, *Imprints of Culture*, 92.

105 Edwards, 84, 162. See also Cousin, *Tissus imprimés du Rajasthan*, 60–62.

106 Beer, *Trade Goods*, 43.

107 For more on this topic, see Edwards, *Imprints of Culture*; and Patel, *India Contemporary Design*. Much of what follows is based on these works, as well as on my own interviews conducted in 2017 and 2018.

108 Edwards, 168; Maurières, Chambon, and Ossart, *Reines de Saba*.

109 Chintz artists in Gujarat cite their participation in the Santa Fe International Folk Art Market as a particularly useful venue for international exposure.

110 See also Edwards, "*Ajrakh*."

111 Mukerji, "Ajit Kumar Das," 91; Ajit Kumar Das, interview by Rajarshi Sengupta, 10 April 2019.

112 Edwards, *Imprints of Culture*, 237.

113 https://www.indianretailer.com/interview/retail-people/profiles/Fabindia-will-continue-to-add-40-50-stores-every-year--Ajay-Kapoor.i1324/, Anuradha Kumara and Vaishali Bahel, personal communication, 17 December 2018.

114 Patel, *India Contemporary Design*, 43, 46, 59.

115 On master craftsmen and contemporary hierarchies, see Patel, 63. On Indian cottons in current fashion media, see Patel, 37.

116 Edwards, *Imprints of Culture*, 304–6.

117 The cotton hybrid has been further associated with farmer suicides due to indebtedness. Menon and Uzramma, *Frayed History*, xxvii–viii.

118 Edwards, *Imprints of Culture*, 165.

119 Eswarudu Rao and Kirit Chitara, in personal communication with the author, 4 April 2018 and 11 December 2018.

120 Pioneers in the development of water effluence treatments for textile dyes are Mala and Pradeep Sinha of the Bodhi label. Edwards, *Imprints of Culture*, 127.

CREATING COLOUR

1 For details on Indian chintz dye practices and their varieties over time and place, see Barnes, *Indian Block-Printed Textiles*; Cardon, "Chimie empirique," 70–81; Cardon, "Colours of Chintz," 50–59; Cardon, *Natural Dyes*; Cohen, "Materials and Making," 16–77; Edwards, *Imprints of Culture*; Holder, *Monograph on Dyes*; Irwin and Brett, *Origins of Chintz*; Martinsen, "Fashionable Chemistry;" Martinsen, "Kattuntryck," 5–15; Mohanty, Chandramouli, and Naik, *Natural Dyeing*; Lotika Varadarajan, *Ajrakh*.

2 Quoted in Baker, *Calico Painting and Printing*, 19.

3 Yellow dyes were sometimes applied with an immersion process in India; see Irwin and Brett, *Origins of Chintz*, 11; Mohanty, Chandramouli, and Naik, *Natural Dyeing Processes*, 109.

4 Gall nuts, or galls, are excrescences created by insects that infest the tree. Cardon, "Colours of Chintz," 53, 57–58; Irwin and Brett, *Origins of Chintz*, 44; Martinsen, "Fashionable Chemistry," 115.

5 On variants of dyeing green, see Irwin and Brett, *Origins of Chintz*, 43, 49.

6 On European export chintz, yellow might be painted over red to achieve orange. Irwin and Brett, 11.

7 Cardon, *Natural Dyes*, 354–55; Cardon, "Colours of Chintz," 56. Over time, areas near Agra, Sarkejh and Biana, Jambusar, and Sindh were reported as producing the best indigo; see Gittinger, *Master Dyers*, 23; Machado, *Ocean of Trade*, 141.

8 Cardon, *Natural Dyes*, 347–48; Cardon, "Chimie empirique," 77–79; Holder, *Monograph on Dyes*, 6.

9 Regional recipes for resists have variously combined lime, gums, resins, mud, and/or beeswax. Edwards, *Imprints of Culture*, 323–24.

10 Irwin and Brett *Origins of Chintz*, 10, 87; Cardon, "Chimie empirique," 78; Gittinger, *Master Dyers*, 33; Gittinger, "Ingenious Techniques in Early Indian Dyed Cotton," 13–14; Barnes, *Indian Block-Printed Textiles*, vol. 1, 52, 57. Antoine Beaulieu and Father Coeurdoux further indicated in the eighteenth-century knowledge of direct indigo painting. Irwin and Brett, *Origins of Chintz*, 10; Cardon, "Colours of Chintz," 56.

11 Swarnalatha (*World of the Weaver*, 58) reports three historic varieties of chay, some wild some cultivated. The madder species *Rubia tinctorum* was cultivated in Kashmir and Sindh; see Cardon, *Natural Dyes*, 132. For more on India's superior red dyes as they relate to painting and printing cottons, see Irwin and Brett, *Origins of Chintz*, 9–10; Gittinger, *Master Dyers*, 20–22; Cardon, *Natural Dyes*, 131–34, 138–40; Mohanty, Chandramouli, and Naik, *Natural Dyeing Processes*, 10–20. Sappanwood (*Caesalpinia sappan*) was used only to colour the mordant with a reddish tinge so that the artist could track his work; see Irwin and Brett, *Origins of Chintz*, 8; Cardon, "Colours of Chintz," 55.

12 Gittinger, *Master Dyers*, 21. Irwin and Brett (*Origins of Chintz*, 10) observe that it was calcium together with aluminum mordant and chay that effected the bright red, which has since been proven scientifically; see Cardon, *Natural Dyes*, 139.

13 William Methwold, ca. 1622, quoted in Irwin and Brett, *Origins of Chintz*, 9.

14 Mohanthy, Chandramouli, and Naik observed that already in the early 1980s chay was employed "only when specially required," being "relatively costly" (*Natural Dyeing Processes*, 100).

15 Some time around 1400, printing resists was replaced by printing mordants. Barnes, *Indian Block-Printed Textiles*.

16 Irwin and Brett, *Origins of Chintz*, 8; Gittinger, *Master Dyers*, 20; Cardon, *Natural Dyes*, 132.

17 Mohanty, Chandramouli, and Naik, *Natural Dyeing Processes*, 18. The first red-dye bath

would boil for two hours and the second for four hours; see Martinsen, "Kattuntryck," 8; Irwin and Brett, *Origins of Chintz*, 40. Mattiebelle Gittinger also reports a case of black achieved by painting with blue and then running it through an alum bath (*Master Dyers*, 33, citing Irwin and Hall, *Indian Painted*, 10.

18 Cardon, *Natural Dyes*, 133; Mohanty, Chandramouli, and Naik, *Natural Dyeing Processes*, 104.

19 In other words, pretreatment of the cloth with myrobalan optimizes the ability of cloth to take red and black shades, serves as tannin/dye for iron to make black, and helps to attract alum to red. Cardon, "Chimie empirique," 74–75; Gittinger, *Master Dyers*, 28; Irwin and Brett, *Origins of Chintz*, 46; Steven Cohen identifies myrobalan as *Terminalia cebula, T. belliraca* ("Materials and Making," 35).

20 Father Coeurdoux, ca. 1745, quoted in Irwin and Brett, *Origins of Chintz*, 45. Cardon, "Chimie empirique," 77.

21 Hariharan, *Cotton Textiles*, 152–82; Martinsen, "Fashionable Chemistry," 165–67.

22 On sunshine, see Edwards, *Imprints of Culture*, 140. Lemon juice could help remove mistakes.

23 Irwin and Brett, *Origins of Chintz*, 38, 40; Cardon, "Colours of Chintz," 56.

24 Cardon, 53–54; Martinsen, "Kattuntryck," 8.

25 Irwin and Brett, *Origins of Chintz*, 46.

26 Martinsen, "Fashionable Chemistry," 156; Edwards, *Imprints of Culture*, 322.

27 Irwin and Brett, *Origins of Chintz*, 11.

THE CALICO ACTS OF EUROPE

1 For the legislation in England, and more generally, see Thomas, "Beginnings of Calico Printing," 206–16; Thomas, *Mercantilism and the East India Trade*; Riello, *Cotton*; Chaudhuri, *Trading World of Asia*, 294–95; Eacott, "Making an Imperial Compromise," 731–62.

2 For more information on the legislation in France, see Raveux, "Du commerce à la production," 22–25; Verley, "Indiennes des Indes," 13–26; Crosby, "First Impressions."

3 Beckert, *Empire of Cotton*, 48.

4 "Fait aussi S.M. défenses à toute personne, de quelque qualité et condition qu'elle soit, de porter, s'habiller ni faire aucun vêtement ni meubles… de toile peinte… à peine de confiscation des habits et vestements dont les particuliers se trouveraient vestus et de 50 livres d'amend." My translation of French act in Crosby, "First Impressions," 58.

5 Public Acts, 11 and 12 William III, c. 10, in Great Britain, *The Statutes at Large*, 10:72.

6 Philip V, Decreto de 4 de junio de 1728, Consejos, libros 146–47, Archivo Histórico Nacional, Madrid, quoted in Thomson, "Explaining the 'Take-Off'," 704. See also Vicente, *Clothing the Spanish Empire*, 11; Thomson, *Distinctive Industrialization*, 69–70.

7 Public Act, 7 George I, statute 1, c. 7, 1720, in Great Britain and Raithby, eds. *The Statutes at Large, of England and of Great-Britain*, 8:369.

8 Wood and Roberts, "Natural Fibers and Dyes," 291. See also von Ranke, *History of the Prussian Monarchy*, 425.

9 Acte royal du 26 octobre, 1726, Bibliothèque nationale de France, F-21652: "Édit . . . qui prononce des peines contre ceux qui introduiront dans le Royaume des toiles peintes ou teintes, écorces d'arbres ou étoffes de la Chine, des Indes et du Levant" (Dijon: A.-J.-B. Augé, 1726), quoted in Crosby, "First Impressions," 3.

10 Public Act, 14 George III, c. 72, 1774.

11 Faroqhi, "Ottoman Cotton Textiles," 97.

THE ORIGINS OF INDIAN CHINTZ AT THE ROM

1 For more on India's exports of painted and printed cottons to Egypt and Persia, see ch. 3 and 4, this volume; Jacqué and Nicolas, "Le Marché persan," 98.

2 Lyons, "Textile Fabrics," 175.

3 Currelly, *I Brought*, 242.

4 Harry Wearne secured many items from the earlier "archive" of French textile designer Arthur Martin; see Schwartz and Brett, "Collection de toiles peintes," 4. For an example of Martin's own Indian chintz-inspired designs, see Keller and Jacqué, "Influence et permanence," 43. Some had featured in exhibits in New York and Paris in 1912 and 1927; Fee, "Colourful Collecting."

5 See the entries for Katharine B. Brett in the Works Cited list.

6 Brett, "Recent Additions," 54.

7 Blyburg, "Champion of Chintz."

8 Barnes, "Indian Cotton for Cairo."

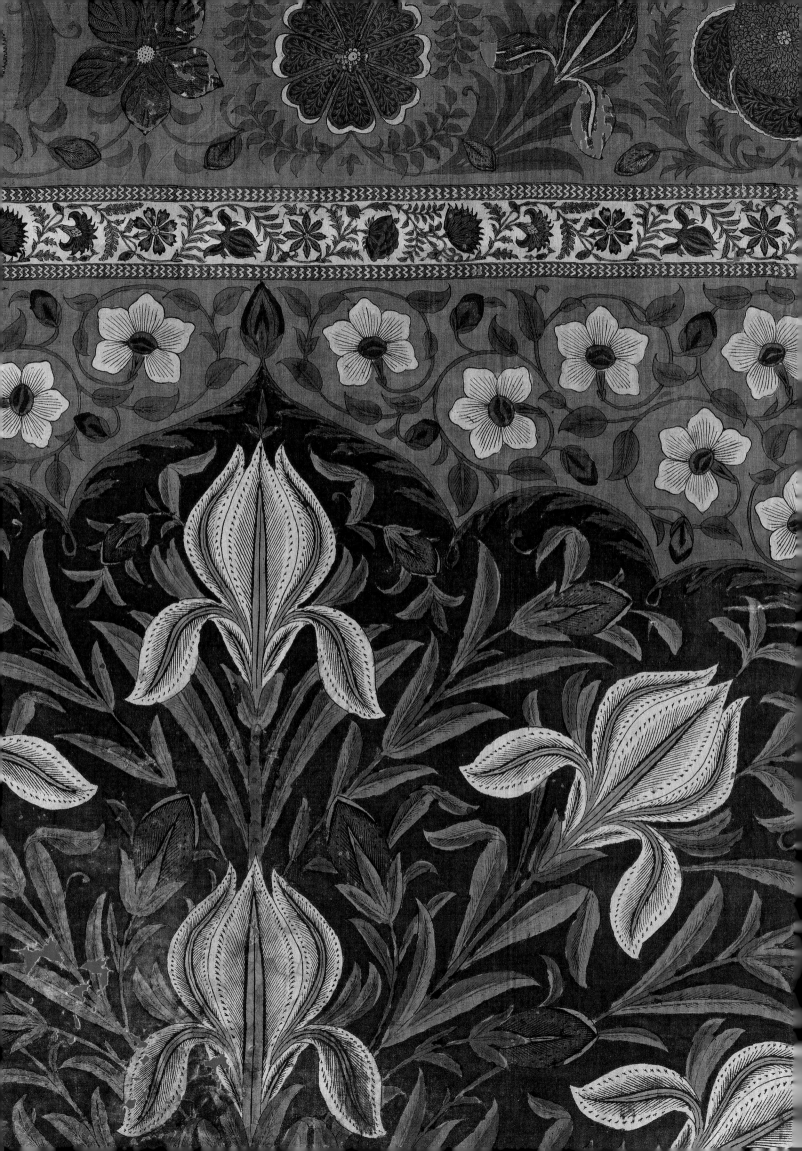

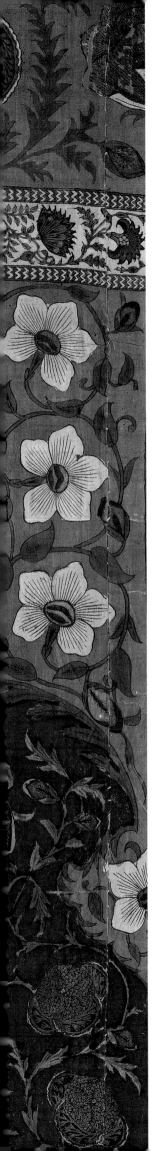

2

CREATING FOR INDIA

PRINTED AND PAINTED COTTONS FOR INDIA'S COURTS,
VILLAGES, AND TEMPLES

ROSEMARY CRILL

I NDIA'S TRADITION OF PATTERNING COTTON CLOTH THROUGH BLOCK PRINTING, drawing, and dyeing ranges from simple block-printed garments for Rajasthani villagers (fig. 2.1) to exquisitely detailed, hand-drawn hangings made for South Indian rulers (fig. 2.6) with countless variations in between. Painted and printed cottons are among the finest of India's textiles made for the highest levels of patronage—comparable to the woven and embroidered masterpieces made for the region's many courts—and the skill and variety of India's printing and painting techniques are historically unrivalled among global textile traditions. Whether made for the humblest or most exalted patrons, all of the pieces discussed in this book spring from the same ancient tradition of cotton fabric decorated by hand by using complex dyeing techniques. These techniques have been carried out across the Indian subcontinent for centuries, even millennia, with variations based on regional tastes, available dyes, local traditions of skill, and changing stylistic influences.

Detail: Tent hanging (*qanat*). Mughal, possibly Burhanpur, ca. 1700. Cotton, mordant- and resist-dyed, painted details, 217 × 111 cm. Stitched together as outdoor screens, such panels defined rulers' space and provided privacy. ROM 961.24

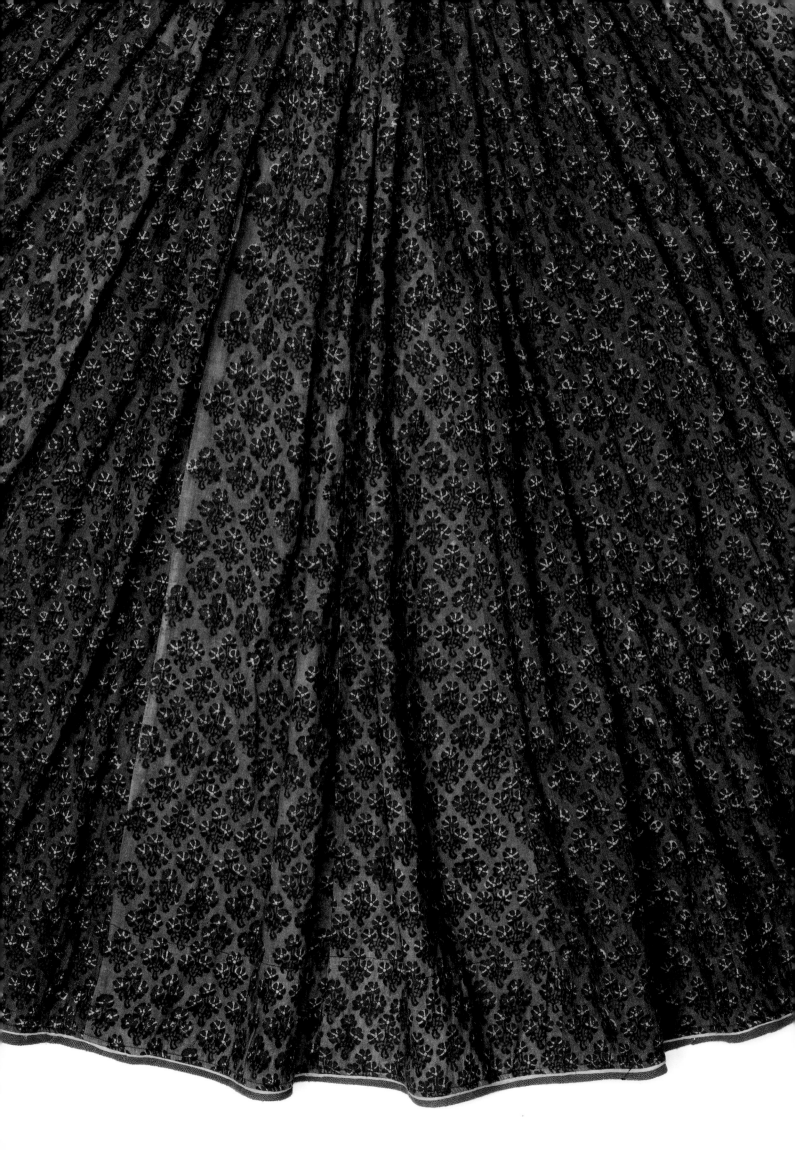

Block Printing

The earliest patterned Indian cotton textiles to have come to light so far are almost all block printed (see ch. 3). Often using just one colour contrasting with the undyed areas of the fabric, they typify a technique that found patronage at all levels of Indian society, as well as in distant export markets, and that ranged from basic geometric motifs to the exquisitely detailed, multicoloured floral patterns used at the Mughal and Rajput courts.

Perhaps the simplest and most conservative block-printed cotton textiles are the stylized floral patterns made for rural communities in Rajasthan and Gujarat in northwestern India, often used as fabric for the full skirts (*ghaghra*) worn by village women (fig. 2.1).[1] Designs such as these may be basic in outline, but the processes involved in making them are far from rudimentary. Block-printed designs are not simply printed onto the cloth, except in the case of modern synthetic dyes. Depending on the colours used, a mordant must be used to make the dye "take" on the cloth or a resist employed to shield those areas not to be dyed; it is these mordants and resists, rather than the colours of the finished product, that are printed onto the fabric, which is then dyed. Saris, which have increasingly taken the place of skirts in much of North India, are also often printed, but they usually exhibit variations on more courtly designs than the rustic skirt patterns do.

OPPOSITE
FIG. 2.1

Woman's skirt (*ghaghra*). Rajasthan, early twentieth century. Cotton, block-printed mordant and resist, dyed, 86 × 208 cm.
ROM 2019.32.1

BELOW
FIG. 2.2

Shoulder cloth or scarf for a man. Sanganer, Jaipur, late eighteenth or nineteenth century. Cotton, block-printed mordants, dyed, 302 x 151 cm.

Block-printed cotton textiles like this were worn as accessories by men. Narrow lengths were wrapped around the waist as a sash and wider examples were wrapped around the hips over a robe.
ROM 962.118.1

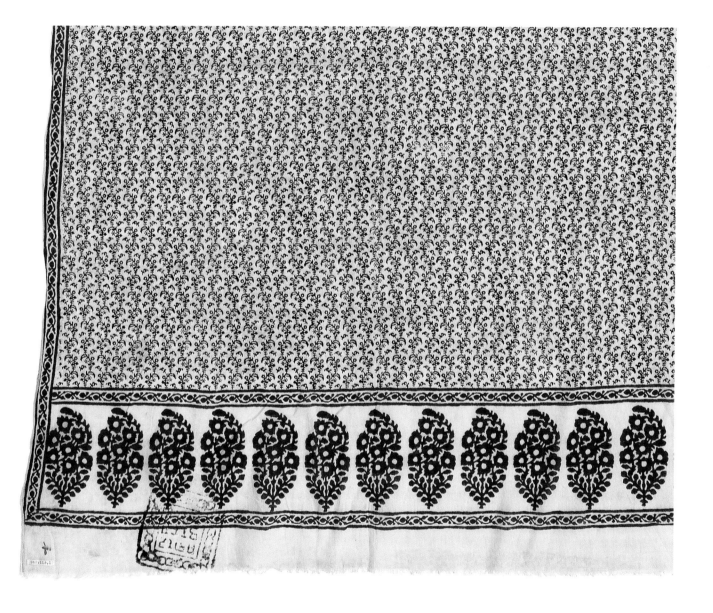

BELOW
FIG. 2.3

Detail: Portrait of Mughal emperor
Aurangzeb (r. 1658–1707).
Unknown artist. Deccan, India,
late seventeenth century. Opaque
watercolour and gold on paper,
19.7 × 13.3 cm.

Men's robes made of block-
printed cotton were popular in
both Muslim and Hindu courts,
and appear in paintings from the
seventeenth century onward.

ROM 965.67.2. Gift of
Miss Dorothy Holliday.

RIGHT
FIG. 2.4

Length of dress fabric. Rajasthan,
probably Sanganer, 1772 or earlier.
Cotton, block-printed mordants,
dyed. 896 × 65 cm.

The fabric bears a storekeeper's
inscription in ink dated 1772 but
the piece may have been made
earlier in the eighteenth century.

Victoria and Albert Museum,
London

A more elaborate type of block printing in both technique and design, *ajrakh*, was historically made for rural clients (and now increasingly for export) in western Rajasthan, Kachchh, and Sindh. In ajrakh, finely detailed wood blocks with geometric and stylized floral designs are traditionally used to create multipurpose rectangular cloths in red, blue, black, and white. From the preparation of the cloth itself to the cutting of the blocks, to the printing of alum mordant and resist in lime, resin, or mud and the precise alignment of the different blocks required for each colour, the finest ajrakh textiles represent some of India's most accomplished block printing—especially when the designs are printed on both sides of the cloth, as is the case only on the finest examples. While their traditional local clientele of farmers and herders in western India and eastern Pakistan has been declining for some decades, ajrakh has found a new market in contemporary urban fashion and export to the wider world (see ch. 19).

Some of the finest block-printed cottons of India were made in Sanganer, near Jaipur, for the Jaipur court and local patrons in the area, and were made predominantly for male accessories such as shoulder cloths (*dupatta*; fig. 2.2), turban cloths (*safa*), all-purpose kerchiefs (*rumal*), and even beard scarves, which kept the luxuriant Rajput beard in place.[2] Their floral designs (termed *buta* for large motifs and *buti* for small-scale ones) are derived from Mughal floral motifs of the seventeenth century and later, and are typically arranged in staggered rows of single motifs (fig. 2.3). These were mordant and resist printed, sometimes in a distinctive palette of black and red on a pure white ground (known as *syahi-begar* [black and alum mordant] as in fig. 2.2) for local men to use as turbans and shoulder cloths. At the upper end of the market, the motifs were printed in a wide range of colours that required expert coordination of blocks and dye sequences (fig. 2.4).[3] The popularity of these delicate floral prints among not only Rajasthani nobles but also Mughal rulers is evident in the many portraits in which the subject is shown wearing a block print in distinctly Sanganeri style (fig. 2.3). High-quality block prints were sometimes embellished with gold leaf laid over adhesive, which was stamped onto the outlines of the design (fig. 2.5).[4]

Printed fabrics were used to great effect at the most prestigious court in India: that of the Mughal emperors. The greatest Mughal rulers, Akbar (r. 1555–1605), Jahangir (r. 1605–27), and Shah Jahan (r. 1627–58), ruled over an increasingly extensive swathe of the subcontinent and used the finest textiles from all over the country to dress themselves and to furnish their palaces and tented camps. In addition to the finely printed yardage for tailored robes (*jama*) and trousers (*paijama*; see both in fig. 2.3), the Mughals used textiles with much larger-scale floral decoration as wall hangings for palaces and as decorations for their hunting and campaign tents (p. 33). One of the finest Mughal-period printed tents belonged to Tipu Sultan of Mysore in southern India (r. 1782–99); although Tipu Sultan did not belong to the Mughal Empire, the ubiquitous floral motif nevertheless clearly had an attraction for this South Indian ruler.[5]

While Rajasthan and Gujarat had their own local patrons and clientele, other centres such as the central Indian town of Burhanpur also supplied printed textiles to the Mughal court.[6] Although there is no concrete evidence, such as an inscription on a textile, that enables us to trace any surviving piece specifically to Burhanpur, it seems likely that many surviving Mughal-style printed cotton fabrics, as well as some that combine printing with hand drawing, may have been produced there, both for tent hangings (such as the one on p. 33) and for dress, especially men's decorative waist sashes (*patka*).

Northwestern India, especially Rajasthan and Gujarat, is today most associated with block printing, but it was also carried out in Punjab and southern India, although never at such a high level of skill as the finest prints from Sanganer. We know that during the later nineteenth century southern India was very active in the craft, as testified by the "portable museum" assembled by John Forbes Watson, published in 1866 (see ch. 17); the majority of its printed samples came from southern Indian centres, such as Madurai, Arcot, Sydapet, Ponnari (where the spotted fabric on the back of the Armenian cope was made; fig. 4.6), Bellary, and Cuddapah.[7] Since Watson's primary aim was not to provide a

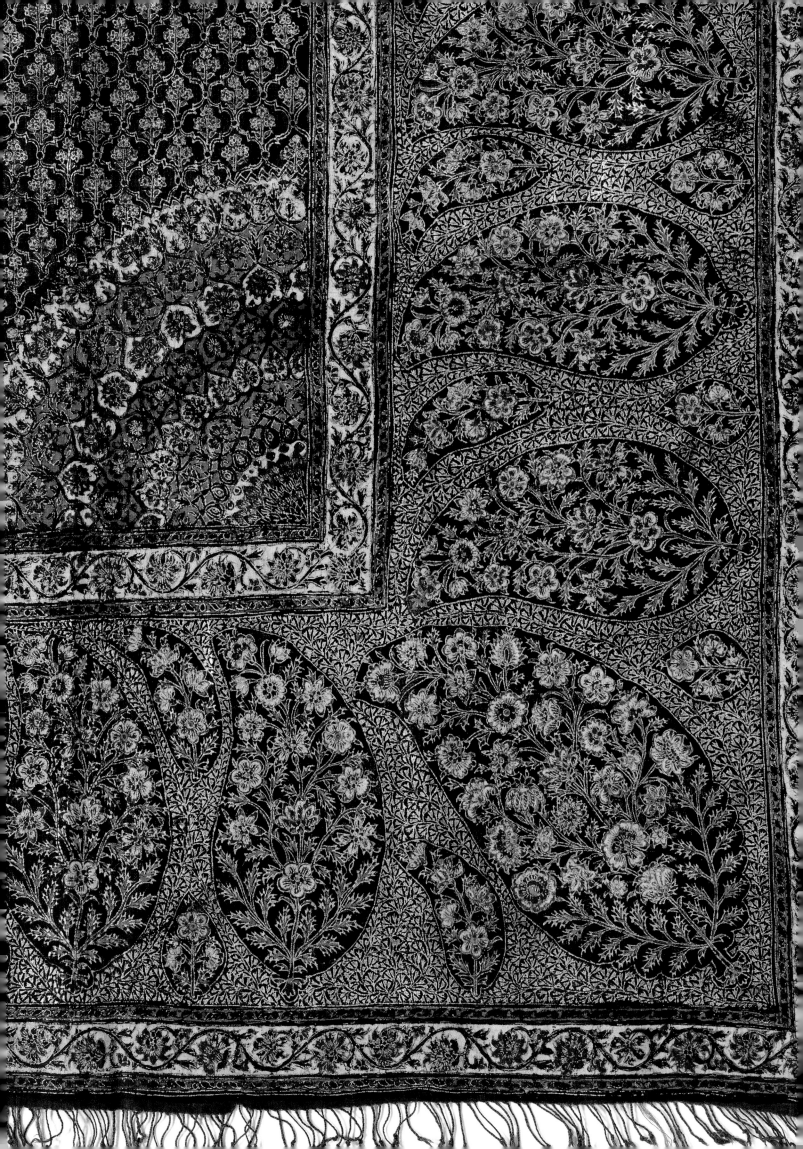

compendium of India's textile types but to show examples of types of cloth that could be copied by British manufacturers, these samples may have been chosen due to their predominantly simple designs that use only one colour of dye, which would have been cheap and easy to replicate.

Hand Painting

South India, and especially the southeast coast, was primarily known not for block printing but for the art of hand drawing and dyeing, a tradition that continued into the early twentieth century. Known as *kalamkari* (pen work) in India and Iran, and often referred to as *chintz* in the West, this technique is uniquely versatile and varied, ranging from relatively simple temple hangings made in Tamil Nadu (fig. 2.7) to the incredibly elaborate and skilful works of art made in the southeast coastal region not only for local rulers (fig. 2.6) but also for export to Southeast Asia and Europe (see ch. 5 and 9). Although termed *hand painting*, in this technique it is not the dyes that are directly applied to the cloth but rather mordants or resists, which are "painted" on with simple sticks. This is one of the few textile processes in which the hand of the artist can be seen and appreciated; the freehand drawing of the outlines of these textiles allows individuality, variety, and, frequently, wit and playfulness (especially in the depiction of animals) to show through the complex processes required to make them (see, e.g., ch. 1, 4, 9).

The hand-painting technique has produced some of the most magnificent textiles ever to have been made in India, such as the piece in figure 2.6. Displaying extraordinarily inventive freehand drawing and unparalleled mastery of dyes, pieces of this quality are as closely akin to paintings as they are to textiles. Such pieces would have been made in coastal Southeast India under royal patronage, and the widely varying designs of surviving pieces from the seventeenth century confirm that they were sought by both Muslim and Hindu rulers. The imagery used in figure 2.6, including characteristics such as the style of dress, jewellery, and architecture, clearly indicates that it was made for a Hindu ruler. Since the hanging is datable stylistically to the mid-seventeenth century, a plausible patron for this piece is Thirumal Nayak of Madurai (r. 1623–59), and the skill of the drawing, as well as of the dyeing, implies the involvement of not only court artists but also the dye experts of one of the major hand-painting centres of the coastal region.[8] The rich and cultured temple city of Madurai has also been suggested as a possible source of patronage (but not manufacture) for another magnificent hand-painted hanging, also depicting scenes from the courtly life of a Hindu South Indian ruler.[9] It is possible that pieces like this were made in the southern portion of the so-called Coromandel Coast, nearer to the southern inland city of Madurai; we know, for example, that the coastal towns of Pulicat and Nagapattinam were producing hand-painted textiles, although so far these seem to have been of lower quality than those from places such as Palakollu, further up the coast.[10]

The Muslim rulers of the Deccan sultanates, especially Golconda, very likely were also patrons of the highest-quality painted textiles. A number of pieces with strongly Iranian-influenced designs and imagery survive, which have been linked (although without hard evidence) to the Golconda court. While it has been previously suggested that they may have been made at Golconda itself, it is much more probable that they were made at one of the hand-painting centres such as Petaboli on the Kistna delta (which was indeed within Golconda's territory) and were used, rather than made, at the Golconda court. Pieces of this type include two superb floor spreads, sets of tent hangings, and a large group of smaller coverlets (*rumal*).[11] Golconda was culturally and diplomatically close to the Safavid rulers of Iran, who were, like them, Shia Muslims (unlike the Sunni Mughals), and much of the painting and decorative arts of the area is deeply suffused with Iranian influence.

OPPOSITE
FIG. 2.5

Shawl. Coastal southeast India, dated AH 1222 (1807 CE). Cotton, block-printed and drawn mordants, drawn resists, dyed; painted details; block-printed adhesive for gilding, 148 × 143 cm.

Fine painted and printed cottons were sometimes enhanced with applied gold leaf or gold paint, both for domestic and export use. This piece is unusual for being finely printed on both sides, although the gilding has been applied to only one side.

ROM 934.4.70. Harry Wearne Collection. Gift of Mrs. Harry Wearne.

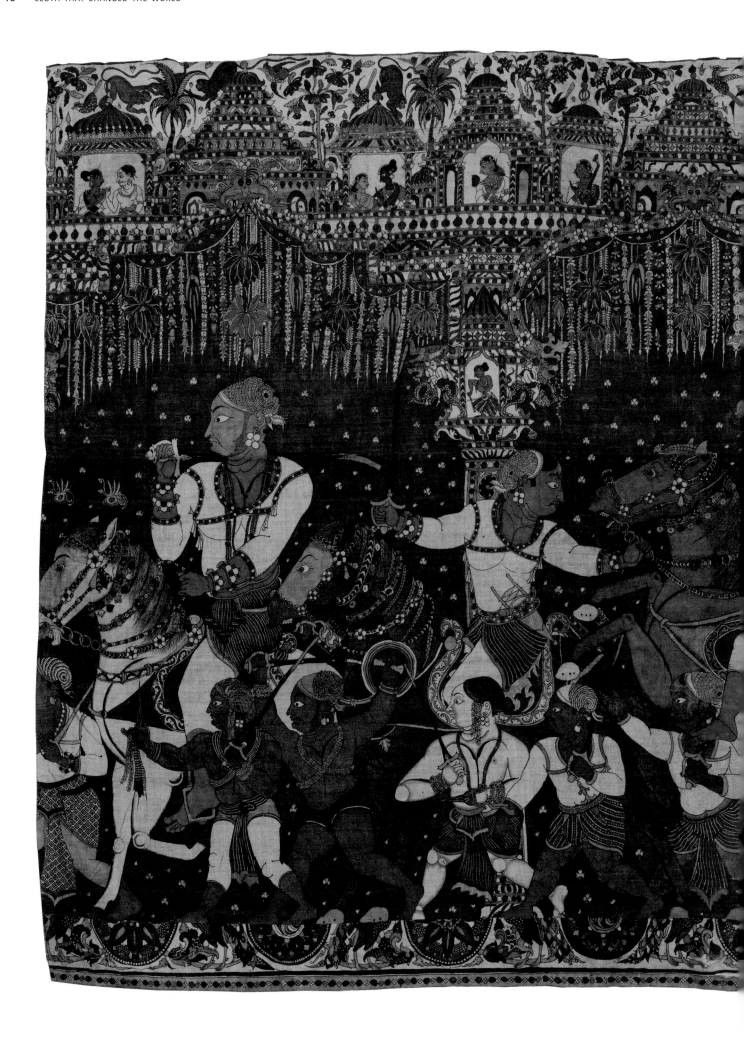

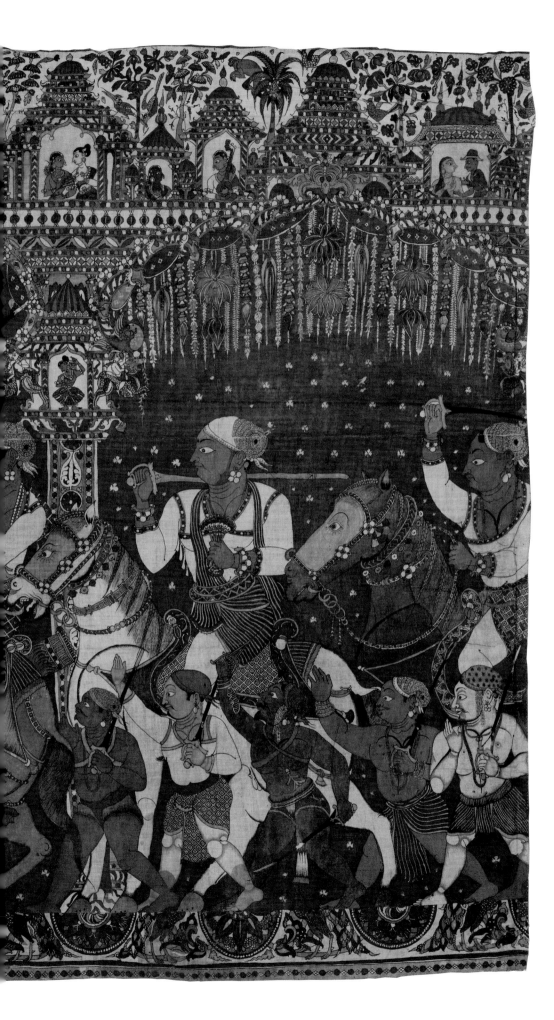

FIG. 2.6

Hanging. Coastal southeast India, ca. 1640–50. Cotton, hand-drawn, mordant-dyed, resist-dyed, painted details, 252 × 173 cm.

This hanging is thought to have been made for Thirumal Nayak, who ruled the southern Indian state of Madurai from 1623 to 1659. Its skilful freehand drawing makes it closer to a court painting than a furnishing fabric.

Private collection

ABOVE
FIG. 2.7

Temple hanging. Tamil Nadu, probably Madurai, nineteenth century. Cotton, hand-drawn, mordant-dyed, painted details, 268 × 189 cm.

This hanging illustrates episodes from the life of the Tamil saint Manikkavachar (upper) and the wedding of Meenakshi and Sundareshwara (southern forms of Shiva and Parvati) at Madurai (lower). Tamil inscriptions written in wax resist identify each scene.

ROM 972.117.7. Gift of Mrs. William C. C. Van Horne.

OPPOSITE
FIG. 2.8

Detail: Temple hanging (pp. 44–45).

While we know from the French traveller François Bernier that chintz ("chittes"), which he identified as being "of the fine workmanship of Masulipatam," were used at the court of the Mughal emperor Aurangzeb,[12] not a single textile of any kind survives today that can be securely traced back to the Mughal court. The hangings that seem to fit best into the Mughal aesthetic are not the freely drawn figural pieces like figure 2.6 or the so-called Golconda-style pieces but rather the formal, flowering-tree designs often attributed to Burhanpur (like that on p. 33), which echo the inlaid floral patterns we see on Mughal architecture of the mid-seventeenth century.

Hand-painted hangings for use by local Hindu patrons in South India show a completely different aesthetic while adhering to the same technique as grander courtly pieces. The simplest types of South Indian temple hangings depict specific temples or holy sites and have basic colour palettes of mordant-dyed red and black, with a brick-red background and sometimes small areas of painted dye (fig. 2.7). Hangings of this type are often attributed to centres such as Madurai in Tamil Nadu.[13] More detailed narrative hangings using a wider range of directly applied colours were made in the temple town of Srikalahasti (formerly Kalahasti), now in Andhra Pradesh (fig. 18.8). Today this is the only place in South India still producing hand-painted hangings according to anything approaching the traditional technique, that is, hand drawing the outline with a bamboo pen (*kalam*) and applying the colours by hand with pointed sticks, although the demanding technique of creating fine patterns in white resist has almost entirely been lost.[14] Nineteenth- and early twentieth-century hangings from Kalahasti often show scenes from the epic poem the *Ramayana*, with narrative panels surrounding a central image of the god Rama and his consort Sita. Somewhat different in style, although also often depicting scenes from the *Ramayana*, are hangings in which the figures and contextual scenes are considerably more detailed (fig. 2.8). The colour palette is wider, with several shades of red, as well as yellow and blue, suggesting the use of resist dyeing and mordants. Pieces like this are likely to have

Rama returning to Oyde of the marriage.

Rama with his wife and brother prostrating before their mothers and taking leave of them
before going to wilderness.

of a crow and Rama killing him. Lakshmana killing the son of Surpanaka the sister of the great Demon Ravana. Sur

Surpanaka reporting to Ravana
the death of her brothers by Rama.

FIG. 2.8

Temple hanging. Southeast India, coastal Andhra Pradesh, nineteenth century. Cotton, hand-drawn, mordant dyed, resist dyed, painted details, 385 × 128 cm.

This finely detailed narrative hanging shows scenes from the *Ramayana*, featuring the blue-skinned Rama and his adversary, the ten-headed demon Ravana. The handwritten ink inscriptions identifying each scene are in English, but apparently not by a native speaker.

ROM 971.361

been made on the northern Coromandel Coast, in present-day Andhra Pradesh.[15] They show evidence of the same range of skills and techniques as do the hangings made for secular patrons, such as figure 2.6, but they are rarely as elaborate.

All of these temple hangings closely recall wall paintings in South Indian temples, both in their format of narrative scenes within rectangular compartments and in their bold visual impact.[16] Like the paintings, the textiles are intended either to depict a place of pilgrimage or to narrate part of a devotional story or poem. While the subject matter may be one of the great pan-Indian epics, such as the *Ramayana*, local subjects are also often incorporated.[17] The fabric versions of these narratives would be especially useful outside of a temple environment, for example, for storytelling in villages, using the textile to accompany a sung narrative. This kind of performance was traditionally carried out in many parts of India by using locally produced illustrated scrolls or textiles, including the paper scrolls of the Bengali *chitrakars*, which tell both local legends and epic tales, and the painted cotton *Pabuji ki padh* of Rajasthan, which tells the story of a local hero and his daring exploits.[18]

The *mata ni pachedi* (mother cloth) of Ahmedabad, Gujarat, is another example of a textile decorated with devotional images of local deities, in this case almost exclusively goddesses (fig. 2.9). Such cloths were traditionally made by and for the Vaghri community, who, because of their low-caste status, were not allowed inside "mainstream" Hindu temples; they therefore made their own makeshift shrines in which they could worship local mother goddesses.[19] These had walls and canopies (*chandarvo*) of cotton cloth on which the deities and their stories were depicted in a combination of printing, drawing, and painting. Patrons commissioned imagery according to their taste, budget, and the goddesses they wished to honour. Traditionally, the resulting cloths were simply but dramatically printed

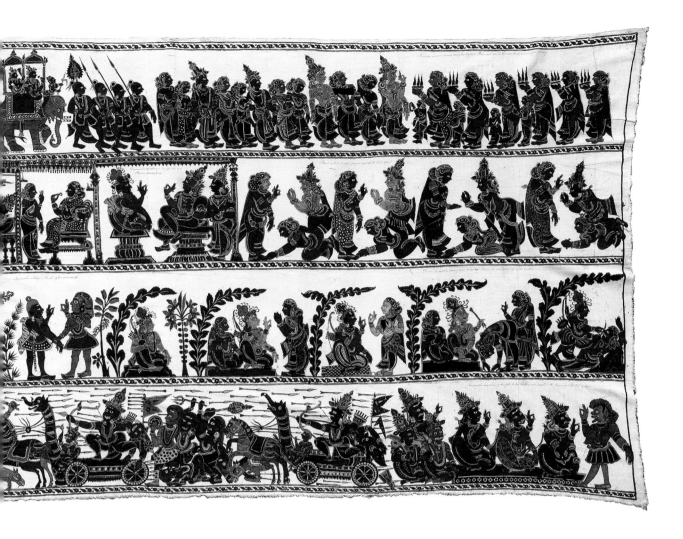

and dyed in shades of red and black; but in recent years these goddess textiles have made a transition from local devotional use to a much wider commercial market, encompassing both Indian and international buyers.[20] The techniques by which they are made have also changed: now they are hand painted, as well as printed, allowing for a far wider range of colours and imagery.

Hangings made specifically for temples venerating the Hindu god Krishna are known as *pichhwai*, meaning "placed behind," since they are hung behind the image of the deity. Their imagery is always associated with Krishna, with many hangings showing him in his human incarnation; it is in this form that some of India's most popular stories depict his exploits as a playful cowherd. Other hangings allude to key festivals that celebrate the seasons—for example, peacock imagery refers to the monsoon—or to stages in Krishna's life, such as depicting rows of cows that connote the time when he became a cowherd. The pichhwai would be changed according to the festival or time of year. Picchwai may be made by any technique, including the fine chain-stitch embroidery of the Mochi community of Kachchh, with stamped gilding from the Deccan or direct pigment painting from southern Rajasthan; but some of the finest are hand drawn and dyed according to the technique associated with coastal southeast India, historically known as the Coromandel Coast.[21]

The ability of India's chintz artists to adapt their skills and designs to whatever the market or patron required was almost as essential to their success as the skills themselves. Whether producing for a specific local clientele or for one of India's great royal courts, India's hand printers, hand drawers and dyers remain unrivalled in the annals of art history. It was only in the nineteenth century that imported Western machine-made and machine-printed textiles started to replace many types of handmade fabrics; these mass-produced

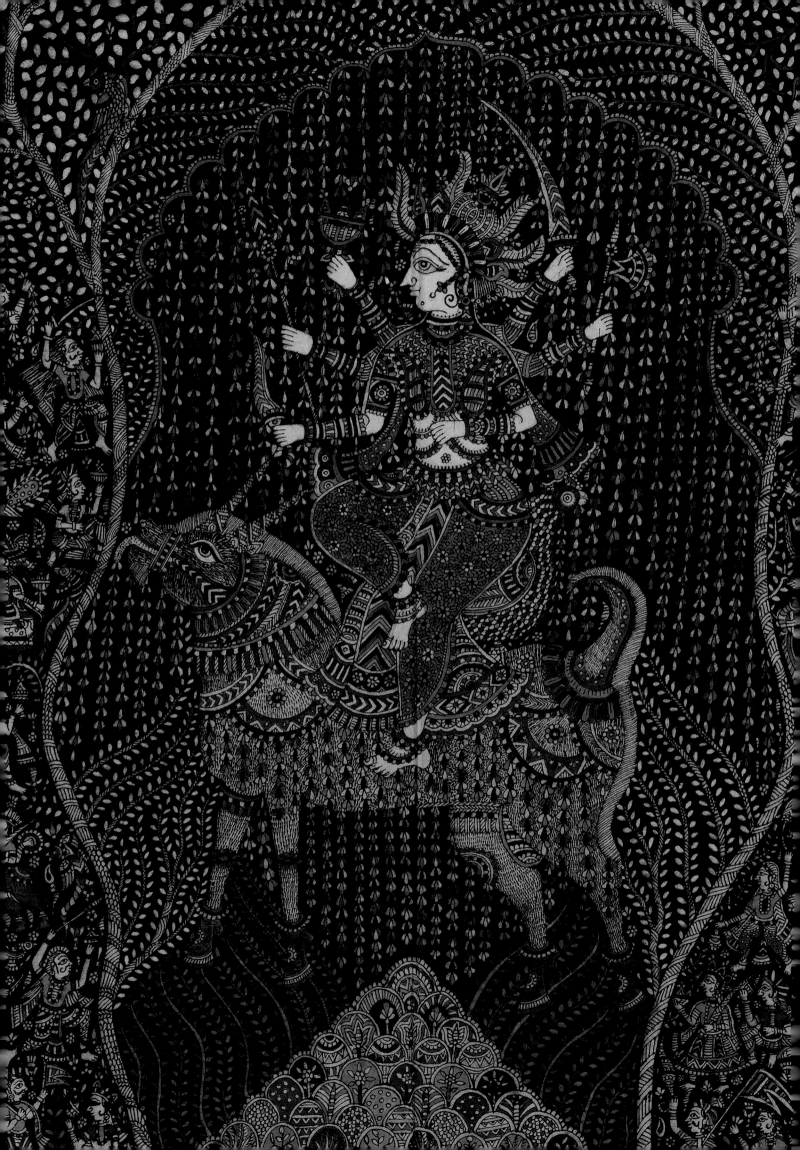

LEFT
FIG. 2.9

Mother-goddess hanging
(*mata ni pachedi*), Chitara
Chandrakant, Ahmedabad, 2018.
Cotton, hand-drawn, mordant-
dyed, painted details,
111 × 155.5 cm.

The Chitrakar (formerly Vaghri)
community of Ahmedabad
traditionally used textile
hangings in their worship of
local goddesses. Block printed
traditionally in red, white, and
black, has been expanded by
contemporary makers, who have
also introduced hand-drawn
designs like this one. They
have become popular as purely
decorative hangings both in India
and abroad.

Opposite: Detail of the centrefield
showing the goddess Meladi
Mata on her black goat mount.
Left: Detail of lower border. As
part of this ROM-commissioned
hanging, Chrandrakant chose to
portray the making of hangings in
the time of his father.

ROM 2019.60.4

fabrics not only were cheaper but also appealed to changing fashions. At the same time, India's courtly patronage declined, resulting in a dramatic decrease in demand for high-quality printed and hand-painted pieces. During the twentieth century, many of India's traditional local markets mostly disappeared, but following the country's independence in 1947, and with the rise of a newly affluent middle class later in the twentieth century, a taste for printed fabrics for both dress and furnishings sparked a considerable revival and regeneration of some of these techniques (see ch. 18 and 19). Today, further embraced by some high-profile Indian interior and fashion designers, India's painted and printed cottons enter a new chapter of their long history.

1 See Irwin and Hall, *Indian Painted*, plate7 8A; Cohen, "Materials and Making," 42. For more on village prints, see also Ronald, *Balotra*.

2 See, e.g., V&A 6742 (IS), which is recorded as being a "scarf or kerchief for the beard." Beard scarf, Jaipur, printed cotton, 104 × 52.5 cm, Victoria and Albert Museum, London, http://collections.vam. ac.uk/item/O481169/scarf-unknown/. The small printed cotton scarves listed in Singh, *Textiles and Costumes*, nos. 1381–89, 1432–36, and 1440–44, are the same size and may also be beard scarves.

3 See Irwin and Hall, *Indian Painted*, 110–12; for *siyahi-begar*, see Skidmore and Ronald, *Sanganer*, 16, 43–51.

4 For other gilded block prints, see Irwin and Hall, *Indian Painted*, no. 31, plate 18 and no. 190, plate 90; Nabholz-Kartaschoff, *Golden Sprays*, 96; and Cohen, "Materials and Making," 44, for a Rajasthani head cover printed only with gold leaf.

5 Crill, "Local and Global," 124–25.

6 Irwin and Hall, *Indian Painted*, 24–25.

7 Watson, *Textile Manufactures of India*.

8 I thank the anonymous owner of this work for allowing me to study it.

9 See Gittinger, *Master Dyers*, 120–27; Crill, "Local and Global," 137.

10 For further discussion of the various centres of production, see Hadaway, *Cotton Painting and Printing*; Crill, *Chintz*, 10–11; Dallapiccola, *Kalamkari Temple Hangings*, 13–16; Gittinger, *Master Dyers*, 116.

11 See Irwin and Hall, *Indian Painted*, 14–21; Gittinger, *Master Dyers*, fig. 79–102. Many of these pieces ended up in the storehouses of the Hindu Rajput rulers of Amber in Rajasthan; they may have been brought there after military campaigns in the Deccan, or the Amber rulers may also have been commissioning such pieces. See Jain, *Textiles and Garments*, nos. 7–15.

12 Irwin and Hall, *Indian Painted*, 23.

13 Dallapiccola, Kalamkari *Temple Hangings*, 15–16, nos. 6-8, 10–11, 15–18.

14 The textile artist Renuka Reddy in Bangalore is the only person (to my knowledge) currently attempting to use the traditional art of drawing fine resist lines.

15 Compare Dallapiccola, *Kalamkari Temple Hangings*, nos. 1 and 2, from Chirala and probably Machilipatnam.

16 For a comparable wall painting, see Dallapiccola, 8.

17 For large temple cloths illustrating the story of Katamaraju, a local semi-divine hero in Andhra Pradesh and Telangana, see Dallapiccola, nos. 12 and 13.

18 For more on these narrative traditions, see Jain, *Picture Showmen*.

19 Fischer, *Temple Tents*; also Edwards, *Imprints of Culture*, 111–12.

20 For early examples of these cloths, see Fischer, *Temple Tents*; also Crill, "Local and Global," 92.

21 For pichhwai with Mochi embroidery, see Krishna and Talwar, *In Adoration of Krishna*, nos. 50 and 51. For Deccani-gilded pichhwai, see Krishna and Talwar, nos. 33, 42–43. For pichhwai in the Coromandel Coast kalamkari technique, see Krishna and Talwar, no. 30. For a fine fragment in Chhatrapati Shivaji Maharaj Vastu Sangrahalaya (CSMVS), Mumbai, acc. no. 63.34, see Crill, "Local and Global," 88. The finest of these drawn and dyed pichhwai is in the Calico Museum of Textiles, Ahmedabad (unpublished).

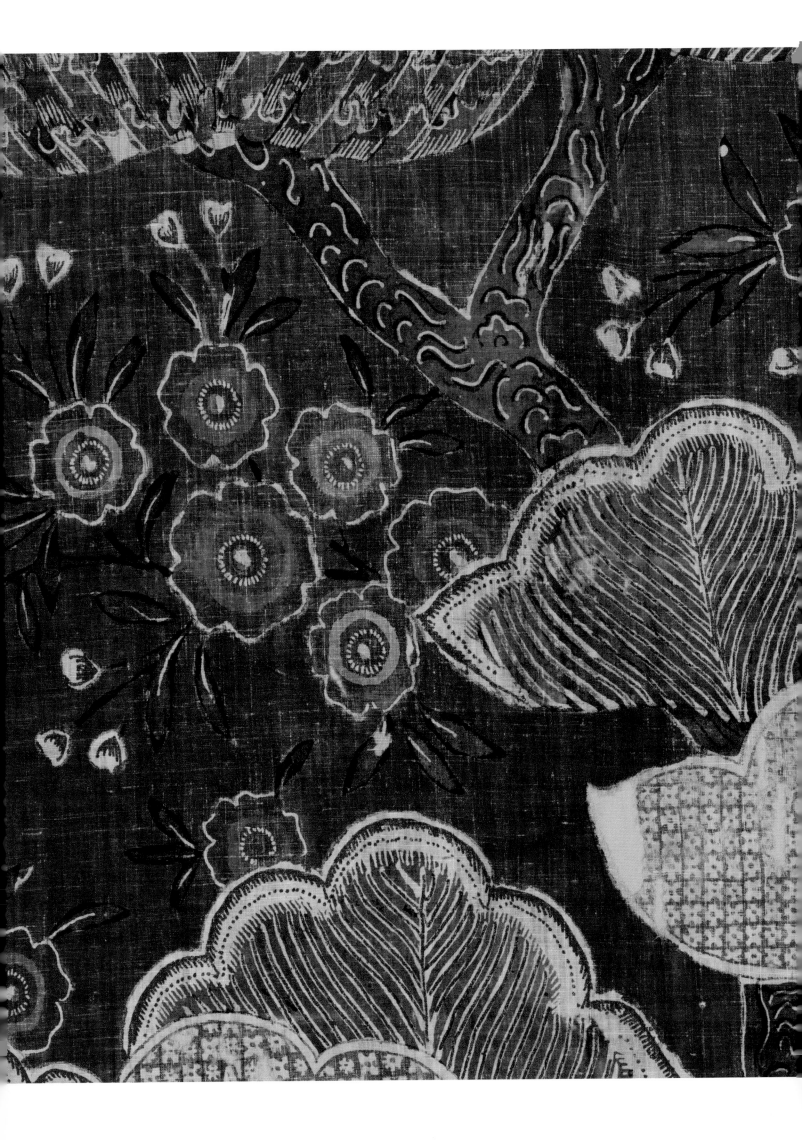

PART TWO

GLOBAL DESIRE FOR
INDIAN CHINTZ

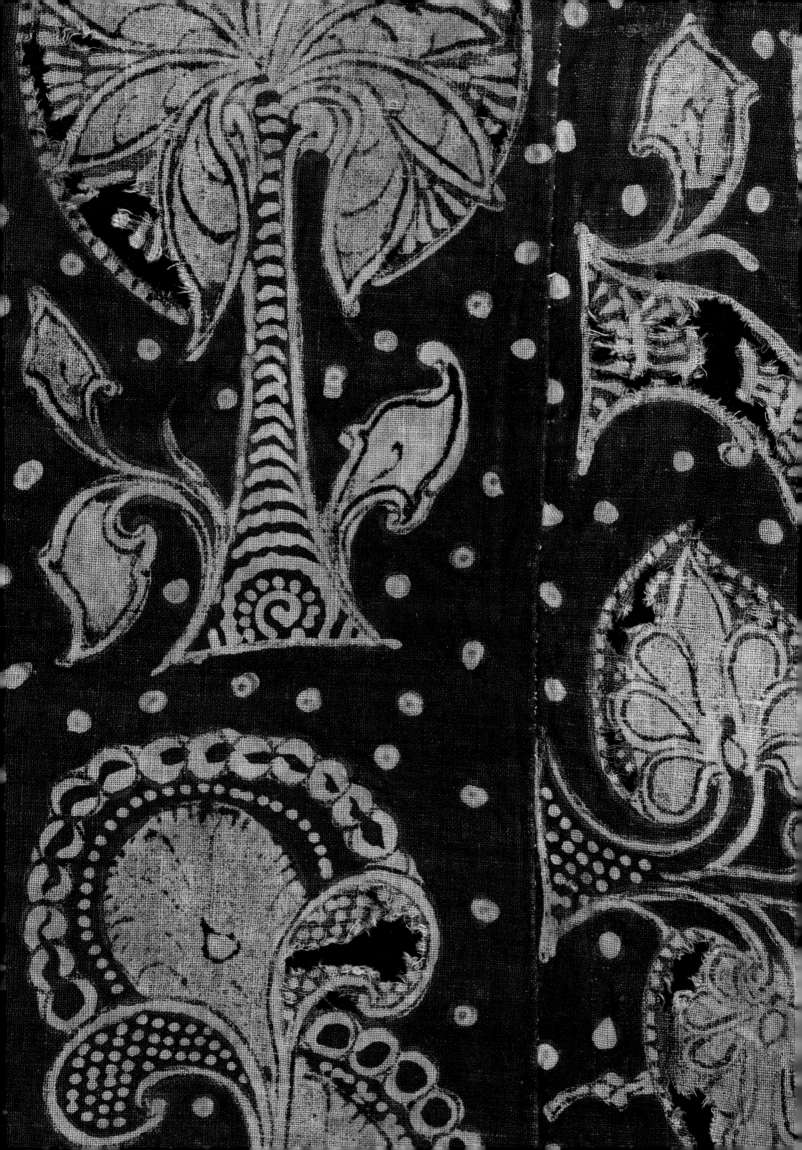

3

EARLY INDIAN TEXTILES IN EGYPT

RUTH BARNES

TEXTILE PRODUCTION AND THE USE OF COTTON IN INDIA GO BACK AT least four thousand years and may even have been established as early as the fourth millennium BCE.[1] The early trade between India and Mesopotamia is well documented by seals, inscriptions, and pottery finds, and it can be assumed that textiles were also part of this exchange, although no remains have survived. Greek and Roman writers do refer to the trade of fine Indian cotton, however, and the second-century CE Greek *Periplus of the Erythraean Sea*, a navigational treatise reporting on the journey between the Red Sea and India, mentions the importance of Indian textiles from three regions of the subcontinent: present-day Gujarat, the Coromandel Coast, and Bengal.[2] All three regions were still famous for their textile production by the time the first European explorers and merchants arrived in the Indian Ocean at the end of the fifteenth century. However, by a cruel twist of history, the earliest textiles made in India have not survived in the subcontinent. Rather, they

Detail: Fourteenth-century cotton textile made in Western India for export to Egypt (p. 55).

OPPOSITE
FIG. 3.1

Overview and detail: Textile
fragment with stepped squares
and diamond shapes in the main
design field and a continuous
running vine border. Western
India, for the Egyptian market,
fifteenth century. Cotton, block-
printed, resist-dyed, 11.3 × 47 cm.

The calibrated radiocarbon
date has an unusually precise
carbon-14 range, with a date
range between 1400 and 1450 CE.

ROM 978.76.304. Abemayor
Collection given in memory of
Dr. Veronika Gervers, Associate
Curator, Textile Department
(1968–1979) by Albert and
Federico Friedberg.

have been found in central Asia and especially in Egypt, where—thanks to arid climactic conditions—a large number survive from the tenth century onward. The great majority of them came from Gujarat, and many are printed or drawn with mesmerizing patterns in vivid blue and red. They were brought to Egypt when the Red Sea trade with South Asia gained in importance under the Fatimid dynasty, which ruled in North Africa, Egypt, and Syria from 909 to 1171 CE, and continued to be imported throughout Ayyubid and Mamluk reigns with the enduring commercial contacts between Egypt and the west coast of India. The Royal Ontario Museum (ROM) holds a small but representative collection of these medieval Indian trade textiles.

Cumulative studies, particularly over the past two decades, have greatly increased our understanding of these patterned-dyed cottons made in India for export to Egypt. They all are cotton, usually block printed with a resist and/or mordant and dyed red and blue. A small number of them are handpainted with resist or mordant, rather than block printed, or combine block printing with painted application (fig. 3.3). These painted cottons account for less than 10 percent of the Indian trade to Egypt. Textiles only survive as fragments, but the numerous seams and hems provide evidence for their use as dress items or domestic furnishings. Approximately two thousand of these textile fragments first appeared in the markets of Cairo and Alexandria in the early 1900s and ended up in public and private collections.[3] Their provenance and date were initially uncertain, as witnessed by the ROM's first director acquiring pieces from Cairo-based dealers and assuming them to be of Egyptian manufacture (see ch. 1). The fragments were not found in archaeological excavations, but almost all came from waste disposal sites, of which the most famous was at Fustat (Old Cairo). Fustat was the first capital of Islamic Egypt, founded as a military camp in 641 CE. Under the Fatimid, the palace and government quarters moved north to al-Qahirah (Cairo) in 969 CE, but Fustat remained a vibrant commercial hub for another two hundred years until 1168–69, when the city was intentionally burnt and abandoned in order to avoid capture by the advancing crusader army.[4] The area became Cairo's refuse site, and by the early twentieth century it was famous as the source of fragmentary medieval Islamic textile, glass, and ceramic finds. The Indian fragments are often referred to as "Fustat textiles," and many of them were probably discovered there. However, during the first controlled excavations at Fustat itself in the late 1910s, textiles were not among the recorded finds, and the association of the Indian fragments with the location remains tenuous.[5] To avoid the ambivalence of the term, it is preferable to refer to the textile fragments as Indo-Egyptian, rather than "Fustat."

The textile historian Rudolf Pfister was the first to identify the cotton fragments as of Indian origin.[6] He compared their designs in particular to motifs found in the architecture of Gujarat, where he saw distinct parallels. As none of the textile material came from a definite provenance or could otherwise be dated, the architecture was therefore used as a means to provide a tentative chronology for the textiles, relating them mostly to the fourteenth to sixteenth century. Similar textile material was finally discovered in an archaeological excavation at the Red Sea port of Quseir al-Qadim, excavated by Donald Whitcomb and Janet Johnson from the University of Chicago during the early 1980s; the Islamic occupation of the site was dated by coin finds to between the thirteenth and mid-fifteenth centuries. There had also been an earlier Roman habitation on the site.[7] In light of this evidence, the site date was accepted, at the time, as likely also for the Indo-Egyptian cotton textiles.[8] It fitted comfortably with the historical evidence for Mamluk trade between the Red Sea, Aden, and northwestern India.

Radiocarbon dating of a substantial number of the textiles held in the Ashmolean Museum, Oxford, eventually pushed back the beginning of the trade to the tenth century.[9] For the historical interpretation of these textiles in Egypt, we therefore have to consider both Fatimid and Mamluk sources. Since the material was certainly not for luxury purposes but for everyday consumption, neither royal treasury accounts nor trousseau lists are helpful, but the information pieced together from the Genizah documents discovered in

Fustat's Ben Ezra Synagogue are of considerable value.[10] In fact, the historian Shelomo Dov Goitein, writing about evidence from the Genizah, describes "cotton cloths from northwestern India, dyed red and black [indigo]," that were extremely popular as wraparound covers and as other garments, as well as sewn into pillows and bolsters.[11]

The ROM's Collection of Indian Textiles Traded to Egypt

The collection in Toronto is modest in size, with less than thirty Indian textiles made in Gujarat for the trade to Egypt. A previous publication surveys the breadth and scope of the material in detail, and it will suffice here to focus on a small representative sample of pieces.[12] Particular emphasis is given to some fragments that were recently radiocarbon dated. The collection is divided into three groups, based on the resist and dye techniques used to create the patterns. The first group is a small number of blue and white textiles. They were printed or painted with resist, most of them probably by using a wax or resin to block out the design prior to dyeing the fabric. As a result, the pattern appears as white against a blue background. The fabric was then immersed into an indigo dye vat, which produced the blue colour. Two samples are illustrated here. The first fragment (fig. 3.1) is an especially attractive example, showing stepped squares and diamond shapes as the main design field, with a continuous running vine border. The block print is carefully executed, and the depth of indigo blue is remarkable, considering it was dyed six hundred years ago. The textile has an unusually precise carbon-14 range, with a calibrated date between 1400 and 1450 CE. The second fragment (fig. 3.2) is interesting for a different reason: although block printed, its design bands are made up of small dots, simulating a tie-dye technique (*bandhani*) that is also associated with Gujarat, specifically with Kachchh. Its calibrated date range is from 1443 to 1618 CE; as comparable textiles in the Ashmolean collection have a fifteenth-century date, the beginning of the range is most likely.

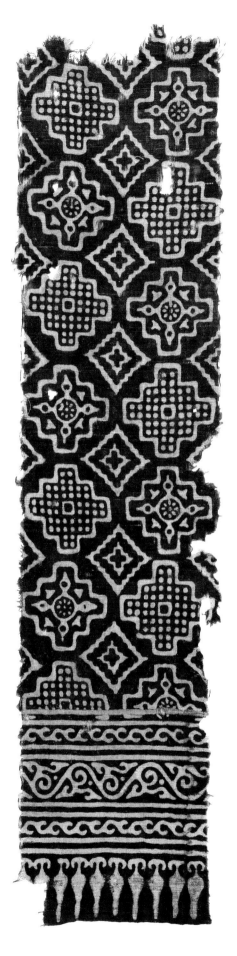

FIG. 3.2

Textile fragment with bands
of dots. Western India, for the
Egyptian market, fifteenth
century. Cotton, block-printed,
resist-dyed, 27.6 × 27 cm.

The small dots simulate a tie-dye
technique (*bandhani*) associated
with Gujarat, specifically
with Kachchh. The textile is
carbon-14 dated 1443 to 1618 CE;
as comparable textiles in the
Ashmolean Museum's collection
have a fifteenth-century date,
an early date within the range
is most likely.

ROM 978.76. 172. Abemayor
Collection given in memory of
Dr. Veronika Gervers, Associate
Curator, Textile Department
(1968–1979) by Albert and
Federico Friedberg.

The second group of fabrics was dyed red. Figure 3.3 shows a piece with flowering trees dyed in various grades of red. It is one of the few textiles that were painted, rather than block printed. To achieve any shade of red, a mordant needs to be added to successfully bind the fibre with the dye substance (see ch. 1). Variations of red, brown, or pink can be achieved by using different mordant substances or by adding different ingredients to the mordant or dye bath, such as pomegranate seeds or rind. Here the textile has three shades of red: the bright background, dark outlines for the leaves, and a reddish purple for some details. Some of the latter has corroded, which indicates that an iron component was added to the dye; the iron produced the darker shade but over the years also destroyed the fibres. This fragment dates to the late thirteenth or fourteenth century. Figure 3.4 provides another example of a case where more than one shade of red was used. The fragment has wide and narrow bands at right angles, one of them including a short Arabic inscription that is repeated. A resist was printed onto the cloth, and it was immersed into a red-dye bath, which contained a mordant that produced the bright red. At some stage during this process, a different mordant was added, which caused the dye to turn brown in parts; this was applied freehand by pen or brush, apparently in a rather careless manner, as the parts dyed brown are irregular.

Finally, the third group in the collection combines indigo and mordant dyeing to create textiles that are red, blue, and white (fig. 3.5–3.7). The overall evidence shows that the fabrics were first mordant dyed to obtain reds and then dyed in indigo to achieve blue. The ROM

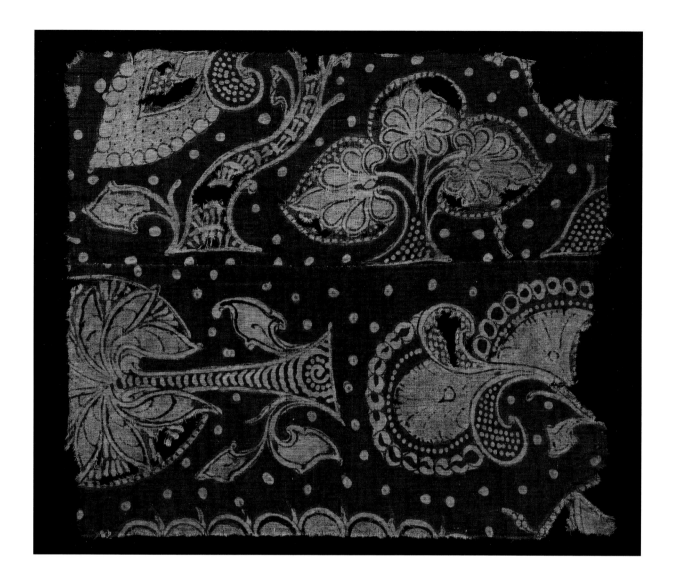

Gujarati collection contains ten of these multicoloured pieces, and three are illustrated here. Figure 3.5 shows a textile with red and blue bands, including one that has a wide Arabic inscription in *naskh* script. The fragment in figure 3.7 displays a design of flowering trees set against a background of small tendrils and leaves. The same pattern also appears on large textiles that were traded to maritime Southeast Asia as early as the fourteenth century. This particular fragment's carbon-14 date places it between the mid-fifteenth and the early seventeenth centuries, which is consistent with radiocarbon dates of similar pieces in other collections. The lappet-shaped textile in figure 3.6 was once part of a larger hanging, used to cover doors or niches, and has a palmette pattern that fills the entire space. Its rich dark background was achieved by overdyeing red with indigo.

We have known for some time of the importance of the material to the Indian Ocean economy. Goitein's publications of the Genizah documents are full of references to the manufacture and trade in textiles, much of it related to India. Eyewitness accounts from early Portuguese travellers, such as Duarte Barbosa and Tomé Pires, commented on the thriving textile production in Gujarat. Writing of the city of Cambay, Barbosa said, "There are also many craftsmen of mechanic trades, and everything [is] good [and] cheap. Here are woven white cotton fabrics both fine and coarse, and others printed in patterns; also much silk cloth and coloured velvets."[13] At the time, Cambay was Gujarat's most important entrepôt for international trade, and Pires stressed the external contacts, particularly the trade to Aden and Malacca: "All the trade in Cambay is in the hands of the heathen.[14] . . . They are men who

FIG. 3.3

Textile fragment with flowering trees. Western India, for the Egyptian market, late thirteenth to fourteenth century. Cotton, hand-drawn, mordant-dyed, 30.5 × 26 cm.

The two shades of red were achieved by applying different mordants; the mordant for the darker shade likely contained iron, which can destroy cotton fibres over time. The textile is sewn together from two pieces.

ROM 961.107.1

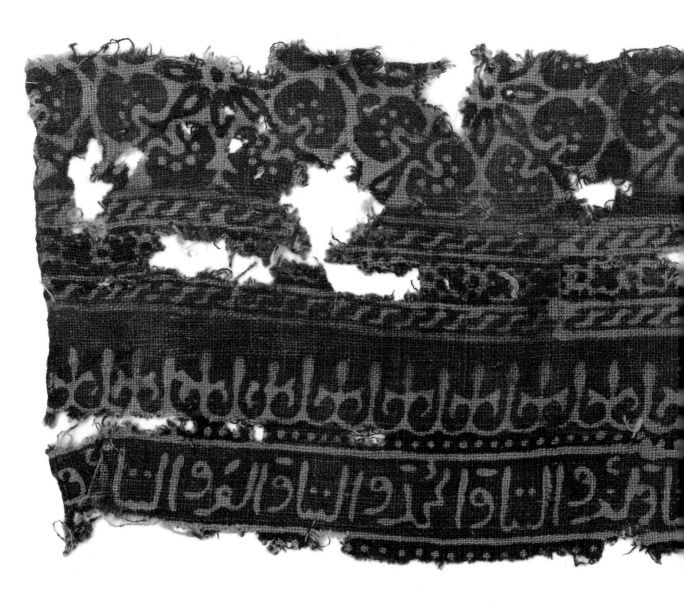

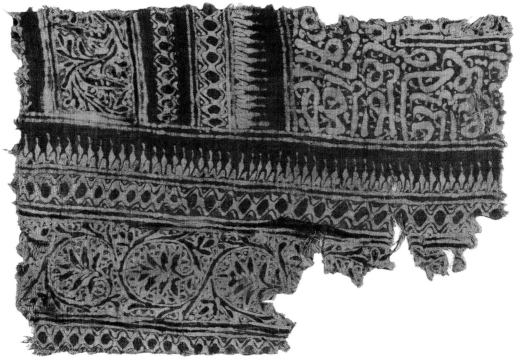

ABOVE
FIG. 3.4

Textile fragment with floral pattern and bands. Western India, for the Egyptian market, fifteenth or early sixteenth century. Cotton, block-printed, hand-drawn, mordant-dyed, 17.4 × 47.4 cm.

One of the bands has a brief Arabic inscription that is repeated.

ROM 980.78.45

FAR LEFT
FIG. 3.5

Textile fragment with red and blue bands with vines and an Arabic inscription. Western Indian, for the Egyptian market, probably sixteenth century. Cotton, hand-drawn, mordant-dyed, resist-dyed, 22.5 × 15.2 cm.

The Arabic inscription uses naskh script. The continuous vine pattern is blue, which means that the background was covered with resist, although it is more common for the resist to define the pattern. This technical shift apparently occurred not earlier than the sixteenth century.

ROM 978.76.140. Abemayor Collection given in memory of Dr. Veronika Gervers, Associate Curator, Textile Department (1968–1979) by Albert and Federico Friedberg.

LEFT
FIG. 3.6

Lappet filled with a palmette. Western India, for the Egyptian market, fifteenth or sixteenth century. Cotton, hand-drawn, mordant-dyed, resist-dyed, 7 × 12.8 cm.

The lappet was once part of a hanging that covered a door or niche.

ROM 978.76.23. Abemayor Collection given in memory of Dr. Veronika Gervers, Associate Curator, Textile Department (1968–1979) by Albert and Federico Friedberg.

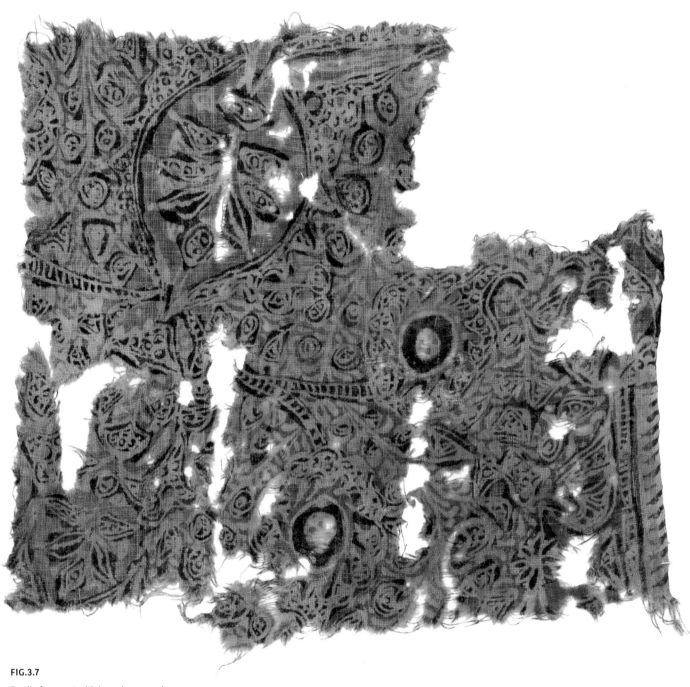

FIG.3.7

Textile fragment with large leaves and
flowering trees. Western India, for the
Egyptian market, fifteenth to early sixteenth
century. Cotton, hand-drawn, mordant-dyed,
resist-dyed, 20.5 × 22 cm.

This fragment's carbon-14 date places it
between the mid-fifteenth and the early
seventeenth centuries, but since the same
pattern appears on large textiles traded
to maritime Southeast Asia as early as the
fourteenth century, an early date within
the range is likely.

ROM 978.76.1104. Abemayor Collection
given in memory of Dr. Veronika Gervers,
Associate Curator, Textile Department
(1968–1979) by Albert and Federico Friedberg.

understand merchandise; they are . . . properly steeped in the sound and harmony of it. . . . Cambay chiefly stretches out two arms, with her right arm she reaches out towards Aden and with the other towards Malacca, as the most important places to sail to, and the other places are held to be of less importance. It has all the silks there are in these parts, all the different kinds of cotton material . . . all of great value."[15] Aden, of course, was the opening to the Red Sea trade, Cairo, and ultimately the Mediterranean, while Malacca was the key entrepôt for contacts with the Spice Islands of Indonesia, on the one hand, and China, on the other.

The trade fragments that survive from a medieval Islamic context have been tantalizing scholars and textile historians for some decades, but until a connection to the wider Indian Ocean field was established in the late 1990s, it was difficult to match up historical sources with surviving material. This has changed dramatically.[16] It is now possible to read the early Portuguese accounts and actually have an image of the items to which they refer. Barbosa mentioned "printed . . . cotton," and he must have seen textiles similar to those we know from Egypt. He also spoke of silks, as did Pires; when their writings later refer to the trade with eastern Indonesia, these are further identified as *patola* (double-ikat silk fabrics). The cloths still survive from these islands, usually as lineage treasures of great ritual and symbolic importance (see ch. 5).[17]

Gujarat's Textiles for the Indian Ocean

Although this chapter focuses on the trade to Egypt, it is useful to expand our view to the other eastern point that Indian textiles reached by the thirteenth or fourteenth centuries. Comparing the Indian cloths that survive from the two extreme ends of the Indian Ocean, one is impressed by the similarities we see in many of the designs. But equally interesting is the information we can gain about geographical market specialization and differences. Figural representations, for example, are not uncommon among the designs of textiles for the eastern market; some are of remarkable quality (see ch. 5). By contrast, very few of the textiles surviving from Egypt contain animal or human figures. Textiles with borders inscribed in Arabic or pseudo-Arabic are common among the Egyptian remains; such inscriptions are usually formulaic, typically containing blessings to the owner. These fabrics containing Arabic script apparently were specific to the trade going to the West, to Egypt, and, possibly, southern Arabia as well. None of them have been found in Southeast Asia, although Islam was well established in the coastal regions by the fifteenth century. A further distinction is that of colour. The Indo-Egyptian material is dyed blue, red, or a combination of the two. All Indian textiles documented so far from Indonesia are either red or a combination of red and blue. No single Indonesian cloth survives that was dyed only blue; it is likely that there is a cultural reason for that, since in most (but not all) Indonesian societies red is an auspicious colour, associated with power and fertility.

This possible cultural influence on textiles brings up one final consideration: the effect these textiles may have had on influencing the artistic choice in societies that received them. For Southeast Asia, the relationship between trade textiles and indigenous textile designs has been studied in considerable detail. For the trade to the Near East, so far little evidence exists that the designs of Indian textiles were assimilated into Islamic design on any larger scale. However, there are some tantalizing hints, in particular in southern Arabia (Yemen), that may indicate a local response to the vibrant quality of these designs. A small *madrasa* (Islamic school) in the town of Rada', dated to the early sixteenth century, has an unusual mixture of patterns painted onto the ceiling domes and blind niches. Several of the designs are strikingly similar to the Indian printed textiles. The *hammam* (bath) on the madrasa's ground floor has smooth relief carvings of linked chevrons, a pattern that was also common as architectural designs in the Mamluk buildings of Cairo. The same chevron pattern is often represented among the Indo-Egyptian trade textiles; this pattern

in particular was apparently made specifically for export into the Mamluk region. There is, as far as I know, no evidence for the chevron pattern in textiles destined for the indigenous Indian market, and it does not appear on any of the cloths surviving from Indonesia.

Yemen certainly has accepted and integrated Indian products in the past. Not far from Rada' is a mosque and madrasa (fig. 3.9) in the small community of Juban, which incorporates columns imported from western India; parallels can easily be found in Gujarat. Tombstones from Cambay were made to order and exported for use in southern Arabia in the late fourteenth century. The fourteenth-century Ashrafiya Mosque in Ta'izz has a door that holds a carved panel strongly reminiscent of the "swaying tree" motif found in Gujarati mosque architecture, as well as in Jain manuscript paintings—and, of course, in Indo-Egyptian textiles dated to the same period (fig. 3.3). The panel was likely made to order in India and brought

on ship to Aden and then on to Ta'izz. To this day, Gujarati printed textiles are imported into Yemen and are worn by women as large body covers (fig. 3.8).

Indian textiles had a special appeal to customers throughout communities of the Indian Ocean. It must have been the combination of pleasing designs and a remarkably resilient dye quality. Although the earliest surviving textiles in Egypt were apparently used and reused until they became rags and had to be discarded, many of them still astonish for the brilliance of their colours. The indigo continues to impress for its deep blue, and the shades of red appeal for their variety and richness.

FIG. 3.9

Recently restored interior paintings of the Al-Amiriya Madrasa, located in Rada', Yemen, and built between 1504 and 1512. The row of small flowering trees in the arch framing the window is identical to an Indian block-printed design.

© Aga Khan Trust for Culture / Anne de Henning (photographer).

1 The earliest evidence comes from the Indus Valley Harappan civilization and dates to the third millennium BCE, although remains of cotton fibre and the imprint of weaving have been identified from an Early Neolithic seasonal hunting camp at Dhuweila in Jordan, radiocarbon dated to 4450–3000 BCE. At this early date, India was the only known source of cotton cultivation for the purpose of textile production in Asia, and the fragment may be evidence for trade of cotton textiles at this extremely early date. For the Harappan evidence, see Watson, "Rise and Spread," 357; Allchin, "Early Cultivated Plants," 325. The Dhuweila find is discussed in Betts et al., "Early Cotton."

2 Casson, *Periplus Maris Erythraei.*

3 Substantial collections are now held in the Museum der Kulturen, Basel, at the Benaki Museum, Athens, and in the Textile Museum, Washington, DC. The largest is the Newberry Collection of over 1200 textiles in the Ashmolean Museum, Oxford.

4 For a summary of the site's history, see Barnes, *Indian Block-Printed Textiles*, 1:27.

5 Bahgat Bey and Gabriel, *Fouilles d'al Foustat.*

6 Pfister, *Les toiles imprimées* and "Tissus imprimées."

7 Whitcomb and Johnson, *Quseir al-Qadim 1978* and *Quseir al-Qadim 1980.*

8 See Gittinger, *Master Dyers*, 30–57; Bérinstain, "Early Indian Textiles"; Vogelsang-Eastwood, *Resist Dyed Textiles*; Barnes, *Indian Block-Printed Cotton.*

9 Barnes, *Indian Block-Printed Textiles*, 1:33–34, 39.

10 A *genizah* is a depository that receives written documents that contain the name of God. Eventually the documents should be ritually disposed of, but in the case of the Fustat synagogue's genizah, this never happened. When the building was restored in the late nineteenth century, a closed-off room revealed over three hundred thousand fragments relating to the Jewish community associated with it. The Cairo genizah papers are now held in several libraries, notably in Cambridge, Oxford, and Manchester in the UK, Jerusalem, and the University of Pennsylvania.

11 Goitein, "Letters and Documents" and *Mediterranean Society.*

12 Barnes, "Indian Cotton for Cairo."

13 Barbosa, *Book of Duarte Barbosa*, 1:141.

14 Pires refers here to Jain merchants, not to Muslims.

15 Pires, "*Suma oriental*," 1:41–43.

16 Barnes, *Indian Block-Printed Textiles*; Guy, *Woven Cargoes.*

17 Barnes, *Ikat Textiles*, 74–81.

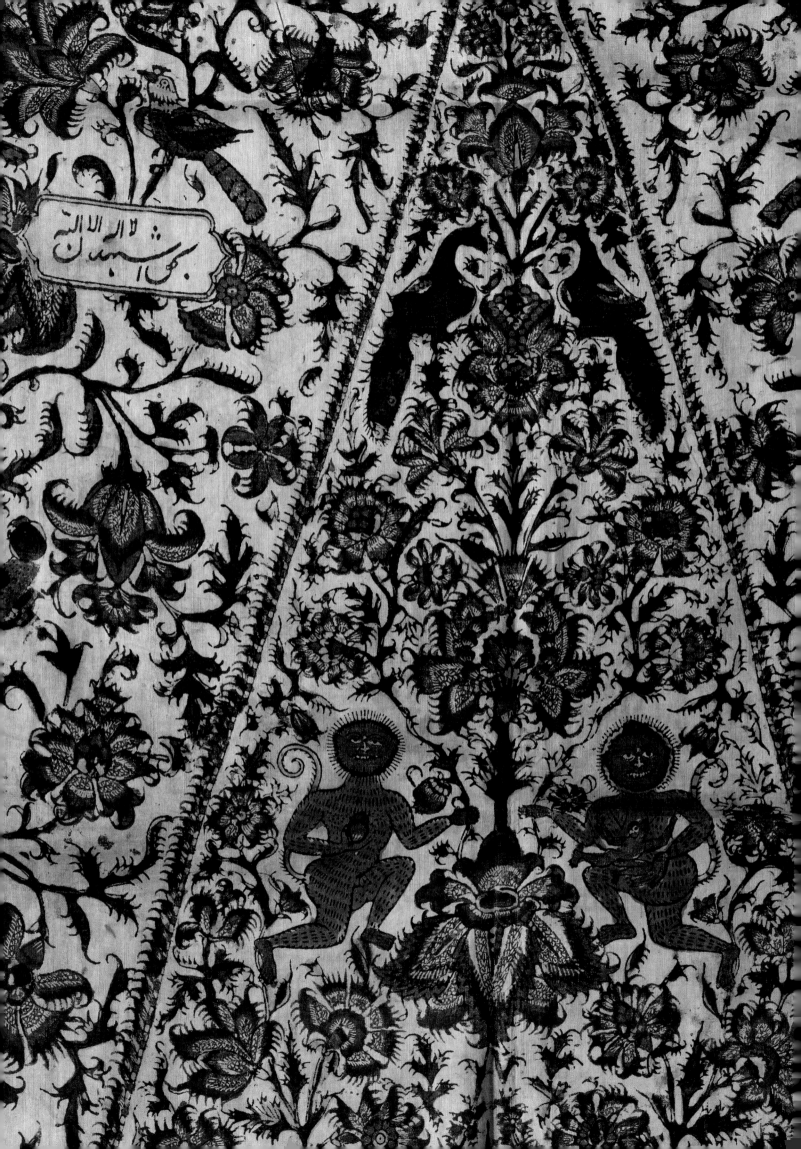

4
—

THE SPECIALIZED MARKETS OF WESTERN ASIA

IRAN AND ARMENIA

STEVEN J. COHEN

The Iranian Market

THE EXPORT OF COTTON CLOTH FROM THE INDIAN SUBCONTINENT to Iran (formerly Persia) was a massive enterprise involving, at its peak, the weaving of over a million pieces of cloth per year.[1] The volume of cotton textiles exported to Iran was probably only matched (or exceeded) by the domestic Indian market and was larger than the volume of cloth produced for any other single geographic area, with the possible exception of Europe at the height of demand in the first half of the seventeenth century. The majority of these cotton textiles were always various grades of bleached, undyed cloth in standard lengths, with a smaller percentage dyed a single colour, primarily indigo blue or madder red. The number that was

Detail: Hanging made in coastal southeast India for the Iranian market (p. 66).

block printed or hand painted in the chintz technique, though economically significant, was even smaller. This trade from India to Iran by both sea and land routes was ancient and indirectly implied by both Greek and Roman historians of the first centuries BCE and CE. All ancient Indian textiles reaching the West would have had to first pass through Iran or its ports, and although we are aware today of archaeological fragments discovered along the shores of the Red Sea and in central Asia dating to around the first to the third century CE (see ch. 3),[2] early Indian cotton textiles have not been found in Iran in significant quantities. In fact, even early eighteenth-century Indian cotton textiles made for the Iranian market would be considered a rarity.

Relatively accurate figures of the Iranian trade have been collated and analyzed by studying the records of the European companies[3] as they struggled to compete with Iranian, Armenian, and Indian merchants to supply the Iranian market with textiles from the 1630s onward, but prior to that date, we lack precise information. What is clear from all accounts—Iranian, Indian, and European—is that the Iranians had always depended on the importation of Indian cotton cloth, not because they could not produce similar goods themselves (we know that occasionally they did, but with only limited success) but because Indians were able to provide cotton goods for the Iranian market that were acknowledged to be of a better quality and a cheaper price than most local Iranian-made equivalents.[4] Most of the major Indian producing areas—Gujarat, the southeast coast, as well as Punjab, Awadh, and Bihar—were implicated. But with specific regard to the Indian block-printed and hand-painted textiles, because the Indian craftsmen were designing them specifically for the Iranian market—with patterns and colour combinations supplied directly by resident Iranian merchants—the Indian-made examples are sometimes difficult to distinguish from similar Iranian examples made in Isfahan in the later nineteenth century. We are reliably informed that at that time the quality of Iranian block-printed and hand-painted cotton textiles greatly improved from their historically low standards.[5] However, prior to the Iranian improvement in quality, although it may be subjective and unscientific, one can almost always differentiate contemporary Iranian from Indian examples of combined block-printed and hand-painted textiles on the basis of their visual qualities: the dyes of the Indian examples are brighter and more saturated, especially the blues and reds; the drafting and printing of the designs is more precise; and, perhaps most significantly, minor borders often have scrolling designs in hand-drawn white resist, a technique never mastered by the Iranian chintz makers.

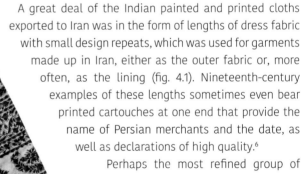

A great deal of the Indian painted and printed cloths exported to Iran was in the form of lengths of dress fabric with small design repeats, which was used for garments made up in Iran, either as the outer fabric or, more often, as the lining (fig. 4.1). Nineteenth-century examples of these lengths sometimes even bear printed cartouches at one end that provide the name of Persian merchants and the date, as well as declarations of high quality.[6]

Perhaps the most refined group of Indian trade textiles associated with the Persian market are the rectangular cotton cloths of approximately a metre wide and between one and a half and two metres long (fig. 4.2). In the centre, there is almost always an area defined by a cusped arch at the top, framed on both sides by three or four vertical floral meander

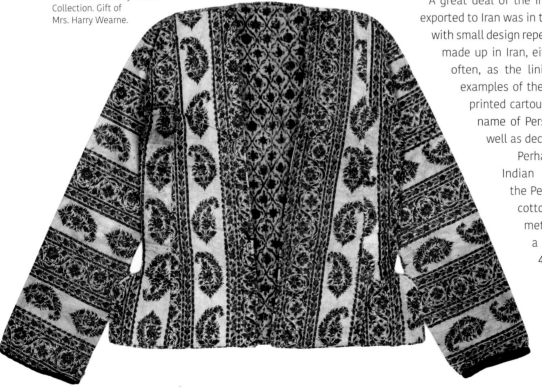

borders, one of which often encloses a column of cypress trees within tiny niches. The lower horizontal border varies widely but most often consists of a row of merlons, other times rows of chevrons; another variation consists of a row of floral swags, which first appeared on European-market chintz from around 1775 but remained popular in Iran into the early twentieth century. The upper border is most often architectural, displaying decorative rows of finials of the sort one might observe at the top of a monumental Deccani gateway to a palace or mosque. The interior central space might be left unadorned, dyed red or yellow, or display offset rows of Mughal style flowers or Kashmiri/Iranian *boteh*s ("paisley" motif); there are so many possibilities. These decorative hangings, referred to by some as "prayer cloths" with no evidence, are assumed to have been made in or near the southeastern Indian port of Machilipatnam, and thousands were exported to Iran throughout the nineteenth century. All were block printed in four to seven colours, with hand-painted resists and additional details distinguishing the higher-quality specimens from those that were more ordinary. The Royal Ontario Museum (ROM) has almost a dozen examples of these hangings, ranging from the very top quality (e.g., fig. 4.2, below) to more standard types that rely on fewer block-printed colours and little or no hand-painted details (fig. 4.2, above).

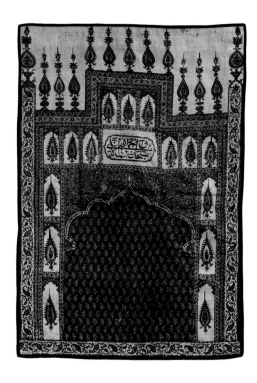

An even more popular Persian export cloth, again presumed to have been manufactured and shipped from the Machilipatnam area of coastal southeast India, combines the same format of multiple floral borders enclosing a central field on four sides, again with a cusped arch and spandrels at the top. This time the central space is dominated by a slightly coarsened version of an earlier European-market rocky mound from which a highly stylized cypress tree rises. Pairs of animals usually flank the base of the tree: peacocks grasping snakes, lions, tigers, or bovines are among the most common types. Birds, monkeys, and imaginary floral forms in the slightly spiky "Iranian style" fill every available central space, and some of these panels display cartouches, some blank and others inscribed with pious Arabic and Persian expressions. In a few examples, typical Persian astrological "sun faces" are placed above the cypress tree in the upper border; but if further proof of their Indian origins were needed, other examples replace the Persian "sun face" with that of a Hindu face, surrounded by a solar nimbus and bearing Shaivite caste marks on its forehead (fig. 4.3). Such cloths give the cursory impression of a hand-painted chintz; yet all of the outlines have been produced by a very clever use of pairs of many small wooden blocks to first outline all of the decorative elements of the design, which either have then been partly coloured by hand, on the finest examples, or have all of their colours printed through the use of additional wooden blocks (fig. 4.4). The same set of outlining blocks can be used to produce more identical panels or, by simply

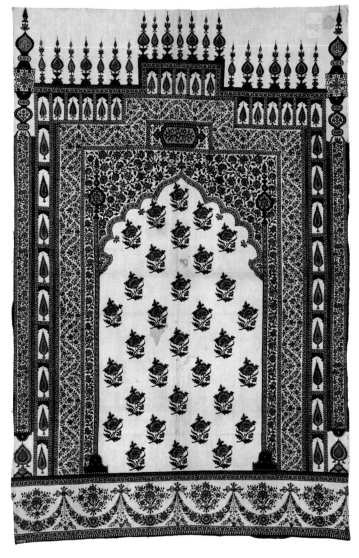

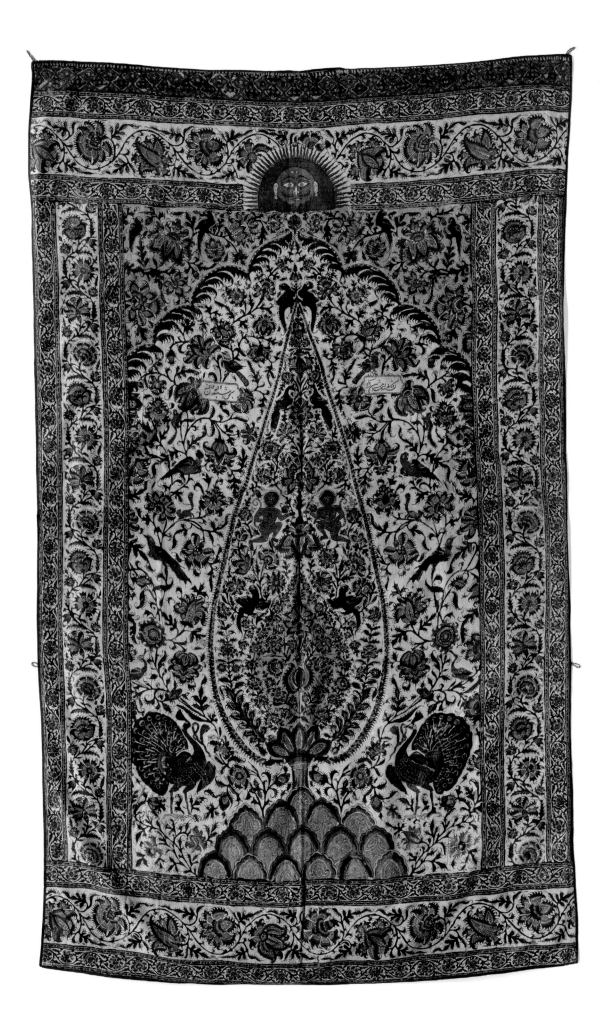

substituting one (or several) identically sized pair(s) of blocks—for example, peacocks could replace lions—similar but nonidentical variations of the first cloth can be easily produced.

Yet one more decorative variation of a typical "Machilipatnam-type" Iranian export cloth dispenses with all human and animal imagery to display a composition that is more balanced and symmetric. The four major borders consist of contiguous chevrons in four alternating colours, while the central field resembles a carpet pattern with quarter corner medallions and a lobed diamond-shaped central medallion against a field of offset rows of tiny boteh. While there are no design elements of these hangings or covers that would have made them unsuitable for the domestic Indian market, the chevron borders, botehs and this specific colour combination ensured that they were especially attractive to nineteenth-century Iranian buyers, their most probable intended market (fig. 4.5).

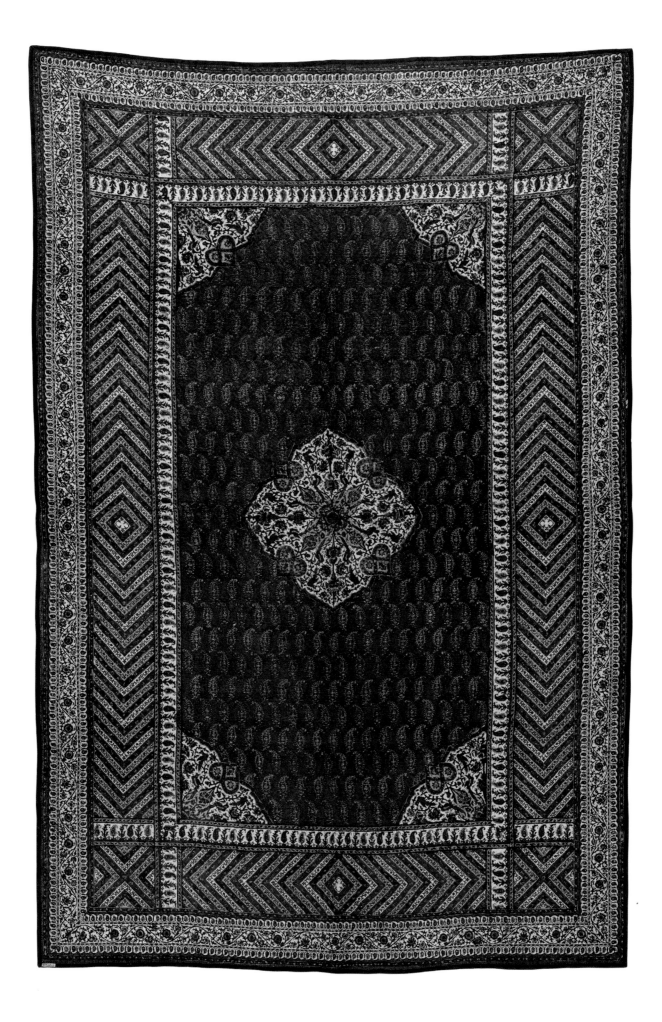

The Armenian Market

Apocryphal histories of the early presence of Armenian merchants in India are well known; the first citation usually alludes to Thomas Cana, a trader working in the spice and cloth business in eighth-century Calicut (Kozhikode) on the Malabar Coast. Whatever the accuracy of that story may be, and despite the relatively small community in India, Armenian merchants were certainly integral to the textile trade between India and Persia long before the first representatives of the European trading companies arrived on the Indian subcontinent. Their dominance as merchants, agents, and exporters of Indian cloth to Europe, Iran, the Ottoman Empire, Southeast Asia, and the Far East is mentioned frequently in the records of all the European trading companies.[7] In a famous quotation repeated by the pioneers in the study of chintz, one is told, "In 1695 the directors of the English East India Company described them [the Armenian merchants] as 'the most knowing men in all the inland parts of the East Indies [more] than the Dutch or any other nation on the face of the earth.'"[8] When the Dutch Vereenigde Oostindische Compagnie (VOC; East India Company) first considered purchasing silk in Iran, they understood that they would have to collaborate with the Armenian merchants who controlled most of that trade. In the early seventeenth century, the Iranian ruler Shah 'Abbas had granted the Armenians in Iran a monopoly on the sale of Iranian silk in his territory, making them the ideal middlemen to facilitate all of the arrangements required by the Dutch: "The first Indian textiles were sent by the VOC via Suratte to Iran in 1624. The Dutch upper merchant Pieter van de Broecke suggested . . . [setting] up a VOC trade post in Iran partly financed with Indian textiles import[ed] in exchange for silk. To promote an active trade between Persia and Suratte in India, the VOC allowed indigenous Iranian (Armenian) and Indian merchants to use VOC vessels to transport goods to both countries . . . Through this channel Armenians imported Indian textiles to Persia or via overland transit trade these textiles were sold in the Ottoman empire."[9]

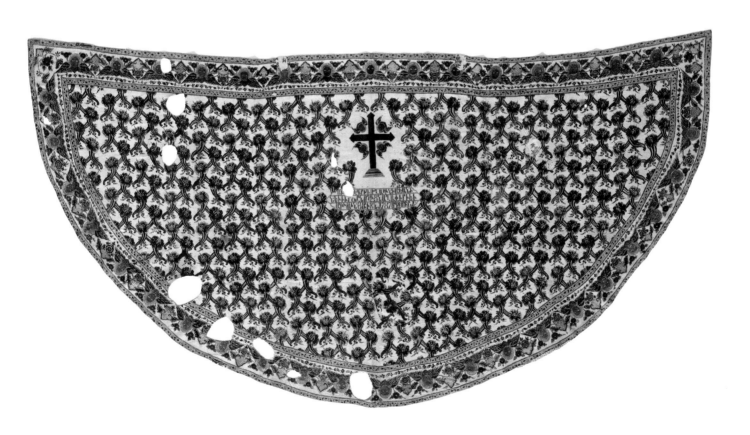

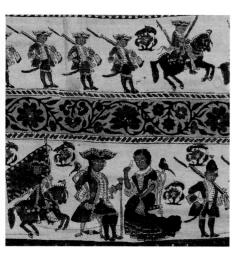

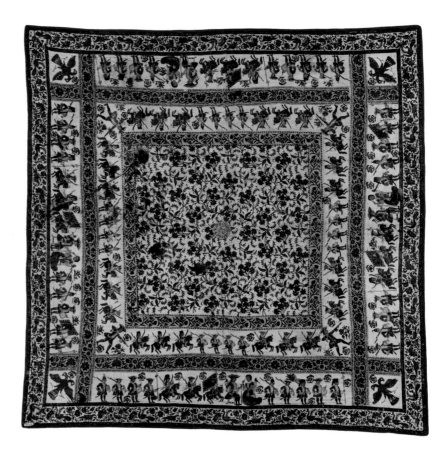

FIG. 4.7

Overview and details: Kerchief. Coastal southeast India, for the Armenian market, stamped date of 1737. Cotton, block-printed mordants and resists, painted details, 90.5 × 92.75 cm.

The central dated, Armenian-script dedication enhances what would otherwise be a somewhat carelessly executed, though interesting, figurative block-printed kerchief.

ROM 934.4.65. Harry Wearne Collection. Gift of Mrs. Harry Wearne.

Obviously, the Armenians were extremely well placed to commission textiles not only for use in their own Christian churches and monasteries in Armenia but also for all their many religious establishments in India, Persia, and across the Armenian diaspora.[10] The cope in the ROM (fig. 4.6) is a typical example of eighteenth-century hand-painted chintz produced in coastal southeastern India. Its overall floral lattice design, with its internal asymmetry reflecting the rococo aesthetic popular in Europe, would not have looked out of place on a European gown.[11] Obviously, the inclusion of angelic winged heads in the borders as well as the dominant cross placed above three lines of dedicatory Armenian script[12] and the date of "1787" had to have been specially commissioned, but such an order would not have been difficult for the chintz painters of southeastern India to produce, once they had been provided with a design to copy. The cope was almost certainly used in India, and probably used for quite a long time, because it is presently lined with a distinctive, but later, South Indian cotton cloth printed with a spot motif imitating Indian tie-dyed textiles. Nineteenth-century samples of such cloths were collected by John Forbes Watson from Ponnari in the late 1850s;[13] the similarities of these samples to the cope lining imply that this South Indian textile would not have been the original lining but a later replacement. This same lining includes smaller fragments of a European printed cotton imitating a more costly French-inspired warp-printed silk *chiné* fabric.

Not all of the textiles commissioned by Armenians were destined for religious purposes or are of high quality. The ROM collection also includes a European-market block-printed handkerchief with no religious significance, and yet it was stamped in the centre with an Armenian text translated as "Son of Ter (or Der) Hagop. Dazdur. 1737," with three initials and the number 121 in the centre (fig. 4.7).[14] Its decoration consists of multiple borders on four sides: some are filled with crudely block-printed birds and flowers, others are entirely floral, while the two major borders display single columns of European military figures on foot and on horseback, with a seated European couple in the centre of the four most prominent borders and double-headed eagles in each corner. The square centre of the handkerchief has

been filled with a poorly executed arabesque arrangement of large flowers, leaves, and stems. None of the decoration of this object was executed with much care, and some of the colours have been roughly hand painted over the printed outlines; but the presence of Armenian inscriptions on this fairly common secular object is intriguing, as no obvious explanation presents itself as to why such an inexpensive textile had been specially commissioned.

The full scale of the import of Indian cotton textiles to Iran will never be known because the record only consists of European company documents and rare surviving examples. But the Iranian market for Indian block-printed cloth with hand-painted details survived longer—into the first decades of the twentieth century—than any of India's other traditional export markets.[15]

1 This trade in goods is extremely difficult to quantify because a significant number of those textiles arriving in Iran were not consumed internally, but were either transshipped through the Iranian ports of Hormuz and Bandar 'Abbas or via towns such as Isfahan, Tabriz, and Herat on their way to Ottoman, Russian, central Asian, or European markets. See Dunlop, *Bronnen*, 484–85, 494, quoted by Floor, "Import of Indian Textiles" (2003), 188–89. H. Dunlop examined the Dutch records for the year 1634. During that year "375,000 pieces of cotton stuffs were exported from Gujarat and Coromandel to Persia by sea and some 217,000 cotton pieces from the Punjab, Awadh and Bihar by land. Thus altogether some 590,000 pieces of cotton stuffs were imported into Persia." Dunlop, 485–86, 494. Those are just the official records for those specific production centres, but the actual number from all sources, of every type of Indian cotton, must have been substantially larger. William Floor states that "in the mid-1630s this trade [from Gujarat, Cambay and Sind to Iran] was estimated at 1.1 million yards of cloth." Floor (2003), 191 n24, citing Foster, *English Factories*, 7:273ff.; and Dunlop, *Bronnen*, 482, 491.

2 Crill, *Fabric of India*, 140.

3 Floor, *Persian Textile Industry*; Floor, "Import of Indian Textiles"(2003); Dale, *Indian Merchants*; and Dunlop, *Bronnen* are among the best sources.

4 Chardin, *Travels in Persia*, 278–79. "They [the Persians] make also *Calico Cloth* very reasonable; but they make none fine, because they have it cheaper out of the *Indies* than they make it [and] . . . they [Persians] understand also the painting of Linnen, but not so well as the *Indians*, because they buy in the *Indies* the finest painted Linnen so cheap, that they would get nothing by improving themselves in that Manufacture." Dale, *Indian Merchants*, 23 (italics in original).

5 Gluck and Gluck, *Survey of Persian Handicrafts*, 186–95.

6 Crill, *Fabric of India*, 145 and ill. 151. The production centre of similar, though earlier, cloths has provoked debate over the years. Some authorities simply assume these to be Persian because they were purchased in Isfahan, while others have suggested Burhanpur in the Deccan as an alternative to the Machilipatnam area of coastal southeast India. While we know from historical records that Burhanpur was an important centre for the production of chintz and block printing in the late seventeenth and eighteenth centuries, we still do not know which surviving textiles were made there. John Irwin and Margaret Hall (*Indian Painted*, 24–25) were early advocates of assigning specific textiles in the Calico Museum to Burhanpur, but their arguments are not convincing.

7 Bekius, "Armenian Merchants" and "Global Enterprise"; Floor, "Import of Indian Textiles" (2003), 5–6 n15, paraphrasing Foster, *English Factories*, 5:124–25: "English East India sources . . . note that large quantities [the transit trade in textiles] were imported from India by Iranians and Armenians, who sold these in Bandar 'Abbas." But in Floor, "Import of Indian Textiles" (2010), n15, Foster is cited without paraphrase. Another reference from Floor ([2010], n38) is his translation from the French paraphrasing Fukusawa, *Toilerie et commerce*, fol. 46: "Painted cottons from Siranj, were among the most important fabrics exported to the Middle East. . . . Their chintzes [*sic*] were worn by people of all classes in Persia and the Ottoman lands. The Armenians dominated this trade." Floor (2010), n61 continues with the information translated and extracted from VOC 1236, van Wijck (Gamron) to Batavia (3/9/1664), fol. 766: "As of the early 1660's the sale of Coromandel textiles by the VOC increased significantly. The reason was that its agents were unable to sell Gujarati fabrics. . . . They were outperformed by their Asian competitors. . . . This should have made the European merchants wary, for Asian merchants competed heavily in this trade as well. Armenian and Muslim traders were believed to dominate the market by the 1670's."

8 Baker, *Calico Painting and Printing*, 1:29, quoted in Irwin and Brett, *Origins of Chintz*, 129.

9 Bekius, "Armenian Merchants," 14 n102; Dunlop, *Bronnen*, 63, from the conference in Oxford, August 2003, where the paper was first delivered. The general idea is mentioned, but the quotation is absent, in the much shortened version; Bekius, "Global Enterprise," 210.

10 See similar examples in Crill, *Fabric of India*, 98–101; Irwin and Brett, *Origins of Chintz*, 129–30, plates 155a–156; Evans, "Armenian Knot"; Guelton, "De l'Inde à l'Arménie."

11 Another fragment with the same curved design as the cope, but with additional gilding, is in the Cooper Hewitt, New York, acc. no. 1902.1.974, Beer, *Trade Goods*, 93–94, no. 19.

12 "In memory of Gregory Ghalandaeian [or Quolandacian or even Kalamdeceian] and his parents Agapia and Martha, in the year 1787. September." Translation in Irwin and Brett, *Origins of Chintz*, 130, no. 186.

13 Watson, *Textile Manufactures of India* (1861), vol. 10, no. 376, recorded as coming from Ponnary, Madras (today Ponneri, Tamil Nadu).

14 My thanks to Berdj Achdjian, his wife Artemis Ohanian, and Gevork Nazaryan who translated the inscription.

15 George Baker toured India in ca. 1919 and reported that "in the Madras Presidency considerable business was being done by a combination of block and wax resist applied with the pencil and dyes." Of Machilipatnam he observed there remained "fifty printers, mostly engaged in printing for the Persian trade." Baker, *Calico*, 1:56–57.

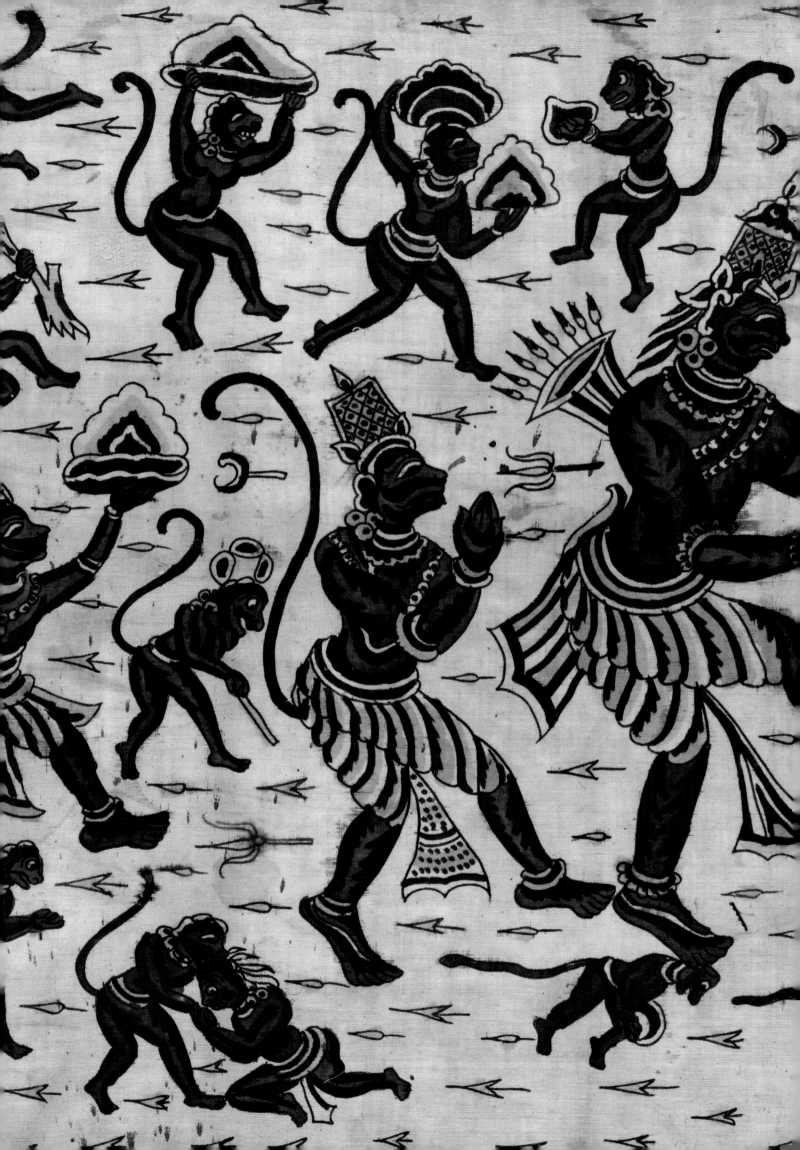

5
—

INDIAN TEXTILES FOR THE LANDS BELOW THE WINDS*

THE TRADE WITH MARITIME SOUTHEAST ASIA

RUTH BARNES

Merchandise we take to Banda [are] Sinabaffs of all kinds and every other kind of fine white cloth from Bengal; all the cloths from Bonuaquelim [Coromandel Coast], to wit, . . . and cloth of all kinds from Gujarat.

—Tomé Pires, *Suma oriental*, vol. 1, 207

IT WAS THE SEARCH FOR SPICES THAT FIRST DREW EUROPEANS INTO LONG-distance oceanic voyages, launching their so-called Age of Discovery. They were, however, latecomers to the Indian Ocean. By the time the first Portuguese ships arrived in the early 1500s, almost all of the coastal realms of Southeast Asia had been in contact with maritime traders from other parts of Asia for centuries. The great cultures of Cambodia and western Indonesia developed their full potential in a fruitful mingling of indigenous and Indian ideas and artistic forms, and Vietnam was deeply affected by China's presence. Arab and later Indian Muslims introduced Islam to maritime Southeast Asia by the thirteenth century and brought about local conversions that contributed to the development of a culture particular to the region, especially the islands we now know as Indonesia and the southern Philippines. This culture is referred to as *pasisir*, from the Malay word for "coastal region." It typically integrates indigenous forms of cultural expression—in religion, social structure, and art and architecture—with strong links to other ports of Asia and the Islamic

Detail: Ceremonial cloth depicting the Hindu epic tale the *Ramayana* (see fig. 5.9).

*"The land below the winds" was the name given to Southeast Asia by Iranian, Arab, and South Asian travellers, in reference to the seasonal monsoon that affected navigation in the Indian Ocean.

FIG. 5.1

Ceremonial cloth (*maa'*) used by the Toraja people, Sulawesi. Western India, for the eastern Indonesian market, seventeenth or eighteenth century. Cotton, block-printed, mordant-dyed, 81.3 × 640 cm.

The design here imitates the more expensive and luxurious double-silk patola cloths that were also made in Gujarat, India, for export to Indonesia. VOC stamp.

Collection of Banoo and Jeevak Parpia.

world. Such a culture of course fostered multiregional connections; for example, when the first Portuguese vessels arrived in 1516 in the Solor Straits of remote eastern Indonesia, they found not only a small but already well-established Arab community, which had made converts to Islam, but also Gujarati and Chinese merchants—the latter manufacturing gunpowder.[1]

In this international world of connections, Indian textiles played a pivotal role. They appear in travellers' accounts as early as Ibn Battuta, writing in the fourteenth century.[2] Early European travellers visiting South and Southeast Asia frequently commented on the richness of the Indian textile trade and on its importance for Asia's maritime commerce; the first Portuguese sources already gave detailed lists of specific textiles for particular locations, although these names are often difficult to identify.[3] Iberian and eventually Dutch and English explorations into Asia were driven by the attempt to find the source of spices and aromatics, and Southeast Asia was a primary target: at the time of their arrival in the sixteenth and seventeenth centuries, the region was the only producer of cloves and nutmeg, as well as the origin of some of the best pepper and sandalwood. In return for their spices, local populations demanded the foreign goods that they deemed valuable, Indian textiles above all. Cloth from the subcontinent was in high demand in many parts of the Indian Ocean, both east and west, for use as dress and for furnishings; but in some regions, these foreign textiles were also integrated into a complex political and social system of gift exchanges or became an integral part of rituals. This integration occurred in particular in Southeast Asia, where Indian textiles frequently moved from a secular into a ceremonial context and would eventually be elevated to the high status of heirloom items.

The region apparently had an insatiable appetite for cloth. Despite having an ancient and highly developed weaving tradition of its own—going back as far as four thousand years—there was considerable demand for imported textiles, especially from India.[4] These foreign fabrics had a formative influence on indigenous societies, both as prestige items that could eventually take on a significant ritual role and as inspiration for the development of local design. For Indonesia, two types of Indian cloth were of particular importance: lengths of woven silk with double-ikat patterning known as patola and mordant- and resist-dyed cotton fabrics; both were initially produced in Northwest India and were exported via the ports of Gujarat. In many of the island cultures, the silk patola were the most highly valued trade cloths; those who could not afford them made do with cotton imitations, block-printed versions with patola patterns created by India's ever-adaptive artisans (fig. 5.1).[5] From at least the sixteenth century onward, more costly "painted" (mordant-painted and dyed) cotton cloths were also created in, and exported from, the southeastern coast to Indonesia, as we read in Tomé Pires's quote above, referring to the trade with the Banda Islands in eastern Indonesia.

The trade of textiles from the South Indian coast to western Indonesia, however, is likely to be much older, since textual references to Indian fabrics in Javanese documents go back to the tenth century.[6]

Indian textile craftsmen were adept at customizing their products for a wide range of different cultural and aesthetic preferences, from Egypt to eastern Indonesia and from southern Arabia to Japan. The production of textiles acceptable for maritime Southeast Asia (present-day Indonesia) was as differentiated as that for any other market. Within the wider region, specific tastes developed in different island cultures, and the Indian suppliers could cater to all. Block-printed or painted cotton textiles had a major impact in South Sumatra and Sulawesi, the Moluccas, Timor, and many other eastern Indonesian societies.

Trade to Sulawesi

The earliest Indian textiles found in Indonesia were discovered among the Toraja of southern central Sulawesi, where radiocarbon analysis attests for the survival of textiles that are as old as the late thirteenth and fourteenth centuries. As these textiles were discovered in quite remote inland locations, they must have followed an earlier coastal presence. The Toraja textiles originate in Gujarat. They are usually coarsely woven cotton, block printed in bold colours, and often of considerable length, measuring up to five metres. Quite often these long textiles are subdivided into two or three design panels (fig. 5.2). The same type of cloth was also traded to the Babar archipelago in the southern Moluccas.[7] A different and quite distinct cloth is resist printed and always dyed red, with a large central field showing small geese circling around an open lotus blossom (fig. 5.3). The geese alternate with lotus buds. One of these textiles, now in the Ashmolean Museum, Oxford, was the first Indian trade textile destined for Indonesia to be radiocarbon dated; it was chosen because of its striking similarity to a fragment that had been made in Gujarat for trade to Egypt, with a fourteenth-century carbon-14 date.[8] The similarity attests to the wide market range that Gujarati block-printed textiles could supply, reaching nine thousand kilometres across the Indian Ocean, from Egypt to eastern Indonesia. The early date for Indian textiles surviving in Sulawesi and elsewhere in Indonesia, established more than twenty years ago, transformed the discussion of Indian Ocean textile trades.

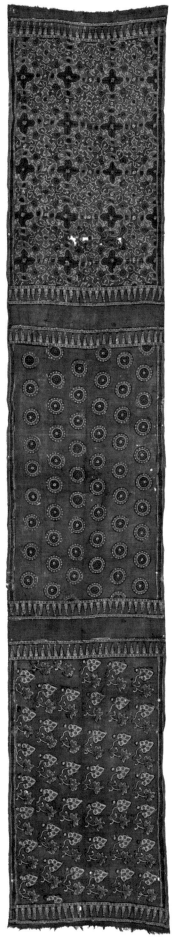

FIG. 5.2

Ceremonial cloth (*maa'*) used by the Toraja people, Sulawesi. Western India, for the eastern Indonesian market, seventeenth or early eighteenth century. Cotton, hand-drawn, block-printed, mordant-dyed, resist-dyed, 75 × 420 cm.

The tripartite design includes leaf, floral and rosette forms.

Collection of Banoo and Jeevak Parpia.

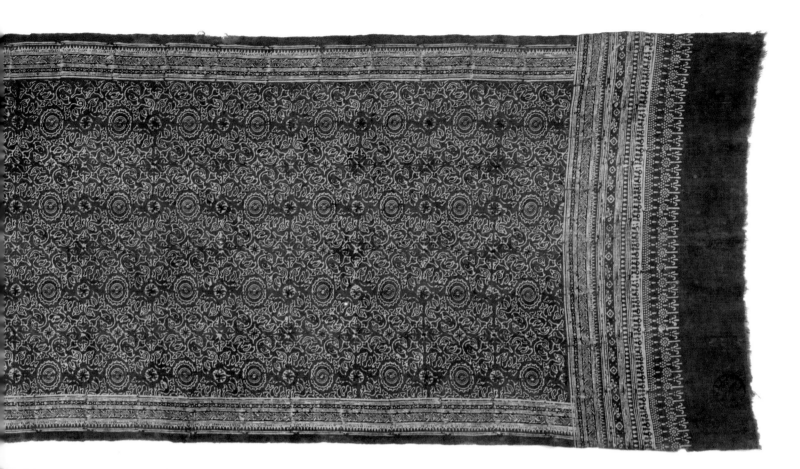

FIG. 5.3

Ceremonial cloth (*maa'*) used
by the Toraja people, Sulawesi.
Western India, for the eastern
Indonesia market, fourteenth or
early fifteenth century. Cotton,
block-printed, mordant-dyed,
89.5 × 581 cm.

ROM 2016.43.2. This acquisition
was made possible with the
generous support of the Louise
Hawley Stone Charitable Trust.

Detail: The characteristic pattern
of hamsa geese circling a rosette.

There is no doubt that the fabrics were traded into the islands' interior via coastal settlements with international contacts. For the fourteenth-century textiles that made their way into the Toraja region, the importing principality may have been Luwu, the major economic and political power in southern Sulawesi at the time and probably the oldest of the Bugis kingdoms.[9] Writing of the spice-rich and wealthy northern Moluccas at the time of first European contact in the early sixteenth century, the historian Leonard Andaya indicates the critical role of Indian cloths in the relationship between the powerful sultans of Ternate and Tidore—who controlled the clove trade—and village societies on Halmahera and in the Bird's Head region of New Guinea.[10] He shows that cloths, in particular foreign Indian ones, were passed on by the ruler to his dependencies on the periphery of the realm, as they were considered essential gifts to confirm local alliances. To the people of the interior, the coastal ruler's ability to present Indian textiles served as a significant indicator of his legitimacy. The reciprocal offering and accepting of these donations confirmed and reinforced the relationship of interdependence.

Although Andaya refers to a more recent period than the one relevant for the earliest textile finds, it is likely that the relationship between coastal and interior regions on Sulawesi followed a similar pattern. There is considerable historical and ethnographic evidence for the social significance of cloth in Indonesian societies, and the emphasis on gift exchanges involving textiles is well documented.[11] Cloth is still presented at life cycle ceremonies, and it is overwhelmingly in evidence at weddings and funerals. As Toos van Dijk and Nico de Jonge recorded for the southern Moluccas, Indian trade textiles sometimes have also been used as bridewealth cloth.[12] In my own field research area among the Lamaholot of eastern Indonesia, the most prestigious textile is a locally woven woman's

ceremonial skirt with patterns that are often inspired by silk patola.[13] As one of my weaver friends once said, "Without cloth we cannot marry," and one may add, nor can people be buried in a respectable manner. The type of cloth appropriately offered on these occasions is well defined and depends on the kinship relation between the donor and the recipient. Once presented, it is checked by women of the kinship group that receives the gift. Weaving is exclusively a female activity, and therefore the assessment of cloth gifts is performed by women.

During ritual ceremonies, the sacred space is often defined by textiles, and lineage houses may be draped with them, as is documented for the Toraja, who use their Indian imported cloths for these occasions (fig. 5.4). Indian textiles serve as an essential part of the annual *merok* ceremony, a thanksgiving ritual and evocation of future prosperity. On that occasion, a buffalo is sacrificed, but first there is a recitation of a poetic litany that consecrates the animal, the *passomba tedong* (laudation of the buffalo). In this recital, the "heavenly *sendana* tree" (sandalwood tree) is evoked, a "tree with the life-fluid of the people of the earth": it is called the tree with "seven branches and seven leaves."[14] An Indian textile with the design of a flowering tree with seven branches and seven large leaves forms part of the ritual. As I have discussed elsewhere, the Indian trade cloth was certainly made to suit the Toraja taste and ceremonial needs.[15]

Southern Sumatra, Java, and Bali

While the Indian textiles that survive from eastern Indonesia tend to be either fine patola silks or relatively coarse block-printed cotton, the trade to western Indonesia includes some very finely made cloths, almost all of them exported from the Coromandel Coast. These textiles tend to date to a period later than those traded to Sulawesi and eastern Indonesia—no surviving examples predate the seventeenth or early eighteenth century—and show a wider range of colours. At the time, Southern Sumatra had become economically dependent on the pepper trade, which brought great riches.[16] It also had close ties to Java, and many of the Indian textiles that survive from the region show Javanese influence in terms of iconography and form. Most spectacular are the large cloths, made of two lengths sewn together, which were probably worn like the Javanese *dodot*, a wide waist wrapper used by aristocratic court society. Indian versions often feature large diamond or lozenge shapes at their centre. Another, less common, genre features a centre with a sunburst motif—either red or more rarely blue—surrounded by faintly printed flower sprigs (fig. 5.5). More unusual are large dodot-sized cloths with a "patchwork" pattern, that is, small triangular designs drawn or painted with intricate infill, with very few repeats; these cloths provide a dazzling range of the Indian and Javanese designs available, including locally made batik patterns used at court (fig. 5.6). Jackets and coats with similar patchwork-like motifs have also survived. In Java jackets made of stitched, patched pieces of cloth were believed to protect the wearer against harmful influences, but it is not certain that the same applied to their use in Sumatra.

Indian artisans also developed designs to appeal to Europeans who lived in the Dutch East Indies (fig. 5.7). Typically these designs reflected current fashions in Europe, often emulating boldly coloured floral and geometric designs of woven silks that were popular for interior decoration in eighteenth-century Europe. Influences of both so-called French bizarre

ABOVE
FIG. 5.4

Antique imported Indian trade textiles (*maa'*) used to decorate a pig litter at the *mangrara banua* ceremony in the Tondon district, Tana Toraja, July 2009.

Photograph by Roxana Waterson.

PAGE 78, ABOVE
FIG. 5.5

Ceremonial textile, with a large sunburst (*matahari*) design. Western India, for the Sumatra market, eighteenth century. Cotton, hand-drawn, mordant-dyed, block-printed indigo, 194 × 278 cm.

ROM 2015.28.1. This acquisition was made possible with the generous support of the Louise Hawley Stone Charitable Trust.

PAGE 78, BELOW
FIG. 5.6

Ceremonial textile with a "patchwork" design. Coastal southeast India, for Sumatran or Javanese markets, eighteenth century. Cotton, hand-drawn, mordant-dyed, resist-dyed, 214 × 376 cm.

Collection of Banoo and Jeevak Parpia.

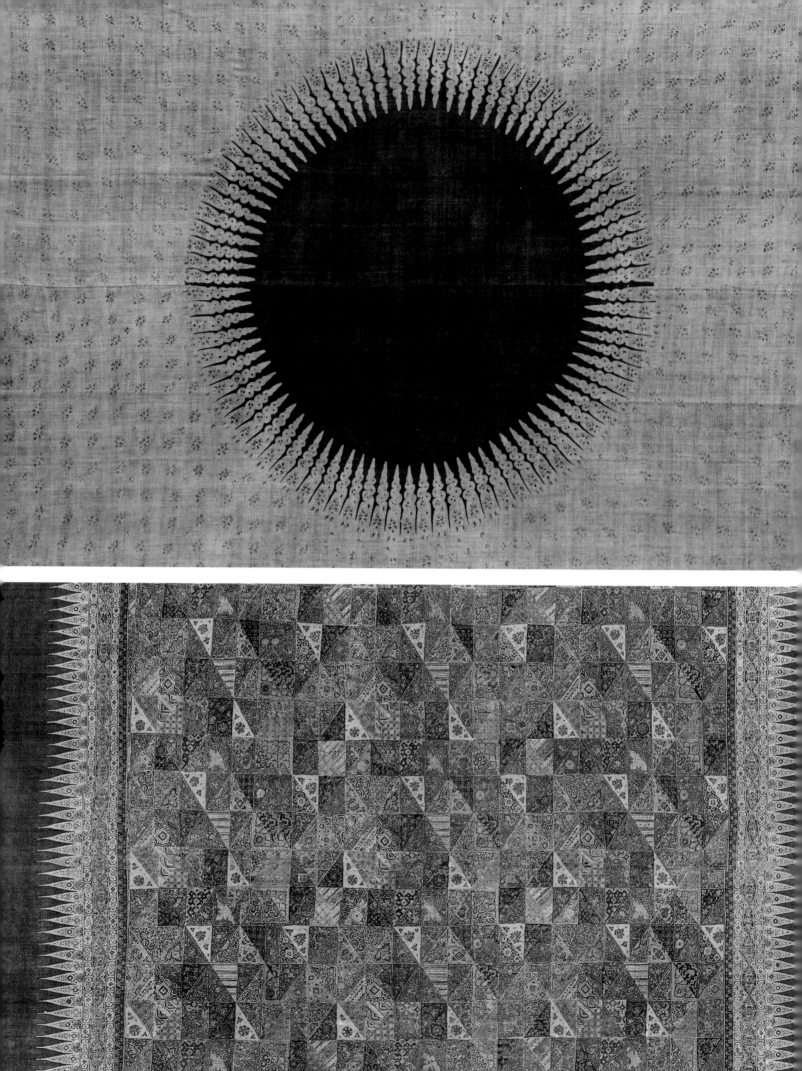

and lace-patterned silks—they themselves originally influenced by Asian design—are readily visible. The Indian chintz version, painted in resist and mordant on cotton, was made on India's southeastern coast and then exported to Sri Lanka, where the Dutch Vereenigde Oostindische Compagnie (VOC; East India Company) had a colony until its demise in 1796. From there the cloths were traded further east to other Dutch settlements in Java, South Sumatra, and southern Borneo. Although originally intended for Europeans settled in South or Southeast Asia, these cloths also found favour among local residents, especially in South Sumatra.[17]

The majority of Indian textiles made for Indonesia feature floral or geometric patterns; however, there are exceptions. Large cloths depicting the major battle scene from the epic poem the *Ramayana*—when Rama defeats the demon king Ravana with the help of the monkey king Hanuman and his army— are commonly found in Bali but also survive in Sulawesi. They were likely made on the southeastern coast or Orissa (fig. 5.9). Another particular type of Indian cloth, depicting large-scale figures, often dancing women, survives in particularly interesting variations. The most accomplished examples are "painted" with mordants and resists, and clearly relate to the manuscript painting style of fifteenth-century Northwest India, although the textiles are far more monumental, showing figures that are half life-size (fig. 5.8). Later versions, printed with large wooden blocks, are repetitive and formulaic, but the resist- and mordant-painted examples are of exceptional quality. They should be appreciated as a major discovery, for they provide unique evidence of a painting style from India of which we are otherwise unaware; it has survived only in the few examples of Indian textiles that were taken to Indonesia.

BELOW, LEFT
FIG. 5.7

Textile length with "lace-patterned" silk design. Coastal southeast India, early eighteenth century. Cotton, hand-drawn, mordant-dyed, 101 × 323 cm.

Although likely made for trade to the resident European community of Sri Lanka or the Dutch East Indies, cloths with these patterns also made their way into Sumatra, where they were preserved as family treasures.

ROM 2008.81.1

BELOW, RIGHT
FIG. 5.8

Ceremonial cloth depicting dancing women. Western India, for the Indonesian market, late fifteenth to mid-sixteenth century. Cotton, hand-drawn, mordant-dyed, resist-dyed, painted indigo, 500 cm × 98 cm.

Opekar/Webster Collection. Textile Museum of Canada, T94.0825

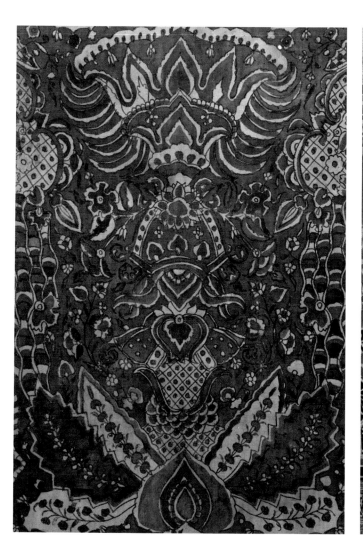

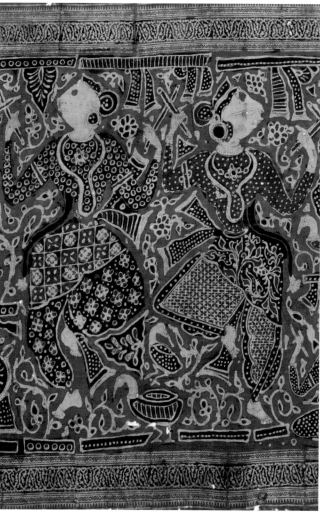

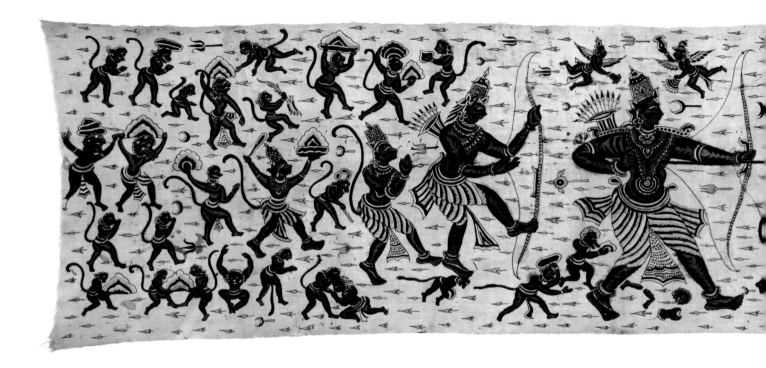

FIG. 5.9

Ceremonial cloth depicting the Hindu epic tale the *Ramayana*. Coastal southeast India or Orissa (Odisha), eighteenth century. Cotton, hand-drawn, mordant-dyed, painted dyes, 105 × 500 cm.

ROM 2016.42.2

Conclusion

What was the particular attraction of Indian cloth for Indonesian societies? Apart from the luxurious appearance of silk and the light yet durable nature of cotton, it was certainly the quality of the dyes used in decorating the fabrics. The brilliance and colourfastness of the designs were unrivalled at the time and remained so until well into the nineteenth century. Their trade was initially in the hands of Arab and Indian merchants but eventually came to be dominated by the European trading companies. The Portuguese and later Dutch, English, and French arrivals in Asia were driven by economic factors and their desire to gain control of certain market products of South and Southeast Asia. The spices and aromatics of India and maritime Southeast Asia represented a source for huge wealth. Yet merchants of all nations found themselves beholden to the Indonesians' desire for Indian cloth. They quickly realized the need to access and preferably to monopolize Indian textiles, as these fabrics formed a major currency in the exchange for eastern Indonesian cloves, nutmeg, and sandalwood, as well as pepper from Sumatra.

The textiles were an essential commodity in the economy of maritime trade, in high demand across the archipelago, with all those connected—even if in an indirect way—to the wider trade network of the Indian Ocean. Yet, if many textiles have survived for hundreds of years until now, it was due to the deep, local cultural meanings that Indonesians subsequently conferred on these foreign cloths. Against all the vagaries of time and weather, families and clans carefully protected them, either as personal belongings of high social prestige or as lineage-owned heirlooms, to be viewed and exhibited only on special occasions; the indigenous cloths influenced by them may similarly have a ceremonial function, specifically as bridewealth and funerary cloth. Textiles have been—and still are—a major transmitter of design and technology, and they tend to convey considerable social meaning. Of course, they share that role with other manufactured goods that have historically moved between societies, both as prestige items and as utilitarian objects. Few products, though, can claim the same convenient portability; while considered fragile in the long term, textiles are initially far more durable and easier to transport than, for example, glass and ceramics. They were, therefore, primary sources of cross-cultural influences.

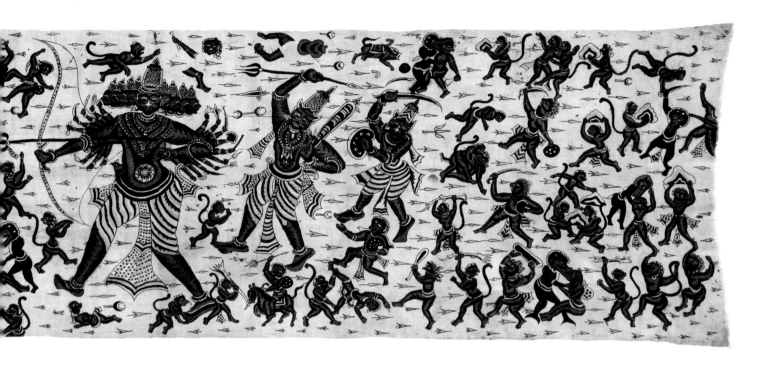

1 Barnes, *Ikat Textiles*, 127.

2 Battuta, *Travels in Asia*, 273.

3 Barbosa, *Book of Duarte Barbosa*; Pires,"*Suma oriental.*"

4 Both linguistic and technological evidence indicate the early presence of weaving in Southeast Asia. Otto Dempwolff (*Austronesisches wörterverzeichnis*, 135) has Austronesian **tenun* "weave." This was refined by Robert Blust to refer specifically to loom weaving, rather than to the wider category including, e.g., basketry; he argues, "The conclusion seems inescapable that the loom was known to speakers of a language ancestral to at least Malay, the Batak languages and various languages of northern Luzon. A minimum time depth of 4,000 years would seem to be implied" (Blust, "Austronesian Culture History," 34). This linguistic interpretation is confirmed by the backstrap loom technology shared by the Aborigines of Taiwan, who are Austronesian, and by peoples of Indonesia whose ancestors left Taiwan close to 3,500 years ago.

5 Bühler, "Patola Influences"; Bühler and Fischer, *Patola of Gujarat*.

6 Christie, "Texts and Textiles," 183.

7 See Van Dijk and De Jonge, "Bastas in Babar," plate 18.

8 Barnes, *Indian Block-Printed Textiles*, 1:39.

9 See Bulbeck and Caldwell, *Land of Iron*. The Bugis are an ethnic and linguistic population based in coastal southern Sulawesi; they have had wide-ranging seafaring contacts historically and to the present day.

10 Andaya, *World of Maluku*, 66, 106–7.

11 For eastern Indonesia, see, e.g., Barnes, *Ikat Textiles*; Hamilton, *Gift*.

12 See Van Dijk and De Jonge, "Bastas in Babar," 18–33, plates 18 and 20.

13 Barnes, *Ikat Textiles*, 82–87.

14 Nooy-Palm, *Sa'dan Toraja*, 220.

15 Barnes, "Indian Textiles," 107–10.

16 Andaya, "Cloth Trade," 38–42.

17 Andaya, "Cloth Trade," 35.

6
─

THE SPECIALIZED MARKETS OF SOUTH AND SOUTHEAST ASIA

THAILAND AND SRI LANKA

STEVEN J. COHEN

The Thai Market

THE THAI COURT'S GREAT LOVE FOR FINE IMPORTED TEXTILES, combined with the nation's strategic position on Indian Ocean trade routes, made Thailand from early times a steady—and discerning— consumer of very high-quality Indian chintz. While the vast majority of the rural population was restricted by sumptuary laws to wearing locally woven garments,[1] Thai nobles were immediately distinguished by their conspicuous display of imported cloths; these fabrics were often lavishly embellished through either the block-printing processes typical of western India or the even more costly hand-painted chintz techniques

Detail: Thai military shirt or tunic (*su'a senakut*) (p. 86).

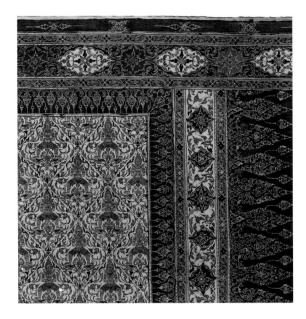

of India's southeastern coast. From the medieval period at least, Arabs, Iranians, and primarily Indian Muslim traders brought these cloths from India to trade with most of the coastal communities ranged along the Bay of Bengal, through the straits of Malacca, and further east with the communities settled on both sides of the South China Sea; they even travelled as far east as the Spice Islands of Indonesia or north to southern coastal China, the Ryukyu Islands, and Japan. The Thai Kingdom was ideally located along this trading route for transshipping, and for those wishing to avoid the sometimes dangerous passage between Sumatra and the Malay Peninsula at Malacca, an alternative overland route was available at the Thai-controlled ports of Mergui and Tenasserim; this route crossed the narrow peninsula to the Gulf of Thailand, from where access to Ayutthaya, by land or water, was relatively easy. When the first European traders arrived at the Thai capital of Ayutthaya in the early years of the sixteenth century, they too quickly discovered the significant cultural and economic role of Indian textiles at the upper levels of Thai society and were obliged to accommodate their very particular tastes in such cottons.

To acquire these highly desired, exotic Indian textiles, the Thais procured a remarkable range of local goods, which hardly changed over the centuries: rice, elephants, and tin were the most important, but also "sappanwood, eaglewood, benzoin, gumlac, deer-hide, elephant teeth and rhinoceros horns," as well as timber, coconut oil, indigo, gold, and both Chinese and Japanese goods (the latter two categories were brought to Thailand on Chinese ships as part of a separate system of eastern trade).[2] The actual profits that foreign merchants could make by selling Indian cloths in Thailand were low, and the costs of most of the goods that Thais exchanged in return were relatively high; the latter formed part of a royal monopoly, the single greatest source of cash for the kingdom, and their prices were thus artificially fixed by the feudal Thai government.[3] Under those apparently unfavourable conditions, why were foreign merchants from Asia willing to accept this unequal arrangement, and why were the merchants of the European trading companies so eager to join in the trade in the seventeenth century? The answer is not difficult to discover.

All those intending to do business in Thailand, including Europeans from the fifteenth century onward, soon discovered that there were far greater profits to be made on the resale of goods from Thailand than on the sale of Indian cloth. Foreign merchants transshipped the elephants to Indian rulers and the deer hides to Japan where they could be exchanged for silver, which was worth more in Europe than in Asia. The Chinese were primarily interested in Thailand's aromatic and medicinal gums, woods, and animal parts, which they exchanged for silk and porcelain; European traders preferred to acquire Chinese porcelain and silk in Ayutthaya rather than having to travel to and from China themselves. And even when there was little or no profit to be earned, the Dutch were happy to exchange Indian cloth for the Thai rice and coconut oil required by their dependants at the Dutch Vereenigde Oostindische Compagnie (VOC; East India Company) headquarters in Batavia on Java. Thailand was, in a word, a great emporium for acquiring high-value goods that could eventually be sold elsewhere at great profit. There was, however, a catch: in order to gain access to all of these coveted Thai goods, foreign merchants had to supply exactly the right Indian textiles.

Perhaps the most consistent message of this catalogue is the remarkable range in shapes, colour, design and subtle specifications of the various world markets (with the exception of Sri Lanka), and the genius of Indian textile artists in responding to each one. The Thai rulers and their nobles were possibly the most fastidious of those consumers, since "Thai-market chintzes" are among the most easily recognized. There are colour combinations characteristic of the group: darker browns, blacks, wine reds, and dark violets,

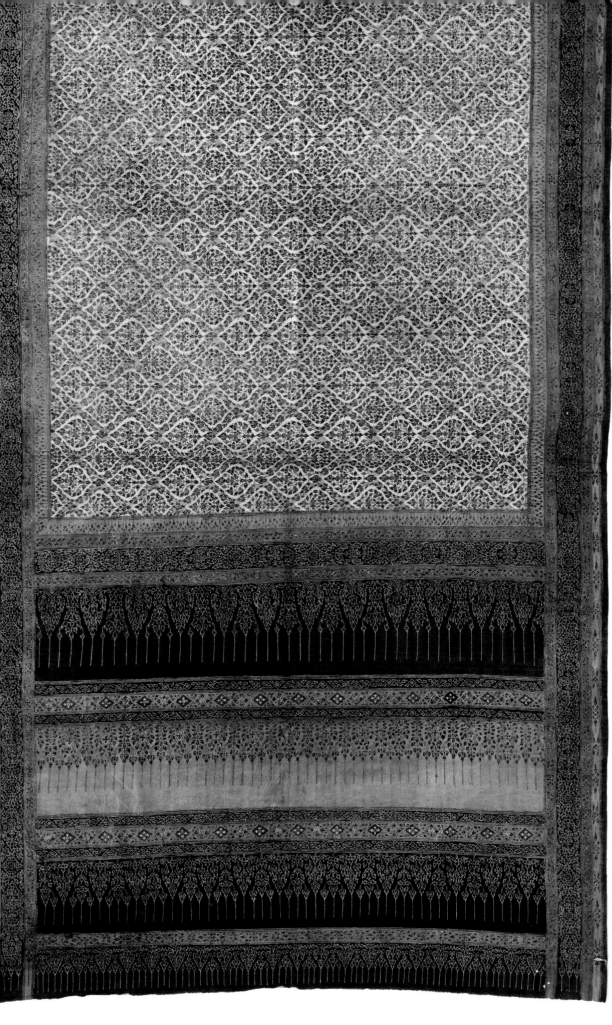

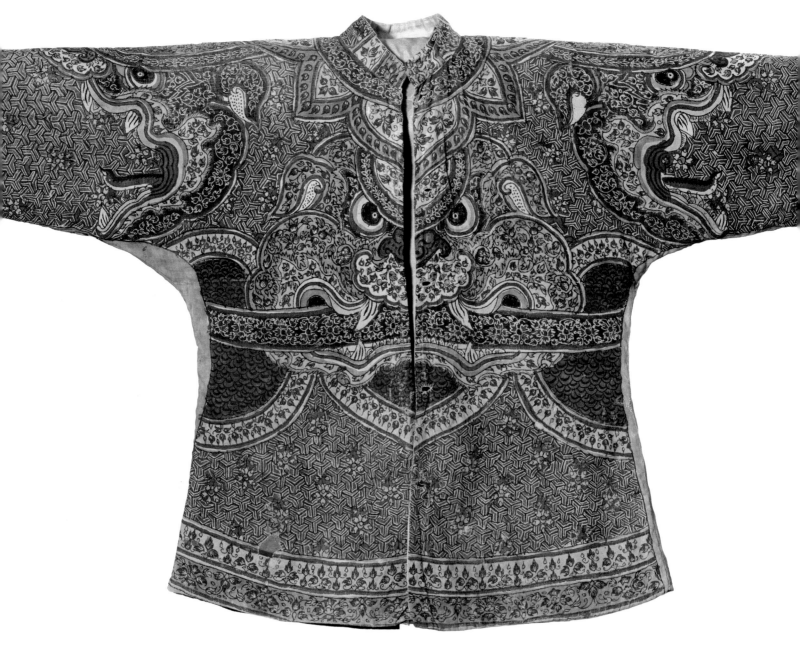

FIG. 6.3

Man's military shirt or tunic (*su'a senakut*); assembled from a single piece of cloth, with the collar cut from the front opening and separately attached, lined with plain cotton. Coastal southeast India, for the Thai market, ca. late eighteenth century. Cotton, hand-drawn resists, painted mordants, dyes, 154.5 (maximum width) × 72 cm (front), 70 cm (back).

Although surviving examples are extremely rare, these royal military garments are depicted in Thai paintings and have been reported by foreign observers.

ROM 983.155.1

as well as pale turquoises and greens that one rarely encounters as dominant colours on the chintz and block prints made for other markets. And these chintz contain figural designs of deities and semidivine beings: Indra, Erawan, Brahma and Garuda, flying *apsaras* (celestial nymphs), serpents, and monster masks (fig. 6.1). In addition, these fabrics destined for Thailand follow distinctive decorative conventions, most noticeably the extensive use of fine white-resisted lines, flaming motifs, and floral lattices less frequently encountered on the cloths made for other markets. Until the nineteenth century, the vast majority of the rural population wore plain white upper and lower unstitched garments woven from local cotton or silk, but what was demanded from the foreign traders were the brightly coloured cloths specifically designed for Thailand's elite nobles.

Collectively, Indian cloths were known in Thailand as *phaa lai*, further differentiated into *phaa lai tet* if their designs were considered foreign, *phaa lai yang* if Thai inspired, and *phaa lai khain thong* when gold was stamped or painted over the decorated surface, as seen on the splendid example in figure 6.2.[4] And, of course, the Thai drew many more subtle sartorial distinctions to further describe the great variety of garments made of unstitched rectangular loom widths of cloth (of approximately 2.5 to 3.5 by 1 m) that could be wrapped around the waist. The designated terms for these garments depended on the gender of the wearer, whether used as an upper or lower garment, or how it was tied. A lower wrapped garment, whether worn by a man or woman, was called a *panung/phaa nung*, but when it passed around the waist and between the thighs to be tied like an Indian dhoti, it was known as a *chong kraben*. When a woman wore such a cloth with pleated folds in the front, it became a *phaa naa nang*, and the upper cloth was usually known as a *sabai*.[5] A few rare chintz garments were tailored. An unusual survivor is a specially designed soldier's shirt (*su'a senakut*)[6] drawn to form with monsters' heads on the front and sleeves, and what might be representations of chainmail (fig. 6.3). In addition to clothing, the same distinctive Thai-market characteristics are to be found on larger furnishing fabrics, including those textiles designed as two cloths joined vertically to be used as floor coverings or wall hangings (*phaa kiao*; fig. 6.4), room dividers, and altar cloths.

FIG. 6.4

Hanging (*phaa kaio*). Coastal southeast India, for the Thai market, ca. early nineteenth century. Cotton, hand-drawn mordants and resists, dyes, 419 × 196.8 cm (two full loom widths, approximately 98.3 and 99 cm wide, sewn together along their selvedges).

These double width textiles were purpose-made from two joined cloths and were intended to be hung on the walls of Thai temples and palaces.

ROM 2012.17.1. This acquisition was made possible with the generous support of the Louise Hawley Stone Charitable Trust.

It is sometimes stated that the Thai kings owned "factories" on India's Coromandel Coast, at Golconda, at Surat, and in Iran,[7] but this is inaccurate. The king and high officials were investors and owned ships involved in the trade between Ayutthaya and India; orders were placed with Indian weavers and dyers for the goods required to fill those ships. However, few, if any, Thais were involved in sailing those ships, placing orders, or running Indian workshops; all of the actual business was in the hands of agents known as *factors*, who worked directly or indirectly for the Thais. It must also be understood that Indian textiles for the Thai market never made up more than a very small proportion of the total Indian textile trade. There is consensus that throughout the seventeenth century, the maximum number of Indian cloths of all varieties (of which only half were block printed or hand painted) required annually in Thailand for local consumption was around fifteen thousand pieces.[8] That may sound like a great many textiles, but compared to export numbers for most other markets, that number is relatively small. And yet, so important was Indian chintz in Thailand that several attempts were made to imitate it. During the nineteenth century, changing royal fashions saw the end of court patronage for the highest-quality hand-drawn Indian chintz from the Coromandel Coast. At the same time, relaxed sumptuary laws created new consumer demand from the majority of the population for India's coloured cottons. Printers in Gujarat developed a new product for this market: inexpensive, small wrappers hastily printed in two or three colours with floral and geometric motifs and a distinctive *tumpal* (repeating elongated triangular pattern) border, known simply as *saudagiri* (trade cloth) or *pha surat* or *pha gujarat* (cloth from Surat/Gujarat) among other names in Thailand.[9] After World War II, however, the *saudagiri* trade expired and, along with it, India's ancient tradition of hand decorating cotton cloth for the Thai market.

The Sri Lankan (Ceylon) Market

Coming to the attention of art historians from circa 2000, the study of Indian textiles made for the Sri Lankan market has only just begun.[10] Evidence can be drawn from the actual textiles collected in Sri Lanka over the past two or three decades, with a small number in private and public collections, supplemented by European records from 1505. Several aspects of the textile trade between India and Thailand are common to those for Sri Lanka, but there exist as well dramatic differences. Like the Thai, the majority of Sri Lankans were also rice farmers, but unlike them, they were never self-sufficient in either rice or the cotton needed to clothe the whole population. Historically, Sri Lanka had thus always depended upon imports of cloth and rice from India. In exchange, again like the Thais, Sri Lankans traded elephants, ivory, gemstones, cinnamon, areca nuts, and black pepper, as well as the red dye *chay* (*Oldenlandia umbellata*). And similarly, long before the first European traders arrived in Sri Lanka, much of the textile trade had been in the hands of the Chulia community,[11] Tamil-speaking Muslim merchants from the southern end of India's southeastern coastal band. These same Chulias dominated the transport of chintz from coastal southeast India to Ayutthaya prior to the arrival of the European trading companies. Also, both the Thai kings and the Dutch in Sri Lanka attempted, but failed, to establish local chintz production in Ayutthaya in the 1690s and in Jaffna, northern Sri Lanka, in the 1660s by settling weavers and dyers from the Coromandel Coast.[12]

But where these two traditions diverge most emphatically is in the designs and colouring of the cloths sent from India to Thailand and of those found in Sri Lanka. It seems that the Sri Lankans, unlike the Thai nobility, were unique in their acceptance of any block-printed or hand-painted Indian cotton cloths. The several hundred eighteenth-, nineteenth-, and even twentieth-century textiles that have come to light in Sri Lanka reveal a remarkable variety: Coromandel Coast hand-painted chintz; Gujarati and South Indian block-printed cloths; and even European roller-printed cotton cloths, which had remained in Sri Lanka

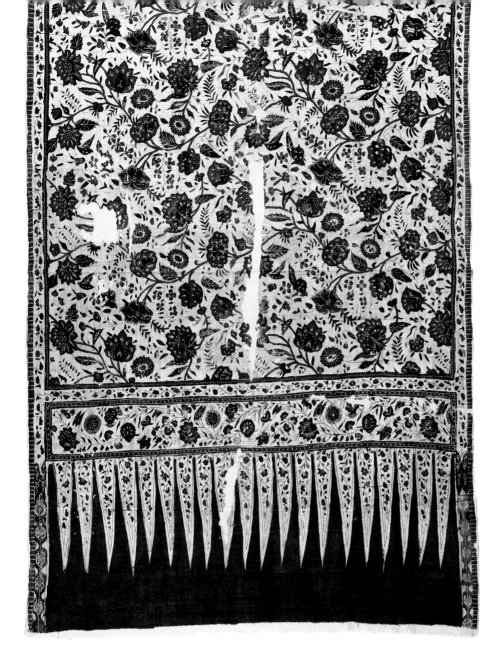

FIG. 6.5

Lower wrapped garment
(*somana tuppotiya*). Coastal
southeast India, for the Sri
Lankan market, ca. eighteenth
century. Cotton, hand-drawn
resists and mordants, dyes,
325 × 103 cm.

Collection of Banoo and
Jeevak Parpia.

in the late twentieth century. Most of these Indian export cottons closely resemble those
that scholars would otherwise label made for the European, the Thai, Malay, Sumatran, and
Javanese markets, yet they were all used by Sri Lankans. Thus, it remains difficult to define
the characteristics of a specific "Sri Lankan market" Indian textile.

Earlier Indian textiles must have been made specifically for the Sri Lankan island, but we
have no idea what they looked like. It is only from the eighteenth and nineteenth centuries
that we have evidence suggesting that Indian textiles were designed with features that
we now associate with Sri Lanka; even those are rarely entirely unique but are more often
unconventional combinations of designs, motifs, or colours associated with Indian textiles
designed for other markets. For example, what we presume to be the earliest surviving Sri
Lankan lower wrapped garments (*tuppotiya*) are cotton cloths slightly larger than 3.5 by
1 metre, decorated in the chintz technique with white central fields displaying repeating
blocks of European-market flowering plants. Their red-ground end panels each display a
row of elongated triangles, known as *tumpals* when made for the Malay/Indonesian market,
but unlike most Indonesian-market *tapis* (skirt cloth) or Thai *phaa nung*, these tumpals
are filled with European-market floral designs (fig. 6.5).[13] Another example is composed of
a handful of top-quality hangings or bed covers displaying the classic eighteenth-century
European-market chintz design: a flowering tree rising from a rocky mound. But unlike those
found in Europe, whether by design or coincidence, those discovered in Sri Lanka (and one in

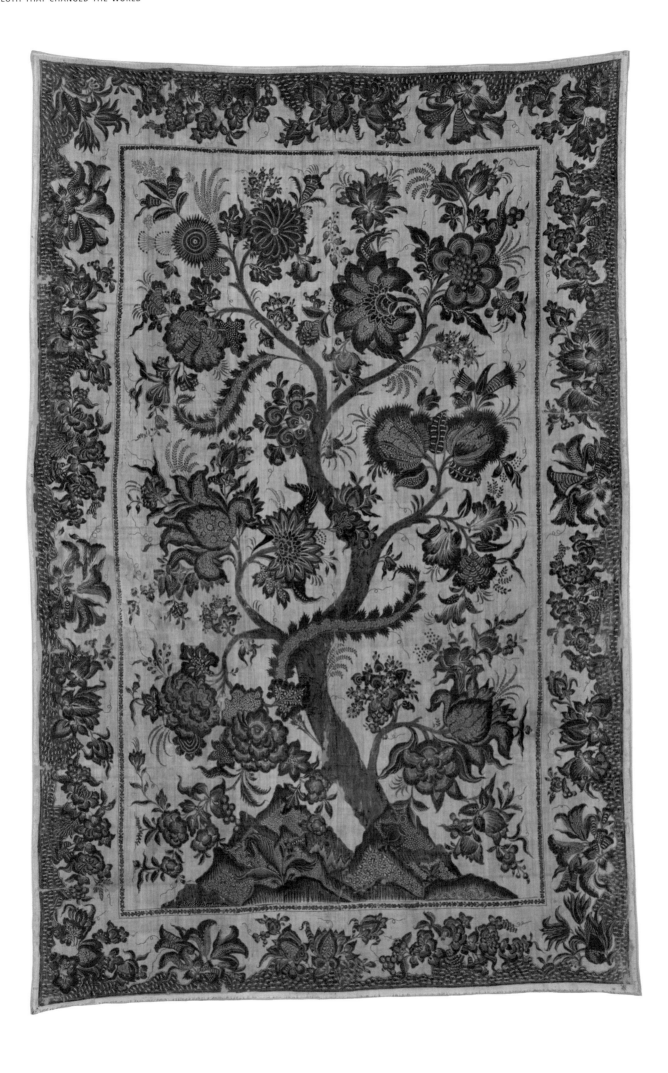

OPPOSITE
FIG. 6.6

Hanging. Coastal southeast India, ca. eighteenth century. Cotton, hand-drawn resists and mordants, dyes, 180 × 119 cm.

Identical to European-market hangings, smaller examples such as this seem to have been made for the Sri Lankan market where it was found.

Collection of Banoo and Jeevak Parpia.

LEFT
FIG. 6.7

Lower wrapped garment (*somana tuppotiya*). Coastal southeast India, for the Sri Lankan market, ca. nineteenth century. Cotton, block-printed and hand-drawn resists and mordants, dyes, 328.5 × 118.4 cm.

These colour combinations, specific motifs, and multiple borders are typical of the lower garments made in southeastern India for the nineteenth-century Sri Lankan market.

Collection of Banoo and Jeevak Parpia.

Indonesia) are all noticeably smaller (fig. 6.6). By far the most common nineteenth-century *somana tuppotiyas* (Indian hand-drawn or block-printed lower garments) display variations of floral-filled lattices or rows of flowering plants on red or pink central fields, enclosed by long red or pink ends consisting of single or multiple rows of tumpals. Most of the flowers displayed on these late somana tuppotiya are almost Victorian in their elaboration, while others seem to have been designed for the Thai or Indonesian market. The colouring of these cloths is dominated by multiple shades of pink and red, which does seem particular to nineteenth-century Sri Lankan–market Indian textiles. Far less common are similarly designed somana tuppotiya with white, blue, or green grounds (fig. 6.7).

While we still know very little about the textiles exported from India to Sri Lanka, surviving examples certainly reveal wide-ranging tastes, probably the most eclectic of all of India's historic export markets.

1 Posrithong, *Chintz in Thai History*, 333–34; Guy, "Indian Textiles," 92. "The restrictions on using Indian textiles by the common people was lifted after European fashion became more popular in the Thai royal court." Posrithong, 339.

2 Posrithong, 334–35; Smith, *Dutch*, 74, 85 (quotation).

3 Kasetsiri, "Origins of a Capital," 77.

4 Posrithong, *Chintz in Thai History*, 337.

5 Gittenger and Lefferts, *Textiles*, 147–48, 257–58; Posrithong, "Indian Trade Textiles," 297–302.

6 Guy, *Woven Cargoes*, 138–46.

7 Caron and Schouten, *True Description*, 148; Posrithong, *Chintz in Thai History*, 296; Smith, *Dutch*, 91.

8 Posrithong, *Chintz in Thai History*, 333; Gittenger and Lefferts, *Textiles*, 158–60.

9 Guy, *Woven Cargoes*, 150–51; Posrithong, *Chintz in Thai History*, 339–47.

10 Coomeraswamy, *Mediaeval Sinhalese Art*; Cohen, "Unusual Textile Trade"; Hartkamp-Jonxis, *Sits*.

11 Andaya, "Ayutthaya," 133–35.

12 Smith, *Dutch*, 105; Cohen, "Unusual Textile Trade," 57–58.

13 Guy and Thakar, *Indian Cotton Textiles*, 86–87, no. 27 is very similar to the example in the Parpia Collection, Ithaca, New York.

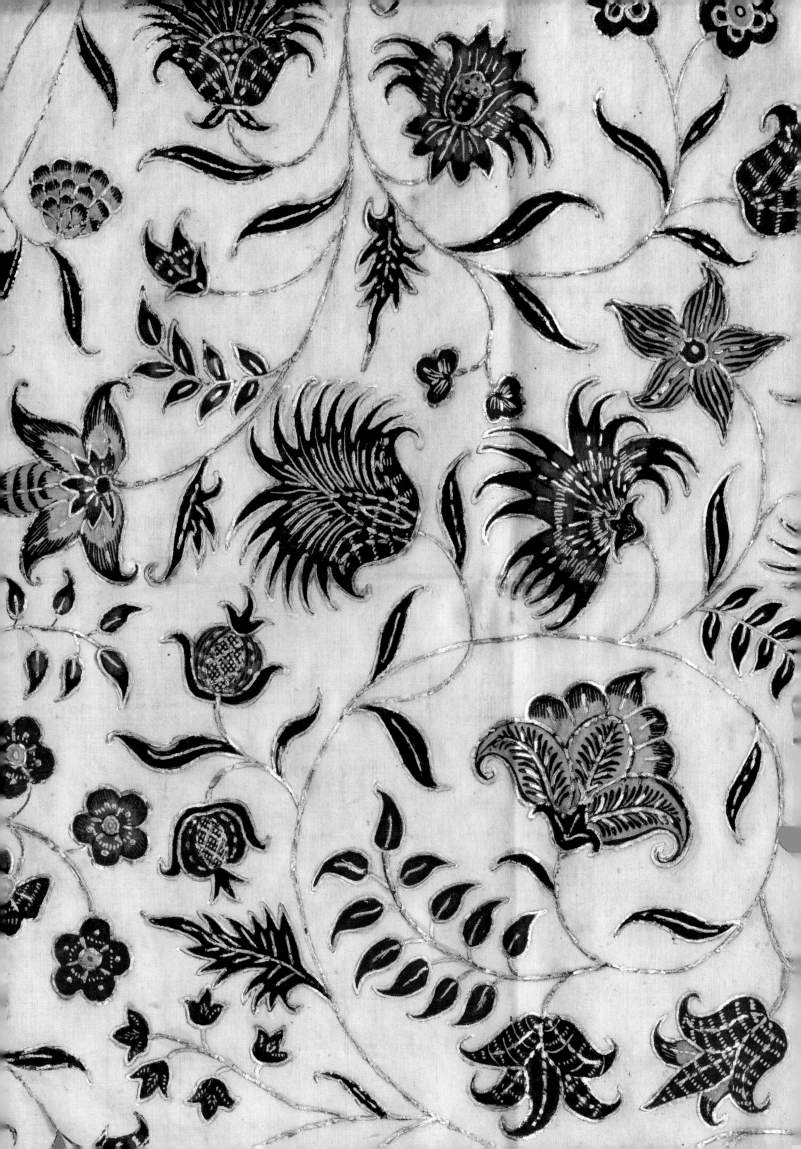

7

SARASA IN JAPAN

HYBRIDITY AND GLOBALIZED DYED COTTON

PETER LEE

HOW WORDS CIRCULATE AND CHANGE MEANING REVEALS A great deal about cultural exchange. In Japan, the term *sarasa* (さらさ or 更紗), like chintz in English, originally referred to mordant- and resist-dyed cottons, but at present its meaning has broadened to encompass any flowery printed pattern on any textile, or indeed on other materials. The origins of the word *sarasa* are uncertain; it has multiple meanings in several South Asian languages but was not associated with textiles in any of those languages.[1] However, the term has long been used in Malay to describe a particular kind of Indian cloth; a reference to "a piece of sarasa" in the *Hikayat Muhammad Hanafiyyah*, a late fourteenth-century Malay text, is one of the earliest attestations of this word.[2] Colonial trade records in Portuguese, Dutch, and English frequently use the term; one of the first Dutch occurences is found in a 1603 glossary of trade textile terms.[3]

Detail: Tea ceremony cloth (p. 96, fig. 7.4).

FIG. 7.1

Borders or *hyōgu* (表具) on scroll paintings, with a lattice *unyade* (ウンヤ手) pattern. Coastal southeast India, probably for the Indonesian market, eighteenth century. Cotton, hand-drawn, mordant-dyed, resist-dyed, 75.5 × 13 cm.

Sarasa with this pattern were made for the Indonesian market, but were much appreciated and collected in Japan.

ROM 961.232.22.B.

In 1613, English merchants obtained permission from the Tokugawa Shogunate to trade in Japan and to establish a factory in the port of Hirado, near Nagasaki. Their cargo included about six thousand pieces of Indian cloth.[4] One of the merchants, Richard Wickham, noted the following year that local traders "buy those comodytys that are most rare & at the time when they are most dearest. . . . So likewise doe they enquire after all sortes of new stuf fantastically paynted or striped, such as are not usually brought heather."[5] The Dutch were equally involved in the textile trade to Japan in this period, and references to *sarassa* and *taffachela* (striped cloth) reinforce Wickham's observation about Japanese demand.[6]

The mechanics of how Indian Ocean trade terms entered the Japanese language is revealed in a receipt issued in October 1615 by Kidera Sanemon, a servant of Hirado's daimyo (feudal lord), to Richard Cocks, another English merchant.[7] The receipt mentions three Indian textiles: *kanakin* (かなきん), *sarasa* (さらさ), and *shima-momen* (島もめん). The first two are transliterations of the trade terms cannekin (white, black, or blue cotton) and sarasa, while the last term is Japanese for imported striped cotton cloth (probably *taffachelas*): *shima-momen* literally means "island cotton." *Sarasa* therefore entered the Japanese vocabulary as a transliteration of a trade term. Its growing currency is revealed by its appearance in an anthology of poems, the *Enokoshū* (犬子集) of 1633, where autumnal foliage is likened to sarasa.[8]

New Japanese terms for the varieties of Indian sarasa developed very quickly. In 1615, Cocks reported that there was little demand for the company's stock of Cambay cloths, except for "some spotted or newe-fangled painted peece."[9] Etsuko Iwanaga has explained that the cloths with spotted patterns were called *salpicados* (salt splash [Portuguese]) in Dutch inventories and *shimofuri sarasa* (霜降更紗; frost-covered sarasa) in Japanese sources.[10] A letter written in 1663 by the wealthy heiress Cornelia van Nijenroode in Batavia to the family of her Japanese mother in Hirado lists several gifts of sarasa, including a piece of *shimofuri sarasa* for her mother and stepfather, attesting to the popularity of this textile and the expanding Japanese taxonomy of Indian cloths.[11]

John Guy provides the most comprehensive exposition in English of Indian chintz in Japan, which encompasses its use in Christian liturgy, in garments for the samurai, merchant classes, and Noh theatre, and the display of Indian and other exotic textiles in the annual Gion Festival in Kyoto.[12] He also refers to the connoisseurship of sarasa expressed in its classification as a *meibutsugire* (名物裂; fabrics for famed objects) and in the publication of books devoted to sarasa. In the sixteenth century, the connoisseurship of "famed objects" (*meibutsu*) and their associated fabrics was closely associated with the tea ceremony, or *chanoyu* (茶の湯). The famed tea master Sen no Rikkyu (1522–91) used Chinese treasures (*karamono* 唐物) such as Song dynasty ceramics and Song and Yuan dynasty textiles. Fine silks from India and Iran were also used for this purpose.

In the seventeenth century, sarasa swiftly joined the rarefied ranks of the *meibutsugire*, due mainly to the influence of the daimyo and tea master Kobori Enshū (1579–1647), who established many ceremonial innovations. Sarasa was used for the pouches protecting tea utensils (*shifuku* 仕覆), as storage-box wrappers (*tsutsumigire*包裂), as ceremonial cloths (*fukusa* 帛紗), and even to mount scroll paintings and hand scrolls as borders (*hyōgu* 表具, fig. 7.1). Kobori's surviving sarasas signal the entry of this textile into the realm of *meibutsugire*.[13] Several daimyo families began assembling collections of sarasa fragments

laid on fine paper, with annotations of the Japanese names for the various patterns; this practice further expanded the taxonomy of sarasa. The most prized variety was *kowatari sarasa* (古渡更紗; old imported sarasa). One of the most renowned collections, with 450 fragments of *kowatari sarasa*, belonged to the Ii family from Hikone Castle and is referred to collectively as *Hikone sarasa* (彦根更紗).[14] These collections demonstrate the wide diversity of sarasa that were imported into Japan, including patterns made specifically for the Japanese market, as well as those for the Thai, European, and Indonesian markets. In the eighteenth and nineteenth centuries, compiling albums of sarasa fragments (called *kiretekagami* 裂手鑑; fig. 7.2) became a cultured pastime, and books on the subject were published with comprehensive illustrations of patterns and their names (see ch. 13).

The arrival of Buddhist monks from Fujian province in China in the mid-seventeenth century led to the rise in Edo Japan of the last wave of Zen Buddhism, the Ōbaku sect.[15] One of the outcomes of this movement was a renewed fascination with late Ming culture and the popularity of a new type of tea ceremony based on Chinese-style loose-leaf tea (*sencha* 煎茶) in the Fujian style: the *sencha do* (煎茶道). A completely different connoisseurship developed for this ceremony, although certain aspects from *chanoyu* remained, such as the use of ceremonial cloths, pouches for utensils, and the importance placed on the provenance of the utensils, which differed considerably from those used for the powdered-tea ceremony. The *sencha* objects were either imported from China or made in Japan to reflect the taste of late Ming scholars and monks.[16] Chinese Yixing clay teapots (*chachō* 茶銚) were prized, and understated wares were favoured, such as small, ordinary porcelain teacups (*chawan* 茶碗), humble pewter saucers (*chataku* 茶托), and tea caddies (*chashinko* 茶心壺). From the eighteenth century, rare or famous sarasa fragments were selected by sencha masters and used extensively (fig. 7.3). Sarasa with gold-leaf decoration (*kinsarasa* 金更紗) were especially prized (fig. 7.4), especially if they had belonged to tea masters or daimyo families. The importance of sarasa among tea ceremony connoiseurs into the early twentieth century is evident in auction catalogues where sencha tea wares are illustrated together with their sarasa pouches.[17]

FIG. 7.2

Album of sarasa fragments (*kiretekagami* 裂手鑑) containing Indian chintz, Indonesian batik, and European industrially printed cottons. Textiles from the seventeenth to eighteenth centuries; album assembled in the early twentieth century. 20 × 320 cm (open book).

Collection of Mr. and Mrs. Lee Kip Lee, Singapore.

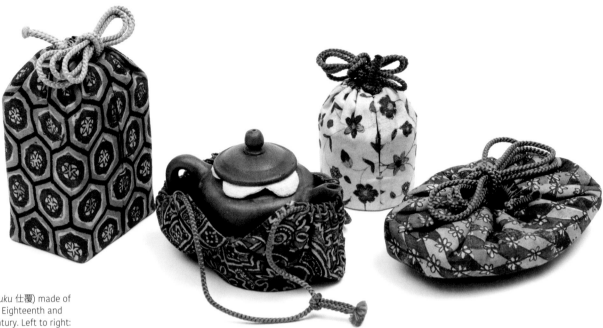

ABOVE
FIG. 7.3

Pouches (*shifuku* 仕覆) made of Indian chintz. Eighteenth and nineteeth century. Left to right: pouch for a Chinese pewter tea caddy with a tortoiseshell *kikkōde* (亀甲手) pattern, made specifically for the Japanese market (H. 6.5 cm); pouch for a Chinese clay Yixing teapot*, with a *gōtenjō* (格天井), "ceiling-grid" pattern, probably for the Indonesian market (H. 6.5 cm); pouch for a Chinese pewter tea caddy, with a floral scroll *sasatsurude* (笹蔓手), gold-leaf decorated sarasa or *kin sarasa* (金更紗; H. 10 cm); pouch for a set of five Chinese pewter saucers*, with lozenge-shaped grid *hanabishide* (花菱手) pattern, made specifically for the Japanese market (W. 12.5 cm).

*Formerly belonging to the artist and sencha tea master Yamamoto Chikuun.

Collection of Mr. and Mrs. Lee Kip Lee, Singapore.

BELOW
FIG. 7.4

Tea ceremony cloth (*fukusa* 帛紗) of a floral scroll design *sasatsurude* (笹蔓手). Southeastern India, 1700–50. Cotton, drawn mordants and resists, dyed, gold leaf (kin *sarasa* 金更紗), 29 × 27.2 cm.

The wooden frame and gilded lacquer box probably date to the early twentieth century. The box inscription records that the cloth belonged to the Ikeda clan, many branches of which were daimyo families during the Edo period.

ROM 2016.42.4. This acquisition was made possible with the generous support of the Louise Hawley Stone Charitable Trust.

From the eighteenth century, European industrially, printed cottons and, later on, batik from Java were imported through Nagasaki, and both textile types were also classified as sarasa, often as European sarasa (エロパ更紗) or Javanese sarasa (ジャワ更紗). Together with Indian sarasa (インド更紗), they not only were used in the sencha tea ceremony, but also found favour among the merchant classes as clothing and accessories: for inner kimonos, purses, tobacco pouches, and bags, among other things. Domestic production of sarasa (*wa-sarasa* 和更紗) also developed in Nagasaki and in Sakai near Osaka, although

these fabrics were preferred for use as quilt covers, wrappers, and other more utilitarian purposes.[18] Japanese artisans also became adept at imitating Indian sarasa by painting designs on authentic Indian cotton, to fulfill the insatiable demand for this textile. The development of this shared terminology in the nineteenth century for different textile types led to a broader academic approach to sarasa as a network of Indian chintz, Indonesian batik, European printed cotton, and Japanese stencil-dyed cottons. This perspective, well entrenched in Japan at least since the middle of the twentieth century, creates a common genealogy of diverse textiles originating from India's painted and printed cottons, and invites further investigations not only into its multidirectional and transcultural dynamics but also into its hybrid outcomes.[19]

1 Ruurdje Laarhoven suggests that the Japanese term *sarasa* (n.b. It was an Indian-trade-textile term before it became a Japanese term), for Indian textiles, is derived from the Hindi *sarasa* (superior). Laarhoven, "Power of Cloth," 57, app. A.

2 "Sehelai serasah." Brakel, *Hikayat Muhammad Hanafiyyah*, 1.20.46. The *Sejarah Melayu* (Malay Annals, composed in the 1650s) recounts how Sultan Mahmud of Malacca had desired to order from India forty pieces of *kain serasah* (*sarasa* cloth) with flowery patterns and had sent an emissary to acquire them. Samad Ahmad, *Sejarah Melayu*, 204, line 22. The term is also found in Javanese manuscripts from the sixteenth to nineteenth centuries. Rouffaer and Juynboll, *De batikkunst*, 484.

3 A Dutch glossary written in 1603 describes the *tapi sarassi* as a garment "that has been painted with foliage and birds" (syn cleetgens die geshildert zyn met loofwerc ook met gevogelte), and the *sarassa gobaer* as "also done in colours completely, but are actually 3 vadem long by 2 pieces, each 1–1/3 vadem long" (Stalpaert van der Wiele, *Informatie*; syn oock van couleur gedaente alleuleens [sic] maer syn 3 vadem lanck te weten se syn aen twee stucken elcq van 1–1/3). This undated manuscript by Stalpaert van der Wiele in the Rijksarchief from the beginning of November 1603, is transcribed in Rouffaer and Juynboll, *De batikkunst*, xii, app. 3. In 1626, gifts presented by the Dutch Vereenigde Oostindische Compagnie (VOC; East India Company) to the king of Bantam included ten pieces of *tape serasse* and two *sarasse gobar* (Heeres, *Dagh-Register*, 265; 10 stucx tape serasse, 2 sarasse gobar). Sarasa cloth was also traded to other regions, such as Tonkin, where, e.g., the VOC traded "fine textiles as well as sarasas" (Colenbrander, *Dagh-Register* 1636, 71; fijne lijwaten als mede sarassen) in 1636, and the king received "one hundred pieces of beautiful sarasas" (De Hullu, *Dagh-Register*, 113; 100 stucx schoone sarasses) in 1644. Unless otherwise indicated, all translations are my own.

4 Farrington, *English Factory in Japan*, 1:5, 126–28.

5 Farrington, 1:7, 162. In 1617, Wickham further requested from Banten "100 fine serassas of St Thome [Madras]" and reported that some chintz cloths did not sell well, including the last shipment of *tappy serassas*, as they were "somewhat coarse." Farrington, 1:586.

6 E.g., "sarasas and taffachelas for Japan" (Colenbrander, *Dagh-Register* 1637, 88; sarassen ende taffachelas voor Japan) are mentioned in a trade report in the Batavian *Dagh-Register* for 1637.

7 Farrington, *English Factory in Japan*, 1:325, plate 5.

8 Iwanaga, "In the Age," 14.

9 Farrington, *English Factory in Japan*, 1:356.

10 Iwanaga, "Names of Trade Textiles," 26–33. Laarhoven describes it incorrectly as a cotton with a floral pattern but notes that it was sold in Batavia in the seventeenth century but not in the eighteenth century, and that it was also shipped to Japan. Laarhoven, "Power of Cloth," 56, app. A.

11 "*Shimofuri sarasa*, one piece . . . *Shimofuri sarasa* for Cornelia's parents" (霜ふりさらさ一端 . . . 霜ふりさらさ . . . コルネリヤ,ちちはは方へ). Manuscript from a private collection on loan to the Matsura Historical Museum, Hirado, Japan. Blussé, *Strange Company*, 190–91; Lee et al., *Port Cities*, 117.

12 Guy, *Woven Cargoes*, 158–77. Guy describes the garments made with sarasa fragments as *kosode* (小袖); however, they were in fact tailored into inner kimonos referred to as *aigi* (間着) and *shitagi* (下着).

13 Iwanaga, "In the Age," 14; *Ages of Sarasa*, 68–69.

14 Collection of the Tokyo National Museum. Satō et al., *Kowatari sarasa*, 19–98; Iwanaga, *Ages of Sarasa*, 108, 131–39.

15 Wu, *Leaving*.

16 Graham, *Tea of the Sages*.

17 For example, the *Ko Tajika Chikuson Sensei Iaihin Nyusatsu*, the auction catalogue of

the collection of the Nanga school artist Tajika Chikuson (1864–1922), includes images of the sarasa pouches for many tea utensils, indicating the importance attached to them.

18 Kumagai, *Wa Sarasa*.

19 Osumi and Wada, *Kowatari Sarasa*; Osumi, *Printed Cottons of Asia*; Yoshioka and Yoshimoto, *Sekai no Sarasa*.

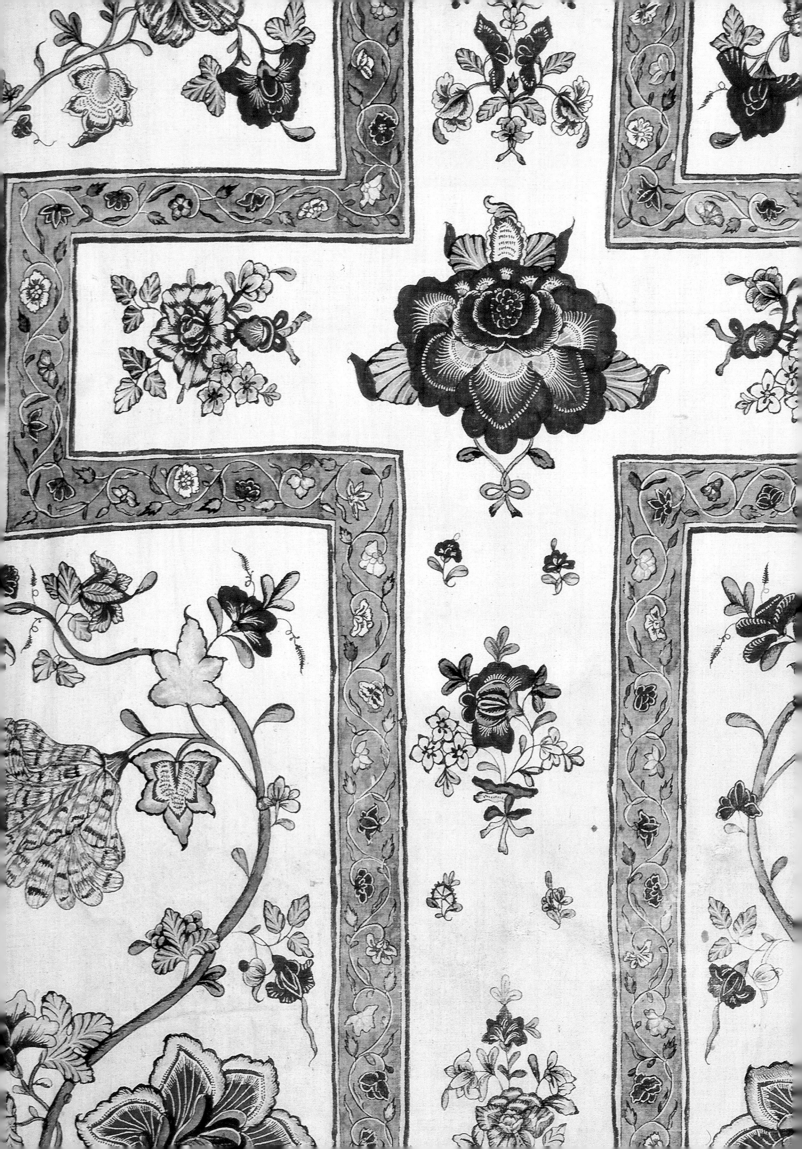

8
—

SPREADING DESIRE, LINKING THE WORLD

PINTADOS AND THE PORTUGUESE (1500–1850)

JOÃO TELES E CUNHA AND MARIA JOÃO FERREIRA

BEGINNING IN 1500, A NEW CHAPTER OPENED FOR INDIAN CHINTZ. For centuries, Europe had received the highly coveted spices—pepper, nutmeg, cinnamon—of Southeast Asia and India via intermediary traders who travelled to the Mameluke sultanate and then crossed the Mediterranean to reach the Italian city states, namely, Venice and Genoa. Bypassing these long traditional routes, in 1498 the Portuguese, led by Vasco da Gama, sailed directly to India around the tip of southern Africa, opening up a direct maritime route to Asia. It quickly became the major channel for Europe to acquire Asia's spices—and its textiles. At the same time, the Portuguese crossed the Atlantic to establish a colony in America: Brazil.

Indian cotton textiles were one of the new Asian commodities introduced by the Portuguese into western markets after they opened these new sea routes. More so than Chinese silks, Indian cottons, with their great diversity in types and qualities, appealed to wide markets and soon became critical in the emerging transatlantic trade; they were

Detail: Eighteenth-century chasuble for the European market (p. 105).

exchanged to acquire captives in Africa, then to clothe both them and their owners in the Americas. Yet Portugal's early and instrumental role in making chintz a truly global fashion, in creating and supplying desire in both hemispheres, is only now becoming apparent through new research and studies.[1]

New Cloth, New Terms

Within a decade of da Gama's return from India in 1499, the word *pintado* (lit., painted) had entered the Portuguese lexicon; the first recorded usage found thus far is the 1507 post mortem inventory of D. Beatriz, mother of King Manuel I (r. 1495–1521).[2] A general term, it was used to reference both painted and printed cottons from India. For a century, this same term *pintado* was employed throughout Europe. It was only replaced by new terms, notably *chintz* from 1600, when the Dutch and then the English displaced the Portuguese as the major European handlers of these goods (on the word *chintz*, see p. xvii). Portuguese also incorporated the term *chintz* from around 1642; a dictionary of 1712 defined it strictly as "a kind of painted cloth from India."[3] More commonly, from 1600 to 1750, Indian fabrics were named for their decoration or places of origin, with hundreds of recorded varieties—a testament to the remarkable range of Indian textile products and artisans, but confounding for researchers today.[4] Those used by the Portuguese in the West African slave trade included names such as *fofolim*, *tafacira*, and *folhinha*; the last, which means "little leaf," likely refers to a printed or painted cotton, and was widely used by António Coelho Guerreiro during his sojourn in Angola in the late 1600s.

Although the same 1712 Portuguese dictionary failed to list *pintado*,[5] the term never entirely disappeared, as witnessed by a Lisbon shop sign board publicizing "fabrics of India white and plain *pintadas*" in the early 1800s, a period characterized by the development of a national printing industry and a craze for chintz.[6]

Commerce and Cloth

Arriving in the Indian Ocean, the Portuguese found themselves dependent on Indian textiles and long-standing trade patterns. From the Swahili Coast of eastern Africa to the eastern reaches of the Spice Islands in present-day Indonesia, local traders would only release their spices, gold, and ivory in exchange for Indian cottons. Just ten years after their arrival in India, as evident in the final receipt of the cloth handled by André Dias as factor of Cochin (1507–9), the Portuguese were already purchasing impressive numbers: 7,984 pieces of plain cloth and 55,094 pieces of pintados, amounts that reveal the size of their involvement in the Indian cotton textile trade at such an early stage of their presence in Asia.[7]

At the beginning of sixteenth century, only a tiny fraction of these fabrics went to Portugal itself through the Carreira da India (Cape Route). Portuguese Crown officials— now stationed throughout the Indian Ocean—purchased Indian textiles in order to transact business in their posts. Beyond demand from the Indian Ocean, and eventually from the home market, pintados, among other Indian textiles, soon became a staple commodity in the newly emerging transatlantic slave trade.[8] Obtaining the correct styles of cloth for all of these markets proved a major challenge. Since no Portuguese fortress in India had a sizable textile production (with the exception of Diu and Daman),[9] the Crown relied, first, on purchasing fabrics brought to its factories and, later, on actively contracting supplies to meet demand.

Given the complexities of these trades, the Portuguese eventually conceded to local knowledge and contractors, mostly Indian merchants, either Bania or Saraswat Brahmins, who monopolized the trade from around 1700 through the 1770s. Though spices had originally

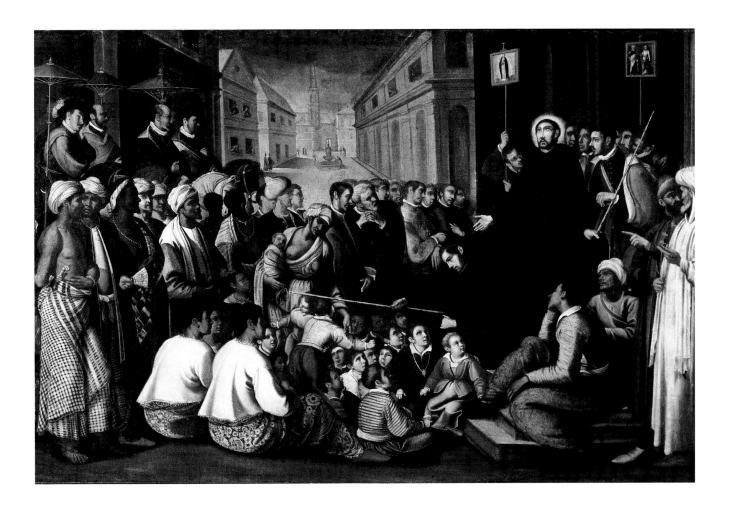

FIG. 8.1

André Reinoso, *St. Francis Xavier preaching in Goa*, ca. 1619. Oil on canvas, 104 × 165 cm.

Note the seated women on the left wearing what are undoubtedly printed or painted Indian cottons. Although working in Lisbon, the artist was known to paint from live models, as well as from Indian fabrics available at the time.

Museu de São Roque/Santa Casa da Misericórdia de Lisboa, Lisbon, inv. 096. Photograph by Júlio Marques.

been the Crown's core business, their profitably diminished from 1560 on, and the number of crossings decreased and then stagnated until the second half of the eighteenth century.[10] For more than a century (1650–1760), the Cape Route thus ran a deficit, which the Crown assumed,[11] trying to revive profits through investment in alternative Indian commodities, including textiles; from 1759 to 1766, for instance, the Crown contracted Indian merchants in Goa to provide fabrics from Surat, Diu, Deccan, Coromandel, and Bengal[12] to sell in the home and the Brazilian markets.

Rather than imperial initiatives, it was Portuguese private trade that drove major innovations in the spread of Indian textiles to Europe and beyond. Prevented from selling spices, a royal monopoly, private traders looked to other commodities, notably textiles and dyes. Already in the sixteenth century, private textile trade outstripped that of the Crown. In 1552, João Brandão estimated the net value of the annual cargo of Indian textiles arriving in Lisbon at 14 million réis per ship.[13] By 1617, this had increased nearly tenfold to 101,668,200,000 réis annually.[14] It is true that textiles amounted only to about 15 percent of a ship's cargo in terms of volume but reached around 92 percent of its total value, together with other goods like diamonds and indigo.[15] In 1739, the Crown seized private capital sent from Lisbon to purchase Indian fabrics amounting to 90 million réis.[16] More than half of this money belonged to Italians (from Genoa and Leghorn) and to French merchants based in Lisbon. The total was probably higher. In 1754, a Portuguese joint-stock company sent 544,959,840,000 réis to buy cotton goods in India.[17] The average private investment in Indian textiles per ship in the mid-1700s attained around 270 million réis; and its value increased with the growth of private shipping after 1770.

The multiple and changing identities of traders over time proved to be a critical factor as well. In addition to private traders, the other most common purchaser of textiles was the Crown official, cleric, or individual living in India who regularly sent "exotic" commodities as presents to family or friends in Portugal. The salvaged cargo of the *Nossa Senhora da Luz* (1615), with more than twenty-six thousand pieces of clothes on board, attests to this.[18] Crew members also partook in this private trade; their "liberties" enabled them to bring Indian commodities on the homebound voyage, which a low estimate in 1552 appraised at twelve million réis per ship.[19] Until 1640, much of the commerce was dominated by the "new Christians," Jews forcibly converted after 1496; with their closely knit global family networks, they were the first great players in trading Indian textiles.[20] They built extensive networks in India to obtain fabrics, investing in other commodities to diversify and reduce their risk, such as indigo in Gujarat and diamonds in the Deccan.[21] In 1607, their shopping itineraries extended to other Indian regions, such as Coromandel and Sind.[22] The vacuum left by this group in the late seventeenth century was filled partly by ship crews who assumed the role of intermediaries, bringing capital from Lisbon-based investors to India, carrying back cargo for them, and selling part of it in Brazil.[23] However, Indian Bania and Saraswat Brahmins, who stepped up as middlemen of Lisbon-based merchants, filled most of the trading void by dominating the trade in Portuguese India until about 1770 and becoming part of a cross-cultural trade with Portuguese, French, and Italian investors.

From 1715, a new wave of Portuguese investors in Indian textiles arose, namely, individual shipowners and financiers and joint-stock companies. These elite businessmen from Lisbon thrived, thanks to their links with the Crown, but only established branches of their family firms in Asia after 1770. Macao and Chinese silk fabrics were their initial objective, but India emerged as another key aim. They revolutionized the India-Portugal trade by integrating the Portuguese South Atlantic ports into their itineraries, calling at Brazil to pick up silver en route to India and selling Indian textiles on the homebound voyage during stopovers in Brazil (Rio, Bahia) and Luanda in Angola. These businessmen consolidated the Portuguese intercolonial market thanks to the rise of Brazil's purchasing power after 1700.[24]

The new players further revolutionized the type of textiles traded, offering more variety in order to appeal to all social groups in Portugal and in her far-flung empire, as evident in the cargo of the *Santo António e Justiça*, which was sold in Bahia, Brazil, in 1757. The types and qualities of the items sold ranged from embroidered and lined satin bedspreads with fringe (9,600 réis) to plain cotton cloth (100 réis); varieties of chintz ranged from fine (4,000 réis) to midfine (3,000 réis) and coarse (1,500 réis).[25]

Chintz and the Cloth of Commerce

It is difficult today to identify the physical characteristics of the pieces that travelled in Portuguese ships, due to confusing terminology and the lack of surviving objects and visual documentation. Among the rare surviving visual sources depicting chintz are André Reinoso's 1619 paintings of the life of St. Francis Xavier (fig. 8.1). This well-known cycle, located in St. Roque Church, Lisbon, depicts St. Francis preaching in Goa, with several attendees dressed in varying patterns of Indian chintz from either Gujarat or the Coromandel Coast. Reinoso painted from live models in Lisbon, as well as from Indian fabrics available at the time (evident from the goods salvaged from the *Nossa Senhora da Luz*).[26]

In Portugal, Indian cotton fabrics held the allure of the novel and the exotic. Upon the death of D. Beatriz, the "painted Indian clothes" in her wardrobe were recycled to make clerical vestments as stoles and maniples.[27] This repurposing reveals several important points. First, highly valued in Portugal, Indian chintz was repurposed in its use, meaning, and form, and given away when it was worn out or no longer fashionable. Figure 8.2 shows

FIG. 8.2

Linings for a Chinese painted silk hanging. India and France?, eighteenth century. Painted and printed cottons, 278 × 213 cm.

Very few Indian chintz have survived in Portugal. The linings here reveal a mosaic of painted and printed Indian cottons, as well as a patch made of a later factory print.

Museu Nacional de Arte Antiga, Lisbon, inv. 2135. c MNAA.DGPC/ADF.

a prime example, a Chinese silk painted cloth with flowers, phoenix, and butterflies, lined with three different kinds of printed cottons: a *chafarcani* (a bar of floral patterns typical of Coromandel) and what seems to be a much-later industrial print made for the Japanese market (*sarasa*; on *sarasa*, see ch. 7).[28] Second, repurposing was a trickle-down process that spread the consumption of Indian printed cottons. Initially the privilege of the wealthy, the consumption of Indian chintz by a larger share of the population rose during the sixteenth century due to the increase in its trade. In addition to goods sold at market, the parcels sent from people in India to their relatives, friends, and protectors in Europe also helped to increase new tastes and consumer habits, as the goods salvaged from the *Nossa Senhora da Luz* show. This trickle-down pattern continued to be felt in Portugal probably until 1715. New marketing techniques further contributed to "mass consumption," such as ads published in the *Lisbon Gazette* announcing the arrival of East Indiamen or leaflets printed with the description of the commodities of the cargo ships for sale (fig. 8.3).[29] Finally, and tragically, despite the vicissitudes of the other markets, the transatlantic slave trade generated a steady demand and reliable market for inexpensive cottons.

Chintz was first desired for interior furnishing, from aristocratic homes to more humble abodes. Inventories made between about 1650 and 1800 reveal that, as elsewhere in Europe, high-income Lisbon families used chintz all over the house, as curtains, slipcovers, table sets, wall and door hangings, and bedspreads, with colourful branches or flowering trees on white grounds.[30] The wealthy owned Indian chintz worth 2,200 réis on average, compared to 720 réis for those of more modest means.[31]

Ironically, although Portugal was the first to trade in Indian chintz, it was one of the last to adopt it as "mass fashion." Unlike the British and Dutch, Portuguese consumers truly embraced chintz as garments only in the late eighteenth century, coinciding with the rise of wages in Portugal, notably in the first half of the century (1700–1750).[32] As dress,

BELOW
FIG. 8.3

Cargo list of the ships *Nossa Senhora dos Prazeres, St. José, King of Portugal*, and *St. Ana, Queen of Portugal*, 1756. Printed on paper, 29 × 20.1 cm.

This cargo list reveals the wide variety of Asian textiles on offer in 1757 in Lisbon, including at least three qualities of chintz (*chitas* and *palampus*) from coastal southeast India.

Centro de Documentação António Alçada Baptista, Museu do Oriente, Lisbon, inv. ASIA 09:339 LIS. © Fundação Oriente/José Manuel Costa Alves.

OPPOSITE
FIG. 8.4

Chasuble. Coastal southeast India, for the European market, eighteenth century. Cotton, hand-drawn, mordant-dyed and resist-dyed, 114 × 71 cm.

The chasuble and its associated maniple and stole were painted to shape, carefully following Catholic design strictures.

Museu Nacional de Arte Antiga, Lisbon, inv. 4578 TEC. c Jose Pessoa. DGPC/ADF.

therefore, chintz became fashionable in Portugal only after 1750, and its signature item was the kerchief. Portugal had another market niche for chintz in its use as church vestments. As early as 1510, there is evidence for ecclesiastic apparel made from pintados in the monastery of Santa Clara in Coimbra.[33] Although some were tailored in Portugal, others were made in India, carefully following Catholic strictures, such as an eighteenth-century chasuble, stole, and maniple, painted to shape with Indian motifs (fig. 8.4); such religious items powerfully attest to the genius and flexibility of Indian artisans.[34]

Lifta da Carga de tres Navios, pertencentes a Negociaçaõ Portugueza da Afia, e China, que chegaraõ ao Porto da Cidade de Lisboa; a faber Noffa Senhora dos Prazeres, Capitaõ Manoel Martins da Fonçeca, que entrou em 4. do corrente mez de Setembro de 1756. S. Jozeph Rey de Portugal Capitaõ Joaõ Xavier Telles, e Santa Anna Raynha de Portugal, Capitaõ Antonio Quarefma Figueira em 8. do dito mez.

Generos da China.

241800 arrateis. de chá Buy.
165880 ars. de dito Sanló.
14560 ars. de dito Ayfon.
4420 ars. de dito Scuchon.
19630 ars. de dito Canfu.
6240 ars. de dito Sequim.
3380 ars. de dito Gobim.
368 Caixoés de Louça de differen-tes qualidades.
38 Caixoés com varios charoés.
9 Colchas bordadas.
6 Veftidos de feda bordados pa-ra fenhoras.
11 Veftias bordadas.
4310 Leques de differẽtes qualidades
9930 Pentes de tartaruga, e Madre-perola.
506 Paliteiros de tartaruga.
842 Caixas para tabaco de cobre ef-maltado.
48 Ditas de louça.
40 Ternos ditas de Tartaruga.
Hũa porçaõ de páu china branco.

Da cofta de Choromandel.

1560 Peffas. de Zuartes.
940 ps. de Selampuris azuis.
630 ps. de ditos brancos.
2561 ps. de Eleffátes de diverf. qualid.
20147 ps. de Lenços de varias fortes.
975 ps. de Betilhas.
400 ps. de Dimitins.
360 Cobertas de hum pano.
298 ditas de 2 panos.
9406 ps. de Guingoés de varias qualidad.
20 ps. de Valpinas vermelhas.
40 ps. de ditas azuis.
120 ps. de cambaya vermelha.
120 ps. ditas azuis.
1954 ps. de chitas de varias qualidades
52 ps. de Palampus de 1 pano.
621 ps. de Morins de differentes qua-lidades.

De Bengala.

6503 ps. de Caffas diverfas.
2219 ps. de Dorias.

176 Peffas. ditas de Daca bordadas.
702 ps. de Tarindams.
805 ps. de Sanas.
2459 ps. de Garras.
836 ps. de Tangebes.
174 ps. de Nainfookes de Daca.
474 ps. de Scerhaut tennas.
233 ps. de Allibalies de Daca bordadas, e lizas.
1352 ps. de Mulmulles diverfos.
921 ps. de Dimitins.
766 ps. de Sucins.
175 ps. de Choquelles.
198 ps. de Nilles de ulmara.
100 ps. de Tipaes.
212 ps. de Tofachelles.
965 ps. de Caridarins.
99 ps. de Gingoés de ulmara.
427 ps. de Bollaques.
9 ps. de Chorrohuntes de Seda.
1303 ps. de Hamamons.
66 ps. de Armezim rifcados.
6858 ps. de Baftas.
378 ps. de Coupins.
32 ps. de Herfures.
180 ps. de Dufutins.
1642 ps. de Fottas de 4 pannos.
161 ps. de Abacais.
101 ps. de Achibanes.
12 ps. de Chardarbanes de rifcas.
20 ps. de Seda empréfa para veftidos
56 ps. de Serfukes.
20 ps. de Rectas de feda.
494 ps. de Chitas.
403 ps. de Defuquefais.
307 ps. de Nainfuques de Daca.
231 ps. de Jungal tanjeb.
194 ps. de Surfugeres.
199 ps. de Dongris de Patana.
100 ps. de Penhafcos de ulmara.
13939 ps. de Lenços diverfos.
911 ps. de ditos de feda.
1240 ps. de ditos de algodaõ brancos.
3825 arrateis. de Seda em rama.
3709 ars. de Trincal.
764877 ars. de Salitre.
66787 ars. de Páo fapam.

Eftas fazendas fe haõ rematar da data defta a dous mezes. Lisboa 10 de Setembro de 1756.

Epilogue: *Chita*

Portugal, like other European countries, unable to ever fully control the trade in Indian chintz, eventually turned to creating industrial imitations of it, known as *chita*.[35] The first cotton printing mill began production in 1775 (in Azeitão) and was quickly followed by other factories in Lisbon, Leiria, Porto, and neighbouring areas.[36] Brazil produced cotton to feed the looms, but home production failed to meet demand. Portugal thus continued to import Indian cottons for both its domestic market and its colonies—especially Brazil, the main consumer from 1796 to 1807.[37] In 1807, the French invasion of Portugal cut off its American supplies of cotton, threatening to extinguish the industry forever.

However, such was the demand for *chita*, Portugal's factory-made colourful fabrics that mimicked Indian patterns and colours, that the industry recovered in 1815. To this day, these prints remain a common household good in Portugal and have been used in Brazil (fig. 12.17), Mozambique, and Angola as a living testament to the earliest Western-Indian entanglements.[38]

1 Ferreira, "Asian Textiles."

2 Freire, "Inventário," 71.

3 "Chitas – Saõ huns pannos pintados da India." For the 1642 attestation, see Arquivo Nacional Torre do Tombo, Lisbon, Orfanológicos, letra F, maço 120 (B), no. 1, fol. 17v. For the 1712 dictionary, see Bluteau, *Vocabulario portuguez e latino*, 1:293. Unless indicated otherwise, all translations are ours.

4 Arquivo Histórico Ultramarino, Lisbon, Açores, caixa 1, doc. 12, fol. 6v, 7, 43v, 52v.

5 Bluteau, *Vocabulario portuguez e latino*, 6:516.

6 "Fazendas da India branca e pintada cha." Madureira, "Inventários," 97.

7 Freire, "Cartas de quitação."

8 Arquivo Histórico Ultramarino, Lisbon, Índia, caixa 9, doc. 2. On António Coelho Guerreiro's sojourn in Angola, see Guerreiro, *O "Livro de rezão"* fol. 18v, 19v, 20v, 21v, 22v, 23v, 24v; Lopes and Menz, "Vestindo o escravismo."

9 Bocarro, *O livro das plantas*, 75–76, 96.

10 Guinote, Frutuoso, and Lopes, *As armadas da Índia*, 27–36.

11 Cunha, "A Carreira da Índia," 705–39.

12 Arquivo Histórico Ultramarino, Lisbon, codex 1150, fol. 9–26.

13 Brandão, *Grandeza e abastança*, 59.

14 Arquivo Histórico Ultramarino, Lisbon, Índia, caixa 8 [4a], doc. 136.

15 Boyajian, *Portuguese Trade in Asia*, 42.

16 Arquivo Histórico Ultramarino, Lisbon, codex 491, fol. 30r–30v.

17 Cunha, "Goa em transição," 767.

18 Viana, *Arquivo dos Açores*, 105, 113, 117.

19 Brandão, *Grandeza e abastança*, 59.

20 Boyajian, *Portuguese Trade in Asia*, 46–48, 64–65, 81–82, 141–42.

21 Cunha, "A economia," 487–99.

22 Biblioteca Nacional de Portugal, Lisbon, codex 2702, fol. 49–51.

23 Arquivo Histórico Ultramarino, Lisbon, codices 491 and 682. The new Christians progressively left the Indian Ocean trade for the South Atlantic due to dwindling profits in Asia and to escape persecution from the Inquisition.

24 Cunha, "A Carreira da Índia," 429–649.

25 Arquivo Histórico Ultramarino, Lisbon, codex 682.

26 Guy, "'One Thing,'" 19.

27 Freire, "Inventário," 71.

28 Museu Nacional de Arte Antiga, Lisbon, inv. nos. 4578 TEC, 4579 TEC, and 4580 TEC.

29 Museu do Oriente, Lisbon, inv. ASIA 09:339 LIS.

30 Watt, "'Whims and Fancies,'" 87.

31 Madureira, "Inventários," 98.

32 Trentmann, *Empire of Things*, 64, 74, 93–94, 108; Costa, Palma, and Reis, "The great escape?," 4–5, 12, 15–19.

33 Arquivo Nacional Torre do Tombo, Lisbon, Corpo Cronológico, pt. 1, maço 10, doc. 10.

34 Crill, "Local and Global," 100.

35 Trentmann, *Empire of Things*, 70, 77.

36 Custódio, "Notas históricas."

37 Pedreira, "Indústria e atraso económico," 247.

38 Ferreira, *Lenços e colchas*, 8–16.

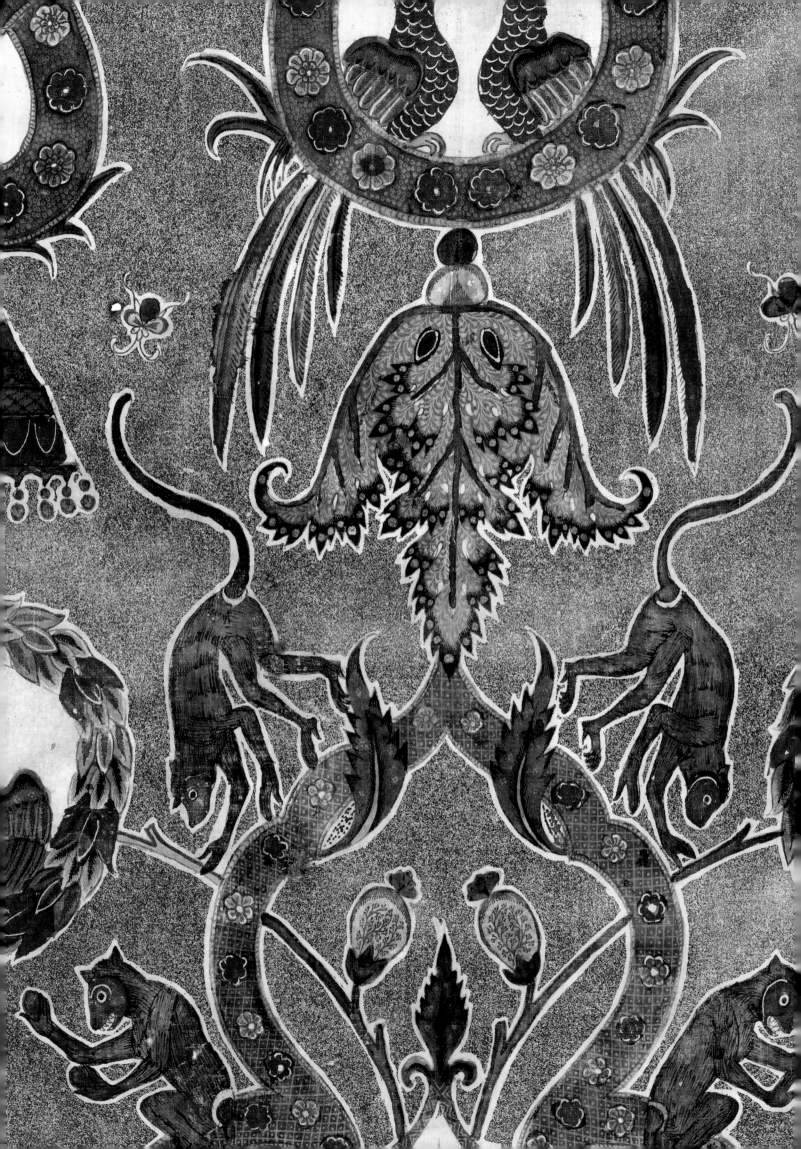

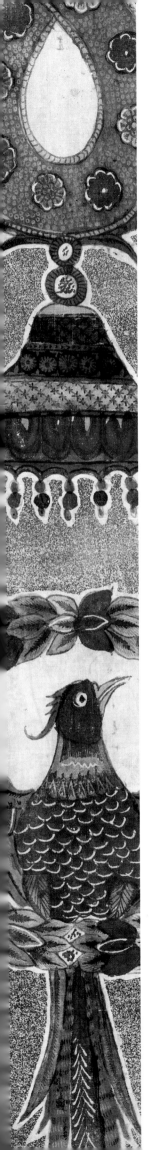

9

A REVOLUTION IN THE BEDROOM

CHINTZ INTERIORS IN THE WEST

ROSEMARY CRILL

COTTON TEXTILES ARE SUCH AN INTRINSIC ELEMENT OF WESTERN furnishings and dress that it can be difficult to envisage a time before they were known in Europe. In fact, both the cotton fabric itself and the dyes and techniques with which the textiles were patterned were completely unfamiliar to most Europeans until the beginning of the seventeenth century. While India had been exporting textiles of all sorts to other parts of Asia and East Africa for centuries, it was only with the arrival of the Portuguese, Dutch, and British, all eager to trade with India in the sixteenth and seventeenth centuries, that Indian cottons and silks started to trickle into European salesrooms. Fabrics called *indiennes* are recorded in France in the 1570s and 1580s, having arrived via the Middle East to the port of Marseilles, and Indian "painted cottons" are recorded in Spain as early as 1547, and even earlier in Portugal (see ch. 8).[1]

Detail: Eighteenth-century Indian chintz bed canopy (p. 123).

OPPOSITE
FIG. 9.1

Palampore (wall or bed hanging).
Coastal southeast India, for the
Western market, ca.1720–1740. Cotton,
hand-drawn, mordant-dyed, resist-
dyed, painted dyes, printed adhesive
with applied gold leaf, 365.6 × 260 cm.

Gold leaf has been applied to this
splendid palampore, suggesting that
it would have been used by a very
wealthy household.

ROM 934.4.13. Harry Wearne
Collection. Gift of Mrs. Harry Wearne.

Below: Details of fig. 9.1 showing the
fine detailing in hand-drawn wax resist.

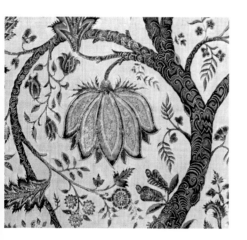

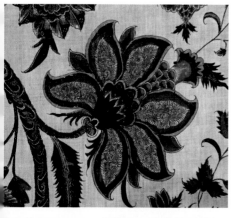

The image of an exotic tree with flamboyant multicoloured flowers has come to epitomize India's textile trade with Europe (fig. 9.1). While this striking design may be the most dramatic of the patterns that transformed Europe's interiors in the seventeenth and eighteenth centuries, it was only one pattern among many. What all the designs have in common is that they are hybrid inventions, many of them combining Chinese, Islamic, European, and Indian elements to form a new category of textile that appealed to the Western taste for the exotic. It was not only the new designs that appealed so strongly to Western consumers but the fabrics themselves. Linen and wool, not cotton, were the usual fabrics for everyday use in the West, and the wealthy also had access to patterned silks from France or Italy. Linen and wool were durable but heavy, and the dyes used for printed and embroidered patterns were limited and not fast. The arrival of brightly coloured, washable, and light cottons from India had a huge impact on the way Europeans dressed themselves (see ch. 10) and furnished their houses, starting with their bedrooms.

Records of the British East India Company (EIC; founded in 1600) tell us that the idea of selling painted cottons—then called by the Portuguese term *pintado* or "pintathoes" (see ch. 8), later by the hybrid term *chintz*—in Britain was suggested as early as 1609, when William Finch, the company's agent in Surat, remarked that "pintadoes of all sorts . . . should yield good profit."[2] Hitherto, the company's interest in Indian textiles had been purely as goods that could be exchanged for spices in the Spice Islands of what is now Indonesia.

The EIC clearly took suggestions like Finch's seriously, and by 1613 pintados were on sale in London. Sadly, no pieces from this early date survive, nor are there descriptions of what they might have looked like, although we know from letters from the company directors in 1643 that they requested chintz with "more white ground," rather than the "sad red grounds" that had been sent.[3] This preference for textiles with a white ground may have been based on their similarity to Chinese porcelain, which also used brilliant white grounds with coloured decoration and which was also starting to be imported into Britain.[4] The earliest surviving chintz made for the European market date from the end of the seventeenth century, and by this time the flowering-tree design was clearly well established. Some of the earliest examples are the so-called Ashburnham group of chintz bed and wall hangings, named after the house in England from which many of the type were bought—unused—in the mid-twentieth century.[5] The sources of this hybrid image can be found in several different cultures, but the underlying concept of sinuous flowering plants growing out of a rocky landscape owes most to early Iranian and Chinese art (fig. 9.2). This format remained influential over centuries and is found on Chinese ceramics of the Yuan dynasty, by which means it entered the Islamic design repertoire, where traces can be found in the rocky landscapes of Persian manuscript paintings.[6]

Ceramics patterned with trees growing out of rocky mounds were exported to Europe, as were Chinese painted wallpapers with the same designs. These exotic goods fit in perfectly to the fashion for chinoiserie that swept British country houses from the late seventeenth to the late eighteenth century. Although named (by later historians) after Chinese imports or objects made in the Chinese style, chinoiserie also incorporated such exotica as Japanese lacquer and Indian textiles. Their actual place of origin was of little or no consequence to their consumers: Chinese wallpaper was referred to as "India paper" and Chinese embroidery as "India work." In 1772, Osterley House in England was described by Agneta Yorke (1726–1780) as "furnished with the finest chintzes, painted taffetys, India papers and decker work [i.e., Indian embroidery], and such a profusion of rich China and Japan that I could almost fancy myself in Pekin."[7]

Closer to home, the specific treatment of the landscape and plants in the early chintz (and their embroidered counterparts) borrowed heavily from late seventeenth-century English crewel-work prototypes (fig. 14.1). The influence of these embroideries can be seen in the shape of the flowers and leaves and in the patterns used to infill them, although the heavy linen or fustian fabrics on which the English embroideries were worked and the thick sombre-toned woollen thread with which they were decorated provide a strong contrast to

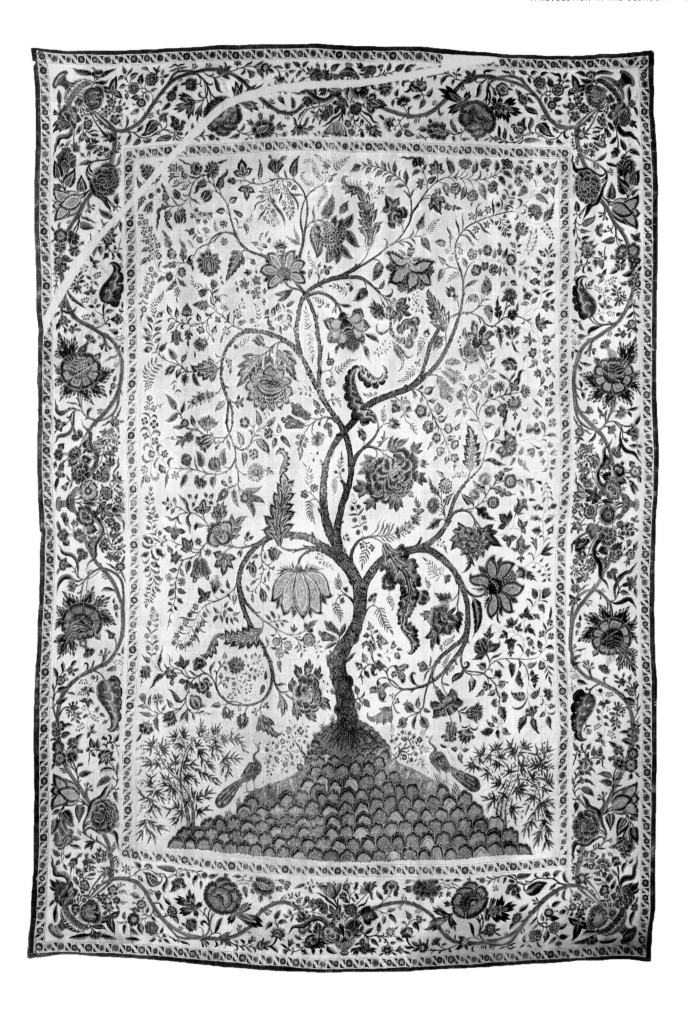

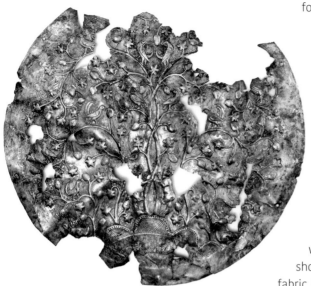

ABOVE
FIG. 9.2

Disk. Iran, Sasanian period, ca. seventh century. Silver and gilt, hammered, chased and gilded, 37 × 42.7 cm.

The flowering-tree design on this dish is a direct forerunner of the chintz designs that became popular in Europe from the seventeenth century.

Arthur M. Sackler Gallery, Smithsonian Institution, Washington, D.C. Gift of Arthur M. Sackler, S1987.139.

OPPOSITE
FIG. 9.3

Palampore (wall or bed hanging). Coastal southeast India, for the Western market, ca. 1740–1750. Cotton, hand-drawn, mordant-dyed, resist-dyed, 275.3 × 220.8 cm.

This hanging depicts a variety of animals such as mountain goats, lions, deer, squirrels, and ducks alongside European figures, and Western heraldic lions in its rocky base.

ROM 934.4.11. Harry Wearne Collection. Gift of Mrs. Harry Wearne.

Right: Detail of rocky mound with creatures and human figures dressed in clothing from ca. 1700.

the fine, brilliantly coloured Indian painted cottons that competed with them for popularity. Tantalizing written references in the 1660s to a fashion for "printing large branches for hangings" in Britain may shed some light on the origin of this taste for vegetal decoration, but none of these hangings have so far come to light.[8] Such hangings may be embroidered or printed precursors of the Ashburnham design, or perhaps they refer to Belgian *verdure* tapestries, with their dense designs of large curling leaves, which had become fashionable by the second half of the sixteenth century and which continued to be popular, in more elaborate landscape formats, in the seventeenth century.

Many of the earliest types of Indian chintz furnishings were intended as bed hangings, rather than as wall decoration. Some came in lengths to be cut to the appropriate size, but others, like those with tree designs, were purpose-made as bedcovers and curtains, with the designs drawn to fit the size and format of the piece. Most showed the colourful tree against the undyed white ground of the cotton fabric (fig. 9.3), but some used red or pink grounds (fig. 9.4). Correspondence from EIC officials tell us that these red-ground chintz were particularly popular with Dutch buyers, and indeed most of the few surviving examples have a Dutch provenance.[9] Chintz hangings and dress fabrics with dark purple and blue grounds also survive, mainly in Dutch collections.[10] An intriguing variant on the deep red ground is that of the speckled red ground on several export pieces (see fig. 9.11).[11]

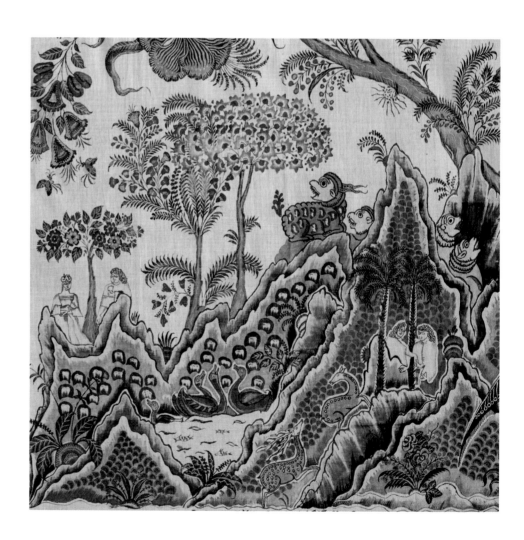

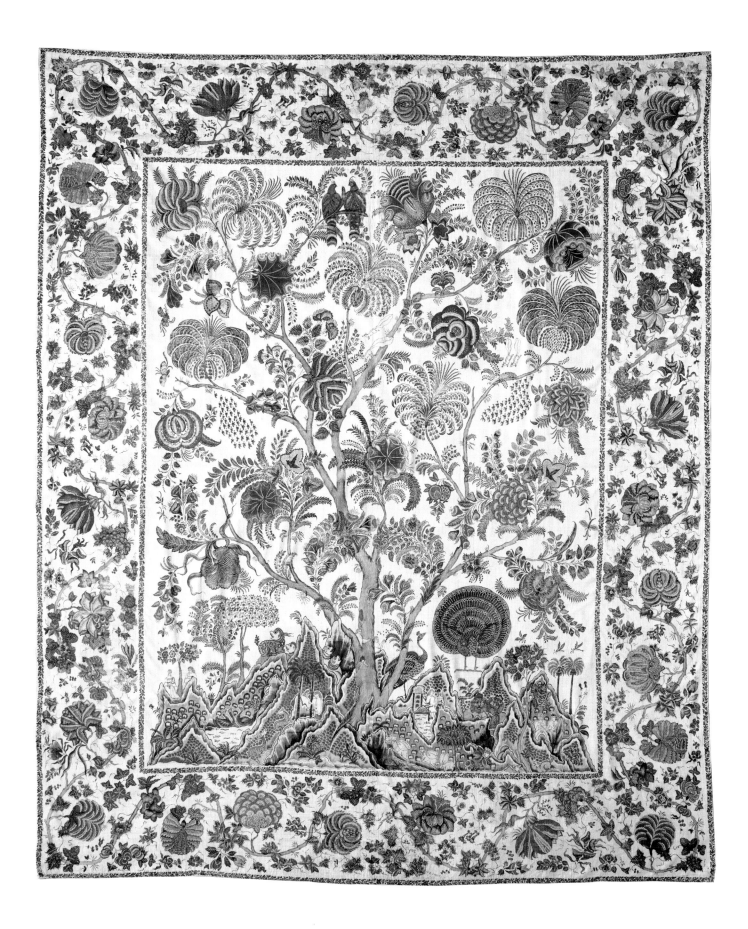

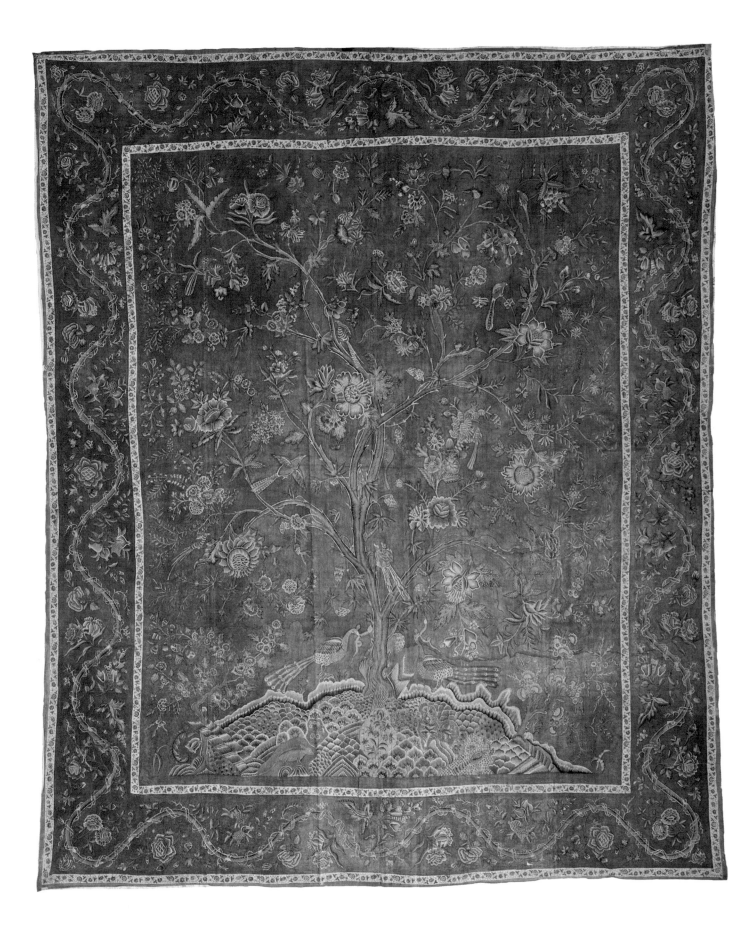

In England, EIC records indicate a boom in pieces made specifically as bed hangings in the 1680s, with quilts and palampores (from the Hindi and Persian word *palangposh* [bedcover]) ordered in great quantities.[12] Quilts were wadded and stitched both in India and in Europe; those made in India were filled with cotton-waste stuffing, and those made in Europe with wool. Styles of stitching on quilts also varied: some followed the outlines of the chintz design,[13] while others were stitched in a completely independent pattern that would be more visible on the plain reverse side of the quilt (fig. 9.5). By 1687, however, unquilted palampores were said to have put quilts "quite out of use."[14] As the eighteenth century progressed, the flowering tree continued to evolve, becoming more overtly Chinese in style. This becomes especially apparent from about 1770, with the addition of spiky-leaved bamboo twining around the tree trunk (fig. 9.6).[15] The designs of palampore borders

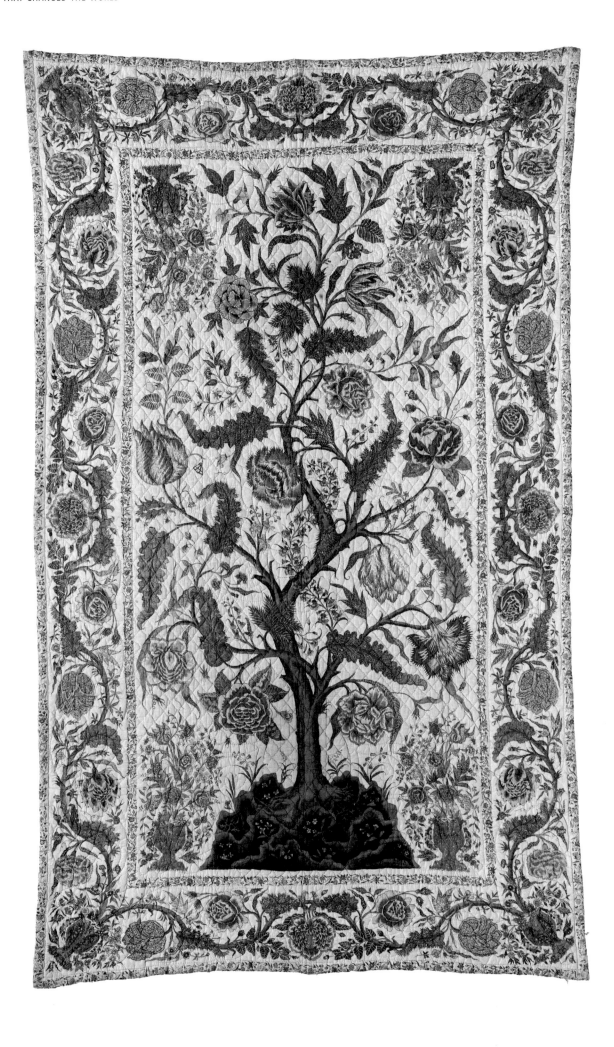

OPPOSITE
FIG. 9.5

Quilted palampore (bedcover).
Coastal southeast India, for the
Western market, ca. 1730–1740.
Cotton, hand-drawn, mordant-
dyed, resist-dyed, painted dyes,
stuffed with wool and quilted
with yellow silk thread, backed
with silk, 231 × 142 cm.

The woollen stuffing of this quilt
implies that it was made up in
Europe rather than in India, where
cotton would have been used.

Detail: Quilting stitches forming
an independent pattern.

ROM 964.215

were sometimes visually linked to the main field, with smaller-scale versions of the main motif repeated, but often the border would have a completely independent pattern of a floral meander or European-style swags of flowers (fig. 9.6).

The bright colours and light cotton fabric of chintz hangings, whether for walls or beds, were in striking contrast to the heavy velvets and silks that were still the preferred fabrics for formal rooms and state beds (beds specially made in expectation of a royal visit) in the West. Chintz was seen mainly as a feminine, informal fabric, making it especially suitable for dressing rooms, minor bedrooms, and women's studies (such as that of Samuel Pepys's wife, for which he bought chintz to line the walls in 1663).[16] If houses were large enough, separate bedrooms could be furnished according to supposed male and female tastes; this was the case at Wanstead House in Essex, the huge home of Josiah Child, head of the EIC, which in 1722 was reported to be furnished with chintz in its minor bedrooms and dressing rooms.[17] The craze for chintz had crossed the Atlantic (by way of Britain) by the 1730s, and around 1758, George and Martha Washington furnished a bedroom at Mount Vernon with flowered

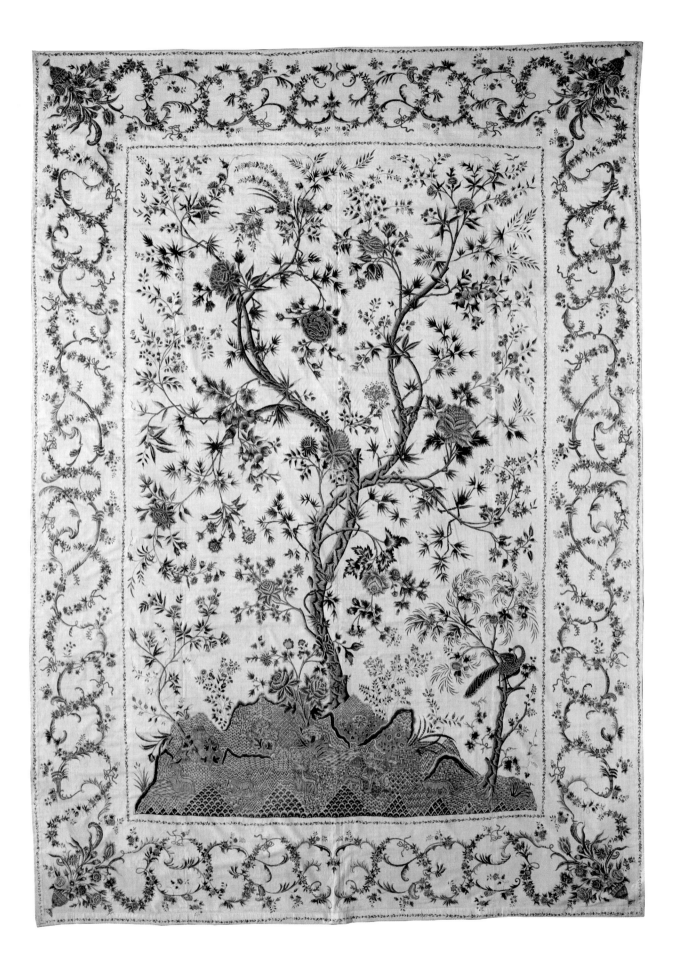

FIG. 9.6

Palampore (wall or bed hanging). Coastal southeast India, for the Western market, ca. 1770–1780. Cotton, hand-drawn, mordant-dyed, resist-dyed, 327 × 226 cm.

Opposite and left: By the later eighteenth century, tree designs had become sparser and included angular bamboos.

Below: Detail showing a scene of a thorn being removed from a tribal woman's foot. This image is often seen on South Indian kalamkaris for the local market but rarely on Western-market pieces.

ROM 934.4.3. Harry Wearne Collection. Gift of Mrs. Harry Wearne.

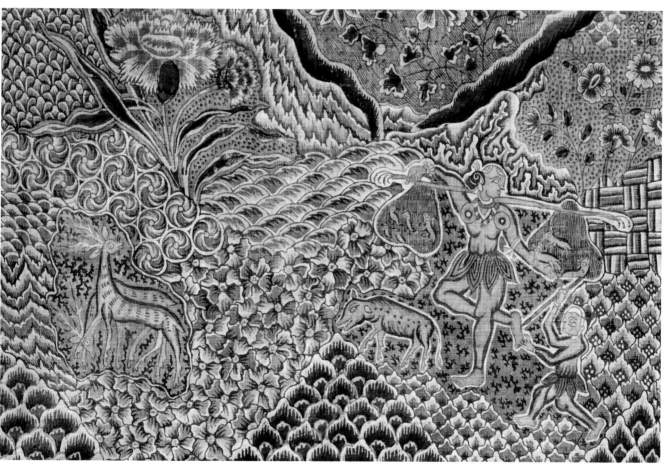

chintz textiles and "India figurd [sic]" wallpaper, although both may actually have been English imitations of Indian and Chinese imports.[18] A somewhat later Indian chintz hanging or bedcover in the Royal Ontario Museum (ROM) collection (fig. 9.7) has a connection to an old Connecticut family, and other North American collections hold chintz furnishings and dress that have eighteenth- and nineteenth-century connections to local residents.[19]

Constantly adjusting to changing global fashions in the decorative arts, Indian artisans also produced large-scale hangings for beds or walls with designs other than trees, among them a striking group that includes large human figures (fig. 9.8).[20] These were adapted from European prints or tapestries; although the source of the scene with the flute player in figure 9.8 has not yet been identified, other figural chintz of a similar type have been traced back to a set of French prints illustrating the story of Don Quixote.[21] French printed designs were also the source of a group of dramatic and elegant hangings based primarily on the work of Jean Bérain (1638–1711), chief designer to the court of Louis XIV (fig. 9.9 and 9.10). Hangings of this type drew on the "grotesque" imagery that had become popular in Italy in the sixteenth century following the rediscovery of Roman buildings decorated in this style, especially the Domus Aurea of the first century CE. These designs incorporated arabesques, strap work, and imaginary human faces and figures, which were sometimes adapted in the Indian chintz into purely architectural or floral elements (fig. 9.9).

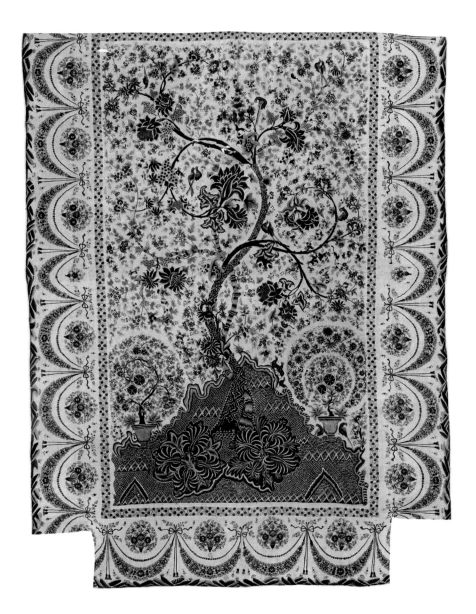

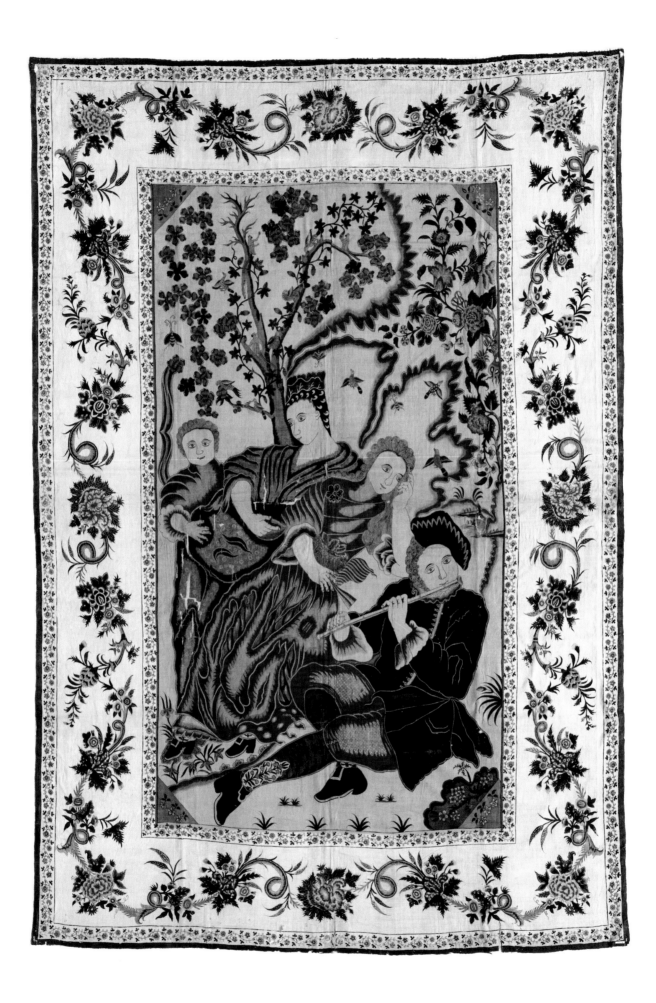

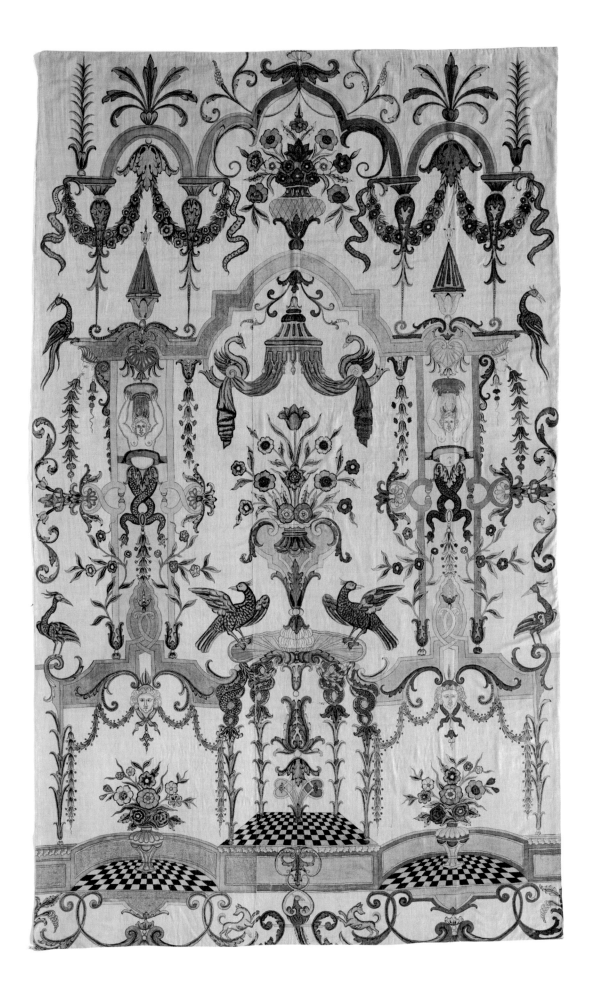

OPPOSITE
FIG. 9.9

Panel from a set of hangings. Coastal southeast India, for the Western (possibly French) market, ca. 1710–1720. Cotton, hand-drawn, mordant-dyed, resist-dyed, 254 × 157.5 cm.

This architectural design is based on compositions by Jean Bérain, chief designer to the court of Louis XIV at Versailles, and would have appealed especially to the French market.

ROM 934.4.18A. Harry Wearne Collection. Gift of Mrs. Harry Wearne.

LEFT
FIG. 9.10

Print with architectural design. Jean Bérain, ca. 1710. Designs like this one provided the inspiration for formal chintz hangings like that in fig. 9.9.

Victoria and Albert Museum, London

A related set of hangings (fig. 9.11), in which the more overtly architectural elements have been converted into symmetrical floral arabesques, is a masterpiece of Indian drawing and dyeing. Set against a speckled red ground, the treatment of the flowers and birds is typical of the highest-quality chintzes of the early eighteenth century. In a departure from the usual repertoire of birds and monkeys, pairs of minutely detailed mongooses wrestling with cobras are depicted at the base of the design (fig. 9.11 detail)—surely a unique design element in Western-market chintz. Cavorting monkeys at the top of some of the remaining fragments (fig. 9.12) and fruit-stealing chipmunks in the field add to the extraordinary playfulness hidden in this otherwise formal composition. The subsidiary animals in export chintz often add humour and wit to rather standardized formats; creatures found frolicking on the rocky mounds of flowering-tree palampores or hanging from their branches often allow us a glimpse of a lighter side to the *kalamkari* (block printing) artist's laborious work (fig. 9.13).

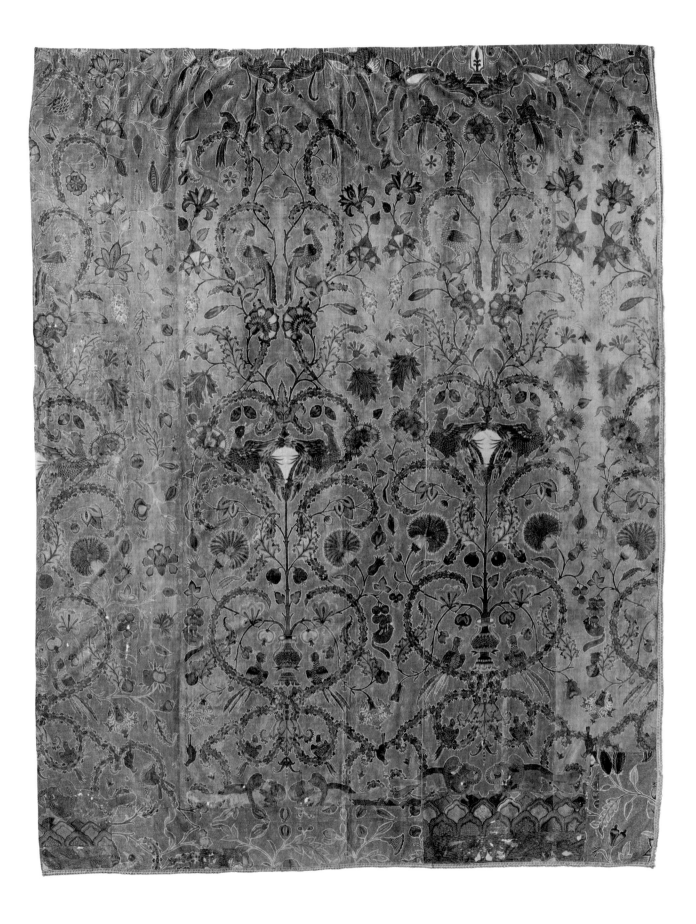

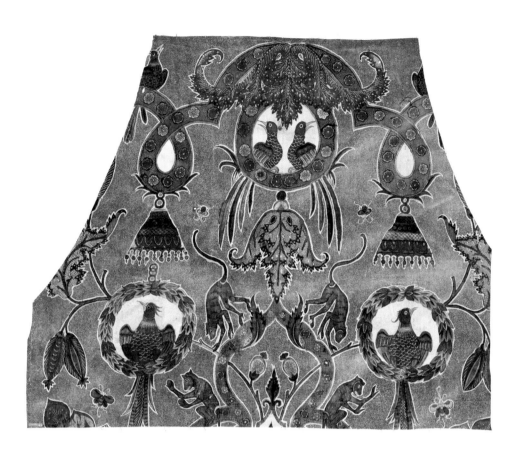

OPPOSITE
FIG. 9.11

Panel from a set of hangings. Coastal southeast India, for the Western market, ca. 1720–1740. Cotton, hand-drawn, mordant-dyed, resist-dyed, painted details, 292 × 231 cm.

The floral design of this hanging is set against an unusual speckled red ground.

Below: Detail from fig. 9.11 showing mongooses and cobra. The exceptionally detailed depiction of animals is a unique feature of this set of hangings.

ROM 934.4.15.A–B. Harry Wearne Collection. Gift of Mrs. Harry Wearne.

ABOVE
FIG. 9.12

Part of a bed canopy. Coastal southeast India, for the Western market, ca. 1720–1740. Cotton, hand-drawn, mordant-dyed, resist-dyed, painted dyes, 66 × 79 cm.

Belonging to the same set as fig. 9.11, this is thought to have been part of a canopy over a bed.

ROM 934.4.15D. Harry Wearne Collection. Gift of Mrs. Harry Wearne.

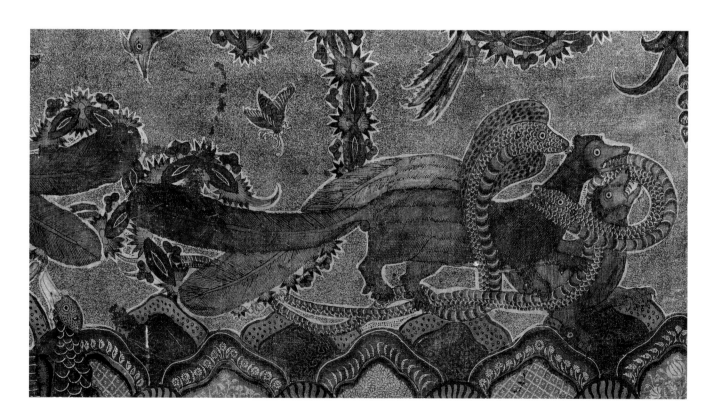

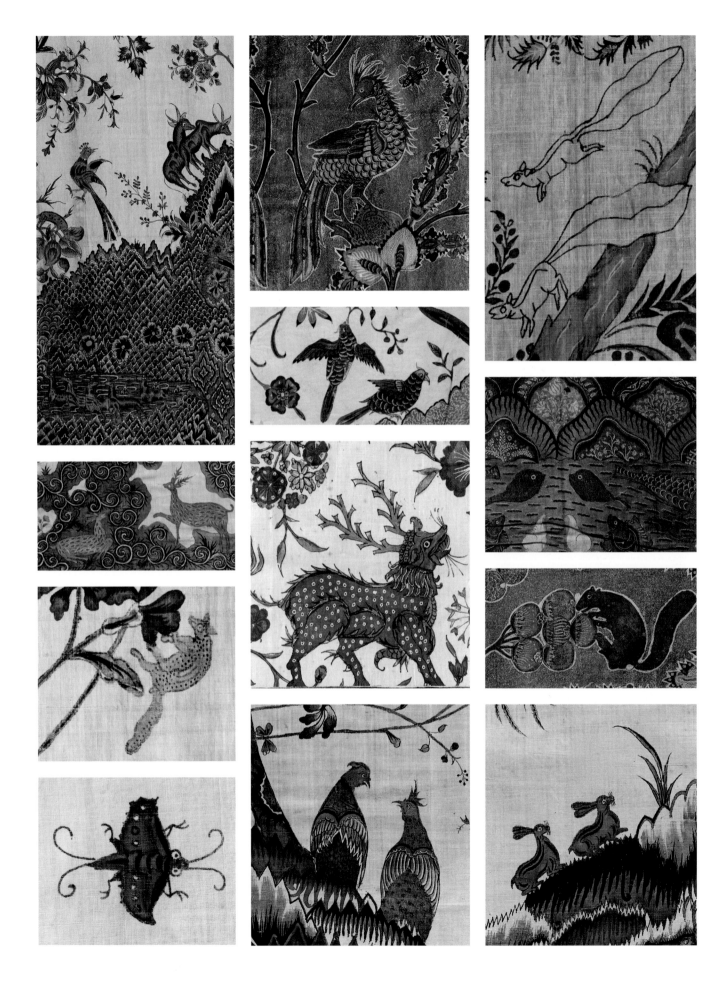

Chinese influence on the hybrid designs of export chintz was often subtle rather than overt, although some pieces drew directly on Chinese sources for their inspiration.[22] More unusual is the direct borrowing of Japanese motifs for Western-market chintz. These motifs are a result of the Dutch East India Company's access to trade with Japan; they were the only nation to be allowed this privilege from 1615 onward, and Japanese designs became fashionable in Holland as a consequence of this exclusive prerogative. A small number of remarkable palampores survive (including fig. 9.14) that all use the same group of Japanese-inspired motifs, which include a water wheel with foaming water, black pine trees, standing cranes, flying ducks, and flocks of birds. The piece shown in figure 9.14 is on a white ground, with a central medallion and corner elements and field motifs arranged to fit the borders, while four others of the group have red grounds and floral borders.[23]

The format of a central medallion and corner elements derives ultimately from Islamic art and is seen from the early Islamic period on book bindings and manuscript pages, and subsequently on carpets and textiles. Its versatility and rectangular format were perfect for Western bedcovers and wall hangings, and, when used in combination with the typical floral motifs of Western-market chintz, became completely disassociated from its Middle Eastern origins (fig. 9.15). In some instances, the central medallion of Western-market chintz contained real or imaginary European coats of arms or heraldic devices (figs. 9.16 and 9.19) or religious emblems such as the "pelican in its piety" feeding its young.[24] The corner elements could be transformed into bouquets, cornucopias, or vases of flowers adapted from European printed images (figs. 9.17 and 9.18).

Much more versatile in use (and less expensive) than large rectangular palampores were lengths of chintz fabric decorated with smaller-scale running designs that could be used for both furnishing (fig. 9.22) and garments. These designs drew on Western repeat-patterned fabrics, especially woven silks. The so-called bizarre patterns of French silks, produced around 1700–20, were especially popular for conversion into chintz designs (fig. 9.21). Repeating designs like these were used for smaller items of furniture, such as slipcovers for the headboards of beds (fig. 9.21) and valances for beds (fig. 9.20); even covers for chair seats were made in chintz (fig. 9.23). All of these items would have been used in interiors with matching chintz furnishings. Several eighteenth-century British female letter writers, such as Celia Fiennes, Mary Delaney, and Mrs. Lybbe Powys, give details of the chintz-filled interiors they had visited and admired. In 1771, Mrs. Powys described Mawley Hall in Shropshire as having "more chintz counterpanes than in one house I ever saw: not one bed without very fine ones," and in 1776 she admired the library at Heythrop in Oxfordshire: "the sofas, chairs and curtains fine chintz, a present from Lord Clive."[25] Gold leaf was sometimes added to palampores (as in fig. 9.1) and dress fabric, but to add gold to a seat cover (fig. 9.23) could be seen as an extravagance that tips over into impracticality.

Chintz furnishings and dress fabrics were also highly prized in mainland Europe, especially in the Dutch Republic (today the Netherlands), but also in France, which traded with India mainly through its own Compagnie des Indes, founded in 1664. Even the remote French outpost of l'Île Bourbon (present-day Réunion) in the Indian Ocean took full advantage of its position as an important staging post on the French route to India or the Cape of Good Hope to access a wide range of Indian textiles—from striped gingham and muslin to painted cotton chintz.[26] Denmark also had its own East India (or "Asiatic") Company, and a small number of chintzes are known to have been produced for use in Denmark.[27] In Europe, as elsewhere, no authentic chintz furnishings survive in situ, but we know of several splendid interiors that were created using eighteenth-century chintz palampores at a later date (fig.9.21).[28]

What truly made chintz a global fashion was its spread across the Pacific and Atlantic Oceans, as Europeans, in their quest for the riches of Asia, began to circumnavigate the globe in the hope of finding shorter routes and bypassing established middlemen. The development of European forts and trading posts and, later, full territorial colonization of what are now the United States, the Caribbean islands, Brazil, and Mexico (to name a

OPPOSITE
FIG. 9.13

Clockwise from top left: Deer, zebu cattle, and stylized peafowl (ROM 934.4.2); stylized pheasant (ROM 934.4.15a); pair of flying squirrels (ROM 934.4.11); fish (ROM 934.4.15b); forest squirrel (ROM 934.4.15a); pair of hares (ROM 934.4.12); stylized junglefowl (ROM 934.4.12); cricket (ROM 934.4.12); genet, civet, or linsang (ROM 934.4.12); male and female spotted deer (ROM 934.4.6).

Centre (top down): Stylized pheasants (ROM 934.4.9); qilin, mythical Chinese hooved and horned creature (ROM 934.4.7).

Harry Wearne Collection. Gift of Mrs. Harry Wearne.

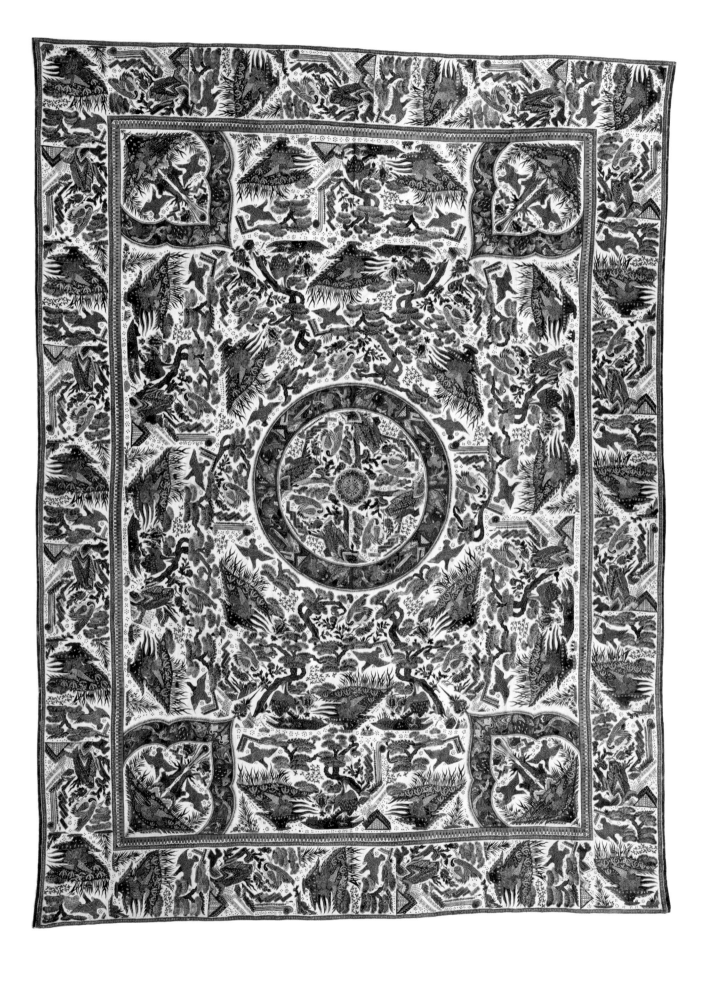

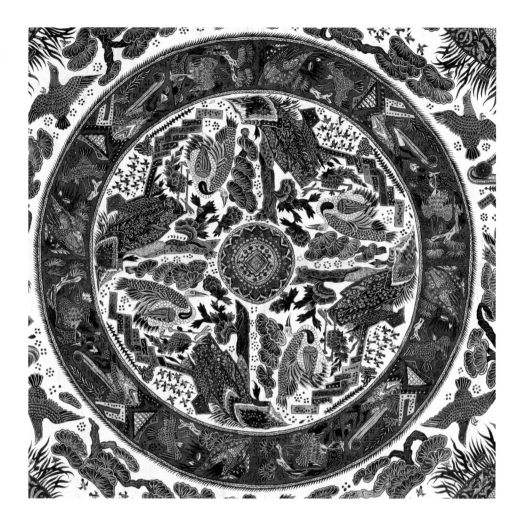

FIG. 9.14

Palampore (wall or bed hanging). Southeast India, for the Western, probably Dutch, market, ca. 1725–1750. Cotton, hand-drawn, mordant-dyed, resist-dyed, painted dyes, 366 × 272 cm.

This design borrows imagery from Japanese sources, probably textiles or lacquerware, which became accessible to Dutch traders through their privileged access to Japan.

ROM 963.13

LEFT, BELOW
Details of fig.9.14 showing Japanese-derived motifs of cranes, pine trees and water-wheels.

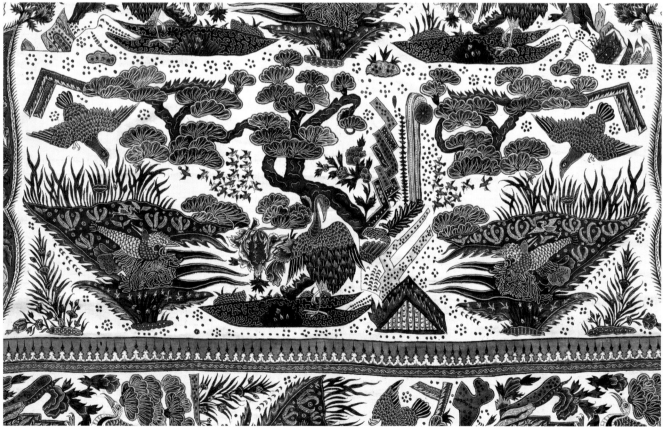

FIG. 9.15

Palampore (wall or bed hanging). Coastal southeast India, for the Western market, ca. 1720–1750. Cotton, hand-drawn, mordant-dyed, resist-dyed, 262.8 × 215.8 cm.

The small-scale floral patterns used in this large piece would have been equally suitable for dress material.

ROM 962.107.1

FIG. 9.16

Palampore (wall or bed hanging). Coastal southeast India, for the Western, possibly Dutch, market, ca. 1725–1740. Cotton, hand-drawn, mordant-dyed, resist-dyed, 356 × 270 cm.

Imaginary heraldic devices, like the central lion and corner elements in this piece, were popular in chintz for the Dutch market in the eighteenth century.

ROM 934.4.7. Harry Wearne Collection. Gift of Mrs. Harry Wearne.

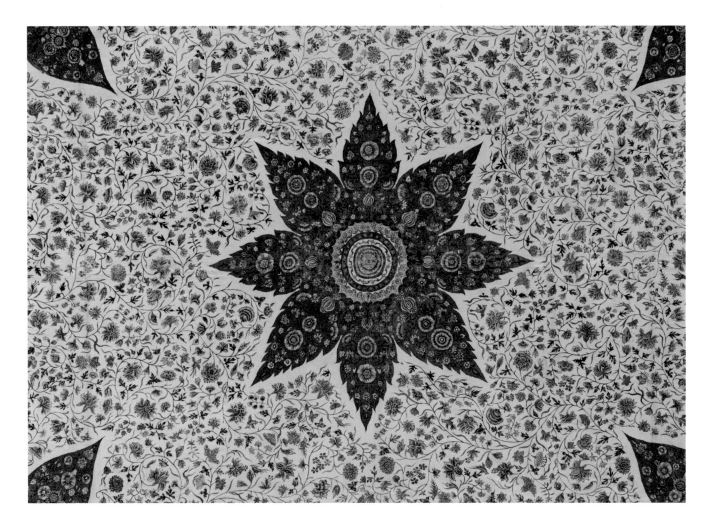

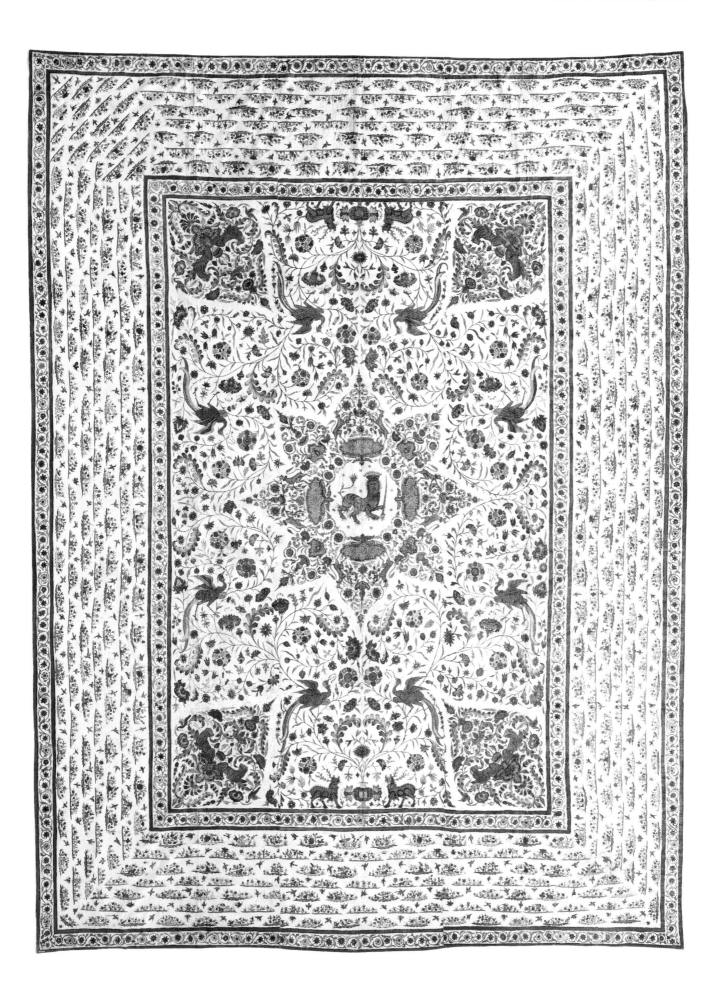

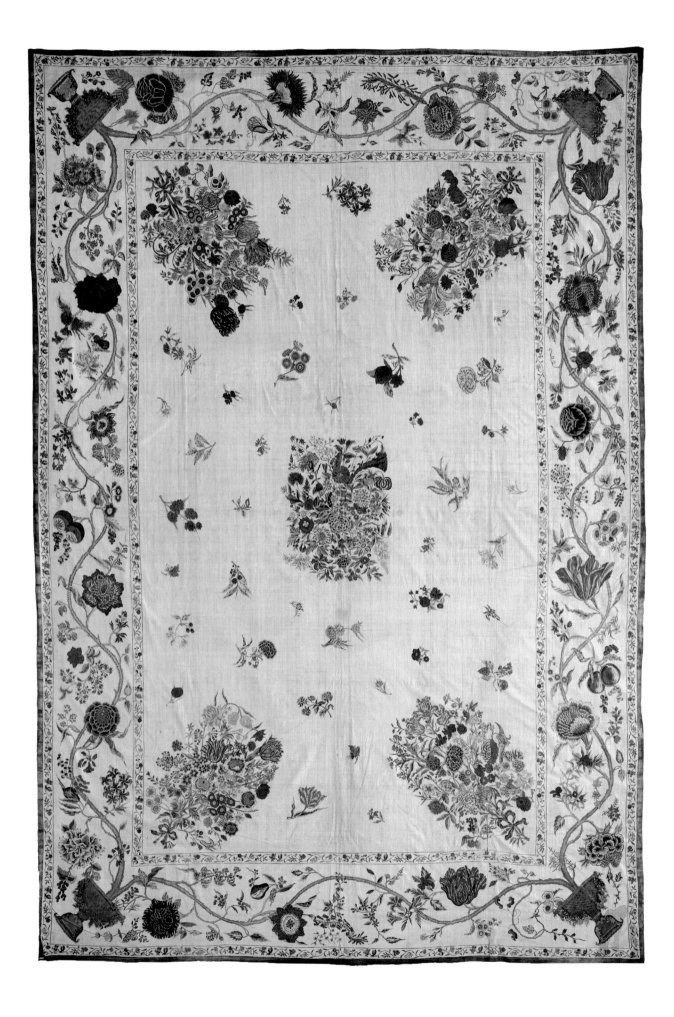

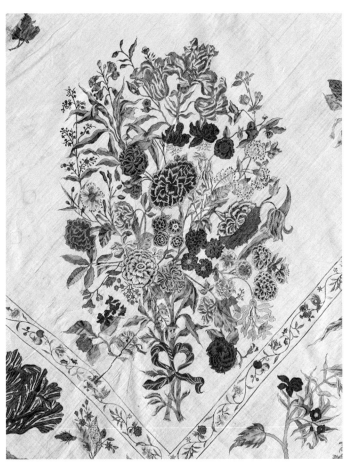

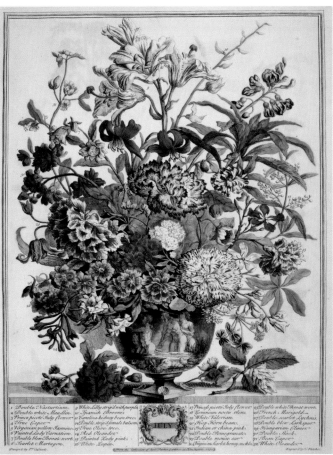

OPPOSITE
FIG. 9.17

Palampore (wall or bed hanging). Coastal southeast India, for the Western market, ca. 1730–1740. Cotton, hand-drawn, mordant-dyed, resist-dyed, 331.3 × 228.6 cm.

The floral bouquets are based on a set of prints, *The Twelve Months of Flowers*, published in London in 1730 and based on paintings by the Flemish artist Pieter Casteels.

Left: Detail of fig. 9.17 showing corner bouquet, which corresponds to July in the print by Pieter Casteels below. Here the chintz painter has reversed the bouquet and added a ribbon in place of the vase.

ROM 934.4.16. Harry Wearne Collection. Gift of Mrs. Harry Wearne.

BELOW
FIG. 9.18

Below: The month of July. From *The Twelve Months of Flowers*, published in London in 1730 and based on paintings by the Flemish artist Pieter Casteels.

Dumbarton Oaks Research Library and Collection, Rare Book Collection, Trustees for Harvard University, Washington, DC.

FIG. 9.19

Part of a palampore (wall or bed hanging). Coastal southeast India, for the Western, possibly Dutch, market, ca. 1725–1740. Cotton, hand-drawn, mordant-dyed, resist-dyed, 255 × 144 cm.

The heraldic motifs in this hanging may have been drawn from genuine family crests, but they have not been identified.

ROM 934.4.9. Harry Wearne Collection. Gift of Mrs. Harry Wearne.

FIG. 9.20

Valance for the side of a bed. Coastal southeast India, for the Western market, ca. 1720–1730. Cotton, hand-drawn, mordant-dyed, resist-dyed, 93 × 193 cm.

This valance would have been part of a set of chintz bed hangings.

ROM 934.4.36B. Harry Wearne Collection. Gift of Mrs. Harry Wearne.

FIG. 9.21

Slipcover for the headboard of a bed. Coastal southeast India, for the Western market, ca. 1705–1715. Cotton, hand-drawn, mordant-dyed, resist-dyed, 104 × 146 cm.

The chintz design is based on French "bizarre" silks of the early eighteenth century, which used floral and imaginary shapes in strongly diagonal arrangements.

ROM 934.4.38. Harry Wearne Collection. Gift of Mrs. Harry Wearne.

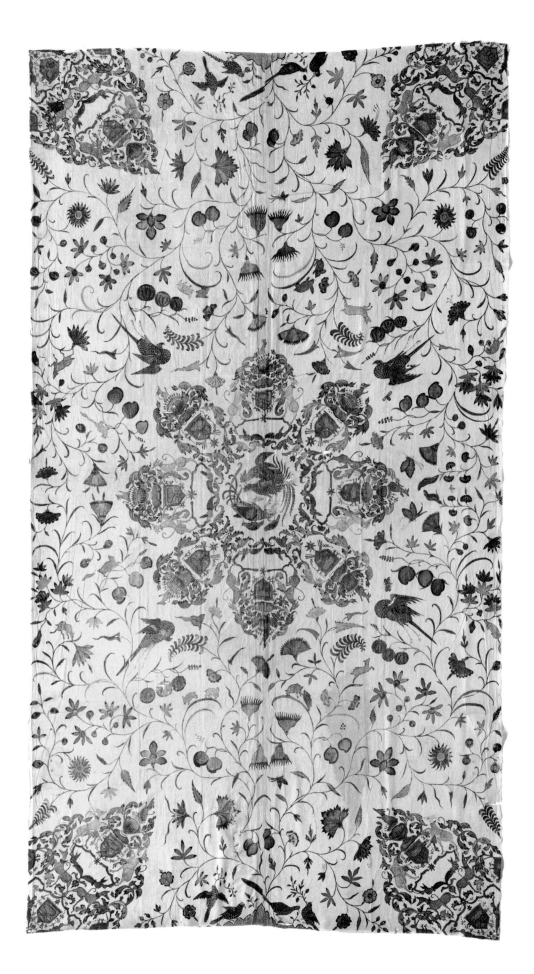

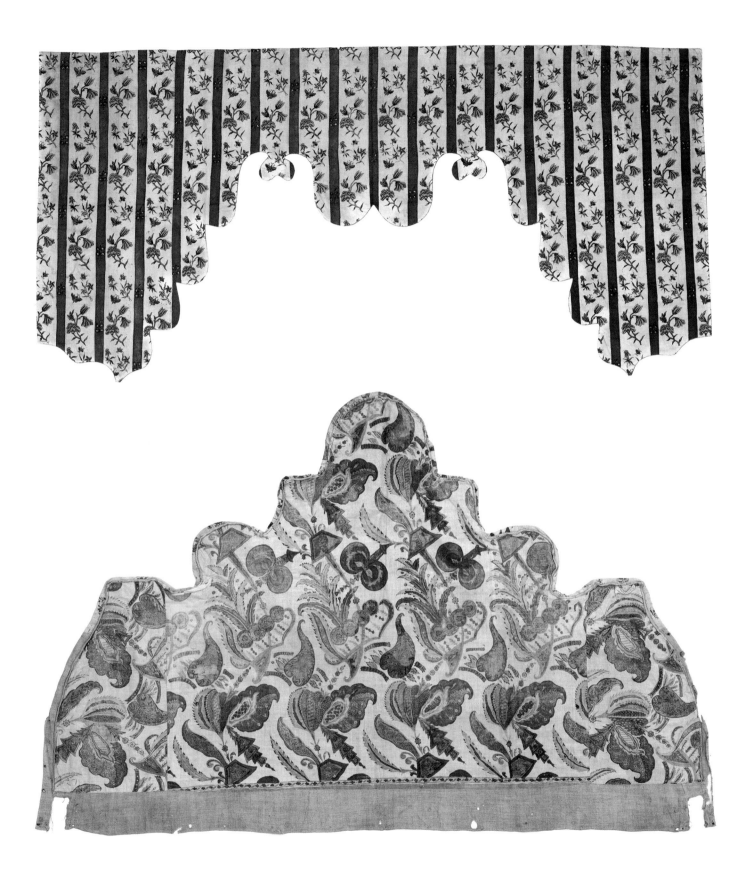

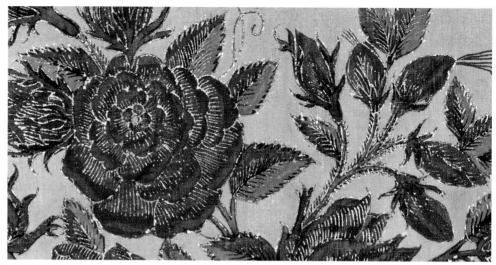

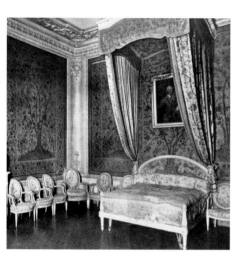

ABOVE
FIG. 9.22

A chintz-covered bedroom in the Château Borély, Marseilles, France, photgraphed before 1920 (from Baker, *Calico Painting and Printing*).

RIGHT
FIG. 9.23

Cover for a chair seat (overview and detail). Coastal southeast India, for the Western market, ca. 1775–1800. Cotton, hand-drawn, mordant-dyed, resist-dyed, painted dyes, with applied gold leaf, 90 × 77 cm.

This seat cover was never used; the rectangular markings for the back of the chair are still uncut. The floral garland borders would have hung down around the sides of the chair.

ROM 959.249

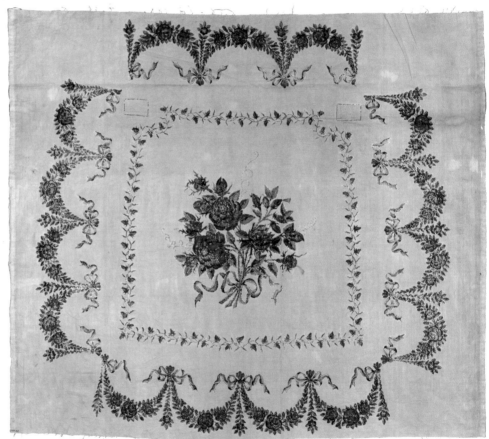

few) spread Indian cotton textiles to many types of communities—whether administrators, settlers, mestizo, or indigenous. While most imported textiles reached Central and South America via Spain and Portugal, Chinese silks and some Indian cottons also arrived in Mexico directly from Asia on the "Manila galleons" that plied between Manila and Acapulco from about 1565 to 1815. Exotic Indian floral textiles (and their local and European imitations) seem mainly to have been used for dress in Latin America.[29] Plain and striped cottons were adopted for clothing in North America as early as the mid-seventeenth century and in the Caribbean by the early eighteenth century;[30] but as the craze for floral chintz furnishings took off in Europe, its reverberations were felt in the bedrooms of George Washington and his contemporaries in North America.

1 Irwin and Brett, *Origins of Chintz, 23; Riello, Cotton*, 115. In Britain too, occasional references to Indian calico textiles in the port city of Southampton from the 1540s to the 1570s suggest that some plain Indian cottons were available, probably through trade with the Portuguese, who had been the first Europeans to establish trading bases in India. Lemire, *Cotton*, 25–26.

2 William Finch, letter dated 30 August 1609, quoted in Irwin and Brett, *Origins of Chintz*, 23.

3 Irwin and Brett, *Origins of Chintz*, 4.

4 This similarity became particularly apparent from about 1720 when so-called *famille rose* Chinese ceramics and Indian chintz, both with white grounds and floral designs in shades of pink and green (now faded to blue in most surviving chintz), were combined in Western interiors.

5 Irwin and Brett, *Origins of Chintz*, no. 7; Crill, *Chintz*, no. 1. Hangings of the same design were acquired by Prince Eugene of Savoy (1663–1736) in the early eighteenth century; see Karl, "Object in Focus," 170–71.

6 For examples from Timurid Iran, see a page from the *Jami' al-tawarikh*, dated 1314 CE; a page from a poetic anthology, dated 1398; and a page from a collection of epics, dated 1397–98 (Lentz and Lowry, *Timur*, 51, 56, 59). For Safavid examples, see *Rustam Sleeping*, from a copy of the *Shahnama*, dated ca. 1510–20; a page from the *Anwar-i Suhayli*, dated 1593; and a page from the Shahnama of Shah 'Abbas of ca. 1590–1600 (Sims, Marshak, and Grube, *Peerless Images*, 163, 164, 166). Quoted in Helen Clifford, "Chinese Wallpaper Case Study: East India Company Family Connections," *East India Company at Home*, 1757–1857 (blog), 2019, http:// blogs.ucl.ac.uk/eicah/ chinese-wallpaper- case-study/chinese-wallpaper-case-study- east-india-company-family-connections/.

7 Irwin and Brett, *Origins of Chintz*, 18.

8 See, e.g., a piece in the Rijksmuseum, Amsterdam, illustrated in Hartkamp-Jonxis, *Sitsen uit India*, no. 7.

9 E.g., a chintz quilt with a deep purple ground in the Peabody Essex Museum, Salem, MA, acc. no. 2012.22.9, acquired from a Dutch collection; a purple-ground chintz dress fabric in the Musée de l'Impression sur Etoffes, Mulhouse, acc. no. MISE 967.195.5, illustrated in Jacqué and Nicolas, *Féerie indienne*, no. 73; and a cape with a blue ground in the Victoria and Albert Museum (V&A), London, acc. no. IS 23-1950, illustrated in Irwin and Brett, *Origins of Chintz*, no. 134 and Crill, *Chintz*, 106.

10 A set of bed hangings in the V&A, acc. no. IS 2-1967, also has this speckled background; see Irwin and Brett, *Origins of Chintz*, no. 62 and Crill, *Chintz*, nos. 12–14. A banyan in the Musée de l'Impression sur Etoffes, Mulhouse, acc. no. MISE 993.7.17, also has

a speckled red ground: Jacqué and Nicolas, *Féerie indienne*, no. 67. A length of chintz fabric in the Rijksmuseum, Amsterdam, inv. BK-1976-134, has the same speckled effect but in purple: Hartkamp-Jonxis, *Sitsen uit India*, no. 26.

11 Irwin and Brett, *Origins of Chintz*, 25.

12 See a piece in the TAPI Collection, Surat, illustrated in Barnes, Cohen, and Crill, *Trade, Temple and Court*, 96–97.

13 Irwin and Brett, *Origins of Chintz*, 27.

14 The set of hangings ordered by the British actor David Garrick in 1774 is a useful, datable example of this style of tree design; see V&A, W.70 (A-K)-1916 and 17-19-1906; Irwin and Brett, *Origins of Chintz*, nos. 34–36; Crill, *Chintz*, no. 22.

15 See also the miniature lying-in room with chintz-covered walls in Petronella Dunois's dolls' house now in the Rijksmuseum, Amsterdam; see Hartkamp-Jonxis, *Sitsen uit Indien*, no. 1; Sardar, "Silk," 79.

16 Macky, *Journey through England*, 22.

17 On chintz crossing the Atlantic, see Riello, *Cotton*, pp.144–45. On Mount Vernon, see Amanda C. Isaac, "Furnishings of the Chintz Room," George Washington's Mount Vernon, May 2016, https://www.mountvernon.org/the-estate-gardens/the-mansion/the-chintz-room/furnishings/.

18 E.g., the chintz palampore from Cherry Hill, Albany, NY (Peck, *Interwoven Globe*, no. 118); the painted cotton "Reynolds

19 Coverlet" in RISD Museum, Providence (Crill, *Fabric of India*, 122); a chintz palampore or "wholecloth quilt" in Winterthur Museum, Garden and Library, Delaware (Eaton, *Quilts*, 117–18); and a chintz jacket and petticoat worn in Albany, NY, ca.1790 (Baumgarten, *What Clothes Reveal*, fig. 112–14; Peck, *Interwoven Globe*, fig. 98). While few actual textiles survive, many records testify to the thriving North American trade in Asian textiles, including Indian cottons; see Peck, "'India Chints.'"

20 For others of this type, see V&A, IS 118-1950 (Irwin and Brett, *Origins of Chintz*, no. 72; Crill, *Chintz*, no. 17) and another example with Chinese figures in the Musée des Arts Décoratifs, Paris (Irwin and Brett, *Origins of Chintz*, 97). An apparently identical unpublished piece with Chinese figures is in the Groninger Museum, Netherlands. A related composition with a large tree and Chinese figures is in the Musée de la Compagnie des Indes, Lorient, acc. no. MCI 2007.1.1, illustrated in Jacqué and Nicolas, *Féerie indienne*, no. 44.

21 Irwin and Brett, *Origins of Chintz*, 96.

22 See, e.g., a palampore in the V&A with Chinese figures and baskets of flowers, acc. no. IS 141-1950, illustrated in Irwin and Brett, *Origins of Chintz*, plate 88; another with Chinese ladies, V&A, acc. no. IS 52-1950

and IS 43-1950, in Irwin and Brett, no. 49; Crill, *Chintz*, plate 39.

23 A very similar palampore to the ROM piece is in the TAPI collection, Surat, illustrated in Shah, *Masters of the Cloth*, no. 35. One red-ground piece in a Dutch collection is illustrated in Crill, *Fabric of India*, 173, and two others in the Metropolitan Museum of Art and the Cooper-Hewitt Smithsonian Design Museum, New York, are illustrated in Peck, *Interwoven Globe*, 184. Another hanging with the same design is found in a Japanese collection illustrated in Guy, *Woven Cargoes*, 176. Part of another hanging, V&A, IS 53-1950, which also uses Japanese-inspired motifs, is illustrated in Irwin and Brett, *Origins of Chintz*, no. 91; Crill, *Chintz*, 64.

24 E.g., V&A, IS 32-1950, in Irwin and Brett, *Origins of Chintz*, no. 82; Crill, *Chintz*, no. 44.

25 Both quoted in Clabburn, *National Trust Book*, 242.

26 Inventories record the use of Indian dyed cottons on l'Île Bourbon between 1725 and 1765, with peak years between 1732 and 1745. See Bérinstain, Cardon, and Tchakaloff, *Indiennes et palampores*, 9, 106, 107, 118.

27 See, e.g., a palampore of 1740–1746 depicting the arms of Christian VI of Denmark in the Designmuseum Danmark, Copenhagen, in Peck, *Interwoven Globe*, fig. 78.

28 As well as the interior of Château Borély, notable interiors include a room at Hütteldorf Castle in Vienna and another in Hluboka Castle in the Czech Republic (both illustrated and discussed in Jacqué, "Deux exemples," 116–17).

29 See Riello, *Cotton*, 142–44 and fig. 7.4. See also Peck, *Interwoven Globe*, fig. 35 for a rare example of a sixteenth- to seventeenth-century block-printed cotton fragment from Gujarat, India, excavated in Peru.

30 Peck, "'India Chints,'" 106; Riello, *Cotton*, 146–47.

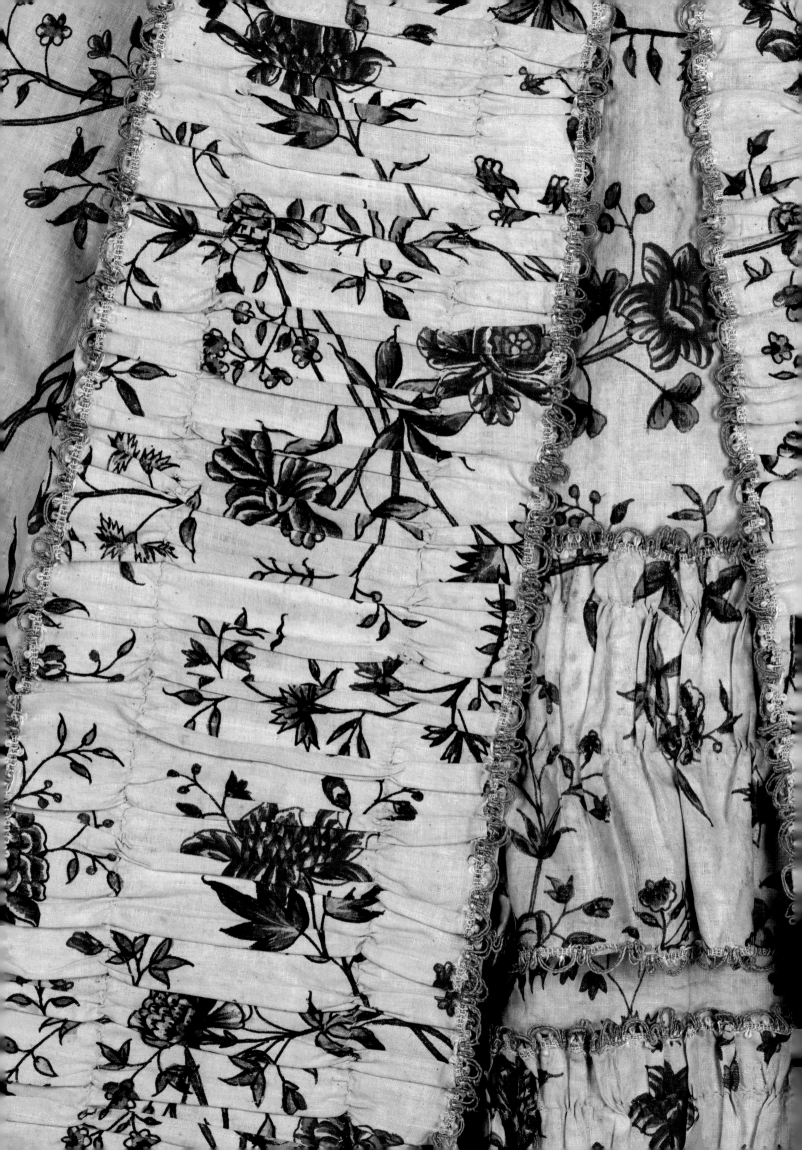

10

FASHIONING CHINTZ

FOR THE WEST IN THE EIGHTEENTH CENTURY

ALEXANDRA PALMER

I**N TODAY'S AGE OF FAST FASHION AND MINIMAL MAINTENANCE, IT IS DIFFICULT** for us to imagine the modernity of the beautiful and colourful Indian cottons for clothing and interior furnishings that arrived in eighteenth-century Europe and the Americas. What was it that so appealed? Certainly, it was the designs. Some emulated complex, but familiar, multicoloured silk patterns controlled by the binary of the warp and weft of the loom (fig. 10.3). Others astonished, as cotton textiles provided an off-loom canvas for painted patterns that ran riotously over single and assembled cloth widths, offering a design freedom previously seen only in handworked embroidery or large-scale tapestry woven textiles (fig. 10.1 and 10.2). Crucial too were the idiosyncrasies of patterns with exotic fusions, which combined elements from the East, South, and Europe, and could be painted and printed to specific shapes and garments. Yet, in addition to these very visible and important features, there were also more subtle, physical features that stimulated desire. As the century progressed, the gap between access to and increasing demand for India's patterned cottons in Europe declined.

Detail: Glazed chintz robings and petticoat flounces with fly fringe trim on *robe à la française* (p. 138).

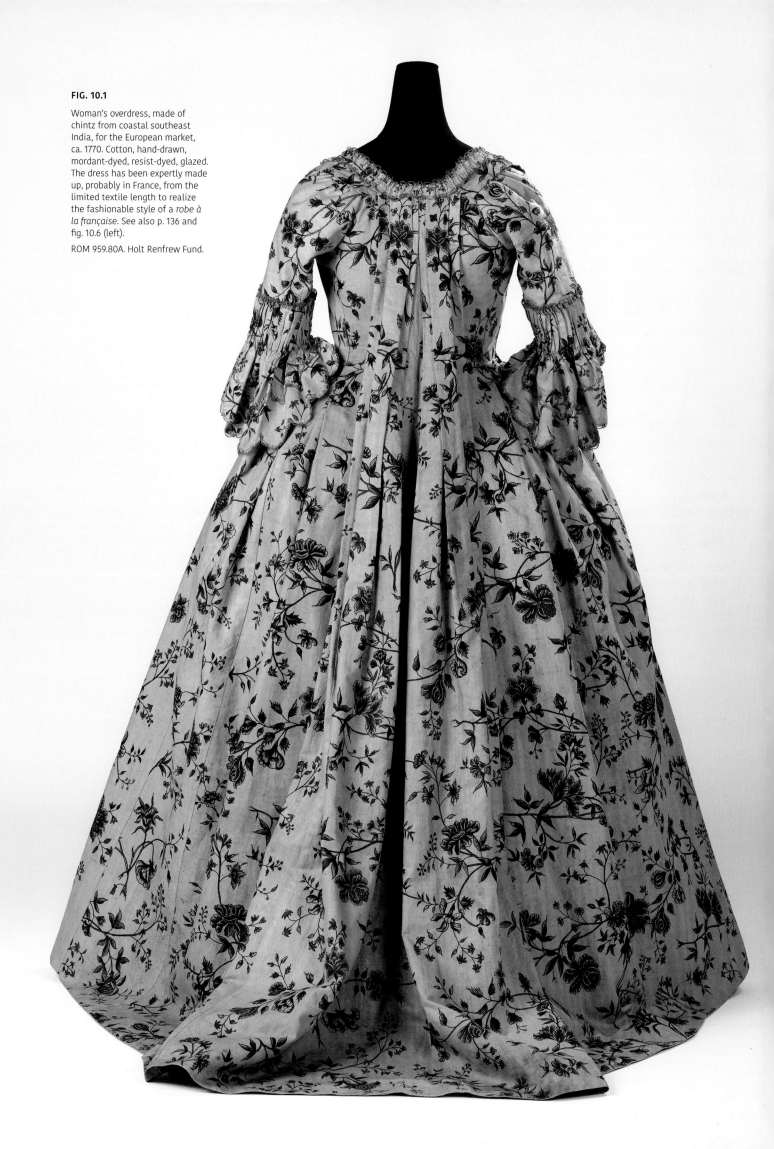

FIG. 10.1

Woman's overdress, made of chintz from coastal southeast India, for the European market, ca. 1770. Cotton, hand-drawn, mordant-dyed, resist-dyed, glazed. The dress has been expertly made up, probably in France, from the limited textile length to realize the fashionable style of a *robe à la française*. See also p. 136 and fig. 10.6 (left).

ROM 959.80A. Holt Renfrew Fund.

Legislated prohibitions in France and England were dropped, and new technological inventions escalated productivity and lowered prices as the cotton industry shifted from a hand art to a mechanized industry (see ch. 1 and 15).[1] By the 1720s, the number of stolen gowns made from printed cotton rose, indicating the market and lucrative profit possible. By the 1750s, "plebeian consumers gradually moved over to cottons and linens for their gowns, it was not the elaborate woven silks of elite fashion they deserted, but cheaper patterned worsteds and silk-worsted mixes"; these accounted for over a third of gowns from the lower classes.[2] Clearly, a distinction must be made between the mass-produced cheaper cottons and those produced for a middle- and upper-class luxury market, which had not only more glorious surface decoration but also a softer surface due to the fine quality of the thread count.[3]

Cleanliness, Colour

Much has been made of chintz's "fastness and luminosity of colour," which survived washing, but how much that actually mattered depended on social class and location.[4] Elite chintz fashions for the West were rarely, if ever, washed. Some garments had interlinings of wool, and most were lined with various qualities and weights of fabrics, ranging from cotton and fustian (linen warp and cotton weft) to silk, making washing impossible without taking the garment apart (fig. 10.6).[5] Historically, clean and white were always a sign of elite refinement and wealth. Clean clothing, in contrast to washing and bathing the body, became part of modern Enlightenment thinking and reflected a knowledge of new medical discourse about the danger of disease and pests.[6]

For centuries, linen chemises and shirts worn next to the body buffered it from chafing caused by tight stays and seams of tailored, close-fitting garments; they absorbed bodily excretions, acting as a protective barrier for the expensive, visible wardrobe. Linen was ideal since the strong fibres withstood the demands of repeated washing, scrubbing, starching, and ironing, making it far superior to cotton for undergarments.[7] In 1731, observers contrasted the ease and results of laundering cotton that looked fresh and clean with the less satisfactory washing of wool that "never looks so clean; or when made dirty, can it so easily be made clean?"[8] It was principally the cheaper, lower-quality chintz goods that were washed when soiled after continual wear and inclement weather. The business of "'d[oing] up muslins'—the curtains, sheets, and garments that took their name from the eastern origins of cotton— was time-consuming and labor intensive."[9] In 1727, Daniel Dafoe condemned calico as "mean . . . and soon in rags," because washing and scrubbing broke down the cotton fibres.[10] Linen for the male shirt and female chemise continued to be the "cornerstone of a new interest in gentility . . . [of] cosmopolitan people on both sides of the Atlantic during the eighteenth century"; it was "an imperial product and the material lingua franca of the Atlantic basin."[11] Cotton's spectacular displacement of linen for shirts and shifts began only in the 1820s, as staggering increased mechanical production in Europe began to "reshape(d) the world."[12]

Merchants and Indian artisans brilliantly composed enticing chintz textiles for specific regional tastes and different budgets. They responded to the rising popularity of cotton in England and France with colourful patterns on white that referenced the exotic, white porcelain grounds of Asian ceramic imports and reflected new socio-cultural attitudes about health, cleanliness, and purity: all clear signifiers of luxury.[13] Scholars attribute the exports of "sad red grounds" to the desires of the Dutch market and can identify specific fashions for dedicated locations, such as Hindeloopen, Friesland (see fig. 10.7).[14] Historian John Styles writes: "The triumph of printed cotton as a gown material for plebeian women resulted . . . from its superior appearance, not its cheapness."[15] The simpler floral patterns and palettes available to the working classes are known to us through documentation in the billet books

ABOVE
FIG. 10.2

European dress back (detail). Coastal southeast India, for the European market, ca. 1770-1775. Cotton, hand-drawn, mordant-dyed, resist-dyed, with design of meandering branches and sprays of flowers.

ROM 934.4.49. Harry Wearne Collection. Gift of Mrs. Harry Wearne.

BELOW
FIG. 10.3

English overdress (detail) in the *robe à l'anglaise* (fitted back) style, ca. 1780. The Indian chintz is designed to emulate the European repeat pattern of woven silks used for fashions or furnishings.

ROM 972.202.12

at the London Foundling Hospital; these recorded the child's sex, any distinguishing marks, and identifying tokens left by the mothers so they might someday reclaim their child. The most common tokens were pieces of textiles from clothing; many were printed, leaving us a unique—and poignant—record of plebian fashion.[16] Printed cotton also held a firm place in upper-middle-class wardrobes, as can be seen in Barbara Johnson's (1738–1825) album of fashion prints from local magazines, in which she pinned swatches and notes about prices and lengths for her formal and informal gowns.[17]

The key appeal of luxury Indian chintz lay in the design and colouration, which "in the premodern era . . . served as the principal marker of status," as demonstrated by two striking informal gowns, cut à l'anglaise (English style with a fitted back).[18] A 1740s overdress, which can also be worn draped à la polonaise, is delicately painted with an exotic floral pattern that only repeats twice across the width of cloth (92.8 cm) (fig. 10.4).[19] It was worn in England by a descendant of the Swettenham family, that was involved in the Staffordshire pottery industry, and it is interesting to consider it in this context, with its porcelain-like ground and painting that influenced the ceramics. The chintz gown is a mark of an upper-middle-class lady of taste.[20] The second dress, indigo dyed and painted with red carnations, has a long, boned, fitted back that demonstrates the evolution of the dressmakers' skills (fig. 10.5). The wrist-length, two-piece sleeves were the height of fashion and a leap forward for dressmakers who were cutting more ergonomic feminine fashions learned from tailored menswear. It was commissioned for the trousseau of Mary Winifred Pulleine, heiress of Roddam, Dissington, and Chirton, who married Walter Spencer-Stranhope of Cannon Hall, Yorkshire, on 21 October 1783. It was one of several "delicate flowered morning gowns" selected in London by her chaperone Mrs. Prades, who sent her client information on the progress of her trousseau via a

> little paper mannequin . . . [that] was manufactured by some clever modiste. Fashioned to resemble the young bride with her pink cheeks, powdered hair and exaggerated hoop, over this could be placed printed paper representation of the various costumes suggested for the trousseau, so that each dress, with the hat appropriate to it, could, in turn be fitted on the little figure, and convey to Miss Pulleine and exact impressing of the effect proposed.[21]

The novel patterns and colours of Indian chintz fashion seen in both gowns record that "by the 1780s the victory of the printed cotton gown was almost complete."[22]

Glazing, Weight, Sound

Elites prized Indian chintz primarily for its look, and it spurred on tailors and dressmakers to adapt and innovate with the new textile that could not be shaped like wool and did not have the hand of silk. The closest experience they had to working with cotton cloth was linen. The beautiful, and exceptionally well-made, robe à la francaise, or sack back (ca. 1770), is an elegant example that highlights the importance of the new patterned cotton and how European dressmakers were required to use it creatively (p. 136, fig. 10.1 and 10.6, left).[23] The dress, fashioned from painted florals with branches of roses, peonies, and chrysanthemums, is glazed. The bodice of the overdress is completely lined with a yellow and grey striped silk taffeta that adds weight and body (see fig. 10.6, left). The importance of drape is reiterated by heavy lead weights, encased in silk taffeta, placed inside the elbow-length sleeves to ensure that they stay demurely down. More importantly, the taffeta provides the sound of luxury: the rustle of silk that heralded the wealthy's arrival—and then how astonishing the surprise must have been at the sight of the woman in her superbly painted imported Indian cotton floral gown, the acme of taste. Similarly, a silk lining has been added to a glazed bodice painted with green stripes (p. 210), a difficult and costly two-step process (blue plus

FIG. 10.4

English overdress in robe à l'anglaise (fitted back) style, ca. 1740s, can also be worn with the skirt gathered up in the back, á la polonaise; made of chintz from coastal southeast India, mordant-dyed and resist-dyed in an exotic, floral rococo style that repeats only twice across the width of cloth.

ROM 967.176.1. Gift of Mr. and Mrs. John Neill Malcolm.

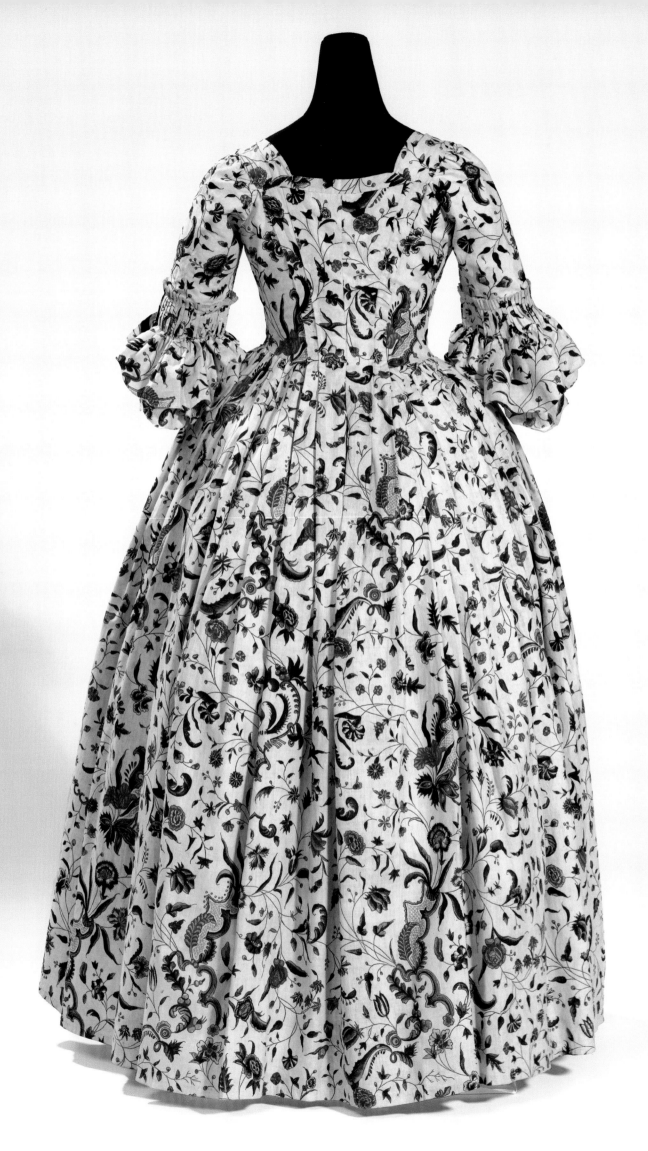

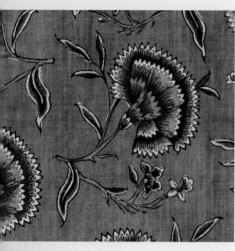

FIG. 10.5

A "delicate flowered morning Gown," made from an Indian chintz of indigo blue with red and pink carnations, with a precisely fitted bodice lined with linen for strength and boned in the elongated back. It was ordered in London for the trousseau of Mary Winifred Pulleine, heiress of Roddam, Dissington and Chirton, for her marriage to Walter Spencer-Stranhope of Cannon Hall, Yorkshire, on 21 October 1783.

ROM 969.85.5

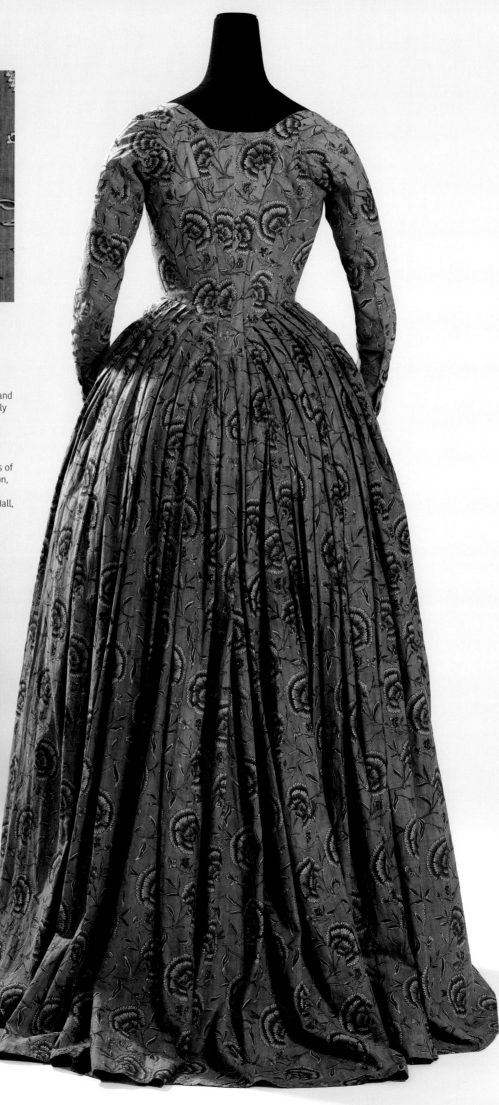

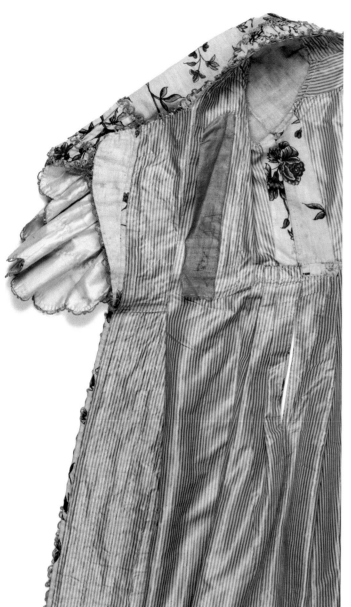

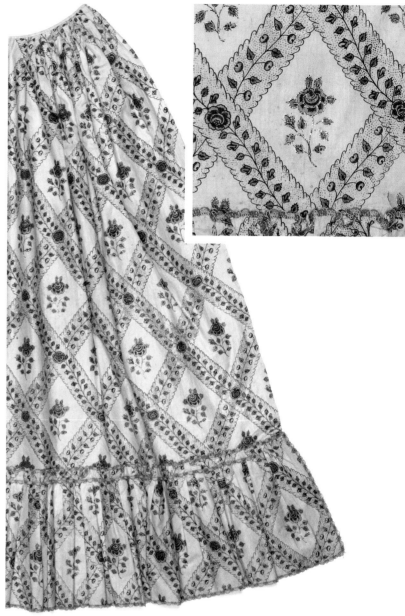

yellow) that has been masterfully controlled in a solid, wide green stripe. It too would have looked and felt remarkable, and been understood by contemporaries as the height of avant-garde luxury.

More costly Indian chintz had a glazed finish (burnished rice starch), which added a stiff, luxurious hand. This made the textile better able to hold form, even without a lining and, for the dressmaker or tailor, offered a more familiar hand, like starched linen or crisp silk. Glazing made the cotton sturdier, though even glazed cotton could barely survive a one-time use for a lining before it wore out, while wool worsteds would wear well for two coats.[24] A glazed finish also provided a surface barrier that allowed easier wiping and repelled stains. Washing would counter the attributes of glazing and is another reason to reconsider the significance of washability as part of the desire for high-end luxury chintz. In addition, the polished glazed surface emulated the light-reflective property of silk and was sometimes further augmented with gilding and silvering (fig. 10.1 and 10.6, right). The identifiable properties of silk—the crisp sound and the glittering appearance—added contemporary taste and ideals of luxury to cotton, a material that responded very well to manipulation.

FIG. 10.6

Western luxury chintz fashions made with linings and interlinings were difficult or impossible to wash.

Left: The striped taffeta lining stiffens the glazed chintz overdress and offers the luxurious sound of silk (see Fig. 10.1).
ROM 959.80A. Holt Renfrew Fund.

Right: Glazing gave the cotton a silk-like reflective sheen and protected the valuable and precious gold or silver painting on the design, seen in the decorative apron.
ROM 934.4.39. Harry Wearne Collection. Gift of Mrs. Harry Wearne.

Design, Redesign

The trade and supply chains by which India produced suitable chintz for Europe were complex, with long timelines—even years—between orders and deliveries.[25] Designing and producing fashionable textiles that incorporated innovation in scale, colours, and patterns for the wide-ranging tastes and national specificities of European markets required imagination and daring in the process of ordering, producing, and delivering textiles.[26] In the 1670s, the consumption of chintz, or *indienne*, was increasingly desired by widening circles of aristocrats and aspiring middle classes, as noted in Molière's often quoted play, *Le bourgeois gentilhomme* (1670), and recorded by Samuel Pepys. While a director of the British East India Company (EIC), he wrote in 1687 that chintz was "the weare of Ladyes of the greatest quality which they wear on the outside of Gowns and Mantuoses, which they line with Velvet and Cloth of Gold."[27] Yet, few examples survive before the second quarter of the eighteenth century, when cotton was sold in all varieties by "many pedlars or petty chapmen [who] sold a wider range of goods. . . . Nancy's chintz gown of 1781 was among the most expensive, five and a half yards, costing £1.14s. The cotton for Mr. Woodforde's morning gowns, for other gowns for Nancy and the maids was cheaper and all about the same price, between 2s and 2s 6d a yard."[28]

A close analysis of three men's "Indian gowns" in the Royal Ontario Museum (ROM) collections offers insight into the links between design, production, construction, and consumption. The unstructured, informal gown to the calf or floor, derived from Asian, Persian, and Indian coats, is known as a banyan, from the word for a Hindu trader from Gujarat, India.[29] It was acceptable attire for conducting private business at home when receiving morning visitors, equals, and inferiors.[30] Wearing a banyan was a clear code for a gentleman and scholar throughout the eighteenth century, as "a man's deportment and gestures are very much conditioned by the nature of his clothes. . . . Easy fitting garments allow freedom of movement and encourage a relaxed posture."[31] The loose banyan helped to induce a freedom of mind and connoted an ideal of intellect associated with ancient philosophers and orators. It was frequently worn for portraiture, as banyans were "like a timepiece capable of shaping its wearer's relation with time," thus preventing the costly painting from becoming dated too quickly.[32] Importantly, the "timelessness" of the banyan, with its untailored cut, insured it would remain in fashion despite the long lag between its commission in Europe and arrival from India, making it an ideal chintz export item.

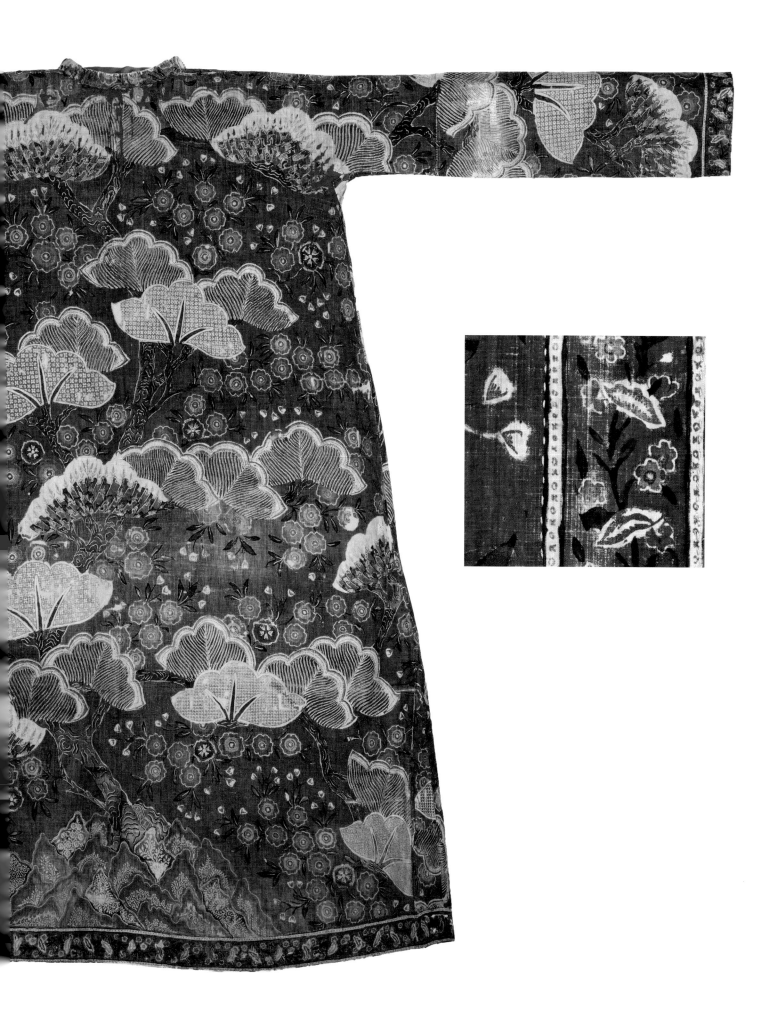

OPPOSITE
FIG. 10.8 (LEFT), 10.9 (RIGHT)

Gentleman's chintz banyans made of Indian chintz from coastal southeast India.

Left, 10.8: The glazed brown, *feuille morte* banyan, ca. 1765-1775, is drawn and dyed with a continuous repeat pattern that reverses on the back as there is no shoulder seam.

ROM 2009.110.1. Gift of the Louise Hawley Stone Charitable Trust and the Textile Endowment Fund Committee.

Right, 10.9: The glazed red ground banyan, ca. 1770, is drawn with the pattern mirrored, or reversed, on the right side; it is lined with plain white cotton.

ROM 2016.43.1. This acquisition was made possible with the generous support of the Louise Hawley Stone Charitable Trust.

The generic T-shape cut was popular until the third quarter of the eighteenth century.[33] The design was usually painted to shape, in garment form, on the textile. It could be shipped as an uncut length, and then taken to the local tailor for making up, or be partially or completely ready-made in India. A red ground Japanese-style banyan acquired by the ROM in 1959 is clearly inspired by the kimono (fig. 10.7).[34] The success of the design is underscored by later alterations; a standing collar has been added and the narrowed sleeves reveal "the shift to slimmer and extra-long sleeves that . . . accentuated the hands," shaping a more "natural," modern Enlightenment body.[35] The green silk lining, much patched and mended, records extensive wear; it adds structure and makes it easy to slip on and off.[36] The lining also protects the chintz, which is painted as a canvas with enormous pine branches and a prunus (stone-fruit tree) that flowers at the end of winter and is a symbol of fidelity.[37] The tree grows from a mound at the back hem and extends over the entire garment. The imagery and symbolism were carefully chosen, as Katharine B. Brett described: "The pine, bamboo and prunus are intermingled under the name 'the three friends,' symbolizing the noble virtues of a gentleman."[38] However, a European design source, not an Asian one, has been identified in a series of French prints, *Livre de designs chinois* (1735), depicting a similar pine tree.[39] Interestingly, this same design source is shared by three other surviving banyans, a textile length, and a palampore, which illustrate how a single chintz design could be easily and economically manipulated for different markets with slight design variations and colouration.[40] For instance, the blue version of the banyan, housed at the Palais Galliera, Paris, lacks the rocky mound on the reverse and has a different variety of motif infills. However, all five textiles were more than likely produced in the same workshop and perhaps by the same hand.

Reutilizing or transferring a design, even to different garment types, was not only practical but also economical for both the merchant and supplier.[41] The flexibility of a single design is seen in another ROM banyan (fig. 10.9) with a dark red ground. The same generic painted pattern can be identified in four other Indian chintz fashions: a banyan held at Historic Deerfield, Massachusetts; a banyan and petticoat at the Fries Museum, Leeuwarden, Netherlands; and an Indonesian baju (jacket) in the TAPI (Textiles and Art of the People of India) Collection, Surat, India.[42] The surface design differences in these five examples lie in the ground colour and modifications of pattern infill; the garments also most likely came from the same workshop that, over decades, modified the pattern design. The centres of the lattice are left blank on the Deerfield banyan and the baju, while they are painted similarly in red, blue, purple, and white on the petticoat and on the ROM banyan. The grounds of the Deerfield banyan and the TAPI baju, which may have been exported as a textile length, are decorated with a scallop-outline motif, while the Friesland petticoat is left plain, and the ROM's banyan is dyed deep and solid red. The red ground of the ROM banyan required a costly Indian dye (chay) and the associated extra washing and bleaching; as a result, its production involved more expense than the seemingly more complex scallop background seen in the Deerfield banyan (fig. 10.10).[43]

Interestingly, the ROM banyan, unlike the Deerfield example, is cut with shoulder seams so that that pattern does not reverse on the back, and it is shaped with narrow arms. A key difference from the other four items is that the left and right fronts have been

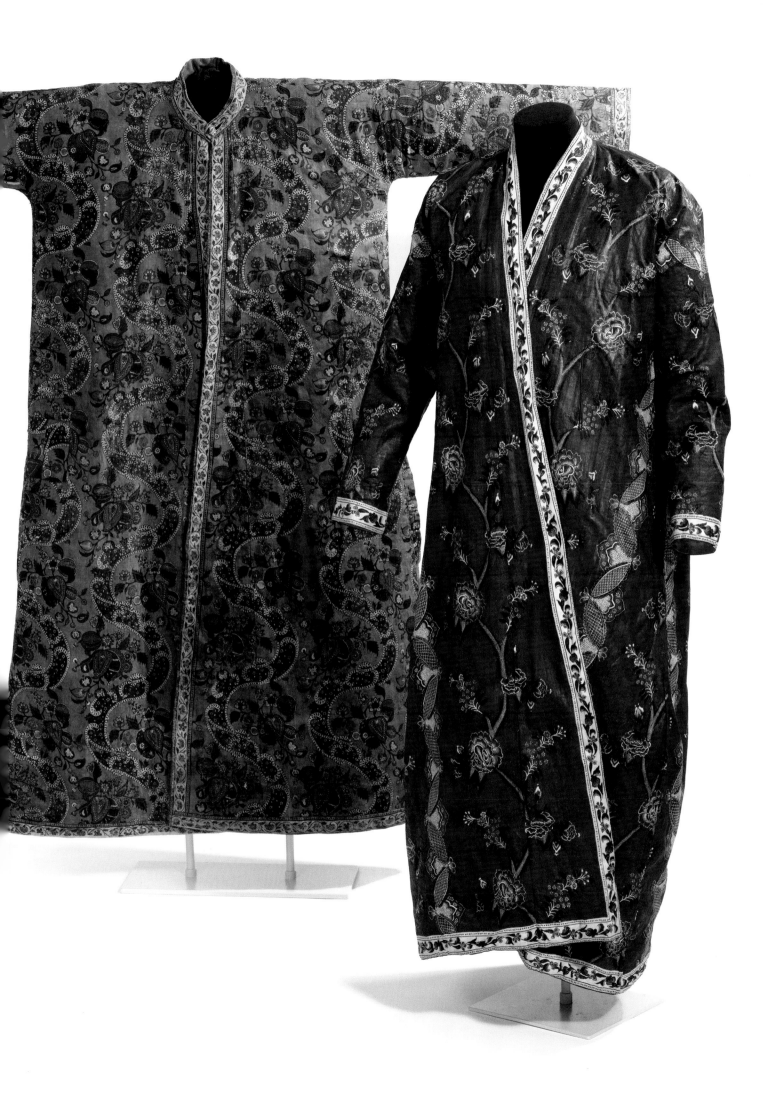

FIG. 10.10

The popular chintz design with a vertically repeated pattern, seen in two men's banyans (top and middle images), and a lady's petticoat (bottom image) from the Netherlands. The textile was very likely made in one workshop and possibly by the same craftspeople.

Top: ROM 2016.43.1. Louise Hawley Stone Strategic Acquisitions Grant.

Middle: Fries Museum, Leeuwarden | Loan of The Ottema-Kingma Stichting

Bottom: Historic Deerfield HD 2000.12. Photograph by Penny Leveritt.

painted symmetrically—mirrored. To achieve this elegant effect, the painter reversed the pattern for the two pattern pieces that make up the right front. The shaped fronts were achieved with a triangular gore painted to shape on the uncut textile with the border, so that it could only be assembled to the left or right front; each is unusable as another part of the garment. When assembled, the pattern is closely matched at the neck and top of the fronts but becomes less aligned as the gore widens toward the hem. This evidence suggests that it was painted entirely to shape prior to assembly. Thus, the ROM banyan is the most sophisticated of the five garments in its overall design and probably the most expensive because it required more steps, planning, and sewing for the final garment.

A mirrored design required ingenuity and preplanning in order to reverse the design on the paper pattern and pounce the same perforated outline on cloth. It was a nuanced change that was technically simple and basically cost-free, and provides clear, visual evidence and that the garment was custom painted and not made from a repeating yardage, adding more exclusivity and status.[44] Mirroring is also seen in the petticoat and overdress of the taffeta-lined two-piece gown that has been made from two different lengths of the same pattern (see fig. 10.1). This decision might have been made to deliberately enliven the ensemble, or perhaps was a mistake by the painter. Brett records that "both are on the same scale, and the variations that occur are incidental . . . since the technique leaves the painter free to add or delete details as he chooses. . . . Probably the design was a popular one which was repeated many times, in this instance with the tracing reversed." She also speculates that there may have been a shortage in the amount of textile available for the dress, since the sleeves have only one ruffle, not the usual three, and the two narrow box pleats at the back have been carefully folded to appear to be full, although they are not. Brett concludes that these clues are all "evidence of a thrifty use of a costly material."[45] The dressmaker was clearly accomplished in order to be able to tease out the dress and petticoat from limited fabric.

A seventeenth-century description of banyan designs in the Netherlands describes, "A Japanese gown with aurora flowers a feuille morte [i.e., colour of dying leaves] background, padded on the inside with wadding and completely lined with light blue taffeta"; this describes a style worn into the eighteenth century, similar to another glazed chintz banyan in the ROM (fig. 10.9).[46] The large curvilinear purple meander emulates a lacey strap work, and the white outlines are so clear against the dusty, almost golden ground, that they might have been mistaken in candlelight for gilding. Since the banyan is cut without a shoulder seam, the pattern reverses on the back body. Because the surface design is almost symmetrical, it is not noticeable that it is upside down, and, as other examples document, this was a very acceptable practice at this time.[47] The range of materials used, including silk construction thread, clearly indicates it was made up in Europe from Indian banyan yardage, complete with painted borders for the front, cuffs, and collar.[48] The borders are clearly defined and organized, with black lines inset with common, quick markings of x's and o's that frame the floral and that formed part of the century's design language. The integrally painted borders at the edges of banyans and petticoats were a defining detail of Indian chintz fashions, signifying its purpose for a specific imported garment that framed the wearer (see border details on fig. 10.7, 10.8, and 10.9).

Painting Indian chintz for European fashion in the eighteenth century required an acute understanding of taste within wide and varied markets. Designers and producers knew how to design clearly recognizable motifs that created value for the transported goods, while economizing on a pattern and the skills of the painter who learned the design. The surviving fashions leave a small trace of the enormous production that modified trusted patterns for new fashions and lengths of yard goods for beautiful, luxury fashions engineered to flatter and appeal to European elites.

1 Kawakatsu, *Lancashire Cotton Industry*, 59.

2 Styles, *Dress*, 113.

3 For a discussion of comparative thread counts, see Kawakatsu, *Lancashire Cotton Industry*, 59.

4 For debate on whether washing improved colour. See, Irwin, "Origins of 'Oriental' Chintz," 87. John Irwin and Katharine B. Brett (*Origins of Chintz*, 1) wrote that there is no evidence for this. Questions remain if it was the price or quality of Indian chintz that made it attractive in different times and places. See, e.g., Irwin and Schwartz, *Studies*, 51; Crill, "Asia in Europe," 269; Parthasarathi, *Why Europe Grew Rich*, 34–37.

5 From 1721 to 1774 weaving cotton in England was banned, unless woven with a linen warp (fustian).

6 McNeil, "Appearance of Enlightenment," 395–96; Miller, "Europe Looks East," 157.

7 Brown, *Foul Bodies*, 261.

8 Fayrer Hall, *The Importance of the British Plantations in America to this Kingdom* (London: J. Peele 1713), 10–11, quoted in Styles, *Dress*, 114.

9 Brown, *Foul Bodies*, 261.

10 Quoted in Styles, *Dress*, 130; Brown, *Foul Bodies*, 261.

11 Brown, 98–99, 358.

12 Styles, *Dress*, 130; Beckert, *Empire of Cotton*, 40, 44.

13 Miller, "Europe Looks East," 157; McNeil, "Appearance of Enlightenment," 395–96; Vollmer, Keall, and Nagai-Berthrong, *Silk Roads*, 131.

14 Irwin, "Origins of 'Oriental Style,'" 109; Irwin and Schwartz, *Studies*, 17; Irwin and Brett, *Origins of Chintz*, 4; Crill, "Asia in Europe," 267.

15 Styles, *Dress*, 127.

16 Styles, 114–23; see also Styles, *Threads of Feeling*.

17 Rothstein, *Barbara Johnson's Album*.

18 The quotation is from McNeil, "Appearance of Enlightenment," 396. This contradicts Irwin and Schwartz, *Studies*, 51.

19 See ROM registration records series 167.176.1–4, 10 July 1967. The donation included a white satin damask formal Spitalfields overdress and skirt panel (ca. 1750), a quilted silk informal jacket, and an embroidered muslin kerchief, all brought to Canada from England. Irwin and Brett, *Origins of Chintz*, 121, no. 152, plate 134, colour plate 6.

20 See ROM 967.176.1 registration records for provenance.

21 Three of the "dolls" survive in Barnsley Museums, United Kingdom (A.320.001 inv.2008, A.320.002 inv.2008), as well as the silk wedding dress woven with lovers' knots (A.318 inv.2010) and a silk dress (A319 inv.2010).

22 Styles, *Dress*, 126.

23 Irwin and Brett, *Origins of Chintz*, 123, no. 161, plate 142.

24 *Trade of England Revived*, cited in Styles, *Dress of the People*, 130.

25 Giorgio Riello notes the time lag between a letter sent and receiving a decision back to avoid overstocking and concern over suitable goods; this timing forced traders to tread a tightrope between novelty and obsolescence. See Riello, *Cotton*, 93, 96.

26 On product customization, see Riello, "Indian Apprenticeship," 335.

27 EIC letter quoted in Irwin and Brett, *Origins of Chintz*, 30. They also note that the ascent to the throne of William and Mary in 1690 gave impetus to Dutch fashions in the UK.

28 Rev. James Woodforde, *The Diary of a Country Parson*, 1758–1802, ed. John Beresford, 5 vols. (London: H. Milford: Oxford University Press, 1924–1931), quoted in Buck, *Dress in Eighteenth-Century England*, 177.

29 Das, "Banyans"; Thunder, "Object in Focus"; Lemire, "Fashioning Global Trade," 373–75.

30 De Marly, *Fashion for Men*, 65.

31 Byrde, *Male Image*, 144.

32 Gernerd, "*Têtes* to Tails," 47–48.

33 Swain, "Nightgown," 10–11; Fennetaux, "Men in Gowns," 78–79.

34 Brett, "Recent Additions," 56–57; Brett, "Japanese Style"; Irwin and Brett, *Origins of Chintz*, 30–31, 57, plate 96; Breukink-Peeze, "Japanese Robes"; *Japonism in Fashion*, 34–38; Peck, *Interwoven Globe*, 263–64; Lemire, "Domesticating the Exotic," 76–77.

35 McNeil, "Appearance of Enlightenment," 394.

36 Saint-Domingue inventories, 1760–1774, records morning gowns were of "waning interest: Not only did less than an eighth of men own one, but many were 'very bad,' 'worn out,' or 'torn,' just two 'new.'" DuPlessis, *Material Atlantic*, 177.

37 Pascale Gorguet-Ballesteros notes the pine is a symbol of fidelity in Japan; see "Inde, Japon, Europe," 135.

38 Irwin and Brett, *Origins of Chintz*, 108; see also Brett, "Japanese Style."

39 Hartkamp-Jonxis, *Sitsen uit India*, 72.

40 Fries Museum Leeuwarden, Netherlands, T2016-038; see Arnolli et al., *Sits, katoen en bloei*, 84–87; Rijksmuseum, Amsterdam, banyan (ca. 1725–1749), BK-1980-99, in Hartkamp-Jonxis, *Sitsen uit India*, 72–73; Palais Galliera (Musée de la Mode de la Ville de Paris), Paris, India Chintzes, banyan, GAL 1920.1.2039. See also Musée d'Impression sur Etoffes, Mulhouse, France, palampore, MISE 986.50.2, painted with flowering prunus motifs illustrated in Jacqué and Nicolas, *Féerie indienne*, 144–145.

41 John Irwin and Katharine B. Brett explain how petticoat material was used for a coverlet and a cope (*Origins of Chintz*, 32).

42 Historic Deerfield, MA, banyan, HD 200.12; Fries Museum, Leeuwarden, banyan, 2016-038, petticoat (ca. 1775), 1956-485; Indonesian baju in TAPI Collection, Surat, 02.161; see Shah, *Masters of the Cloth*, fig. 15.

43 Hartkamp-Jonxis, *Sits*, 204; Maeder, "A Man's Banyan." The Deerfield banyan has a seemingly more complex patterned ground than the ROM example (fig. 10.9) but is simpler in conception. It is painted to shape, cut, and sewn in a T-shape, without shoulder seams, so the pattern is reversed on the back. It is unlined and sewn with cotton thread, indicating that it was assembled in India. The same pattern is applied to an undyed white ground with a deep border painted as a straight length for a petticoat, which would have been fashioned with front pleats and a gathered waistband (Fries Museum, Leeuwarden, 1956-485).

44 Mirroring had been employed in woven goods that demanded a far more complex set-up, as recorded in a ca. 1700 description of a damask silk banyan; see Miller, "Europe Looks East," 163.

45 Brett, "Recent Additions," 54–55.

46 Description quoted in Breukink-Peeze, "Japanese Robes," 56; see also another possible example of the *feuille morte* ground, Rijksmuseum, Amsterdam, BK-NM 8247.

47 See ROM 909.33.1, banyan made from silk reused from a woman's gown; on the back, the pattern is reversed on one side.

48 The glazed blue wool lining is interlined with wool for warmth. The sleeves and pockets are lined with linen. The pocket facings are fustian (cotton weft, linen warp). Both would wear well. Thanks to Anne Marie Guchardi, Conservation, for the textile analysis.

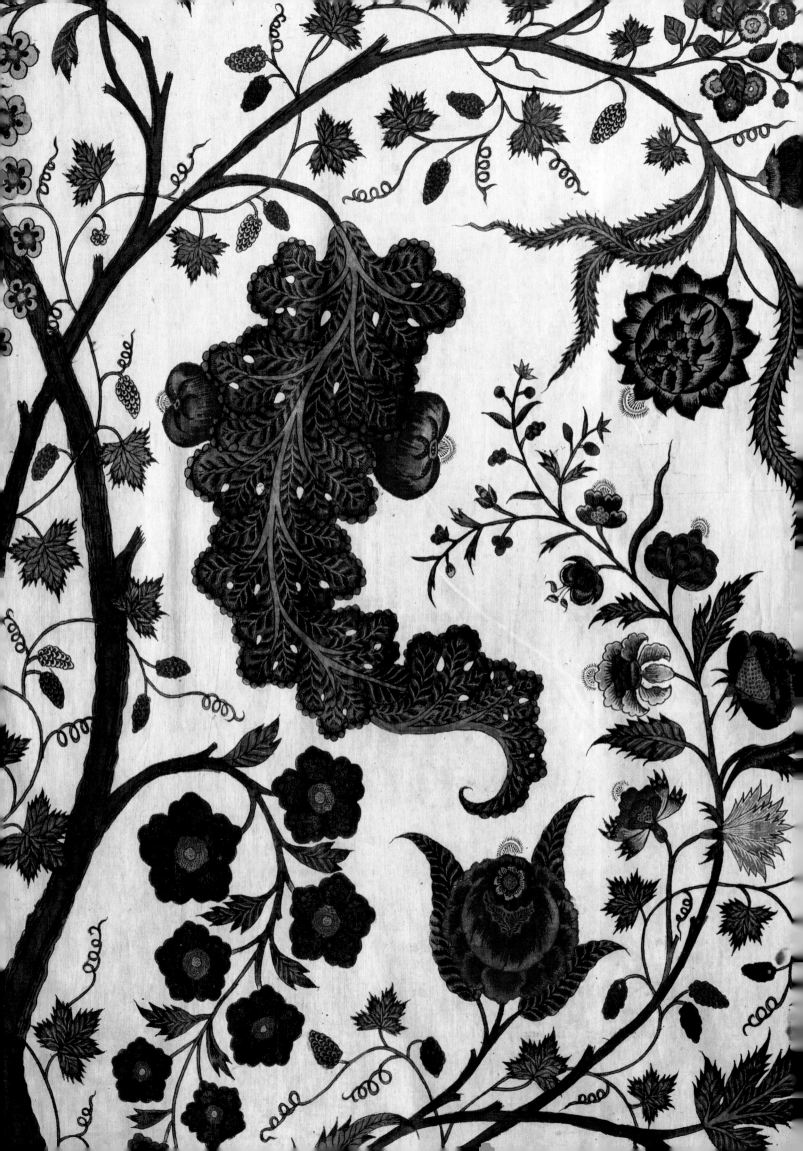

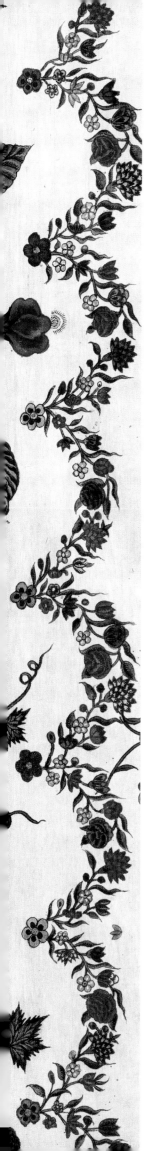

11

THE FLOWERS OF INDO-EUROPEAN CHINTZ

DEBORAH METSGER

F LOWERS ON INDO-EUROPEAN CHINTZ IN THE EIGHTEENTH CENTURY must be considered in the context of the rise in popularity of plants, flowers, and gardens in Europe. This was the era of trade, empire building, and exploration, during which natural historians travelled the globe, returning with vast quantities of plants previously unknown to Europe, elevating botany into a science that became quite distinct from medicine.[1] The Swedish botanist Carl von Linné (Linnaeus) revolutionized the process of identifying and naming plants by using a sexual system of classification and a binomial nomenclature whereby plants were assigned a generic name and a species name.[2] As botanical gardens in Europe expanded in number and in size to grow and describe plants, so too did their distribution and cultivation of exotic plants for science, commerce, and pleasure.[3] This was the "Golden Age of Botanical Illustration," when illustrators and flower painters were in high demand to document the new plant discoveries, and popular botanical books and magazines proliferated.[4] Enthusiasm for

Detail: Hanging (palampore), coastal southeast India for the European market (ROM 961.7.6).

BELOW, TOP
FIG. 11.1

Detail of a hanging (fig. 4.2). This cone-shaped boteh motif, resembling a serrated paisley or palm fruit, is depicted at the base of the columns.

BELOW, BOTTOM
FIG. 11.2

Detail of a textile length. Made in India for the European market, first quarter of eighteenth century. Cotton, drawn mordants and resists, dyed, 43.4 × 29 cm.

Though modified in proportion and colouration, this plant, with its many pointed petals, round, peltate leaves (joined in the middle), and bristly stems, has the features of sacred lotus (*Lotus nucifera*)—not a peony, as it has been called.

ROM 934.4.57. Harry Wearne Collection. Gift of Mrs. Harry Wearne.

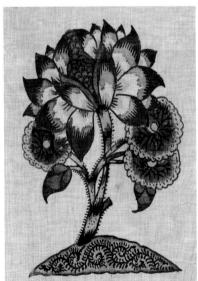

flowers and gardens was everywhere. Western European consumers craved floral Indian chintz as much as ever, even in France and Britain where formal legislation had prohibited the import and use of Indian chintz as dress or furnishing from 1686 (see chapters 1 and 15).

In the seventeenth century, directors of the British East India Company (EIC) began to closely monitor chintz making, responding to metropolitan fashion trends by instructing their agents in India to "modify patterns according to English taste" (see ch. 9).[5] In general, the flowers for "English taste" included those that were domestic and familiar—rose, tulip, dianthus, narcissus, morning glory, peony, prunus, chrysanthemum, and marigold; all of these, by the seventeenth century, had become common in European gardens and florilegia, were used in embroidery, and later were seen on exotic wallpapers (see ch. 9 and 12).[6] These species already formed a mainstay of the Indian-textile floral palate, having been part of repeated cross-cultural exchanges between India, Europe, and Asia that contributed to the development of the Mughals' naturalistic style.[7] Despite the rich literature on Indian chintz, little is known about the original designs, as none of the early pattern musters survive,[8] and there is no record of the artists who painted them.

Royal Ontario Museum (ROM) curator Katharine Brett's groundbreaking work in identifying flowers on Indian chintz and other textiles linked floral motifs, patterns, and designs to their sources.[9] One of her most cited works examines a palampore (fig. 9.17) decorated with bouquets copied from *The Twelve Months of Flowers*, an innovative nursery catalogue published by Robert Furber in 1730.[10] Brett painstakingly matched the flowers in each bouquet to their source plates (fig. 9.18), analyzing the quality and comparability of the composition created by the chintz painter.[11] Building on Brett's work, art historians have since linked eighteenth-century floral patterns on European porcelain, printed cottons, and silks to botanical illustrations by prominent natural historians and artists, including Jean Lamarck (fig. 16.2) and Maria Sybilla Merian.[12] The English silk designer Anna Maria Garthwaite based many of her very precise botanical designs on Merian and other sources, often using a single element from an illustration, such as a leaf or a flower, rather than copying the whole thing. Other designers would adhere to botanical accuracy while shifting the perspective of the illustration to achieve their own designs.[13] Perhaps future research will link more floral motifs on Indian chintz to published botanical works.

For a botanist, such as myself, identifying flowers on Indian chintz, or any textile, requires observing them through several different lenses. The aesthetic lens recognizes decorative motifs, like the palmette, the boteh (fig.11.1) or the acanthus leaf, which were derived and simplified from plants in nature and have been passed down and reinterpreted between artisans, cultures, and continents throughout history.[14] The botanical lens examines plant morphology (form), assessing the shape, number, and arrangement of component parts in an analytical way and comparing them to known plants (fig. 11.2). A third lens, which botanists often refer to as the gestalt[15] or jizz, is an immediate overall impression or pattern recognition based on experience, which conjures what something "is" or has the "shape of" (fig. 11.3 a and b). It is this third lens that provides the starting point for an identification of another type of floral motif ascribed to Indian chintz: the seemingly "imaginary" or "fantastical" flowers.

In addition to orders for "English taste," EIC officials periodically requested Indian chintz made "in the Country Fashion."[16] For these pieces, Indian artisans were asked to run with their imagination and create exotic patterns, "good brisk colours, the works of any sort of rambling fancy's of the country, but not English patterns (fig. 11.4; see also fig. 9.3 and 10.4)."[17] Much less scholarship has been devoted to examining these types of floral motifs. It is easy to assume that, because these flowers and fruits are not naturalistic in style or readily matched to recognizable species or classic motifs, they are entirely fictitious constructs. However, my research on extant objects at the ROM and observations from the

literature suggest otherwise. These forms seem to be inspired by nature but move away from it as either abstract renditions of individual plants (fig. 11.4) or as composites of multiple unrelated plant parts (p. 150). These flowers are vibrant, with much movement, energy, and detail. Though unreal and fanciful, aspects of their form and composition can readily be related to real plants (fig. 11.4, floral details). Where did chintz artists draw inspiration for their "fancy's"? Was it simply a case of randomly taking plants apart and rearranging them in novel ways, as has been done for the flowering-tree motifs on palampores (see ch. 9),[18] or perhaps a purposeful creation, like the paradisiacal flowers that surpass the laws of nature on the Taj Mahal?[19]

I would conjecture that the so-called imaginary flowers of chintz draw on the designer's experience of the rich flora of the Indian subcontinent and elsewhere—both in nature and in art.[20] Artists combined morphological features—or their sense of them—from a range of different flowers and leaves, and embellished them to create hyper-real flowers and fruits. The appeal of these imaginary flowers is heightened by the natural elements they contain: pistils with feathery stigmas, exsert stamens, whorls of petals or tublular corolla lobes in patterns and numbers true to nature. In an odd way, they bring us closer to the real plants and flowers by constantly keeping us guessing what they are. Few eighteenth-century ROM chintz pieces depict imaginary flowers on their own but instead pair them with stylized versions of real species—both those familiar to Europeans, such as fritillary, and exotics, such as cashew (fig 9.1, top detail) that were brought to India much earlier. Collectively, this artistic strategy quite successfully presents the requested "rambling fancy's of the country."

Meriting further research is the tantalizing conjecture by some scholars that the same Indian artisans who painted Indian chintz were later hired by the East Indian companies' botanists and others to create botanical illustrations for their publications on Indian flora.[21] Little is known about these anonymous illustrators, except that they were from southern India and received training from the companies.[22] Some may have first transitioned from working on cloth to manuscript illustration.[23] Their early illustrations of Indian plants were

ABOVE, LEFT
FIG. 11.3A

Detail of a palampore border (fig. 9.15). The inner guard motif, originally catalogued as an "upright pointed leaf pattern," in actuality has the shape of the fruit of plants in the geranium family (Geranicaceae).

ROM 962.107.1. Gift of Mrs. A. Eecen-van Setten.

ABOVE, RIGHT
FIG. 11.3B

Many species in the geranium family are called cranesbill, after their fruits, which, like those shown here, have an elongate, persistent style that looks like the bill of a crane.

Plate 778 from James Sowerby, *English Botany; or, Coloured figures of British plants, with their essential characters, synonyms, and places of growth : to which will be added occasional remarks*, vol. xi. London: Printed for the author, by J. Davis, 1800.

ROM Library and Archives. Gift of Dr. Noel Hynes.

FIG. 11.4
Detail of a palampore, designed in the "country fashion," 1700–1750. Cotton, hand-drawn, mordant-dyed, resist-dyed.

ROM 934.4.21. Harry Wearne Collection. Gift of Mrs. Harry Wearne.

RIGHT
Top row: The purple chintz flower (left) has petals splayed backward; its white stamens surround its style, topped with a whorl of stigmas that rise high above the flower. It is a stylized version of the elephant apple, *Dillenia indica* (right), native to India.

Bottom row: The shape and reflexed orientation of the petals on this chintz flower (left) match those of the flame lily, *Gloriosa superba* (right), native to India.

Illustration courtesy of the Board of Trustees of the Royal Botanic Garden Edinburgh.

BELOW
Detail showing stylized yet discernible flowers, including clematis, poppy, cotton?, elephant apple, and flame lily.

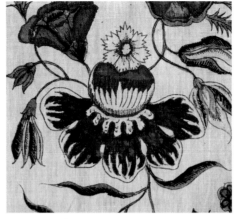

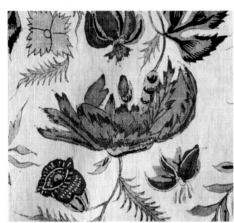

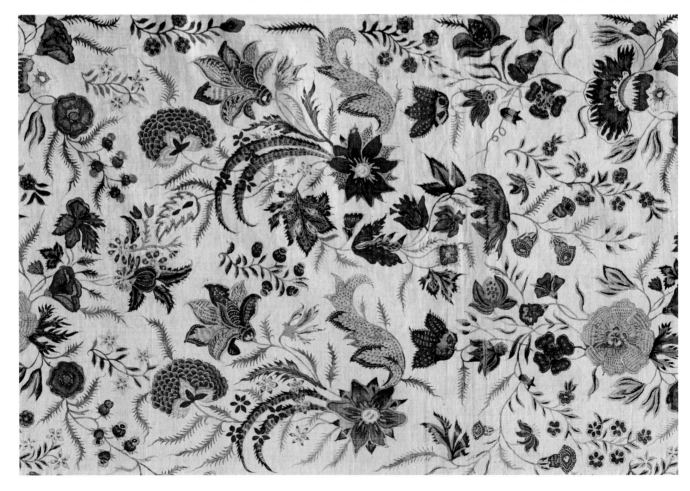

criticized by European botanists for being imprecise and heavy. Later works, which included the desired scientific details, are praised not only for their beautiful rendering but also for their hybrid style and vivid colours, which give them a hyper-realism characteristic of the Mughal miniatures.[24] These paintings, like the chintz flowers, exemplify the tremendous skill and artistic heritage of Indian artists in copying and portraying plants and nature.[25]

Whether imagined, copied, exotic, or domestic, the flowers on Indo-European chintz all burst with energy, stimulate our curiosity, and encourage cross-disciplinary scholarship by botanists and art historians. Such collaboration will hopefully reveal more about the origins of these floral motifs and the artists who created them.

1 For discussion of the links between botany, trade, and the geopolitical world of the eighteenth century, see Batsaki, Burke Calahan, and Tchikine, *Botany of Empire;* Kumar, "Botanical Explorations."

2 Stearn, "Introduction," 3; Wagner, "Flower Gardens," 18; Knapp and Magee, Introduction to *Flora*, 15.

3 Beattie, "Thomas McDonnell's Opium," 171–72.

4 Eisley quotation in Reddy, "*Ars botanica*," 15. "The very close link between the science of botany and the artists who depicted plants resulted in ever greater demands for minute accuracy." Hulton and Smith, *Flowers in Art*, x. "The purpose of botanical illustration is to further the understanding of the science, to provide the botanist, physician and gardener with an aid in identification. The beauty expressed in many of the drawings has always been secondary to the function of capturing the essence or character of the plant itself and thereby developing knowledge of the plants as a whole." Knapp and Magee, introduction to *Flora*, 12. See also Wagner, "Flower Gardens," 19. "*The Botanical Magazine* (also known as *Curtis's Botanical Magazine*), founded in 1787 by William Curtis of London, provided a means for the less affluent household to possess beautiful pictures of plants in cultivation that had previously only been affordable to the wealthy." Knapp and Magee, 19.

5 Irwin, "Indian Textile Trade," pt. 1, 14.

6 Florilegia were books that provided portraits of plants in private gardens and elsewhere; Wagner, "Flower Gardens," 18, 23; Digby, "Elizabethan Embroidery," 40–43. Peter Stent's *Book of Flowers* is an example of the many embroidery-pattern books that reprinted plates from natural history illustrations.

7 Vijay Krishna writes that "flowers commonly used in the Indian textile designs seem to have been borrowed from the long established Persian carpet motif" ("Flowers," 2). On the Mughal style, see Singh, *Real Birds*, 6, 9, 21–29; J. P. Losty, "Mughal Flower Studies and

Their European Inspiration," *Asian and African studies Blog*, British Library, last modified 14 March 2014, https://blogs.bl.uk/ asian-and-african/2014/03/mughal-flower- studies-and-their-european-inspiration. html. A vase of flowers in marble relief on the dado of the Taj Mahal tomb chamber, begun 1631 (Agra artist, ca. 1810–1815, add. or. 1771), is matched to Collaert, *Florilegium*, 555.d.23(3), plate 3; Koch, "Flowers." "The Mughal artists did not only copy flowers from European herbals. They also adopted the composition in the rendering of a flower, the use of front and side views of blossoms, the progression from bud to full blossom on one plant, and the arrangement of the blossoms to display the botanical details of stamen and carpels" (28); Irwin and Brett, *Origins of Chintz*, 16.

8 Irwin and Brett, 9.

9 Brett, "Chintz"; *Bouquets in Textiles*; "Variants."

10 Brett, "English Bouquets." See also Irwin and Brett, *Origins of Chintz*, plate 76, no. 79; Brett, "English Source"; "The Catalogues of Robert Furber," *The Gardens Trust* (blog), 23 January 2016, https://thegardenstrust. blog/2016/01/23/the-catalogues-of-robert- furber/.

11 By comparing the flowers in each section of the piece, Brett was able to determine that there had likely been two different artists: one for the body of the piece and one for the border. She attributed omissions and errors in interpretation of the flowers to the artists' lack of familiarity with the printing technique used to produce the muster, and especially with the flowers themselves.

12 Baer, "Botanical Décors," 90, plate 82; Browne, "Influence," fig. 8–13, 21, 22.

13 Browne, "Influence," fig. 11.

14 Christie, *Pattern Design*, 111–19.

15 From the German *gestalt*, meaning "shape, figure, or form." Wikipedia, s.v. "gestalt," last modified 21 February 2019, https:// en.wiktionary.org/wiki/gestalt.

16 Irwin, "Indian Textile Trade," pt. 1, 15.

17 Baker, *Calico Painting and Printing*, 1:34.

18 Unlike animals, which are nearly always observed as single organisms, plants grow in a progression of stages from vegetative to flower, to fruit—often observed independently of each other. This progression makes it easy for the artist to use pieces from different species of plants to reconstruct a new and fanciful entity.

19 "They handled their models quite freely, however, juxtaposing botanical species with imaginary flowering plants or creating hybrids of the two. These were perhaps meant to represent a realistic but unworldly paradisiacal species outside the laws of nature." Koch, *Complete Taj Mahal*, 218–19.

20 Irwin and Brett, *Origins of Chintz*, 9. I am implying not that chintz painters drew directly from nature, but rather that the experience of real plants and of patterns in nature influenced the development of the initial designs.

21 Noltie, "Moochies," 42; Raj, "Jardin de Lorixa," 52; Lambert, "Hands," 87, 88; Noltie, "Artists," 15.

22 Reddy, "Introduction," 15, 16.

23 Raj, "Jardin de Lorixa," 53.

24 Mabey, "Growing Together," 235.

25 The ink and watercolour illustration over pencil of *Gloriosa superba* (fig. 11.4) was created for the Scottish physician and botanist Hugh Francis Clarke Cleghorn in 1846 by an unknown Indian artist. It is one of thousands of botanical illustrations produced by anonymous Indian artists for European botanists who were documenting the Indian flora; Noltie, "Copying," 31–35.

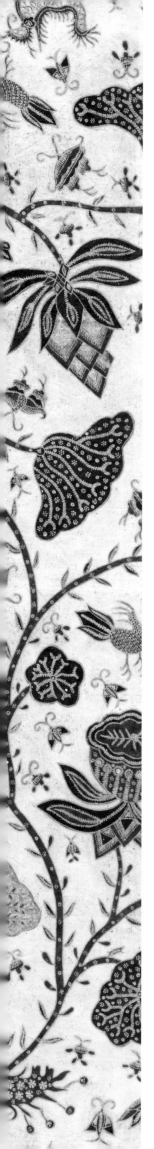

12
—

THE FLOWERING FAMILY TREE OF INDIAN CHINTZ

REGIONAL TEXTILE AND DRESS ARTS

SARAH FEE

THE GLOBAL DESIRE FOR INDIAN CHINTZ DID NOT END WITH NEW fashions, furnishings, and sacred objects entering vast social and geographical spaces. Rather, this "unsettling textile," as Beverly Lemire has called it, inspired emulation and imitation most everywhere it went.[1] Like China's porcelains, India's painted and printed cottons "triggered translations that were a tribute to the potency of the decorative merchandise itself."[2] Artisans admired the materials, techniques, and design of Indian chintz. Foreign merchants appreciated that half of the cloth's value lay in the painted or printed embellishment, while some foreign governments bemoaned trade imbalances with India. For all these reasons, cotton-printing workshops, some state sponsored, emerged by the 1500s in Iran, the Levant, and the Middle East.[3] In the 1600s, workshops likewise appeared in Europe. Award-winning works by economic historians have recently reminded new generations that Europe's efforts to imitate and supplant Indian cottons—chintz in particular—became the "launching pad"

Detail: Batik sarong from the North Coast of Java, Indonesia (p. 162).

OPPOSITE
FIG. 12.1

Ceremonial wrapper (*dodot*).
Central Java, Indonesia. Early
twentieth century. Cotton, hand-
drawn (*tulis*), resist-dyed batik,
358 × 214 cm.

The rich brown and deep blue
colours are characteristic of
batik made in the royal courts of
central Java.

ROM 2011.73.8. Gift of Rudolf
G. Smend.

for Britain's broader Industrial Revolution, in turn stimulating industrialization in Europe, the Americas and Japan.

As significant and worthy of attention are the domestic textile arts and regional "folk" dress traditions that have been intensely shaped by India's painted and printed cottons. Mindful of the difficulty in unpacking long-entangled traditions to trace origins and interactions—"the vexed question of the flow of influences," as John Guy terms it[4]—this essay presents examples from Southeast Asia, Africa, the Pacific, Europe, and the Americas that have well-documented relationships to chintz, whether directly with the Indian originals or via other branches of the "family tree," notably Indonesia's wax-resist batik.

"Exuberant and Defiant": Indonesia's Resist-Dyed Cottons

As observed in earlier chapters of this volume, maritime Southeast Asia—today's Indonesia in particular—was one of the oldest and most ardent importers of Indian textiles. Although India's artisans had to adapt their cloth to meet Indonesian tastes, Indian trade textiles arguably had an even more powerful impact on Indonesia's domestic textile arts. The first was India's double ikat silk *patola* cloths, costly luxuries that greatly influenced Indonesian handweavers. The second was Indian chintz, which likewise offered "inspiration for the development of local design,"[5] particularly for fluid media.[6]

The most striking, enduring, and large-scale of Indonesian traditions "intimately connected with Indian chintz" is the batik cloth of Java.[7] This resist-dye technique involves applying wax to the surface(s) of a cotton cloth, followed by dipping in dye baths. Although scholars continue to debate the origins of the batik technique—a term of Indonesian origin—they concur that the Javanese had, by the twelfth century, developed a unique system of hand drawing (*tulis*) wax on cotton cloth, using a special copper pen (*canting*) by the early 1600s.[8] At this time, the art greatly expanded to "deliberately imitate the prestigious imports" of Indian chintz.[9] So successful was Javanese batik with local consumers that Dutch colonial authorities were unable to suppress its production in order to prop up sales of their own imported Indian cottons.[10] By the eighteenth century, three types of production flourished in Java: royal court workshops, export textiles for Sumatra, and imitation of Indian chintz—with grids, diapers, and scrolling florals[11]—what the Dutch called "counterfeit Coromandels." As with many imitations of Indian chintz before and after, colour proved the downfall of this last category: the colours bled. From 1820, batik was newly invigorated when laws restricting some royal motifs were lifted. To meet mass demand—and to compete with new industrial imitations imported from Europe—Javanese workshops invented copper blocks (*cap*) to stamp wax. The hundreds of commercial operations that arose—overseen by Chinese, Dutch, Arab, Javanese, and mestizo women and men—displaced both Indian chintz and European industrial imitations of Indonesian batik.[12] Recognizing defeat, European traders carried the latter to other markets, most fatefully to Africa (see "African Prints," p. 164).

Although stimulated and shaped by Indian chintz over centuries, Javanese batik represents a unique textile art in terms of technique, design, and palette. Women have been the main practitioners and entrepreneurs in Java. The copper pen, printing blocks, and wax recipes of Java are novel, as is the unmistakable colouring derived from regional sources: mellow browns from the *soga* plant (*Maclura cochinchiensis*) and vibrant "Lasem red" from local varieties and recipes of *Morinda citrofolia*. Batik designers further generated "a unique ornamental style by harmoniously blending the introduced forms with local imagery"[13] (fig. 12.1). Inland Islamic courts combined Buddhist, Hindu, and Islamic elements, further "adjusted to existing Javanese worldview," for instance reinterpreting chintz motifs as local sacred signs;[14] they reconfigured the flowering tree so that it "surpassed the Indian prototypes in popularity."[15] The cosmopolitan north coast, meanwhile, generated designs all at once "exuberant and defiant" and "extremely hybrid—a mélange of European, Indian,

BELOW
FIG. 12.2

Sarong, North Coast of Java, Indonesia, 1870–1880. Cotton, natural and synthetic dyes, hand-drawn (*tulis*), resist-dyed, gilded, 107 × 205 cm.

Earlier Indian-chintz-inspired florals became fashionable again in the 1870s. The deep green dye suggests the piece was made in the workshop of Indo-European batik entrepreneur Carolina Josephina von Franquemont.

ROM 2011.73.16. Gift of Louise Hawley Stone Charitable Trust.

OPPOSITE
FIG. 12.3

Ceremonial cloth (*sarita*) (detail and overview), Toraja people, Sulawesi, Indonesia, twentieth century. Cotton, mordant-dyed, 490 × 25.5 cm.

Like many *sarita*, the piece features local signs of prosperity, such as water buffalo.

ROM 980.213.1. Gift of Mrs. Diane Daniel.

Chinese, and Javanese motifs" taking inspiration from sources as varied as imported porcelains to Grimm's fairy tales, and further embracing early synthetic dyes, notably soft pastels.[16] Interestingly, from the 1850s, eighteenth-century Indian chintz florals again became fashionable as design in Java's north coast batik (fig. 12.2).[17]

Indian chintz imports have been further linked to a small but immensely meaningful historic practice on a neighbouring island. In the central highlands of Sulawesi, Toraja women made sacred cloths known as indigenous *maa'* and *sarita*.[18] They formed patterns by painting or printing—using bamboo tubes, carved bamboo, or wooden blocks—in combination with red dyes, tannic sources, and iron-rich mud and/or resists and indigo dye baths. A few indigenous maa' have been painted on top of faded, older imported Indian chintz,[19] a practice that suggests efforts to prolong the life of a clan's precious stock of sacred cloths, to create equivalents when imports proved unavailable, or to foreground local signs of prosperity. The majority of surviving Torajan pieces are a muddy brown; only a few achieved the bright red of Indian imports. Yet, like their imported counterparts, local cloths were imbued with extraordinary powers to enhance fertility and abundance, and were carefully preserved for display at life-enhancing rituals. One design variety shows "strong Indian influence in composition and layout," with trees growing from rocky mounds and "an abundance of tendrils, leaves, and flowers," locally interpreted as the "world tree" of Torajan cosmology. Most sarita (fig. 12.3) feature a banded arrangement of highly localized imagery: chintz motifs reinterpreted as water spirits, water buffalo, or references to shell ornaments. In this sense, beyond literal emulation, indigenous maa' and sarita formed part of the "full Torajan cosmology in motion."[20]

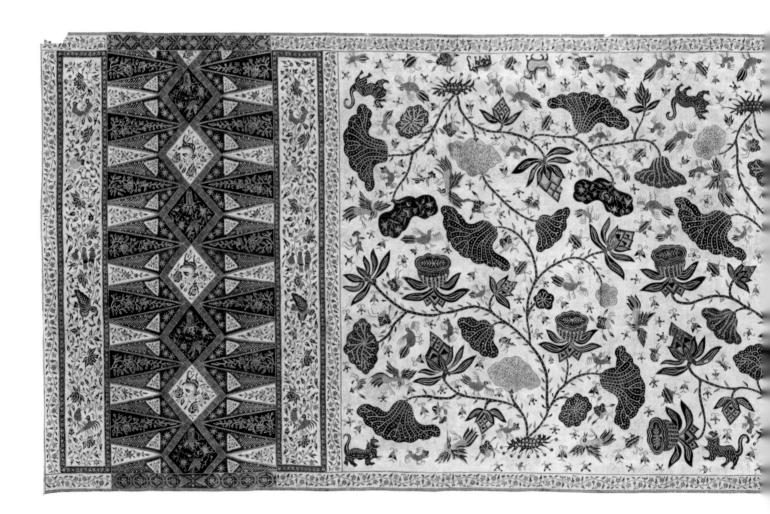

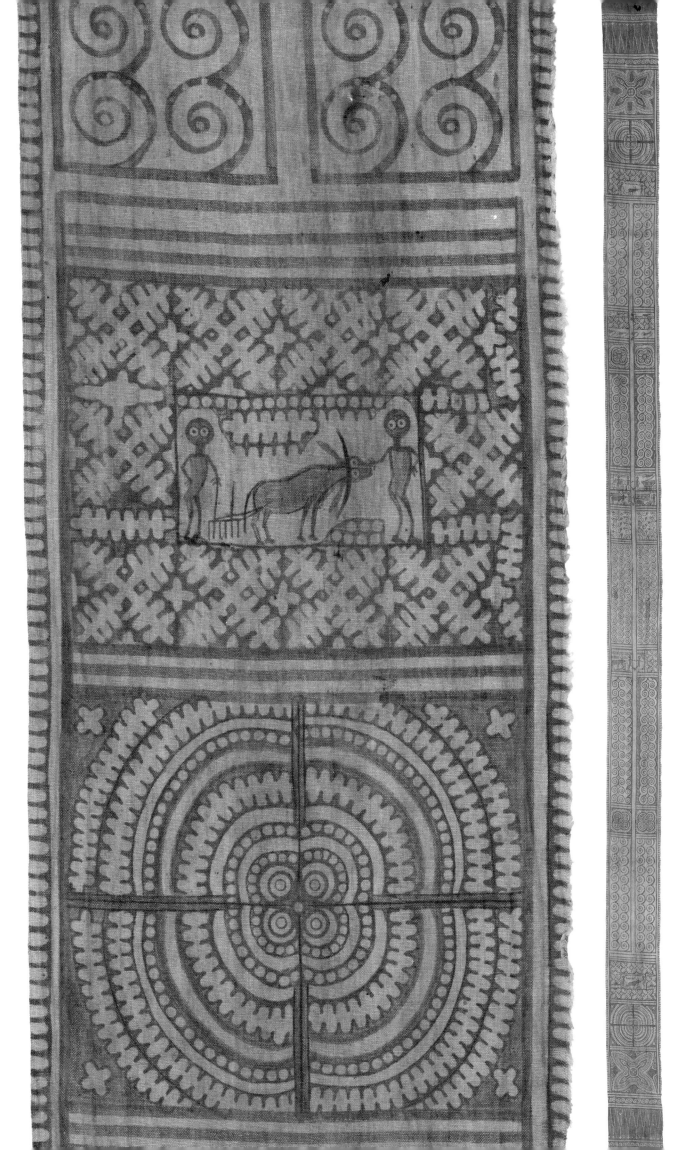

FIG. 12.4

Wrapper in *kisutu* design. Western India, for the East African market, ca. 1870. Cotton, block-printed, mordant-dyed, applied indigo, 105 × 200 cm.

The *kisutu* became a mass fashion on the Swahili coast and in Madagascar and the Comoros Islands.

bpk Bildagentur / Ethnologisches Museum, Staatliche Museen, Berlin, Germany / Claudia Obrocki / Art Resource, NY Object i.d. III E 432.

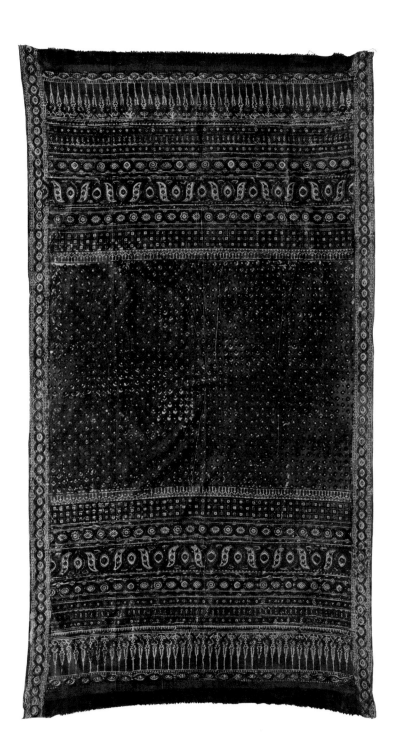

"African Prints" and "African Chintz"

Sub-Saharan Africa was likewise an active player in shaping global cotton revolutions, patronizing first India's handcrafted textiles, then, in the eighteenth century, European substitutes. Ironically, while the continent is famous today for its love of colourful, boldly patterned printed cotton cloth—so-called African wax or African prints—in early modern times, few African consumers desired Indian chintz. Overwhelmingly they preferred Indian cloth that approximated locally crafted types: loom-patterned checks and stripes, plain white, or solid blue indigo-dyed cloth; some areas actively rejected florals.[21] Nevertheless, Indian chintz—either directly or through various simulations—influenced fashion and, to a lesser extent, domestic textile arts on the two halves of the continent.

The eastern coast of Africa—today's Somalia, Tanzania, Kenya, Mozambique, and Madagascar—was from at least 300 CE in direct maritime contact with western India and with its cloth. Trade records reveal that from 1500 to 1800 only a very small percentage of imported Indian cottons were printed or, more rarely, painted. This changed forever around 1830, when Swahili women embraced a Gujarati-made printed cloth as the primary sign of fashionability and free status. Known locally as *kisutu* and *msutu*, and measuring about 125 x 200 cm, the cloth was worn in pairs, one around the chest and the other as head cover. Only one known handcrafted Indian example of the kisutu has survived (fig 12.4); it reveals an indigo-blue centrefield with a diaper pattern of small red stepped squares, its dominant feature being multiple end bands of geometric figures with a bottom row of "sawtooth" triangles. The close design affinity between prints made for eastern Africa and Southeast Asia suggests shared Gujarati merchant or artisan networks. In the 1870s, Swahili female fashion shifted to a new fabric: cotton wrappers printed in European factories (*kanga, leso*). Although industrially made, the cloth's novel designs represent a "co-production": Indian shopkeepers gathered African female tastes and relayed these to European manufacturers. The general format built upon the Indian-printed square handkerchief, enlarging the central field and adding cartouches inscribed with locally meaningful sayings (see fig. 12.15).[22] To this day, the kisutu remains the preferred wrapper for Swahili brides, while the kanga is considered "traditional" dress, integral to female identity across southeastern Africa.[23]

West Africa knew distinctly different trade histories and connections, yet surprisingly similar patterns in the reception of Indian cottons. The overland trans-Saharan routes connecting inland cities such as Timbuktu to the Mediterranean were rerouted in the 1400s to the Atlantic coast and maritime routes operated by Europeans. From 1720 to

LEFT
FIG. 12.5

Founded in 1846, the Vlisco company of the Netherlands, has for the past one hundred years catered exclusively to the African market, one line still using costly resist techniques. In 2006, it remade itself as a luxury fashion brand, offering collections such as "hommage a l'art," May 2013.

Photograph by Koen Hauser.

BELOW
FIG. 12.6

In Ghana, the African-print kaba (blouse) and slit (skirt) ensemble is especially valued as women's "national costume."

Left: Mrs. Gladys Prempeh (right) and a close friend wearing "shared" African-print cloth to attend post-funeral "Thanksgiving" church services, Kumasi, Ghana, 1990.

Right: Madam Adowa Manu, a cloth trader in Kumasi Central Market, 1990.

Photographs by Suzanne Gott.

1770, Indian textiles accounted for 30 to 50 percent of goods traded to West Africa by French and English trading companies.[24] Here, too, Indian checks and solids were vastly preferred, although some niche markets demanded painted Indian chintz, notably the Bight of Benin (present-day Nigeria) and the Senegal River.[25] Scholars concur that the phenomenal mass desire for colourful printed cottons emerged only in the second half of the nineteenth century; it was sparked neither by Indian chintz nor by its British industrial imitations, but rather by a separate "branch" of the chintz family tree: Indonesian batik. Dutch and British manufacturers, having failed to sell their industrial, imitation Indonesian batik in Java, sent it instead to Africa; joined from 1890 by Japanese producers, they artfully marketed and remade batik for African tastes, infusing new patterns, motifs, and colourways (fig. 12.5 and 12.6). In the 1960s, newly independent African nations established their own cotton-printing factories, so that "African prints" became widely accepted as a sign of national or African identity.[26]

Today, history has come full circle: most of Africa's printed cottons are once again manufactured in India (or China). Now using industrial methods, Asia has reclaimed its earlier mastery and control of the global textile trade. While many people today consider industrial prints "traditional" African dress, some studio artists, most famously Yinka Shonibare MBE, question the cloth and use it as a medium to critique the nexus of consumption, enslavement, and imperialism that is bound up with the origins of African prints.

Historian Colleen Kriger additionally connects Indian chintz to two iconic African-made patterned-dyed cottons, which she calls "West African chintz."[27] The first is Ghana's famous *adinkra* cloth, large cotton wrappers covered in bold black geometric designs arranged in rows or grids. Evidence for adrinkra production appears in the early 1800s, when the designs were stamped or painted using chicken feathers. Over time both technique and design have been completely localized. Akan men devised carved calabash stamps and iron-mordanted dyes to stamp motifs referencing regional events and aphorisms; the cloth has been adopted by many groups for their unique mourning and funerary rites. Kriger suggests that the starch-resist indigo-dyed *adire eleko* cloths made by women in Nigeria from the early 1900s may likewise trace their genealogy back to Indian chintz. The area's earlier documented taste for Indian resist-dyed cloths translated into experiments with tie resist and starch resists, facilitated from the late 1800s by the influx of inexpensive factory-made base cloth and synthetic indigo.

Literal Impressions in the Pacific

Floral cotton fabrics are synonymous today with dress in certain parts of the Pacific, most especially eastern Polynesia: Tahitian women's dress immortalized in Paul Gauguin's paintings, Hawaii's industrially printed "aloha shirts," and—in a very different category—Hawaiian women's lovingly hand-stitched cotton quilts. Scholars continue to debate the floriated design lineages of these disparate traditions, but where many do see a direct design influence of Indian chintz is in a short-lived artistic practice of Tahiti, described below.

Historically, the peoples of wider Polynesia dressed in wrappers or ponchos made by women through beating and felting the soft inner bark of several tree species, with the paper mulberry (*Broussonetia papyrifera*) yielding the finest fabric. When Europeans first arrived in the area, beginning with British captain James Cook in 1769, they observed that Tahitian women decorated some barkcloth with geometric and circular shapes. By 1788, new leaf and floral motifs, created in a novel way, had joined their repertoire: women dipped actual fronds, leaves, or flowers in a tannin dye source and then pressed them onto the

FIG. 12.7

Wrapper or cape (*ahu fara*), Tahiti, collected before 1815. Paper mulberry, dyes, 104 × 179.5 cm.

The impressed fronds are likely from the fern *Sphenomeris chusana*.

ROM 901.1.2. Reverend William Ellis Collection.

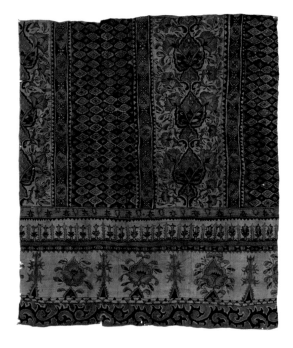

barkcloth, arranging the figures in a variety of patterns. In the 1820s, the British missionary William Ellis observed in Tahiti,

> The leaf, or flower, is laid carefully on the dye; as soon as the surface is covered with the colouring matter, the stained leaf or flower, with its leaflets or petals correctly adjusted, is fixed on the cloth, and pressed gradually and regularly down. When it is removed, the impression is beautiful and clean.[28]

The barkcloth scholar Simon Kooijman first suggested that this new Tahitian patterning was inspired by "printed calicoes of Indian origin," gifted by the first British fleets.[29] However, it is uncertain if James Cook carried the cloth; guessing at possible appropriate "presents of friendship," his 1772 mission carried metal tools, "red baize," and "Fine Old Sheets," as well as checkered shirts.[30] Later voyages, notably Captain Bligh's in the 1790s, did include printed cottons, namely "3 printed calico drapes, 200 yards of cotton chintz," while missionaries subsequently used chintz for bartering.[31] Further research may reveal if this cloth was of Indian manufacture or a European-made imitation.

External prototypes aside, as Suzanne d'Alleva stresses, Tahitian women made the art form their own, basing their experiments "as much on the artistic models available within their own culture."[32] Red dye continued to be sourced from the bark of the candlenut tree (*Aleurites moluccana*), and yellow from a kind of pepper (*Piper methysticum*). Impressions were made using all-local species of ferns, flowers, and leaves. Elite women prided themselves on personalized and fine designs, at first using the plant impressions to accentuate borders—some resembling local tattoo patterns—later expanding to decorate centrefields, with the impressions arranged in a myriad of symmetrical and asymmetrical patterns.[33] The Royal Ontario Museum stewards an exquisite Tahitian *ahu fara* cape collected by William Ellis himself before 1820, its designs likely formed from the fronds of the lace fern *Sphenomeris chusana* (fig. 12.7).[34] Frond tips were pressed around all four edges to create a frame, with a second row added to the two narrow ends; the centrefield features six clusters of frond impressions arranged in seemingly diagonal rows, each cluster formed of three or four fronds radiating outward from their crossed stems. The overall design is unusual in recalling chintz wrappers produced in India for Southeast Asian markets.

From the 1820s, eastern Polynesians increasingly took to dressing their bodies and homes in imported cottons, soon completely abandoning the manufacture of barkcloth, such that only a few dozen examples of these delicately plant-impressed barkcloths survive to hint at the richness of this short-lived fashion.

Inventing Traditions: European Block-Printed Folk Dress

The best-known connection between Indian cottons and European textile making is the industrial story, the "import substitution" that occurred over the eighteenth century as Europe sought to outcompete India, which it eventually achieved through mechanization and mills. However, as Giorgio Riello underscores in chapter 15, Europe's innovtions were an apprenticeship than a revolution, requiring a century of experimentation to achieve the colour and quality of India. Until around 1770, the many cotton-printing workshops spread from Moscow to Ireland were very much based on India's handcrafts: hand printing mordants

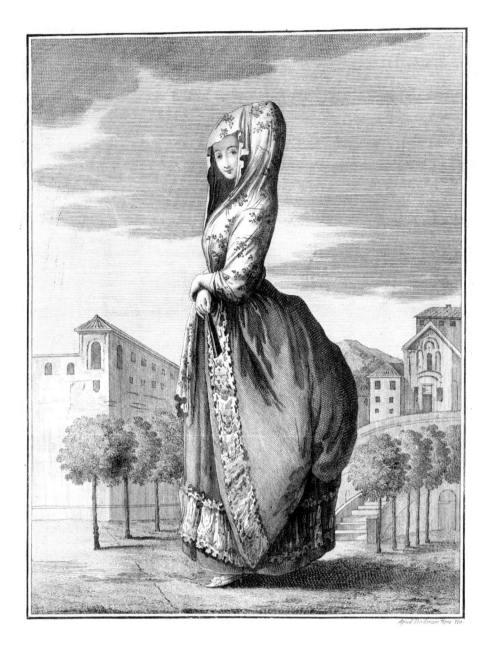

Apud Teodorum Viero Ven.

FIG. 12.9

"Cittadina di Genova che va al passeggio / Bourgeoise de Gênes à la promenade" (A Genoese lady) by Teodoro Viero, ca. 1783, etching and engraving on laid paper.

Mitchell Library, State Library of New South Wales (e33695)

with wooden blocks, dyeing in madder baths, using wax resists or hand pencilling with tropical indigo, locating operations near rivers—including the Thames—deemed of superior water properties, bleaching with animal dung, and sunning in fields.

While most European manufacturers in the nineteenth century shifted to mechanized procedures, some did remain craft based. Into the 1930s (and beyond), workshops in the Netherlands and Britain relied on hand block printing to produce cottons in small batches for export to Africa and Asia.[35] With a radically different intention, artists and craft activists, most famously William Morris in the 1870s, embraced hand block printing fabrics with natural dyes as one way to counter industrial sameness and alienation; a few of Morris's designs and colour schemes drew on Indian chintz.[36] But it is Genoa, in northwestern Italy, and its wider region of Liguria that may claim one of the longest-running European traditions of hand printing cottons based on Indian prototypes (fig. 12.9 and 12.10).

Residing in an active trade port, Genoese women in the seventeenth century became enamoured of floral Indian chintz furnishings and dress fabrics in place of heavier and more expensive silks. As Marzia Cataldi Gallo has meticulously documented, imitations imported

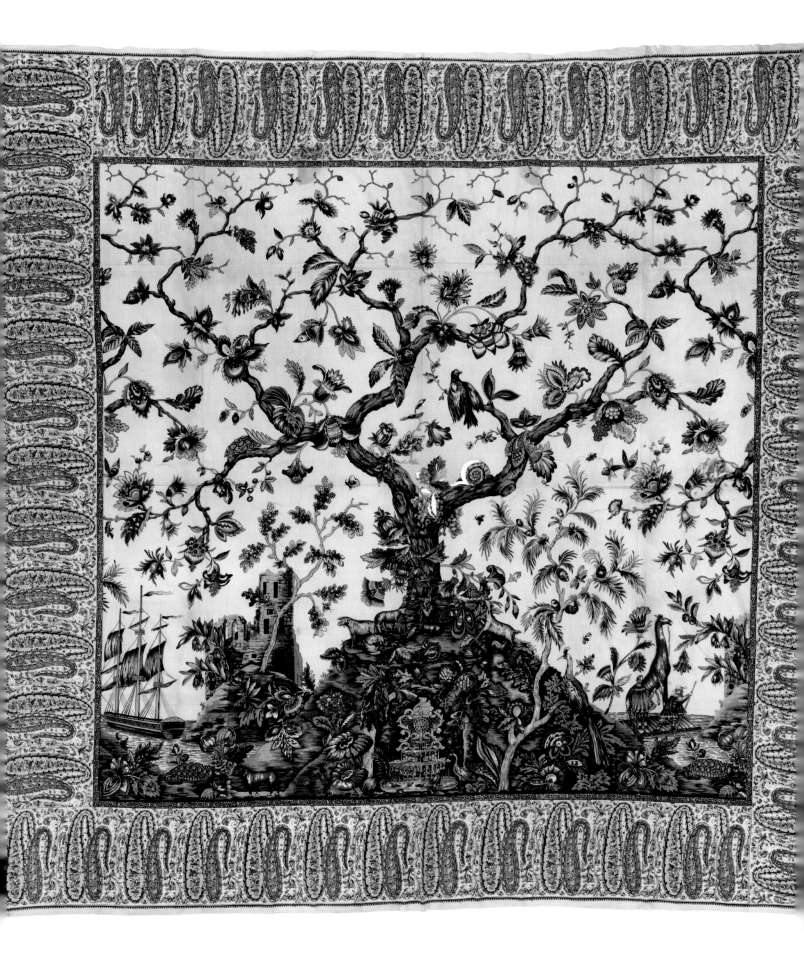

from Germany and England soon gained favour, inspiring merchants to establish workshops in Genoa itself.[37] Using iron acetate, alum, and madder dye, Genoese printers closely followed Indian chintz designs. Their most distinctive product was the *mezzaro* (veil, plural *mezzari*), an enormous headcloth or shawl measuring up to 275 x 225 cm, reportedly popularized by a Ligurian priest. In a unique Italian twist, this rectangular female garment was printed not only with repeating florals but also with the great flowering tree of palampores used for furnishings (see ch. 9). Printers adjusted the composition to fit the horizontal mezzaro format and further added European animals and scenes, such as ships or Alpine views. Over the nineteenth century, the printed mezzaro veils fell from fashion, first among elites and then working classes. From the twentieth century, however, women have again embraced the cloth as festive folk dress, an emblem of Genoese heritage.

Several other iconic "ethnic" costumes of Europe trace their origins to Indian chintz. Not coincidentally, they are found in areas where imports of the cloth had never been banned: in the northern Friesland district of the Netherlands and the region of Provence in southern France. Although today the cloth may be industrially produced, and its original ties to India long forgotten, these and other European folk dress owe a great debt to the Indian encounter (fig. 12.14).

"The Art of Flowering":[38] Indigenous North America

Scholars, including authors in this volume, underscore that increased contact between Europe, Asia, and the Atlantic world from 1500 saw an explosion in the popularity of floral motifs, which crossed and recrossed artistic media and geographic borders. Part of their appeal lay in their amenability "to wide cultural interpretation."[39] A striking example comes from indigenous communities of the Great Lakes regions of North America, where florals "became deeply assimilated into material culture and artistic production,"[40] leading to "the complete transformation of . . . decorative arts," albeit always informed by local sensibilities.[41]

Prior to the eighteenth century, women in the Great Lakes woodlands region used dyed quills, local seeds, and moose hair to embellish hide garments and other objects with geometric and curvilinear abstract designs, as well as stylized representations of animal and spirit beings; from this time, they increasingly created floral imagery made additionally from glass beads, silk embroidery, silk ribbon, and appliqué.[42] This shift occurred within the new socio-political and material context of the European fur trade. From 1600, indigenous groups in the contact zone came to trade away the hides they previously used as dress; overwhelmingly, they demanded in exchange European-made wool fabrics—striped blankets and colour-saturated broadcloth—which matched pre-existing aesthetic, taxonomic, and spiritual criteria. In contrast, painted and printed cottons (and linens) were desired in far fewer numbers, times, and places, adopted mostly for new garment forms, such as tailored shirts, skirts, shawls, or appliquéd to hide accessories.[43] Surviving objects and images show small floral repeats for men's shirts (fig. 12.11) with, at the western reaches of the fur trade zone, a vogue in the 1810s for women's skirts and shawls emblazoned with large sinuous floral heads.[44] While noting that florals came through other media as well, such as trade silver, ceramics, and embroidery instruction from Catholic nuns, scholars maintain that imported printed and painted cottons—manufactured in both India and Europe—had an oversized influence on local women's artistic embrace of floriated design.[45]

OPPOSITE
FIG. 12.10

Mezzaro ("veil"). Genoa, Italy, 1840–1860? Cotton, block-printed, 256.2 × 268.6 cm.

In a unique fashion twist, women of Genoa, Italy, wore the "flowering tree" design as great headcloths or shawls. Block printed in Genoa, they feature European imagery such as ships. Here, fashion has been updated for the mid-nineteenth century by featuring "paisley" motifs along the borders.

ROM 934.4.661. Harry Wearne Collection. Gift of Mrs. Harry Wearne.

BELOW
FIG. 12.11

George Catlin, *Hól-te-mál-te-téz-te-néek-ee, Sam Perryman*, 1834, oil on canvas.

Initially indigenous groups north of the Rio Grande preferred wool and silk trade textiles. By 1834 most of the Creek/Muscogee people of the southeastn U.S. were "clad in calicoes" according to painter George Catlin, although "tasselled and fringed" according to local fashions. The Muscogee were repeatedly displaced to make way for large scale cotton cultivation.

Smithsonian American Art Museum. Gift of Mrs. Joseph Harrison, Jr.

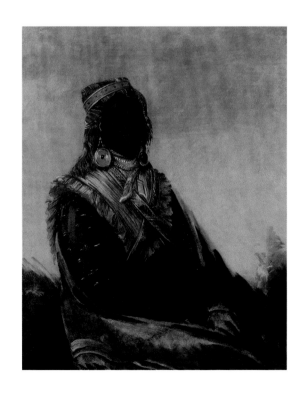

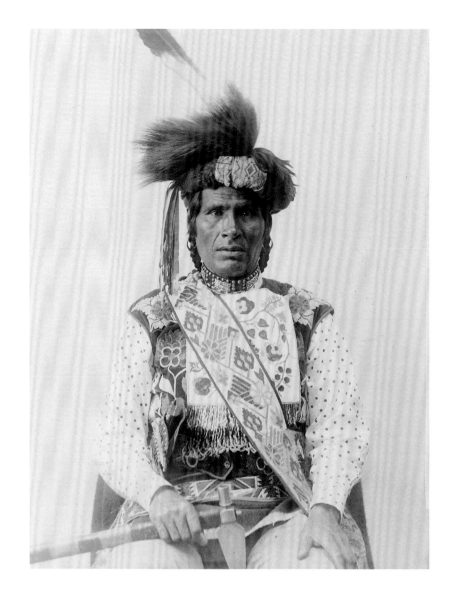

FIG. 12.12

Friendship (bandolier) bag.
Anishinaabeg, ca. 1900. Cloth,
glass beads, 114 × 35 cm.

ROM 976.35.5

FIG. 12.13

One-Called-From-A-Distance
(Midwewinind), White Earth
Reservation, Minnesota, 1894.

National Archives, photo no.
106-INE-1.

What merits attention, according to Ruth Phillips, is the "historic processes of negotiation" and dialogic process that shaped new practices.[46] One revealing example is found in the men's friendship (bandolier) carrying bags that were designed and redesigned by Anishinaabe women over the nineteenth and twentieth centuries. The form of the bag innovatively drew from both European and regional conventions. While indeed "mixing sizes and life phases of leaves and flowers on meandering vines without concern for realism" akin to Indian palampores,[47] and made of imported glass beads, the bag's floral renderings were never identical to any foreign prototype (fig. 12.12). Women composed "through preexisting color preferences, formal sensibilities, and concepts of spatial composition,"[48] and overwhelmingly chose plants from local species, often foregrounding berries, leaves, and fruit. Women in what is now Minnesota depicted maple, bloodroot, bunchberry, and forest canopies, further drawing on motifs from both ancestral sources and new fashions such as crazy quilts (fig. 12.13).[49] The large, lively friendship bags of the Anishinaabe were gifted, traded, and carried far and wide, while floriated garments were likewise adopted by other North American indigenous communities. If perhaps at first worn to communicate trade and alliance acumen, florals were increasingly chosen during the nineteenth century to "preserve a distinctive cultural identity," providing an ornamental vocabulary "acceptable" to hegemonic settler states embarked on aggressive assimilationist policies. In some instances, the motifs may have carried "sacred signification," a way to dissimulate animist beliefs or visionary experiences.[50]

Roots and Branches

"The legacy bequeathed [by Indian trade textiles] to regional designs, organizational concepts, and textile technology itself was profound and lasting," observed the renowned textile historian Matiebelle Gittinger in 1982, inspiring "national and ethnic design vocabularies of people around the world."[51] Since the time of her writing, historians and art historians have multiplied the examples, as well as deepened our understandings of the processes of authentication, appropriation, and indigenization, and the wider social and economic repercussions that accompanied the emulation of Indian chintz. And the story is still unfolding: for the 2019 coronation of Thailand's King Maha Vajiralongkorn, the royal court dispatched master weaver Ajaan Weeratham to learn chintz techniques on India's southeast coast in order to produce the requisite royal garments within Thailand itself.[52] The following chapters of this section explore other diverging branches of Indian chintz's ever-flowering family tree.

FIG. 12.14

The printed cotton furnishing fabrics now emblematic of Provence in southern France can trace their origins to historic government policies that gave the region special dispensations to first import Indian chintz, and later to imitate it.

Tor Eigeland / Alamy Stock Photo

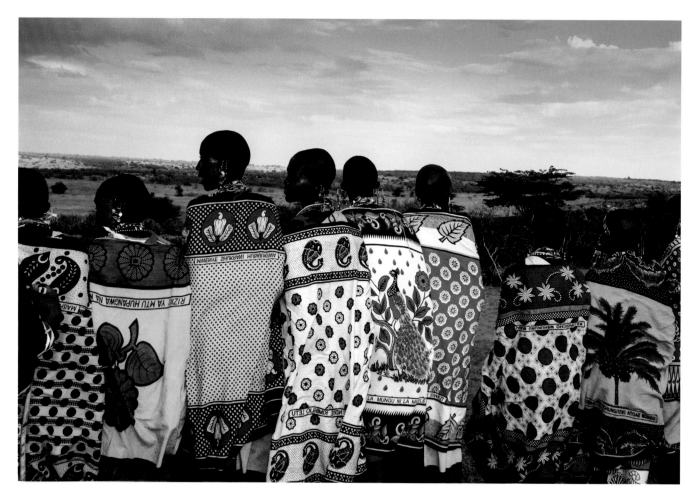

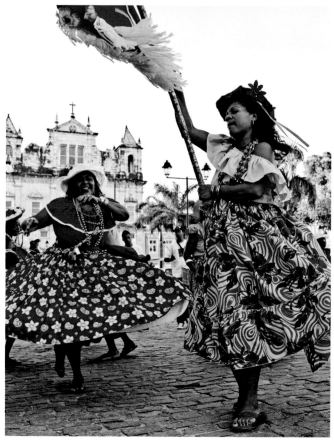

OPPOSITE ABOVE
FIG. 12.15

Maasai women of Kenya wearing the industrially printed wrappers (*leso, kanga*) popular throughout the greater western Indian Ocean region; their design and motifs still carry elements of the original handcrafted Indian imports.

Paulette Sinclair / Alamy

OPPOSITE BELOW LEFT
FIG. 12.16

In Thailand in recent years, Indian chintz designs have reappeared in popular films and street clothing, including t-shirts and jackets silk-screened as su'a senakut or "warrior's jackets" (see fig. 6.3).

Photograph by Alexandra Dalferro.

OPPOSITE BELOW RIGHT
FIG. 12.17

Brazil's printed "chita" cloth was infused with tropical themes and colours to distance it from earlier Indian chintz and Portuguese-made chita to create a sign of national identity (see Nassu, "From Chintz to Chita," 345–54.

John W. Banagan / Getty

Thanks to research assistant Angela Weiser for her help with various matters in this chapter, and to Ruth Barnes, Arni Brownstone, Alexandra Dalferro, and Beverly Lemire for suggesting references and/or reading various sections of the chapter. All interpretations remain my own.

1 Lemire, *Global Trade*, 67.

2 Lemire, 248.

3 Riello, *Cotton*, 70–72.

4 Guy, *Woven Cargoes*, 17.

5 Barnes, "Textiles," 13.

6 Maxwell, *Textiles of Southeast Asia*, 344.

7 Maxwell, *Sari to Sarong*, 146.

8 For a recent discussion on origins, see Heringa, "Upland Tribe," 12–131.

9 Laarhoven, "Silent Textile Trade War," 3; Guy, *Woven Cargoes*, 119.

10 Laarhoven, 6.

11 Lee, *Sarong Kebaya*, 75, 145.

12 On the rise of *cap* and commercial workshops, see among others Sekimoto, "Batik," 111–25.

13 Wronska-Friend, *Batik Jawa Bagi Dunia*, 19.

14 Wronska-Friend, 16.

15 Maxwell, *Sari to Sarong*, 144. "Many of the most popular batik patterns are . . . stylized versions of the Indian prototypes," 148.

16 Lee, *Sarong Kebaya*, 191.

17 Lee, 240.

18 For more on these cloths and articulations with India, see Nooy-Palm, *Sa'dan-Toraja* and "Sacred Cloths," 163–80. Recent radiocarbon dating suggests they may have been made as early as the seventeenth century, perhaps by tools associated with Javanese batik; Barnes and Kahlenberg, *Five Centuries*, 266.

19 Nooy-Palm, "Sacred Cloths"; Barnes and Kahlenberg, *Five Centuries*, 276.

20 McGowan, "Unfolding the Foreign," 21.

21 Eicher, "Kalabari Identity," 153–71; Evenson, "History of Indian Madras," 4; Kriger, *Cloth*, 38; Fee, "'Cloth with Names,'" 49–84.

22 For recent studies on *kisutu* and *kanga* design lineages, see Sachicko, "Are National Costumes," 43–46 and Ryan,

"Decade of Design," 101–32.

23 Madagascar, Zambia, the Comoros Islands, and Mozambique likewise embrace as national dress industrial cotton prints; such prints are also co-productions of African-Indian-European actors, although each shows distinct design proclivities.

24 Parthsarathi, *Why Europe Grew Rich*, 24.

25 Kriger, *Cloth*, 38, 123.

26 A largely discredited genesis story held that African soldiers serving in Indonesia returned with a taste for batik. For a comprehensive work on West African prints, see Gott et al., *African-Print Fashion Now!*

27 Kriger, *Cloth*, 144–61.

28 Ellis, *Polynesia Researches*, 176.

29 Koojiman, *Polynesian Barkcloth*, 22 and 57. Art historians have generally supported an origin in Indian or European prints; see Neich and Pendergast, *Pacific Tapa*, 85; Thomas, "Case of the Misplaced Ponchos," 87.

30 Cook, *Journals of James Cook*, 924.

31 Pyke, "Trading Gifts," Davies, *History*, 72–73.

32 D'Alleva, "Change and Continuity," 35.

33 D'Alleva, "Change and Continuity" and "Elite Clothing," 47–60. See also Ellis, *Polynesia Researches*, 77.

34 Identification by Deborah A. Metsger, ROM Assistant Curator of Botany.

35 Nooy-Palm, "Sacred Cloths," 171; Ryan, "Decade of Design."

36 On Morris's engagement with historic and "Eastern" textiles, see Morris, "William Morris," 173–74. His block-print patterns from 1875 to 1877 appear most directly Indian inspired, characterized also by warmer colours. Parry, *William Morris Textiles*, 53–55.

37 Gallo, *Mezzari and the Cotton Route* and *I mezzari tra Oriente e Occidente*. Smaller Genoese-printed fashion textiles included

handkerchiefs and summer-weight shawls. Gallo, *Mezzari and the Cotton Route*, 72–74.

38 Lewis Henry Morgan, quoted in Phillips, *Trading Identities*, 162. I thank Beverly Lemire for generously sharing ideas and sources for this section.

39 Lemire, *Global Trade*, 248.

40 Racette, "My Grandmothers," 77.

41 Penney, "Floral Decoration," 54.

42 This paragraph draws largely from Berlo and Phillips, *Native North American Art*, 101–8; Phillips, *Trading Identities*, 155–90; Penney, "Floral Decoration;" Racette, "My Grandmothers;" and Lemire, *Global Trade*, 30–86.

43 Orders for painted or printed cottons were seemingly sporadic and accounted for as little as 5 percent of cloth imported for trade to indigenous communities. DuPlessis, *Material Atlantic*, 94, 109, 114, 119; Phillips, *Trading Identities*, 171; Lemire, *Global Trade*, 274, 277.

44 Racette, "My Grandmothers," 76–77; Peers, "Almost True," 530.

45 Berlo and Phillips, *Native North American Art*, 102, 150; Phillips, *Trading Identities*, 171; Lemire, *Global Trade*, 274–75, 287; Anderson, *A Bag Worth a Pony*, 76. Further research is necessary to pinpoint manufacture in "East India" or Europe. "Manila shawls," chintz appliqué quilts and Eastern European embroidered shawls are other proposed floral fabric prototypes. Anderson, 76–77; Phillips, *Trading Identities*.

46 Phillips, *Trading Identities*, 156.

47 Anderson, *A Bag Worth a Pony*, 76.

48 Phillips, *Trading Identities*, 172.

49 Anderson, *A Bag Worth a Pony*, 55–60, 62, 73–75.

50 Penney, "Floral Decoration," 56, 69; Phillips, *Trading Identities*, 195.

51 Gittinger, *Master Dyers*, 172.

52 Alexandra Dalferro, personal communication, 22 July 2019.

赤
墨
赤
赤
赤
赤
赤
赤
白
白
白
藍
赤
白
白

ハ合セズ⟨⟩

13

PERFECTING THE PRINTED PATTERN

EDO PERIOD MANUALS FOR EMULATING CHINTZ

MAX DIONISIO

J APAN HAS BEEN ONE OF THE MOST ARDENT AND SUSTAINED ADMIRERS OF Indian chintz, known generically there as *sarasa* (さらさ,更紗,佐羅紗; see ch. 7). This love of the cloth spurred a parallel world of connoisseurial study and bookmaking of several kinds. Usually only peripherally mentioned or illustrated in Western works on India's painted and printed cottons, these cherished and beautifully made books merit appreciation as objects in their own right. In addition, they testify that Europe was not the first, or the only, region eager to develop a home industry to imitate or emulate the Indian originals.

Japanese collectors in the seventeenth and eighteenth centuries searched for sarasa fragments and compiled them into private catalogues. Since the original pattern names had been forgotten, the designs were thus collectively known as *kowatari* (古渡り), meaning "brought to Japan from long ago." By the mid-eighteenth century, Japanese book publishers began consulting the sarasa fragment catalogues. Bookmakers would not only give new names to the patterns, using familiar Japanese terms, but also publish their own pattern

Page from Inara, *Sarasa zufu*, 180.

OPPOSITE
FIG. 13.1

The colophon from Inaba,
Sarasa zufu (1785). This page
contains relevant bibliographic
information, such as place of
publication, year of publication,
name of the publisher, and other
publications available from the
printer.

ROM Library, Rare NK9503.2.J3
I533 1785

books in the hopes of profiting from the popularity of the fashionable textiles. These pattern books are collectively called *sarasabon* (更紗本).

There was healthy competition among sarasabon publishers. Three of the most important were Hōrai Sanjin Kikyō (蓬莱山人帰橋; d. 1789), Kusumi Magozaemon (久須美孫左衛門; 1734–1810), and Inaba Michitatsu (稲葉通龍; 1736–86).[1] Hōrai began his career as a comedic writer in Edo. In 1778, he published a book of chintz patterns called *Sarasa benran* (A manual of sarasa; 佐羅紗便覧). Kusumi worked for a chintz seller and, detecting deficiencies in Hōrai's work, published *Zōho kafu benran* (A chintz manual supplement; 増補華布便覧) in 1781. Inaba was an Osaka sword merchant who turned to book publishing. Familiar with Kusumi's publication, Inaba set out to make corrections; as a result, Inaba's completed work contains most of the patterns from *Zōho kafu benran*. Although he produced well-known works on swords and sword making, Inaba's 1785 *Sarasa zufu* (Chintz patterns graphically depicted; 更紗圖譜) became the most popular sarasabon in late eighteenth-century Japan.[2] As a testament to the sustained appreciation of sarasa, the last revision of *Sarasa zufu* appeared as late as 1913, with publication of the eighth and final edition. Inaba's success was not accidental—working as a swordsmith and dealer, he had experience decorating sword handles with popular sarasa patterns.[3]

It is important to recognize that *Sarasa zufu* was published in Osaka, the centre of the cotton trade during the Edo period. Merchant and artisan guilds had been formed to focus the marketing and processing of cotton fibre into cloth for the city of Osaka.[4] It is probable that family-run manufacturing houses would purchase the cotton cloth to make sarasa by hand. Artisans working for the family business would then consult the sarasabon, recreate the patterns, and source the necessary dyes for their production.

Sarasabon typically include the following components: title page, table of contents, preface and/or introduction, pattern examples, concluding text (if no preface or introduction is included), and a colophon. The colophon (fig. 13.1) contains relevant bibliographic information, such as place of publication, the year of publication, the name of the publisher, and other publications available for purchase from the printer. In the opening lines of *Sarasa zufu*'s preface, Inaba acknowledges both Hōrai's and Kusumi's influence, and also includes his assurance that readers will appreciate both the patterns he has selected and their clearly legible names.[5] The preface is followed by an introductory essay on the history and usage of colours and pigments, helpful content, as the patterns in the book are accompanied by instructions suggesting the appropriate colours for each design element. For example, one of the patterns with human figures (*ningyōde* 人形手; fig. 13.2) depicts two individuals sitting on an elephant.[6] Motifs are marked with instructions in Japanese recommending a specific colour. In the *ningyōde* pattern, the riders' robes are to be rendered in alternating red and black stripes, with boots of white and blue. The elephant is adorned with white decorative bells and collars. Leaves of white, blue, and red frame the top.

Side-by-side comparisons of eighteenth-century sarasa samples from India's Coromandel Coast with sarasabon designs confirm both that the authors of these texts had access to the original textiles and that eighteenth-century Japanese textile manufacturers closely adhered to the suggested sarasabon colour palettes.[7] Book publishers were also interested in rendering sarasabon designs in full colour. In 1907, Asano Kokō (浅野古香; 1881–1913) published a book of colourized sarasa titled *Sarasashū* (A collection of sarasa; さらさ集) and included examples from *Sarasa zufu* and *Sarasa benran* (fig. 13.3).

The popularity of sarasabon, especially *Sarasa zufu*, demonstrates the deep, widespread, and enduring appreciation of sarasa by the eighteenth century, as well as the books' importance to Japanese material culture (fig. 13.4 and fig 13.5). Authors such as Inaba sought to capitalize on the popularity of these textiles. By collecting, editing, and reproducing popular sarasa, these individuals succeeded in preserving the heritage of Japanese *kowatari*. In striving to replicate the perfect pattern—complete with colour instructions—it is possible that these creators managed both to preserve knowledge of how these textiles may have looked when they first entered the country and to promote

更紗圖譜

裝劍奇賞　後藤家及諸工　系譜新增改正　全七冊　先年より發行

同餘藻　附錄舶貢奇玩圖　并珉瑠目利之事　全五冊　近々板刻

鮫皮精義　柄鮫鞘鮫之事　其品目目利書　全二冊　出來

更紗圖譜　附錄オクビ、并異布ヲアツム　全壹冊　近刻

天明五年乙巳極月發行

浪華書林　塩町心齋橋西へ入　稲葉新右衛門藏板

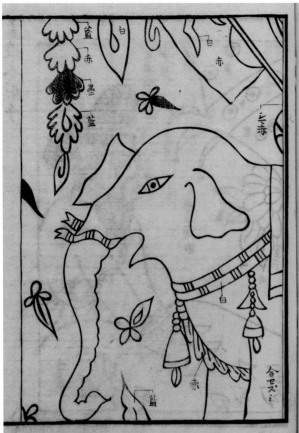
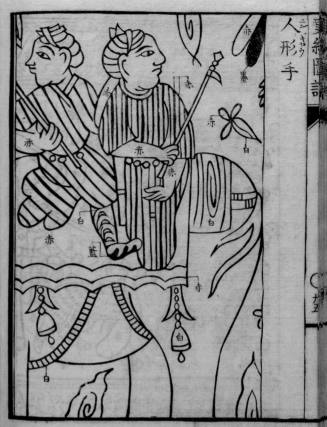

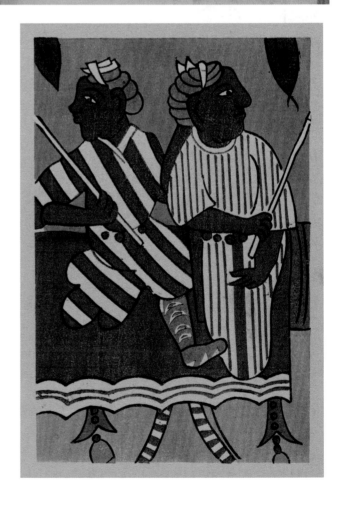

藍 赤

ウンヤ手 地黒

LEFT
FIG. 13.4

Inaba, *Sarasa zufu*, 32.
Another popular design,
Hanabishide, a lozenge-shaped
grid pattern with flowers. See fig.
7.3 of an actual textile.

ROM Library, Rare NK9503.2.J3
I533 1785

RIGHT
FIG. 13.5

Inaba, *Sarasa zufu*, 21. *Unyade*
pattern, a popular *kowatari*
design comprising arabesque-
influenced elements. See fig. 7.1
of an actual textile.

ROM Library, Rare NK9503.2.J3
I533 1785

a colour aesthetic that would be handed down for generations. Sarabason were key tools in Japan's varied attempts—through both age-honed hand skills and later industrial mechanization—to imitate the beloved originals.

1 In Japanese, the surname comes before
 the given name.

2 Yokoyama and Hachiya, "Sarasabon," 101.

3 Gotō, *Inaba Michitatsu*, 31.

4 Hauser, "Textiles and Trade," 113.

5 Inaba, *Sarasa zufu*, 1, 2–3.

6 Inaba, 25–26.

7 Iwanaga, *Ages of Sarasa*, 130–35.

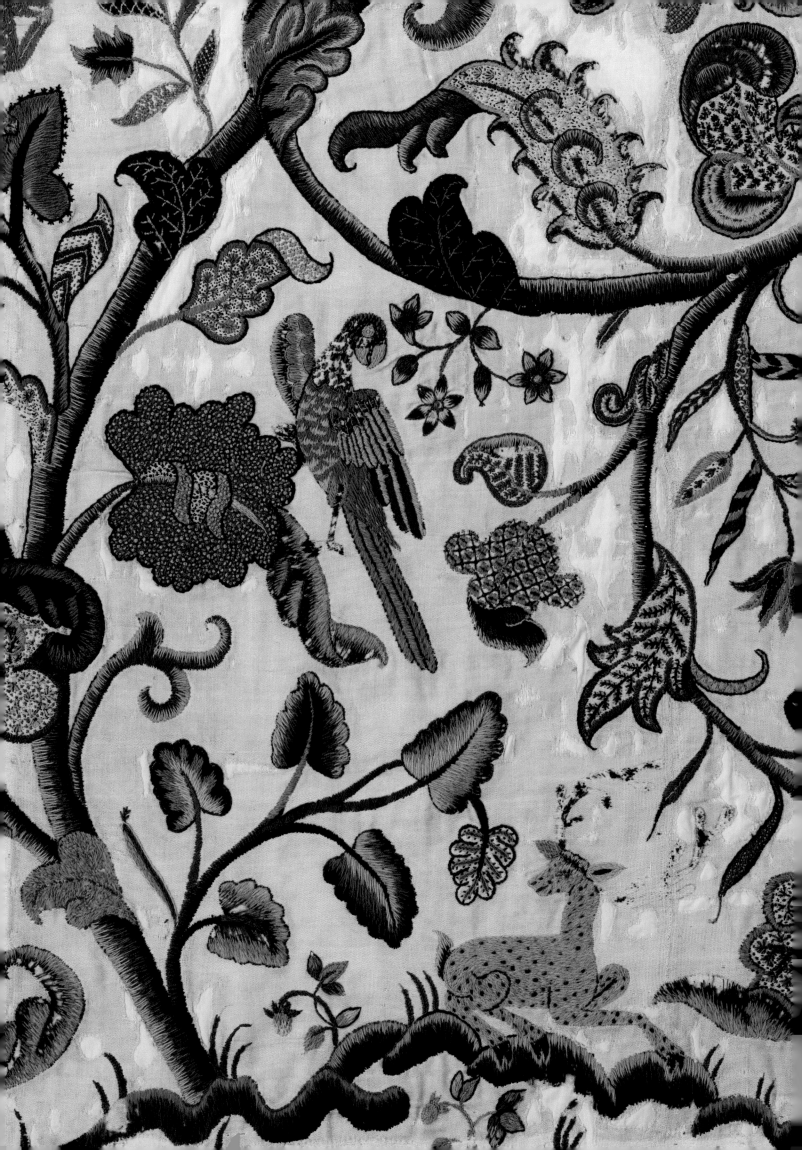

14

ORIGINS IN ENTANGLEMENT

CONNECTIONS BETWEEN ENGLISH CREWEL EMBROIDERY AND INDIAN CHINTZ

SYLVIA HOUGHTELING

IF THE INDUSTRIAL FATE OF BRITAIN WAS FAMOUSLY ENTANGLED WITH INDIAN cotton, so too was the early modern history of its domestic arts. We now appreciate that the maritime connections between Europe and Asia from the sixteenth century onward led to lively material exchanges and the emergence of what one scholar recently called "the globalization of style in textile design."[1] This hybrid aesthetic and its regional expressions flourished in the two traditions of English crewel embroidery and Indian chintz.

Crewel embroidery or crewel work were the terms applied to embroidery made with smooth, long-staple worsted-wool fibres called crewels.[2] In the latter half of the seventeenth century, a noticeable design change took place in English crewel work: formal conventions, such as regular compartments and coiling stems, which enclosed roses, thistles, frogs, and rabbits, gave way to free-form blossoming trees that were snaked with vines and bore effulgent flowers (fig. 14.1).[3] The rise of this novel embroidery style in Britain coincided with the early influx of "painted"-cotton textiles from India. The profound

Detail: Curtain. Britain, 1666–1722 (p. 189).

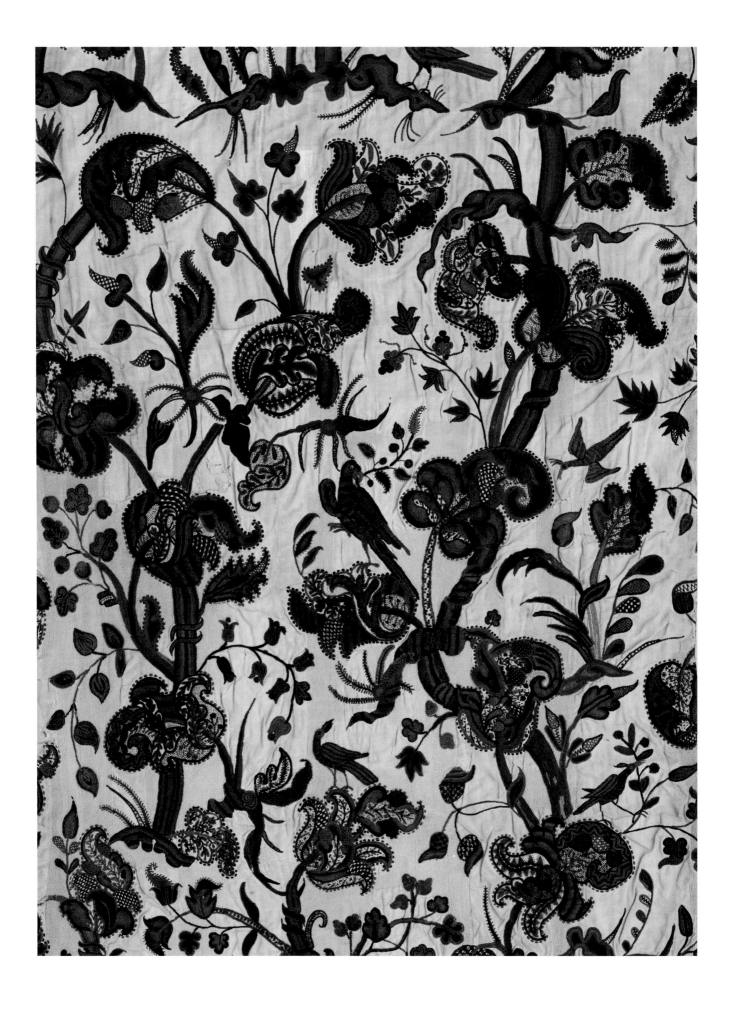

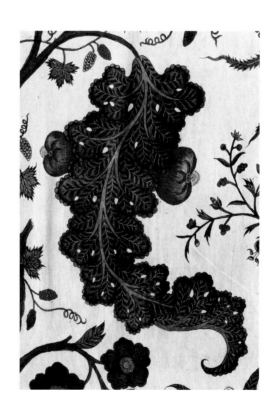

similarities between the patterns for crewel work and the painted-cotton palampores, made in India specifically for the European market (fig. 14.2)—different in style from those made for local consumption (see ch. 2)—suggest that the two types of textiles developed in dialogue. The chintz and the crewel-work textiles share a vocabulary of dentated leaves, flowers overflowing with petals, and miniature animals playing amid the foliage. Tracing the full history of these individual motifs through the lineage of English embroidery and the stylistic evolutions of South Asian chintz is beyond the scope of this study and is a path of inquiry that has intrigued scholars, practitioners, and needlework-pattern designers since before the current fascination with global connections.[4] In a more focused way, this essay proposes that crewel work and chintz shared not only iconographic features and similar stylistic motifs but also subtler aspects of patterning, colouration, and the texture of the textile ground used for the embroidery, suggesting that textile artists in India and England studied both the visible elements on their counterparts' cloths and the skills and techniques used to achieve these ornamental effects.

An early—and influential—argument about chintz and crewel work, put forward by John Irwin in 1955, held that the original source for the crewel work with fantastical flowers came not from India but from England.[5] Irwin argued that Indian chintz designers had copied their motifs from musters similar to "pattern-books published in England for domestic embroiderers."[6] Yet extant English pattern books and embroidery samplers from the seventeenth century rarely show evidence of the asymmetry seen in the crewel-work patterns. Irwin's explanation for this lay in the chintz painters' process of adaptation: "In making free-hand enlargements, Indian draughtsmen would have been compelled to elaborate according to his own imagination details of the flora and fauna with which he was not familiar. This often resulted in common English motives becoming distorted out of all recognition—for example, the oak leaf, which appears in Indian painted calicoes with exaggerated dentations, or the strawberry fruit, which the Indian copyist renders with unduly large seeds."[7] Thus, even if the motifs were copied from pattern books, as Irwin contends, they were reimagined in the process. In subsequent years, Irwin's conclusions have been revised, but the close visual study that he gave to the textiles bears reconsideration.

More recent scholarship on the shared floral motifs of crewel work and chintz has illuminated alternative paths of connection. Beverly Lemire has shown that the trade in Indian textiles and Chinese porcelains coincided with the early imports of live plants from Asia, which meant that the exotic flowers that appear on chintz textiles were also adorning the botanical gardens and wealthy homes of Britain.[8] Ebeltje Hartkamp-Jonxis writes of how the large-scale, abstracted flowers on Indian chintzes and East Asian ceramics, "in which each flower consists of clearly defined petals filled in with simply graded colors," had come to be known by the early eighteenth century as "*Indianische Blumen* or *Fleurs des Indes* ('Indian flowers' in German and French, respectively)," whereas "a more naturalistic, botanically recognizable representation of flowers in European textiles and porcelain became popular in about 1740."[9] It was partly their stylized, graduated colouring, rather than simply their biological exoticism, that identified the blooms as the products of India—and of Asia, more generally.

Resonances with the architecture and painting of South Asia have also led scholars to argue that many of the more striking stylistic traits of chintz and crewel work can be attributed to the cosmopolitan Indo-Persian visual culture of the Deccan region from which the chintz textiles originated.[10] The "seeds," as it were, of the floral textiles were manifold and diverse, leading to a shared style that emerged around 1700 across Europe, Asia, and the Americas. What was unique about the style was that it appeared exotic in some way to individuals across each geographic region.[11]

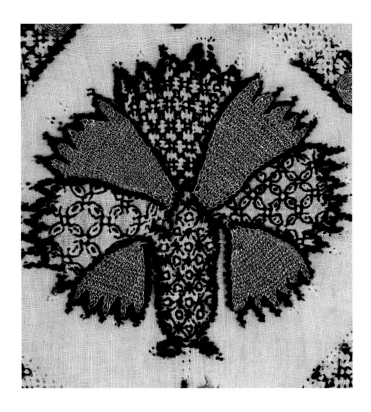

Given its cross-cultural reach, it is also easy to overlook that the mobility of this cosmopolitan style occurred not just across diverse lands but also across distinctive media, including painted ceramics, metalwork, and lacquer, as well as silk, wool, and cotton textiles. For instance, the internal patterning of leaves seen in crewel work and chintz also occurs in painted designs on East Asian porcelain, where it is also possible to find precedents for the spaciousness of the white backgrounds that are set behind the colourful flowering trees on chintz palampores.[12] The techniques employed to produce these various classes of objects share little in common, meaning that when the floral style passed from one textile to another, not only an exotic iconography but also a foreign method of patterning a surface had to be adapted and sometimes imitated.

The commonalities between chintz and crewel-work motifs are especially surprising given the differences in how chintz and crewel work are constructed. While the chintz "painter" used a sharpened bamboo pen (*kalam*), the crewel embroiderer deployed worsted wool, crafted in distinct stitches but resulting in fuzzier lines. The cloth painter had the advantage, but also the challenge, of using liquid mordants to draw the tips of leaves, branches, or a phoenix's trailing wings. While chintz cloth was bright and thin, British crewel-work motifs were thickly layered so that they rose sculpturally from the surface of the cloth.

One of the most striking features shared by chintz and crewel embroideries is their textured, toothy leaves. The dentated shape and twisting curves of the leaf forms can be attributed to a variety of materials and objects: classical acanthus leaves rendered in pattern books; Ottoman silk patterns or ceramics in the *saz* style, characterized by complex flowers and twisting foliage; or a reinterpretation of an English oak leaf, as Irwin suggested.[13] Yet it is also important to study the way these leaves were rendered and how the various artists used their tools. On a set of crewel-work curtains that are stitched with the date of 1696, the maker rendered snaking vines and leaves that curl and droop at oblique angles (see fig. 14.1). The centres of the leaves are filled with layers of deep green, blue, and brown dots, waves, and checkers.

Irwin argued that these abstract filling patterns derived from an earlier English embroidery technique, known as *blackwork*, where leaves were outlined thickly and then filled in by a wide range of stitched interlace designs (fig. 14.3).[14] Others have noted that Venetian needlepoint lace also contains leaves dense with patterned filling.[15] Irwin wrote that this practice of "hatching abstract patterns inside naturalistic leaf-forms" was "foreign to Indian tradition . . . the fillings or subsidiary patterns employed by the Indian designer were invariably naturalistic, and he would never have thought of combining naturalism and abstraction in the contemporary English manner."[16]

Irwin ascribed undue limitations to the potential for Indian design, but in this passage, he inadvertently helps to draw attention to subtler patterning elements of Indian painted-cotton textiles. The practice of "hatching abstract patterns" can readily be found in the details of early eighteenth-century chintz textiles, a feature that is easy to overlook in the midst of what Irwin correctly identifies as their profuse naturalistic decoration. Within a hybrid design of European-inspired strap work juxtaposed with fanged mongooses, the textile painter in South Asia shows a brilliant capacity for interspersing naturalistic and abstract decoration. A latticework of white lines, inscribed on an indigo-blue ground, encloses

a series of smaller white circles that fill the empty space of a rocky outcropping. Elsewhere, the lattice is filled in with a series of four dots, while a naturalistic floral vine creeps nearby. Like their English counterparts, the painters of the chintz have also filled their jagged-edged leaves with abstract patterning, including angular lines and repetitive bundles of spots (fig. 14.4). As Rosemary Crill notes, chintz painters would sometimes translate these abstract lines to create volume that replicated the hatching techniques they encountered on imported European floral engravings.[17] Yet in most cases, this geometric infill was not an import or a new phenomenon in South Asian cloth decoration. When the pattern is comprised of tiny white circles, reserved against a dark ground, the patterning style imitates the *bandhani* (tie-dye) technique, which can be found on Indian cotton textiles at a very early date (see ch. 3).

From this perspective, the contrasts between the crewel work and the chintz appear to result from differing media, rather than from the patterning proclivities of their makers. While Indian cloth painters and dyers used a wax resist to create their intricate internal patterning, the embroiderers sent the texture outward, replicating the patterns with brick stitch, tied herringbone, "Algerian eye" stitch, and volumetric French knots.[18] When the English embroiderers wanted to supplement their geometric designs with more naturalistic patterns, they layered the vines and flowering branches on top of the leaves, which were already thick with stitches (fig. 14.5).

The chintz and the crewel work also share a language of colour shading. Colour shading is more readily achieved in the dyeing processes of Indian chintz. For the red and pink blooms that appear on many of the cloths, the painter could apply different mordants to the cloth, which would yield gradations of colour upon immersion in the dye bath (fig. 14.6). By contrast, English embroiderers were working with discrete stitches that made colour shifts more visible. Late seventeenth-century English embroiderers were concerned with achieving gradual shading of colours in their work and purchased their pre-dyed crewel threads in a nuanced range of hues.[19] Hannah Wolley, whose volume *The Queen-Like Closet* (first published in 1670) instructed housewives on everything from the making of trifle, candy, and cheesecake to the production of cosmetics, also included a few words on embroidery. Her main emphasis was on the importance of the "shadow," or the darker colour that creates a sense of volume in its contrast with the lighter accent colours: "Now for the folds of your Leaves or Flowers there must be a place for shadow, but that must be begun with a middling Colour, and fall very light . . . but be sure not to choose your Colours too near in such a case, but skip a Colour, or sometimes two, and you will find it very fine work."[20]

Wolley's advice manual indicates certain priorities of seventeenth-century embroiderers that can also be found in the objects themselves, where a "middling colour" that helps the eye transition into the "shadow" beneath a leaf or flower often appears. But the embroiderers may have also looked to chintz for the kinds of close colour contrasts that emerged in the beginning of the eighteenth century. In figure 14.7, the embroiderers have begun to expand their palettes to red, blue, and yellow, which differed from the greener tones of seventeenth-century English embroidery.[21] In this example, the needle worker has replicated the chain stitch of imported embroideries that were brought from India's western region of Gujarat. Indeed, embroiderers in England soon began to use chain stitch "to the exclusion of almost all other stitches" to trace out the fine outlines and inner veins of jagged leaves and slender branches.[22] To capture the "shadow" at the edge of a flower, the embroiderers packed together single curving lines of different shades of red, ranging from pale peach and rose to maroon and wine colour. This juxtaposition of pink and red right next to each other was another unique visual trait of South Asian chintz textiles.[23]

In perhaps the most understated form of connection with cotton chintz, the crewel-work embroiderers also strove to emulate the appearance and performance of a cotton ground for their embroideries.[24] The majority of crewel-work embroideries from this time are stitched not upon pure linen but on a fustian ground, the name typically used for a cloth made from linen warps and cotton wefts (although the exact meaning of the word *fustian* in

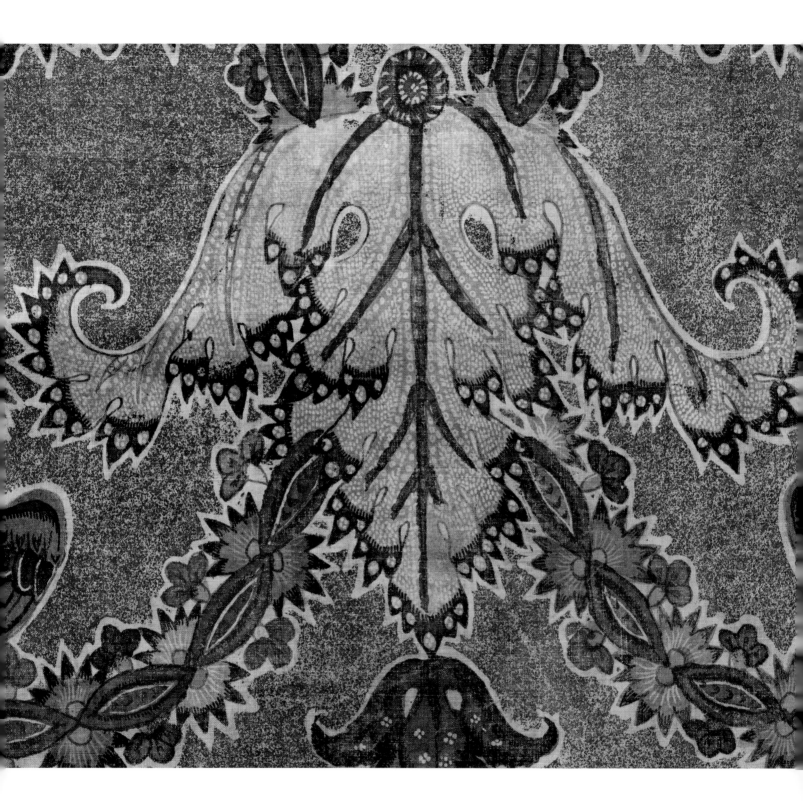

FIG. 14.4

Bed curtain (detail). Coastal
southeast India, for the European
market, 1700–1750. Cotton, hand-
drawn, mordant-painted, resist-
dyed, glazed, 292 × 231 cm.

ROM 934.4.15 A. Harry Wearne
Collection. Gift of Mrs. Harry
Wearne.

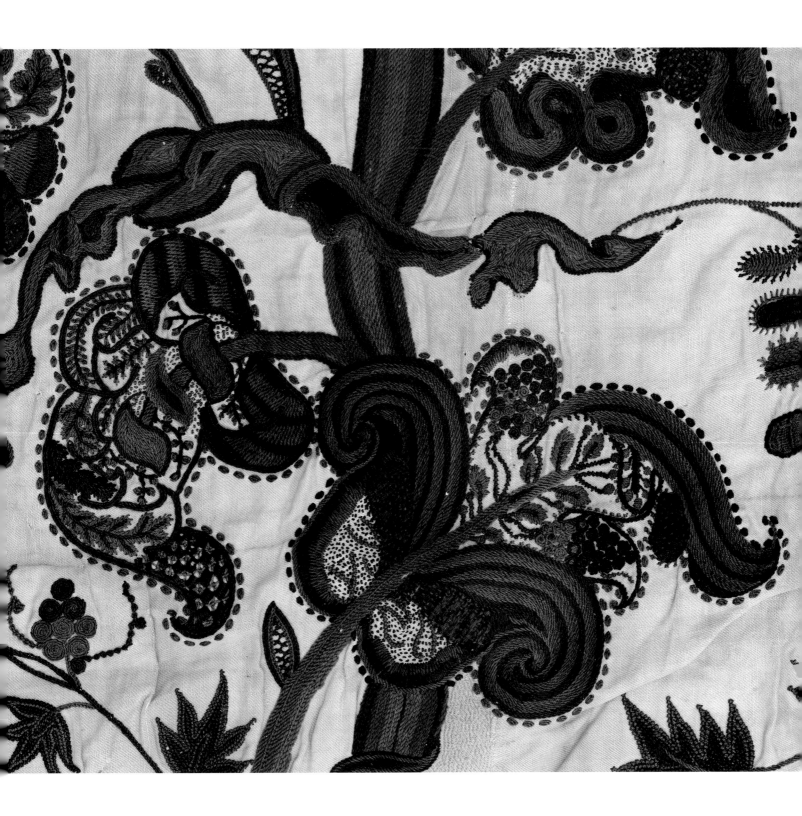

FIG. 14.5

Curtain (detail). Britain, 1666–1722.
Crewel-work (wool) embroidery on
fustian, 208 × 165 cm.
ROM 959.60.2. Gift of Elinor Merrell.

RIGHT
FIG. 14.6

Detail showing painterly
gradation of colour of a chintz
flower (fig. 9.1, p. 109).

BELOW
FIG. 14.7

Embroidered quilt. Britain,
1700–1725. White linen quilted and
embroidered in coloured wools,
205.7 × 167.5 cm.

ROM 949.189

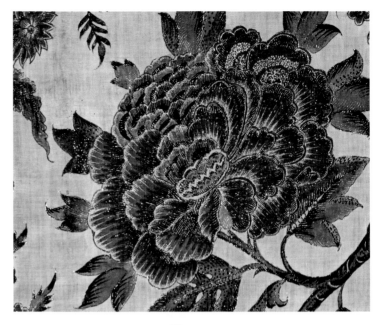

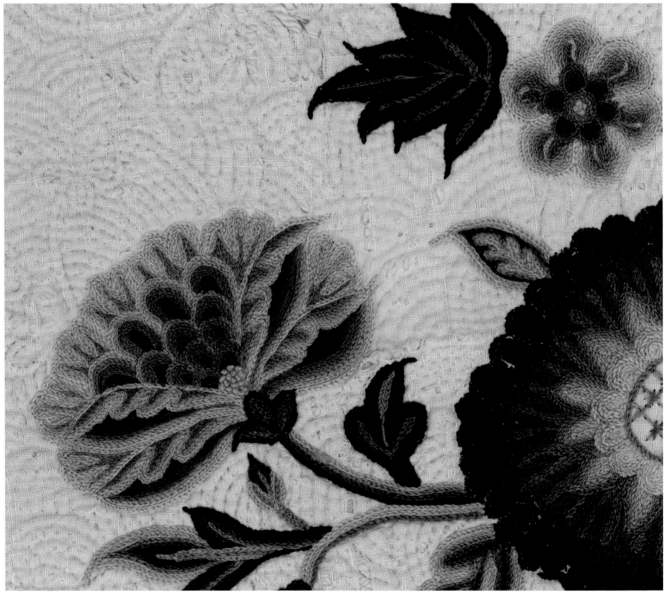

historical records is, as Philip Sykas noted, "even more confused" than most textile terms).[25] In most cases, Katharine Brett wrote, "the soft cotton weft almost entirely hides the firm linen warp."[26] This hybrid cloth, which was produced in medieval and early modern Germany and northern Italy, represented a specific instance of the use of cotton in the English domestic household in the period before Indian chintz imports were ubiquitous.[27] With its white colour and soft texture, it was the closest fabric to Indian cotton that Europeans produced. It seems fitting, then, that chintz makers and crewel embroiderers both used cotton in their base fabric. From this "common ground," they drew inspiration from each other not only for the whirling shapes of leaves and the plush petals of flowers but also for the technical, colouristic, and material inventions that came to flourish in crewel and chintz.

1 Guy, "'One Thing,'" 13.

2 Brett, *English Embroidery*, 43; Synge, *Art of Embroidery*, 146.

3 A. F. Kendrick describes English embroidery of the early seventeenth century as characterized by a "wide ornamental framework enclosing flowers and fruit." Kendrick, *English Needlework*, 70. Lanto Synge contrasts the later style with "earlier crewelwork curtains embroidered in the tradition of blackwork [which] had a single overall pattern, usually of leaves, endlessly repeated over the fabric." *Synge, Art of Embroidery*, 148.

4 Nevinson, *Victoria & Albert Museum*, 59; Hughes, *English Domestic Embroidery*, 36; Davis, *Art of Crewel Embroidery*, 19.

5 Irwin, "Origins of 'Oriental Style.'" Demonstrating the reach of Irwin's article, Kendrick's second edition of *English Needlework*, published in 1967, cites Irwin: "It used to be thought that the designs of these hangings were derived from the painted and printed cottons of Masulipatnam which were imported into England in large quantities in this period, but it now seems that the story of their evolution is more complicated. Printed or painted designs of leafy branches were sent out to India to be copied at least as early as 1660 and the crewel-work designs seem to be the result of a complex interplay of influence." Kendrick, *English Needlework*, 138.

6 Irwin, "Origins of 'Oriental Style,'" 113.

7 Irwin, 113.

8 Lemire, "Domesticating the Exotic," 69–70.

9 Hartkamp-Jonxis, "Cat. 62," 216; Hartkamp-Jonxis, *Sits*, 86–87.

10 Sardar, "Seventeenth-Century *Kalamkari* Hanging," 156–60; Haidar and Sardar, *Sultans of Deccan India*, 285–86; Houghteling, "Tree of Life," 94–103.

11 Peck, "Trade Textiles," 2. John Irwin and Katharine B. Brett observed, "The flowering-tree palampore appears no less exotic to Asian eyes than it does to European. Observed from either standpoint, its inspiration seems to be alien, irreconcilable with the observer's own culture." Irwin and Brett, *Origins of Chintz*, 16. The author is grateful to Navina Haidar for drawing her attention to this important insight.

12 Oliver Impey draws particular attention to the "considerable areas of undecorated transparent glaze" found on Japanese Kakiemon ceramics, which were popular in Europe. Impey, *Chinoiserie*, 94–95.

13 On the interplay between the acanthus leaf and more exotic pineapple-leaf forms, see Guy, "Long Cloth," 199–200; Wearden, "Saz Style"; Denny, "Dating Ottoman"; Irwin, "Origins of 'Oriental Style,'" 113.

14 Irwin and Brett make this comparison in *Origins of Chintz*, 19. See also Watt, "Coif," 153.

15 Synge, *Art of Embroidery*, 147

16 Irwin, "Origins of 'Oriental Style,'" 110.

17 Crill, *Chintz*, 15.

18 Brett, *English Embroidery*, 45.

19 Nevinson, *Victoria & Albert Museum*, xiii.

20 Wolley, *Supplement to Queen-Like Closet*, 79.

21 Synge, *Art of Embroidery*, 148.

22 Brett, *English Embroidery*, 43. On chain stitch used in South Asian textiles, see Crill, *Indian Embroidery*, 7–9; Morrell, *Indian Embroidery*.

23 The author thanks Ruth Barnes for pointing out the prevalence of juxtapositions of pink and red in South Asian chintz, which can also be found in the crewel-work embroideries.

24 Kendrick writes that the "Oriental"-style crewel-work curtains and bed hangings were stitched on a light-coloured ground "invariably of a twill weave with linen warps and cotton wefts." Kendrick, *English Needlework*, 137.

25 Sykas, "Fustians in Englishmen's Dress," 1.

26 Brett, *English Embroidery*, 43.

27 Mazzaoui, *Italian Cotton Industry*, 28–56, 129–53; Schneider, "Rumpelstiltskin's Bargain," 180–81; Ulrich, "From Fustian to Merino," 222.

15

HOW CHINTZ CHANGED THE WORLD

GIORGIO RIELLO

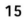N THE LONG HISTORY OF INDIA'S TEXTILE EXPORTS, PAINTED AND PRINTED cottons formed a small fraction of total production; however, their impact on the world proved enormous. Current thinking recognizes Indian chintz as the first truly global fashion and acknowledges the many profound consequences—social, economic, environmental—that followed when Europe began first to trade in the cloth and then to imitate it in Europe and North America. From the seventeenth century especially, European trading companies stoked and supplied the demand for Indian cottons in Africa and the Americas, expanding the already existing consumption in Asia and Europe. Next, Europe embarked on the large-scale production of cotton textiles in imitation of India, which also proved hugely disruptive: new areas of the globe began to cultivate raw cotton, in particular the Americas, using the plantation system and slaves brought from West Africa. This great drive to rival and replace India in cotton-cloth making eventually led to the mechanization of textile production in Europe and thus was of fundamental importance to the industrialization

Cotton spinning and weaving factories in Burnley, Lancashire, England, c. 1905. By 1820, using industrial methods, England had replaced India as the world exporter of cotton yarn and cloth. Amoret Tanner / Alamy Stock Photo.

of the West. The production and trade of cotton textiles—printed and painted cloth in particular—can therefore be said to have played a key role in the shaping of the global economy in the last millennium.

Learning and Connecting: Europe as Trader and Consumer of Indian Cottons

Since at least the beginning of the second millennium CE, India had emerged as the world leader in the production of cotton fabrics. The coastal regions of Gujarat, Coromandel, and Bengal produced hundreds of varieties of cotton cloth, and long-distance trade in these articles was developed by communities of Hindu, Jewish, Armenian, and Muslim merchants. Around this same time, many areas of the world—most notably eastern China, Southeast Asia, West Africa, and the Middle East—also became producers of several varieties of cotton fabrics, but it was India alone that excelled at painting and printing cottons.[1] This was due to several natural assets, notably good-quality cotton fibre, dyestuffs from semitropical plants, and appropriate waters for dyeing, but also to the skill and knowledge deployed in converting raw materials into elaborately patterned, colourful cotton cloth, through spinning, weaving, bleaching, dyeing, mordant and wax painting or printing.[2]

By the later Middle Ages, Indian cotton textiles were therefore common items of apparel and furnishing in many regions of the Indian Ocean and beyond. Whether the arrival of European traders substantially altered this system of exchange is a matter of debate. What is certain is that from 1500 Europeans created new markets by carrying Indian cotton textiles, especially to Europe and the Americas, so that Indian textiles made inroads into the habits of consumers almost everywhere in the world.[3] Painted and printed fabrics were at the core of the trade of the European East India companies, trading organizations often considered to be the precursors of modern corporations. The Portuguese Carreira da Índia, established in the early sixteenth century, and subsequently the English (EEIC), Dutch (the so-called

FIG. 15.1

Textiles Imported from Asia into Europe by the Portuguese Carreira da Índia and the Dutch, English and French East India companies, 1586–1830 (in thousand pieces per year).

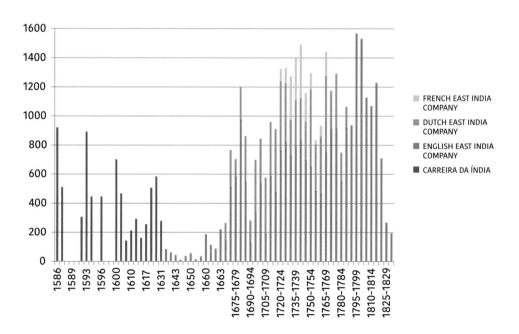

FRENCH EAST INDIA COMPANY

DUTCH EAST INDIA COMPANY

ENGLISH EAST INDIA COMPANY

CARREIRA DA ÍNDIA

VOC [Vereenigde Oostindische Compagnie] or East India Company), French (FEIC), Swedish, and Danish companies, from the seventeenth century, purchased millions of pieces of Indian printed, painted, and plain cotton cloth to be sold to European consumers. By the late seventeenth century, the European companies imported six to eight hundred thousand pieces (each approximately fifteen metres long) per year of Indian cottons; a century later these quantities had doubled (fig. 15.1).

The companies' trade of cloth was not only to Europe; they also made high profits in the "country trade" (i.e., intra-Asian trade), peddling India's cotton textiles to other Asian ports, a business that soon outpaced the trade in spices. Cotton cloth was a key commodity for Europeans to gain political and economic power in Asia, thus setting a path toward imperialism. By the 1770s, for instance, European traders controlled approximately half of all shipments of goods from Batavia (present-day Jakarta) to India.[4] Batavia was the entrepôt for trade in various Indian cotton textiles, such as cheap striped or monochrome "guinea cloth" and *salempuri* (white cotton cloth with red borders) produced on the Coromandel Coast and in Surat. The long hand of Europe is visible in the control of both production and consumption markets.

Although Portugal initiated early significant imports to Europe, it was Dutch and English companies that substantially altered European consuming habits in the first half of the seventeenth century through their imports of Indian painted and printed cotton. Europeans—like many other consumers across the world—were attracted by the properties of the cotton fibre: its light weight and ease of washing, and chintz's colourful and, at times, exotic designs. Initially employed for household furnishings, sometime in the second half of the seventeenth century Indian cottons started to be used also for clothing (see ch. 10 and 16). The anonymous author of *The Trade of England Revived* (1681) explained that consumers wanted "a Bangale that is brought from India, both for Lynings to Coats, and for Petticoats too."[5]

Economic historians are revising the long-held belief that Indian cottons found easy markets in Europe because they were cheaper than locally produced textiles. In eighteenth-century Britain, for instance, imported cotton textiles were a third more expensive than an equivalent linen cloth; yet Indian cottons cost only a third of top-quality Holland linen and possibly a quarter of the price of good-quality woollen cloth and broadcloth.[6] Nor did Indian textiles necessarily find immediate success among European consumers. Far from being a "calico craze," the acceptance of Indian cloth as dress in Europe was a slow affair that took several generations. It was also a process that was aided by the East India companies through trial and error.

Even more significantly, European traders made India's cotton textiles a global fashion phenomenon by carrying them into the vast space of the Atlantic Ocean—to West Africa and the Americas. The high demand in these new markets reshaped not only people's consuming habits but also the economies and societies of the Atlantic world. An important outlet was West Africa, where checkered and striped cotton textiles especially—both Indian originals and imitations produced in Europe—were sold in exchange for slaves who were forced to work in the American plantations to produce raw materials (such as raw cotton) and commodities (sugar, tobacco, and cocoa) to be sold in Europe. West Africa was a discerning market: a Dutch trader explained that "the Blacks . . . would rather have the

FIG. 15.2

Miguel Cabrera. *4. From Spaniard and Black, Mulatto Woman,* 1763, oil on canvas.

Private collection

entire purchase sum in dry goods, such as cottons, gingham, salempuris [cloth], calavap [cloth], etc. A sensible ship's captain knows, at whatever place on the Coast he is, which of his goods are in demand."[7] Figures of the trade of England, France, and the Dutch Republic to West Africa show how important Indian textiles were in the functioning of the Atlantic slave trade, although printed and painted cottons were less desired than other varieties in this market (see ch. 1).

Greater demand for India's painted and printed cottons came from North and Latin American consumers. Already in 1700, the British colonies of North America were supplied with Indian calico quilts exported from London to places such as New York, Pennsylvania, and Virginia. By the mid-eighteenth century, various types of cotton textiles categorized by merchants as "Blue," "India," and "Negro," as well as printed and painted, were exported from England to the American colonies.[8] Similarly, *casta* (lit. lineage) paintings representing the ethnic mix of the Spanish American population depict men, women, and children wearing a variety of high-quality Indian cottons: plain and brightly coloured painted cottons (fig. 15.2).[9]

An Industrial "Evolution": Printing Cottons in Europe

Soon, Africa and the Americas would be drawn into a new chapter in the story of chintz: the imitation of Indian chintz in Europe. One has to remember that Europe's climatic conditions did not allow large-scale cotton cultivation. The little cotton cultivated in the Mediterranean islands, southern Spain, and the Balkans was of a short-staple variety, forcing imports of raw cotton and spun yarn into Europe from the Levant.[10] Importing longer-staple raw cotton from India in large quantities proved overly expensive because of freight cost. As a solution for cotton supplies, Europeans forced cultivation of cotton in the Americas, inaugurating a new form of what historian Alfred Crosby calls "ecologic imperialism": the use of extra-European land to cultivate "tropical" products—among them raw cotton, as well as indigo—to be used for producing cloth in Europe.[11] In this first modern "commodity chain," an industry based in one continent (Europe) depended on resources produced in another (the Americas).

Novel too was the production system developed for growing cotton: the slave plantation (fig. 15.3). Since the eleventh century, Europeans had promoted the plantation system for the cultivation of sugar in the Mediterranean islands, extending it to the islands of the Atlantic Coast of Africa in the fifteenth century and to the Americas in the following century. Plantation owners used the labour of slaves whom traders had bought on the coasts of West Africa in exchange for beads, metals, weapons, and most of all textiles. Yet cotton growing in the New World was not an immediate success. Sustained cotton cultivation was first practised in Barbados in the 1620s, spreading to the islands of the Bahamas in the following decade.[12] Over the next half a century, cotton made inroads into most of the West Indies, with its cultivation being first practised in Jamaica in the 1670s. It also reached mainland North America, arriving in Virginia in the late 1640s and South Carolina in the mid-1660s.[13]

Cotton's success involved the unparalleled exploitation of both human life and the environment. The harsh conditions and suffering of the enslaved African labour force are now acknowledged as the dark side of modern commodity production. The intensive cultivation of the fibre also spelled some of the earliest man-made environmental catastrophes: by the end of the eighteenth century, cotton had exhausted the soil of most of the West Indies, and no more virgin forest remained to "slash and burn." Some places, such as the Crooked Islands, were by the early nineteenth century all but deserted: one contemporary observed that once-prosperous cotton plantations "from the failure of crops were now abandoned, and had become covered with . . . indigenous shrubs and plants."[14]

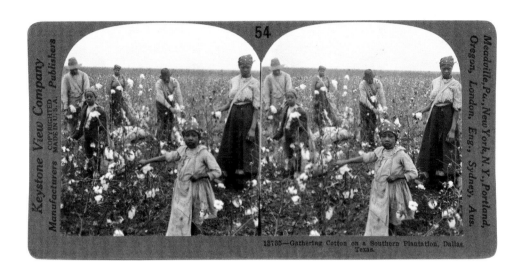

More cultivable land was, however, to be found on the American mainland. In the 1730s, two Swiss introduced West Indian cotton seeds to South Carolina and Georgia, respectively. Benefiting from the crisis of the West Indies, planters in the American South created enormous cotton plantations where slaves were treated more inhumanely than ever. At the end of the eighteenth century, the newly independent United States exported relatively little raw cotton, but by 1811 more than half of all cotton used by British mills came from the American South (fig. 15.4). To make way for cotton cultivation, the United States (US) government increasingly removed Native Americans from their homelands in the southern territories.[15] The rise of what came to be known as "King Cotton" continued up until the crisis of the American Civil War, providing endless supplies to the fastest growing industry in human history.[16] The elasticity of American cotton supplies allowed this new European industry to develop at a uniquely rapid rate without substantial real price increases for the raw fibres. This was facilitated first by the introduction of a new ginning machine by Eli Whitney in 1794, which greatly reduced the labour of cleaning cotton, and second by the introduction of new varieties of cotton that could be cultivated in more frigid climates, thus expanding US production dramatically.[17]

That Europe would develop a cotton textile industry is in fact surprising. The continent had neither easy access to raw cotton nor the expertise to print or paint cloth to the level of Indian artisans. Moreover, there seemed to be little incentive to manufacture a type of cloth that could be supplied in large quantities, and at relatively modest prices, from India. The creation of cotton manufacturing and its eventual mechanization in Europe is explained instead by observing how consumers and their governments reacted to Indian cloth. A major incentive to replace imported Indian printed and painted cottons came from bans imposed on Asian textiles across most of Europe in the period 1686–1774 (see ch. 1 and fig. 15.5). Governments thought it wise to forbid the importation and wearing of Indian cotton textiles in order to support their replacement with linens and woollens, as well as with locally produced cottons. Trading companies were allowed, however, to re-export the cloth to the American colonies and other markets.[18] Yet, it seems that such bans were quite ineffectual at stopping consumers from purchasing Indian cloth on domestic markets.[19] In England, as in France and elsewhere, people continued to wear forbidden cloth, risking

LEFT
FIG. 15.3

Cotton picking in Texas, ca.1900. Long after the American Civil War, the global demand for cotton pushed the cotton frontier ever west, with profound continuing social and environmental consequences.

Photographs and Prints Division, Schomberg Center for Research in Black Culture, The New York Public Library.

RIGHT
FIG. 15.4

Cotton picking sack. Louisiana, United States, ca. 1950. Cotton, rubber nubs, 124.5 × 67.5 cm.

This bag, made to hold a hundred pounds of cotton, was reportedly among the last used for hand picking in the United States.

ROM 986.280.1 Gift of Mr. Gus Green.

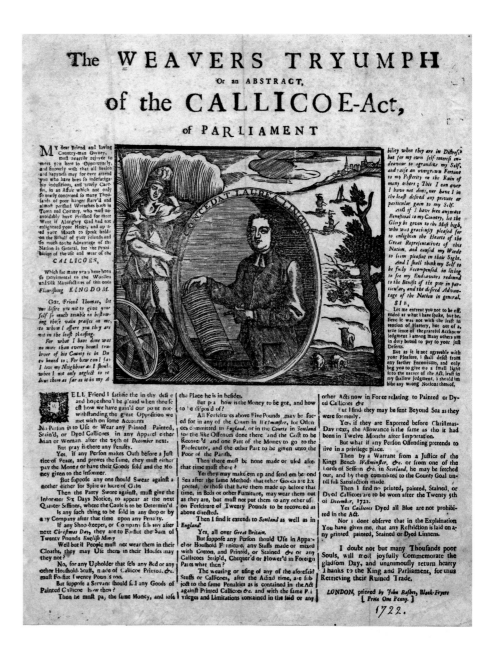

fines, incarceration, or simple humiliation. In 1719, for instance, Londoner Dorothy Orwell was "Assaulted by a Multitude of Weavers in Red-Lion-Fields in Hoxton, who tore, cut, and pull'd off her [cotton] Gown and Petticoat by Violence, threatened her with vile Language, and left her naked in the Fields."[20]

But beyond protectionism, forces of fashion were also at play. The distance and complexity of provisioning cotton cloth from Asia meant Indian producers were at a disadvantage in a fashion system of a seasonal nature and in their ability to fully respond to the tastes and requests of European consumers.[21] As painted and printed cloth became fashionable among the European elites and common people alike, consumers expressed choices that could not be easily satisfied by waiting up to two years, the time needed to send an order to India and receive back the final product in Europe. One 1693 order reveals the precise demands in London: "As much variety as may be, but 50 at least of each work, some purple, and some dark grounds, some red grounds and a few green; but the greatest quantities white grounds, some purple flowered, some red flowers. Note, half the quantity upon stripes, and half upon flowers and some both striped and flowered."[22] We do not know whether this request was satisfied, but museum collections certainly reveal such products (see fig. 10.3).

Conventional wisdom attributed the rise of European producers' "substitution" of Indian cottons to the English spinning industry and its great mechanized factories, but it arguably began much earlier, with European mastery of the processes of printing and painting cloth in imitation of the Indian, practised with sufficient proficiency by European textile artisans in the last quarter of the seventeenth century to provoke ill feeling from other textile producers toward their upstart competitors.[23] Attempts to replicate processes of production of Indian cotton textiles, especially in printing and dyeing, led to the creation of a thriving cotton printing and painting industry in Europe a century before Richard Arkwright's introduction of new spinning technologies (fig. 15.6a and b).[24] Such processes were carefully observed in India, conveyed by employees of the East India companies, and much discussed by chemists and specialists in eighteenth-century Europe. Partnerships with Armenian craftsmen from Anatolia were an additional way that technologies were transferred from Asia to Europe. The process continued over more than two generations, and by the second half of the eighteenth century, European calico printers could rival the high quality of Indian producers (fig. 15.7). They often printed on white cloth imported from India (legally sourced, once bans were repealed in France in 1759 and Britain in 1774). The celebrated eighteenth-century French calico printer Christophe-Philippe Oberkampf, for instance, long insisted on purchasing plain white Indian cotton cloth for his workshops at Jouy-en-Josas near Paris (see ch. 16).[25]

Rather than "revolutionary," the rise of the new cotton industry in Europe took nearly two centuries, as European merchants and entrepreneurs struggled to master the making of cotton textiles by replacing different parts of a global commodity chain. In summary, merchants began by importing finished cloth and then trained consumers to appreciate it; manufacturers then started printing on imported white cloth (as this allowed designs and colours better suited to local European customers) and in doing so learned the finishing stages (fig. 15.6a).[26] Next they started thinking about producing their own ground cloth, first by seeking out yarn and raw cotton and eventually by finding a way to spin and weave such cloth themselves. A series of mechanical inventions, starting with John Wyatt and Lewis Paul's spinning frame (1738) and followed by James Hargreaves's spinning jenny (1765, patented 1770) and Arkwright's water frame (1767, patented 1769) finally allowed the production of cheap cotton yarn, thus completing the process of the substitution of Indian cloth.[27] The

BOTTOM LEFT
FIG. 15.6A

Initially Europe's "calico printers" closely followed Indian printing methods, using carved wooden blocks, river washing, and bleaching with dung and sunshine.

The Book of English Trades and Library of the Useful Arts (1823).

World History Archive / Alamy Stock Photo

BOTTOM RIGHT
FIG. 15.6B

From 1750, Europe's new printing technologies included engraved copper plates and, from 1790, engraved cylinders, driven by water or steam, with chemical bleaching.

James Richard Barfoot (1794–1863), "Printing" from *Progress of Cotton*, London: Darton Publisher, ca. 1840, hand-coloured lithograph.

Yale Center for British Art, Paul Mellon Collection

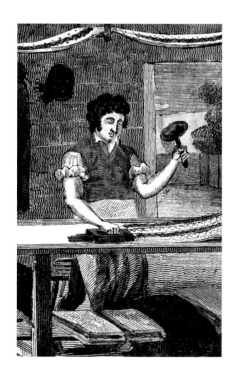

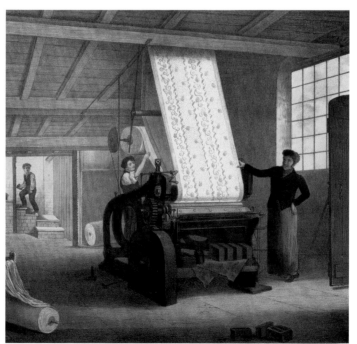

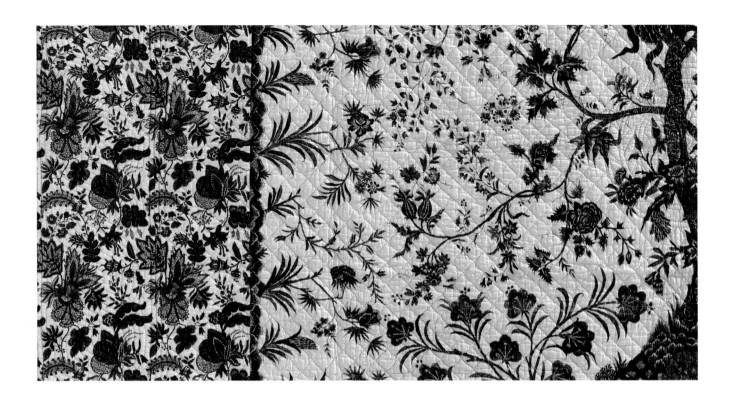

use of machinery reduced European manufacturers' labour costs to become competitive
with wages of Indian craftsmen. In 1793, a committee of the English East India Company
commented upon the fact that "the slow Progress of an Indian Manufacture, unaided by
Machinery, will require Ten, Twelve, perhaps Fifteen Persons to perform the same Work which
a single British Manufacturer can execute, assisted as he is by numerous Inventions and
Improvements."[28] Enormous expenditures from private and public sectors would, decades
later, result in the development of new ways of applying dyes directly to the cloth surface
(see ch. 19).

It was the combination of abundant raw materials, new technologies, and new markets
that allowed the production of good-quality cotton cloth in Europe for the first time. The
global appeal of cotton textiles, particularly prints, prompted intense import-substitution
processes across the world—in Europe, in particular—which eventually led to a shift (from
India to western Europe) and reconfiguration (from manufacturing to industry) of this key
sector in the early modern-world economy.

Return to Asia

The reconfiguration of manufacturing on a global scale has been termed the "Great
Divergence" by economic historian Kenneth Pomeranz.[29] While Europe and, a few
decades later, North America industrialized and became economically dominant, Asian
economies stalled and even regressed. European commodities such as mass-produced
printed cottons conquered markets not only in Europe and the Americas but also in Africa
and Asia. By the 1820s, India's textile artisans in some areas and in some sectors were
outcompeted by the cottons churned out in millions of yards by English mills, which led
to mass dislocations and poverty. And while indeed the demand for expensive painted
cottons radically dwindled, printed cottons fared better. As essays in this volume suggest,
India's textile printers took advantage of the cheaper mill-made cotton yarn and cloth—
produced first by British mills, and from the 1870s, by Indian mills—as well as of the new

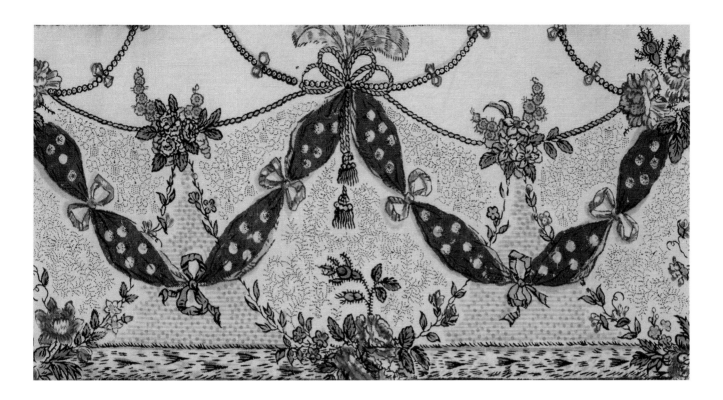

aniline dyes (see ch. 1 and 17). They produced some high-end chintz for export to Indian Ocean networks, but most made low-end prints for use in local villages and towns. Yet in this way, knowledge and many hand skills were sustained.

The story of cotton is also one of unexpected comebacks. Perhaps the rise of Europe and the industrialization that cotton textile manufacturing brought about was just a parenthesis. Since the 1970s and even more so with the growth of what are now called "emerging economies" in the new millennium, India and China have once again become the world's largest producers of cotton fibre, textiles, and clothing, this time using industrial methods, claiming back the leadership that they had enjoyed in the production of cloth for centuries before the advent of European industrialization.

FIG. 15.8

Many European printers struggled to match the rich and durable colours of India. On this mid-eighteenth century British (?) block-printed cotton, the ribbon and border were perhaps originally red, or intended to be red, but have turned brown.

ROM 934.4.246. Collection of Harry Wearne. Gift of Mrs. Harry Wearne.

1 See, e.g., Riello and Roy, *How India Clothed*, 1–28.

2 Crill, *Indian Chintzes*, 8–27.

3 Riello, "Globalization of Cotton Textiles."

4 Knaap, *Shallow Waters*, 88.

5 *Trade of England Revived*, 16–17.

6 Riello, "Indian Apprenticeship," 344–45.

7 Rømer, *Reliable Account*, 191.

8 Riello, "Globalization of Cotton Textiles," 284.

9 Fisher, "*Mestizaje*," 66–67.

10 Davis, *Aleppo and Devonshire Square*, 27.

11 Crosby, *Ecological Imperialism*.

12 Jaquay, "Caribbean Cotton Production," 60–61.

13 Knight, *Working the Diaspora*, 76–83.

14 Edwards, *History, Civil and Commercial*, 4:350.

15 Johnson, *River of Dark Dreams*, 30.

16 Dattel, *Cotton and Race*, 30–31. See also Beckert, *Empire of Cotton*, ch. 1.

17 Hobhouse, *Seeds of Change*, 187–88; Johnson, *Early American Republic*, 90.

18 Eacott, *Selling Empire*, ch. 2.

19 Lemire, *Cotton*, 33–64.

20 "Trial of Peter Cornelius, July 1720" (t-17200712-28), Proceedings of the Old Bailey, www.oldbaileyonline.org, quoted in Wigston Smith, "'Callico Madams,'" 33–34.

21 Berg, "In Pursuit of Luxury."

22 Quoted in Baker, *Calico Painting and Printing*, 1:33.

23 Longfield, "History," 26.

24 Riello, "Asian Knowledge."

25 Chapman and Chassagne, *European Textile Printers*, 156–58.

26 Lemire and Riello, "East and West." On the role of embroidery, see also Lemire, "Domesticating the Exotic."

27 O'Brien et al., "The Micro-Foundations."

28 East India Company, *Report of Select Committee*, 6.

29 Pomeranz, *Great Divergence*.

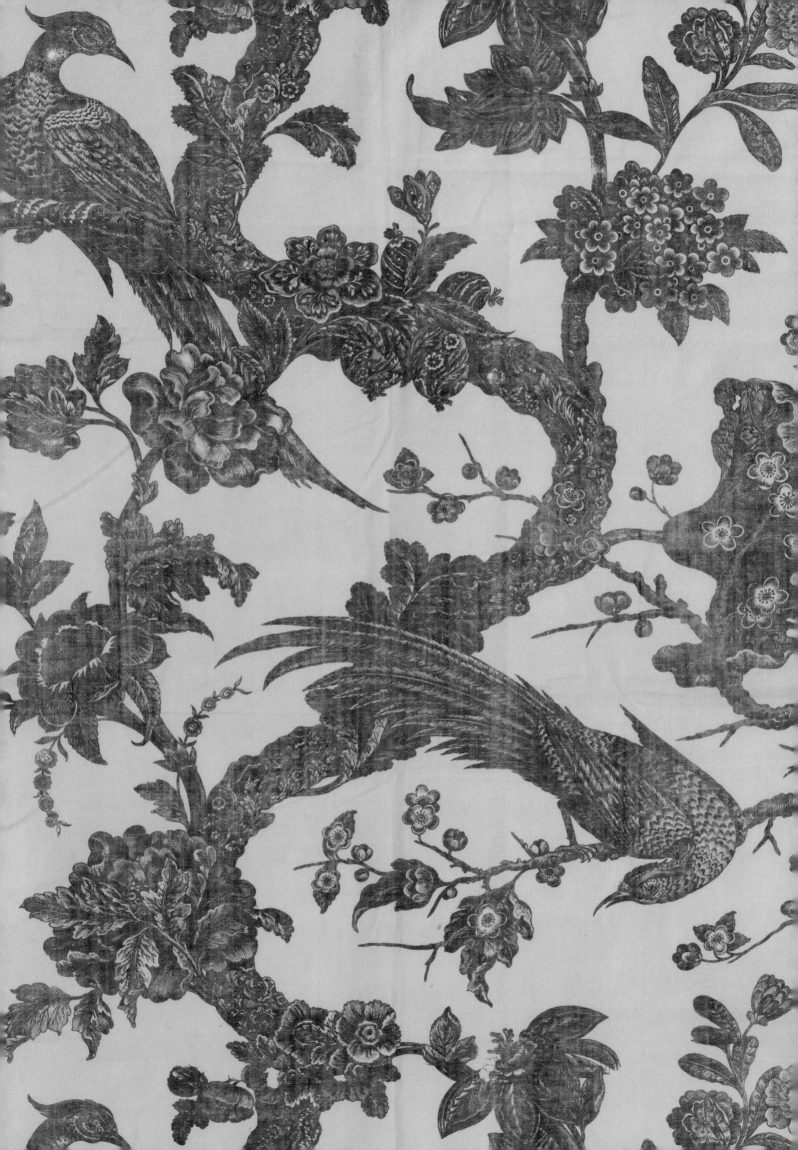

16

REFASHIONING INDIAN CHINTZ IN THE EUROPEAN MANNER

PHILIP A. SYKAS

THE PLAYWRIGHT MOLIÈRE'S FAMOUS WOULD-BE GENTLEMAN, THE *bourgeois gentilhomme*, appears on stage in a gown of printed Indian cotton, assured in his notion that this was how people of quality dressed in the morning.[1] Already in 1670, this descent to the bourgeois class signals the beginning of a transition from an elite toward a mass market. A century and a half later, Europe had succeeded in building upon Indian technology and craft practice by devising new mechanized means for imitating the prized chintz fabrics. Europeans adopted from Indian models their design vocabularies, their colouration principles, and their fine delineation, but refashioned them for changing aesthetic and social contexts. Under the guise of increased productivity, Europeans used printed textiles to showcase their claims to scientific advancement.

Detail: Furnishing textile, Nixon & Co., England, ca. 1760–1770 (p. 207).

FIG. 16.1

Furnishing textile. Cotton, spun and woven in India, block printed with mordants, dyed and finished at the Oberkampf manufactory, Jouy-en-Josas, ca. 1795. 28.5 × 94 cm.

ROM 934.4.191. Harry Wearne Collection. Gift of Mrs. Harry Wearne.

Reimagining Floral Patterns

The Indian floral chintz arrived on the European scene at a time of religious division. The Catholic Church encouraged the use of flowers and their symbolic interpretation in devotional observance. The beauty of nature was seen to offer salutary lessons for the conduct of a virtuous life. By contrast, Protestants saw the beauty of flowers as a distraction from the Word of God and objected to offerings of flowers in the church.[2] However, by the seventeenth century, flowers had entered the secular context of the home, freeing them from divisive religious beliefs. In domestic surroundings, the aesthetic value of flowers was emphasized alongside their general symbolism of the transience of earthly things. Indian chintz, although originally offering flowers of unfamiliar or imaginary form, chimed with this secular return of flowers to a decorative function in the home. Meanwhile, Europe's foreign trade stimulated an interest in botany and the collection of new plants from abroad that reached its peak in the eighteenth century. This increased scientific interest in plants gave rise to the botanical style in printed textiles (see ch. 12).

The premier calico printer of France, Christophe-Philippe Oberkampf, continued to use fine woven cottons from India to print designs for dress and furnishing using wooden blocks. Around 1795, he brought out a polychrome block print portraying a range of exotic floral forms scattered over a light ground (fig. 16.1). The arrangement of motifs recalls the density of Indian floral chintz for the Persian market (Iran), where flowers are seen in full-face (rosettes) and in profile (see ch. 4), although here the design is less structured, evoking a millefleurs (carpet of flowers) effect. The designer has retained the concept of exotic flora from Indian work but has presented not imaginary flora but real examples (see ch. 11), not only from India but also from East Asia, Africa, Australia, and North and South America. These flowers were sourced from the engraved plates of Jean Lamarck's *Encyclopédie méthodique botanique*; fourteen plants were chosen from the first two volumes of the accompanying *Receuil de planches* (Album of plates) issued between 1791 and 1794 (see table on opposite page).[3] Oberkampf's print is assumed to have been produced within a year of the latter volume, benefiting from the topicality of interest spurred by Lamarck's publication.

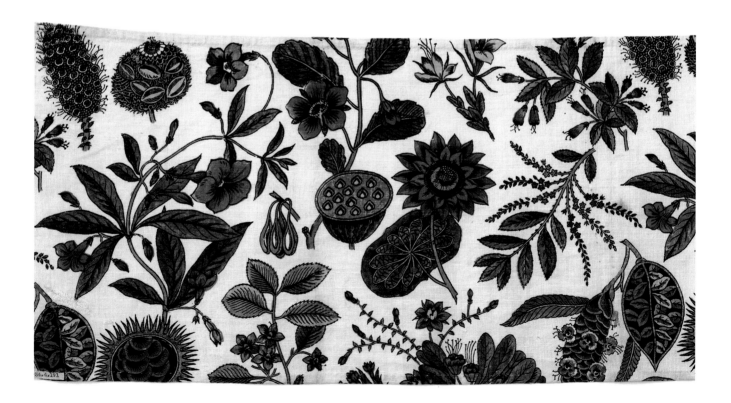

PLANT NAME	PLATE	ORIGIN	VOL:PG
Kaempferia (Zédoaire)	1	East Indies, Ceylon	8:852
Amomum	2	Madagascar, India, Malabar, Ceylon	1:132
Banksia	54	New Holland, New Zealand	1:369
Humbertia (Endrach)	103	Madagascar	2:316
Retzia	103	Cape of Good Hope	6:185
Weigela	105	Japan, Korea	8:788
Itea	147	Virginia, Carolina	3:314
Ambelania	169	L'Île de Cayenne	1:126
Allamanda orelie	171	L'Île de Cayenne	4:601
Parkinsonia	336	Jamaica	5:22
Samyda	355	Jamaica, St. Domingo	6:488
Halesia	404	Carolina, Pennsylvania	3:66
Nelumbium	453	India, China	4:454
Ochna	472	Central America, Madagascar, India	4:510

FIG. 16.2

Illustrations from Jean Lamarck's *Receuil de planches*, vol. 1, plates 1 and 2. Engraving on paper by Jacques Eustache de Sève.

Image from the Biodiversity Heritage Library. Contributed by Missouri Botanical Garden.

FIG. 16.3

Woman's bodice and pattern detail. Probably Alsace, France, ca.1810. Cotton, block printed forming six colours by the "lapis" technique, using mordants, resists, and dyes, 65.5 × 69 cm.

ROM 2013.29.3.1. Lillian Williams Collection. This acquisition was made possible with the generous support of the Louise Hawley Stone Charitable Trust Fund.

The first selection, *Kaempferia* (fig. 16.2), suggests a play on the name Oberkampf. A possible anagram of the initial letters of the plants selected for the block-printed cloth is OBERK. AW ISPAHAN (Oberkampf in Ispahan). The Persian styling of the floral design makes this analysis appealing, but if it is correct, only a select few may have been privy to the secret.[4] The desire to represent a wide geographical coverage, along with aesthetic needs, probably prevailed in the choice of plants. The modification of some of the Lamarck images suggests that the designer put attractive arrangement above botanical accuracy. However, in the concerted move from floral fantasy to the botanical style, we see the European designer adapting the chintz heritage to suit new forms of meaning for flowers, leaving aside moral symbolism for concrete references to science.

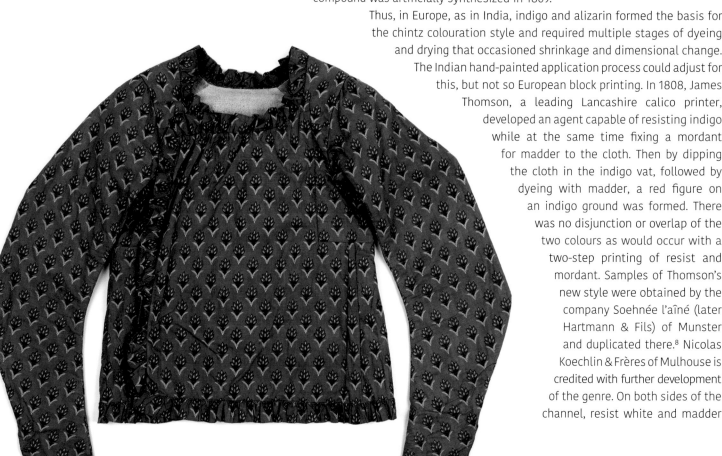

Revisiting Colour: The Lapis Style in England and France

Much of the attraction of Indian chintz lies in its colours enabled by Indian agricultural mastery of local plant resources. India's indigo is about ten times more concentrated than its European equivalent, woad, and eventually supplanted it. Not only was indigo stronger, but it was also effective in a cold vat, which opened the possibility for resist pastes. The Indian sources for alizarin—the chemical compound that produces red—were two plant roots, *chay* (*Oldenlandia umbellata*) and *al* (*Morinda citrifolia*) (see ch. 1). These roots furnished "dyes of a purity and depth of colour that defy imitation."[5] Their cost, however, probably prevented their becoming common dyestuffs in Europe. Chay root sold for one guinea per pound in 1789, and trials that year to raise the plant in the West Indies, with the aim of starting a plantation, were unsuccessful.[6] Oberkampf experimented with Indian chay root for his copperplate "Louis XVI, Restaurateur de la Liberté," produced in 1789, but local European madder plants resolutely remained the European source for alizarin red until the compound was artificially synthesized in 1869.[7]

Thus, in Europe, as in India, indigo and alizarin formed the basis for the chintz colouration style and required multiple stages of dyeing and drying that occasioned shrinkage and dimensional change. The Indian hand-painted application process could adjust for this, but not so European block printing. In 1808, James Thomson, a leading Lancashire calico printer, developed an agent capable of resisting indigo while at the same time fixing a mordant for madder to the cloth. Then by dipping the cloth in the indigo vat, followed by dyeing with madder, a red figure on an indigo ground was formed. There was no disjunction or overlap of the two colours as would occur with a two-step printing of resist and mordant. Samples of Thomson's new style were obtained by the company Soehnée l'aîné (later Hartmann & Fils) of Munster and duplicated there.[8] Nicolas Koechlin & Frères of Mulhouse is credited with further development of the genre. On both sides of the channel, resist white and madder

black were quickly added to the possibilities of the style. By overprinting with yellow, it was then possible to obtain a full range of seven chintz colours, thereby reducing to three dyeing stages the lengthy Indian chintz process. The Alsatian designer Henri Lebert wrote, "This style, by the novelty of its hitherto unknown effects and the numerous variations of colouring possible using fast colours, was revolutionary for textile printing."[9] In France, this style was known as *lapis*, named after the lapis lazuli mineral, because of its azure blue ground, while in Britain it was referred to as the *neutral* style.

The day dress whose bodice is seen in figure 16.3, made of block-printed fine cotton cambric, is an early example of lapis printing, probably around 1810. Given its French provenance, it is likely to have been printed by either Soehnée l'aîné or Koechlin & Frères. Here, the basic red on blue has been elaborated with resist white and overprinting in yellow and black. The design is a small, evenly distributed spot motif characteristic of the introductory period of the lapis style and loosely evoking the woven sprigs of Kashmir shawls, another great design source from the Indian subcontinent. Later lapis patterns became more elaborate, showing less ground.[10] In the detail (fig. 16.3), it is evident that the black calyx of the flower fails to cover completely the white resist below, another indication of the early stage of development. To the European, the lapis style represented the latest advances in the application of chemical knowledge, and the wearer of this dress would likely have been proud to reflect both the beauties of Kashmir and the achievements of science.

Reinventing Delineation: Francis Nixon and Copperplate Printing

Europe's long familiarity with Indian chintz had accustomed consumers to the fine outlines and detailed infills of mordant-painted and resist work, directing European manufacturers toward a similar high calibre of delineation and density of incident. European wood-block printers did not match this standard until the 1780s; however, some decades earlier, a system enabling fine-printed detail was achieved by using engraved copperplates. Developed from map-printing technologies, the new process also supported the shading of three-dimensional forms catering to the expectations of Western pictorial taste.[11]

Printing textiles from engraved copperplates had been practised from the seventeenth century, most notably in Holland, but on singular products, like handkerchiefs, rather than on patterned lengths of cloth.[12] The pioneering English printer William Sherwin used engraved plates to print cotton with mordants by the 1670s. However, the process only achieved wider commercial use after Francis Nixon introduced copperplate work at Drumcondra, Ireland, in 1752. His epitaph honestly records his achievement as "perfecting," not inventing, the process. Nixon was soon prevailed upon to license the process to George Amyand, an East India merchant, who set up a printworks near Merton in Surrey, moving there as a partner in March 1757 and remaining until his death in 1765. Amyand died in 1766 but was succeeded by his son, and the firm became known as Nixon & Co. until the printworks was sold in 1789.

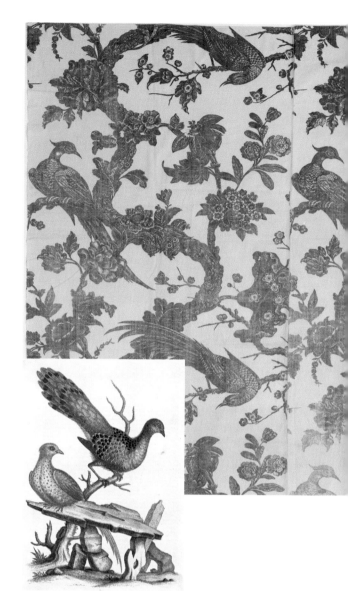

FIG. 16.4

Furnishing textile. Nixon & Co., England, ca. 1760–70. Linen and cotton fabric (fustian), mordant printed with engraved copperplate, dyed, 185.5 × 158.5 cm.

ROM 971.22.1

FIG. 16.5

Illustration from George Edwards, *Natural History*, vol. 2, plate 69, "The Hen Peacock Pheasant, from China." Etching printed on paper and hand coloured, signed, and dated 1746 by Edwards.

Image from the Biodiversity Heritage Library. Digitized by Smithsonian Libraries.

The example shown in figure 16.4 is a rare bird-and-branch pattern, which probably originates from Nixon's early period at Merton.[13] The pattern is printed in madder red on a linen-and-cotton-mixture fabric, the so-called fustian that allowed British calico printers to escape the ban then in force on printing all-cotton fabrics. Pheasants perch on a serpentine branch in a flowering tree in the manner of European chinoiserie, but the image owes much to the collaborative style of chintz evolved through Indian interpretation of European models. Unlike the logic of single trees in large-scale Indian hangings (palampores) and Chinese wallpaper precedents, the repeating patterns of copperplates risked the absurdity of a tree that grows on and on without end. To counteract this problem, the designer used a half-dropped arrangement for the repeat that emphasizes opposing diagonals where the viewer's attention is held by large blossoms and the birds' gaze.

The designer of the pattern in figure 16.4 sourced his birds from the second volume of George Edwards's *A Natural History of Uncommon Birds*, published in 1747, but elements from plates showing the Chinese silver pheasant and peacock pheasant were rearranged (see fig. 16.5). Edwards protested against the mangling of his work: "Printers of linen and cotton cloths have filled the shops in London with images . . . copied . . . after the figures in my History of Birds . . . though the figures are so miserably lamed and distorted that the judicious part of the world can form but a mean opinion of the work from which they are plunder'd."[14] But Edwards's birds attracted the designer because they showed a variety of poses and were often presented in pairs, unlike the stiff profile images of previous bird artists. Nixon's designer, following his Indian counterparts, felt compelled to elaborate the tail feathers, to turn the necks, and to exaggerate the crests and beaks, tempering realism with fantasy in the chinoiserie tradition.

One of the greatest debts in this print to its Indian chintz forebears is hidden in plain sight: the red outline. In addition to black, Indian artists used alizarin red as an outline colour to give a softer edge to motifs coloured red, like flower petals. Copperplate patterns printed in monochrome red probably owe their acceptance to taste preconditioned by the Indian originals.

Conclusions

In 1693, Daniel Havart of the Dutch East India Company remarked, "This painting of chintzes goes on very slowly, like snails which creep on and appear not to advance."[15] But the lengthy Indian methods represented knowledge accumulated over generations of craft practice. European attempts to imitate chintz with shortened processes introduced many problems. Most difficult to master were the invisible ingredients, such as thickeners for making the mordant into a paste suitable for application. Not until late in the eighteenth century was the changeover from mordant painting to block printing resolved with the discovery of acetate of aluminum. This alum mordant, which did not crystallize—thus giving it time to penetrate the cloth—was hailed by chemist Edward Bancroft as the greatest European improvement in the art of calico printing.[16] The desire to imitate Indian chintz was a stimulus for European innovation; as we have seen, copperplate printing enabled fine delineation, and the lapis technique produced the basic chintz colour range. Further innovations in chemical and mechanical engineering eventually made possible the full mechanization of textile printing. However, Europe maintained its affection for the original Indian product, as seen in its enduring use of three borrowed design vocabularies: the blossoming branch, the Kashmir sprig, and the Persian-style floral.

In Focus

Printing in Green

by HANNA E. H. MARTINSEN

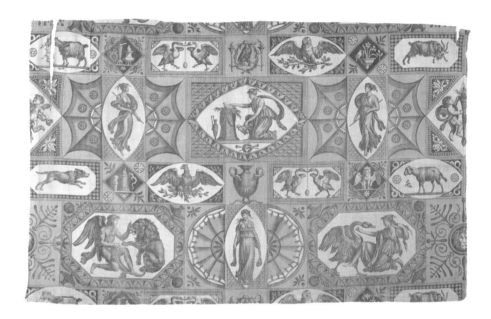

Furnishing textile, *Le lion amoureux* or *Léda*. Designed by Jean-Baptiste Huet and roller printed by the Oberkampf factory of Jouy in 1809. Cotton, dyes, 58.4 x 91.5 cm; repeat 54 × 94 cm. (ROM 934.4.528) Harry Wearne Collection. Gift of Mrs. Harry Wearne.

The fact that no single vegetable substance could yield a permanent green colour was a shared problem facing both Indian and European textile painters, printers, and dyers. In India, the green design elements of cotton textiles were typically achieved by covering all sections of the pattern that were not intended for blue or green with wax before the textile was submersed in the indigo vat.[1] This process was completed by then superimposing yellow dye on top of the blue parts. In Europe, by the mid-1700s, manufacturers had streamlined the process by directly applying indigo dye to the cloth surface (through the addition of toxic arsenic sulphate, orpiment); however, creating green still required a separate application of yellow colour. Thus, in both India and Europe, the practice was very time consuming, as the textile had to be treated twice and required highly skilled workers to ensure that the two colours covered each other precisely.

European textile printers developed two new techniques for applying mordants to cotton textiles: using copperplates and copper rollers. These techniques produced distinctive monochromatic graphic designs in red, grey, puce (a shade of violet), and blue. Unfortunately, the two-step printing process could not be used to produce textile prints in green, which pressured English chemists to develop a colourfast green dye that could be applied in one single printing process. The Royal Society in London offered an award of two thousand pounds sterling to encourage this pursuit. Finally, the 18 July 1810

Details of *Le lion amoureux* or *Leda*, p. 209. The fine hairs on the goat's underbelly reveal the perfect precise made possible by the single-printing process.

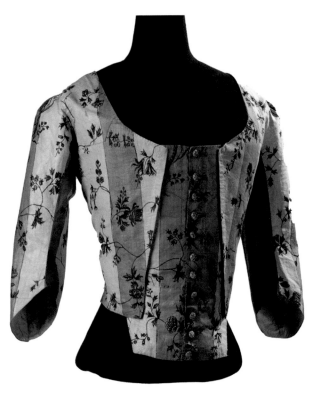

Woman's bodice, made of hand-drawn, mordant- and resist-dyed Indian chintz, ca. 1780–1789. In the eighteenth century, both Indian and European cotton painters and printers formed green by applying yellow on top of sections previously dyed blue. ROM 2013.29.4. Lilian Willams Collection. This acquisition was made possible with the generous support of the Louise Hawley Stone Charitable Trust.

Journal du Commerce announced that the one-step green process had been achieved in France.[2] Much more than a chemical discovery, it became a symbol of national French pride.

The method had been developed by Samuel Widmer, who worked with his uncle Christophe-Philippe Oberkampf at his establishment in Jouy-en-Josas, where Widmer first presented his method in 1808. He named the process *vert faiencé* because the colour was obtained by "introduisant dans le bleu faiencé *[sic]* une certain quantité d'oxide *[sic]* stanneux ... pour produire du vert,"[3] this combination of indigo and tin oxide will, during the subsequent submersion in a yellow dye vat, turn the printed areas green.

When Oberkampf decided to introduce this novelty, it was presented as a roller print in the fashionable neoclassical style designed by the French painter Jean-Baptiste Huet (opening figure, p. 209). The motif, entitled *Le lion amoureux* or *Léda*, was taken from Greek mythology and depicted repeats of cartouches containing classical figures and mythological images; hatched details and backgrounds were created by fine lines with meticulous details as in a graphic print—a design typical for plate prints and roller prints. The Royal Ontario Museum (ROM) owns one of the two known samples of *Le*

lion amoureux or *Léda* printed in green, the other held in the collection of Bibliothèque Forney in Paris. The fine lines and minute details that are characteristic of these prints are impossible to achieve by the old-fashioned two-step method, as can clearly be observed by the detail showing the hairs from the goat's underbelly (See details of *Le lion amoureux* on opposite page).

The Prix décennaux (ten-year prize) was established by Napoleon Bonaparte with the objective that France retain the superiority it had achieved in science and art. In October 1810, the Grand Prize of First Class was presented for the first time, and the award "for the founder of an establishment of importance to the industry" was given to Oberkampf. In their report, the jury gave an honourable mention to M. Widmer for printing green in one process, "one of the most vital conquests of applied chemistry for the manufacturers. . . . To the great satisfaction of the French this discovery was done in France and the prize was not won in England."[4]

1 There is ongoing debate as to whether—and how—Indian printers and dyers practised direct indigo application in medieval and early modern times, by using orpiment or other techniques. See Barnes, *Indian Block-Printed Textiles*, vol. 1, 52, 57; Gittinger, "Ingenious Techniques" and *Master Dyers*; Cardon, "Colours of Chintz" and "Chimie empirique"; Floud, "English Contribution," 345; Q[uarelles], *Traité*, 34–39; Schwartz, "Contribution à l'histoire"; Berthollet and Berthollet, *Elements of the Art*, 2:79–80; Martinsen, "Fashionable Chemistry," 207–12. **2** Widmer, "Mémorial." **3** Persoz, *Traité théorétique*, 3:388. **4** "Prix décennaux."

1 "Je me suis fait faire cette Indienne-cy. . . . Mon Tailleur m'a dit que les Gens de Qualité éstoient comme çela le matin" (Molière, *Le bourgeois gentilhomme*, 8; I had this Indian-style [gown] made for me. . . . My tailor told me that people of quality appear this way in the morning [my translation]).

2 See Goody, *Culture of Flowers*, esp. 166–205.

3 Lamarck, *Encyclopédie méthodique botanique* and *Recueil de planches*. The explanations of plates 1 to 445 were published by 1793, but since two plates beyond 445 were chosen by Oberkampf, it is likely these appeared in 1794.

4 The fact that the pair to this print (taken mainly from the third volume of Lamarck's plates) does not appear to work anagrammatically makes such an analysis seem coincidental. Twelve of the fifteen plants represented in the second print can be identified, but the name of only one begins with a vowel. The pair is discussed together in Anderson-Hay, "Botanical Illustration."

5 Watt, "Vegetable Resources of India," 322.

6 "Cochineal Opuntia," *Kentish Gazette*, 13 October 1789, 2.

7 Taylor, "Jouy Calico Print."

8 Henri Lebert claimed an earlier discovery for the Munster firm by 1805 and stated that the chemists who worked on its development were M. Robert of Paris and Charles Bartholdi of Colmar. See Lebert, "Notice," 15.

9 Author's translation. "Ce genre, par la nouveauté d'effets jusqu'alors inconnus et ses nombreuses variations de colorations possibles en couleurs solides, fit une revolution dans la fabrication des toiles peintes." Lebert, 15.

10 A discussion of the stylistic development of lapis can be found in O'Connor, "Lapis."

11 Schoeser, "Mystery," 21.

12 Floud, "English Contribution," 429.

13 Attribution is based on stylistic comparison with identified prints, noting especially the treatment of the birds' eyes and beak shape. However, engravers could work for different firms, so stylistic identification cannot be certain. Melinda Watt ("Textile with Pheasants") attributed the example in the Metropolitan Museum, New York, to Talwin and Foster, which is a plausible alternative.

14 Quoted in Jackson, *Bird Etchings*, 98.

15 Quoted in Irwin, "Indian Textile Trade," pt. 2:31.

16 Bancroft, *Experimental Researches*, 176. See also Schwartz, "French Documents," 42.

17

KNOWING CHINTZ

INDIAN PRINTED COTTON, 1850–1900

DEEPALI DEWAN

We most frequently hear India spoken of as a farm from which we are to draw our supplies or raw produce ... or as a field which we have to cover with our manufactures, rather than an estate we have to improve, and on the inhabitants of which we are to watch the effects of our manufacturing inundations.

—J. Forbes Royle, "Art and Manufactures" (1852), 444

THIS QUOTE BY J. FORBES ROYLE, ORGANIZER OF THE INDIA SECTION of the 1851 Great Exhibition of the Works of Industry of All Nations, London, describes India in three ways: as a farm, a field, and an estate. This characterization aligns with Britain's engagement with cotton, the wonder fabric that brought traders from far and wide to India's shore. At first, Britain imported Indian cottons that had been grown, woven, and decorated in India, as if from a farm. Subsequently, Britain reproduced Indian designs and exported them back into the Indian market—the field, as mentioned above. But it was from about 1850 onward that Britain recognized and tried to curb the perceived negative impacts of its own products and designs. By this time, of course, India was no longer a trading partner but rather a British colony and, like an estate, was seen as a space to be developed and improved. This essay focuses on this last stage, with an emphasis on printed cottons in India in the latter half of the nineteenth century, a critical moment for Indian chintz. Specifically, I argue, the arena

Detail: Photograph showing the stand of A. H. Sumsoodin at the 1889 Paris Exhibition (p. 222).

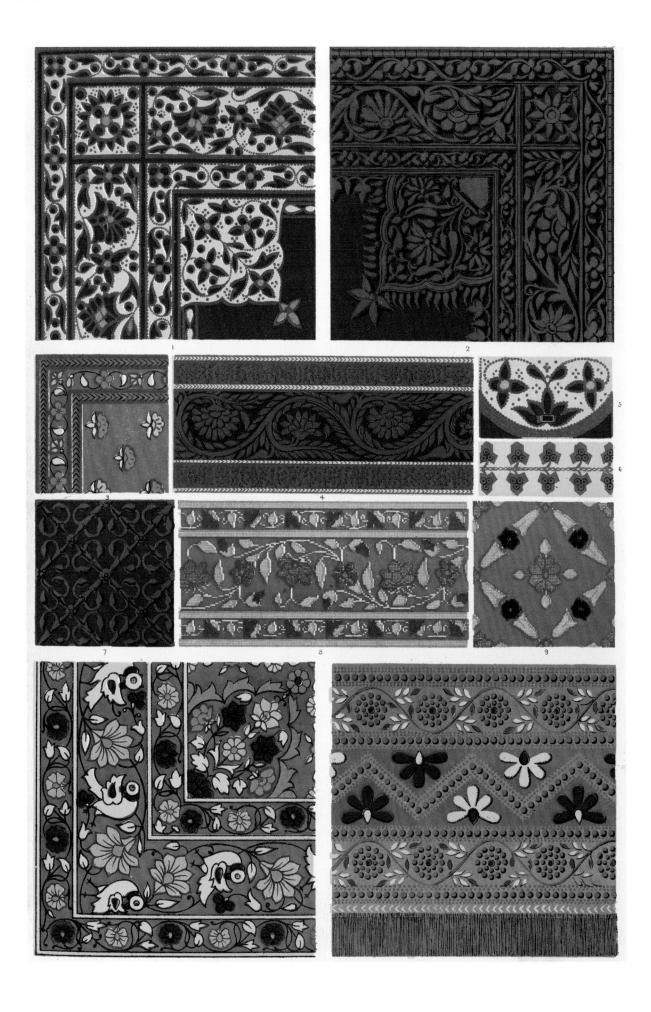

of colonial art education reveals the dynamics of late nineteenth-century chintz production but also shaped knowledge about Indian printed and painted cottons that still impacts attitudes toward them today. By reading with, through, and against colonial publications, one can discern how colonial knowledge both hides and reveals much.

The 1851 Great Exhibition and Its Lessons

The above statement by Royle was made shortly after the 1851 Great Exhibition, a turning point in the relationship between Britain and India's manufactures. Royle had published an extensive volume on the culture and commerce of cotton in India as a lead-up to the Great Exhibition, in which he argued that cotton could serve as a model for other natural products from India to be transformed by the British into articles of commerce.[1] The Great Exhibition of 1851 was the first of its kind to bring the art and manufactures from different parts of the world under one roof. It came at a time of intensified concerns over Britain's ability to produce its own raw materials and misgivings about Britain's dependence on other lands—including slave labour for cotton in the southern United States[2]—and was meant to boost British industry and standardize trade. India had long been a major trading partner, and the East India Company, by this time, had politically colonized great patches of the Indian subcontinent, enabling it to move goods quickly to its ports. It is no surprise that India was given more space than any other colony at the exhibition—thirty thousand square feet—and that it was the most comprehensive display of Indian material to date.[3] As a long-standing export product, cotton was represented in the exhibition through raw materials, weaving and printing implements, and sample cloths, from locations such as Assam, Calcutta (present-day Kolkata), Gwalior, Dacca, Nagpore, Murshidabad, Patna, and Agra.[4] That the locations were mostly from the vicinity of Bengal may reflect the networks available at the time to source and ship cloth for the exhibition.

The anxiety around the British economy that prompted the exhibition seemed to only deepen after it. British administrators and the public were astonished at the variety and quality of art manufactures in the world, making British products pale by comparison. Further, while the British had long known about Indian chintz, they were surprised to find a vibrant domestic production and consumption. Thus, efforts to document and distribute lessons from the exhibition were many. Perhaps the most well known among these was Owen Jones's *The Grammar of Ornament* (1856), which featured 112 chromolithographic plates from 19 cultural regions.[5] A good portion of Jones's budget was used to secure 139 Indian objects, 65 of them textiles. The chapter on "Indian" ornament, one of the larger in the volume, featured textile designs in order to provide British manufactures with patterns that could be industrially imitated and exported to India (fig. 17.1). Yet, the illustrations did not capture the level of detail required to separate embroidered from woven patterns, nor printed and painted designs from those on ceramic, lacquer, or metal work sharing the same page. In this way, there was much lost in translation.

John Forbes Watson's *The Textile Manufactures of India* (1866) seems to have been an attempt to correct the mistakes made by Jones's earlier publication.[6] In keeping with his role as reporter at the Indian Museum, the repository of the East India Company's collections, the publication was meant not to capture a totalizing view of Indian textile production but rather to "reorder metropolitan museum collections so that they could be put to work in a commercial context."[7] Consisting of eighteen volumes, this massive project contained seven hundred samples of real cloth (fig. 17.2). At GBP 150 per set, or ten times the price of *The Grammar of Ornament*, only twenty sets were distributed to chambers of commerce and art schools in Britain (thirteen sets) and India (seven sets).[8] Printed cottons appear briefly in sections on loom-made saris for females, glazed chintz cloth worn by Malay women, the calicoes, and in a chapter on printed-cotton goods that is divided into white ground,

OPPOSITE
FIG. 17.1

"Ornaments from Embroidered and Woven Fabrics." Jones, *The Grammar of Ornament*, ch. 12, plate 50. Chromolithograph.

ROM Library and Archives, Rare OS NK1510 .J7 1868.

"Chintzes (unglazed). 'Palampore' (bedcover)." Watson, *Textile Manufactures of India*, plate 476. Fabric samples mounted on paper.

Courtesy of the Harris Museum, Library & Art Gallery, Preston.

coloured ground, and palampores or bedcovers. These samples covered a wider geographic span than the 1851 Exhibition, offering about fifty samples across four volumes from the North-West Province (NWP), Punjab, Bengal, Agra, and Bijapur.[9] Yet the bulk of the samples represented the Madras presidency and were already familiar to British manufacturers; moreover, they were taken from the collections stored at the Indian Museum that Watson had cut up in order to produce the volumes.[10] These fabrics were not systematically collected nor necessarily reflective of a domestic consumption; however, they do provide a resource for Indian textile production in the nineteenth century and also show us how ideas about historical textile design prior to the import of foreign goods were shaped.[11]

Colonial Art Education and Its Forms of Knowledge

After 1857, Britain gained more access to the domestic Indian market. The South Kensington School of Art and Design was established in 1852 and provided a training ground both for existing manufacturers to enhance their skills and for a new generation of designers; it also supplied teachers to colonial art schools in India. The arena of colonial art education served as the portal to survey and document domestic production and assess it for its benefit to Britain.[12] A product of this arena of art education was a large body of illustrated literature in the form of reports, journals, catalogues, and monographs.[13]

One important publication was the *Journal of Indian Art and Industry* (*JIAI*). A total of 136 issues were published in seventeen volumes between 1886 and 1916 by William Griggs, a London publisher at the forefront of colour-illustration technology. The *JIAI* was central to the circulation of ideas about South Asian art, defining the aesthetic parameters of "tradition."[14] The numerous articles contained in its pages were written in large part by the South Kensington-trained principals and administrators preoccupied with knowing and preserving traditional handcrafted design. The *JIAI* provided British art-school students and manufacturers with patterns to create products to be sold in India; at the same time, the journal was meant to counter the perceived decline of traditional Indian manufactures resulting from the influx of foreign goods. These competing, indeed contradictory agendas— to promote and to curb the impact of British goods in India—mixed with colonial discourse that sought to justify colonial rule. On the one hand, this approach valorized handcrafted works, the hereditary craftsman, and the village as a space where tradition and the authentic in India was preserved. On the other hand, these very same aspects constructed India as a place without progress, with a population in need of guidance.

Reading With and Through

Many of the articles within the pages of *JIAI* describe locations for printed-cotton production, the types of products produced, and their quality. In almost all, there is commentary on the decline of a local industry due to the competition from British goods, but also on the survival of a local industry or the emergence of a new one. One of the frequent contributors to the *JIAI* was its editor, John Lockwood Kipling, student of the South Kensington School and principal of the Mayo School of Art, Lahore, from 1875 to 1893. Kipling conducted several surveys of the manufactures of the Punjab in the 1870s and 1880s. In one article, he highlights a trip to Kot Kamalia, today in Punjab, Pakistan, where he found a local industry of printed cloth used to divide architectural spaces, reminiscent of earlier tent structures. This cloth was designed with architectural forms showing an "arcade or panels of variously coloured foliage" and used like a curtain (purdah) to hang along a wall or to separate interior spaces (fig. 17.3).[15] This example, Kipling claims, is new: taking an arcade motif, familiar in

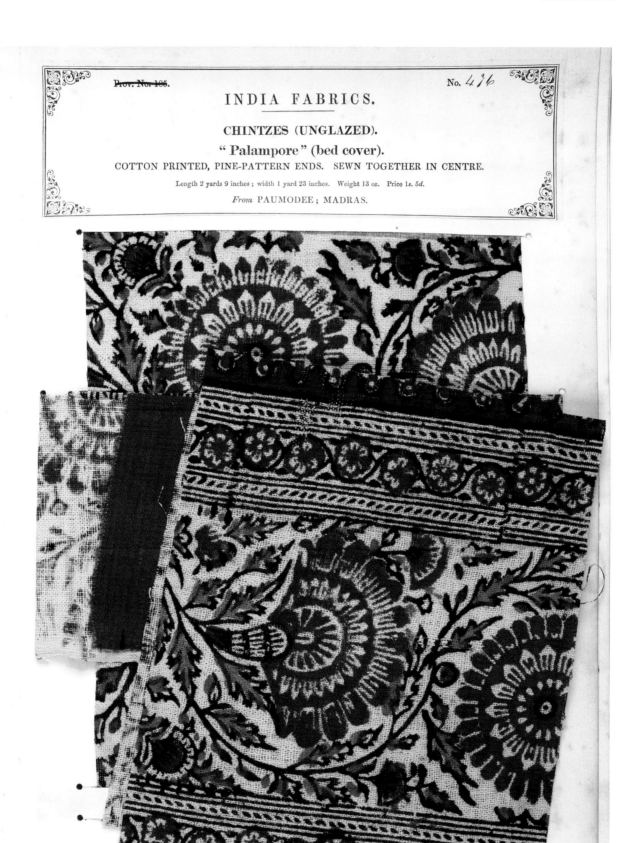

Prov. No. 105.

No. 476

INDIA FABRICS.

CHINTZES (UNGLAZED).

"Palampore" (bed cover).

COTTON PRINTED, PINE-PATTERN ENDS. SEWN TOGETHER IN CENTRE.

Length 2 yards 9 inches ; width 1 yard 23 inches. Weight 13 oz. Price 1s. 5d.

From PAUMODEE ; MADRAS.

FIG. 17.3

"Cotton Prints. Punjab," by Alla Yar of Kot Kamalia. Kipling, "Punjab Cotton Prints," *The Journal of Indian Art and Industry*, vol. 1, plate 14, August 1886. Chromolithograph.

ROM Library and Archives, P.S. Jo 1070 v. 1: no. 9–16.

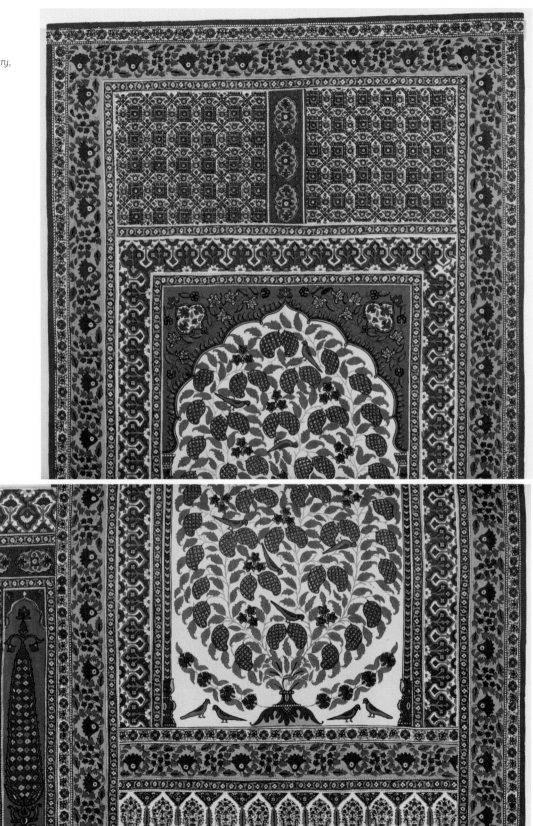

Punjab on inlaid marble pottery, fresco painting, and wood carving, and applying it to cotton cloth. Other articles describe continuing industries particularly for special occasions or export to other Asian locales. E. B. Havell, principal of the Madras School of Art and later Calcutta School of Art, writes that the printing and hand painting of cotton is still done in the Madras presidency for mythological subjects adorning Hindu cars and temples at Kalahasti, Salem, and Madurai.[16] He adds that the painted cloths for Hindu religious ceremonies are quite remarkable and the best produced in Kalahasti in North Arcot; in addition, printed-cotton cloths of Masulipatam include canopies, screen cloths, prayer cloths, men's handkerchiefs, turbans, cloth of Muslim jackets, and women's clothing. Havell also references that the best examples of painted palampores popular as export cloth—featuring tree-of-life designs on white ground and partially or fully hand painted—come from Kumbakonam and Nagore and are exported to Singapore and Penang.[17] While these journal articles hardly represent systematic surveys, they do reflect fieldwork that led the authors to encounter producers and products of chintz, and thus indicate a production across a wide geographic span.

Sometimes the description of a local industry includes the name of a producer. The illustration accompanying one of Kipling's articles depicts a sample made by an individual craftsman, whom Kipling names as Alla Yar (fig. 17.3). It displays several sections of decoration featuring a tree within an arch. Kipling is quick to answer would-be critics that this chintz is "an attempt to Europeanise a purely Indian trade," but then adds that this accusation is not likely to be brought against Alla Yar's work, "for though it is capable of being put to an English use it is as truly and thoroughly Punjabi as are the soil and salt of the Province."[18] In this example, it is interesting how Kipling balances innovation, usually perceived as a negative force, with the assurance that it is still connected in some deep way to the place. His use of the craftsman to make that leap is not a coincidence but draws on lessons he learned at South Kensington. Craftsmen who made things by hand were considered a dying breed due to the increased mechanization of manufactures. The figure of the hereditary craftsman as the only salvation against the onslaught of mechanization was promoted by individuals like Sir George Birdwood, curator of the Indian Museum after Watson, who claimed that everything in India—down to the cheapest toy—was hand wrought and thus a work of art. In this way, Kipling and Birdwood were part of a Victorian tendency to romanticize the hereditary craftsman, equating lineage and the work he did, as if knowledge and skill were somehow passed down biologically. This notion is reflected in the portrait of a block printer at work, which accompanies another article by Kipling on cotton in North India; in contrast to the precise individual identification of Alla Yar in the text, this image appears to be a generic portrait of a craftsman at work (fig. 17.4). Posed as if in the middle of making an imprint, the choreographed nature of the scene is revealed through the

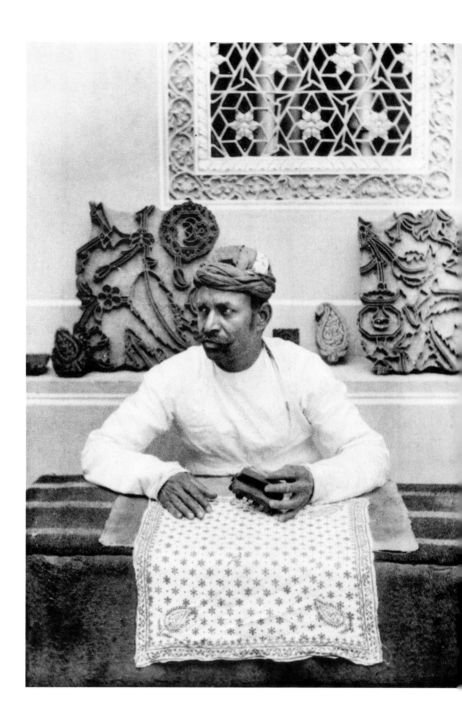

FIG. 17.4

"A Cotton Printer at Work." Kipling, "The Industries of the Punjab." *The Journal of Indian Art and Industry*, vol. 2, no. 23, plate 6, July 1888. Photolithograph.

ROM Library and Archives, P.S. Jo 1070 v. 2: no. 17-24.

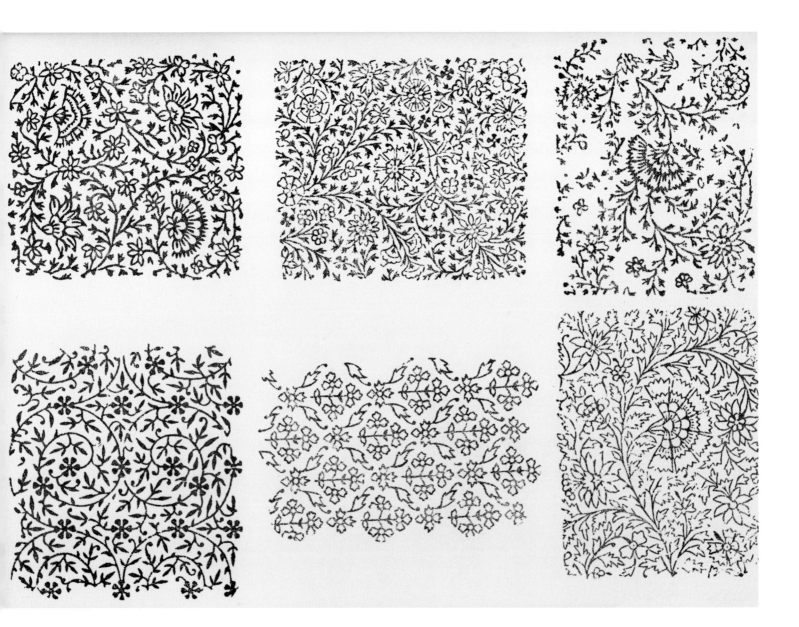

FIG. 17.5

"Arcot Wood Blocks." Thurston, "The Cotton Fabric Industry of the Madras Presidency." *The Journal of Indian Art and Industry,* vol. 7, no. 59, July 1897, plate 81. Lithograph.

ROM Library and Archives, P.S. Jo 1070 v. 7–8: no. 57–64.

printer's gaze, which is not focused on his work, and through the cloth sample in front of him, which seems finished. Tellingly, a photographic portrait of a dyer at work, taken in the same setting as the block printer, accompanies an article on cotton in South India.[19]

By extension, the wood blocks used for printing were seen to have some indexical relationship to a traditional industry. For example, Havell recounts how he found and saved old printing blocks in North Arcot that had been piled up in the corners or on the roof, covered with dust or cut up into smaller pieces for use in patterns.[20] It is unclear if the blocks were actually old, or simply not used anymore, but Havell ascribes this meaning to them. Havell assumes that they are unused due to competition from imported foreign goods or neglect by Indian producers, rather than due to changing styles and fashion in printed cotton or innovation in design that required the carving of new blocks. These same blocks appear in an article almost a decade later, not as blocks but as the stamp imprints of the blocks, to show the pattern (fig. 17.5). As such, they bear an indexical relationship to the traditional Indian craftsman and his work. Reading with and through the *JIAI* reveals an active and evolving printed cotton industry, but one which became framed by colonial knowledge and its narrative of decline.

Reading Against

The notion of changing fashion is reasserted in most articles on printed cotton. Edgar Thurston, superintendent of the Madras Government Museum from 1885 and author of *Castes and Tribes of Southern India* (1909), describes the replacement of the tribal turban of the Todas of the Nilgiris with a red knitted nightcap and the adoption of the machine-made coloured blazer by native cricketers.[21] And yet, these changes in fashion are read in only one way: as decline. Indeed, the narrative of decline is so pervasive that colonial administrators, even in the face of contrary proof, had a hard time letting it go.

 The level of frustration at the negative impact of cheaper industrial English cloth imports seems most advanced with Thurston, who saw decline in Indian manufactures in everything around him. He expressed frustration at the use of aniline dyes instead of natural colours. He expressed frustration at the showy paper textile labels that would captivate the native eye.[22] And he expressed frustration at the new designs in women's fashion that did not follow tradition. Yet Thurston's frustration was not toward English manufacturers who sent the new products but toward the native population for not having the taste not to

FIG. 17.6

"Imported Colour-printed Fabrics." Thurston, "The Cotton Fabric Industry of the Madras Presidency (continuation)." *The Journal of Indian Art and Industry*, vol. 7, no. 60, October 1897, plate 92. Chromolithograph.

ROM Library and Archives, P.S. Jo 1070 v. 7–8: no. 57–64.

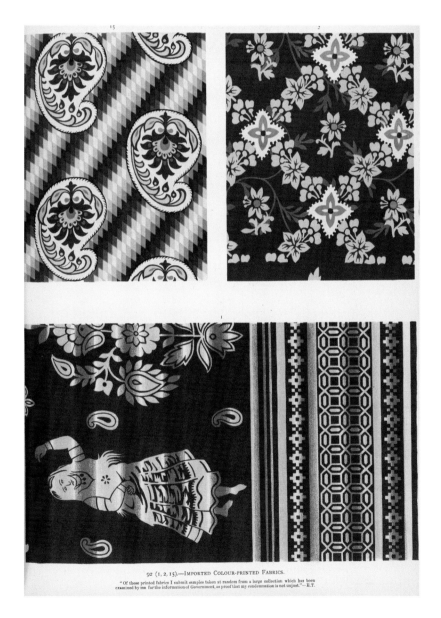

92 (1, 2, 15).—Imported Colour-printed Fabrics.

"Of these printed fabrics I submit samples taken at random from a large collection which has been examined by me for the information of Government, as proof that my condemnation is not unjust."—E.T.

FIG. 17.7

View of A.H. Sumsoodin, Bombay stall, "British-Indian Section. Paris Universal Exhibition, 1889." *The Journal of Indian Art and Industry*, vol. 3, no. 28, October 1889. Photolithograph.

ROM Library and Archives, P.S. Jo 1070 v. 3: no. 25–32.

buy them. This is seen most prominently in his observation on women's clothing in Madras (present-day Chennai), which he believed had a love of the grotesque as a governing design principle.[23] In one article, he described how printed cottons with new patterns came to dominate the local Indian market: sometimes a popular design on a piece of fabric from Manchester or Glasgow was reproduced by a local merchant but sold off in bulk when tastes moved on to another design.[24] One particularly loathsome design for Thurston featured images of bicycles repeated in the border among floral motifs; the bicycle was a new vehicle to the port city of Madras at the time. (Sadly, an example of this design is not reproduced in his article, but a number of others are.) And yet, unlike the other illustrations in *JIAI* that serve as patterns to be emulated, Thurston's illustrations are framed as examples of bad design (fig. 17.6). As a way to emphasize this point, he includes the same caption on every page of the illustrations: "'Of these printed fabrics I submit samples taken at random from a large collection which has been examined by me, for the information of Government, as proof that my condemnation is not unjust.'—E.T."[25] And yet, the very examples Thurston sees as degraded fashion can be read as examples of innovation and change within the local cotton-printing industry.

One final example shows how local chintz production is revealed when the artifice of colonial art education is absent. Many articles in *JIAI* report on the large annual exhibitions that took place regularly over the second half of the nineteenth century. These exhibitions

INDIAN SERAI.

(a) Forest Department. (b) Messrs. Ardeshir & Byramjee, Bombay.
(c c) Framjee Pestonjee Bhumgara, Bombay and Madras.

FIG. 17.8

View of stalls by Messrs. Ardeshir and Byramjee, Bombay, and Framjee Pestonjee Bhumgara, Bombay and Madras, "British-Indian Section. Paris Universal Exhibition, 1889." *The Journal of Indian Art and Industry*, vol. 3, no. 28, October 1889. Photolithograph.

ROM Library and Archives, P.S. Jo 1070 v. 3: no. 25–32.

were usually organized by colonial administrators, who would collect samples for display. But the 1889 Paris Exhibition was different; it was meant to commemorate the anniversary of the French Revolution, but the "monarchical governments of Europe" declined to participate "upon the ground that they could not assist in the celebration of the decapitation of a king." And yet, "in the interest of commerce," they decided to allow "any exhibitors from their respective countries."[26] Thus, without the formal participation of the British government or of administrators to police taste, commercial businesses served as the sole exhibitors, who— while usually present at other exhibitions within the private exhibitors' area—were seldom visualized within the pages of *JIAI*. These illustrations of the 1889 Paris Exhibition show dense displays of furniture and decorative arts where printed and painted cottons feature heavily (fig. 17.7 and 17.8). For example, the images of the exhibits show large flowering-tree palampores hanging upside down like curtains, horizontal panels resembling Kipling's purdah cloth with architectural motifs, a southern Indian temple cloth hanging, depicting the *Ramayana*, and numerous others used as tablecloths. While it is difficult to know much about each exhibitor without more research, one of them, Framjee Pestonjee Bhumgara, was a company named after its Parsi owner and based in Bombay (present-day Mumbai) and Madras (present-day Chennai). They were "well known jewelers and Curio merchants"; in the 1880s they opened offices in London and, following an audience with the queen, were appointed jeweller to the court.[27] A letter from the Duke of Fife to Mr. Bhumgara appeared in the newspapers in 1889, indicating that the merchant was trying to open a market in England for swami jewellery and other ornamental work in carved metals after having first made a trip to familiarize himself with Western taste.[28] An ad from 1897 shows the company having addresses in Bombay, Madras, Calcutta, London, and New York as manufacturers and importers of a range of goods, the "only wholesale house in the United States that deals in East India goods exclusively" (fig. 17.9). Among the items listed is "a large stock of printed and embroidered Summer draperies [that are] always on hand."[29] This remarkable view into another aspect of nineteenth-century art manufactures reveals not an industry in decline but rather Indian merchants patronizing Indian producers for new markets. While British manufacturers were exporting fabrics of Indian design to India, Indian manufacturers were exporting "traditional" designs to the West. Instead of being used as bedcovers, as in the eighteenth century, these fabrics were, a century later, intended for private and museum collections.

Unknowability

In the latter half of the nineteenth century, colonial administrators found a thriving cotton-printing industry in India that was not focused on Europe. While British cloth may have entered the Indian market and caused the change or disappearance of certain kinds of local production, this did not necessarily mean that a profound transformation in the production of Indian printed cottons took place. Rather, the printed- and painted-cotton industry had already changed over time. Colonial reports from the arena of art education provide a glimpse of late nineteenth-century Indian printed cottons, but the level of production exceeded a colonial administrator's ability to document it, quantify it, control it, or even fully understand it. Many printed cottons were of local production for local use, while others were produced to export elsewhere, within India or abroad. Most were coarse cotton cloth for the purposes of daily wear, and the finest production was saved for special commissions by a few artists. The narrative of decline is a powerful one, framing and permeating all colonial reports on printed cotton. But despite the dire predictions, chintz production continued through the nineteenth century and into the twentieth century, and beyond. While British industrial cloth may not have had as strong an impact as colonial officials thought, colonial knowledge did. It may not be possible to know the extent of chintz production outside of the colonial knowledge that tried to reflect it but then ended up shaping it. How we judge and view the aesthetics of chintz today—as manifest in the continued condemnation of aniline dyes, a preference for hand-painted designs over mass-produced, and the search for authentic motifs devoid of foreign influence— comes directly out of colonial knowledge and provides a framework that permeates museum collecting practices and the very ways in which we "know" Indian chintz today.

1 Royle, *On the Culture*, vii.

2 Kriegel, "Narrating the Subcontinent," 154.

3 Kriegel, 152.

4 Dowleans, *Catalogue*, 51–58.

5 *The Grammar of Ornament* actually compiled objects from both the Great Exhibition of 1851 and the Paris Exhibition of 1855. The illustrations in the "Indian Ornament" chapter were all of objects from the 1851 Great Exhibition.

6 A companion volume, Watson, *The Textile Manufactures and the Costumes of The People of India* (1866), provides an introduction to the sample volumes and describes how textiles were used through ethnographic illustrations.

7 [Watson, John Forbes, obituary], n.p.; Driver and Ashmore, "Mobile Museum," 364.

8 Driver and Ashmore, 371.

9 Watson, *Textile Manufactures of India*, vol. 8 (samples 310–12 from Futtygurh, NWP; samples 315, 319 from Shikarpore, Sind; sample 320 from Bijapur), vol. 10 (samples 368–97 from Masulipatam, Ponnary, Arcot, Sydapet, Bellary in Madras and Agra), vol. 4 (samples 151–60 from Futtygurh, Begal and Shikarpore, Sinde and Hazars, Punjab), vol. 12 (samples 475–78 from Masulipatam,

Paumodee in Madras).

10 Driver and Ashmore, "Mobile Museum," 356.

11 Swallow, "India Museum."

12 Colonial art schools were set up in India at Madras (1850), Kolkata (1852), and Mumbai (Bombay; 1857). While each school had a unique character and a different relationship with South Kensington, they were part of an arena of art education, along with museums and annual exhibitions, that developed and promoted certain ideas about Indian art. See Dewan, "Crafting Knowledge."

13 Advancements in reproduction technology facilitated these efforts; illustrated literature went from labour-intensive hand-coloured prints produced at great cost to mass-produced chromolithographs and later off-set colour printing.

14 Dewan, "Scripting"; Hoffenberg, "Promoting."

15 Kipling, "Punjab Cotton Prints," 104.

16 Havell, "Industries of Madras," 10.

17 Havell, 11, 14.

18 Kipling, "Punjab Cotton Prints," 104.

19 Dewan, "Body at Work."

20 Havell, "Industries of Madras," 10.

21 Thurston, "Cotton Fabric Industry," 21.

22 Thurston, 22.

23 Thurston, 22.

24 Thurston, 22.

25 Thurston, 25, plate 93 (8, 9).

26 "British Indian Section," 9–12.

27 Hayavadana Rao, "Asad Ali Khan," 14. Asad Ali Khan was a merchant who later bought the company Framjee Pestonjee Bhumgara.

28 *The Watchmaker, Jeweller and Silversmith*, 2 September 1889, cited in "Indian Colonial Silver & Indian Subcontinent Trade Info," Online Encyclopedia of Silver Marks, Hallmarks & Maker's Marks, 3 August 2013, http://www.925-1000.com/forum/viewtopic. php?f=38&t=28477&start=60.

29 *Watchmaker, Jeweller and Silversmith*.

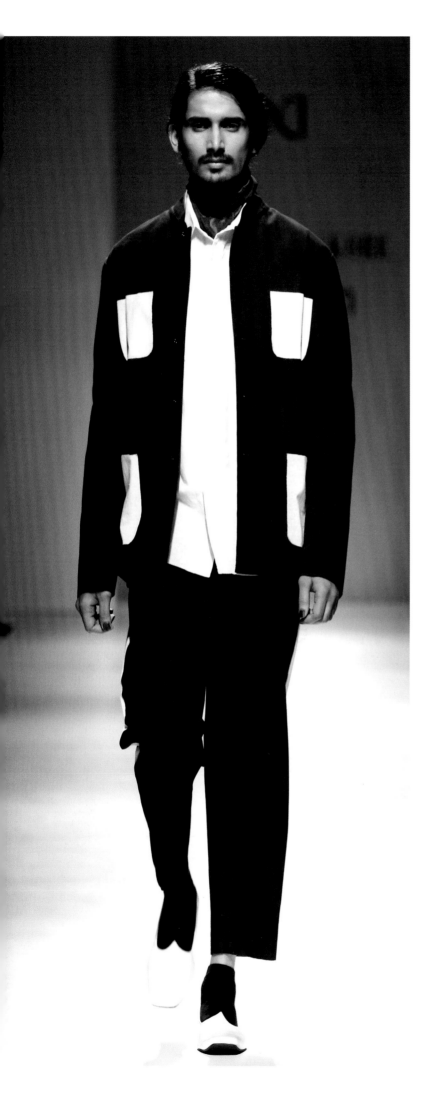
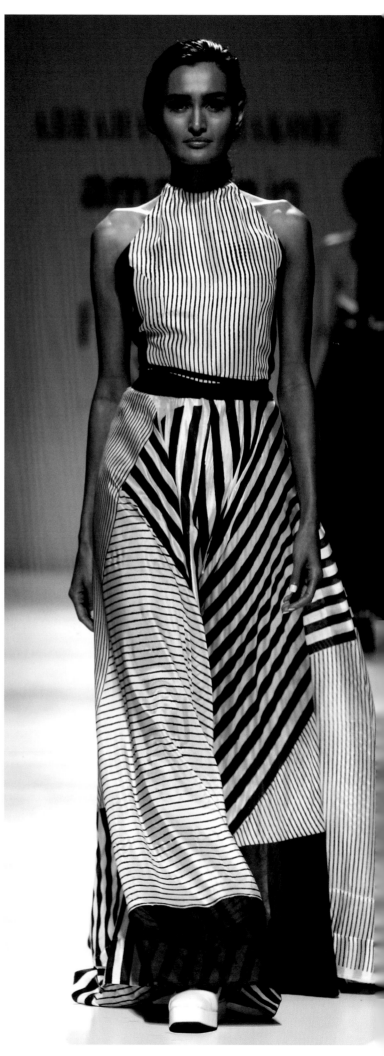

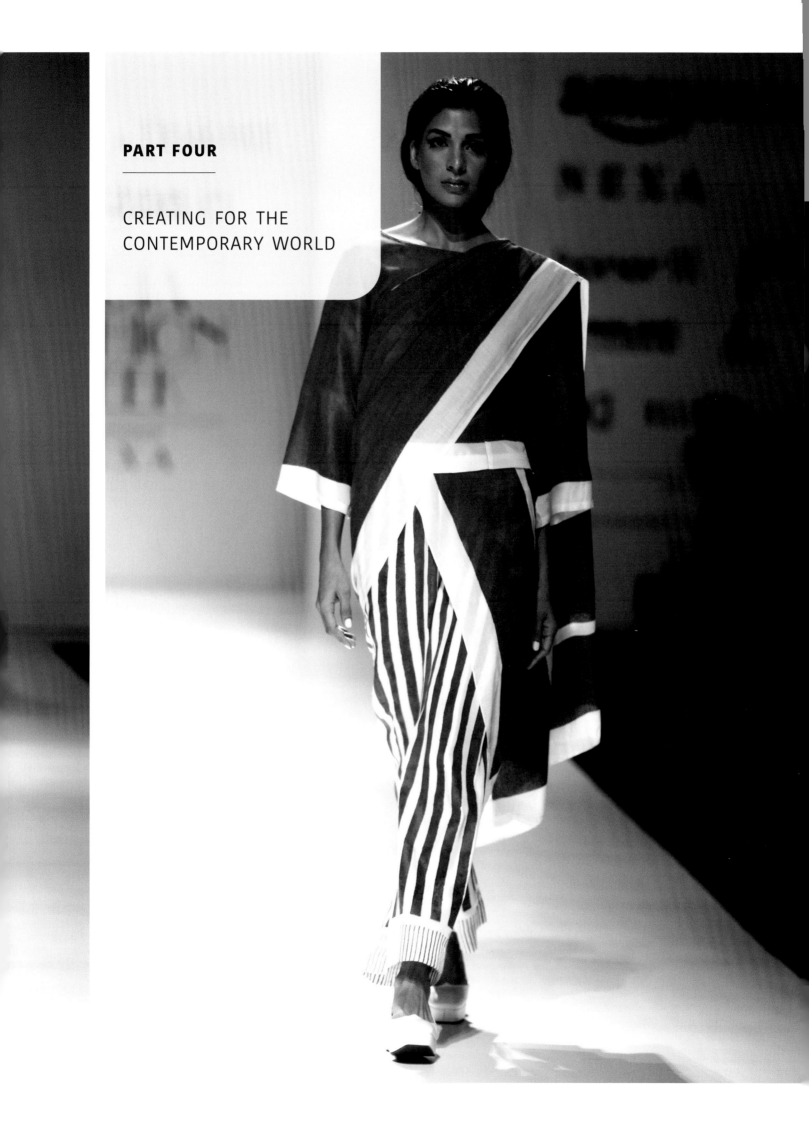

PART FOUR

CREATING FOR THE
CONTEMPORARY WORLD

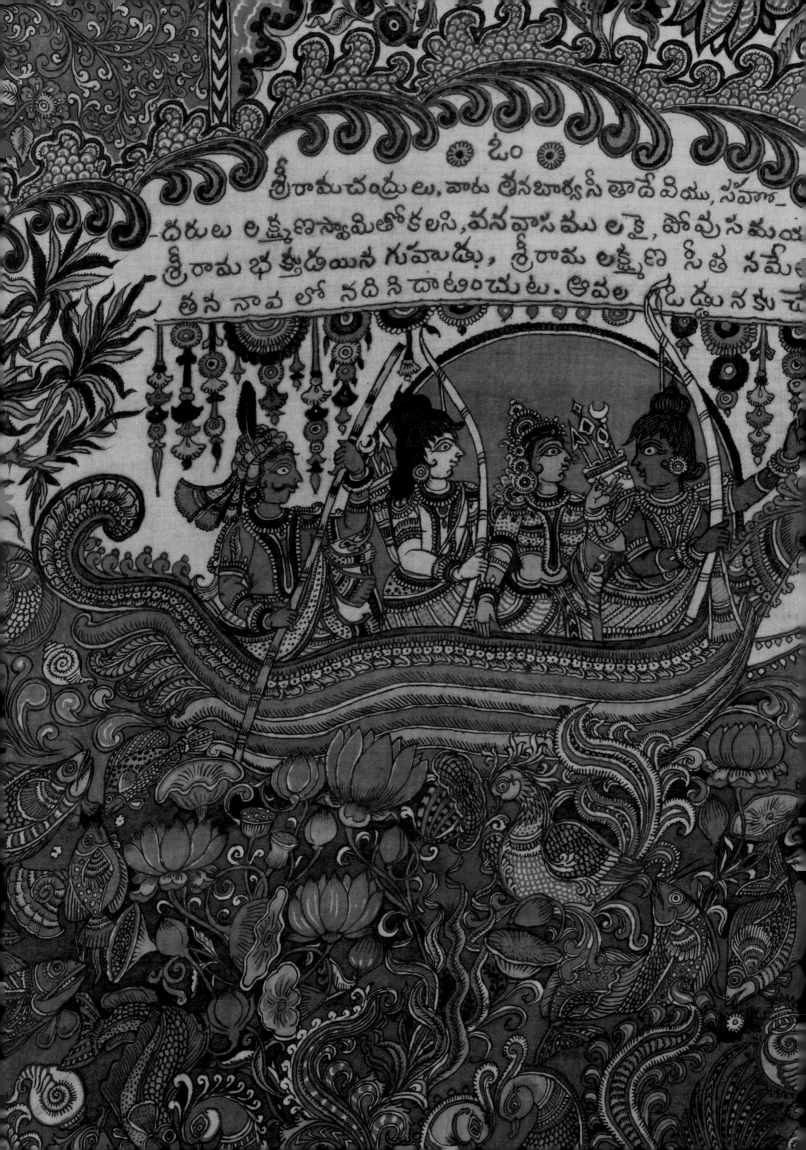

ఓం

శ్రీరామచంద్రులు, వారు తనభార్య సీతాదేవియు, సహా_
దరులు లక్ష్మణస్వామితోకలసి, వనవాసము లకై, పోవు సమయ
శ్రీరామ భక్తుడయిన గుహుడు, శ్రీరామ లక్ష్మణ సీత నమే
తన నావ లో నదిని దాటించుటు. ఆవల ఓడ్డు నకు

18

RUPTURES, CONTINUATIONS, AND INNOVATIONS

ON CONTEMPORARY *KALAMKARI* MAKING IN SOUTHERN INDIA

RAJARSHI SENGUPTA

VERY FEW PHYSICAL TRACES REMAIN TODAY INDICATING THE great former trading importance of the southeastern coast of India previously known as the Coromandel Coast. Its once-bustling ports and busy textile centres, famous the world over for colourful printed and painted cottons, are now largely quiet. Celebrated textile centres such as Palakollu, Pulicat, and Nagapattinam ceased production in the nineteenth century. Yet connections with this proud past are visible if one knows where to look. In Machilipatnam, that great historic cosmopolitan port town, central neighbourhoods retain the name of former trading communities, such as "Englishtown" (Englishpeta) and "Desaitown" (Desaipeta), the latter perhaps referencing settlers from Gujarat or Maharashtra. A short drive to the south, past the throngs of concrete shops and scooters, takes one to the old Dutch fort and cemetery, while a short drive north brings one to the hamlets of Pedana and Polavaram, where artisans are busy carving wooden

Detail: Sitamma sari hand-drawn by Kailasham, 2018 (p. 235).

printing blocks and weaving and printing cotton. They are not alone. In the temple town of Srikalahasti, some four hundred fifty kilometres to the southwest, and in the great city of Hyderabad four hundred kilometres to the northwest, textile artisans have continued, through all the great ups and downs of recent centuries, to carry forward the torch of past practices—including natural dyes and hand drawing with the bamboo *kalam* pen. The very physical inbetweenness of Machilipatnam offers a good metaphor for the present practices associated with the making of chintz textiles along India's southeastern coast and its deep hinterland, known as the Deccan. Contemporary practitioners of *kalamkari*, as both painting and printing cotton are today known in these regions, while inspired by immediate socio-cultural surroundings and market systems, are also deeply informed by long-established historical practices. The genius of present-day makers lies in bringing historical techniques into conversation with the challenges posed by ever-changing material resources, consumer responses, and market economies.

Artisan-Institution Alliances in Post-Independence India

Understanding the ongoing practices of kalamkari making in the Southeast and Deccan regions requires an appreciation of the political transformations of the twentieth century in South Asia and beyond. It also calls for recognizing the individuals who nurtured and advanced the craft into a new chapter. The printed and painted cottons of Machilipatnam enjoyed the patronage of Iranian consumers into the 1920s, when Iran banned their import to protect its own cloth printers. Artisans were thus compelled to either discontinue their craft or enter a few and changing professions.[1] Fortuitously, around the same time, Mohandas Karamchand Gandhi's Swadeshi movement to buy Indian handcrafted cloth gained momentum and drew public attention to locally produced hand-spun and handwoven cotton. Influenced by this movement, the freedom fighter, activist, and scholar Kamaladevi Chattopadhyay played a major role in founding the All India Handicrafts Board (AIHB) in 1952, following the independence of India. Chattopadhyay travelled all over India to encourage and provide institutional support to a wide variety of craftspeople. Pupul Jayakar, a craft activist and scholar, also played a pivotal role by establishing a long-term relationship between the artisans and the AIHB. These AIHB-artisanal collaborations further boosted scholarly research into textiles of coastal southeast India, prompting several important publications in the field.[2] Gira and Gautam Sarabhai also made substantial contributions in their founding of the Calico Museum of Textiles in Ahmedabad. Acting upon the recommendation of art historian Ananda Coomaraswamy, they amassed a significant collection of Indian textiles to promote the study and revival of historical traditions.[3] International acclaim was renewed by the 1955 exhibition *Textiles and Ornamental Art from India* at New York's Museum of Modern Art (MoMA); its display of historical textiles alongside contemporary examples actively demonstrated the continuing masterful skill of Indian artisans.[4]

The passion of Chattopadhyay and Jayakar, together with the various initiatives of the Indian government in the 1950s and 1960s, nurtured a steady growth of kalamkari making in the Coromandel and Deccan regions, as did the Weavers Service Centres (WSC) established in all the major cities in India to provide training and support to regional textile makers.

The 1961 census of India is a precious resource for tracing the fate of craft practices and practitioners of the Coromandel region in this period. It records that three chintz painters were still practising at the far southern edge of Andhra Pradesh, in the town of Srikalahasti. The three men, Jonnalagadda Lakshmaiah, Jonnalagadda Ramaiah, and Cherumathur Ramachandra, were all working part time, having lost the patronage of local landlords and textile centres in Chennai (former Madras).[5] Lakshmaiah, the eldest of the group, had in fact three years earlier become a major figure in the creation of a new training centre to promote the art. Built in Panangal, on the outskirts of the town, the Pilot Production-cum-Training

Centre was founded in 1958 by the activist Chattopadhyay after her visit to Srikalahasti that year.[6] Lakshmaiah was appointed the principal instructor and trained numerous students, including Aithur Munikrishnan and Lakshmaiah's own son, Jonnalagadda Gurappa Chetty, who would emerge as an innovative artist in his own right (fig. 18.1). For Machilipatnam, meanwhile, the census named two printing workshops: the Balyalagudem Kalamkari Works, founded by Vinnakota Venkataswamy Naidu in Desaipeta, and the Rekapalli Parthasarathy Kalamkari Works, founded by Rekapalli Parthasarathy Naidu in Rustumbada.[7] Whereas Venkataswamy Naidu diligently followed the natural dyeing and wax-resist techniques from the region, Parthasarathy Naidu had switched to synthetic dyes. In a "lateral move" characteristic of the region (see below), Venkataswamy Naidu passed on his printing knowledge to a weaver, Nageswara Rao. Eventually, Rao established his own dyeing and printing workshop in Polavaram, at a short distance from Machilipatnam. As for block carvers, the census lists only two men, Gujjaram Rukmaji and Gadireddi Narayana, from the Malavollu neighbourhood of Machilipatnam.[8] The records also show that, far from skills or activities being confined to separate "castes" or communities, individuals ranged freely between the arts of dyeing, painting, block making, and printing on textiles.

New training initiatives, workshops, and talent continued to appear in the 1970s and 1980s. Although the Pilot Centre in Srikalahasti stopped functioning during the 1970s, as it could not ensure job security, some students embarked on independent paths. Kalamkari painter Malipuddu Kailasham moved to Hyderabad to take work with the WSC, which at that time paid chintz painters by the piece.[9] Kailasham's talent was eventually recognized by textile preservationist Martand Singh, whose praise earned him recognition in the burgeoning craft scene in India.[10] The Festival of India held in Britain in 1982 should be recognized—like the world expositions a century earlier—as a great catalyst for the national and international promotion and recognition of the textile arts.[11] As part of the artisan-institutional collaborations organized in preparation for the festival, the WSCs sent dyeing experts to Srikalahasti and Polavaram, among other places. A month-long workshop at Nageswara Rao's dyeing workshop organized by the WSC introduced a new, wider colour scheme to the dyers and printers in Polavaram.[12] At the centre in Hyderabad, Kailasham executed highly ambitious large-scale kalamkari (i.e., chintz) hangings, while Gurappa Chetty created a hanging with Christian themes—acquired by the Victoria and Albert Museum—which would give rise to a new subgenre. Around the same time, activist and textile enthusiast Suraiya Hasan initiated a workshop to promote the revival of *himroo* weaving in Hyderabad and promoted dyed textiles.[13] Another major player was the nonprofit organization Dastakar Andhra, created in 1988 by a group of dynamic personalities, including activist-scholar Uzramma and dye expert Jagada Rajappa; the organization encouraged both sustainable indigenous modes of textile production and innovations.[14]

The art of block carving, meanwhile, was reinvigorated in the mid-1980s when master block maker Kondra Gangadhar and his brother Kondra Narsaiah travelled to Pedana from Hyderabad and settled there.[15] Presently, the Kondra brothers are the most prominent block makers in coastal southeast India and the Deccan, supplying nearly all printing workshops, which produce for both local and international markets. Jayakar created a post for block makers in the WSC, Hyderabad, specifically to accommodate V. Bhikshamayya Chary, who subsequently carved the wood blocks currently in the collections of the centre.[16] Ultimately, many institutional and artisanal actors in this period not only sought to revive or continue historical modes of production but also encouraged innovations.

Often working in obscurity, and sometimes with little remuneration, these makers and the individuals who supported them created an exciting, collaborative synergy among people of many walks of life and origins. Scholars too, both national and international—notably Lotika Varadarajan, John Irwin, Margaret Hall, and Katharine Brett—made important contributions to this multisector and multidisciplinary movement through their painstaking research and publications on historical techniques. Access to books provided crucial historical designs to artisans at a time when few historical objects were available for study within India.

Histories at the Workshops Today

How is historical memory embodied in the work and workshops of the Deccan's chintz makers today? Below I explore how contemporary block makers, dyers, and printers negotiate between histories and contemporary necessities, and between their complex and embodied entanglement.[17]

The acquired skill of the artisans, the materiality of their resources, and the historically informed bodily actions and tools are responsible for both the continuation and the transformation of historical knowledge. The process of preparing a block at the Kondra brothers' workshop is an example that helps to unravel the layers of histories embedded within their bodily actions employed in problem solving.[18] The block-making workshop consists of three covered spaces and an open courtyard allowing light and fresh air into the work areas. The wooden blocks are prepared from the cross-sections of teak, a hardwood tree now imported from several states: Kothagudem (Telangana), Palasa (Andhra Pradesh), and Bastar (Chhattisgarh). Before working on a block, the artisan first ensures that the surface is smooth and then begins to transfer images by tracing, using pencil and carbon-copy paper. He draws the contour lines of the images more prominently than the internal details and pays careful attention to linear form, enabling him to understand and internalize the characteristics of the predefined visual templates. The block maker replicates each line during the primary stage of drawing, mimicking the width of every line but making adjustments to the drawing as necessary to ensure a better structural integrity of motifs. Both the mimetic actions and impromptu enhancements are conscious artisanal decisions shaped by an attentiveness to materials, histories, and image making. The blocks are then carved with a set of iron tools known as *kalam*, a term of Persian origin, which in the southeast region also designates a writing

implement (i.e., a pen). Through this exercise, a hand-drawn image morphs into an engraved impression on the wooden block (fig. 18.2). Once prepared, the blocks are dipped in mustard oil overnight to prevent the absorption of dye when used in printing. Since the majority of craft techniques are practised and not written down, repetition of techniques acts as a tool of remembrance. The bodily practice of the block makers becomes the medium through which histories are reenacted and carried forward into the future.

A consideration of dyeing practices, meanwhile, enables us to appreciate the crucial role of local resources and changing artisanal strategies in utilizing them.[19] Geographically, the southeastern coastline constitutes a narrow strip between land and the sea and is criss-crossed by numerous canals, wells, and water bodies of the harbour area, which serve as the lifelines of chintz textile production.[20] This strategic locale offers unique resources and community engagements different from those in the interior. Localized artisanal knowledge of waters, so critical to arts of printing, washing, and dyeing, has been transmitted through generations of dyers and yet must be continually reinvented when faced with changing contingencies. This I learned during my studies in the workshop of the late master dyer Mukkantieswarudu Rao, initially founded by his father N. Rao (fig. 18.3). The dyers intimately understand the material properties of both the salty and sweet waters of the coastal region and continually experiment to obtain the new shades demanded by contemporary consumers, employing new and old sources of vegetable and mineral-based dye materials, and mordants as needed. As was true in the past, they master both reliable local sources, such as fruit of the myrobalan trees, which grow in workshop courtyards, and ingredients supplied from other parts of southern India—indigo cakes, pomegranate, and scrap iron—whose quality and concentration are never consistent.[21] All of these variables allow for both continuity and innovation, different intensity and mordants, a varied range of tones. Dyers act as intermediaries between the material resources and intangible localized knowledge to produce and sustain chintz textiles.

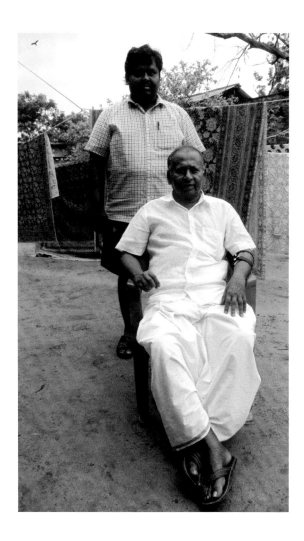

FIG. 18.3

Late master dyer Mukkantieswarudu Rao (*seated*) with his son Nageswara Rao in his workshop. Polavaram, Andhra Pradesh, 2017.

Photograph by Rajarshi Sengupta.

Contemporaneity of Histories

A comparison of an early nineteenth-century kalamkari hanging from the Machilipatnam area (fig. 18.4), of the type made for export to Iran (see ch. 4), with one made nearly two hundred years later in 2016, in the workshop of Eswarudu Rao (fig. 18.5), reveals the historically informed choices made by modern artisans in regards to tracing, tools, skills, dyestuffs, and waters. The central motif of both pieces is a large cypress tree, or *pandu*—as block makers today refer to it—a loaded visual motif in Islam, symbolizing the paradisiacal garden. The tree emerges from a triangular mound or hill, printed from small diamond-shaped blocks, a convention from the "painted" hangings historically made for many export markets (see ch. 5, 9, 10, and 11). Above the tree rises a cusped archway, a visual referent to the mihrab, or recessed niche, of mosques and Islamic prayer halls; it is this feature that distinguishes the design subgenre for contemporary makers, who refer to it as *mehrab*. The composition is framed on all sides by wide borders and narrow guards, infilled with flower heads and meanders of various scales. Altogether, in both cases, the surface is entirely covered, with a brilliant colour distribution that emphasizes the prominence of some motifs over others, thus achieving a fine balance between flat areas and patterned surfaces.

RIGHT
FIG. 18.4

Hanging. Machilipatnam area, stamped date of 1832. Cotton, block-printed, hand-drawn, mordant-dyed, resist-dyed, painted dyes, glazed, 140 × 182 cm.

Today, this style of design formerly made for the Iranian market is known widely in India as *kalamkari*, and in the area of Machilipatnam as *mehrab*.

ROM 927.40.4

BELOW
FIG. 18.5

Mehrab and other bedspreads drying between dye baths. Workshop of Mukkantieswarudu Rao, Polavaram, Andhra Pradesh, 2015.

Photograph by Rajarshi Sengupta.

OPPOSITE
FIG. 18.6

Kailasham, Hyderabad, 2018. Sitamma sari. Cotton, hand-drawn, mordant-dyed, painted dyes, 571 × 116 cm.

Kailasham chose to depict landscape scenes from the epic poem the *Ramayana*, featuring on one end (*pallu*) the boat carrying Rama, Sita, and Laksmana across the Ganges River.

ROM 2019.57.1. This acquisition was made possible with the generous support of Patricia Sparrer.

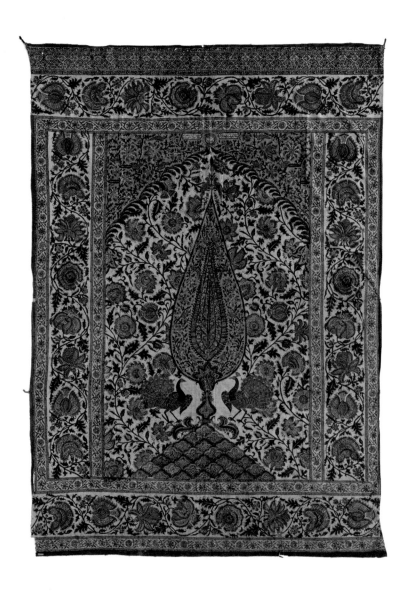

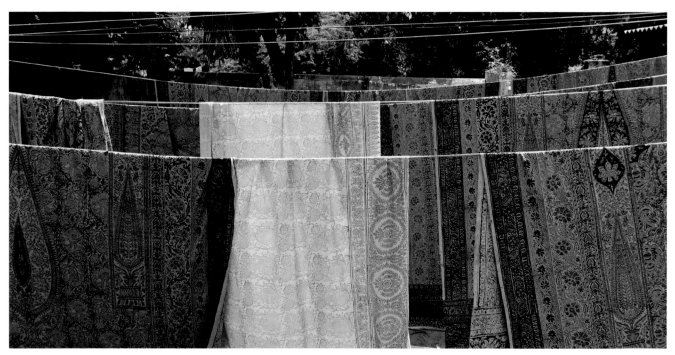

The similitude between the historical and contemporary hangings reveals the common threads that connect them, and how present-day artisanal practices juxtapose histories with the present, materiality with abstract ideas, and aesthetics with livelihoods.

Meanwhile, in Srikalahasti, other choices are unfolding. Here the hallmark of the craft remains hand drawing with the bamboo *kalam* pen. The kalam artist, usually a master, uses a locally made iron mixture to draw the prominent black outlines, but, for the details, natural dyes have largely given way to bright synthetics. While only three artists were recorded in 1961, Srikalahasti is today home to dozens of practitioners, some of them women. The flowing linearity produced by the kalam still makes it the ideal medium for complex narrative temple hangings, the main historical commission in this Hindu temple town. One wide hanging, possibly made by the training instructor Lakshmaiah (see above) in the 1960s, depicts the *Virata parva* book of the Indian epic *Mahabharata*, bringing extraordinary life to this chronicle of the Pandava brothers (fig. 18.7).[22] Framed on all four sides by conventional lotus-head borders, the centrefield panel depicts the deity Seshashayin Vishnu being attended by his devotees and divine guardians.[23] The surrounding narrative panels, flowing horizontally, are composed of dynamic visuals supported by textual descriptions. The depiction of certain figures—the *upakichakas* (attendants of Kichaka) and the attempt to immolate Panchali with her abuser Kichaka—reveals this to be a regional version of the *Mahabharata*.[24] A fascinating redux of this conventional compositional arrangement was undertaken in the 1990s by painter Munikrishnan, a contemporary of the better-known Gurappa Chetty (see fig. 18.1). Although diligently following the structure and arrangement of the temple hangings, Munikrishnan chose to feature Sai Baba, a syncretic nineteenth-century saint from Shirdi, Maharashtra (fig. 18.8). Made for an unknown patron, this unfinished monochromatic hanging is likewise framed by continuous rows of lotus flowers, which emphasize the prominence of Sai Baba, featured in the large central panel.[25] The highly animated narrative panels depict the saint and his devotees in a naturalistic style, from various angles and distances. The close-up views and abruptly cut figures are uncommon in temple hangings but common to comic strips. Munikrishnan's clever reference to comic books is further evident in the presence of speech balloons and occasional phrases in English, as well as in his use of shading and hatching within the figures. This extraordinary hanging embodies the layered developments in the contemporary era.

Other artisans and fashion designers have taken the visuals of Srikalahasti hangings in all new directions, transforming them into wearable textile art (fig. 18.6). The kalam artist Kailasham created the Sitamma sari (2018), drawing on artist J. K. Reddayya's rendition of an episode of the epic poem *Ramayana*.[26] Instead of following the narrative, Kailasham chose to emphasize the forest landscape, depiction of wildlife, and the boat carrying Rama, Sita, and Lakshmana across the Ganges River. Pursuing other inspirations, Niranjan Chetty, now a third-generation kalam artist, has among other things undertaken a series of meditations on the so-called tree-of-life design. Fashion designer Gaurang Shah, meanwhile, has decided to use the medium to reinterpret scenes from the famous fourth-century Buddhist cave frescoes of Ajanta and turn them into wearable fashion. Shah grew up in his father's fabric store in Hyderabad, fascinated by the earthy tones and imagery of the stacks of chintz textiles from Srikalahasti and Machilipatnam.[27] He translated this fascination into one

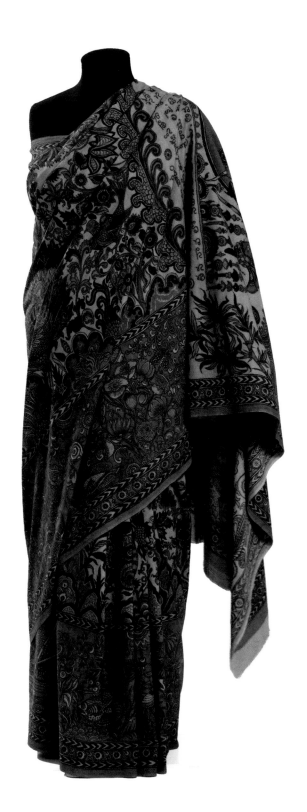

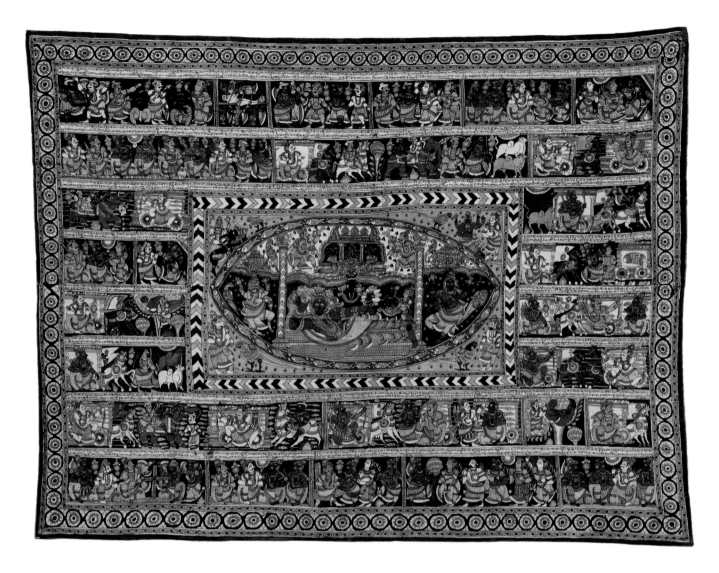

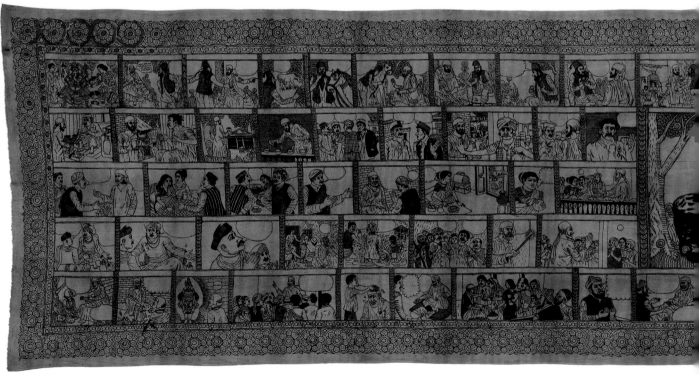

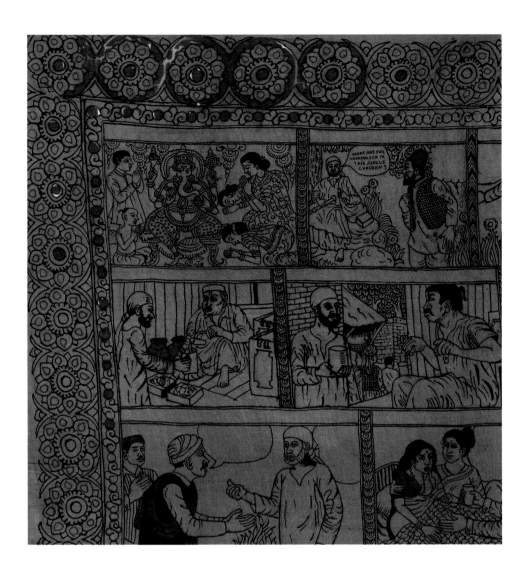

OPPOSITE, ABOVE
FIG. 18.7

Jonnalagadda Lakshmaiah(?), Srikalahasti, before 1960. Hanging depicting the *Virata parva* book of the *Mahabharata*. Painted cotton, 214 × 228 cm.

Inscriptions in Telugu narrate each scene.

ROM 960x98

BELOW
FIG. 18.8

Aithur Munikrishnan, unfinished kalamkari hanging depicting Sai Baba. Srikalahasti, late 1970s/ early 1980s. Cotton, hand-drawn mordants, 121 × 485 cm.

Details (left) show a ritualistic evocation of Lord Ganesha, followed by narrative beginning with Sai Baba speaking to a devotee.

ROM 2018.60.1

of his most recent collections, Chitravali, staged at the Lakme Fashion Week of 2017 and the result of a decade-long collaboration with over forty households of textile artisans in the Telugu-speaking region. Working with painters from Srikalahasti, after much trial and error over six months, the artisans finally translated scenes successfully from the Ajanta frescoes onto wearable textiles. Shah, like many contemporary designers, preferred lustrous silk to cotton, choosing local Kanchipuram silks made in southern India (fig. 18.9).[28] These ancient Deccani murals were translated into the language of early modern temple hangings by using the kalam technique to represent the contemporaneity of fashion in India.

For all the international admiration lavished on the Coromandel's textiles from at least 100 CE, and still embodied in the street names of Machilipatnam, it was only homegrown movements in post-independence India that began to recognize the makers as much as their cloth. Artisans infuse their unique personalities into their works through multifaceted manoeuvres, from adapting methods to responding to geographic conditions, or retranslating contemporary visual culture in the form of comic-strip narratives. The culturally and historically informed processes of making craft are often ascribed to large groups—usually based on region (e.g., Coromandel) or community (e.g., dyers)—but it is equally important to consider craft practices as the expressions of individual artisans and their approaches to problem solving and creative actions. Further research may allow us to find this historically. A rare and excellent example appears in an eighteenth-century chintz

palampore (fig. 18.10). Hidden in the blue border at the bottom is an inscription reading యు|నర్సు (Ya|Narsu, in Telugu). It probably indicates the identity of the master artisan responsible for drawing this piece. Executed in resist drawing, it further references indigo immersion dyeing, a specialty of the northern Coromandel that is no longer practised. The entanglement of a name with a specific technique signals the deep connections between craft techniques, artisanal knowledge, and agency. The contemporary practitioners build upon these connections to rupture and continue generational practice, infuse innovations in the textiles, and enliven their histories through conscious renewals.

1 Varadarajan, *South Indian Traditions*, 47. My initial research suggests that the end of trade with Iran led in part to the rise of the rolled-gold jewellery industry in Machilipatnam, as evidenced in the close similarities between the tools of block carving and jewellery making.

2 From 1955 to 1967, the Calico Museum of Textiles, Ahmedabad, published a journal titled *Journal of Indian Textile History*, featuring important essays by scholars such as John Irwin, Katharine B. Brett, and Pupul Jayakar, among others.

3 "About Calico Museum: The Story of the Calico Museum," The Calico Museum of Textiles and the Sarabhai Foundation Collections, last modified 2014, accessed 10 June 2019, https://calicomuseum.org/the-story-of-the-calico-museum/.

4 Wheeler, Jaykar, and Irwin, *Textiles and Ornamental Arts*.

5 Chandrasekhar, "(iii) *Kalamkari* Temple."

6 Jonnalagadda Gurappa Chetty and Niranjan Chetty, interviews with author, November 2012.

7 Chandrasekhar, "(iv) *Kalamkari* Cloth Printing."

8 Mukkantieswarudu Rao, interview with author, September 2015.

9 M. Kailasham, interview with author, May 2018.

10 With Martand Singh's intervention, Kailasham's work was featured as part of *Visvakarma* exhibitions, initiated by Martand Singh with support from the Development Commissioners (Handlooms), and WSC, India. See Chishti and Jain, "Dye Painted Textiles."

11 Jain, *Master Weavers*.

12 M. Rao, interview with author, September 2015. M. Rao also stated that this workshop enabled experimentation with a wide range of natural dyes.

13 Suraiya Hasan and Umar Syed, interviews with author, July 2011. By dyed textiles, I refer to kalamkari and ikat textiles.

14 Jagada Rajappa and Uzramma, interviews with author, June 2017.

15 Kondra Gangadhar and Kondra Narsaiah, interviews with author, September 2015.

16 V. Bhikshamayya Chary, interview with author, May 2017.

17 I am thankful to art historian and curator Dr. Kathleen Wyma for her thoughtful comments on this issue.

18 By problem solving, I refer to the artisanal process of encountering a challenge and to artisanal abilities to address that challenge through the artisans' practice.

19 Sennett, "Hand," 151.

20 The numerous canals (కొలువ, or *kaluva* in Telugu) in and around Machilipatnam connect the river Krishna with the Bay of Bengal. The canal water is used in both agricultural and textile production. Some dyers prefer washing in running water, whereas M. Rao preferred still water from a pond adjacent to his washing and boiling unit.

21 Indigo, alizarin, turmeric, and other dyestuffs are supplied from Tindivanam in Tamil Nadu. Scrap iron used for making black dye is bought from Vijayawada, which is about sixty-five kilometres from Polavaram.

22 The Hindu epic *Mahabharata* depicts the troubled relationship between the Kaurava and Pandava brothers, and their struggles to dominate Aryavarta. Draupadi, or Panchali, married to the five Pandava brothers, emerged as a strong central character in this epic. The *Virata parva* book of the *Mahabharata* focused on Panchali's and the Pandava brothers' stay in the palace of King Virata. In this section, Panchali and the Pandavas disguised themselves as commoners and served the royal family for a year.

23 Lord Vishnu is often portrayed lying on the coils of Sesha, the *naga* (snake) at the bottom of the primordial sea, symbolizing the *yoganidra* (yogic sleep) state of Vishnu. In this portrayal (fig. 20.5), Vishnu is accompanied by his consort(s), mount, devotees, and divine guardians. In the North Indian versions, Vishnu is portrayed with his consort Lakshmi; in the South Indian versions, such as this one, he is

attended by his two consorts, Sridevi and Bhudevi. Vishnu's vehicle mount Garuda, devotees, and the guardians Jaya and Vijaya are also depicted around him.

24 Kichaka, the brother-in-law of King Virata, lusted after Panchali and forced her to meet in his quarters after nightfall. Upon this news, Bhima, one of the Pandava brothers, disguised himself as a woman, arrived in Kichaka's quarters, and killed him. In this hanging (fig. 20.5), this story is extended by the mention of *upakichakas*, the attendants of Kichaka. After Kichaka's death, the upakichakas tied Panchali to the corpse of Kichaka and carried them to the cremation ground. Bhima valiantly fought them and freed Panchali thereafter. The story about the upakichakas is not commonly found, which suggests that the version of the *Mahabharata* depicted in this hanging is a regional one in South India.

25 Information about the patronage and creation of this hanging was obtained from Obbu Padma and N. Devi, interview with author, May 2018, Srikalahasti.

26 The Hindu epic *Ramayana* depicts the story of Prince Rama, his wife Sita, and his brother Laksmana's fourteen-year-long travels through the forest terrains of northern, central, and southern India. After banishment from Ayodhya, Rama, Sita, and Lakshmana arrive at the bank of the Ganges River, where a boatman Guhak takes them across the river. This episode inspired the creation of the Sitamma (mother Sita) sari.

27 Gaurang Shah, personal communication to author, June 2018.

28 The Buddhist caves of Ajanta in the Indian state of Maharashtra developed between the second century BCE and the fifth century CE. These rock-cut caves house a wide range of frescoes depicting the Buddhist *jataka* (previous births) tales, narratives from Buddha's life, and a variety of celestial figures. For further reading, see Spink, *Ajanta*.

19

TEXTILES IN BLOOM

BLOCK-PRINT REVIVAL AND CONTEMPORARY FASHION
IN NORTHWESTERN INDIA

EILUNED EDWARDS

HILE THE HISTORY OF INDIAN COLOURED COTTONS is increasingly well documented, with new narratives emerging from the French-, Dutch-, and German-speaking spheres,[1] developments within contemporary India have gone largely unreported. Yet this new chapter in its history is as important and deserving of study and recognition as earlier ones. Since the 1970s, the uptake of block prints in India has grown exponentially; embraced by Indian designers, they have become popular as home furnishings and are evident at all levels of fashion, from haute couture to the high street (more accurately, the mall in India), while continuing to influence fashion the world over. In the following pages, I address these developments in India in the post-colonial era, in the northwestern regions of the country, tracing the transition of block prints from rural Gujarat (fig. 19.1) and Rajasthan to the catwalk, malls, and interiors of urban India.

Detail: Silk *ajrakh* sari from Jaypore's Ajrakh Attractions Collection, 2018 (p. 249).

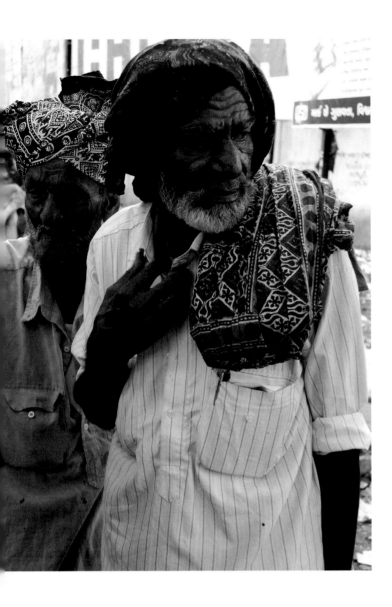

Ajrakh worn by *maldharis* (cattle herders) from Banni area, North Kachchh, Gujarat, as caste dress, 2011. The turban of the man on the left is polyester ajrakh; his friend on the right wears handmade ajrakh from Khavda village in Banni, North Kachchh.

Photograph by Eiluned Edwards.

Craft Development after 1947

After Indian independence in 1947, block printing and dyeing, along with other crafts, became the focus of a revival program initiated by the government of India led by Jawarharlal Nehru (in office 1947–64). Craft was to be at the heart of the country's economic and cultural revival; it would generate rural employment and export earnings, and accrue prestige abroad as an aspect of Indian heritage; it would, moreover, help to establish a uniquely Indian national identity as the newly independent state sought to make its mark on the world stage.

Craft revival was initially handled by national agencies including the All India Handicrafts Board (founded 1952), the National Crafts Museum (1956), the National Institute of Design (NID; 1961), and state-level craft organizations (1970s onward). Initiatives included a rolling program of exhibition-cum-sales in India's metros and artisans' participation in cultural festivals overseas; at the NID, students engaged in craft documentation as part of their diploma courses, which led craft to become central to design for generations of Indian designers. While these agencies raised awareness of craft, it was the development of new products suitable for the urban and overseas markets and the creation of retail outlets in India for craft goods that proved crucial to artisans' livelihoods and ultimately secured the craft's sustainability; shops specializing in handmade products for urban consumers started to appear in the 1970s.

Revive: Redevelop: Retail

One of the earliest of these shops was Gurjari, the retail wing of the Gujarat State Handicrafts and Handlooms Development Corporation (GSHHDC), which stocked block prints from the desert district of Kachchh in the far west of the state. Established in Ahmedabad in 1974, GSHHDC was led by Brij Bhasin, a craft enthusiast who saw his role as managing director thus: "My task was to discover as many new craftsmen as possible and I was very lucky because the National Institute of Design was in Ahmedabad."[2] His coupling of craft with modern design effectively introduced the concept of artisan-designer collaboration to the craft sector and created opportunities for the first generation of professional designers to emerge from the NID.

Archana Shah (fig. 19.3), an early NID graduate, was sent in the mid-1970s with fellow student Sulekha Goolry by Brij Bhasin to work with hereditary block printer Khatri Mohammad Siddik, in the village of Dhamadka in Kachchh. Between them, they were to adapt block prints such as *ajrakh*, which until that time was primarily worn as caste dress by local herders (fig. 19.1), for use as domestic textiles in urban homes. The complex geometric borders and flowing floral patterns of ajrakh were applied to a range of bedspreads, cushion covers, tablecloths, and napkins that were sold in the Gurjari store in Ahmedabad. Shah recalls the experience: "You know it was a time—it's very different now—when craftspeople were exposed to another world for the first time . . . When you have been isolated, when you're very good at your [craft] . . . you don't necessarily have the skills of dealing with urban people—people who have a completely different mindset."[3]

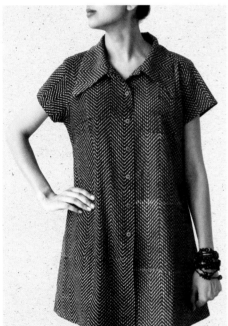

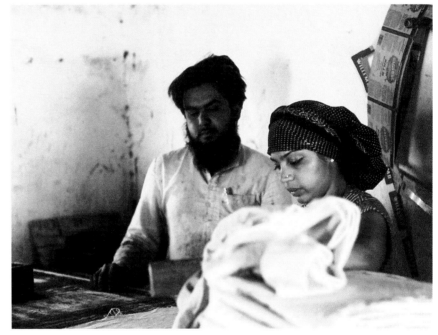

ABOVE
FIG. 19.2

Dhobis laying out block printed
textiles to dry after washing in
the Sabarmati River, Ahmedabad,
2006. The prevalent use of
synthetic dyes, including toxic
naphthols, from the 1960s was a
contributing factor that led many
municipalities to forbid washing in
rivers or ponds in the early 2000s.

robertharding / Alamy Stock Photo

BELOW
FIG. 19.3

Right: Archana Shah and
Abdulrazzak M. Khatri at
Dhamadka, 1978.

Left: A tunic designed by Shah
for Bandhej, printed in Dhamadka,
1990s.

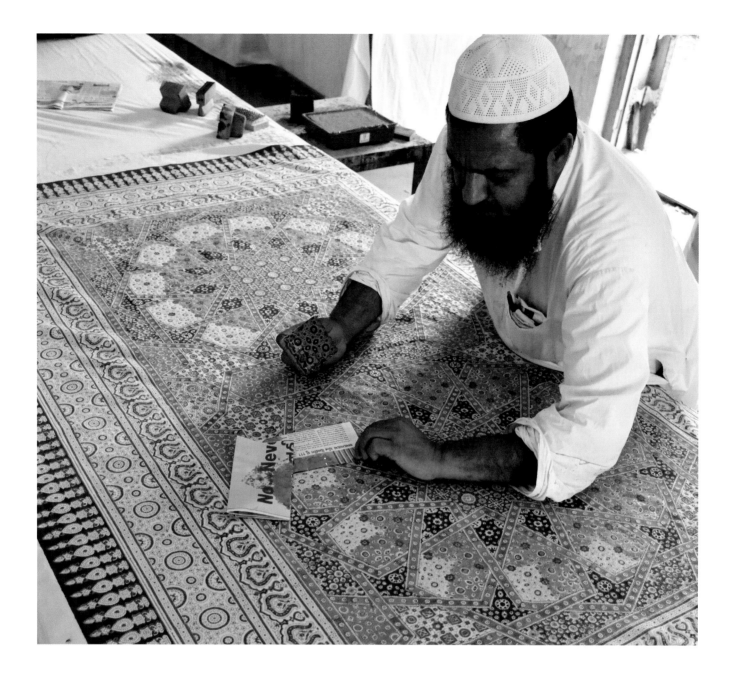

FIG. 19.4

Abduljabbar M. Khatri block printing an ajrakh "masterpiece" in his workshop at Dhamadka, Kachchh, March 2018. The textile was commissioned by the ROM and features his own design, which combines traditional ajrakh motifs and pan-Islamic tessellated patterns. It is block printed on cotton and is resist and mordant dyed using natural colours, including indigo and madder.

Photograph by Eiluned Edwards.

From Mohammad Siddik's perspective, working with Gurjari provided a lifeline. Aware that his local clientele was deserting him—lured by brightly coloured polyester fabrics that had lately arrived in the local bazaars and not only offered novelty but were also cheaper than handmade textiles—he needed customers and embraced the opportunity to establish a new market. In this respect, Mohammad Siddik was unlike many Khatris who were suspicious of change and wary of people from outside their community; his boldness, allied to the quality of his prints and the popularity of the products developed with Shah and Goolry, brought him success. His experience persuaded other Khatris to take a chance; as he acknowledged, "Slowly the whole village became involved with Gurjari,"[4] and Dhamadka went on to become a block-printing centre of international renown.

Regular work for Gurjari offered Mohammad Siddik financial security and gave him a platform for a project close to his heart: the revival of natural dyes. Like most block printers and dyers in India, he had been using synthetic dyes since the 1950s but was concerned that the Khatris' knowledge of organic dyes, passed down through generations, was being lost. As his sons, Abdulrazzak, Ismail, and Abduljabbar, grew up and joined him in the workshop,

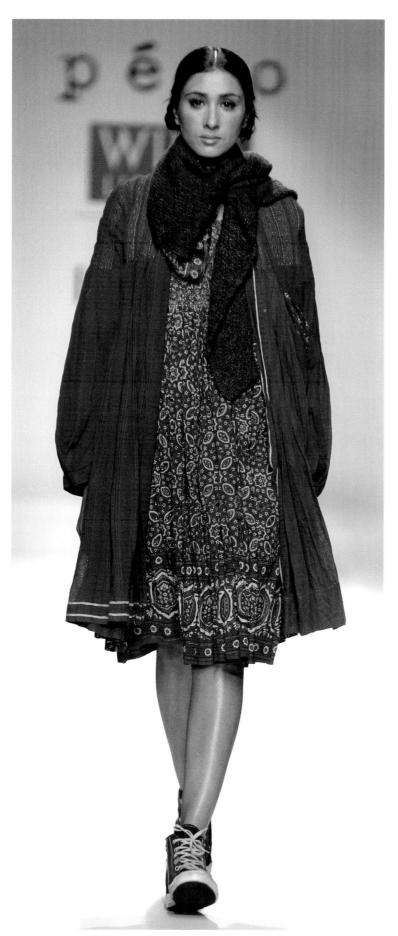

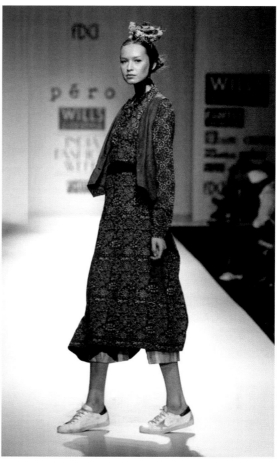

FIG. 19.5

Cotton dresses featuring *ajrakh* block printed and dyed with natural colours by Sufiyan Khatri at Ajrakhpur, Kachchh. Pero Autumn/Winter Collection, 2011. Designer Aneeth Arora, who set up her label Pero in 2009, has worked with Sufiyan Khatri since she was a student at the NID, Ahmedabad, in the mid-2000s. Autumn/Winter 2011 was her breakthrough collection, which garnered considerable critical acclaim and helped her to secure the first Vogue Fund Award in 2012. She has been applauded for her sensitive use of traditional textiles, long-term commitment to the artisans with whom she collaborates, and insistence on sustainable design.

Photographs courtesy of Aneeth Arora.

they were inculcated with the use of natural dyes such as indigo and madder, pomegranate and turmeric, as well as with the subtleties of mordants; ajrakh dyed with natural colours became the family's unique selling point (fig. 19.4). Mohammad Siddik was at the vanguard of an India-wide resurgence in the use of natural dyes, which has been endorsed in recent years by the global "slow clothes" movement whose proponents include many in India's rising generation of fashion designers (fig. 19.5).

Since their collaboration for Gurjari, Mohammad Siddik's family has worked continuously with Shah. In 1985, she founded Bandhej, one of India's first lifestyle stores, "with a vision to uphold, preserve and sustain the precious hand skills and inherent knowledge of the indigenous artisans when it comes to handloom clothes through collaborative design interventions."[5] After Mohammad Siddik's death in 1998, his sons carried on supplying Shah with block prints for soft furnishings, saris, scarves, and yardage for Bandhej's clothing ranges. Now joined by their own sons—block printing is a resolutely male occupation in Kachchh—they also collaborate with a host of other designers and entrepreneurs from India and overseas, and ajrakh is seen on the catwalk at India Fashion Week, as well as on the rails of retailers such as Fabindia, Anokhi, and Westside in the malls of metropolitan India. It has also penetrated the North American market, becoming a popular choice for fashion accessories and soft furnishings through the Khatris' long-term collaboration with Charllotte Kwon, whose company Maiwa Handprints is based in Vancouver, Canada (see fig. 19.8).

Commercializing Craft

In the neighbouring state of Rajasthan, Jaipur and surrounding villages have been noted for blockprinting almost since the Pink City was founded by Maharaja Sawai Jai Singh II (r. 1688–1744) in 1727.[6] Sanganer, now subsumed by Jaipur's sprawl, was described in 1903 as "the very metropolis of the calico-printing craft of India."[7] Formerly famous for its *syahi begar* (red and black) printing on sun-bleached muslin, which was worn at court, this tradition has largely given way to screen printing for the masses. The town of Bagru, on the other hand, thirty kilometres to the southwest of Jaipur, was renowned for its resist printing employing mud (*dabu*)—used to adorn local women's skirts with small florals and bud (*buti*) designs—and remains a prominent centre for block printing with natural dyes, notably indigo.[8] By the mid-twentieth century, however, the region's hereditary block printers—predominantly members of the Chhipa community—like their Khatri counterparts in Kachchh, found that demand for their goods was starting to disappear as local popular taste favoured synthetics.

Lacking a dynamic state crafts organization like Gurjari, salvation for many Chhipas came from the export and then retail sectors in the form of Anokhi, a Jaipur-based fashion company founded by John and Faith Singh in the early 1970s, which specialized in regional block prints. Jitendra Pal (John) Singh, a Rajput from Uttar Pradesh, met Faith, the daughter of Anglo-Irish missionaries, in 1967 by the pool at the Rambagh Palace Hotel in Jaipur. Over the next three years, the idea of a craft-based company that would make block printing a viable livelihood for Rajasthani printers took shape, and Anokhi was launched in 1970 (fig. 19.6). Now with a global reach and twenty-four shops across India, it works with over a thousand block printers and focuses on "creating an interface between the craft and the market and providing for contemporary tastes from the traditional craft base,"[9] according to Pritam Singh, John and Faith's son and the managing director of Registhan Pvt. Ltd., the company that owns the Anokhi brand (fig. 19.7). But as Faith recalled, when the company started, "block printing was on the point of dying out in terms of its traditional form of patronage. There was no new export market in place at all so we were at the very beginning of that."[10] Captivated by local mud-resist dabu prints and the quality of *syahi begar* textiles, she perceived their commercial potential, as she commented, "Men still wore a white scarf with black and rust—*angochha*. You still saw it used quite a lot in

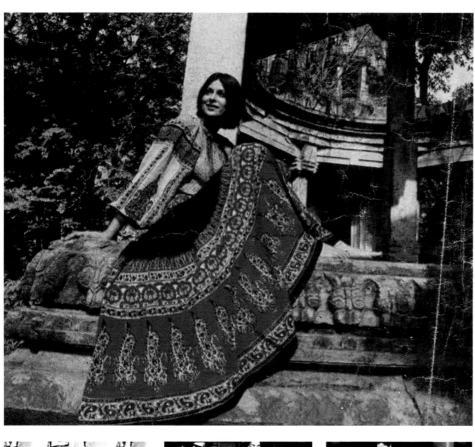

ABOVE
FIG. 19.6

Cotton maxi-skirt block printed with traditional Rajasthani designs. Anokhi, 1970s. The foundations of Anokhi were laid by John and Faith Singh in the late 1960s to early 1970s and coincided with the flowering of so-called hippie culture. The period was marked by a trend favouring the exotic; Eastern philosophies and music were popular, and "ethnic" dress became all the rage with the younger generation, trickling up to infuse Western designer fashions.

Photograph courtesy of and reproduced by permission from Rachel Bracken-Singh and Anokhi Archives, SNP012.

BELOW
FIG. 19.7

Contemporary Anokhi designs.
Anokhi Instagram @anokhijaipur

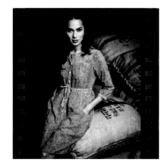

FIG. 19.8

Contemporary dabu mud resist products of Bagru, Rajasthan.

Above: Mahesh Dosaya discussing fabrics for a dabu collection with designer Sophena Kwon of Maiwa.

Below: Dabu resist prints dyed with indigo used for soft furnishings at Maiwa Handprints, Vancouver. Charllotte Kwon and her team have worked with Mahesh Dosaya for over 20 years.

Photograph courtesy of Charllotte Kwon, Maiwa.

OPPOSITE
FIG. 19.9

Sari, western India. Silk, block printed, natural dyes, 644 × 116.5 cm. This sari was block printed using the ajrakh technique at the Pracheen ("ancient" or "old" in Hindi) workshop in Mumbai, 2018. Khatri Ahmed Latif and his son, Sarfraz, specialize in printing and dyeing silk with natural colours. Preferring to work on a small scale, they design and produce a sophisticated range of scarves, stoles and saris for a designer clientele.

ROM 2019.60.1

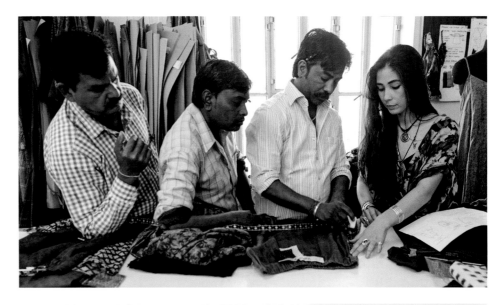

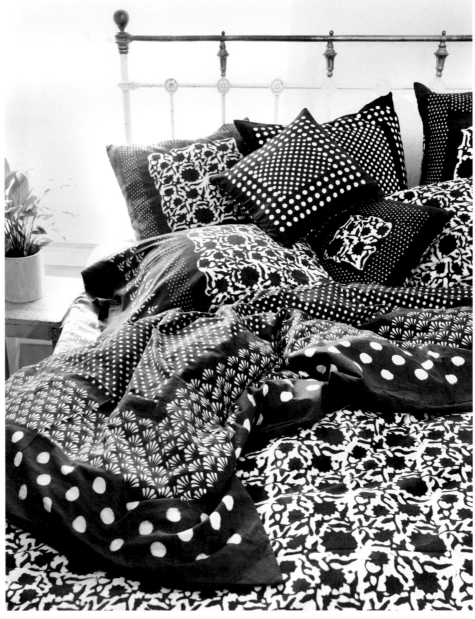

those days, either wrapped around the head or around the neck, or used as a sweat cloth—India's wonderful multi-purpose cloth. One of the first garments I made was out of a couple of *angochha*. It had a milky softness to it."[11] She and John sought out local printers and began working with the Dosaya family in Bagru, artisans who specialized in mud-resist printing and natural dyes.

The late Satnarayan Dosaya was one of the original Anokhi printers; his son Mahesh (see fig. 19.8) described his father's routine prior to working with the company: "Monday to Friday he would print *fadat* (women's skirt lengths) and a small number of *gandhi* (men's shoulder cloths), so about 60 metres of fabric. Saturday and Sunday he would go to Jaipur, to the *haat wada* (market place) near the Hawa Mahal (Palace of the Winds) to sell it. Then he would bring home 60 metres of 'grey' (loomstate) fabric for printing and the next week he would print it and then go to Jaipur again."[12] Printing for Anokhi transformed the family business; the volume of work was such that Satnarayan employed other printers, and between 1972 and 1985 he managed a labour force of 125 workers. By 1977, he had ceased to do "local" work, and Anokhi became his main customer. The arrangement came to an end in 1985 when Anokhi switched much of its production to synthetic dyes in order to meet the growing demand (fig. 19.8).

The timing of the company's inception was fortuitous; Anokhi prints captured the zeitgeist of the late sixties and early seventies when hippie counterculture was flourishing. The company focused on selling to foreigners—embassy staff, cultural envoys, and tourists—with whom their peasant blouses, gypsy skirts, and kaftans were popular. The first Anokhi store opened in Jaipur in 1984, but it was only after the liberalization of the Indian economy in 1991 that the domestic market began to grow. The rise of middle-class consumers in the past twenty-five years, reflected in India's burgeoning malls, has seen them embrace Anokhi's stylish printed home and clothing ranges. Today the company balances fashion's demand for innovation with its commitment to the traditional repertoire, as Rachel Bracken-Singh, design director, describes it: "We have a large archive of traditional prints that have been associated specifically with Bagru and other areas—*and* we work with contemporary designers. It's a mix I suppose in a way; we do contemporary because people would have those, too; and we do *butis* and traditional designs because *we* would like to have those."[13]

Craft and Technology

The recent rise of e-commerce in India has seen block prints being purveyed online. One of the fastest-growing platforms is Jaypore, which was founded in 2012 by Shilpa Sharma and Puneet Chawla (fig. 19.9). The website states, "We curate unique and exclusive collections that represent India's finest craft-based designs, so that you can savour the delightful treasures at leisure, with us. Immerse yourself in the beauty of India. Shop for handmade sarees, dupattas, jewellery, shawls, home decor, art and more."[14] The company has commissioned several prominent block printers, including Ismail Mohammad Khatri and his sons Sufiyan

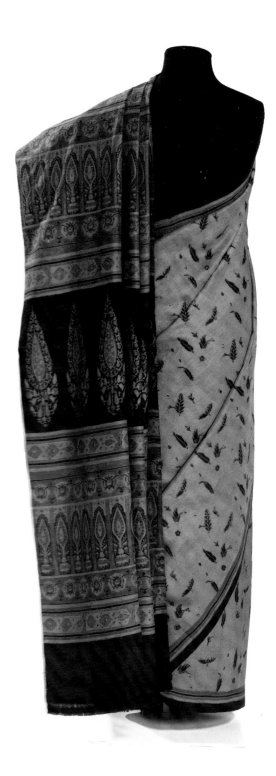

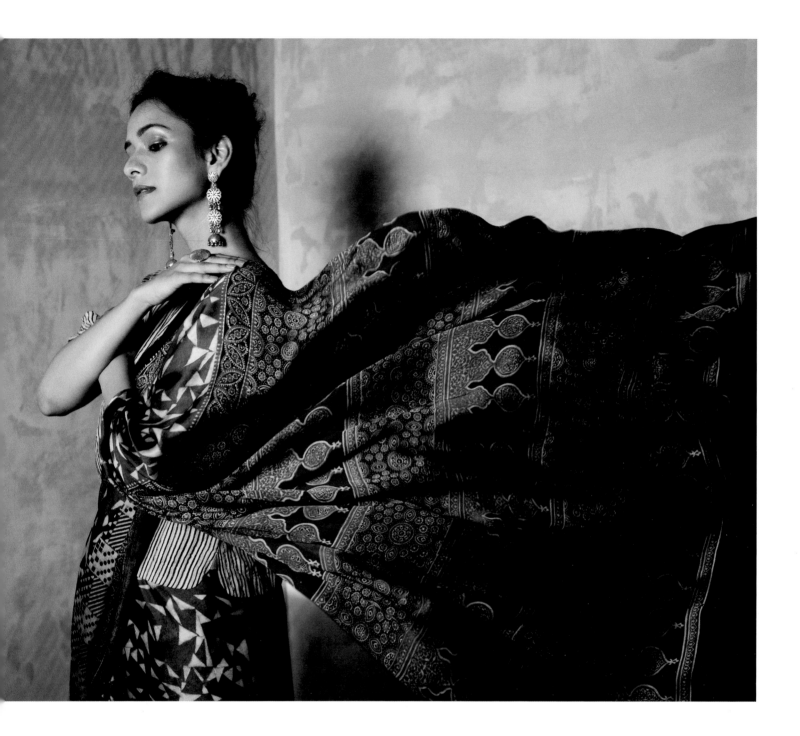

FIG. 19.10

Sari from Jaypore's Ajrakh Attractions Collection, 2018. Silk, block-printed, mordant-dyed, resist-dyed natural colours in the workshop of Dr. Ismail Mohammad Khatri at Ajrakhpur, Kachchh, Gujarat. Jaypore is one of the largest online platforms for craft goods in India and commissions high-quality textiles, jewellery, and leather work from artisans throughout the subcontinent.

Photograph by Pawan Yadav, courtesy of Jaypore.com.

and Junaid, whose exquisite ajrakh dupattas, kurtas, and saris are featured on the website at the time of writing (fig. 19.9); there are also several pages of garments fashioned from mud-resist dabu prints from Rajasthan.

The internet not only has enabled e-commerce but also has transformed the way artisans conduct business and has given them access to a cornucopia of new patterns to add to their traditional repertoire. While some printers may have a home computer, all of them do have a mobile phone, which they use to stay in regular touch with clients via applications such as WhatsApp; orders are often reviewed as they are being printed. Similarly access to Google Images, Instagram, and similar apps serve as important resources in terms of new pattern ideas, and most members of the younger generation of printers have a Facebook profile and follow the catwalk shows at India Fashion Week online, especially if their own work is featured.

Conclusion

The prominence of block prints in contemporary fashions in India is unprecedented, and some of the interventions that have helped to revive and sustain the craft in northwestern India, such as taking prints from rustic dress to the catwalks and malls of urban India, have been discussed in this essay.[15] But a note of caution is necessary: while the craft has benefited from design-led interventions, designer-artisan collaborations have not been without problems. Some less scrupulous entrepreneurs have simply treated skilled artisans as hired labourers, appropriated heritage designs, and reproduced them by cheaper, faster means; conversely, some artisans have struggled to meet production deadlines and quality control requirements. An ongoing complaint from artisan communities is that their contribution to fashion goes unacknowledged, while couture designers, especially, are "names" and reap applause for their "heritage" collections; several designers, for example, Aneeth Arora at Péro, have conscientiously tried to rectify this.[16] Despite the inequity of the situation, design interventions have undoubtedly transformed the prospects of handmade textiles, embedding them in the subcontinent's fashion psyche, and as a result, the production of heritage block prints such as ajrakh, dabu, and *kalamkari*[17] is blooming.

1 Recent work on the influence of Indian coloured cottons includes Crosby, "First Impressions"; two exhibitions in the Netherlands, Corrigan et al., *Asia in Amsterdam* (catalogue; Rijksmuseum, Amsterdam, 17 October 2015–17 January 2016) and Gieneke et al., *Sits: katoen en bloei*, Fries Museum, Leeuwarden, 11 March–10 September 2017. Jordan, Schopf, and Sibenhüner, *Cotton in Context*.

2 Brij Bhasin, personal communication to author, New Delhi, 12 March 2013.

3 Archana Shah (designer-entrepreneur, owner of lifestyle store Bandhej), personal communication to author, Ahmedabad, 8 December 2012.

4 Khatri Mohammad Siddik (block printer), personal communication to author, Dhamadka, 14 September 1997.

5 Bandhej mission statement, Bandhej (website), accessed 27 August 2018, https://www.bandhej.com.

6 Jaipur is known as the Pink City because of the pink wash applied to the city walls and all the buildings along the main streets. This cosmetic approach was prompted by Maharaja Sawai Jai Singh II's desire to emulate the imperial cities of Delhi, Agra, and Fatehpur Sikri, which had been built from pinkish-red sandstone—a material not available to the maharaja. See Tillotson, *Jaipur Nama*, 26–27.

7 Watt, *Indian Art at Delhi*, 247–49.

8 For a detailed study of Bagru textiles, see Mohanty and Mohanty, *Block Printing and Dyeing*.

9 Sankar Radhakrishan, "A Truly *Anokhi* Story," Hindu Business Line, 15 December 2003, https://www.thehindubusinessline.com/life/2003/12/15/stories/2003121500020100.htm.

10 Faith Singh, personal communication to author, Jaipur, 12 December 2001.

11 Singh, personal communication to author, Jaipur, 12 December 2001.

12 Mahesh Dosaya (block printer and entrepreneur), personal communication to author, Bagru, 7 November 2012.

13 Rachel Bracken-Singh, personal communication to author, Jaipur, 28 November 2013.

14 Jaypore (website), accessed 27 August 2018, https://www.jaypore.com.

15 I have explored these themes in more depth elsewhere; see Edwards, "*Ajrakh*."

16 I have discussed in detail elsewhere Aneeth Arora's efforts to have Sufiyan Khatri's contribution to her collection Aneeth Arora for Zuba, made for the fashion retail chain Westside in 2014, recognized. See Edwards, "*Ajrakh*."

17 *Kalamkari* prints are associated with Machilipatnam and surrounding villages in Andhra Pradesh; see ch. 18.

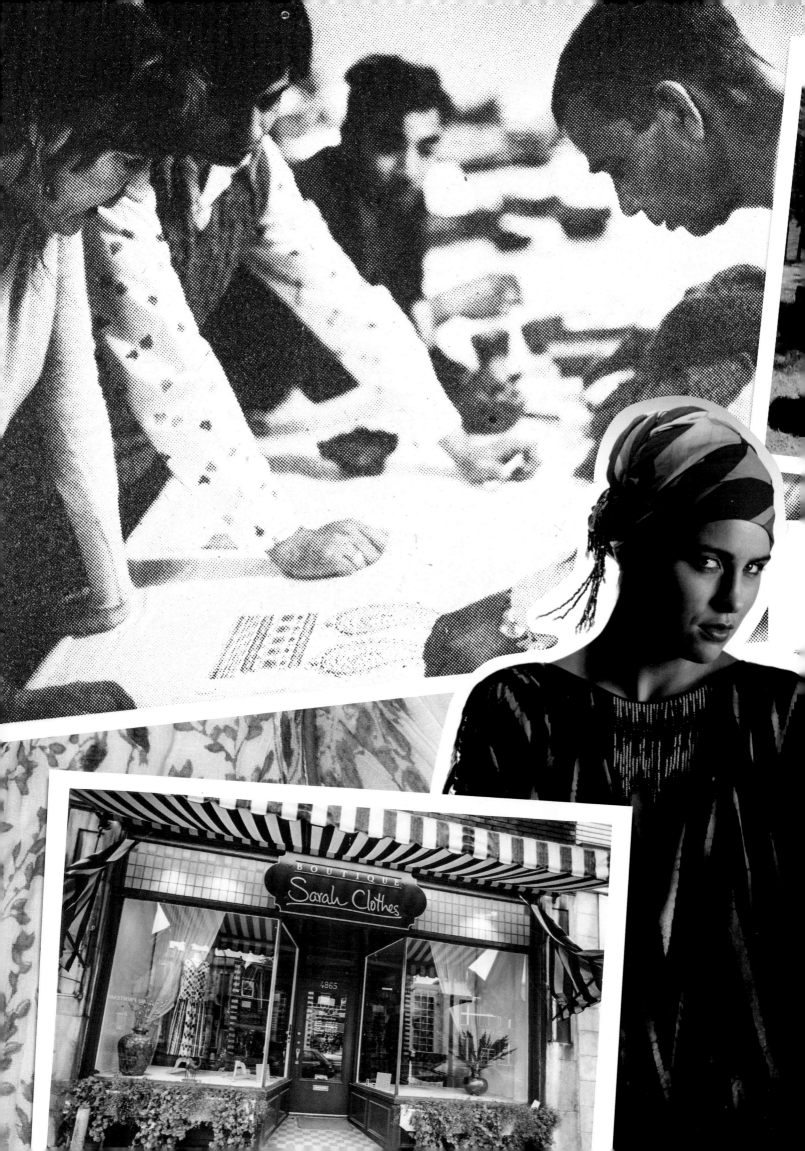

20

SARAH CLOTHES

BRINGING INDIA TO CANADA, 1975–1996

ALEXANDRA PALMER

I am interested in human clothing ... We can't keep on throwing away. We've got to have more durable things ... With luck, maybe we can make real clothes a kind of inverted chic.

—Sarah Pouliot, 1974

BY THE 1960S, DESPITE THE EFFORTS OF INDIAN NATIONALIST ACTIVISTS, cotton printing in many areas of India was depressed. Some relief came from emerging global demand from the hippie movement and several foreign entrepreneurs who worked in India. As Eiluned Edwards has pointed out, "The dynamic retailers who have helped to establish new markets, reinvented products for changing tastes [and are] often omitted from the narrative of crafts ... deserve a place in the heart of any conversation about the contemporary market."[1] The stories of John Bissell and Brigitte Singh, for instance, are well known. But there were many other international entrepreneurs, such as Sarah Pouliot, who with her daughters Andrée and Madeleine, left an indelible mark designing and manufacturing Sarah Clothes in India for export (fig. 20.1).[2]

Sarah Clothes' romantic fashions belie the hurdles faced by a "40-year-old housewife of 17 years who had no previous business training." Her recognizable, "unique 'Sarah' designs, some hand-blocked," were "carefree and colorful clothes for every woman," worn year-round

Sarah Pouliot of Sarah Clothes working in India, 1976; Athlyn Fitz-James seven months pregnant in Sarah dress, 1988; "Africa" dhabu resist top and summer catalogue drawn by Andrée Pouliot, 1984; Westmount, Montreal store, 1980.

for leisure and work by Canadian brides, wedding guests, and pregnant and mature women (p. 252).[3] It is important to remember that the company operated in the pre-digital age, when it took months to have a telephone installed in India, and the fastest means of communication was a telegram, a telex, then fax. Sarah claimed that "if I can do it, anyone can do it," but it was not simple.[4] Her seasonal notebooks offer a dizzying study of the complexities of the business: sketches, measurements, swatches; endless notes and questions for her Indian suppliers and manufacturers; things to ask and check up on and to "beware" of; long "to do" lists and "goals"; style numbers and quickly sketched tables to cross-check, check off, work out, and coordinate elements of each line; the accounting of each garment ordered and landed; reminders about the needs of the warehouse and her stores in Canada.

This microhistory of Sarah Clothes highlights the socio-cultural and economic history of the late twentieth century.[5] It also resonates with older East India Company macrohistories of supplying Indian textiles and fashions, which share the same challenges of operating over vast distances of geography and cultures. Sarah's narrative reverberates across centuries and echoes the historical challenges and complexity of communication, the need to establish trusting relationships, and the centrality of flexibly navigating networks to cope with fluctuations and inconsistencies of international laws and taxes. She faced the same challenges that merchants and makers experienced globally across time. Hers is a story of creativity, entrepreneurship, and great tenacity, embedded in a deep engagement with India's rich textile heritage.

Sarah Clothes, 46 Elgin Street, Ottawa

Born in 1928 in Montreal, Sarah Pouliot (née Bale) first learned how to sew from her mother. Her increasing knowledge of measuring, pattern making, design, and construction was acquired through years of custom designing for private clients and by working in wardrobe for theatre and ballet. Sarah worked for the first two seasons at the Stratford Festival, Stratford, Ontario, the National Ballet, Toronto, and in the wardrobe at the National Arts Centre, Ottawa.

In 1967, she moved her custom sewing workshop from her home in Ottawa into the historic Central Chambers building at 46 Elgin Street. With the help of a "wonderful tailor" named Angelina and her sister Immaculata, Sarah began to design and sew ready-made garments. She turned irresistible Indian textiles, such as block-printed bedspreads and silk saris, bought in Montreal at Expo 67 at the Indian pavilion, into elegant kaftans and peasant-style blouses with drawstrings.[6] Concurrently, she spent four years designing on commission for Noel Lomer's Ottawa firm, Lung Mei Trading Company. With Lomer, she learned through trial and error about manufacturing in Thailand and wholesaling in Canada. In one instance, they happily received an order from Simpsons department store for what they thought was twenty-four shirts and then realized that it was in fact for twenty-four dozen.[7] Sarah began to appreciate that "you can't make a living doing custom clothes . . . I didn't really get a sound financial footing until I started making clothes in multiples."[8] She called this enterprise Sarah Clothes and entered "a new and exciting Indian phase"; her first designs, in the spring of 1976, were so fresh and different they were featured in *Miss Chatelaine*.[9]

The business quickly grew "from a cramped room in her home . . . to a half a million dollar a year sales," with wholesale accounting for half of the revenue.[10] Merchandise was produced and shipped from India to the Ottawa warehouse and then distributed across Canada through Eaton's department stores, as well as by other national retailers and small boutiques (fig. 20.2

Featuring beautiful QUILTS, cushions, tablecloths...

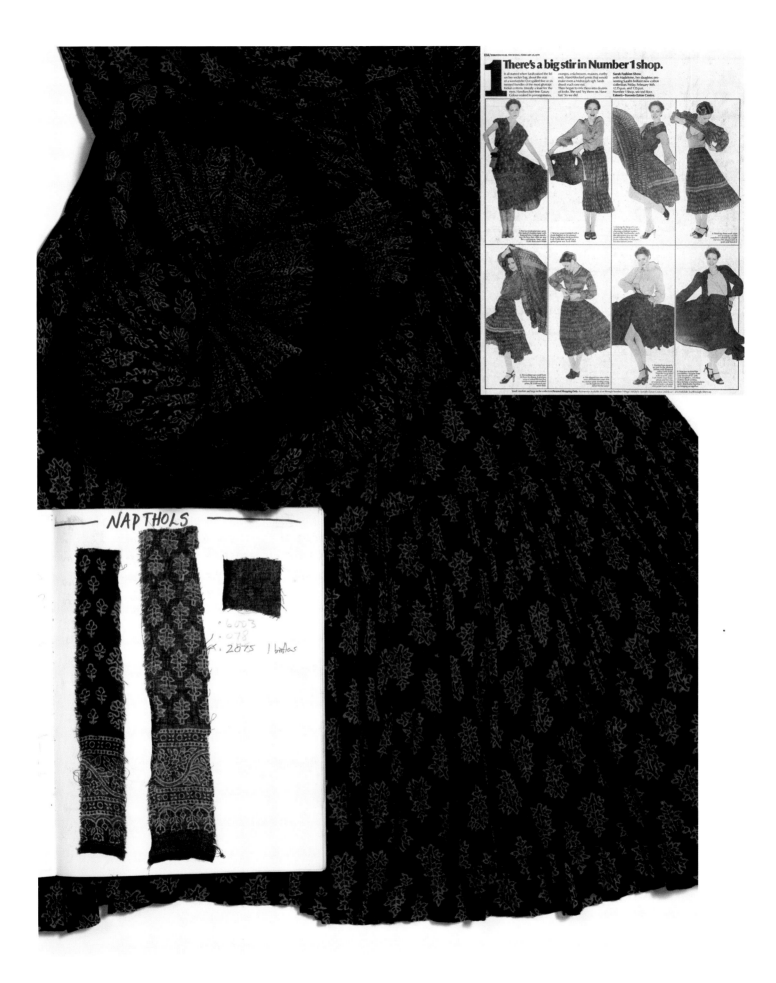

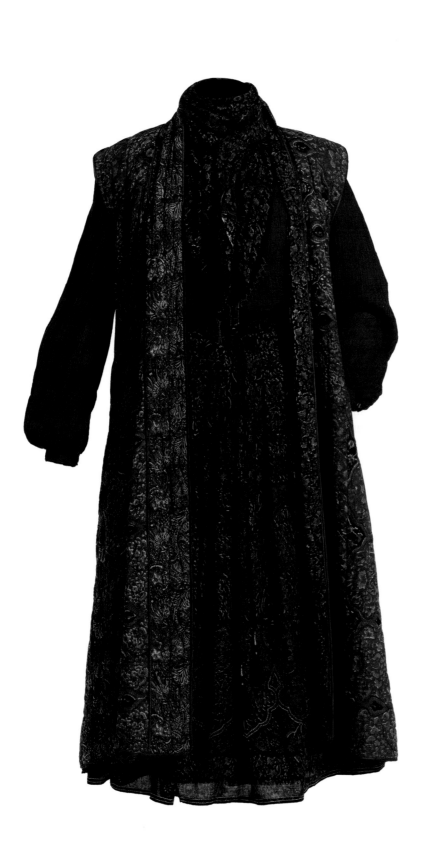

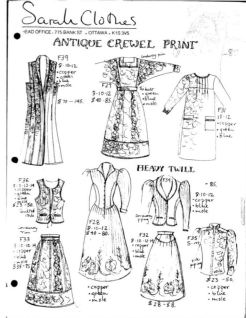

and 20.3). However, the rapid success and expansion of Sarah Clothes' wholesale and retail operations created unforeseen difficulties, causing Sarah to decide that the safest and sanest approach was to "pull her own strings."[11] She then reined in her wholesale production that was difficult to control due to merchandise returns and lack of payments, often for months or even never, when a retailer had closed. Instead, she expanded her retail operations. By 1988, there were six Sarah Clothes stores in Toronto, Ottawa, and Montreal.[12]

Sarah's shops offered a new consumer experience. The flagship, on Elgin Street, introduced a new playful display: "Unlike a conventional shop, with racks and racks of carefully pressed and hung clothes, much of what Pouliot sells is found in baskets."[13] Sarah, unwittingly and successfully, flaunted the rules of conventional retail that favoured floor space for merchandise by installing a large platform bed-style sofa loaded with pillows. It was a perfect place to leave infants and children to play, to pile up desired merchandise, and, most importantly, a place for husbands to sit comfortably and read the sports section of the newspaper while spouses were trying on designs. By 1988, the business had "carved out a niche for itself in clothes and home furnishings made from colorful Asian textiles."[14]

Collaborations: Anokhi, Ethnic, SOMA . . . for Sarah Clothes

American John Bissell, who established Fabindia in 1960, commented that "the greatest thing that happened to our business was the move in Europe and America . . . to the natural look—natural textures, natural fibers—and away from things like polyester and nylon."[15] Sarah's introduction to chic, modern Indian-made fashion was in the early 1970s when she first saw romantic Pre-Raphaelite-inspired fashions in London at shops such as Liberty (1875–present) and Monsoon (1973–present), the latter carrying the fine voile and handcrafted fabrics from the Indian company Anokhi (1970–present). She recalled, "I saw things in London in these two places . . . So, then I kind of found out . . . where they came from . . . Jaipur."[16] Sarah then went to Jaipur and sought out Faith and John Singh, the founders of Anokhi, who at the time were still designing and making their unique block-printed textiles solely for export, as they had not yet established shops in India.[17]

On her first trip to India in 1973, Sarah sourced textiles in New Delhi from retail shops such as the Central Cottage Industries, operated by the Ministry of Textiles, which had been established to showcase and sustain Indian crafts.[18] Lacking the volume necessary for full orders of printed cottons, Sarah cleverly partnered with other businesses, modifying their designs for Canadian customers. These designs bore the label Anokhi for Sarah Clothes. Sarah also sourced designs from other manufacturers, such as Mary Jean and Shektar, producing them under different labels; Ethnic for Sarah Clothes and SOMA for Sarah Clothes.

Sarah remarked how much better it was working with Anokhi than alone, because "they did such good work . . . I was longing to work somewhere where I could really relax and just see that it was coming out properly—as good as their workmanship."[19] But Anokhi also learned from Sarah, who modified and styled new patterns for them. Sarah emphasized that there was nothing comparable to Anokhi's infrastructure. The company was so respected in India that, through them, Sarah could even obtain the hard-to-get export quotas required to land each garment into Canada.[20] With help in production and shipping, she could now concentrate on the fashion design, saying, "Let's put piping all around the whole thing, and let's embroider the pockets, let's line it, make sure it's lined with a different pattern. So, that's one of the things that made the [clothes] so distinctive (fig. 20.4)."[21]

Sarah worked primarily between Delhi and Jaipur for six months of the year, producing two collections annually that each comprised eighty to one hundred designs, both prints and plains, to keep up with Canadians' demand. For instance, one shop alone was ordering up to forty-four pleated skirts per colour, and all carried ten to fifteen pieces per style in

OPPOSITE
FIG. 20.4

A classic, four-piece, layered Sarah Clothes cotton ensemble in "Baroque" print collection, winter 1982. A plain pleated voile blouse with a printed and pleated skirt and a bead trim scarf is coordinated with a long, quilted vest cut with signature pockets inset in the seam. The vest pattern was based on a traditional Tibetan garment Sarah sketched when she visited the ROM in summer 1979. She carefully modified the cut so it sat comfortably on the body (top image), and followed the print pattern in the quilting (fabric detail). The vest was repeated in various prints, such as "Antique Crewel," for winter 1983. An illustrated catalogue, drawn seasonally by Andrée Pouliot, presented the latest collection to professional buyers (centre image).

Sarah Clothes Archive

any given print story.[22] She wanted to "revive some of the wonderful but vanishing beauty of traditional hand-printed clothes on a commercial scale," using up to five blocks for a print; and if gold was added, it required a separate workshop.[23] To create unique prints with her own colours, Sarah purchased precut blocks and commissioned new ones; she also coordinated blocks and all the trims for border designs.[24] In 1979, she sought out mud-resist *dabu* cloths for her collection and the hard-to-find block-printed *kalamkari* (chintz) textiles dyed with natural madder, turmeric, and iron mordants.[25] Sarah found different suppliers and contracted out "everything from embroidery to buttons," having indigo dyed in Jaipur and embroidery worked in Lucknow.[26] She carefully educated customers on the uniqueness of the textiles, providing hang-tags that read, "Cloth is hand printed in India with small carved wooden blocks. Dyes often involve such products as brown sugar, indigo, turmeric or pomegranate. Slight flaws are inevitable so we hope you will accept these irregularities as the difference between man (or woman) and the machine."[27]

Despite "heavy rains, shortages in raw materials which delay regular operations and quotas on imports," business was good.[28] Yet the practicalities of sampling, producing, and getting the textiles made, then making the patterns and manufacturing the garments to a quality she wanted, became increasingly difficult as the business expanded.[29] Having demonstrated her concept on a sewing machine, Sarah would then admire the Indian tailors' workmanship, saying, "You should see the guys doing gathering . . . And he's running this under the needle . . . zooming down—and then you look at it, and they're all exactly the same . . . better than our teeth."[30] She also quickly learned that she had to bring Canadian supplies such as snaps and zippers, which were unobtainable in India in the years before economic liberalization (fig. 20.5 and 20.6).[31]

The Business of Sarah Clothes

Sarah navigated the intricacies of the international business world through first-hand experience of profits, losses, loans, and federal, provincial, and international export and import laws, and weathered the global recession of the early 1980s. Russell Barton, a friend of hers, had strongly urged her to invest in gold, so she went with him "a number of times" to the bank, and her investments grew dramatically. When she received her first large order from the national department store Eaton's, she was "an outfit that had no capital" and needed to borrow one thousand dollars. Sarah described the meeting with the banker, who asked her, "'What do you have for collateral?' . . . I put my hand in my pocket, and I had this— like a cake of soap of gold. I had learned that gold is to make money . . . And it was really quite amazing, because I never cared about money before, but this seemed like a really good game. So, we did, we did it."[32]

Sarah learned about provincial retail laws that were sometimes advantageous and at other times not. Ontario's antiquated laws prohibiting shopping on Sundays were in place until 1987 when a new Retail Business Holidays Act permitted stores of less than five thousand square feet and with fewer than eight employees to open—if they were closed the prior Saturday. Over forty stores in Ottawa's Glebe Business Group opened on a Sunday during the Christmas shopping season. Madeleine Pouliot, vice president of Sarah Clothes, estimated it was three times as busy as a regular Saturday: "We're totally understaffed. None of us has had a lunch yet."[33] By 1991, a modified Sunday shopping law permitted retailers to be open four Sundays before Christmas. Sarah Clothes had more than enough sales to make this worthwhile.[34]

Quebec laws had to be met by the Montreal stores. The first Sarah Clothes shop, at 4972 Sherbrooke Street West, was in the anglophone area of Westmount. When a second store was about to open in the francophone district on Rue Saint-Denis, they received complaints

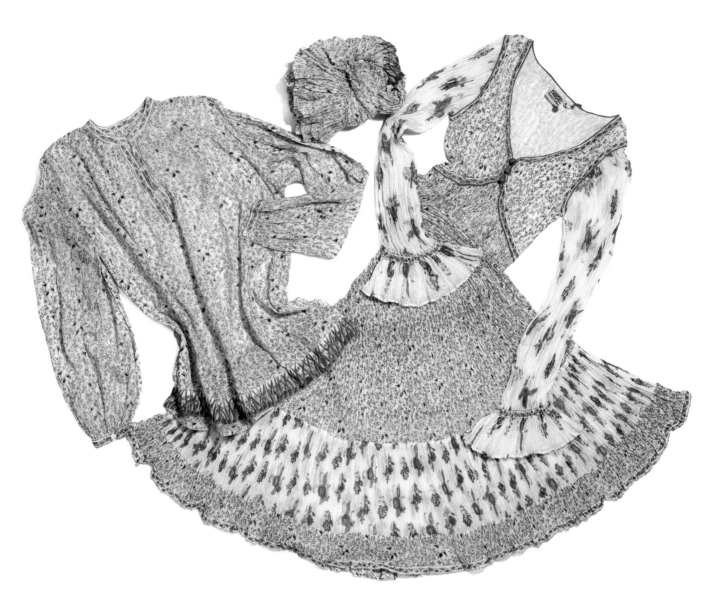

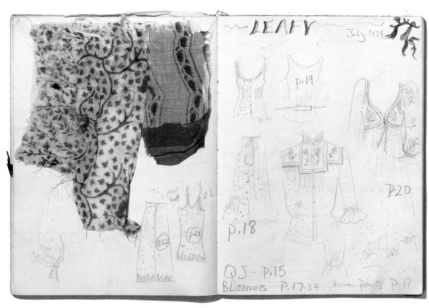

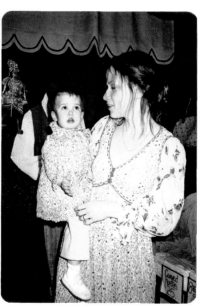

that the store name did not conform to Bill 101, whereby French was the sole language allowed for signage. The stores were then called Boutique Sarah Clothes, and staff were "scrupulous about French signs in the windows" for announcements of hours and sales, or when posting notices asking for sales help.[35] There were also surprises, such as when the Quebec government announced immediate changes to the provincial goods-and-services tax as part of the new 1994 budget. The 8 percent tax on goods and 4 percent tax on services was to be replaced with a new 6.5 percent across-the-board tax as of the upcoming Thursday at midnight. It caused huge confusion among business owners, who were not sure when to implement the new tax and did not have time to have their cash registers reprogrammed. At Sarah Clothes, they figured it out by hand.[36]

There were also federal laws to navigate. In 1976, just as Sarah was becoming established, Canada imposed complex import quotas. New bilateral agreements with exporting countries were introduced because "shipments of imported garments [had] jumped to one dozen garments for every man, woman and child in Canada." The introduction of protectionist measures was intended to decrease the costs of the increased clothing imports from Taiwan, South Korea, and Hong Kong, but it also included other countries, such as India, that produced more competitive goods in the low-cost field.[37] By 1980, the Textile and Clothing Board, a federal agency that monitored the special protection given to the industry, reported that protecting Canadian textile and garment producers with quotas was expensive, counterproductive, and "not a viable long-term solution," but the system continued until 1994 when it was gradually phased out.[38]

A fixed quota was instituted for each garment type permitted for export from each country. However, the quota numbers were constantly changed and re-evaluated based on the previous sales quarter between Canada and India. In order to get her clothes from India to Canada, Sarah had to rely on the Indian manufacturers who made the clothes, as they were responsible for securing the quota from the Indian government to export their products. Sarah's relationships with manufacturers were therefore crucial, as they had to not only produce quality goods to her satisfaction, and on time, but also be able to ship them out.[39] Problems were constant. For instance, it could be difficult to obtain the blouse quota for matching skirts that had already obtained quotas. This led to creative nomenclature. Women's drawstring pants might be called men's if it was easier to export. Quotas then became a type of black-market economy that was more lucrative for some producers than making garments.[40] Sarah recalled, "At the time, there were a lot of people who were getting into the garment industry who didn't know a damn thing about it. But it seemed like something that you could . . . step through . . . The part that they didn't know was how to do the paperwork and all the rules on the Indian side and all the rules on the Canadian side and quotas. Oh, that was a bad period."[41] Sarah Clothes successfully operated under these difficult years with high interest rates and tariffs on clothing and textile imports instituted to protect the domestic Canadian textile and clothing industries.

Sarah Clothes: A Fashion Solution

Sarah Clothes held an interesting space both inside and outside the Western fashion system. The designs moved fluidly within the international retail and consumer market and were sold in exclusive boutiques, such as Dianne B in New York, alongside "Azzedine Alaia, Issey Miyake, Castelbajac, Gaultier, Dorothee Bis and Crolla," as the revival of "Ashram fashion—or guru gear" was the "mark of influential European designers."[42] Sarah commented, "People who wear our clothes feel they have some kind of magic. The fabric feels good and feels soft and the colors are gentle and becoming."[43] She never adopted the 1980s shoulder pads that made "women look like quarterbacks," and her fashions, "more starlet than harlot," were aimed at consumers who "like to look well-dressed . . . not

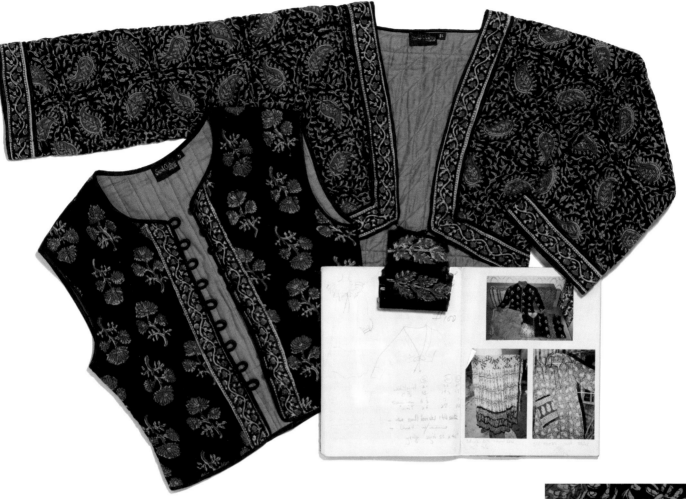

outrageous."[44] In 1984, her fashions were in sync with a nostalgic colonial-India revival due to the popularity of the BBC television series *The Jewel in the Crown* and David Lean's film *A Passage to India*, which created a "rage for Raj decorating" that was as "comforting as high tech is austere and functional" (fig. 20.7 and 20.8).[45]

However, Indian fashions were also suspect for women who "came of age in the '60s Indian cotton" era, as they were synonymous with a "sloppy hippie-look they now want to avoid."[46] Women were mastering the latest "dress for success" style as they entered professional positions in the workplace.[47] But Sarah Clothes, made "from finely pleated Indian voile are soft, feminine, romantic and in sharp contrast of the conservative, no-nonsense look now in vogue." The subtlety of her "flower-sprigged cotton gauze in a mixture of green shadings" was contrasted to contemporary Paris fashions with "highly visible patterns of animal dots and stripes."[48] Sarah Clothes tapped into the Eurocentric idea that traditional and regional styles were frozen in time and beyond the Western seasonal fashion cycle, and thus "classics." They appealed to customers who eschewed the "power look" and preferred "ethnic inspirations" that were modern and embodied "a multicultural style . . . that is easy to look at and easy to wear."[49]

FIG. 20.9

Sarah Pouliot, age 86, at her cottage in Jaipur wearing a favourite kaftan printed and designed by Brigitte Singh, a close friend, 2014.

Photograph by Jenny Hallengren.

One journalist wrote, "Sarah Pouliot is proof that a designer can thumb her nose at fashion's dictates and still be a winner."[50] Each garment could be mixed and matched with another, thus making them ideal for travel, as they were "weightless, effortless clothes" that "could be worn all day, washed out at night and worn the next morning. Or when not being worn, twisted into a ball, tied in a knot and tossed into a drawer, or a suitcase."[51] Sarah actively sought out design inspiration from her daily life and was acutely observant.[52] She sketched a dress she saw being worn on the street by "a French girl" and transformed a traditional Indian masculine bias-cut undershirt into a dress, "which fits as comfortably as a tee-shirt."[53] She visited museums such as the Royal Ontario Museum and Victoria and Albert Museum, sketching fifteenth- to nineteenth-century fashions from Europe and Asia.[54] The "timelessness" of Sarah Clothes straddled a modern space that blended ethnic, folkloric, and romantic historicism with hand-blocked textiles and "primitive pleating," in styles that drew upon Western historic costume, folk, and Asian cuts.[55]

Traces of an Era: Traces of Time

Sarah, who brought "a little bit of Rajasthan . . . to Ottawa," was keenly aware of the fragility of the myriad of hand skills held by artisans upon whom she relied, and in 1980 predicted that the art of Indian hand-blocked textiles would not survive another five to eight years. She said, "I feel fortunate that my personal story includes working in the mainstream of this textile tradition in the East."[56] Thankfully, she has been proven wrong. The twenty-first century has shown a remarkable renaissance in the demand and production of Indian heritage textiles, in which prints play a leading role. However, the fact that Indian textile crafts and fashion production remain so vibrant today is due, in no small part, to the creativity and industry of a generation of Indian and foreign entrepreneurs in the 1970s to the 1990s, who ran thriving businesses, such as Sarah Clothes (fig. 20.9).

A special and heartfelt thank you to Sarah, Andrée, and Madeleine Pouliot for their time and generous sharing of memories and archives that add to the precarious and limited history of small creatives making important innovations in the global fashion and textile industries.

*Photo credits for opening image on p. 252: Sarah Pouliot working in India, first published in the *Glebe Report*: "Glebe dress designer, Sarah Clothes," vol. 4, no. 4, April 1976, Library and Archives Canada, IEC/CSF (HD-IEC) Coll. de préservation / (HD-CSF) Preservation Coll.NJ.OR.111. Irving Solero (photo), Athlyn Fitzjames with Tom Hamilton. Remaning images courtesy of Sarah, Andrée, and Madeleine Pouliot.

Epigraph

Joyce Carter, "Asia Leads Ottawa to 'Human' Clothes for Leisure, Work," *Globe and Mail*, 18 July 1974, W5.

1 Edwards, *Imprints of Culture*, 223.

2 Madeleine Cross, "Sarah Clothes Comes to the Glebe," *Glebe Report*, 18 July 1980, 5. Sarah Pouliot's first trip to India was in 1973, when she was returning from Bangkok and had a thirty-six-hour layover in New Delhi. Andrée Pouliot, email to author, 15 February 2019; Mary McGrath, "Sarah Celebrates 25 Years," *Toronto Star*, 1 October 1992, F2.

3 Mary Walpole, "Around the Town," *Globe and Mail*, 24 May 1979, T6.

4 Cross, "Sarah Clothes."

5 Compiled from interviews with the Pouliots, company records, and archival research.

6 See Nancy Gall, "Clothing Maker Heads Back in Time," *Ottawa Citizen*, 22 September 1988, D6; Cross, "Sarah Clothes"; Sarah Pouliot video interview, 15 September 2017, Ottawa.

7 Sarah Clothes sold Lung Mei Trading Company designs, such as unisex judo shirts, and her own designs, including a men's kaftan (sold for $25.00) for after work and leisure wear. See also S. Pouliot, video interview; Carter, "Asia Leads Ottawa."

8 Melinda Hughes, "Making It In: Fashion Design and Importing," *Chatelaine*, June 1978, 28, in Pouliot, Scrapbook.

9 Pat Davey, "Glebe Dress Designer, Sarah Clothes," *Glebe Report*, 3 April 1976, 7; "Spring Fling," *Miss Chatelaine*, Summer 1976; Hughes, "Making It In."

10 Sarah Clothes items were sold in England through Monsoon. Diahne Martindale, "Sarah's Empire Expands West," *Ottawa Journal*, 4 October 1979.

11 Martindale, "Sarah's Empire," 40. By 1980, Sarah had opened a second store in Ottawa, "on the sunny side" of Bank Street. See Cross, "Sarah Clothes." In April 1979, Sarah opened a new shop in Toronto's Yorkville Village. See Walpole, "Around the Town."

12 Gall, "Clothing Maker"; McGrath, "Sarah Celebrates."

13 "Brightly coloured, patterned balls of fabric untwist into skirts, dresses and blouses. No pressing required: as she [Pouliot] says, wear and enjoy." Martindale, "Sarah's Empire."

14 Gall, "Clothing Maker."

15 Kenneth N. Gilpin, "John L. Bissell, 66, Entrepreneur in Handloomed Textiles in India," *New York Times*, 3 March 1998, D23.

See also Edwards, *Imprints of Culture*, 229–34, which discusses the trade practices from the 1960s to the present.

16 She recalled Monsoon at 9 Beauchamp Place. S. Pouliot, video interview.

17 The Singhs' first success was a disco, called The Boss, in the basement of the palace of the maharaja of Jaipur; Sarah and Andrée Pouliot, video interview, 15 September 2017, Ottawa. See Edwards, *Imprints of Culture*, 234–42.

18 Edwards, 220–23.

19 S. Pouliot, video interview. A. Pouliot conjectured that Anokhi may have used military tailors. Andrée Pouliot, video interview, 15 September 2017, Ottawa.

20 M. Pouliot emphasized how important and unique Anokhi was and how well it treated its workers, including providing a daycare on site. Madeleine Pouliot, telephone conversation with author, 22 February 2019.

21 A. Pouliot, video interview.

22 Madeleine Pouliot, email to author, 1 February 2019.

23 S. Pouliot, video interview.

24 Jane Bower, "Andrée Designs Clothing as an Art Form," *Glebe Report*, 12 June 1981, 14.

25 Pouliot would buy *kalamkari* in cloth and sari lengths whenever she could find it, making skirts from sari lengths or tablecloths, curtains, and pillows, as it was very popular in Canada. Bower, "Andrée Designs Clothing"; M. Pouliot, telephone conversation with author, 22 February 2019; Walpole, "Around the Town."

26 Jane Hess, "Exotic Color New Twist on Cool Cotton," *Toronto Star*, 12 June 1980, B1.

27 S. Pouliot, Notebook, Summer 1979.

28 Hughes, "Making It In."

29 Joyce Carter, "Indian Influence in Fine Fabrics," *Globe and Mail*, 16 June 1981, F13.

30 S. Pouliot, video interview.

31 I.e., before 1991. S. Pouliot, video interview.

32 S. Pouliot, video interview.

33 Jim Bronskill, "Shoppers Flock to Glebe Stores for Sunday Sales," *Ottawa Citizen*, 7 December 1987, C2.

34 "Retailers Say Sunday Opening Justified, but . . .," *Ottawa Citizen*, 16 December 1991, B11.

35 Michael Farber, "Bigot Threatens St. Denis Store," *Gazette* (Montreal), 16 September 1987, A3.

36 Lisa Fitterman, "Caught with Cash Drawers Down; Firms Scramble to Register Budget's Tax Change; BUDGET '94," *Gazette* (Montreal), 14 May 1994, A1.

37 "Ottawa Faces Protection Issue for Textiles

and Clothing," *Globe and Mail*, 28 October 1980, B23.

38 Hart, Trading Nation, 180–81; "Ottawa Faces Protection." See also James Rusk, "End Quotas on Third-World Textiles; Counter-Productive, Ottawa Advised," *Globe and Mail*, 17 March 1981, 1; "New GATT Rules Vital for Canada," *Toronto Star*, 5 Apr. 1989, A20. David Crane, "Canada Gains in GATT Deal," *Toronto Star*, 15 April 1994, B1.

39 A. Pouliot, email to author, 16 February 2019; M. Pouliot, telephone conversation with author, 22 February 2019.

40 S. Pouliot, video interview.

41 S. Pouliot, video interview.

42 Anne-Marie Schiro, "In SoHo, 2 New Boutiques," *New York Times*, 22 September 1986, B10; "Simple Indian Guru Gear Is Making a Comeback," *Toronto Star*, 13 October 1983, B7.

43 Margo Roston, "Sarah," *Ottawa Citizen*, 8 October 1992, G1.

44 Elaine Marlin, "Glebe Businesses Shine in Fashion Festival," *Glebe Report*, 10 April 1987, 7.

45 Nancy Gall, "RAJ: The Ornate Combining of the Stodgily English with the Airy Indian," *Ottawa Citizen*, 13 December 1986, D1; Catherine Patch, "A Passion for India," *Toronto Star*, 16 May 1985, B1.

46 Hess, "Exotic Color."

47 John T. Molloy's bestseller *Dress for Success* was published in 1975 and followed in 1977 by *The Women's Dress for Success Book*. Mary Walpole, "Around the Town," *Globe and Mail*, 5 June 1980.

48 Martindale, "Sarah's Empire"; Iona Monahan, "Cotton Cools Off a Hot City," *Gazette* (Montreal), 22 June 1981, 18.

49 Francine Parnes, "Cross-Cultural Clothes; Looks That Came out of Africa, Morocco, China . . .," *Ottawa Citizen*, 27 May 1993, H1.

50 Martindale, "Sarah's Empire."

51 Mary Walpole, "Around the Town," *Globe and Mail*, 14 June 1979, T7.

52 Mary Walpole, "Around the Town," *Globe and Mail*, 11 June 1981, T4.

53 Pouliot, Notebook, Summer 1979; Mary Walpole, "Around the Town," 5 June 1980, T4.

54 Pouliot, Notebook, Summer 1979.

55 Carter, "Indian Influence."

56 Sarah Pouliot, letter to editor, *Surfacing Journal*, 12 November 1980, 11, in Pouliot, Scrapbook.

21
—

FASHION

A FUTURE FOR PRINTED AND PAINTED TEXTILES?

DIVIA PATEL

O VER THE LAST THIRTY YEARS, INDIA'S FASHION INDUSTRY HAS grown from strength to strength. It caters to an increasingly wealthy Indian middle class, as well as to an international clientele that includes the growing diasporic communities across the globe. For many fashion designers, India's wealth of handcrafted textile techniques and skilled artisans are a source of inspiration and a means of embedding an Indian identity into their garments. Hand-printing and hand-painting techniques offer many possibilities, and this concluding chapter explores some of the more innovative approaches that designers have taken to expand our perception of what can be achieved through traditional craft-based practices. They have moved beyond using purely cotton and experiment with different fibres such as silk and linen; and for some, screen printing offers another technique for the realization of their creative vision.

Block printing is just one of the techniques that designers keep returning to. It was introduced into contemporary urban casual clothing through the Anokhi and Fab India

Detail: A piece of dress fabric by 11:11/eleven eleven, 2019. Silk, block-printed resist, dyed in natural indigo, CellDSGN Pvt. Ltd.

péro spring/summer 2011

péro spring/summer 2011

brands in the 1970s (see ch. 19 and 20). For centuries the appeal of block-printed dress fabrics came from the regular and even repeat of pattern as seen in Mughal and Rajasthani garments discussed in previous chapters of this volume (ch. 2). Contemporary block printing continues to embrace that quality, with delicate floral and decorative patterns appearing on the catwalks regularly. Aneeth Arora, one of the major young designers of her generation, and her brand Péro's 2011 collection sought to "revive the finest Indian textiles which were once made exclusively for royalty" and were "exquisitely woven of fine threads upon which were brass block printed floral motifs in crisp clarity."[1] The delicate black and white printing seen in that collection was an indication of the quality and attention to detail for which Péro has become known. Subsequent collections have incorporated block printing of *ajrakh* designs, made in collaboration with master printer Sufiyan Khatri (ch. 1), and screen printing. In some instances, designers have substituted floral motifs with quirky symbols of modernity. The artists' collective People Tree, based in New Delhi, has built a reputation around this concept. Its block-printed T-shirts and dresses are decorated with cars, telephones, fish, dancing women, umbrellas, and much more; the animated motifs create a sense of movement in their prints. One line is made using natural dyes, mordants, and mud resists (*dabu*), a dynamic process of designing and printing undertaken in a collaborative initiative with Chippa printers at the Chaubundi Studios in Rajasthan.[2] While many of their designs are over a decade old, the same prints remain popular and continue to be produced in limited numbers.

OPPOSITE
FIG. 21.1

Postcards advertising Péro's 2011 collection.

Above: Block printed garments.

Below: Brass printing blocks used in the Péro collection.

FIG. 21.2

T-shirts with banana tree and auto rickshaw designs by Orijit Sen, People Tree. Produced in collaboration with Bindass Collective and Chaubundi block printing studio. Cotton, block printed, natural dyes.

Renowned fashion and textile studio Abraham & Thakore took an experimental approach to the block-printing process to create a range of high-end clothing in its 2017 collection entitled #blockblackwhite. Its minimalist aesthetic, often monotone with a splash of primary colour, has always driven its approach to the techniques it uses to articulate its vision. In this collection, rather than printing a repeat of delicate motifs using a precisely incised wooden block, the designers "deconstruct the process of creating pattern" by leaving the block uncarved in its *gadh* state, flat and plain.[3] The cotton fabric is layered with colour—either black or blue pigment dyes—and the pressure placed on the block by the artisan gives subtle variations; as it is pressed onto the fabric, the naturally occurring indentations on the block add texture. It is a "non-pattern" that offers the welcome marks of a handmade textile. The garment patterns are marked onto the fabric before it is sent to the printer to be block printed, after which it is cured with heat to fix the colour, cut, and stitched. From a distance this may look like a piece of plain black fabric, but on closer inspection the irregularity within the blocks of colour and the size and placements of the blocks becomes apparent. One of the most striking pieces from the collection is a man's suit designed around the concept of negative space; the colourless patch where the jacket pocket should be is not a white block print on black fabric, but rather a space has been left empty. The process involved using a stencil to mask the four pockets that were to remain white and then plotting the block printing around them. Abraham & Thakore is based in Noida, an urban centre just outside of Delhi, which has become a fashion hub attracting designers' studios and factories because of low property prices; the result is the evolution of an infrastructure that offers supporting facilities, such as printing workshops to which designers can subcontract their requirements. Abraham & Thakore outsources its printing to Arun Parihar, who comes from the Farrukhabad area in Uttar Pradesh, a traditional block-printing centre where his family still practises. Pinhar came to Delhi around 2008 to set up his unit to meet local demand. Work is steadily increasing; he has expanded his workshop, JMD Prints, bringing in other printers from Farrukhabad to work for him, and he now offers silkscreen printing too.

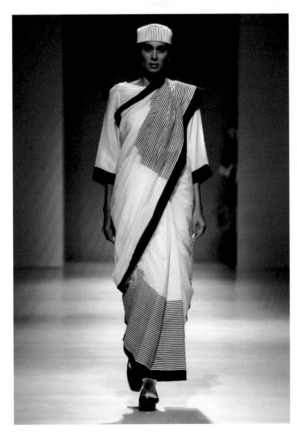

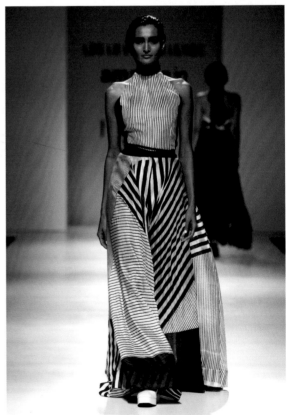

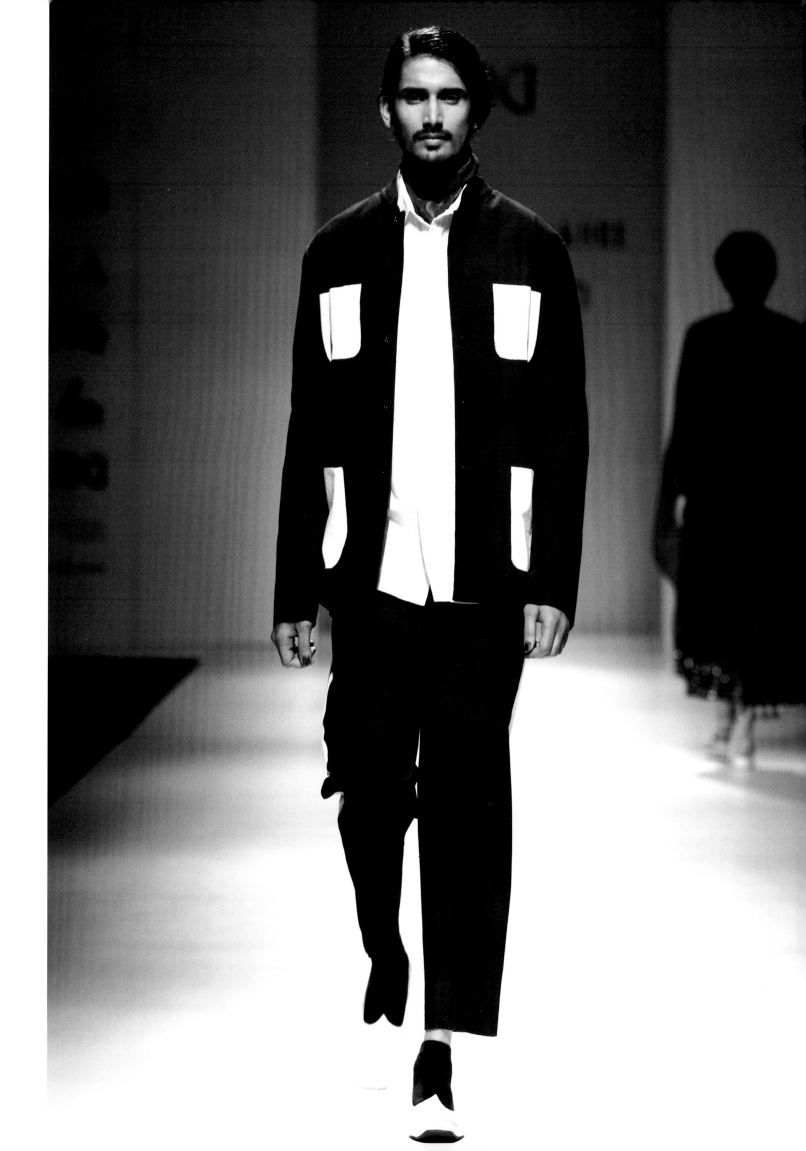

A more discreet collection, which is still in a developmental stage, is that of the designer Swati Kalsi. She too is using the *gadh* block, but on linen and in a range of different sizes to create an abstract pattern of patchwork blocks. Most crucially, the blocks do not repeat, a fundamental shift away from the typical process of printing repeats. The overall pattern is largely preplanned, but the engineering of the block placements can be challenging when trying to achieve a clean print/edge where there are big blocks of colour while maintaining the beautiful inconsistency of block printing. Kalsi uses natural dyes: black made with iron, jaggery, and salt; red created by using alum, alizarin, gums (*gond*), fuller's earth (*multani mitti*), calcium sources (*chuna*), and tree (*dhawai phool* [*Woodfordia fruticosa*]); and resist made of gum and calcium sources. There is also some use of a metallic outline to create highlights within the pattern. The pieces go through many rounds of resist printing and at least two rounds of printing with mordants and dyeing to achieve these colours on the linen fabric.[4]

Designer Rajesh Pratap Singh also embraces the power of pattern in his 2018 collection entitled Welcome to the Jungle, in which he takes inspiration from the designs of William Morris and the imagery of Rudyard Kipling's *The Jungle Book*. William Morris (1834–96) was a British nineteenth-century designer and champion of handmade production. He was a member of the Arts and Crafts movement, which abhorred the effects of industrialization and the consequent decline of traditional crafts, and promoted the joy and beauty of handmade craftsmanship. Morris's textile and wallpaper designs were based on nature, his observations of the flora and wildlife in his garden, and the countryside in which he lived, in addition to historic European and Asian textiles, including Indian.[5] His designs are characterized by swirling intertwined vines and dramatic acanthus leaves that merge with flowers and birds. Morris was an advocate of natural dyes and worked with Thomas Wardle (1831–1909), a leading textile manufacturer and dyer, to produce his prints. Wardle is recognized as an expert on the Indian silk industry and in the 1870s produced a set of designs inspired by Indian patterns.

Rajesh Pratap Singh, an admirer of Morris's designs and philosophy, studied the collection of Morris textiles at the Victoria and Albert Museum in 2017. Inspired and excited by the textiles, he developed a range of patterns that he has executed in woven, dyed, and printed fabrics, which have been used in both men's and women's wear. Among them is a wonderfully vibrant man's suit made from cotton and hand block printed with indigo based on Morris's design "Brer Rabbit"—inspired by the African American folktale—in which pairs of rabbits and song-thrush birds with their speckled chests sit opposite each other, surrounded by foliage, encircling acanthus leaves, acorns, and garden flowers. Pratap Singh skilfully manipulates this design and merges Indian elements into the pattern. Two Indian parrots with their distinctive beaks and long tails replace the song thrush, and the delicate floral design on their chests replaces the speckles. The rabbit makes way for the howling wolf, and in alternating rows from out of the jungle comes a roaring tiger, mouth wide open, teeth and fangs flaring, and eyes glaring menacingly. In among the foliage is a male face peering out into the jungle, which is interesting since the figurative never appears in Morris's designs. There is a strength of expression in merging the gentleness of a domestic garden with the menace of a jungle.

Three carved blocks are needed to complete this single colour print, and the printing process takes place in the designer's workshops in Faridabad. It is interesting to note that "Brer Rabbit" was designed by Morris specifically for the indigo discharge method, which he was keen to develop—it was later printed in other colourways. Pratap Singh's bold blue and white print pays homage to the Morris aesthetic, and Morris himself was paying tribute to the Indian artisanal skill in dyeing and craftsmanship. It can be said that this suit symbolizes a circle of cross-cultural inspiration through design, technique, and ideology, across borders and across time. Morris had a utopian vision of a guild system for crafts, which was informed by, among other things, George Birdwood's contemporaneous writings on India's village crafts, a system that managed to reinvent itself in the face of industrialization.[6] An admirer of India's textile art and artisans in his lifetime, Morris would be astounded at the survival and innovation of high-quality handmade textiles in the twenty-first century.

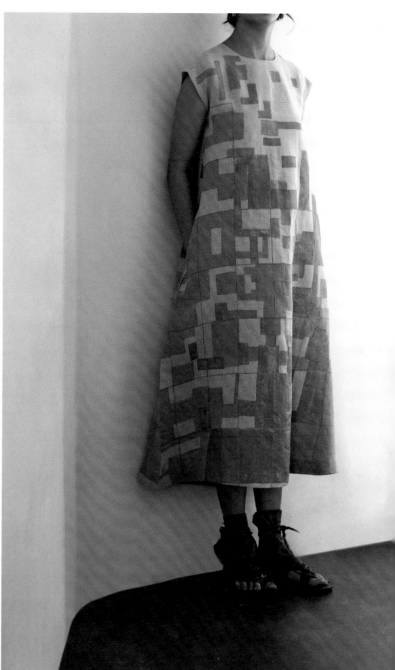

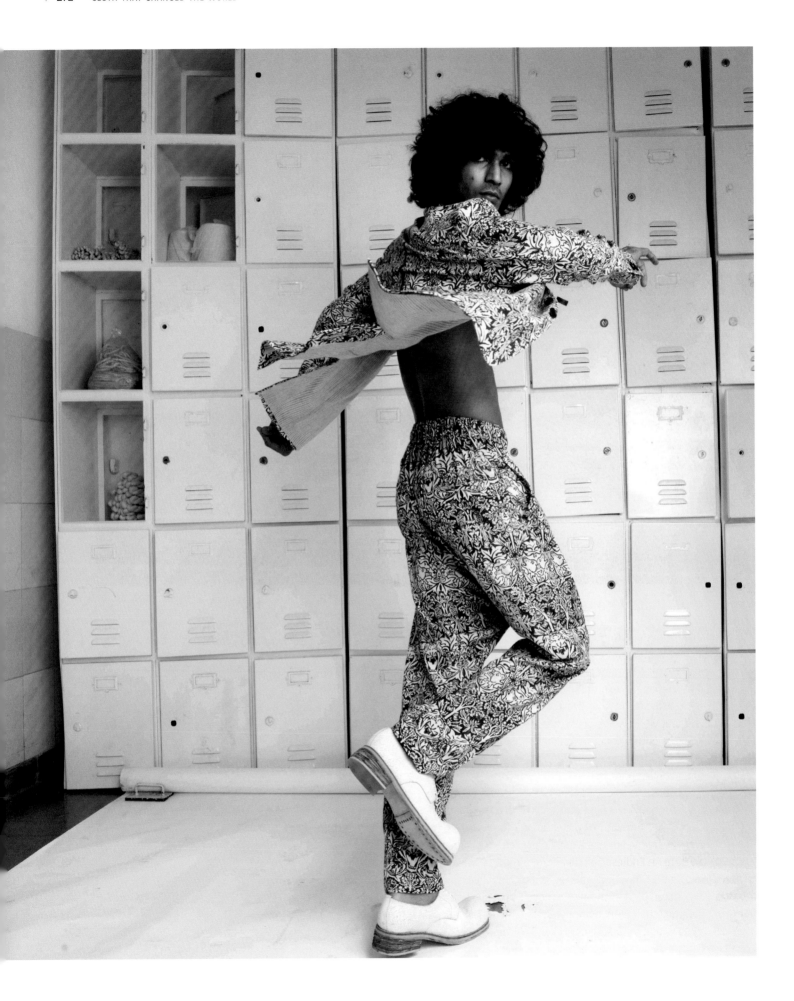

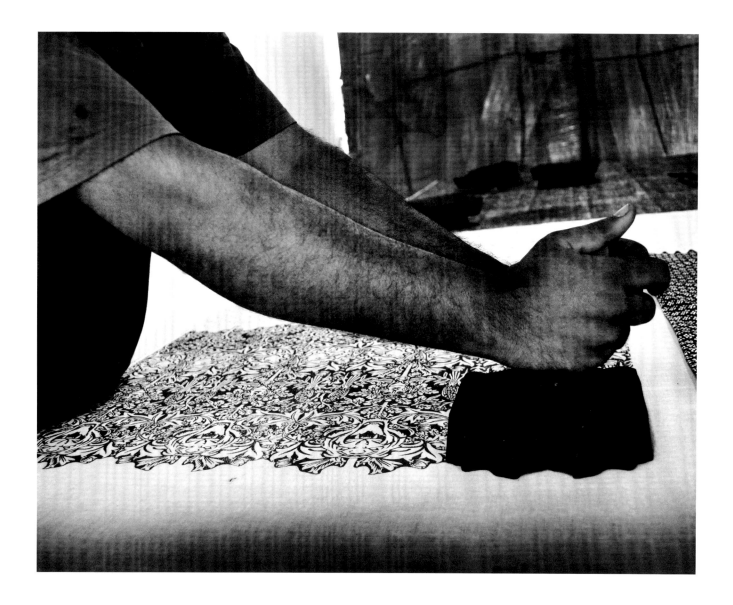

Another technique currently utilized by fashion designers is screen printing. Although it is perhaps less well known or instantly recognizable than block printing, it deserves to be appreciated as a craft that requires skill and is time consuming and labour-intensive. Designer Sabyasachi Mukherjee has expressed the desire to save the screen-printing tradition in West Bengal by showcasing its possibilities in his recent collection. Mukherjee is particularly sought after for his bridal wear, which draws heavily on heritage aesthetics and cultural traditions for inspiration. His outfits combine a variety of Indian fabrics, textile techniques, and ornate embellishment. The designer's ethos views clothing as a reflection of national identity, of being Indian and taking pride in that heritage. He references the full spectrum of textile crafts and motifs, and dips into the vast canon of India's visual culture—from the popular prints of Ravi Varma to Mughal and Rajput paintings. A master of clever juxtapositions and layering, Mukherjee mixes pattern with colour in a way that creates an aesthetic that is both very Indian and very nostalgic but has a good dash of contemporary glamour.

With his 2018 An Endless Summer Collection, Mukherjee offers large, bold floral designs in bright colours that have been screen printed on silk organza and made into voluminous *lenghas* (long flared skirts) and diaphanous dupattas, both edged with gold-embroidered borders. When matched with a vintage-style blouse and with bridal jewellery, they present a refreshing new look for a summer bride. The use of lightweight organza in breezy, bright colours moves away from Mukherjee's more typical heavy bridal outfits. Mukherjee runs

FIG. 21.8

Detail of sari. 11:11/eleven eleven, 2019. Silk, tie-dyed and hand painted, natural dyes. The ferrous and tamarind seed in the dyes produces the bronze colour seen in the sari.

Photograph courtesy of CellDSGN Pvt. Ltd.

large workshops in Kolkata, where he has screen-printing facilities and where he houses the Sabyasachi Art Foundation. Here artists hand draw and develop the designs for printing; for this particular collection, forty-three artists from the studio were involved with the printing of the *lenghas*. Also in the collection are a set of *shikargah* saris that are inspired by those traditionally woven in Varanasi and contain hunting scenes set in dense landscapes of trees and flowers. Mukherjee's printed saris are created from a staggering twenty-nine different screens to fully achieve the depth and detail required. It takes two skilled printers nine hours to produce one sari; however, this does not reflect the time taken to develop the original design and to work out the separation of the pattern and printing process into twenty-nine individual screens, each with a different colour that must be layered one after the other to create this complex pattern. Furthermore, demonstrating his varied influences and his knowledge of Indian textile history, Mukherjee has also recreated a version of eighteenth-century chintz fabric, made for the European market, which has been fashioned into a male wedding outfit; its muted red flowers against a cream background are both elegant and arresting.[7]

Few designers use hand painting in conjunction with natural dyes in their work, but the brand 11:11/eleven eleven is an exception that emphasizes the purity of handcrafted processes, starting from the base textile that is always pure khadi (handwoven fabric made from hand-spun thread). 11:11's khadi-denim jeans—indigo dyed in Auroville, Pondicherry—have become a trademark item. The brand works with artists from Srikalahasti in South India, today's centre of hand-drawn *kalamkari*, to produce a range of silk garments that are embellished by using a fine-tipped *kalam* (pen) and natural dyes. In other garments, tie-dyeing and the kalamkari technique are combined; artisans in their workshops in Kachchh, Gujarat, tie fine knots on constructed garments and then dye the knotted piece. When the knots are undone, the garment is adorned with hand-painted details by a kalamkari artist using a kalam bamboo pen with a much thicker tip to produce a more abstract impression. The brand is dedicated to creating ethical products with traceability from "seed to stitch"'; each piece of 11:11 clothing has a unique number through which it is possible to trace every maker involved in the process and how long each part of the process takes.[8]

Designers and artisans will always continue to explore the possibilities of handcrafted techniques, and as the images in this chapter show, there is a wealth of creativity and skill active and engaged with some of these processes. However, the consumer demands and commercial considerations underpinning these processes will decide which techniques continue to flourish and which (momentarily) fall from fashion.

1 See promotional postcards for the 2011 Spring/Summer Collection.

2 Meeta and Sunny, "Chippas of Rajasthan."

3 See press booklet for #blockblackwhite.

4 Swati Kalsi, email interview by author, June 2019.

5 William Morris was known to have admired and reproduced aspects of Persian, Turkish, Indian, and medieval European (Italian) textiles, viewing them at South Kensington Museum. Morris, "William Morris," 173–74

6 Birdwood, *Industrial Arts*. For a discussion on Birdwood's arguments on Indian craft culture and its influence on Morris, see also Brantlinger, "Postindustrial Prelude."

7 Sabyasachi Mukherjee launched this collection online on his Instagram account in February 2018; Sabyasachi Mukherjee (@sabyasachiofficial), 21 February 2018, https://www.instagram.com/p/BfdouH9HFX7/?utm_source=ig_embed. Alongside a range of images from the collection are messages from the designer describing the craftsmanship and process of making some of the pieces in the collection. It is from this account that the details of the numbers of artists and screens involved in the screen printing process are taken.

8 Shani Himanshu, telephone interview by author, 4 July 2019.

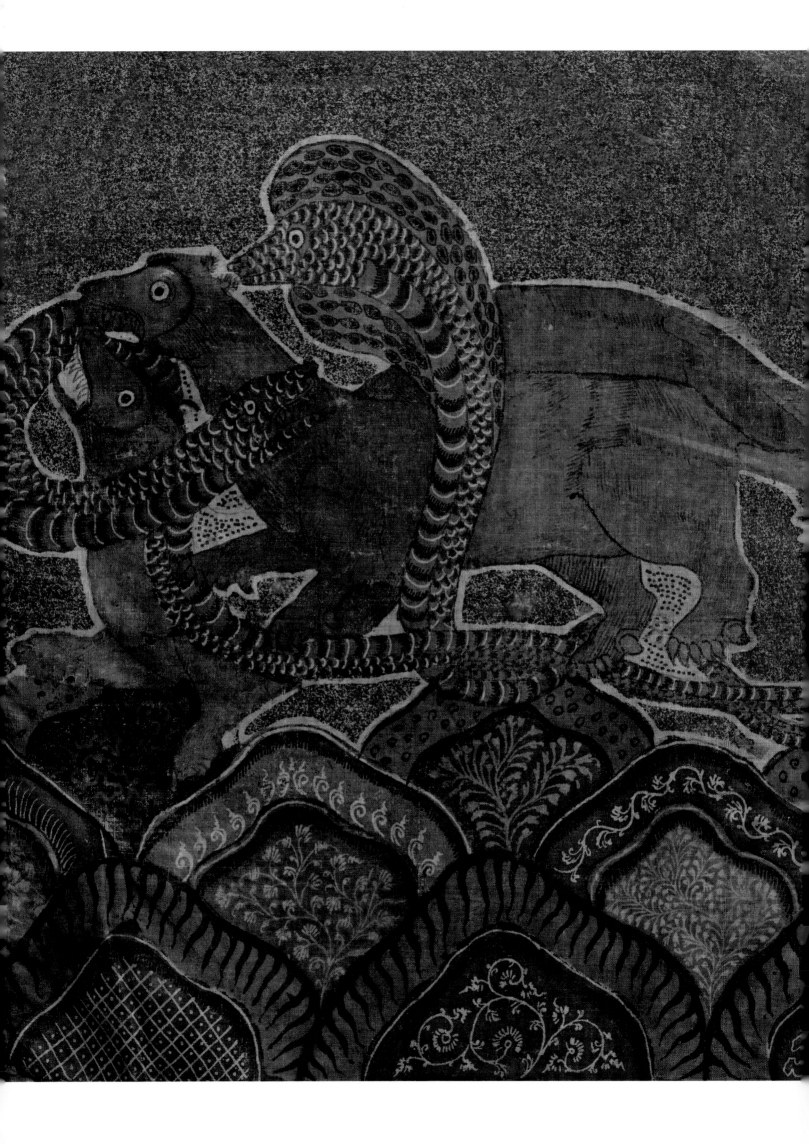

GLOSSARY

ajrakh
Block-printed cotton cloth from Gujarat and Sind dyed in indigo and madder, associated with distinctive geometric motifs

alizarin
Potent red-dye stuff contained in the roots of certain red-dye plants; often used today to designate synthetic red dye

alum
Oxide of aluminium used as a mordant before dyeing

Bagh
A town in Madhya Pradesh, associated today with a repertoire of block-printed motifs derived from tribal symbols

bandhani
Tie-resist technique

banyan
An informal robe worn by elite European men from the seventeenth century; made of several kinds of fabric, including Indian chintz. The term derives from a Gujarati word for "trader, merchant"

batik
Cotton cloth that has been resist dyed, using beeswax and tepid dyes, associated with Java, Indonesia

boteh, *buta*, *buti*
Floral, bud, or cone motifs of various sizes

calico
Either white cotton cloth or printed, coloured cotton cloth, depending on time and place

chay
The plant Oldenlandia umbellata (Rubiaceae), endemic to southern India and Sri Lanka; its roots provide a bright-red dye.

chintz
Anglicized and pluralized version of Hindi chint (spotted, sprayed); originally used by Europeans to reference both painted and printed cottons

chippa
A cotton block printer, often a hereditary occupation

chita
Portuguese term that designates industrially printed fabrics

dabu
Paste made of mud and additional ingredients; used in western India as a resist before dyeing

dodot
A large wrapper worn for ceremonies in Java, Indonesia

dupatta
Shoulder cloth

fustian
Cloth made of a linen warp and cotton weft

gadh
Block used to print the ground area, one of a larger set

ghaghra
Woman's skirt worn in parts of western India

hamsa
Goose, often appearing in the art of northwestern India

indigo
Blue dye prepared in India from fermented leaves of Indigofera plants

jaggery
Cane molasses

jama
Man's tailored robe with tie fasteners

kalam
Bamboo pen with a wool reservoir used for hand drawing and painting mordants, resists, and dyes

kalamkari
From Persian, meaning "pen work"; used today to designate cloth patterned by drawing with the kalam, or a style of block-printed cottons made in the region of Machilipatnam

kanga
An industrially printed cotton wrapper popular in eastern Africa, known also as leso

khadi
Cloth that is handwoven from hand-spun cotton

madder
The plant Rubia coridoflia; its roots provide a red dye.

maa'
Heirloom and ceremonial cloth used by the Toraja people of Sulawesi, Indonesia; many were of imported Indian chintz.

mata ni pachedi,
mata ni chandarvo
Wall hanging or canopy made to honour the mother goddesses venerated by several communities in Gujarat

mordant
From the Latin word mordere, meaning "to bite"; a metallic salt applied prior to applications of vegetable dyes to form red, black, and purple shades

mordant dyeing
Applying mordants (by steeping, printing, drawing, or painting) prior to dyeing to produce durable colour on cotton

myrobalan
The plant Terminalia sp., its fruit and gallnuts, used in dyeing for tannins and as an aid in alum absorption

palampore
Anglicized form of the Persian and Hindi term palangposh; a bedcover

palla, pallu, pallav
The ornamented end of a sari or shawl

patka
Decorative waist sash

patola (sing. *patolu*)
Double ikat-silk textiles woven in Gujarat

pichhwai
Literally, "what goes behind"; cloth that is hung by devotees behind images of Krishna

pintado
Portuguese term meaning "spotted," used in Europe until 1600 to designate India's painted and printed textiles

pounce
Design patterning using perforated paper and charcoal powder

qanat
Cloth panels joined to create a screen, used typically in outdoor settings

rekh
Wooden printing blocks carved with fine outlines, part of a set

resist dyeing
Technique for creating pattern by a applying a substance such as wax before immersion in a dye bath; resists can be applied by drawing, painting, or printing.

rumal
All-purpose kerchief

sarasa
A Japanese term used to designate imported Indian chintz or, today, all fabrics printed with flower motifs

sarita
Ceremonial cloth made by the Toraja people of Sulawesi, Indonesia

shalwar kameez
Outfit consisting of trousers and tunic

syahi begar
Chintz variety from Sanganer, Rajasthan, with a bleached, white ground and bold patterning in deep black and bright red

takli
Brass hand spindle

tumpal
Rows of triangular motifs decorating cloth ends

REFERENCES CITED

Aberigh-Mackay, George, ed. *The Times of India Handbook of Hindustan*. London: Times of India Office, 1875.

Allchin, F. R. "Early Cultivated Plants in India and Pakistan." In *The Domestication and Exploitation of Plants and Animals*, edited by Peter Ucko and G. W. Dimbleby, 323–29. London: Duckworth, 1969.

Andaya, Barbara Watson. "The Cloth Trade in Jambi and Palembang Society during the Seventeenth and Eighteenth Centuries." *Indonesia* 48 (1989): 26–46.

Andaya, Leonard Y. *The World of Maluku: Eastern Indonesia in the Early Modern Period*. Honolulu: University of Hawaii Press, 1993.

———. "Ayutthaya and the Persian and Indian Muslim Connection." In *From Japan to Arabia: Ayutthaya's Maritime Relations with Asia*, edited by Kennon Breazeale, 119–36. Bangkok: Toyota Thailand Foundation / Foundation for the Promotion of Social Sciences and Humanities Textbooks Project, 1999.

Anderson, Marcia G. *A Bag Worth a Pony: The Art of the Ojibwe Bandolier Bag*. St. Paul, MN: Minnesota Historical Society Press, 2017.

Anderson-Hay, Susan. "Botanical Illustration and Printed Textiles: Some Examples from Jouy." *Bulletin de liaison du Centre International d'Étude des Textiles Anciens* 63/64 (1986): 113–22.

Arnolli, Gieneke, with Julia Dijkstra, Ebeltje Hartkamp-Jonxis, and Renuka Reddy. *Sits, katoen en bloei: Sitsen uit de collectie van het Fries Museum*. Edited by Marlies Stoter. Zwolle: Wbooks, 2017.

Asano, Kokō 浅野古香. *Sarasashū* さらさ集 [A collection of sarasa]. Kyoto: Yamada Unsodō, 1907.

Baer, Winfried. "Botanical Décors on Porcelain." In *Flowers into Art: Floral Motifs in European Painting and Decorative Arts*, edited by Vibeke Woldbye, 82–92. The Hague: SDU, 1991.

Bahgat Bey, Aly, and Albert Gabriel. *Fouilles d'al Foustat*. Paris: E. de Boccard / Musée National de l'Art Arabe, 1921.

Baker, C. J. *An Indian Rural Economy*. New York: Oxford University Press, 1984.

Baker, George Percival. *Calico Painting and Printing in the East Indies in the XVIIth and XVIIIth Centuries*. Edited by Henri Clouzot.

London: Edward Arnold, 1921.

Bancroft, Edward. *Experimental Researches concerning the Philosophy of Permanent Colours, and the Best Means of Producing them by Dying, Callico Printing, &c.* London: T. Cadell Jun. & C. W. Davies, 1794.

Barbosa, Duarte. *The Book of Duarte Barbosa: An Account of the Countries Bordering on the Indian Ocean and Their Inhabitants, Written by Duarte Barbosa, and Completed about the Year 1518*. Translated and edited by Mansel Longworth Dames. 2 vols. London: Hakluyt Society, 1918–1921.

Barfoot, James Richard. "Printing." *Progress of Cotton*. London: Darton, 1840.

Barnes, Ruth. *The Ikat Textiles of Lamalera: A Study of an Eastern Indonesian Weaving Tradition*. Leiden: Brill, 1989.

———. *Indian Block-Printed Cotton Fragments in the Kelsey Museum, the University of Michigan*. Ann Arbor: University of Michigan Press, 1993.

———. *Indian Block-Printed Textiles in Egypt: The Newberry Collection in the Ashmolean Museum, Oxford*. 2 vols. Oxford: Clarendon, 1997.

———. "Indian Cotton for Cairo: The Royal Ontario Museum's Gujarati Textiles and the Early Western Indian Ocean Trade." *Textile History* 48, no. 1 (2017): 15–30.

———. "Textiles for the Trade with Asia." In Barnes, Cohen, and Crill, *Trade, Temple and Court*, 10–87.

Barnes, Ruth, Steven Cohen, and Rosemary Crill. *Trade, Temple and Court: Indian Textiles from the Tapi Collection*. Mumbai: India Book House, 2002.

Barnes, Ruth, and Mary Hunt Kahlenberg, eds. *Five Centuries of Indonesian Textiles: The Mary Hunt Kahlenberg Collection*. New York: Prestel, 2010.

Batsaki, Yota, Sarah Burke Calahan, and Anatole Tchikine, eds. *The Botany of Empire in the Long Eighteenth Century*. Washington, DC: Dumbarton Oaks, 2016.

Battuta, Ibn. *Travels in Asia and Africa 1325–1354*. Translated and edited by H. A. R. Gibb. London: Routledge and Kegan Paul, 1983.

Baumgarten, Linda. *What Clothes Reveal: The Language of Clothing in Colonial and Federal

America*. New Haven, CT: Yale University Press, 2012.

Beattie, James. "Thomas McDonnell's Opium: Circulating Plants, Patronage, and Power in Britain, China, and New Zealand, 1830s–50s." In Batsaki, Burke Calahan, and Tchikine, *Botany of Empire*, 165–90.

Beckert, Sven. *Empire of Cotton: A Global History*. New York: Alfred A. Knopf, 2014.

Beer, Alice Baldwin. *Trade Goods: A Study of Indian Chintz in the Collection of the Cooper-Hewitt Museum of Decorative Arts and Design, Smithsonian Institution*. Edited by the Cooper-Hewitt Museum. Washington, DC: Smithsonian Institution, 1970.

Bekius, René. "Armenian Merchants in the Textile Trade in the 17th and 18th Centuries: A Global Enterprise." Paper presented at conference Carpets and Textiles in the Iranian World 1400–1700, Oxford, 31 August 2003.

———. "A Global Enterprise: Armenian Merchants in the Textile Trade in the Seventeenth and Eighteenth Centuries." In *Carpets and Textiles in the Iranian World 1400–1700*, edited by Jon Thompson, Daniel Shaffer, and Pirjetta Mildh, 206–35. Oxford: May Beattie Archive / Ashmolean Museum / University of Oxford, 2010.

Berg, Maxine. "In Pursuit of Luxury: Global History and British Consumer Goods in the Eighteenth Century." *Past & Present* 182, no. 1 (February 2004): 85–142.

———. *Luxury and Pleasure in Eighteenth-Century Britain*. Oxford: Oxford University Press, 2005.

———. "Quality, Cotton and the Global Luxury Trade." In Riello and Roy, *How India Clothed*, 391–414.

Bérinstain, Valérie. "Early Indian Textiles Discovered in Egypt." In *In Quest of Themes and Skills: Asian Textiles*, edited by Krishna Riboud, 16–24. Mumbai: Marg, 1989.

Bérinstain, Valérie, Dominique Cardon, and Thierry-Nicolas C. Tchakaloff, eds. *Indiennes et palampores a l'Ile Bourbon au XVIIIe siècle*. Saint-Louis: Maison Française du Meuble Créole, 1994.

Berlo, Janet C., and Ruth Phillips. *Native North American Art*. New York: Oxford University Press, 1998.

Berthollet, Claude-Louis, and Amédée Berthollet. *Elements of the Art of Dyeing: With a description of the Art of Bleaching by Oxymuriatic Acid.* Translated by Andrew Ure. 2 vols. Printed for Thomas Tegg, 73 Cheapside; Simpkin and Marshall, Stationers' Court; also B. Griffin & Co., Glasgow; and J. Cumming, Dublin. Edinburgh: Walker & Greig, 1824.

Betts, Alison, Klaas van der Berg, Ari de Jong, Catherine McClintock, and Mark van Strydonck. "Early Cotton in North Arabia." *Journal of Archaeological Science* 21 (1994): 489–99.

Bilgrami, Noorjehan. *Sindh jo ajrakh.* Karachi: Department of Culture and Tourism, Government of Sindh, 1990.

Bilgrami, Noorjehan, Tehmina Ahmed, and Nihon Mingeikan, eds. *Tana bana: The Woven Soul of Pakistan.* Karachi: Koel, 2004.

Birdwood, G. C. M. *The Industrial Arts of India.* New Delhi: Rupa, 1992. First published 1880 by Chapman and Hall (London).

Blussé, Leonard. *Strange Company: Chinese Settlers, Mestizo Women and the Dutch in VOC Batavia.* Dordrecht: Foris, 1986.

Blust, Robert. "Austronesian Culture History: Some Linguistic Inferences and Their Relations to the Archaeological Record." *World Archaeology* 8 (1976): 19–43.

Bluteau, Rafael. *Vocabulario portuguez e latino.* Vol 1. Coimbra: Colégio das Artas da Companhia de Jesus, 1712.

——. *Vocabulario portuguez e latino.* Vol. 6. Lisbon: Oficina de Pascoal da Sylva, 1720.

Blyburg, Janice C. "The Champion of Chintz." *Hali Magazine* 183 (Spring 2015): 83–91.

Bocarro, António. *O livro das plantas de todas as fortalezas, cidades e povoações do Estado da Índia Oriental.* Edited by Isabel Cid. Vol. 2. Lisbon: Imprensa Nacional / Casa da Moeda, 1992.

Boyajian, James C. *Portuguese Trade in Asia under the Habsburgs, 1580–1640.* Baltimore: Johns Hopkins University Press, 1993.

Brakel, L. F., ed. *The "Hikayat Muhammad Hanafiyyah": A Medieval Muslim-Malay Romance.* Bibliotheca Indonesica of KITLV 12. The Hague: Martinus Nijhoff, 1975.

Brandão, João. *Grandeza e abastança de Lisboa em 1552.* Edited and annotated by José da Felicidade Alves. Lisbon: Livros Horizonte, 1990.

Brantlinger, Patrick. "A Postindustrial Prelude to Postcolonialism: John Ruskin, William Morris and Gandhism." *Critical Inquiry* 22, no. 3 (Spring 1996): 466–85.

Brett, Katharine B. *Bouquets in Textiles: An Introduction to the Textile Arts.* Toronto: Royal Ontario Museum of Archaeology, 1955.

——. "Chintz, an Influence of the East on the West." *Antiques* 64, no. 6 (December 1953): 480–83.

——. "English Bouquets in Indian Chintz." *Antiques* 79, no. 2 (1961): 190–93.

——. *English Embroidery: Sixteenth to*

Eighteenth Centuries; Collections of the Royal Ontario Museum. Toronto: Royal Ontario Museum, 1972.

——. "An English Source of Chintz Design." *Journal of Textile History* 3 (1956): 40–55.

——. "The Japanese Style in Indian chintz." *Journal of Indian Textile History* 5 (1960): 42–50.

——. "Recent Additions to the Chintz Collection." *Annual of the Art and Archaeology Division, Royal Ontario Museum* 2 (1960): 54–59.

——. "Variants of the Flowering Tree in Indian Chintz, Part II." *Antiques* 77, no. 3 (1960): 280–83.

Breukink-Peeze, Margaretha. "Japanese Robes: A Craze." In *Imitation and Inspiration: Japanese Influence on Dutch Art,* edited by Stefan van Raay, 54–59. Amsterdam: Art Unlimited Books, 1989.

"British-Indian Section, Paris Universal Exhibit, 1889." *Journal of Indian Art* 3, no. 28 (1890): 19–22.

Brown, Kathleen M. *Foul Bodies: Cleanliness in Early America.* New Haven, CT: Yale University Press, 2009.

Browne, Claire. "The Influence of Botanical Sources on Early 18th Century English Silk Design." In *Seidengewebe des 18. Jahrhunderts: Die Industrien in England und in Nordeuropa / 18th-Century Silks: The Industries of England and Northern Europe,* edited by Regula Schorta, 25–38. Riggesberg: Abegg-Stiftung, 2000.

Buck, Anne. *Dress in Eighteenth-Century England.* London: B. T. Batsford**,** 1979.

Bühler, Alfred. "Patola Influences in Southeast Asia." *Journal of Indian Textile History* 4 (1959): 4–46.

Bühler, Alfred, and Eberhard Fischer. *The Patola of Gujarat: Double Ikat in India.* Basel: Krebs Verlag, 1979.

Bulbeck, David, and Ian Caldwell. *Land of Iron: The Historical Archaeology of Luwu and the Cenrana Valley.* Hull, UK: University of Hull / Centre for South-East Asian Studies, 2000.

Byrde, Penelope. *The Male Image: Men's Fashion in Britain, 1300–1970.* London: B. T. Batsford, 1979.

Cardon, Dominique. «Chimie empirique et savoir-faire traditionnel indien dans la teinture.» In Bérinstain, Cardon, and Tchakaloff, *Indiennes et palampores,* 70–81.

——. "The Colours of Chintz: Empirical Knowledge of Chemistry in 18th-Century India." *MARG* 65, no. 2 (2013): 50–59.

——. *Natural Dyes: Sources, Tradition, Technology and Science.* London: Archtype, 2007.

Caron, François, and Joost Schouten. *A True Description of the Mighty Kingdoms of Japan and Siam.* Translated by Roger Manlet. Bangkok: Siam Society, 1969. First published 1671 (London).

Casson, Lionel, ed. *The "Periplus Maris Erythraei": Text with Introduction, Translation, and Commentary.* Princeton: Princeton

University Press, 1989.

Chandrasekhar, A. "(iii) *Kalamkari* Temple Cloth Painting of Kalahasti." In *Census of India 1961, Volume II Andhra Pradesh,* 39-40. Delhi: Manager of Publications, 1962.

——. "(iv) *Kalamkari* Cloth Printing of Masulipatnam." In *Census of India 1961, Volume II Andhra Pradesh,* 54-55. Delhi: Manager of Publications, 1962.

Chapman, Stanley D., and Serge Chassagne. *European Textile Printers in the Eighteenth Century.* London: Heinemann Educational Books, 1981.

Chardin, John. *Travels in Persia, 1673–1677.* London: Argonaut, 1927.

Chaudhuri, K. N. *The Trading World of Asia and the English East India Company.* Cambridge: Cambridge University Press, 2006.

Chishti, Rta Kapur, and Rahul Jain. "Dye Painted Textiles." In *Tradition and Beyond: Handcrafted Indian Textiles,* edited by Martand Singh, 29-33. New Delhi: Roli, 2011.

Christie, Archibald H. *Pattern Design: An Introduction to the Study of Formal Ornament.* New York: Dover, 1969.

Christie, Jan Wisseman. "Texts and Textiles in 'Medieval' Java." *Bulletin de l'École française d'Extrême-Orient* 80, no. 1 (1993): 181–211.

Clabburn, Pamela. *The National Trust Book of Furnishing Textiles.* London: Viking / National Trust, 1988.

Clouzot, Henri. "Les toiles peintes de l'Inde au Pavillon de Marsan." *Gazette des beaux-arts,* 4th ser., 8 (1912): 282–94.

Cohen, Steven. "Materials and Making." In Crill, *Fabric of India,* 16–77.

——. "The Unusual Textile Trade between India and Sri Lanka: Block Prints and Chintz 1550-1900." In *Textiles from India: The Global Trade,* edited by Rosemary Crill, 56–80. Kolkata: Seagull Books, 2006.

Colenbrander, H. T. *Dagh-Register gehouden int Casteel Batavia vant passerende daer ter plaetse als over geheel Nederlandts-India, anno 1636.* The Hague: Martinus Nijhoff, 1899.

——. *Dagh-Register gehouden int Casteel Batavia vant passerende daer ter plaetse als over geheel Nederlandts-India, anno 1637.* The Hague: Martinus Nijhoff, 1899.

Collaert, Adriaen. *Florilegium ab Hadriano Collaert caelatum, et à Philip. Galleo editum.* Antwerp: Philips Galle, 1590.

Cook, James. *The Journals of James Cook.* Edited by J.C. Beaglehole. Vol. 2. Cambridge: Published for the Hakluyt Society, 1965.

Coomeraswamy, Ananda. *Mediaeval Sinhalese Art.* 3rd ed. Colombo: Pantheon Books, 1979.

Corrigan, Karina, Jan van Campen, and Femke Diercks, with Janet C. Blyberg, eds. *Asia in Amsterdam: The Culture of Luxury in the Golden Age.* New Haven, CT: Yale University Press, 2015.

Costa, Leonor Freire, Nuno Palma, and Jaime Reis. "The Great Escape? The Contribution of

the Empire to Portugal's Economic Growth, 1500–1800." *European Review of Economic History* 19, no. 1 (February 2015): 1–22.

Cousin, Françoise. *Tissus imprimés du Rajasthan*. Paris: L'Harmattan, 1986.

Crill, Rosemary. "Asia in Europe: Textiles for the West." In *Encounters: The Meeting of Asia and Europe, 1500–1800*, edited by Anna Jackson and Amin Jaffer, 262–71. London: V&A, 2004.

———. *Chintz: Indian Textiles for the West*. Edited by Ian Thomas and Victoria and Albert Museum. London: V&A, 2008.

———, ed. *The Fabric of India*. London: V&A, 2015.

———. *Indian Chintzes*. London: V&A, 2007.

———. *Indian Embroidery*. London: V&A, 1999.

———. "Local and Global: Patronage and Use," in Crill, *Fabric of India*, 78–179.

———. "Textiles for the Trade with Europe." In Barnes, Cohen, and Crill, *Trade, Temple and Court*, 88–109.

Cristea, Daniela, and Gerard Vilarem. "Improving Light Fastness of Natural Dyes on Cotton Yarn." *Dyes and Pigments* 70, no. 3 (2006): 238–45. https://pdfs.semanticscholar.org/4976/0fea6a1 69479d98f4364b71fbc8c02b99147.pdf.

Crosby, Alfred W. *Ecological Imperialism: The Biological Expansion of Europe, 900–1900*. 2nd ed. Cambridge: Cambridge University Press, 2004.

Crosby, Gillian. "First Impressions: Printed Calicoes in France during the Years of Prohibition, 1686–1759." PhD. diss., Nottingham Trent University, 2016.

Cunha, João Teles e. "A Carreira da Índia e a criação do mercado intercolonial português, 1660–1750." PhD. diss., Universidade de Lisboa, 2007.

———. "A economia de um império: A economia política do Estado da Índia em torno do Mar Arábico e do Golfo Pérsico; Elementos conjunturais, 1595–1635." Master's thesis, Universidade Nova de Lisboa, 1995.

———. "Goa em transição na correspondência de Pierre-Philippe Rocquefeuil (1755–1757)." In *Goa passado e presente*, edited by Artur Teodoro de Matos and João Teles e Cunha, 2:751–82. Lisbon: CEPCEP / CHAM, 2012.

Currelly, Charles T. *I Brought the Ages Home*. Toronto: Ryerson Press, 1956.

Custódio, Jorge. "Notas históricas acerca da primitiva indústria de tecidos de Alcobaça e das estamparias portuguesas no Antigo Regime (1775–1834)." In *Lenços e colchas de chita de Alcobaça*, edited by Patrícia Salvação Barreto, 18–52. Lisbon: Gabinete de Relações Internacionais do Ministério da Cultura / Instituto Camões, 2001.

Dale, Stephen. *Indian Merchants and Eurasian Trade, 1600–1750*. Cambridge: Cambridge University Press, 1994.

Dallapiccola, Anna L. Kalamkari *Temple Hangings*. London: V&A, 2015.

D'Alleva, Anne. "Change and Continuity in Decorated Tahitian Barkcloth from Bligh's Second Breadfruit Voyage." *Pacific Arts* 11/12 (July 1995): 29–42.

———. "Elite Clothing and the Social Fabric of Pre-Colonial Tahiti." In *The Art of Clothing*, edited by Susanne Küchler and Graeme Were, 47–60. London: UCL; Portland: Cavendish, 2005.

Das, Rajrupa. "Banyans: A Subcontinental Connection." Unpublished manuscript. Academia.edu. Accessed 30 January 2019. https://www.academia.edu/6667442/Banyans_A_ Sub_continental_Connection.

Dattel, Gene. *Cotton and Race in the Making of America: The Human Costs of Economic Power*. Chicago: Ivan R. Dee, 2009.

Davies, John. *The history of the Tahitian Mission, 1799–1830: with supplementary papers from the correspondence of the missionaries*. Edited by C. W. Newbury. Cambridge: Published for the Hakluyt Society at the University Press, 1961.

Davis, Mildred J. *The Art of Crewel Embroidery*. New York: Crown, 1962.

Davis, Ralph. *Aleppo and Devonshire Square: English Traders in the Levant in the Eighteenth Century*. London: Macmillan, 1967.

De Hullu, J. *Dagh-Register gehouden int Casteel Batavia vant passerende daer ter plaetse als over geheel Nederlandts-India, anno 1644–1645*. The Hague: Martinus Nijhoff, 1903.

De Marly, Diana. *Fashion for Men: An Illustrated History*. New York: Holmes & Meier, 1985.

Dempwolff, Otto. *Austronesisches Wörterverzeichnis: Vergleichende Lautlehre des Austronesischen Wortschatzes*. Vol. 3. Beiheft zur Zeitschrift für Eingeborenen-Sprachen 19. Berlin: Reimer, 1938.

Denny, Walter B. "Dating Ottoman Turkish Works in the Saz Style." *Muqarnas* 1 (1983): 103–21.

Dewan, Deepali. "The Body at Work: Colonial Art Education and the Figure of the 'Native Craftsman.'" In *Confronting the Body: The Experience of Physicality in Modern South Asia*, edited by Satadru Sen and James Mills, 118–34. London: Anthem, 2004.

———. "Crafting Knowledge and Knowledge of Crafts: Art Education, Colonialism and the Madras School of Arts in Nineteenth-Century South Asia." PhD diss., University of Minnesota, 2001.

———. "Scripting South Asia's Visual Past: *The Journal of Indian Art and Industry* and the Production of Knowledge in the Late Nineteenth Century." In *Imperial Co-Histories: National Identities and the British and Colonial Press*, edited by Julie Codell, 29–44. Madison: Fairleigh Dickinson, 2003.

Digby, George W. *Elizabethan Embroidery*. London: Faber and Faber, 1963.

Dowleans, A. M., ed. *Catalogue of East Indian productions collected in the presidency of Bengal and forwarded to the Exhibition of Works of Art and Industry to be held in London in 1851*. London: W. Thacker, 1851.

Driver, Felix, and Sonia Ashmore. "The Mobile Museum: Collecting and Circulating Indian Textile in Victorian Britain." *Victorian Study* 52, no. 3 (2010): 353–85.

Dunlop, H. *Bronnen tot de geschiedenis der Oostindische Compagnie in Perzië 1611–1638*. 'S-Gravenhage: M. Nijhoff, 1930.

DuPlessis, Robert S. *The Material Atlantic: Clothing, Commerce, and Colonization in the Atlantic World, 1650–1800*. Cambridge: Cambridge University Press, 2015.

Eacott, Jonathan. "Making an Imperial Compromise: The Calico Acts, the Atlantic Colonies, and the Structure of the British Empire." *William and Mary Quarterly* 69, no. 4 (October 2012): 731–62.

———. *Selling Empire: India in the Making of Britain and America, 1600–1830*. Chapel Hill: University of North Carolina Press, 2016.

East India Company, ed. *Report of the select committee, of the Court of Directors of the East India Company, upon the subject of the cotton manufacture of this country: with appendixes*. London: Parliament, House of Commons, 1793.

Eaton, Linda. *Quilts in a Material World: Selections from the Winterthur Collection*. New York: Abrams, 2007.

Edwards, Bryan. *The History, Civil and Commercial, of the British Colonies in the West Indies*. Vol. 4. Philadelphia: James Humphreys, 1806.

Edwards, Eiluned M. "*Ajrakh*: From Caste Dress to Catwalk." *Textile History* 47 (2016): 146–70.

———. *Imprints of Culture: Block Printed Textiles of India*. New Delhi: Niyogi Books, 2016.

Edwards, George. *A Natural History of Uncommon Birds and Some Other Rare and Undescribed Animals*. 4 vols. London: G. Edwards, 1743-1751.

Eicher, Joanne. "Kalabari Identity and Indian Textiles in the Niger Delta." In *Textiles from India: The Global Trade*, edited by Rosemary Crill, 153–71. Kolkata: Seagull Books, 2006.

Ellis, William. *Polynesia Researches During a Residence of Nearly Six Years in the South Sea Islands*. Vol. 2. London: Fisher, Son and Jackson, 1829.

Evans, Ben. "The Armenian Knot." *Hali* 179 (Spring 2014): 92–103.

Evenson, S. L. "A History of Indian Madras Manufacture and Trade: Shifting Patterns of Exchange." Unpublished PhD. diss., University of Minnesota, 1994.

Faroqhi, Surayia. "Ottoman Cotton Textiles: The Story of a Success That Did Not Last, 1500–1800." In Riello and Parthasarathi, *Spinning World*, 89–103.

Farrington, Anthony. *The English Factory in Japan, 1613–1623*. 2 vols. London: British Library, 1991.

Fee, Sarah. "'Cloth with Names': Luxury Textile Imports in Eastern Africa, ca. 1800–1885." *Textile History* 48, no. 1 (2017): 49–84.

——. "Colourful Collecting: 'Indian Chintz' at the Royal Ontario Museum." *Textiles Asia* 11, no. 2 (2019): 2–16.

——. "Filling Hearts with Joy: Handcrafted 'Indian Textiles' Exports to Central Eastern Africa in the Nineteenth Century." In *Transregional Trade and Traders: Situating Gujarat in the Indian Ocean from Early Times to 1900*, edited by Edward Alpers and Chhaya Goswami, 163–217. New Delhi: Oxford University Press, 2019.

Fennetaux, Ariane. "Men in Gowns: Nightgowns and the Construction of Masculinity in Eighteenth-Century England." *Immediations: The Research Journal of the Courtauld Institute of Art* 1, no. 1 (2004): 76–89.

Ferreira, Maria Augusta Trindade. "Lenços e colchas de chita de Alcobaça." In *Lenços e colchas de chita de Alcobaça*, edited by Patrícia Salvação Barreto, 8–16. Lisbon: Gabinete de Relações Internacionais do Ministério da Cultura / Instituto Camões, 2001.

Ferreira, Maria João. "Asian Textiles in the Carreira da Índia: Portuguese Trade, Consumption and Taste, 1500–1700." *Textiles History* 46, no. 2 (November 2015): 147–68.

Fischer, Eberhard. *Temple Tents for Goddesses in Gujarat, India*. Zürich: Artibus Asiae, 2013.

Fisher, Abby Sue. "*Mestizaje* and the *cuadros de castas*: Visual Representations of Race, Status and Dress in Eighteenth Century Mexico." PhD diss., University of Minnesota, 1992.

Floor, Willem. "The Import of Indian Textiles into Safavid Persia." Paper presented at conference Carpets and Textiles in the Iranian World 1400–1700, Oxford, 31 August 2003.

——. "The Import of Indian Textiles into Safavid Persia." In *Carpets and Textiles in the Iranian World 1400–1700*, edited by Jon Thompson, Daniel Shaffer, and Pirjetta Mildh, 186–205. Oxford: May Beattie Archive / Ashmolean Museum / University of Oxford, 2010.

——. *The Persian Textile Industry in Historical Perspective 1500–1925*. Vol. 11. Paris: L'Harmattan, 1999.

Floud, Peter C. "The English Contribution to the Development of Copper-Plate Printing." *Journal of the Society of Dyers and Colourists* 76 (July 1960): 344–49.

Foster, William, ed. *The English Factories in India 1618–1669*. 13 vols. Oxford: Clarendon, 1906–27.

Freire, Braamcamp. "Cartas de quitação del Rei D. Manuel." *Archivo Historico Portuguez* 1 (1903): 278–79.

——. "Inventario da Infanta D. Beatriz: 1507." *Archivo Historico Portuguez* 9 (1914): 71.

Fukusawa, K. *Toilerie et commerce du Levant d'Alep à Marseille*. Paris: CNRS, 1987.

Furber, Robert. *Twelve Months of Flowers*. Painted by Pieter Casteels, engraved by Henry Fletcher, London 1730.

Gallo, Marzia Cataldi. *Mezzari and the Cotton Route*. Genoa: San Giorgio, 2007.

——. *I mezzari tra Oriente e Occidente*. Genoa: Sagep, 1988.

Gernerd, Elisabeth Brooks. "*Têtes* to Tails: Eighteenth-Century Underwear and Accessories in Britain and Colonial America." PhD diss., University of Edinburgh, 2015. http://hdl.handle.net/1842/21695.

Gittinger, Mattiebelle. "Ingenious Techniques in Early Indian Dyed Cotton." *MARG* 40, no. 3 (June 1987): 4–15.

——. *Master Dyers to the World: Technique and Trade in Early Indian Dyed Cotton Textiles*. Washington, DC: Textile Museum, 1982.

Gittinger, Mattiebelle, and H. Leedom Lefferts Jr. *Textiles and the Thai Experience in Southeast Asia*. Washington, DC: Textile Museum, 1992.

Gluck, Jay, and Sumi Hiramoto Gluck. *A Survey of Persian Handicrafts*. Tehran: Bank Melli Iran, 1977.

Goitein, S. D. "Letters and Documents on the India Trade." *Islamic Culture* 37, no. 3 (1963): 188–205.

——. *A Mediterranean Society: The Jewish Communities of the Arab World as Portrayed in the Documents of the Cairo Geniza*. Vol. 4, *Daily Life*. Berkeley: University of California Press, 1983.

Goody, Jack. *The Culture of Flowers*. Cambridge: Cambridge University Press, 1993.

Gorguet-Ballesteros, Pascale. "Inde, Japon, Europe: Croisement de cultures à travers trois robes de chambre de la première moitié du XVIIIe siècle." In *Japonisme & Mode*, edited by Kyōto Fukushoku Bunka Kenkyū Zaidan and Musée de la mode et du costume, 131–35. Paris: Paris musées, 1996. Published in conjunction with an exhibition of the same title presented at Les Musées de la Ville de Paris, Paris Galliera, Musée de la mode et du costume, 17 April–4 August 1996.

Gotō, Shōichi 後藤捷. *Inaba Michitatsu to sono chosho* 稲葉通龍と其著書 [Inaba Michitatsu and his works]. Ōsaka: Ōsaka Shidankai, 1941.

Gott, Suzanne, Kristyne S. Loughran, Betsy D. Quirk, and Leslie W. Rabine, eds. *African-Print Fashion Now!: A Story of Taste, Globalization and Style*. Los Angeles: Fowler Museum at UCLA, 2017.

Graham, Patricia J. *Tea of the Sages: The Art of Sencha*. Honolulu: University of Hawai'i Press, 1998.

Great Britain. *The Statutes at Large, From the Fifth Year of the Reign of King George the Third to the Tenth Year of the Reign of King George the Third, inclusive*. Vol. 10. London: C. Eyre and W. Strahan, 1911.

Great Britain and John Raithby, eds. *The Statutes at Large, of England and of Great-Britain, From Magna Carta to the Union of the Kingdoms of Great Britain and Ireland*. Vol. 8, *From 3 George, A.D. 1716–To 13 George, A.D. 1726*. London: G. Eyre and A. Strahan, 1911.

Grosfilley, Anne. *African Wax Print Textiles*. Munich: Prestel, 2018.

Guelton, Marie-Helene. "De l'Inde à l'Arménie: La fabrication des rideaux de choeur peints et imprimés." In *Ors et trésors d'Arménie dans le cadre de l'année de l'Arménie en France*, edited by Maria-Anne Privat-Savigny and Musée Lyonnais des Arts Décoratifs, 48–61. Lyon: Musée des Tissus et des Arts Décoratifs / Musée d'Art Réligieux de Fourvière, 2007. Published in conjunction with an exhibition of the same title presented at Musée des Tissus et des Arts Décoratifs and Musée d'Art Réligieux de Fourvière, Lyon (France), 22 March–15 July 2007.

Guerreiro, António Coelho. *O "Livro de rezão" de António Coelho Guerreiro. 1684–1692*. Facsimile, with an introduction by Virgínia Rau. Lisbon: Companhia de Diamantes de Angola, 1956.

Guinote, Paulo, Eduardo Frutuoso, and António Lopes. *As Armadas da Índia, 1497–1835*. Lisbon: CNCDP, 2002.

Guy, John. "Indian Textiles for the Thai Market: A Royal Prerogative." *Textile Museum Journal* 31 (1992): 82–96.

——. "Long Cloth." In Peck, *Interwoven Globe*, 199–200.

——. "'One Thing Leads to Another': Indian Textiles and the Early Globalization of Style." In Peck, *Interwoven Globe*, 19–21.

——. *Woven Cargoes: Indian Textiles in the East*. New York: Thames and Hudson, 1998.

Guy, John, and Karun Thakar. *Indian Cotton Textiles*. London: Hali, 2015.

Hadaway, William Snelling. *Cotton Painting and Printing in the Madras Presidency*. Madras: Superintendent, Government Press, 1980. First published 1917.

Haidar, Navina, and Marika Sardar, eds. *Sultans of Deccan India, 1500–1700: Opulence and Fantasy*. New York: Metropolitan Museum of Art, 2015. Published in conjunction with an exhibition of the same title presented at the Metropolitan Museum of Art, 20 April–26 July 2005.

Hamilton, Roy. *From the Rainbow's Varied Hue: Textiles of the Southern Philippines*. Los Angeles: Fowler Museum of Cultural History / University of California Press, 1998.

——, ed. *Gift of the Cotton Maiden: Textiles of Flores and the Solor Islands*. Los Angeles: Fowler Museum of Cultural History / University of California Press, 1994.

Hall, Fayrer. *The Importance of the British Plantations in America to this Kingdom*. London: J. Peele, 1713.

Hariharan, Shantha. *Cotton Textiles and Corporate Buyers in Cottonopolis: A Study of Purchases and Prices in Gujarat, 1600–1800*. Delhi: Manak, 2002.

Hart, Michael. *A Trading Nation: Canadian Trade Policy from Colonialism to Globalization*. Vancouver: University of British Columbia Press, 2002.

Hartkamp-Jonxis, Ebeltje. "Cat. 62: Palampore, Coromandel Coast, India, 1720–1730." In Corrigan et al., *Asia in Amsterdam*, 216–17.

——, ed. *Sits: Oost-west relaties in textile.* Zwolle: Uitgeverij Waanders, 1987.

——. *Sitsen uit India = Indian Chintzes.* Amsterdam: Rijksmuseum; Zwolle: Waanders, 1994.

Haudrère, Philippe. "La compagnie des Indes et le commerce des toiles indiennes." In Jacqué and Nicolas, *Féerie indienne*, 13–21.

Hauser, William B. "Textiles and Trade in Tokugawa Japan." In *Textiles in Trade: Proceedings of the Textile Society of America Biennial Symposium*, coordinated by Mattiebelle Gittinger and Rita J. Adrosko, 112–25. Los Angeles: Textile Society of America, 1990.

Havell, E. B. "The Industries of Madras." *Journal of Indian Art and Industry* 3, no. 27 (1890): 9–16.

——. "The Printed Cotton Industry of India." *Journal of Indian Art* 2, no. 19 (1888): 18–20.

Hayavadana Rao, C. "Asad Ali Khan." In *Indian Biographical Dictionary.* Madras: Pillar, 1915.

Haynes, Douglas. *Small Town Capitalism in Western India: Artisans, Merchants and the Making of the Informal Economy, 1870–1960.* Cambridge: Cambridge University Press, 2012.

Heeres, J. E. *Dagh-Register gehouden int Casteel Batavia vant passerende daer ter plaetse als over geheel Nederlandts-India, anno 1624–1629.* The Hague: Martinus Nijhoff, 1896.

Hendley, T. Holborn. "The Arts and Manufactures of Ajmere-Merwarra." *Journal of Indian Art and Industry* 3, nos. 25–32 (1890): [1]–[78].

Heringa, Rens. "Upland Tribe, Coastal Village, and Inland Court: Revised Parameters for Batik Research." In *Five Centuries of Indonesian Textiles*, edited by Ruth Barnes and Mary Hunt Kahlenberg, 12–131.

Hobhouse, Henry. *Seeds of Change: Six Plants That Transformed Mankind.* London: Folio Society, 2007.

Hoffenberg, Peter. "Promoting Traditional Indian Art at Home and Abroad: 'The Journal of Indian Art and Industry,' 1884–1917." *Victorian Periodicals Review* 37, no. 2 (Summer 2004): 192–213.

Holder, Edwin. *Monograph on Dyes and Dyeing in the Madras Presidency.* Madras: Superintendent, Government Press, 1896.

Houghteling, Sylvia. "The Tree of Life and the World of Wonder: *'Ajā'ib* Imagery on Seventeenth-Century *Kalamkari*." In *Scent upon a Southern Breeze: The Synaesthetic Arts of the Deccan*, edited by Kavita Singh, 88–107. Mumbai: Marg, 2018.

Hughes, Therle. *English Domestic Embroidery.* London: Abbey Fine Arts, 1961.

Hulton, Paul, and L. Smith. *Flowers in Art from East and West.* London: British Museum, 1979.

Impey, Oliver. *Chinoiserie: The Impact of Oriental Styles on Western Art and Decoration.* London: Oxford University Press, 1977.

Inaba, Michitatsu 稲葉通龍. *Sarasa zufu* 更紗圖譜 [Chintz patterns graphically depicted]. Ōsaka: Naniwa Shorin, 1785.

Inikori, Joseph. *Africans and the Industrial Revolution in England.* Cambridge: Cambridge University Press, 2002.

——. "Slavery and the Revolution in Cotton Textile Production in England." *Social Science History* 13, no. 4 (1989): 343–79.

Irwin, John. "The Etymology of Chintz and Pintado." *Journal of Indian Textile History* 4 (1959): 77.

——. "Indian Textile Trade in the Seventeenth Century." Pts. 1 and 2. *Journal of Indian Textile History* 1 (1955): 4–33; 2 (1956): 24–42.

——. "Origins of 'Oriental' Chintz Design." *Antiques* 75, no. 1 (1959): 84–87.

——. "Origins of 'Oriental Style' in English Decorative Arts." *Burlington Magazine* 97, no. 625 (April 1955): 106–14.

Irwin, John, and Katharine B. Brett. *Origins of Chintz: With a Catalogue of Indo-European Cotton-Paintings in the Victoria and Albert Museum, London, and the Royal Ontario Museum, Toronto.* London: HMSO, 1970.

Irwin, John, and Margaret Hall, eds. *Indian Painted and Printed Fabrics.* Ahmedabad: Calico Museum of Textiles, 1971.

Irwin, John, and P. R. Schwartz. *Studies in Indo-European Textile History.* Ahmedabad: Calico Museum of Textile: 1966.

Iwanaga, Etsuko. *Ages of Sarasa.* Translated by Edward Lipsett. Edited by Etsuko Iwanaga and Sachiko Shoji. Fukuoka: Fukuoka Art Museum, 2014. Published in conjunction with an exhibition of the same title presented at the Fukuoka Art Museum, 11 October–24 November 2014.

——. "In the Age of Sarasa." In *Ages of Sarasa*, 12–26.

——. "The Names of Trade Textiles in 17th and 18th Century Records: What Exactly Were Salpicado, Gingham, and Sacerguntes?" In *Ages of Sarasa*, 26–40.

Jackson, Christine E. *Bird Etchings: The Illustrators and Their Books, 1655–1855.* Ithaca, NY: Cornell University Press, 1985.

Jacqué, Bernard. "Deux exemples d'utilisation d'indienne en ameublement conservés actuellement en République tchèque." In Jacqué and Nicolas, *Féerie indienne*, 116–17.

Jacqué, Jacqueline. "Avant-propos." In Jacqué and Nicolas, *Féerie indienne*, 10–11.

Jacqué, Jacqueline, and Brigitte Nicolas. "Catalogue des oeuvres: Le marché persan." In Jacqué and Nicolas, *Féerie indienne*, 98.

——, eds. *Féerie indienne: Des rivages de l'Inde au royaume de France.* Paris: Somogy, 2008.

Jain, Jyotindra. *The Master Weavers: Festival of India in Britain, Royal College of Art, Autumn 1982.* Bombay (Mumbai): Tata, 1982.

——, ed. *Picture Showmen: Insights into the Narrative Tradition in India.* Mumbai: Marg, 1998.

——. *Textiles and Garments at the Jaipur Court.* New Delhi: Niyogi Books, 2016.

Japonism in Fashion: Tokyo [*Mōdo no Japonisumu*]. Translated by Amanda Mayer Stinchecum. Kyoto: Kyoto Costume Institute, 1996.

Jaquay, Barbara Gaye. "The Caribbean Cotton Production: An Historical Geography of the Region's Mystery Crop." PhD diss., Texas A&M University, 1997.

Johnson, Paul E. *The Early American Republic.* New York: Oxford University Press, 2006.

Johnson, Walter. *River of Dark Dreams: Slavery and Empire in the Cotton Kingdom.* Cambridge, MA: Belknap / Harvard University Press, 2013.

Jones, Owen. *The Grammar of Ornament: Illustrated by Examples from Various Styles of Ornament.* London: B. Quaritch, 1868. First published in 1856.

Jordan, John, Gabi Schopf, and Kim Siebenhüner, eds. *Cotton in Context: Manufacturing, Marketing, and Consumption of Early Modern Textiles in the German Speaking World (1500–1900).* Vol. 4, *Ding Materialität Geschichte.* Köln: Böhlau, forthcoming.

Karl, Barbara. "Object in Focus: Set of Bed Hangings." In Crill, *Fabric of India*, 170–71.

Kasetsiri, Charnvit. "Origins of a Capital and Seaport: The Early Settlement of Ayutthaya and its East Asian Trade." In *From Japan to Arabia: Ayutthaya's Maritime Relations with Asia*, edited by Kennon Breazeale, 55–79. Bangkok: Toyota Thailand Foundation / Foundation for the Promotion of Social Sciences and Humanities Textbooks Project, 1999.

Kawakatsu, Heita. *The Lancashire Cotton Industry and Its Rivals: International Competition in Cotton Goods in the Late Nineteenth Century; Britain versus India, China, and Japan.* Tokyo: International House of Japan, 2018.

Keller, Jean-François, and Jaqueline Jacqué. "Influence et permanence des indiennes dans les tissus imprimés en Alsace." In Jacqué and Nicolas, *Féerie indienne*, 38–45.

Kendrick, A. F. *English Needlework*, 2nd ed. London: Adam & Charles Black, 1967.

Kenoyer, J. M. "Ancient Textiles of the Indus Valley Region: A Brief Overview from 7000–1900 BC." In *Tana bana: The Woven Soul of Pakistan*, edited by Noorjehan Bilgrami, Tehmina Ahmed, and Nihon Mingeikan, 18–31. Karachi: Koel, 2004.

Kipling, John Lockwood. "The Industries of the Punjab." *Journal of Indian Art* 2, no. 20 (July 1888): 25–42.

——. "Punjab Cotton Prints." *Journal of Indian Art* 1, no. 14 (1886): 104.

Knaap, Gerrit J. *Shallow Waters, Rising Tide: Shipping and Trade in Java around 1775.* Leiden: KITLV, 1996.

Knapp, Sandra, and Judith Magee. Introduction to *Flora: An Artistic Voyage through the World of Plants*, edited by Sandra Knapp, 10–23. London: Scriptum Editions and Natural History Museum, 2003.

Knight, Frederick C. *Working the Diaspora: The Impact of African Labor on the Anglo-American World, 1650–1850.* New York: NYU Press, 2010.

Koch, Ebba. *The Complete Taj Mahal and the Riverfront Gardens of Agra.* London: Thames and Hudson, 2012.

——. "Flowers in Mughal Architecture." In "The Weight of a Petal: *Ars botanica*," edited by Sita Reddy. Special issue, *MARG* 70, no. 2 (December 2018–March 2019): 24–33.

Koojiman, Simon. *Polynesian Barkcloth.* Aylesbury: Shire Publications, 1988.

Ko Tajika Chikuson Sensei Iaihin Nyusatsu 故田近竹邨先生遺愛品入札. Kyoto: Kyoto Bijutsu Kurabu, Taisho 12, 1923.

Kriegel, Lara. *Grand Designs: Labor, Empire and the Museum in Victorian Culture.* Durham, NC: Duke University Press, 2008.

——. "Narrating the Subcontinent in 1851: India at the Crystal Palace." In *The Great Exhibition of 1851: New Interdisciplinary Essays,* edited by Louise Purbrick, 146–78. Manchester: Manchester University Press, 2001.

Kriger, Coleen E. *Cloth in West African History.* Lanham, MD: Altamira, 2006.

Krishna, Kalyan, and Kay Talwar. *In Adoration of Krishna: Pichhwais of Shrinathji, Tapi Collection.* Surat: Garden Silk Mills; New Delhi: Worldwide Distribution / Roli Books, 2007.

Krishna, Vijay. "Flowers in Indian Textile Designs." *Journal of Textile History* 7 (1967): 1–20.

Kumagai, Hiroto. *Wa Sarasa Mon Yō Zufu* 和更紗文様図譜. Tokyo: Creo Corporation, 2009.

Kumar, Deepak. "Botanical Explorations and the East India Company: Revisiting 'Plant Colonialism' in East India Company and the Natural World." In *The East India Company and the Natural World,* edited by Vinita Damodaran, Anna Winterbottom, and Alan Lester, 16–34. Hampshire: Palgrave MacMillan, 2015.

Kumar, Prakash. *Indigo Plantations and Science in Colonial India.* Cambridge: Cambridge University Press, 2012.

Laarhoven, Ruurdje. "The Power of Cloth: The Textile Trade of Dutch East India Company (VOC), 1600–1780." PhD diss., Australia National University, 1994.

——. "A Silent Textile Trade War: Batik Revival as Economic and Political Weapon in 17th Century Java." *Proceedings of the Textile Society of America, 2012.* Nebraska Digital Commons.

Lamarck, Jean Baptiste Pierre Antoine de Monet, Chevalier de. *Encyclopédie méthodique botanique.* 8 vols. Continued by J. L. Marie Poiret. Paris: Panckoucke, 1783–1808.

——. *Recueil de planches de botanique de l'Encyclopédie.* 4 vols. Paris: Mme Veuve Agasse, 1791–1823.

Lambert, Meghan. "The Hands That Painted Plants of the Coast of Coromandel." In "The Weight of a Petal: *Ars botanica*," edited by Sita Reddy. Special issue, *MARG* 70, no. 2, (December 2018–March 2019): 85–88.

Lebert, Henri. "Notice sur les Développements du dessin d'Impression des toiles peintes en Alsace." *Revue d'Alsace*, 3rd ser., 1 (1865): 5–16, 70–80.

Lee, Peter. *Sarong Kebaya: Peranakan Fashion in an Interconnected World, 1500–1900.* Singapore: Asian Civilisations Museum, 2014.

Lee, Peter, Leonard Y. Andaya, Barbara Watson Andaya, Gael Newton, and Alan Chong. *Port Cities: Multicultural Emporiums of Asia, 1500–1900.* Singapore: Asian Civilisations Museum, 2016.

Lemire, Beverly. *Cotton.* New York: Berg, 2011.

——. "Domesticating the Exotic: Floral Culture and the East India Calico Trade with England, c. 1600–1800." *Textile: The Journal of Cloth and Culture* 1, no. 1 (March 2003): 64–85.

——. "Fashioning Global Trade: Indian Textiles, Gender Meanings and European Consumers, 1500–1800." In Riello and Roy, *How India Clothed*, 365–89.

——. *Global Trade and the Transformation of Consumer Cultures: The Material World Remade, 1500–1820.* Cambridge: Cambridge University Press, 2018.

Lemire, Beverly, and Giorgio Riello. "East and West: Textiles and Fashion in Early Modern Europe." *Journal of Social History* 41, no. 4 (2008): 887–916.

Lentz, Thomas W., and Glenn D. Lowry. *Timur and the Princely Vision.* Los Angeles: Los Angeles County Museum of Art, 1989.

Lipson, Ephraim. *The History of the Woollen and Worsted Industries.* London: Frank Cass, 1965.

Longfield, Ada K. "History of the Irish Linen and Cotton Printing Industry in the 18th Century." *Journal of Royal Society of Antiquaries of Ireland* 58 (1937): 26–56.

Lopes, Gustavo A., and Maximiliano M. Menz. "Vestindo o escravismo: O comércio de têxteis e o contrato de Angola (século XVIII) / Dressing the Slavery: Textiles, Slaves, and the Contrato de Angola (18th century)." *Revista Brasileira de História* 39, no. 80 (January/April 2019). http://dx.doi.org/10.1590/1806-93472019v39n80-05.

Lyons, Agnes M. M. "The Textile Fabrics of India and Huddersfield Cloth Industry." *Textile History* 27, no. 2 (1996): 172–180.

Mabey, Richard. "Growing Together: The East India Company's Fusion Art." In *The Cabaret of Plants*, 232–38. London: Profile Books, 2015.

Machado, Pedro. *Ocean of Trade: South Asian Merchants, Africa and the Indian Ocean, c. 750–1850.* Cambridge: Cambridge University Press, 2016.

Macky, J. *A Journey through England. In familiar letters. From a gentleman here, to his friend abroad.* London: Printed for J. Pemberton and J. Hooke, 1722.

Madureira, Nuno Luís Monteiro. "Inventários: Aspectos do consumo e da vida material em Lisboa nos finais do Antigo Regime." Master's thesis, Universidade Nova de Lisboa, 1989.

Maeder, Edward F. "A Man's Banyan: High Fashion in Rural Massachusetts." *Historic Deerfield* 1 (Winter 2001), n.p.

Martinsen, Hanna E. H. "Fashionable Chemistry: The History of Printing Cotton in France in the Second Half of the Eighteenth and First Decades of the Nineteenth Century." PhD diss., University of Toronto, 2015.

——. "Kattuntryck: How the Indian Method Was Modified by the European Textile Printers of the 17th and 18th Century." *Garde Robe* (2017): 5–15.

Maurières, Arnaud, Philippe Chambon, and Eric Ossart. *Reines de Saba: Itinéraires textiles au Yemen.* Aix-en-Provence: Edisud, 2013.

Maxwell, Robyn. *Sari to Sarong: 500 Years of Indian and Indonesian Textile Exchange.* Canberra: National Gallery of Australia, 2003.

——. *Textiles of Southeast Asia: Tradition, Trade, and Transformation.* Revised edition. Hong Kong: Periplus Editions, 2003.

Mazzaoui, Maureen Fennell. *The Italian Cotton Industry in the Later Middle Ages, 1100–1600.* Cambridge: Cambridge University Press, 1981.

McGowan, Kaja. "Unfolding the Foreign: Mining for Sacred Maa' in Torajan Local Texts." *Traded Treasure: Indian Textiles for Global Markets,* edited by Ellen B. Avril and Ruth Barnes, 18–31. Ithaca, NY: Herbert F. Johnson Museum of Art and Cornell University, 2019.

McNeil, Peter. "The Appearance of Enlightenment." In *The Enlightenment World*, edited by Martin Fitzpatrick, Peter Jones, Christa Knellwolf, and Iain McCalman, 381–400. New York: Routledge, 2004.

Meeta and Sunny. "Chippas of Rajasthan . . . Bindaas Unlimited." In *Threads & Voices: Behind the Indian Textile Tradition,* edited by Laila Tyabji, 31–43. Mumbai: Marg, 2007.

Menon, Meena, and Uzramma. *A Frayed History: The Journey of Cotton in India.* New Delhi: Oxford University Press, 2017.

Miller, Susan. "Europe Looks East: Ceramics and Silk 1680–1710." In *A Taste for the Exotic: Foreign Influences on Early Eighteenth-Century Silk Designs*, edited by Anna Jolly, 155–74. Riggisberg: Abegg-Stiftung, 2007.

Mohanty, Bijoy Chandra, K. V. Chandramouli, and H. D. Naik. *Natural Dyeing Processes of India.* Ahmedabad: Calico Museum of Textiles, 1987.

Mohanty, Bijoy Chandra, and Jagadish Prasad Mohanty. *Block Printing and Dyeing of Bagru, Rajasthan.* Ahmedabad: Calico Museum of Textiles, 1983.

Molière [Jean-Baptiste Poquelin]. *Le bourgeois gentilhomme, comédie-balet faite à Chambort, pour le divertissement du Roy.* Bibliothèque Nationale de France, Rés. p-Yf-56 (Gallica). Paris, 1671.

Morrell, Anne. *Indian Embroidery: Techniques at the Calico Museum of Textiles; A Working Guide.* Ahmedabad: Sarabhai Foundation, 1999–2003.

Morris, Barbara. "William Morris and the South Kensington Museum." *Victorian Poetry* 13, no. 3/4 (Fall–Winter, 1975): 173–74.

Morris, Frances. "Indian Textiles in the

Exhibition of Painted and Printed Fabrics." *Metropolitan Museum of Art Bulletin* 22, no. 6 (June 1927): 170–72.

Mukerji, Kanika. "Ajit Kumar Das: Using Natural Dyes in Art." *MARG* 65, no. 2 (December 2013): 84–93.

Mukharji, T. N. *Art-Manufactures of India: Specially Compiled for the Glasgow International Exhibition.* Calcutta (Kolkata): Superintendent of Government Print, 1888.

Nabholz-Kartaschoff, Marie-Louise, ed. *Golden Sprays and Scarlet Flowers: Traditional Indian Textiles from the Museum of Ethnography, Basel, Switzerland.* Kyoto: Shikosha, 1986.

Nassu, Willian. "From Chintz to Chita: A Brazilian Textile and the Construction of National Identity." *Textile Society of America 2016 Biennial Symposium Proceedings: Crosscurrents: Land, Labor, and the Port, Savannah, Georgia, October 19–23, 2016,* coordinated by Jessica Smith, Susan Falls, and Liz Sargent, paper 968, 345–54. Lincoln: Digital Commons of University of Nebraska, 2016.

Neich, Roger, and Mick Pendergrast. *Pacific Tapa.* Honolulu: University of Hawai'i Press, 2004.

Nevinson, John L. *Victoria & Albert Museum Catalogue of English Domestic Embroidery.* London: HMSO, 1950.

Noltie, H. J. "The Artists." In *Robert Wight and the Botanical Drawings of Rungiah and Govindoo,* 2:12–21. Edinburgh: Royal Botanic Garden, 2007.

———. "Copying and the Hybridity of Indian Botanical Art." In *Robert Wight and the Botanical Drawings of Rungiah and Govindoo,* 1:31–35. Edinburgh: Royal Botanic Garden, 2007.

———. "Moochies, Gudigars and Other Chitrakars: Their Contribution to 19th-Century Botanical Art and Science." In "The Weight of a Petal: *Ars botanica,*" edited by Sita Reddy. Special issue, *MARG* 70, no. 2 (December 2018–March 2019): 35–43.

Nooy-Palm, Hetty. "The Sacred Cloths of the Toraja: Unanswered Questions." In *To Speak with Cloth: Studies in Indonesian Textiles,* edited by Mattiebelle Gittinger, 163–80. Los Angeles: Museum of Cultural History, University of California, 1989.

———. *The Sa'dan Toraja: A Study of Their Social Life and Religion.* Vol. 1, *Organization, Symbols and Beliefs.* Verhandelingen van het Koninklijk Instituut voor Taal-, Land- en Volkenkunde 87. The Hague: Martinus Nijhoff, 1979.

O'Brien, Dónal, Pamela Sharkey Scott, Ulf Andersson, Tina C. Ambros, and Na Fu. "The Micro-Foundations of Subsidiary Initiatives: How Subsidiary-Manager Activities Unlock Entrepreneurship." *Global Strategy Journal* 9, no. 1 (February 2019): 66–91.

O'Connor, Deryn. "Lapis: Recognising a Colour Phenomenon Found in Some Printed Cottons in Early Nineteenth Century Patchwork." *Quilt Studies* 4 (2003): 7–20.

Official and Descriptive Catalogue of the Madras Exhibit of 1855. East India Papers 219 A. Madras: East India Company, 1855.

Official Report of the Calcutta International Exhibition, 1883–84. Vol. 7. Calcutta: Bengal Secretariat, 1885.

Osumi, Tamezo. *Printed Cottons of Asia: The Romance of Trade Textiles.* Translated by George Saito. Tokyo: Bijutsu Shuppan Sha / C. E. Tuttle, 1963.

Osumi, Tamezo, and Sanzo Wada. *Kowatari sarasa* 古渡更紗. 6 vols. Tokyo: Bijutsu Shuppansha, 1958.

Parry, Linda. *William Morris Textiles.* London: V&A Publishing, 2013.

Parthasarathi, Prasannan. "Cotton Textiles in the Indian Subcontinent." In Riello and Parthasarathi, *Spinning World,* 17–41.

———. *Why Europe Grew Rich and Asia Did Not.* Cambridge: Cambridge University Press, 2011.

Parthasarathi, Prasannan, and Giorgio Riello. "Introduction: Cotton Textiles and Global History." In Riello and Parthasarathi, *Spinning World,* 1–13.

Patel, Divia. *India Contemporary Design: Fashion, Graphics, Interiors.* New Delhi: Roli Books / V&A, 2014.

———. "Textiles in the Modern World." In Crill, *Fabric of India,* 182–233.

Peck, Amelia. "'India Chints' and 'China Taffety': East India Company Textiles for the North American Market." In Peck, *Interwoven Globe,* 104–19.

———, ed. *Interwoven Globe: The Worldwide Textile Trade, 1500–1800.* New York: Metropolitan Museum of Art, 2013. Published in conjunction with an exhibition of the same title, presented at the Metropolitan Museum of Art, 16 September 2013–5 January 2014.

———. "Trade Textiles at the Metropolitan Museum: A History." In Peck, *Interwoven Globe,* 2–11.

Pedreira, Jorge. "Indústria e atraso económico em Portugal, 1800–1825." Master's thesis, Universidade Nova de Lisboa, 1986.

Peers, Laura. "Almost True: Peter Rindisbacher's Early Images of Rupert's Land, 1821–1826." *Art History* 32, no. 3 (June 2009): 516–44.

Penney, David W. "Floral Decoration and Culture Change: An Historical Interpretation of Motivation." *American Indian Culture and Research Journal* 15, no. 1 (1991): 53-77.

Persoz, Jean François. *Traité théorétique et pratique de l'impression des tissus.* 5 vols. Paris: Victor Masson, 1846.

Pfister, R. *Les toiles imprimées de Fostat et l'Hindoustan.* Paris: Les Éditions d'art et d'histoire, 1938.

———. "Tissus imprimées de l'Inde médiévale." *Revue des arts asiatiques* 10 (1936): 161–64.

Phillips, Ruth. *Trading Identities: The Souvenir in Native North American Art from the Northeast, 1700–1900.* Seattle: University of Washington Press; Montreal: McGill–Queen's University Press, 1998.

Phipps, Elena. "New Textiles in a New World: 18th Century Textile Samples from the Viceregal Americas." In *Textile Society of America 2014 Biennial Symposium Proceedings: New Directions; Examining the Past, Creating the Future, Los Angeles, California, September 10–14, 2014,* edited by Ann Svenson, paper 898, 1–15. Lincoln: Digital Commons of University of Nebraska, 2014.

Pires, Tomé. *The "Suma oriental" of Tomé Pires.* Edited by Armando Cortesao. 2 vols. London: Hakluyt Society, 1944.

Pomeranz, Kenneth. *The Great Divergence: China, Europe and the Making of the Modern World Economy.* Princeton: Princeton University Press, 2000.

Posrithong, Prapassorn. *Chintz in Thai History.* Bangkok: OS Printing House, 2018.

———. "Indian Trade Textiles as a Thai Legacy." In *The Sea, Identity, and History: From the Bay of Bengal to the South China Sea,* edited by Satish Chandra and Himanshu Prabha Ray, 329–49. New Delhi: Manohar, 2013.

Pouliot, Sarah. Notebook. Summer 1979 and 1985. In the author's possession.

———. Scrapbook. Private collection. In the author's possession.

"Prix décennaux fondés pour Napoleon." In *La pochette Berthollet (le Comte Claude Louis) dossier manuscrits,* 71–76. Paris: Archive de l'Académie des sciences.

Pyke, Susan. "Trading Gifts: Cross-Cultural Exchange in Tahiti." *Pacific Island Focus* 1, no. 2. Laie, Hawaii: Institute for Polynesian Studies, Brigham Young University, Hawaii Campus, 1989.

Q[uarelles], Monsieur. *Traité sur les toiles peintes dans lequel on voit la manière dont on les fabrique aux Indes, & en Europe.* Amsterdam, 1760.

Racette, Sherry Farrell. "My Grandmothers Loved to Trade: The Indigenization of European Trade Goods in Historic and Contemporary Canada." *Journal of Museum Ethnography* no. 20 (2008): 69-81.

Raj, Kapil. "Jardin de Lorixa." In "The Weight of a Petal: Ars botanica," edited by Sita Reddy. Special issue, *MARG* 70, no. 2 (December 2018–March 2019), 52–53.

Rau, Virgínia. *O livro de rezão de António Coelho Guerreiro.* Lisbon: Companhia de Diamantes de Angola, 1956.

Raveux, Olivier. "Du commerce à la production: L'indiennage européen et l'acquisition des techniques asiatiques au XVIIe siècle." In Jacqué and Nicolas, *Féerie indienne,* 22–25.

Ray, Himanshu Prabha. "Warp and Weft: Producing, Trading and Consuming Indian Textiles across the Seas (1st–13th centuries)." In *An Ocean of Cloth: Textile Trades, Consumer Cultures and the Textile Worlds of the Indian Ocean,* edited by Pedro Machado, Sarah Fee, and Gwyn Campbell, 289–311. Cham, Switzerland: Palgrave Macmillan, 2018.

Reddy, Sita. "*Ars botanica*: Refiguring the Botanical Art Archive." In "The Weight of a Petal: *Ars botanica*," edited by Sita Reddy. Special issue, *MARG* 70, no. 2 (December 2018–March 2019), 15–21.

Ribeiro, Aileen. *Dress in Eighteenth-Century Europe, 1715–1789*. London: B. T. Batsford, 1984.

Riello, Giorgio. "Asian Knowledge and Development of Calico Printing in Europe in the Seventeenth and Eighteenth Centuries." *Journal of Global History* 5, no. 1 (2010): 1–28.

——. *Cotton: The Fabric That Made the Modern World*. Cambridge: Cambridge University Press, 2013.

——. "The Globalization of Cotton Textiles: Indian Cottons, Europe and the Atlantic World, 1600–1850." In Riello and Parthasarathi, *Spinning World*, 261–87.

——. "The Indian Apprenticeship: The Trade of Indian Textiles and the Making of European Cottons." In Riello and Roy, *How India Clothed*, 309–46.

——. "Luxury or Commodity? The Success of Indian Cotton Cloth in the First Global Age." In *Luxury in Global Perspective: Objects and Practices, 1600–2000*, edited by Karin Hofmeester and Bernd-Stefan Grewe, 138–68. New York: Cambridge University Press, 2016.

Riello, Giorgio, and Prasannan Parthasarathi, eds. *The Spinning World: A Global History of Cotton Textiles, 1200–1850*. Oxford: Oxford University Press, 2009.

Riello, Giorgio, and Tirthankar Roy, eds. *How India Clothed the World: The World of South Asian Textiles, 1500–1850*. Leiden: Brill, 2009.

Rømer, Ludvig Ferdinand. *A Reliable Account of The Coast of Guinea (1760)*. Translated by Selena Axelrod Winsnes. New York: Diaspora Africa, 2013.

Ronald, Emma. *Balotra: The Complex Language of Print*. Jaipur: Anokhi Museum of Hand Printing, 2007.

Roques, Georges. *La manière de négocier aux Indes: 1676–1691, la compagnie des Indes et l'art du commerce*. Annotated by Valérie Bérinstain. Paris: Maisonneuve et Larose, 1996.

Rothstein, Natalie, ed. *Barbara Johnson's Album of Fashions and Fabrics*. London: Thames and Hudson, 1987.

Rouffaer, G. P., and H. H. Juynboll, eds. *De batikkunst in Nederlandsch-Indie en haar geschiedenis*. Utrecht: A. Oosthoek, 1914.

Royle, J. Forbes. "The Art and Manufactures of India." In *Lectures on the Results of the Great Exhibition of 1851*, edited by Royal Society of Art, 441–538. London: D. Bogue, 1851.

——. *On the Culture and Commerce of Cotton in India and Elsewhere: With an Account of the Experiments Made by the Hon. East India Company Up to the Present Time*. London: Smith, Elder, 1851.

Ryan, Mackenzie Moon. "A Decade of Design: The Global Invention of the Kanga, 1876–1886."

Textile History 48, no. 1 (2017): 101–32.

Sachiko, Shoji. "Are National Costumes Trade Textiles? An Introduction to *Sarasa* and Africa." In *Ages of Sarasa*, edited by Iwanaga Etsuko and Shoji Sachiko, 41–47. Fukuoka-shi: Fukuoka-shi Bijutsukan, 2014.

Samad Ahmad, Abdul. *Sejarah Melayu*. Kuala Lumpur: Dewan Bahasa dan Pustaka, 1979.

Sangar, Satya Prakash. *Indian Textiles in the Seventeenth Century*. New Delhi: Reliance, 1998.

Sardar, Marika. "A Seventeenth-Century *Kalamkari* Hanging at the Metropolitan Museum of Art." In *Sultans of the South: Arts of India's Deccan Courts, 1323–1687*, edited by Navina Najat Haidar and Marika Sardar, 148–61. New York: Metropolitan Museum of Art, 2011.

——. "Silk along the Seas: Ottoman Turkey and Safavid Iran in the Global Textile Trade." In Peck, *Interwoven Globe*, 66–81.

Satō, Rumi et al. *Kowatari sarasa: Edo o someta Indo no hana/Sarasa; Flowers of the Textile Trade, the Gotoh Museum*. Tokyo: Goto Bijutsukan [Gotoh Museum], 2008. Published in conjunction with an exhibition of the same title, presented at the Gotoh Museum, 25 October–30 November 2008.

Schneider, Jane. "Rumpelstiltskin's Bargain: Folklore and the Merchant Capitalist Intensification of Linen Manufacture in Early Modern Europe." In *Cloth and Human Experience*, edited by Annette B. Weiner and Jane Schneider, 177–213. Washington, DC: Smithsonian Books, 1989.

Schoeser, Mary. "The Mystery of the Printed Handkerchief." In *Disentangling Textiles: Techniques for the Study of Designed Objects*, edited by Mary Schoeser and C. Boydell, 13–22. London: Middlesex University Press, 2002.

Schwartz, Paul R. Appendices A–C in Irwin and Brett, *Origins of Chintz*, 36–58.

——. "Contribution à l'histoire de l'application de bleu d'indigo (bleu Anglaise) dans l'indiennage européen." *Bulletin société industrielle de Mulhouse* 2 (1953): 63–79.

——. "French Documents on Indian Cotton Painting II: New Light on Old Material." *Journal of Indian Textile History* 4 (1957): 15–44.

——. *Printing on Cotton at Ahmedabad, India in 1678*. Ahmedabad: Calico Museum of Textiles, 1969.

Schwartz, Paul R., and Katharine B. Brett. Introduction and preface to *Collection de toiles peintes d'H. Wearne*, by Harry Wearne. Mulhouse: MISE, 1966. Published in conjunction with an exhibition of the same title, presented at the Musée de l'Impression sur Etoffes de Mulhouse, May–October 1966.

Sekimoto, Teruo. "Batik as a Commodity and Cultural Object." In *Globalization in Southeast Asia: Local, National and Transnational Perspectives*, edited by Shinji Yamashita and J.S. Eades (New York: Berghann Books), 111–25.

Sennett, Richard. "The Hand." In *The Craftsman*, 149–78. New Haven, CT: Yale University Press, 2008.

Shah, Deepika, ed. *Masters of the Cloth: Indian Textiles Traded to Distant Shores; TAPI Collection*. Surat: Garden Silk Mills; New Delhi: National Museum, 2005. Published in conjunction with an exhibition of textiles from the TAPI (Textiles and Art of the People of India) Collection, National Museum of India, 10 November 2005–18 December 2006.

Sims, Eleanor, Boris I. Marshak, and Ernst J. Grube. *Peerless Images: Persian Painting and Its Sources*. New Haven, CT: Yale University Press, 2002.

Singh, Chandramani. *Textiles and Costumes from the Maharaja Sawai Man Singh II Museum*, Jaipur: Maharaja Sawai Man Singh II Museum Trust, 1979.

Singh, Kavita. *Real Birds in Imagined Gardens: Mughal Painting between Persia and Europe*. Los Angeles: Getty Research Institute, 2017.

Skidmore, Suki, and Emma Ronald, eds. *Sanganer: Traditional Textiles, Contemporary Cloth*. Jaipur: Anokhi Museum of Hand Printing, 2009.

Smith, George Vinal. *The Dutch in 17th Century Thailand*. Special report of Northern Illinois University, Center for Southeast Asian Studies, no. 16. Detroit: DeKalb, 1977.

Spink, Walter M. *Ajanta: History and Development*. Leiden: Brill, 2005.

Stalpaert van der Wiele, Cornelis. *Informatie van diverse landen en eylanden gelegen naer Oost-Indiën om aldaer bequamelick te handelen ende wat coopmanschap daer valt en daer best getrocken is*. In Rouffaer and Juynboll, *De batikkunst*, xii, app. 3.

Stearn, W. T. "An Introduction to the *Species Plantarum* and Cognate Botanical Works of Carl Linnaeus: I. Nomenclatural Importance of the *Species Plantarum*." In Carl Linnaeus, *Species Plantarum*, 1:1–176. London: Ray Society, 2013. Facsimile of 1753 edition, London.

Stent, Peter. *A Book of Flowers, Fruits, Beasts, Birds, and Flies: Seventeenth-Century Patterns for Embroiderers*. Austin: Curious Works, 1995.

Stewart, Kristin. "Dress and Fichu." In Peck, *Interwoven Globe*, 234–35.

Sowerby, James. *English botany; Or, Coloured Figures of British Plants, With Their Essential Characters, Synonyms, and Places of Growth: To Which Will Be Added Occasional Remarks*, vol.xi. London: Printed for the author, by J. Davis, 1800.

Styles, John. *The Dress of the People: Everyday Fashion in Eighteenth Century England*. New Haven, CT: Yale University Press, 2008.

——. *Threads of Feeling: The London Foundling Hospital's Textile Tokens, 1740–1770*. London: Foundling Museum, 2010.

Swain, Margaret H. "Nightgown into Dressing Gown: A Study of Mens' Nightgowns Eighteenth Century." *Costume* 6 (1972): 10–21.

Swallow, Deborah. "The India Museum and the British-Indian Textile Trade in the Late Nineteenth Century." *Textile History* 30, no. 1 (1999): 29–45.

Swarnalatha, P. *The World of the Weaver in Northern Coromandel, c. 1750–1850.* New Delhi: Orient Longman, 2005.

Sykas, Philip A. "Fustians in Englishmen's Dress: From Cloth to Emblem." *Costume* 43 (2009): 1–18.

Synge, Lanto. *Art of Embroidery: History of Style and Technique.* Woodbridge, Suffolk: Antique Collectors Club, 2001.

Taylor, George W. "A Jouy Calico Print Using Chay Root." *Dyes in History and Archaeology* 9 (1990): 32–34.

Thomas, Nicholas. "The Case of the Misplaced Ponchos: Speculations Concerning the History of Cloth in Polynesia." In *Clothing the Pacific,* edited by Chloë Colchester, 79–96. Oxford. Berg, 2003.

Thomas, Parakunnel J. "The Beginnings of Calico Printing in England." *English Historical Review* 39, no. 154 (April 1924): 206–16.

———. *Mercantilism and the East India Trade.* London: Frank Cass, 1963. First published 1926.

Thomson, James K. J. *A Distinctive Industrialization: Cotton in Barcelona 1728–1832.* Cambridge: Cambridge University Press, 1992.

———. "Explaining the 'Take-Off' of the Catalan Cotton Industry." *Economic History Review,* n.s., 58, no. 4 (November 2005): 701–35.

Thunder, Moira. "Object in Focus: Man's Banyan." Unpublished manuscript. PDF file. http://www.fashioningtheearlymodern.ac.uk/wordpress/wp-content/uploads/2012/02/Banyans-21.pdf.

Thurston, Edgar. "The Cotton Fabric Industry of the Madras Presidency." *Journal of Indian Art and Industry* 7, nos. 59/60 (1897): 20–24, 25–32.

Tillotson, Giles. *Jaipur Nama: Tales from the Pink City.* New Delhi: Penguin Books India, 2006.

The Trade of England Revived: and the Abuses Thereof Rectified, in Relation to Wooll and Woollen-cloth, Silk and Silk-weavers, Hawkers, Bankrupts, Stage-coaches, Shopkeepers, Companies, Markets, Linnen-cloath, Etc. London: Printed for Dorman Newman, 1681.

Trentmann, Frank. *Empire of Things: How We Became a World of Consumers from the Fifteenth Century to the Twenty-First.* London: Penguin Books, 2017.

Ulrich, Pamela V. "From Fustian to Merino: The Rise of Textiles Using Cotton before and after the Gin." *Agricultural History* 68 (1994): 219–31.

Van Dijk, Toos, and Nico de Jonge. "Bastas in Babar: Imported Asian Textiles in a South-East Moluccan Culture." In *Indonesian Textiles: Symposium 1985,* edited by Gisela Völger and Karin von Welck, 18–33. Ethnologica NF 14. Cologne: Rautenstrauch-Joest-Museum, 1991.

Varadarajan, Lotika. *Ajrakh and Related Techniques: Traditions of Textile Printing in Kutch.* Ahmedabad: New Order Book, 1983.

———. *South Indian Traditions of* Kalamkari. Ahmedabad: National Institute of Design; Bombay (Mumbai): Perennial Press, 1982.

Verley, Patrick. "Indiennes des Indes, indiennes d'Europe." In *Indiennes, un tissu revolutionne le monde!,* edited by Helene Bieri Thomson, Bernard Jacqué, Jacqueline Jacqué, and Xavier Petitcol, 13–26. Lausanne: La Bibliothèque des Arts, 2018.

Viana, Mário, ed. *Arquivo dos Açores.* 2nd ser. Vol. 1. Ponta Delgada: Centro de Estudos Atlânticos Gaspar Frutuoso / Universidade dos Açores, 1999.

Vicente, Marta V. *Clothing the Spanish Empire.* New York: Palgrave Macmillan, 2006.

Vogelsang-Eastwood, Gillian M. *Resist Dyed Textiles from Quseir al-Qadim, Egypt.* Paris: AEDTA, 1990.

Vollmer, John, E. J. Keall, and E. Nagai-Berthrong. *Silk Roads, China Ships.* Toronto: Royal Ontario Museum, 1983.

Von Ranke, Leopold. *History of the Prussian Monarchy.* Translated by F. C. F. Demmler. London: T. C. Newby, 1847.

Wagner, Peter. "Flower Gardens, Flower Fashions and Illustrated Botanical Works: Observations on Fashion from a Botanist's Point of View." In *Flowers into Art: Floral Motifs in European Painting and Decorative Arts,* edited by Vibeke Woldbye, 9–23. The Hague: SDU, 1991.

Watson, Andrew M. "The Rise and Spread of Old World Cotton." In *Studies in Textile History,* edited by Veronika Gervers, 355–68. Toronto: Royal Ontario Museum, 1977.

Watson, John Forbes. *The Textile Manufactures of India.* 1st ser. 18 vols. London: South Kensington Museum, 1866.

———. *The Textile Manufactures and the Costumes of the People of India.* London: G. E. Eyre and W. Spottiswoode, 1866.

[Watson, John Forbes, obituary]. *Journal of Indian Art* 23 (July 1888): n.p.

Watt, George, ed. *Indian Art at Delhi, 1903: Being the Official Catalogue of the Delhi Exhibition, 1902–1903.* Calcutta (Kolkata): Superintendent of Government, 1903.

———. "Vegetable Resources of India." *Bulletin of Miscellaneous Information, Royal Gardens, Kew* 93 (September 1894): 315–28.

Watt, Melinda. "Coif." In Peck, *Interwoven Globe,* 153–54.

———. "Textile with Pheasants and Exotic Flowers." In Peck, *Interwoven Globe,* 211–12.

———. "'Whims and Fancies': Europeans Respond to Textiles from the East." In Peck, *Interwoven Globe,* 82–103.

Wearden, Jennifer. "The Saz Style." *Hali* 30 (1986): 22–29.

Wendt, Ian. "Four Centuries of Decline? Understanding the Changing Structure of the South Indian Textile Industry." In *How India Clothed the World,* edited by Giorgio Riello and Tirthankar Roy, 193–215. Leiden: Brill, 2009.

Wheeler, Monroe, Pupul Jaykar, and John Irwin. *Textiles and Ornamental Arts of India.* New York: Museum of Modern Art, 1955.

Whitcomb, Donald, and Janet H. Johnson. *Quseir al-Qadim 1978: Preliminary Report.* Cairo: American Research Center in Egypt, 1979.

———. *Quseir al-Qadim 1980: Preliminary Report; American Research Center in Egypt Report 7.* Malibu, CA: Undena, 1982.

Widmer, Gottlieb. "Mémorial de la manufacture de Jouy." Unpublished manuscript, 1854. Typescript transcription at the Musée de la Toile de Jouy.

Wigston Smith, Chloe. "'Callico Madams': Servants, Consumption, and the Calico Crisis." *Eighteenth-Century Life* 31, no. 2 (2007): 29–55.

Wolley, Hannah. *The Queen-Like closet, or Rich Cabinet: Stored With All Manner of Rare Receipts for Preserving, Candying and Cookery. Very Pleasant and Beneficial to All Ingenious Persons of the Female Sex. To Which is Added, A Supplement, Presented to All Ingenious Ladies, and Gentlewomen.* London: Printed for Richard Lowndes at the White Lion in Duck-Lane, near West-Smithfield, 1675.

Wood, Frances A., and George A. F. Roberts. "Natural Fibers and Dyes." In *The Cultural History of Plants,* edited by Sir Ghillean Prance and Mark Nesbitt, 287–313. New York: Routledge, 2012.

Woodforde, Rev. James. *The Diary of a Country Parson, 1758–1802.* Edited by John Beresford. 5 vols. London: H. Milford: Oxford University Press, 1924–31.

Wronska-Friend, Maria. *Batik Jawa Bagi Dunia = Javanese Batik to the World.* Jakarta: Indonesian Cross-cultural community, 2016.

Wu, Jiang. *Leaving for the Rising Sun: Chinese Zen Master Yinyuan and the Authenticity Crisis in Early Modern East Asia.* Oxford: Oxford University Press, 2015.

Yokoyama, Manabu 横山學, and Ayano Hachiya 蜂谷綾乃. "Sarasabon shohon no kenkyū" 更紗本諸本の研究 [A study on various versions of Japanese batik design books, 1778 to 1808]. *Seikatsu bunka kenkyūjo nenpō* 27 (2014): 91–192.

Yoshioka, Tsuneo, and Shinobu Yoshimoto. *Sekai no Sarasa* 世界の更紗: *Sarasa of the World; Indian Chintz, European Print, Batik, Japanese Stencil.* Kyoto: Kyoto Shoin, 1980.

INDEX

CONTRIBUTORS

Sarah Fee is Senior Curator of Fashion & Textiles, Royal Ontario Museum. Her publications examine textile making and trade in the western Indian Ocean; she co-edited *Textile Trades, Consumer Cultures and the Material Worlds of the Indian Ocean* (2018).

Steven Cohen is an independent textile historian specializing in the carpets and textiles of the Indian subcontinent. Among his publications are *Trade, Temple and Court* (2002) and *Kashmir Shawls: The Tapi Collection* (2012).

Alexandra Palmer Nora E. Vaughan Senior Curator, Royal Ontario Museum, oversees more than 44,000 artifacts in the collection of western fashionable dress and textiles. She has curated and written award-winning exhibitions and publications.

Giorgio Riello is Chair of Early Modern Global History at the European University Institute in Florence, Italy. Giorgio is the author of *Cotton: The Fabric that Made the Modern World* (2013); and *Back in Fashion* (2020).

Rajarshi Sengupta Rajarshi Sengupta is an art practitioner, researcher, and a PhD candidate in art history at the University of British Columbia, and the first recipient of the IARTS Textiles of India Grant (2017).

Renuka Reddy's work experiments with the possibilities of producing 18th-century-quality today. Her work is part of permanent collections at the Fries Museum, the Kiran Nadar Museum of Art, and the TAPI Collection.

Peter Lee is an independent scholar and the Honorary Curator of the NUS Baba House. Since 1998 he has curated numerous textile and photography exhibitions. His book *Sarong Kebaya: Peranakan Fashion in an Interconnected World* (2014) was shortlisted for the Singapore History Prize, 2018.

Deborah Metsger is Assistant Curator of Botany at the Royal Ontario Museum. She frequently identifies botanical motifs on decorative arts objects and speaks to the role of plants at the intersection of science and culture.

Philip Sykas is a Reader in Textile History at Manchester Metropolitan University. Specialising in printed textiles, he explores the relationship of technology to design, production and marketing during the long nineteenth century through object-based methods.

Eiluned Edwards Eiluned Edwards's research focuses on Indian textiles, fashion and craft development, and examining the role of state-agencies, NGOs, and entrepreneurs. Her books include *Block Printed Textiles of India* (2016) and *Textiles and Dress of Gujarat* (2011).

Rosemary Crill was formerly Senior Curator for South Asia at the Victoria & Albert Museum, London. Her books include *Indian Embroidery, Marwar Painting, Indian Ikat Textiles, Chintz: Indian Textiles for the West* and *The Fabric of India*.

Joao Teles e Cunha is Professor at the Institute of Oriental Studies and is member of Centro de Estudos Clássicos (University of Lisbon). Economic history of the Indian Ocean and the cultural entanglement of Portugal with the Persian Gulf and South Asia are two areas of his present research.

Max Dionisio Ph.D., MISt, is Librarian of the Bishop White Committee Library of East Asia at the ROM and Adjunct Professor at the University of Toronto's iSchool. He researches Japanese bibliography and Japanese Christian iconography.

Hanna E. H. Martinsen began as a Textile Arts and Crafts Teacher. She has a degree in Textile Engineering and a Master's in Art History specializing in textiles. Her PhD dissertation addresses the science and technology of textile printing on cotton during the 17th and early-18th centuries.

Divia Patel is a Senior Curator in the Asian Department of the Victoria and Albert Museum, London. She specializes in aspects of 19th to 21st century art, design, fashion, popular culture, and photography from South Asia.

Ruth Barnes Ruth Barnes is the Thomas Jaffe Curator of Indo-Pacific Art at the Yale University Art Gallery. Her recent book, *Five Centuries of Indonesian Textiles*, co-edited with Mary Kahlenberg, received the Textile Society of America's R. L. Shep Award in 2010.

Maria Joao Ferriera is an Art Historian Researcher at CHAM – FCSH/NOVA - Uac. Her studies focus on Asian Textiles for export and their consumption in Portugal during the early modern period.

Sylvia Houghteling is Assistant Professor of History of Art at Bryn Mawr College. She has published in *Ars Orientalis, Marg*, and *The Textile Museum Journal*. Her book, *The Art of Cloth in Mughal India*, is forthcoming.

Deepali Dewan is the Dan Mishra Curator of South Asian Art and Culture, Royal Ontario Museum and affiliated faculty at the University of Toronto. Her research examines colonial, modern, and contemporary visual culture of South Asia and its Diasporas, with a focus on photography and historiography.

Cloth That Changed the World: The Art and Fashion of Indian Chintz was published in conjuction with the exhibition *The Cloth That Changed the World: India's Printed and Painted Cottons* held at the Royal Ontario Museum from April 4 to September 27, 2020.

Published by the Royal Ontario Museum with the generous support of the Louise Hawley Stone Charitable Trust. The Stone Trust generates significant annual funding for the Museum, providing a steady stream of support that is used to purchase new acquisitions and to produce publications related to the ROM's collection. The Louise Hawley Stone Charitable Trust was established in 1998 when the ROM received a charitable trust of nearly $50 million—the largest cash bequest ever received by the Museum—by its long-time friend and supporter, the late Louise Hawley Stone (1904-1997).

Library and Archives Canada Cataloguing in Publication

Title: Cloth That Changed the World: The Art and Fashion of Indian Chintz / edited by Sarah Fee.
Names: Royal Ontario Museum, host institution, publisher. | Fee, Sarah, 1963- editor.
Description: Complements an exhibition held at the Royal Ontario Museum from April 4, 2020 to September 27, 2020.
Includes bibliographical references and index.
Identifiers: Canadiana 2019020026X
Subjects: LCSH: Chintz—India—History—Exhibitions. | LCSH: Textile fabrics—India—History
Classification: LCC NK8976.A1 R69 2019 | DDC 746.60954—dc23
ISBN 9780300246797
Library of Congress Control Number: 2019952310

Manager, Publishing: Sheeza Sarfraz

Senior Designer: Tara Winterhalt

Editor: Carla DeSantis

Proofreaders: Barbara Czarnecki and Anne Holloway

ROM objects photographed by Brian Boyle and Tina Weltz.

Photo Credits:
ii: ROM2018-057. **vi, viii, xii:** Photograph by Tim McLaughlin, Maiwa. **xvi:** ROM 934.4.49, ROM 939.24.2, ROM 962.118.1, ROM 2017.68.1.13. **1:** ROM 2017.68.1.3, ROM 2017.68.1.8, ROM 2017.68.1.11, ROM 2017.68.1.13. **47–48:** ROM 959.112. **156:** Left: ROM 934.4.447.B, Right: Photographs and Prints Division, Schomburg Center for Research in Black Culture, The New York Public Library. **226–227:** #blockblackwhite Collection, 2017; courtesy of Abraham & Thakore. **276:** ROM 934.4.15.A–B. **293:** Photograph by Tim McLaughlin.

Distributed by
Yale University Press
302 Temple Street
P.O. Box 209040
New Haven, CT 06520-9040
yalebooks.com/art
Printed and bound in Canada.

The Royal Ontario Museum is an agency of the Government of Ontario.